Great Themes in Art

E. JOHN WALFORD

WHEATON COLLEGE, ILLINOIS

Prentice
Hall

Upper Saddle River, New Jersey 07458

To Maria, Sam and Ginger, Deborah, David and Aimee, in loving appreciation for your loyal support.

Cover:
Claude Monet, *Wild Poppies*. 1873. Musée du Louvre, Paris

Library of Congress Cataloging-in-Publication Data

Walford, E. John, 1945–
 Great themes in art / E. John Walford.
 p. cm.
 Includes bibliographical references and index.
 ISBN 0-13-030297-X
 1. Art–History. 2. Humanism in art. I. Title.

N5300 .W165 2001
709–dc21

2001036840

VP/Editorial Director: Charlyce Jones Owen
Publisher: Bud Therien
Editor-in-chief, development: Susanna Lesan
Development Editor: Roberta Meyer
Assistant Editor: Kimberly Chastain
Editorial Assistant: Wendy Yurash
Marketing Director: Beth Gillett
Marketing Manager: Sheryl Adams

© 2002 by Prentice-Hall, inc
A Division of Pearson Education
Upper Saddle River, N.J. 07458

Printed in China
10 9 8 7 6 5 4 3 2 1

This book was designed and produced by
Calmann & King Ltd, London
www.calmann-king.com

Editor: Kara Hattersley-Smith
Map editor: Eugene Fleury
Designer: Cara Gallardo, Area
Picture researcher: Juliet Brightmore

Table of Contents

Preface

I have written this book for those seeking an introduction to art and art history that emphasizes the connections between art and human values. My basic approach involves a combined chronological and thematic structure that focuses on artistic responses to human experience as it both recurs and changes through time.

When I was a student in art history, the standard texts analyzed the stylistic changes represented by great works of art. They explained how to differentiate the style of the drapery folds in Romanesque and Gothic sculpture; they elaborated on the stylistic differences between Rubens and Rembrandt. But I and my fellow students were often left wondering, so what? What was the larger human significance of these differences?

My professors, on the other hand, introduced a methodology of art analysis that encouraged us to look for the links between the artistic form, expressive content, and social contexts of art. Always, we were made aware of the values and meaning embodied in art and architecture, as also manifest through the process of stylistic change. This led to the satisfying discovery that artists vividly express humanity's deepest-held values, desires, hopes, and fears, and that buildings, beyond their formal "textbook" qualities, also serve practical functions, and convey potent symbolic meaning within the larger social fabric of cities and communities. The twentieth-century German artist Max Beckmann has, perhaps, expressed art's significance as well as anyone: "all important things in art... have always originated from the deepest feelings about the mystery of Being... . It is the quest of our self that drives us along the eternal and never-ending journey we must all make." The joy of sharing such insights with my students inspired this book.

Organization of *Great Themes in Art*

Most introductory texts have not changed since my student days. They still present art by examining successive styles as they unfold chronologically. Others focus on media, techniques, and design principles. Both approaches isolate art from its larger social contexts—from the dominant values and ideas of the culture that inspired it.

This book seeks to address that imbalance by uniting these two approaches with a thematic structure. *Great Themes* moves chronologically through the periods and styles of Western art, relating stylistic and technical changes to the social and intellectual context of the period. Introductory sections to each chapter set the stage for students to understand how works of art express the key values, insights, and aspirations of their makers, patrons, and the surrounding culture. Following each introduction, works of art from the period are grouped and discussed within four themes, each representing a major dimension of human experience. The themes are followed by a "Parallel Cultures" section typically looking at art produced outside the Western cultural tradition.

Spirituality examines artists' expressions of religious faith, spiritual aspirations, and humanity's place in the universe. A wide range of works introduces students to artists' changing responses to this universal, powerful dimension of human life. Students will also see how religious art reflects the powerful and changing role of the Christian Church in Western culture.

The Self encompasses works that express social and political values. In these sections, we consider artists' perceptions of themselves and others—as well as their expressions of the way others wish to be perceived. Students will discover art that projects and enhances royal and aristocratic power and vanity; art that reflects on middle class domestic life; art that constructs and reinforces gender roles; and art that explores humanity's search for meaning in an uncertain world. The final chapters introduce students to artists' expressions of outrage and despair in the years after two world wars. Students will also encounter artists' reactions to the consumer culture of the post-war years and the power of the media to shape our perceptions of reality.

Nature Nature's power both to sustain life and to destroy it, to soothe and to terrify, has been expressed by artists since prehistoric times. Each chapter discusses artworks—including landscape design—that reflect the significance of the natural world and our changing relationship to it.

The City The fourth thematic section of each chapter focuses on the design of cities as they symbolize the values of civic leaders and influence citizens' social relationships. After reading these sections, students who travel will recognize that the buildings and streets that comprise a city—its layout, its public monuments, and open spaces—reflect and shape the social hierarchies of its citizens and express the priorities of civic leaders and rulers.

Parallel Cultures In *The Buried Mirror*, Mexican writer Carlos Fuentes wrote: "People and their cultures perish in isolation, but they are born or reborn in contact with other men and women, with men and women of another culture, another creed, another race. If we do not recognize our humanity in others, we shall not recognize it in ourselves" (1992, p. 353). This has been exactly my experience with art and with life. Art has helped me to discover what it means to be a human being, connecting me to others; so, too, have my personal "cross-cultural" experiences. Born and educated in Britain, I received my undergraduate education in Holland, married an Italian, and ultimately moved to the U.S. All of these experiences have stretched my self-awareness, forced me to reflect on attitudes and beliefs that I had assumed were universal, but discovered were not always shared, even within Western culture.

Out of these experiences came the commitment to including "Parallel Cultures" sections as a means to open a window onto other

cultures. Works of art are discussed within the context of the culture in which they were produced, then contrasted to Western art of the same period. Thus, a Chinese landscape painting or a Buddhist monastery is discussed on its own terms, then briefly contrasted to Western designed landscapes or religious architecture presented earlier in the chapter. Such an approach, I hope, will encourage students to understand the Western tradition as but one among many artistic expressions of humankind's shared concerns and aspirations. In all such artistic expressions, we can find a mirror image of our own selves.

Continuity and Change

The chronological structure of *Great Themes in Art* ensures that all art works are considered within the contexts that provided their inspiration, meaning, and purpose. Each theme appears in the same sequence in each chapter, so the reader can follow and compare artists' responses to humanity's enduring concerns from one historical period to the next. Students can also compare artists' responses across broad themes within the same period. Throughout the text, cross-references draw attention to contrasting approaches to similar themes and highlight the links between changes of outlook and styles.

I hope that such an approach will enable the reader to make stronger connections between art forms and the larger human issues that artists in each historical period and place have confronted. In this way, artistic form may be appreciated in relation to both its expressive and social contexts.

Features

"Materials and Techniques" boxes presenting specific artistic materials and techniques appear at the points where they first become relevant, with diagrams to help students understand technical processes. This approach is designed to integrate discussion of materials and techniques within the larger context of art's functions. Since modern assumptions about the role of artists do not necessarily apply to the past, in a series of boxes titled "The Artist," we describe the changing role of the artist in society. Where appropriate, as well, boxes discuss the characteristic symbols seen in works of art and the ideas that shaped artists' understanding of life during that period.

It is hoped that this thematic and integrative method of organization will enable any reader to make the connections between the rich and varied art forms created over the centuries and the common human concerns that inspired them. After reading this book, it is hoped that a greater appreciation will be gained of the wealth of insight that artists have offered and continue to offer, not only to our eyes but also to our whole selves.

Acknowledgments

A book of this scope necessarily draws from the wisdom and writings of many scholars, too numerous to name individually, whose works are listed in the bibliography. However, I would like to acknowledge specifically my debt to my professors at the Vrije Universiteit, Amsterdam, especially C. A. van Swigchem and the late Hans Rookmaaker, who introduced me to the methodology of art history that first inspired the perspective of this book, to Graham Birtwistle, also of the Vrije Universiteit, for his introduction to modern art, as well as to the late Michael Jaffé, former Director of the Fitzwilliam Museum, Cambridge, for his wise tutelage.

A textbook such as this also results from the efforts of a large team of people, contributing their particular skills and expertise at different stages. Among these, some deserve special mention. In particular, I gratefully acknowledge the assistance of Cherith Lidfors Lundin, who researched and wrote the first draft of most of the "Materials and Techniques" boxes, and also prepared the glossary. Early on, Ruth Alldridge and Matthew Lundin gave helpful input from a student's perspective, and my brother-in-law, Colin McCorquodale, gave that of the informed general reader. James Romaine provided timely suggestions for coverage of contemporary art, and Cheryl Seefeldt assisted with research. My special thanks also to Karen Halvorsen Schreck and Blossom Wrede for critiquing my prose in early drafts. I am also indebted to the reviewers for Prentice Hall, Inc., whose many valuable suggestions brought greater clarity and precision to the text: Steve Arbury, Radford University; Roger J. Crum, University of Dayton; David Darst, Florida State University; Carroll Gibbons, Lake Land College; John Hutton, Trinity University; Charles W. Johnson, University of Richmond; Louise Lewis, California State Universiy–Northridge; Lily Mazurek, Nova Southeastern University; Jerry D. Meyer, Northern Illinois University; Sharon K. Tetley, University of Idaho; Frederick J. Zimmerman, SUNY–Cortland; Harold Zisla, Indiana University, South Bend.

I would never have begun this book, but for the tenacious prodding of Mary Choi, nor would it have come to fruition without the vision, trust, and patience of Norwell "Bud" Therien, Jr., both of Prentice Hall. But the hard task of reining me in fell to Roberta Meyer at Prentice Hall, who endured my stubbornness with grace and spared the reader many circuitous trains of thought. For this and more, I am deeply grateful. I am also deeply indebted to Kara Hattersley-Smith of Calmann & King, Ltd., for her detailed suggestions for improving the text, as well as for her capable leadership of the design and production team at Calmann & King, including designer Cara Gallardo and picture researcher Juliet Brightmore. My thanks also to Michael Bird for the sharp mind he brought to copyediting, to Gerald Lombardi whose editing added clarity to several chapters, and to Sheryl Adams at Prentice Hall for her marketing insights and initiatives. Wendy Yurash provided efficient and good humored administrative assistance.

Finally, a textbook author soon discovers the need for support of patient colleagues, encouraging friends, and loving family members to maintain sanity through a long and grueling process. I have been blessed on all three fronts. My colleagues at Wheaton College, Greg Schreck, Joel Sheesley, Alva Steffler, and Jeff Thompson have enlarged my understanding of art and endured my distractions— with special thanks to Alva Steffler for checking the "Materials and Techniques" boxes. I have also benefited greatly from the encouragement and advice of Mark Amstutz, Robb Cooper, Em Griffin, Bruce Howard, and Mark Noll, as well as enjoying the support of Dean George Arasimowicz, and, before him, Ward Kriegbaum. Above all, this book could not have been completed without the backing of my family, whose loving care and loyalty are my sustaining inspiration. My mother magnanimously accommodated a hectic production schedule by tenaciously clinging to life at a critical juncture, and so it is to her, my wife Maria, to Sam and Ginger, Deborah, David and Aimee that *Great Themes in Art* is gratefully dedicated.

E. John Walford, Wheaton, Illinois, May 9, 2001

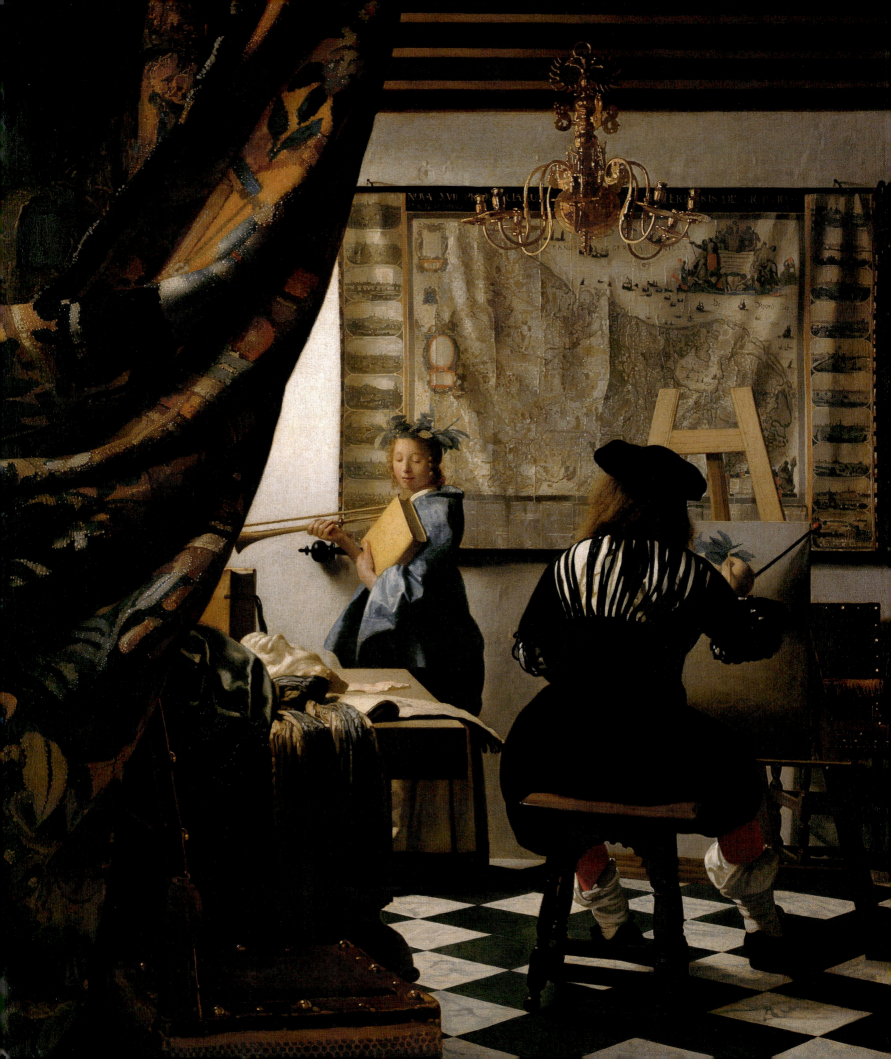

I Engaging Art

Art is as old as human experience. Yet, many people find it strange, even intimidating, and are left wondering: What do artists do? Some, such as the Dutch painter Johannes Vermeer (1632–75), have addressed that question head on, by making paintings about the art of painting itself (fig. 1.1). When, in the late 1660s, Vermeer painted this scene of an artist working in his studio, he was a minor celebrity in his native city of Delft in the Netherlands, yet he struggled to support his large family. His working method was painstakingly slow, severely limiting his production. Vermeer painted at most forty small paintings, some of which he exchanged for bread to feed his family.

A French collector who traveled to Delft to see Vermeer's work was directed to the local baker, who held, perhaps as security for debt, a Vermeer valued at 600 guilders, a high price at the time. When Vermeer died, at age forty-three, the baker accepted two more paintings as security for debt. Vermeer's widow did all she could to keep *The Art of Painting* in the family, but it eventually went on the auction block to pay off his debts. In effect, Vermeer and the baker exchanged a feast for the eyes for food.

THE ARTIST AT WORK

About 250 years after Vermeer's *Art of Painting*, the French artist Henri Matisse (1869–1954) offered another answer to the question "what do artists do?" in his painting *The Red Studio* of 1911 (fig. 1.2). Looking at both works, we see two artists confronting

the same subject in significantly different ways, reflecting changes in the role of artists, in the history of art, and in history itself.

Both used oil paint on canvas as their medium; both used studio props and other images, shown hanging on their studio walls, to convey their approaches to their profession. What they chose for these props and images, and how they presented them to the viewer, also reveal quite a lot about each painter's notion of the artist's role in society.

Vermeer used the device of a stage curtain, pulled back to suggest that we approach his painting as we would a theatrical production. But the drama presented by the visual artist is frozen in one critical moment, which must "say it all." On his "stage" is a model, acting the role of Clio, the Muse of History, holding a history book in one hand, and Fame's trumpet in the other. With this image, Vermeer suggests that art is concerned with life's great themes. On the wall behind his model, Vermeer depicts an old map bordered by a series of miniature city views. His technique of

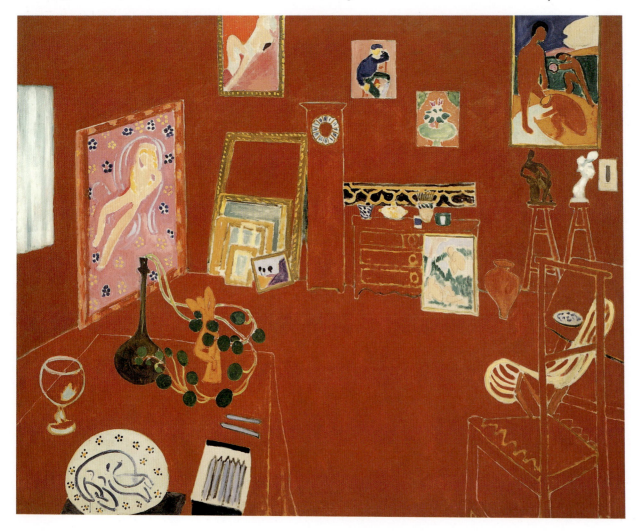

1.2 Henri Matisse, *The Red Studio.* 1911. Oil on canvas, 71¼" x 86⅓". The Museum of Modern Art, New York

painting creates the illusion of light coming from a side window streaking across the map, catching all its wrinkles and creases in highlights and shadows. We accept the illusion, just as we do the illusion of a stage set.

Matisse rejected the conventions of spatial depth, light, and shadow, as used by Vermeer, for something more like the conventions of a map. He asks us to accept his abbreviated markings to connote objects and space, just as we accept the blue line on a map as denoting a great river, or a jagged set of lines for an entire mountain range. As children, we learn these cartographic conventions and accept them as normal. Matisse, in effect, asks us to learn and accept a different set of conventions from the ones used by Vermeer. We call this a change of style.

Throughout history, artistic style has undergone continuous change. Most of the time the shifts are so slight that only an expert can discern them; sometimes, as when we compare Vermeer and Matisse, they are so pronounced that we cannot miss them: The flattened space, and all that red paint! One contemporary critic dubbed Matisse a "fauve," or "wild beast." To our eye, Matisse's *Red Studio* is vibrant, yet at the same time tame, as many artists since have been far wilder. Yet, when compared to Vermeer, we see that the intense red Matisse lavishes on his studio, Vermeer restricts to a slim highlight on the artist's stockings.

As we get used to Matisse's style, we begin to find familiar elements. Matisse doesn't show an artist working from a model, as Vermeer did. But, as we look around his studio, we see that he has been busy, both painting and sculpting from the model, only this time she's nude. To understand why he studied the human figure nude, we would have to go back into art history. There we discover the critical role of the human figure in artistic expression, and the discipline by which Western artists have mastered all its subtlety of movement and expression.

In Matisse's studio we also see landscape and still-life paintings, which, with the theme of the human figure in the landscape or the interior, have recurred throughout the history of Western art. On the foreground table Matisse has painted a design on a ceramic dish, as aritsts have done wherever human civilization has existed. We also see that, for both Vermeer and Matisse, women played the role of artists' models. Until fairly recently, social convention greatly restricted women's opportunities to study or practice art. While we will find a few women artists achieving prominence in the seventeenth and eighteenth centuries (see chapters 9, 10, and 11), it's not until the late twentieth century that women really have a strong presence (see Chapter 15, "The Artist as Woman and Minority," page 478).

THEMES OF ART: CONTINUITY AND CHANGE

As we look at art across time, we can expect to find both continuity of human interest and changes in artistic style. Radical changes generally signal a significant shift in the interests and outlook of both artists and their audience. Vermeer, for example, was ignored and forgotten in the eighteenth century, only to be rediscovered in the nineteenth, and elevated to celebrity status in the twentieth. His changing status reflects the larger patterns of shifting taste and values, values that will interest us throughout this book.

As we approach the art of the past and present, we find some truth to the old saying that the more things change, the more they stay the same. By this we mean that the specific concerns of artists and their audiences may change from generation to generation, as will artists' styles, or modes of expression—life is never static. Yet human experience remains fundamentally the same. The themes of life are constant across all cultures: The cycle of birth, maturity, and death; wonder about immortality; needs and longings; curiosity about the world; striving for survival and success; relating to each other, to society, and to nature. Just as great writers express the themes of life, so do visual artists and architects, using their own distinct language. How artists and architects throughout history have responded to these enduring human concerns is the subject of this book. We focus primarily on Western art, but each chapter ends with an essay, "Parallel Cultures," offering a contrasting perspective from other cultures of the same period of time.

Although human experience is densely interwoven, for convenience we have divided these fundamental human concerns into four major themes:

Spirituality

How do artists express spiritual aspirations, religious beliefs, and concerns about humanity's place in the universe? How have artistic responses to this powerful dimension of human life changed over time?

The Self

Artists have expressed and reacted to the entire spectacle of human life, from joyous love and domesticity to the horrors of war, to the search for meaning in an uncertain world. In so doing they reveal their perceptions of themselves and others, at times portraying the way others wish to be perceived. Such works open a window onto the dominant beliefs and values of their time.

Nature

Nature's power to sustain life and destroy it, to soothe and to terrify has been expressed by artists since prehistoric times. Each chapter discusses artworks, including landscape design, that reflect the significance of the natural world and our changing relationship to it.

The City

A city's design reveals the values of the powerful and influences the social relationships of all of its citizens. In every age, a city's buildings and streets, its layout, public monuments, and open spaces reflect its social hierarchies and the priorities of its leaders.

As we explore these themes, we discover that art functions as a powerful means of expressing the vital concerns, values, vision, and aspirations of both individuals and society, wherever it has been made, and in whatever form. Throughout history and in every human culture, artists have worked in an extraordinary range of media, especially various forms of pictures, sculpture, and architecture. We will focus mostly on these three media.

TIME AND PLACE: THE CONTEXT OF ART

As you look at the works of art represented in this book, you'll notice that those from a particular time or place, or from a single artist, share common sets of visual characteristics. Egyptian tomb paintings have a

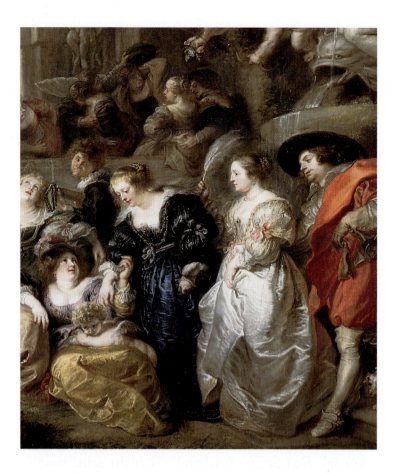

1.3 Peter Paul Rubens, *The Garden of Love* (detail; see fig. 9.29 for whole painting). c. 1632–5. Oil on canvas, 6'6" x 9'3 1/2". Museo del Prado, Madrid

distinctive style, as do Impressionist landscapes, and there is no mistaking a Rubens for a Renoir (figs. 1.3 and 1.4).

Stylistic consistency arises because artists working at about the same time often share the same artistic conventions, that is, visual formulas widely used and understood within that culture. Ancient Egyptians, for example, typically painted figures in profile, although the eye was drawn as if seen full face (see fig. 2.26). Art historians study such conventions of a given historical period, region, or individual artist, as well as changes within that style.

The history of art usually focuses on the interplay between artistic convention and innovation, between the qualities that unify and those which add diversity to any given body of work. Art historians are also concerned with what these dynamics signify. Do changes in artistic conventions reflect or undermine changing ideas within a culture? For example, when twentieth-century architects rejected decorative stone carvings in favor of sleek exteriors of glass and steel, what did that dramatic shift say about twentieth-century society? And, in the twenty-first century, what can we make of the move back to exterior decoration?

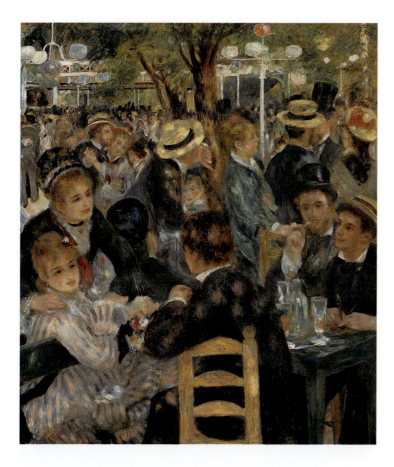

1.4 Pierre-Auguste Renoir, *Le Moulin de la Galette* (detail of fig. 13.12 for whole painting). 1876. Oil on canvas, 51½" x 69". Musée d'Orsay, Paris

ANALYZING A WORK OF ART

As we consider the hundreds of works of art represented in this book, we analyze these works in similar ways, looking for the relationship between visual form and expressive content, and how both derive from a work's historical and social context. We ask, what values and ideas marked the age? What purpose did this work serve, and what can we say about its form and content within its historical and social context? How does it compare to other similar works? In considering each work, we will draw selectively from the following categories and questions. The reader is encouraged to carry the process further:

Identification

Who made or built this work; when, where, and why? Did someone commission it? What purpose or function did it serve or does it still serve?

Description

What is the work's subject? What symbols can we identify and what did they connote at the time? (This is called **iconography** and **iconology**.) What can we say about the media and technique, the ways in which materials have been handled? This will lead us to questions about style and the formal elements of art, and how they are composed. How does the work relate to a particular historical, regional, or individual style? How has the artist used the various elements of line, shape, mass, light, color, texture, and space? How are details of objects treated, and what is their combined effect?

Analysis

What unites and gives coherence to a work? What is its focal point? What is emphasized and what subordinated? What provides variety to the image? What patterns and rhythms are established within the work? How are the various elements balanced and contrasted? Overall, what controls the composition, and what is its cumulative effect? Such questions will inform our interpretation and evaluation of the work.

Interpretation

What is the work's meaning and intent? How does it relate to its subject, function, and historical context? How does it compare to the typical style of its time and place? What is being communicated and why? What values, meaning, and human insight does the work convey?

Evaluation

Only after coming to an understanding of the different dimensions of a work of art outlined above are we in a position to pass any form of judgment, to compare this work with other such works and weigh its effectiveness—aesthetically and technically. Is it true to human experience? How may it enrich us? What is its historical significance? Finally, we can ask ourselves how our particular circumstances and perspective affect the way we respond to the work and how, in turn, the work affects us.

In the pages that follow, we'll apply this system of analyzing art to selected works from each of the media featured in this book. We begin with two paintings: Jan van Eyck's (c. 1390–1441) *Arnolfini Marriage Portrait* of 1434 (see fig. 1.5), and Titian's (c. 1490–1576) *Venus and Adonis* of 1554 (see fig. 1.6).

LOOKING AT PAINTINGS

In looking at paintings, prints, and drawings, the viewer has to be willing to accept the conventions of the particular medium. The power of painting depends on our willingness to accept the illusion of what is conjured by paint on a flat surface—just as we accept the illusion of reality in film, television, and theater.

Jan van Eyck's *Arnolfini Marriage Portrait*

The inscription above the mirror tells us that this painting (fig. 1.5; see also fig. 8.19) was made in 1434 by Jan van Eyck, a Flemish painter working in the city of Bruges. It is an oil painting on a wooden panel, of moderate dimensions (32$\frac{1}{4}$" x 23$\frac{1}{2}$"). The painting was commissioned by the couple represented, Giovanni Arnolfini, a wealthy Italian silk merchant living in Bruges, and Giovanna Cenami, the daughter of another such merchant, to commemorate their marriage.

The subject of the painting is a full-length double-portrait of this Italian couple, with hands joined, their free hands gesturing, his as if swearing an oath. They are portrayed in a Flemish interior whose architectural details and furnishings are consistent with the period of the painting, including an expensive oriental rug on the floor. To the left is an open window, on the right a bed. A fine brass chandelier and a decorated convex mirror hang dead center, between the couple, with a little dog below.

Various other details catch the eye—two pairs of shoes, fruits by the window, a string of prayer beads, a duster, figurative carvings on the furniture, and a single lit candle. Looking closely at the mirror reveals the reflected image of the backs of the couple, two figures in a doorway beyond them, and the setting sun glimpsed through the window. There are even ten minute scenes on the frame of the mirror, representing the passion and death of Christ. Van Eyck creates the illusion of light streaming through the window, illuminating the scene and highlighting the characteristic surface texture of all the objects, just as if we were there. How has he managed to depict so much detail on such a small surface, and achieve such lifelikeness? The answer lies in the medium—oil painting—and in the

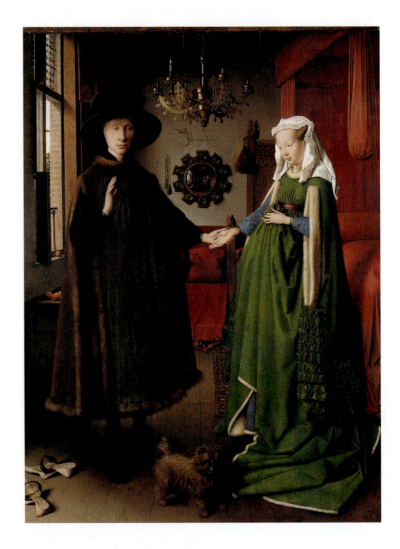

1.5 Jan van Eyck, *Arnolfini Marriage Portrait*. 1434. Oil on panel, 32$\frac{1}{2}$" x 23$\frac{1}{2}$". The National Gallery, London

artist's technique in using it (see Chapter 8, "Materials and Techniques: Oil Painting," page 246).

What can we say about the style and composition of the painting? Van Eyck's painting shares with other examples of northern European art of the early fifteenth century a high degree of naturalism. This style is based on scrupulous observation and transcription of minute details of the natural world, combined with an illusionistic spatial construction—that is, one that looks consistent with sight, as created by the skilled use of perspective (see Chapter 7, "Materials and Techniques: Methods of Perspective," page 196). This naturalistic effect is reinforced by rendering objects as they would appear when seen under normal lighting conditions. The mirror in the painting—besides its other possible associations—may also be intended as a metaphor of art's function as a mirror of nature, since the artist represents himself, reflected in the mirror.

As for the painting's composition, it is constructed symmetrically around a central dividing axis. Because of this symmetry, we see every element in relation to this central division, encouraging us to compare each side with the other. For instance, details from each side differentiate the couple's gender roles, the center, their union. The man stands by the window to the outside world, dressed for the street, with outdoor shoes beside him; the woman's side is carpeted, and includes a pair of indoor shoes, the bed, and a duster. Between them, aligned down the center, their joined hands signify their union, while the dog, by its inherent nature, signifies fidelity. (The dog's name, Fido, derives from the Latin *fido*, meaning faithful.) The spotless mirror, at the time, suggested purity, a virtue valued within marriage.

Finally, the reference to the sacrifice of Christ on the mirror's frame reminds the young couple that, according to the Bible, the relationship between a man and his wife is intended to serve as an image of the relationship of Christ to his church, thus one of loving support. Whatever further significance the painting may carry, we can interpret van Eyck's *Marriage Portrait* as a portrait of

a specific young couple—at the time a great novelty—and as a visual essay on the virtues of marriage, as then understood. If we then compare the views conveyed in this painting to our modern views about marriage and gender roles, we would find some distinct differences.

Further analysis of the painting would reveal its historical significance in terms of the novelty of its style, technique, and subject, and its level of craftsmanship. But finally, we must admit that our evaluation of the painting may also be influenced by the value we ourselves place on such detailed representation and whether we enjoy exploring its symbolism.

Titian's *Venus and Adonis*

We turn now to another painting (fig. 1.6) that offers an interesting comparison to Van Eyck's double portrait. The Venetian artist Tiziano Vecelli (anglicized into Titian) made this painting for Prince Philip (later King Philip II of Spain). It is also painted in oils, but on canvas, and its dimensions ($73^{1}/_{4}$" x $81^{1}/_{2}$") are much

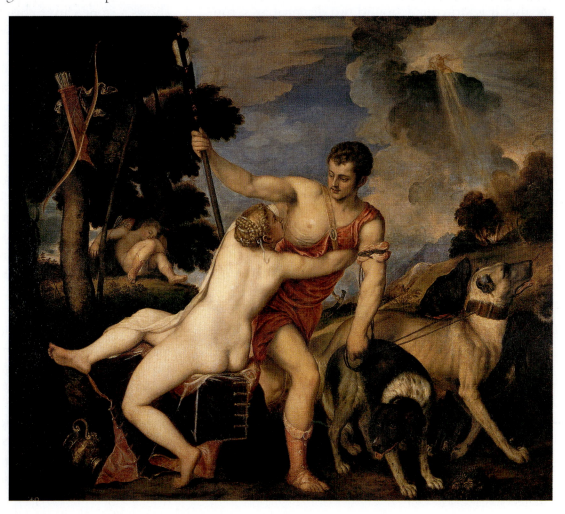

1.6 Titian, *Venus and Adonis*. 1554. Oil on canvas, $73^{1}/_{4}$" x $81^{1}/_{2}$". Museo del Prado, Madrid

larger than van Eyck's painting. It was one of a series of mythological works commissioned by the young prince that were inspired by subjects derived from the ancient Roman poet Ovid's *Metamorphoses*. In Ovid's telling of the myth of Venus and Adonis, Venus leaves her lover, Adonis, in an air-borne chariot; only then does Adonis succumb to his fatal passion for hunting. In Titian's painting, Adonis leaves Venus.

Why did Titian depart from the myth? Here, Adonis tears himself away from Venus to go hunting, a pursuit through which, as Venus feared, he meets his death. By changing the myth, Titian creates a far more dynamic exchange between the lovers, heightening the visual drama. Framed by secondary elements that symbolize their fate, Titian poses Venus and Adonis so as to join and contrast the conflicting elements of repose and action, pleasure and peril, love and separation. Even the landscape reinforces the contrast between happiness and doom, with a secluded bower on the left and rougher, hilly terrain on the right, all seen under a blue sky threatened by an approaching cloud.

Look now at the painting's composition. You will see that it is structured around two diagonal axes, running from the four corners and intersecting in the center, at the point where the lovers' bodies are joined. All elements of the painting are held in tension in relation to these axes, and distributed around them according to their respective significance. The composition of the whole, then, gives the painting both visual and thematic coherence.

Comparison

One of the paintings just discussed was produced in northern Europe, the other in Italy, both during the Renaissance. In this context, we find many interesting differences, reflecting the time and place in which these artists worked. Most striking, are their different subjects and styles: Van Eyck's representation of an actual couple, in contemporary dress; Titian's mythological figures, with the woman nude. In style, each artist treats the human figure quite differently: Van Eyck's figures are down-to-earth and naturalistic; Titian's are idealized, based on models of classical antiquity and recent Italian artists who sought to emulate the ancients, such as Raphael (Raffaello Sanzio; 1483–1520). Van Eyck used oil paint to highlight fine details; Titian applied his oils in broad gestures, to

indicate more generalized forms. Van Eyck defined space as exactly as he could; Titian evokes depth more loosely, and secondary objects more sketchily. Van Eyck's world appears static and secure, rooted firmly in established Christian tradition. By contrast, Titian's world is dynamic, adventurous, and more uncertain; he risks painting Venus nude. Van Eyck's world seems governed by reason, Titian's by passion. Each artist is dealing with human relationships, to which we can relate, and each has the power to capture our attention, provoke our interest, and stimulate our imagination.

LOOKING AT SCULPTURE

More than two centuries before Vermeer painted *The Art of Painting* (see fig. 1.1), the Florentine sculptor, Nanni di Banco (1385?–1421) offered an answer to the question, "what do sculptors do?" His carving of an early fifteenth-century Florentine workshop (fig. 1.7) shows a stone-carver chiseling a nude figure out of a piece of marble. Today's sculptors may choose different materials, techniques, and subjects, yet they contend with similar challenges and formal considerations. Here, too, we encounter continuity and change.

Painting may create the illusion of space on a two-dimensional surface, but sculpture actually occupies space. This significantly affects our response to it, since it shares our own space. Sculpture is most typically a public art form, and it is often related to architecture or set up in public spaces. There are two types of sculpture: Relief sculpture projects from a flat surface, such as the wall of a building; sculpture in the round may be set against a wall, in a niche, or be free-standing, so that it can be seen from all sides. Whether free-standing or relief, its scale and setting also affect the way we relate to it.

From earliest times, sculptures embodied a community's beliefs and values. Sculpture also took on a commemorative role in society, honoring the memory of national leaders, saints, and heroes. Consequently, the human figure became the preeminent subject of sculpture. Given this demand for sculpting the human figure, for centuries sculptors had to meet the challenges of transforming three-dimensional materials into human figures that possess an enduring sense of lifelikeness.

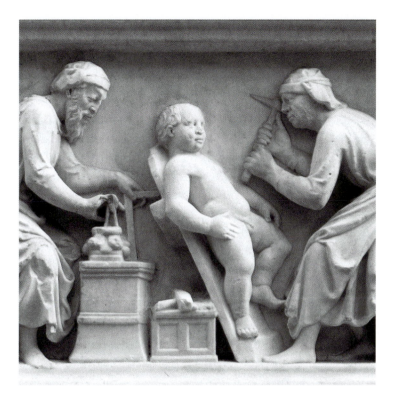

1.7 Nanni di Banco, *Sculptors in their Workshop* (detail). 1412–5. Marble relief. Orsanmichele, Florence

which it is balanced, how it is positioned relative to a certain axis, and if and how the limbs (if the human figure is depicted) or other elements project. The way limbs project is critical in relating a figure to the surrounding space, and may provide a sense of motion and suggest specific directional thrust into the surrounding space.

Beyond these fundamental considerations, in order to achieve their desired effects, sculptors manipulate their handling of three-dimensional masses, surface qualities, and how shifting surface planes catch the light at different angles. Because a sculpture is usually designed to be seen from many angles, unlike a painting, it must captivate the eye from as many points of view as possible.

Sculpture and painting also differ with respect to color. Besides its great sensory appeal, color strongly affects the way we perceive reality, that is, whether something appears lifelike. During the Middle Ages, sculptors producing religious art typically painted their wooden or stone sculptures, but during the Italian Renaissance, sculptors sought to emulate excavated examples of ancient Greek and Roman sculpture, on which no paint was found. Thereafter, Western artists associated purity of sculptural form with unpainted marble or bronze, in contrast to the painted medieval sculptures. For centuries, sculptors in the West worked with the innate color of their materials, relying on light, shadow, and texture to animate their forms. In fact, though, evidence shows that the Greeks did paint their sculpture, and sculpture is commonly painted in many other cultures. Today artists once more feel free to paint their sculptures; yet in the making and viewing of much Western sculpture, color in itself plays a negligible role; a role that has to be filled in other ways.

With this awareness of the differences between sculpture and painting, and of the distinct qualities of sculpture, we can refine our approach to the analysis of art. Here, we will compare the figurative expression of sorrowful resignation in Auguste Rodin's (1840–1917) *The Burghers of Calais* of 1884–6 (see fig. 1.8) to a Modernist, abstract expression of resilient triumph in Naum Gabo's (1890–1977) *Construction* for the Bijenkorf Department Store, Rotterdam, of 1954–7 (see fig. 1.9).

Sculpture today is made from a wide range of materials, but the most traditional are wood, stone, clay, and bronze. Each calls for different sculpting techniques. Some processes, such as modeling, are additive; others, such as carving, are subtractive: with modeling, materials such as clay are built up to create a form; with carving, materials such as stone and wood are cut into to produce a form; and with casting, molten material such as bronze is poured into a mold, to harden into a form (see Chapter 3, "Materials and Techniques: Carving and Modeling," page 65, and "Materials and Techniques: The Lost-wax Process," page 64).

Beyond these traditional materials and techniques, twentieth-century sculptors, responding to the conditions of modern life, have explored many other materials, both man-made and natural. They also work these materials with new techniques, such as welding metal sheets, molding plastics and plexiglass, constructing and assembling diverse materials, and even transforming the landscape on an environmental scale (see Chapter 14, "Materials and Techniques: Collage and Assemblage," page 449, and Chapter 15, "Materials and Techniques: Modern and Contemporary Sculpture," page 488).

A sculpture's initial impact relies on the physical placement of the finished work, its scale relative to our own body, and the interplay between three-dimensional, solid masses and the voids (empty spaces) between these masses. Its impact is also affected by the degree to

Auguste Rodin's *The Burghers of Calais*

Rodin was an outstanding Parisian sculptor who had gained a reputation in the late 1870s for his startling departures from prevailing academic technique. His sculpture *The Burghers of Calais* (fig. 1.8) was commissioned by the French city of Calais in 1884 but was not installed until 1895, after years of argument over the artist's interpretation of its subject. Even then, it was not sited as originally intended, before the medieval Town Hall, but was moved there only in 1926. Life-sized and cast in bronze, it commemorates the city's six medieval citizens who in 1347 surrendered themselves to the King of England for execution in order to spare their city from warfare. The city wanted Rodin to create a grand monument to proud and stoic virtue, but what he gave them was a profound image of grief-struck mortals confronting an array of passions evoked by the imminence of death.

How did Rodin achieve the depth of expression in *The Burghers of Calais*? Rodin was preeminently a modeler, rather than a carver, building up his figures in plaster, literally and figuratively, from the inside out, with every human feeling emanating in a corresponding gesture in the sculptural form. He began this work by making plaster maquettes, or small models, no more than one or two feet high, of each figure as well as of the entire group, and made further such studies of individual heads and hands. When he was satisfied, he used the studies as models for the greatly enlarged molds from which the casting was done.

Rodin worked from studies he made of nude models, adding drapery only after he was satisfied with the movement, gestures, and expression of each figure. He exaggerated these expressions and gestures to ensure the force of their impact when seen in a large, open space.

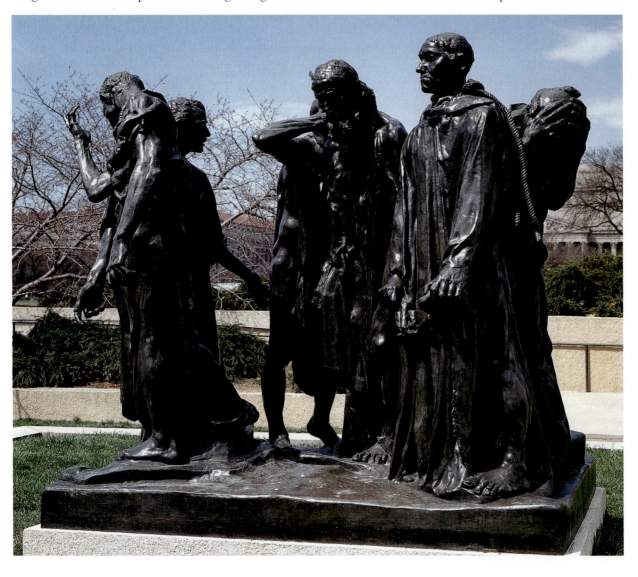

1.8 Auguste Rodin, *The Burghers of Calais*. 1884–6. Bronze, 7'1" x 8'2" x 6'6". Hirshhorn Museum and Sculpture Garden, Smithsonian Institution, Washington, D.C.

Projecting forms and receding hollows are unnaturally accentuated, but these unnatural exaggerations of form, combined with sharply shifting surface planes and a rough surface texture, create bold highlights and heavy shadows that evoke an effect of somber gravity. The individual figures are combined into a group through a slow, weighty rhythm whose movement is almost circular, even as the group appears to stumble forward. One of the burghers turns to exhort his companions, another is braced with resolve, while the other four, with bowed heads, turn to the front, back, and sides. The drapery falls from their bowed shoulders in heavy folds, their dragging legs and massive feet seeming to provide reluctant motion to their bent and weary bodies.

Rodin's conception of sculpture and its deeply expressive qualities could not be further from the conventions of his own time and place. Nineteenth-century France was enthralled with a Neoclassical taste for idealized mythological subjects that were carved with technical precision from white marble and finished to highly polished, smooth surfaces, and whose emotional content was impersonal and shallow. Rodin, by contrast, was inspired by the pathos of medieval religious sculpture, by Michelangelo, and, above all, by his own careful scrutiny of people he saw on the street.

Rodin broke even further from tradition by wanting to place his *Burghers of Calais*, not on an elevated pedestal, as was customary, but directly on the ground, at the viewer's eye level. The implications of this choice are significant, because he confronts the viewer with individuals like themselves, not some remote and elevated heroes. Rodin sought to insert his group directly into the viewer's space, on their level and on their own scale. In so doing, he was making full use of the fact that sculpture occupies real, not just fictional space.

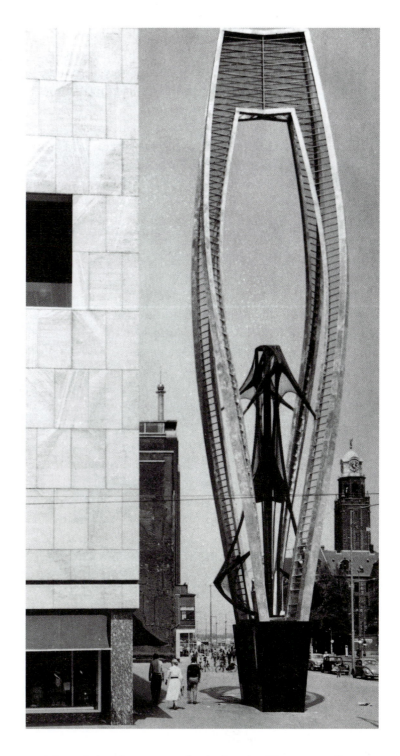

1.9 Naum Gabo, *Construction* for the Bijenkorf Department Store, Rotterdam. 1954–7. Steel, bronze wire, and freestone substructure, height 85'

Naum Gabo's *Construction* for the Bijenkorf Department Store, Rotterdam

How we respond to Rodin's sculpture depends significantly on our natural capacity to find in it a mirror of our own humanity. In many examples of twentieth-century sculpture, that explicitly human dimension is much less evident, if not altogether absent. Even so, art always remains to some degree an imitation of nature, however abstract in form. At the very least, its forms are dependent on the nature of materials themselves.

How then can we approach a piece of modern, non-figurative sculpture, and for what type of qualities shall we look? Let us examine Naum Gabo's *Construction* for the Bijenkorf Department Store,

Rotterdam, of 1954–7 (fig. 1.9). As noted above, in contrast to Rodin's figurative expression of sorrowful resignation, it is an abstract expression of resilient triumph. On what is such a response based, and how does one arrive at such a conclusion?

In looking at Gabo's *Construction*, we must concentrate more carefully on the material, form, and context, since no subject matter in any narrative sense comes into play. Naum Gabo was Russian-born and had established his reputation in Moscow in 1920 with the joint publication with his brother, the sculptor Antoine Pevsner (1886–1962), of "The Realistic Manifesto"; by the time he made this sculpture, he was living in the United States. Gabo's approach to sculpture is perfectly exemplified in this work, which stands adjacent to the Bijenkorf Department Store on one side of a commercial and residential square. This square had been built in a Modernist style as part of the reconstruction of Rotterdam after its near total destruction by German bombs during World War II. Gabo's gigantic *Construction*, eighty-five feet high, is made of steel and bronze wire, and stands on a seven-foot-high freestone substructure.

How can we engage this sculpture? First, we notice that space rather than mass is an essential element of its formal structure. This change overturns the traditional conventions of sculpture: Rather than creating a solid mass that occupies a certain volume of space, Gabo transformed space itself into a defining quality of his sculptural form. The shape of the structure is not defined by any solid mass, but by the edges of the four transparent planes as they appear to rise, turn, and unite, and, in so doing, define the space between them. Within this open core, Gabo has inserted another form, likewise comprised of linear movement through open space. It rises almost to the widest point of the enfolding form, its shape creating a sense of vertical thrust. This sets the entire structure into a tension that suggests expanding but contained energy.

As for the choice of materials, Gabo claimed that "the emotions aroused by materials are caused by their intrinsic properties" and that "every single material has its own aesthetic value." Therefore, the materials he chose are intended to represent nothing other than their own inherent qualities and the process of their construction.

Following the tenets of his "Realistic Manifesto," Gabo's *Construction* expresses his ideal that sculpture be realistic, dynamic, and objective. It is "realistic" not in the sense that it represents everyday appearances, as in realist art. Rather, Gabo considered space and time as "the only forms on which life is built," and thus attempted to capture the realities of space and time in sculptural form. It is "dynamic" in the sense that its flow of lines and shapes suggests kinetic rhythm, that is, a sense of movement, if not actual motion through time and space. Finally, it is intended to be "objective," in that, as Gabo conceived it, its lines and shapes have no descriptive value, conjure no subjective sentiment or feeling, but rather exist in themselves, speak their own language and have a force of their own, whose emotional impact is intrinsic to the material and therefore absolute.

Given Gabo's aims for sculpture, we would not expect his *Construction* to convey any specific reference to the context in which it was commissioned. Nevertheless, it is appropriate to its context. The work makes no attempt to reconstruct or recall the past; instead it embodies the power and potential of a modern, industrial society. Both the medium and construction technique of Gabo's structure depend on the industrial practices of a modern society. We can, therefore, see it as an emblem of the modern reconstruction of Rotterdam, a seaport whose revived prosperity depended on trade and industry. This, in turn, resulted in the establishment of large department stores, such as the Bijenkorf, before which Gabo's *Construction* stands. It seems justifiable, therefore, to see the sweeping vertical thrust and energy of Gabo's *Construction*, in its specific context, as an expression of resilient triumph and renewal.

LOOKING AT ARCHITECTURE

While painting creates the illusion of space and sculpture occupies actual space, architecture both occupies and encloses space, as well as giving significance to the space around it. Architectural design depends on many of the same principles as other art forms. Yet buildings possess distinct properties and offer architects a range of expressive means that depend on effective manipulation of a diverse array of materials and construction

1.10 Assistants of architect Frank Gehry working on a model of the Stata Center, Massachusetts Institute of Technology, Cambridge, Mass., scheduled for completion in 2003. Photograph

techniques, many of which will be encountered in the pages of this book. In figure 1.10, assistants of the Canadian born, California based architect Frank Gehry (b. 1929) work on a model of the Stata Center, Massachusetts Institute of Technology, scheduled for completion in 2003. Gehry has designed some of the most daring and original buildings of the modern era (see fig. 15.42). Yet he too, like generations of architects before him, must respect laws of gravity, the nature of materials, and other factors that influence the visual impact and practical effectiveness of buildings. So, here again, in the evolving practice of architecture, even where there is a high degree of innovation, we find elements of continuity as well as change.

Architecture is, first and foremost, a social art. More comprehensively than either painting, sculpture, or other media, buildings are intended to have specific functions. Because of their social role, buildings embody the values, ideals, and aspirations of civic leaders and rulers in ways that painting and sculpture do not always need to. At the same time, buildings function on both practical and symbolic levels, serving both body and mind. Typically, they are shaped by the needs and vision of both the client and the architect, in a process in which architects' dreams are often changed by budgetary and other practical constraints.

The first-century BCE Roman architect and theorist Vitruvius, and most architectural theorists since, have discussed architecture in terms of three interdependent criteria: Structure, function, and beauty. Namely the effectiveness and stability of the chosen materials and

techniques; the suitability of the structure to its intended purposes; and its visual impact. Studying architecture offers unique rewards because of the way that social and cultural forces combine with practical and technical considerations to create an architectural style. Buildings can also be studied in terms of the changing responses of subsequent generations, since they remain in space but are used and perceived differently over time.

Architecture's Expressive Elements

Just as painters and sculptors manipulate the elements appropriate to their media, architects work with another set of elements, manipulating them in different ways to achieve their intended effects. Those differences affect the character and quality of a building and contribute to its visual impact. We cannot see any building completely from any one spot. Architects therefore design buildings to be experienced as a series of impressions to be taken in from different angles, and as a sequence of spaces through which the user passes. Since a single photograph cannot show such spatial sequences, we will also refer to architectural plans. Below is a short overview of the elements that make up any work of architecture.

Setting and Scale
Setting refers to the way that a building is related to its surroundings, whether natural or man-made. It may fit in harmoniously, contrast sharply, or do neither. The scale of a building (larger, similar, or smaller) relative to surrounding structures, as well as to the human body, also significantly influences the overall effect. Surrounding features can be used to frame the approach to a building, making it seem protected, set apart, or the climax of a dramatic vista. Setting and scale play a large role in determining the impact of a building upon the viewer.

Materials and Structural Devices
An architect's choice of building materials (such as brick, stone, steel, or concrete) and structural devices (such as solid wall, steel-frame, arches, vaults, or domes) is fundamental.

Volumes and Their Grouping
A building's volume is all of the three-dimensional space it encloses. A building may be either compact or

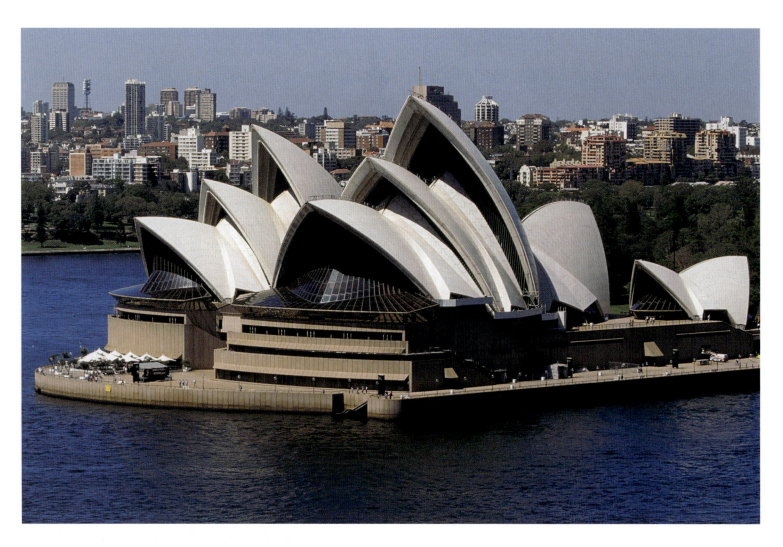

interior was finished in 1972 by Australian architects, but not to Utzon's original designs.

Utzon achieved the stunning impact of the Sydney Opera House without any of the traditional motifs of Western architecture that Garnier used so abundantly. We see no columns, capitals, arcades, or domes, no ornamentation at all. Instead, Utzon capitalized on the sculptural potential of a modern material, reinforced concrete (see Chapter 13, "Materials and Techniques: Reinforced Concrete and Steel-frame Construction," page 432). Yet, the same principles of design inform the architect's choices as in any other building—setting and scale, the manipulation and grouping of volumes; the contrasts of solids and voids; the patterns and rhythms of the lines of force; the articulation of roofing; and the flow, rhythm, and sequence of internal spaces.

The site of the building is a spit of land jutting out into Sydney Harbor, separated from the city by a small park. Utzon designed the performing arts complex as a group of structures mounted on a wide, elevated

1.12 Jørn Utzon, Sydney Opera House. 1959–72. Reinforced concrete, height of highest shell 200'

platform, facing the harbor. But visitors approach it from the land side, up a series of ceremonial flights of steps across a flat, spacious forecourt, such as Utzon had seen in ancient Mayan temple precincts in the Yucatan Peninsula of Central America.

Utzon's Sydney Opera House is built of reinforced concrete and comprises a series of shell-like vaults faced with white ceramic tile whose color and sheen offset the subdued cream-gray base. The mouths of the shells are enclosed by a web of amber-tinted glass sheathing. Through his extraordinarily imaginative manipulation of these two materials—concrete and glass—Utzon capitalized on the potential of the site to create a structure whose unprecedented and memorable sculptural form has come to symbolize the city of Sydney, if not Australia itself.

Seen from the land side, the form and color of the Opera House's shell-like vaults have provoked many to

compare them to great white ships' sails seen against the water and sky of Sydney Harbor. From the land side, the vaults have more of a protective quality, like tents staked to the ground; but from the harbor side, the effect is more of great birds, throwing back their heads to release their song, and rising from a quiet prelude to a great crescendo. Whatever associations these forms may evoke, architecturally they depend on an elemental contrast between rising forms and a horizontal plane. The former provides dynamic energy, the latter stability.

The structure is so inherently sculptural that it is not orientated in one single direction. Most people would think of the side facing the harbor as the front of the building. Yet this is not where one enters. A building's façade normally faces its approach and contains the main entrance. With the Opera House, such expectations are overturned. The ceremonial approach from the city leads up to the backs of the largest shells. Once inside, the array of glass provides the visitor with panoramic views of Sydney Harbor.

In dispensing with the traditional motifs of Western architecture, the architect intended that the visual interest of the Sydney Opera House complex should depend more fundamentally on the overall shapes, patterns, and rhythms of forms that create the play of solids and voids and suggest the lines of force within each part of the complex of buildings.

Since the two main structures stand beside each other, and yet are different in size, the viewer is invited to compare the articulation of such elements from one to the other. Thus we see that the main theme of each is a series of horizontal bands of concrete and glass that set up alternating patterns of solids and voids, light and shadow, the rhythms of which are different on each structure. In this way their relative sizes are visually counterbalanced, adding to the dynamic tension between them. The similarity of the surmounting shell structures also links the two, each based on a progressive rising rhythm of alternating solids and voids.

With its compelling power to attract the eye, Utzon's Opera House immediately became a world-renowned symbol for the city and country that commissioned it. That is how architecture is supposed to function, meeting practical needs through durable and compelling forms that symbolically represent contemporary social values and aspirations.

People may be drawn to Garnier's Paris Opéra because its opulent forms are redolent with historic associations that lift the imagination out of the rut of everyday life and transport one into a fantasy world of luxury and grandeur. Paris is an ancient city, already filled with monuments and historic associations, to which Garnier's Opéra can instinctively be related. Sydney is a young city, short on such historical associations, but full of promise and potential. Utzon's Opera House draws together that sense of forward-looking optimism and condenses it on a magnificent site into a building of daring structure and uplifting forms that resonate with an optimism analogous to the personality of the city. By these standards, the Paris and Sydney Opera Houses can each be judged successful on its own terms and in its own context.

QUALITY IN ART AND ARCHITECTURE

The three sets of comparisons presented in this chapter make it clear that artistic quality cannot be measured against any absolute standard. As we've seen, the aesthetic qualities of art (visual forms and their effects on viewers) are interwoven with the social demands, expressive intents, and artistic conventions of any given time and place. Any work of art, then, must be judged within its specific context, in relation to other works made in the same time and place. To be effective, a work of art must have a perceived relevance and resonance within its own context. It should be judged on that basis as well as in terms of its ongoing and changing relevance to subsequent viewers and users, including ourselves. These are factors to bear in mind as you encounter the works presented in the chapters that follow.

2 Prehistoric and Ancient Art

2.1 Hall of the Bulls
(detail of fig. 2.3),
Lascaux caves, France.
c. 15,000–13,000 BCE.
Paint on limestone

When or where people first made images we today call art remains a mystery, but a series of accidents has led to some extraordinary discoveries. One of those accidents occurred in 1940, when a dog fell into a hole in the ground in Lascaux, France, leading its rescuers to a stunning sight: In a network of caves, skillfully drawn images of bulls, reindeer, and other animals covered the walls. Through an analysis of the color pigments, scholars believe these images were painted around 15,000–13,000 BCE. Similar cave paintings had been discovered before, in Altamira, Spain, and even earlier ones since, most recently in 1995, in a cave at Vallon-Pont-d'Arc, France, dating from about 30,000–28,000 BCE.

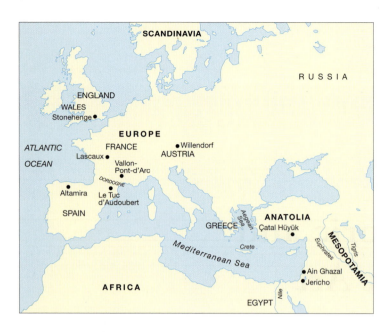

Map 2.1 Prehistoric Europe and the Near East

These paintings were made in the Paleolithic era, the Old Stone Age (from the Greek "*paleo-*" = old, and "*lithos*" = stone), named for the time when people, using stone tools, lived in nomadic communities of hunter-gatherers, and agriculture was still unknown. These cultures arose in Europe between about 40,000 and 35,000 BCE and are called "prehistoric," because they predate the earliest surviving recorded history. Evidence of Paleolithic culture has been found across an area stretching from northern Spain to southern Russia. Most likely, these early people hunted the types of animals depicted in the caves.

Around 9000–8000 BCE, at the beginning of the Neolithic era, or New Stone Age, people began to domesticate animals and cultivate food grains in the Near East (the area that comprises present-day Turkey, Iran, Iraq, Israel, Jordan, Lebanon, and Syria). This led to a more settled existence and to the art of architecture, as wood, brick, and stone were used to build permanent structures. The earliest surviving evidence of Neolithic city life has been found in the Near East at Jericho in Jordan, dating back to around 8000 BCE, and at Çatal Hüyük in Anatolia (central Turkey), dating to around 6500 BCE (see fig. 2.8).

Between about 4000 and 3500 BCE copper smelting began in the Near East. The discovery that copper and tin together produced a harder, stronger material—bronze—would have far-ranging consequences, from waging war to making art. With bronze, artisans could fashion new tools, including weapons that would give their owners the power to conquer other peoples. At about this time (between about 4000 and 3000 BCE), more complex civilizations arose between the Tigris and Euphrates Rivers, the region we call Mesopotamia (Greek for "land between two rivers"), and in Egypt. The prosperity of the Mesopotamians and Egyptians led to flourishing city life and, with it, art of great refinement and architecture of monumental proportions. Around 3000 BCE another civilization, known as Minoan, developed on the island of Crete, in the Aegean Sea (see Map 2.1).

Meanwhile, between about 4000 and 2000 BCE, a highly developed society was also forming in China along the Yellow and Yangzi River valleys, and around 2700 BCE another great river valley civilization grew up around the Indus River of India. We will consider a few examples of the art from these civilizations in the "Parallel Cultures" section on pages 54–7.

In all these societies, art and architecture contributed significantly to maintaining the political unity, well-being, and spirituality of communal life. We focus first on the prehistoric art of Europe and the Near East, followed by that of Mesopotamia, Egypt, and the Aegean, for in these cultures we find the roots of Western art.

PREHISTORIC EUROPE AND THE NEAR EAST

The earliest art we know seems to have sprung from the deepest human fears and needs. Before nature's power, humans are weak and vulnerable. If unseen forces controlled those powers they feared, then appeasing those forces might increase the odds for survival. And, in fact, the earliest art does appear to have served the need for human survival as expressed in spiritual rituals.

Spirituality

In the prehistoric and ancient world, artists participated in forming ritualized responses to the mysterious forces that provide for life. Totally dependent on an unpredictable world for fertility and survival, human existence demands that nature should be engaged with both nurturing and violence: Life must be protected, but

also taken. The ritual and art of ancient people suggests those concerns, and however much our lives have changed outwardly, modern religious rituals still echo the concerns inscribed in the art of our Paleolithic ancestors.

Fertility Figurines

As one of the earliest nurturant images, this four-inch high "Venus" (fig. 2.2) belongs to a group of miniature sculptured female figures of highly polished ivory or, as in this case, stone, made about 25,000–20,000 BCE. In almost all of these figurines, gender-neutral parts, such as hands and feet, and individual facial features are insignificant, while pendulous breasts, protruding stomachs, bulbous buttocks, and sometimes the pubic area, are accentuated. The name "Venus," after the Roman goddess of love and beauty, may be misleading. Most likely, these figures were not valued for any erotic connotations, but as fetishes or magical objects that held the promise of fertility. Perhaps the Venus was a Paleolithic antidote to the fear of extinction, a good-luck charm with hoped-for magical powers that manifests hopes and fears we share today, but express quite differently.

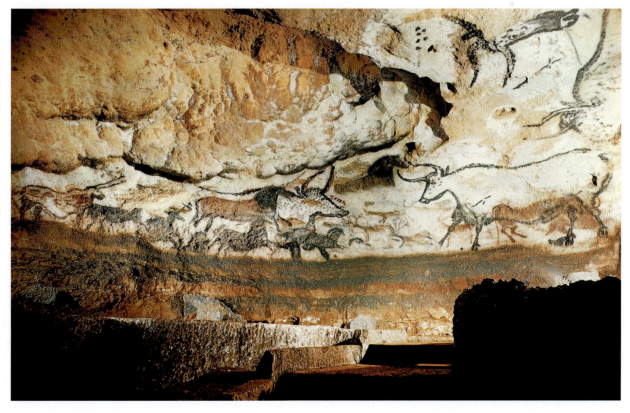

2.2 "Venus" of Willendorf, Austria, c. 25,000–20,000 BCE. Limestone, height 4³⁄₈". Naturhistorisches Museum, Vienna

The Hall of the Bulls

The fertility figurines have been found among traces of human habitation, but the earliest surviving paintings were discovered in the still darkness of deep caves. Holding no traces of daily living, the caves seem to have been ceremonial sites, entered for magic or religious rituals, in some cases revisited over thousands of years. The caves' images, such as those in the "Hall of the Bulls" (figs. 2.3 and 2.1) at Lascaux in the Dordogne region of southern France, painted between about 15,000 and 13,000 BCE, invariably depict wild animals, including cows, bulls, bison, horses, deer, and woolly-haired rhinos. Occasionally human figures are included, and at times sets of human handprints. Many geometric markings, such as patterns of linked squares, and groups or lines of dots, appear as well. Reed pipes for spray-blowing paint have also been found in these caves, as well as small stone lamps. The animals are drawn in profile, emphasizing their most characteristic features, and often overlap one another.

2.3 Hall of the Bulls, Lascaux caves, France. c. 15,000–13,000 BCE. Paint on limestone

Pigments

At least since the earliest surviving cave paintings were created, people have known how to derive colored pigments from minerals, such as blackish manganese dioxide and red and yellow ochers. Blue pigment comes from grinding azurite and costly lapis lazuli, or blue chrysocolla (a copper compound mined in Arizona). When pigments are mixed with other substances, such as water, linseed oil and turpentine, molten wax, egg yolk, or an acrylic plastic, the resulting material can be applied to a variety of surfaces. Historically, artists had to grind and mix mineral pigments in the studio immediately before using them, but that changed in the nineteenth century, when chemical pigments were invented. Not only did the range of available colors widen to include cobalt violet, viridian green, and cerulean blue, but a new kind of packaging, in tubes, freed artists from the studio to work outdoors. The new pigments, and the new freedom, contributed significantly to the brilliance of Impressionist paintings, which we will encounter in Chapter 13.

They are painted in natural earth colors, such as a reddish-brown ocher and a black derived from manganese (see "Materials and Techniques: Pigments," above).

What motivated the cave painters is still debated, but most scholars believe that the animal images served a ritual, magical function, related to hunting or the breeding season. Some paintings show arrows striking the beasts, and in others, actual gouges in the images suggest that real spears were hurled at the painted animals, perhaps to invoke success in hunting. In one such image, a bearded human figure with the antlers of a deer, the paws of a bear, and the tail of a wolf suggests the role of a magician or shaman. The prevalence and consistent subject matter of cave paintings attest to our prehistoric ancestors' constant need to come to terms with the natural environment, and the intertwined fate of humans and animals.

Ritual Architecture: Stonehenge

With the domestication of animals and the development of agriculture during the Neolithic period, concerns about fertility and the power of nature took new forms. These included the creation of massive ritual architecture. Most architectural sites were dedicated to burial rites; some sought harmony with the life-giving rhythms of nature. The most memorable of these, Stonehenge (fig. 2.4), was built in various stages around 2000 BCE and still stands today, in majestic isolation on Salisbury Plain, in Wiltshire, England.

Stonehenge consisted of a series of stone circles surrounded by a bank and a ditch (fig. 2.5), approached by a ceremonial avenue. The outer circle is made up of immense, vertical sarsens (sandstone blocks) supporting a continuous ring of horizontal lintels. While this outer circle is made of sandstone, an inner ring of smaller posts, without lintels, is made of bluestone, found only in Wales, about 190 miles from Salisbury Plain. Inside this bluestone ring stood a horseshoe-shaped group of five pairs of sarsen posts and lintels (see "Materials and Techniques: Post-and-lintel Construction," page 34). Enclosed within this group is a second horseshoe of bluestone posts without lintels. At the apex of this horseshoe lies a single slab, now known as the Altar Stone. If you look out from the Altar Stone, down the avenue to the east, and beyond the outer ditch, you will see the "heel stone," which marks the point at which the sun rises at the midsummer solstice. Other axes seem to align with where the sun sets in midwinter, and with the most northerly and southerly points where the moon rises. Whatever religious signification Stonehenge may have had, it certainly provided a reliable calendar guide to the cycle of the seasons and the planting and harvesting of crops. Considering the work and sheer will needed to move, shape, and mount such massive stones—some weighing about fifty tons, and some brought from far away—its importance must have been profound.

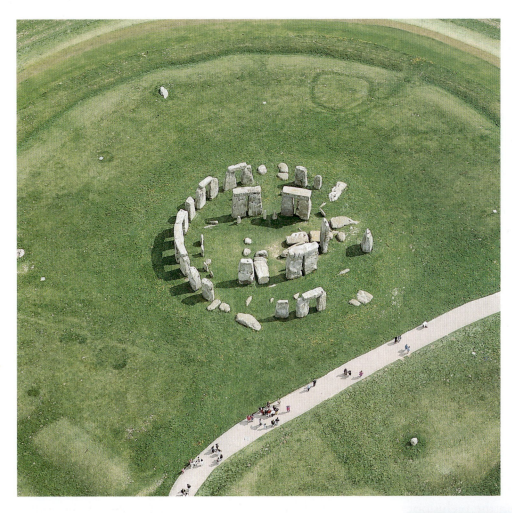

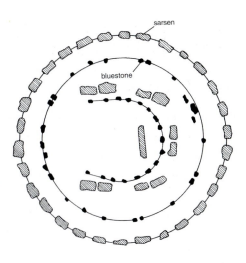

2.5 Plan of Stonehenge

2.4 Stonehenge (aerial view), Salisbury Plain, Wiltshire, England. c. 2000 BCE. Diameter of circle 97'

The Self

The human images in prehistoric art are largely symbolic and associated with ritual and survival. Similarly, the role of the prehistoric artist was also ritualistic (see "The Artist as Shaman," page 35). Neolithic culture also provides the earliest evidence of any attempt to preserve the likeness of individuals. Excavating a site in prehistoric Jericho, archeologists uncovered a series of sculptured heads based on actual human skulls, dating from about 7000 BCE (fig. 2.6).

The individual features were reconstructed in colored plaster, with seashells for the eyes. The heads seem to have been displayed above ground, over the site where the actual body was buried. A group of full-length painted plaster figures, at most three feet tall, with individualized features, dating from about 7000–6000 BCE, was found in 1981 at a Neolithic settlement at Ain Ghazel, near Amman in Jordan. They too may have

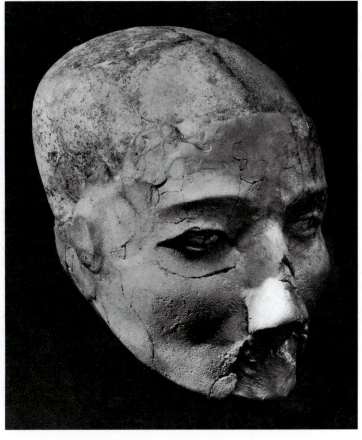

2.6 Head from Jericho, Jordan. c. 7000–6000 BCE. Human skull, colored plaster, and shell. Amman Archeological Museum, Jordan

Post-and-lintel Construction

The post-and-lintel method of construction is one of the earliest architectural systems. Two separate, vertical supports, the posts, carry the weight of the horizontal lintel, which is placed across their tops. Varying this basic form of construction creates countless architectural possibilities, including the ancient Egyptian architecture we'll consider in this chapter, for example, see figures 2.20 and 2.33, and the Classical Greek orders (see Chapter 3).

served a cult of ancestor worship, or perhaps were votive figures, such as the much later examples from Tell Asmar, discussed below (see fig. 2.12). These memorials anticipate by thousands of years the Romans' veneration of their ancestors, a practice on which Western portraiture is ultimately grounded (see Chapter 4).

Nature

Prehistoric people depended on an abundance of wild animals and success in hunting them. No wonder animals were a prime subject for prehistoric artists. Surviving representations of wild animals abound in the prehistoric cave paintings of southern France and northern Spain (see fig. 2.3). We've discussed their likely magical or ritual purposes; now, we will view them as works of art. Cave painters created remarkably naturalistic depictions of a wide range of animals. Cows, bulls, bison, horses, deer, woolly-haired rhinoceroses, bears, lions, panthers, and hyenas are all recognizable. With great skill, the artists have conveyed each species' characteristic movements, in some areas creating the effect of a stampede.

Two Bison

Nearly all these animals are represented in profile, and virtually all in paintings on the cave walls and ceilings. Only a few have survived in sculptural form, among them a pair of bison modeled in clay, attached to a large rock lying in a chamber some 750 yards in from the cave's entrance at Le Tuc d'Audoubert, near Ariège, in France (fig. 2.7). Dating from about 15,000–10,000

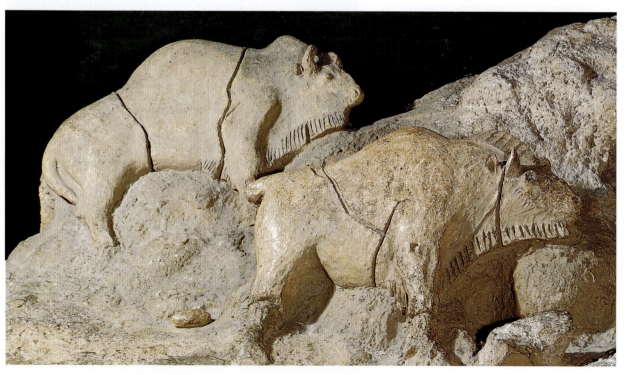

2.7 Bison, Le Tuc d'Audoubert, Ariège, France. c. 15,000–10,000 BCE. Unbaked clay, length 25" and 24"

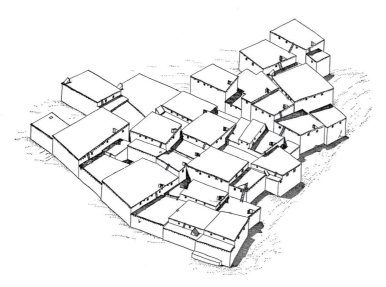

2.8 Reconstruction of section of Level VI, Çatal Hüyük, Turkey. c. 6000 BCE

BCE, each figure is approximately two feet long, and placed to suggest a male pursuing a female, perhaps intending to mount her. While the dried clay has cracked, the artist's clear grasp of the form of the bison remains intact. The main volumes and shape were probably modeled by hand, but the marks of a tool pulled repeatedly over the surface to smooth it down are still visible, as are various incisions to suggest eyes, nose, mouth, and mane. Clearly, the hunter's attentive observations carried over into the artist's rendering of natural form. For both artist and hunter, mastery of the animals was a matter of life or death.

The City

Passing from a nomadic existence as hunter-gatherers through the beginnings of agriculture, and then to settled city life in the early Neolithic period had profound effects on human experience and culture. This last phase began about 8000 BCE in the Near East. As Neolithic peoples' agricultural advances began to ensure food surpluses, communities started accumulating raw or crafted resources beyond their needs. They also began to want what they lacked. As trade with other communities flourished, urban life came into being. The oldest urban settlement discovered to date is Jericho, dating back to about 8000 BCE, from where the sculpted plaster heads mentioned above (see fig 2.6) were found. Located on the west bank of the River Jordan, it was fortified by a stone wall, expanded over time, and later surrounded by a further massive wall. Its collapse before the Hebrew armies is recorded in the Book of Joshua of the Bible's Old Testament.

Çatal Hüyük

Another of the earliest known Neolithic cities, Çatal Hüyük in Anatolia (central Turkey), was excavated in the 1960s. It shows signs of occupation between about 6500 and 5500 BCE. (See fig. 2.8 for a schematic reconstruction drawing of a section of the city.) It was a large trading city, and is notable for its complete absence of streets. Rectangular houses of varying sizes but standard design rise in terraces on a slight incline, and abut one another on all sides, allowing for access to the inside only from above. The houses are laid out on a regulated plan, built of mud brick around a timber frame, and many include shrines. These feature rich interior decorations, including wall paintings, bulls' skulls, and various fertility symbols. In one such shrine there is even a wall painting that appears to depict the city itself in schematic form, with a double-headed volcano in the background, which is consistent with the local topography.

The dead were buried beneath the floors, the men with weapons, the women with personal ornaments. Other remnants attest to the life of a prosperous city, manufacturing tools from volcanic obsidian, and plying the crafts of weaving and pottery as well as copper smelting, painting, and sculpting.

❖ **THE ARTIST as Shaman** ❖

The evidence of the earliest surviving art suggests that makers of such art served their communities in the struggle for survival. These Paleolithic artists are often compared to the shaman, found even today among African bushmen, Native Americans, and Eskimos: Part priest, part magician, part healer, and also a maker of images, an artist. This may have been the role of the earliest artists.

Relief Sculpture

Unlike free-standing sculpture, relief sculpture is attached to a background: Forms project from a relatively flat plane. Reliefs, which can be carved in three different types or levels, typically decorate walls or columns.

In **low relief** (or bas-relief), the figures are relatively flat (see fig. 2.9); in **high relief**, as in the *Stele of Hammurabi* (see fig. 2.13), the forms project farther from the background and therefore appear to be more three-dimensional. In **sunken relief**, used predominantly in ancient Egyptian art, forms are cut into the background, thus receding from a flat plane (as on the obelisk in fig. 2.20).

When light strikes a relief, its different levels cast shadows of varying intensity, helping to define the forms. To create the illusion of depth, artists varied the relief levels of figures, moving from high to low within the sculpture. We will see many examples of relief sculpture across cultures and centuries, particularly in chapters 3, 4, and 7.

The Self

Some of the best-known images from Mesopotamia are Sumerian votive figures, statuettes that could represent an individual forever before their gods. A fine example, made about 2900–2600 BCE, is a group of votive figures (fig. 2.12) from the ruins of the Temple of Abu, god of vegetation, at Eshnunna (modern Tell Asmar, Iraq), a small outlying Sumerian town. Cylindrical, with squared shoulders and arms, they were created in a variety of sizes, the tallest being about 30 inches high. People would have commissioned artists to make these to fulfill a specific need (see "The Artist as Artisan," page 39). It's possible that individuals simply requested that these figures be made in a specific height, but it may also have been a way of differentiating ordinary–and thus smaller–worshippers from the priests and priestess. Notice that all assume a similar pose, with hands clasped, appealing to a god, and all have enlarged eyes that are emphasized by colored inlays. The eyes of the largest figure are dis-

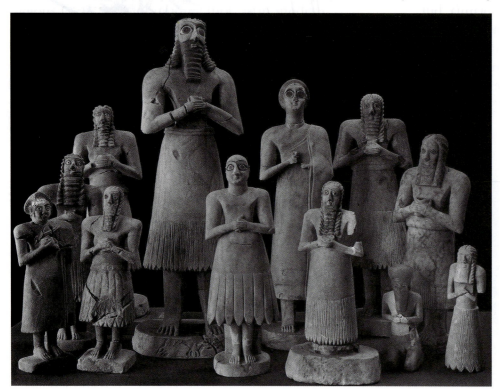

2.12 Votive statues, from the Abu Temple, Eshnunna (modern Tell Asmar, Iraq). c. 2900–2600 BCE. Limestone, alabaster, and gypsum, height of tallest figure c. 30". Iraq Museum, Baghdad

proportionately larger than all the others. These eyes might be understood as "windows of the soul," staring awestruck into the face of eternity.

Stele of Hammurabi

The Sumerian votive figures gaze up toward their god. A thousand years later, about 1792–1750 BCE, the great Mesopotamian king Hammurabi, founder of the Babylonian dynasty, had his image carved on a stone slab standing directly before the sun god Shamash (fig. 2.13). Such a commemorative carved stone slab is called a stele. Hammurabi, a brilliant ruler, derives two primary benefits from this image: It provides divine sanction for his authority and also presents him as the one who can stand before the gods on behalf of his people. Indeed, ancient Mesopotamian rulers claimed, as mediators between the gods and humanity, to function as the agents through whom social stability would be ensured.

Look, for example, at how Hammurabi is depicted on his stele: He stands, confident and erect, saluting the enthroned sun god, whose feet rest on three layers of patterned blocks that—

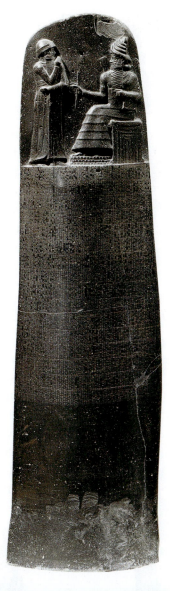

2.13 *Stele of Hammurabi*, from Susa (modern Shush, Iran). c. 1760 BCE. Basalt, height 7'4". Musée du Louvre, Paris

like the tiers of a ziggurat—signified a sacred mountain. The god is identified by a four-tiered headdress of bull-horns and by the sun-rays emanating from behind his shoulders. In his hand he holds a measuring rod and a rope band, symbols of justice and power. He symbolically extends these toward the priest-king, as his earthly delegate and chosen intermediary between god and humanity. Each figure is carved in such high relief that both have a compelling presence, underscored by the pronounced eye contact between them (see "Materials and Techniques: Relief Sculpture," page 38). Inscribed on the surface of the stele below them is the famous law code of Hammurabi, whose authority is asserted by the image of the priest-king as man's high priest and the god's vice-regent. This deliberate attempt to influence the viewer's perception is fundamental to all artistic acts of self-representation. Throughout this book, we will see that images of the self—both in public and private life—show how a person desires to be perceived, rather than revealed.

❖ THE ARTIST as Artisan ❖

In the ancient world—whether Egypt, Mesopotamia, Greece, or Rome—those whom we today call artists were viewed as artisans, skilled workers who made things with their hands. Artisans worked together in a shared workshop, dividing tasks, and even often working on the same project. As manual laborers, they typically came from the slave class and, like all who worked with their hands, were looked down on by the ruling classes. Even if their works were admired, as skilled in a manual art, rather than a liberal art, they were only credited with *techne*, skill in making things, rather than *sophia*, or inner wisdom. This emphasis on the physical aspect of art-making promoted high technical accomplishment; but in ancient cultures, it also meant that artists were esteemed for their ability to create works that were variations of a particular model or formula rather than for their conceptual originality. This ancient view of the artist as artisan carried with it the stigma of manual labor, a stigma that has endured long after Michelangelo's later insistence that an artist paints with his brain.

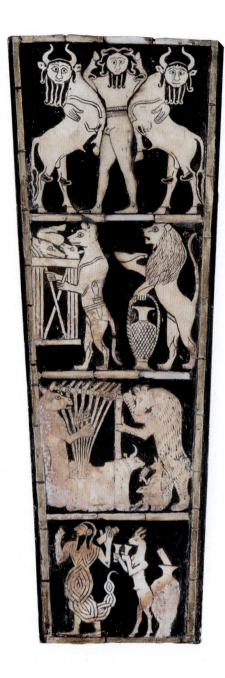

2.14 Detail of bull lyre, from the tomb of Queen Puabi, Ur (modern Muquaiyir, Iraq). c. 2685 BCE. Wood with gold, lapis lazuli, and shell, reassembled on modern wooden support, height 17". University Museum, University of Pennsylvania, Philadelphia

The Bull's Head Lyre

A beautiful example of attributing human qualities to animals, or anthropomorphizing, is found in the decorations of a harp from the tomb of Queen Puabi of Ur, made about 2685 BCE (fig. 2.14). Its sound-box terminates in the head of a bull, a symbol of strength and virility. On a panel below the bull's head four scenes are created from fine shell inlay. In them animals impersonate humans, bearing ritual offerings, playing music, and making intercession. In the uppermost register a naked man embraces paired human-headed bulls, a motif that recurs in the art of the ancient Near East and spreads far and wide down through the centuries on metalwork and fabric design. As for the bearded bull, it too reappears in variant forms, as in the man-bull guardian figures at the entrances to Assyrian palaces (see fig. 2.17).

Lioness Mauling a Nubian Boy

The intense struggle between humans and animals in the ancient world inspired both religious awe and creative expression. In the small ivory relief carving of a lioness mauling a Nubian boy (fig. 2.15), the artist skillfully expressed the pathos of beauty and violence intertwined. Believed to have been made about 700 BCE by a Phoenician craftsman, it was found in Nimrud,

Nature

As agricultural communities grew, artists expressed peoples' age-old fears about fertility, but now in the context of agriculture. On the lower registers of the alabaster vase from Uruk (see fig. 2.9) notice that tribute of barley stalks, date palms, ewes, and rams is offered to a nature goddess. As we've seen, in prehistoric cultures nature was rarely represented strictly for itself; it was always linked to a ritual, symbolic, or metaphorical meaning. Similarly, artists also created hybrid monsters, part human, part animal. In some, people display the qualities of animals they admired or feared; in others, the animals have human traits, allowing the artist to caricature human behavior.

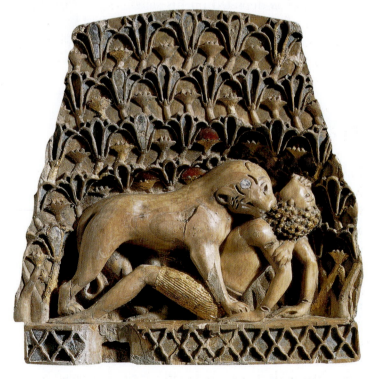

2.15 *Lioness Mauling a Nubian Boy*, from Nimrud, c. 700 BCE. Ivory, gold, faience, and lapis lazuli, height 2³/4". The British Museum, London

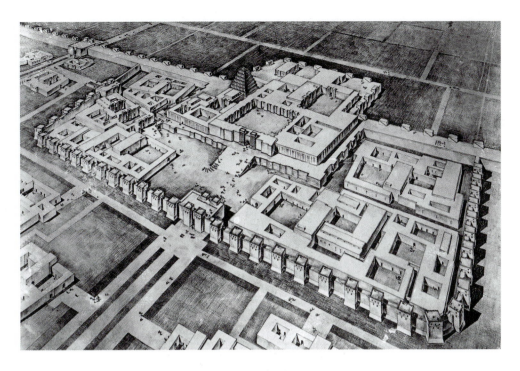

2.16 Reconstruction drawing of the citadel and palace complex of Sargon II, Dur Sharrukin (modern Khorsabad, Iraq). c. 721–706 BCE (after Charles Altman)

city of their Assyrian overlords, who would have received it with other fine tribute.

In the interlocking of boy and beast against a background of flowers, the artist has sharply juxtaposed beauty and brutality, life and death: Joyful warmth exudes from the upward-spreading lines of the background floral design; the full, rounded, relief carving of the boy and lioness provides a potent visual contrast. Even the refined delicacy of craftsmanship, fusing gold, lapis lazuli, and red faience with the ivory ground, contrasts with the raw violence of the subject. The chill of death is intensified by the beauty of life.

The City

Little remains of the famed ancient cities of Mesopotamia—Uruk, Ur, Nineveh, Babylon, and others—which began to be founded around 4000 BCE. Through ancient Sumerian literature, however, we can glimpse what these cities meant to their citizens, and which of their features were most valued. A myth about the moon goddess Nanna written at the beginning of the second millennium BCE begins: "Behold the bond of Heaven and Earth, the city ..." It goes on to praise its walls, river, canals, quays, and fresh water.

As we've seen above, these cities are described as the gift of the gods, held in stewardship by a ruler, who served as a priest-king, mediating between the gods and humanity—representing the assumed interests of each to

the other. Thus, the temple precinct and the ziggurat of the city's patron god—their chosen protector—formed the center of early Mesopotamian cities. In time, however, the man chosen as the god's chief steward (his representative on earth) assumed the status of a secular king. And with that change, the royal palace gained status as well. No longer an adjunct of the temple precinct, the palace assumed the prominence once given to the ziggurat, and the ziggurat, with all its potent symbolism, was subsumed into the vast, sprawling palace precinct.

The Palace of Sargon II

This new configuration appears in a drawing based on the excavation of the citadel and palace complex of the Assyrian king Sargon II at Dur Sharrukin (modern Khorsabad, Iraq) (fig. 2.16), which was built about 721–706 BCE. (The ziggurat is located beside and behind the palace, on its left side.)

The ziggurat complex had once served as the citadel, the point of last defence within the city. However, now the palace complex has become the citadel, with its back to the outer city wall. To see the king, visitors had to pass through the city, and the gates of the citadel, cross a large courtyard, and go up a ramp onto a raised platform, on which stood the palace. Then they had to walk between two massive, awe-inspiring sculptures of human-headed, winged bulls (called *lamassu*) guarding the entrance (fig 2.17). These massive guardian figures, almost fourteen feet high, were carved from limestone blocks about 720 BCE. Despite their massive scale, the sculptor has carefully

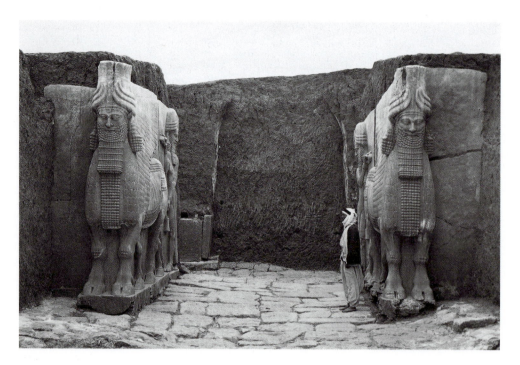

2.17 Human-headed winged bulls (*lamassu*), guarding the gateway of the Palace of Sargon II, Dur Sharrukin (modern Khorsabad, Iraq). c. 720 BCE (during excavation)

rendered details of the wing feathers, curls of hair, and even veins in the legs. These guardian creatures echo the sphinx that protected the approach to the temples and pyramids at Giza in Egypt, made about 2570–2544 BCE, the paired lions at Mycenae (see fig. 2.33), and the cherubim of Solomon's temple in Jerusalem (see fig. 2.36).

At the palace of Sargon II, having passed these guardian creatures, visitors crossed two more courtyards, before finally reaching the throne room. On the base of the throne itself was a stone relief carving of the king in his chariot, surveying a mounded pyramid of the heads of his defeated enemies. Because such architectural and sculptural displays of power were reinforced by a history of ferocity on the battlefield, no one was more feared than the Assyrians.

With the growth of Mesopotamian cities came specialization and social stratification. Farmers, craftspeople, builders, merchants, priests, administrators, and rulers held different status. The design and architecture of these ancient cities made the hierarchy of power clear to all. First, cities were divided into zones, each dedicated primarily to a particular type of citizen and activity, such as administration, trade, crafts, and manufacture. Within these zones, the scale and setting of prime civic, religious, and trading structures, as well as rulers' palaces, signaled civic priorities. Then as now, the design of cities reflects the social relationships and values of generations of inhabitants, ideally in ways that are also aesthetically effective.

EGYPT

About the same time that Mesopotamia was flourishing, a powerful agrarian society arose in the river valley of the Nile (see Map 2.3). Although the Egyptians shared some traits with the Mesopotamians, their art suggests a major difference: Egyptians were preoccupied with the afterlife and devoted great energy to providing for their material and spiritual well-being in the hereafter.

Map 2.3 Ancient Egypt

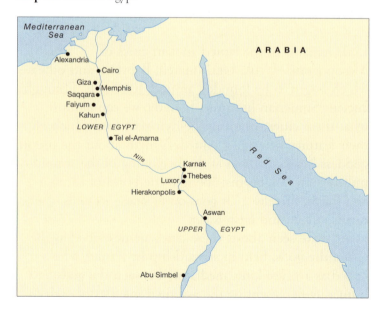

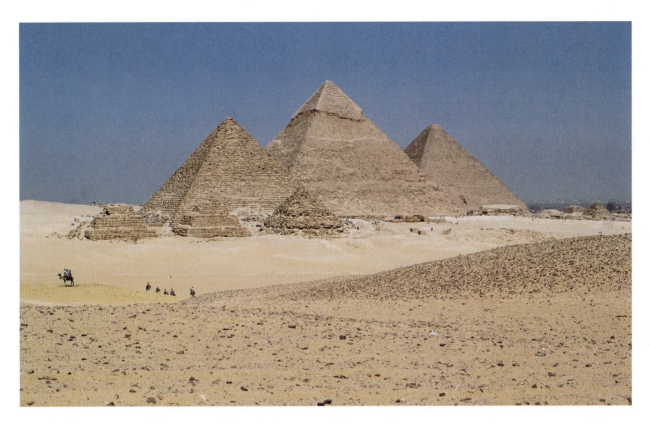

Spirituality

In Mesopotamia, architectural effort was focused primarily on meeting the needs of this world—whether in religious or secular terms—but offered no prospect for the hereafter. In Egypt, by contrast, the greatest effort and the most durable building materials were reserved for the needs of the afterlife. This craving for immortality led to the creation of expansive "Cities for the Dead," dominated by the massive forms of splendid temples and pyramids. The pyramids' austere geometry is thought to echo the angle of the sun's rays beating down on the desert sands.

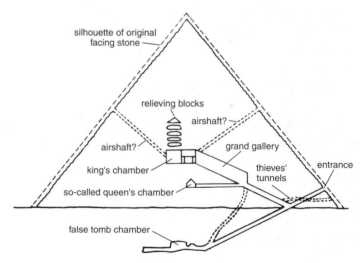

The Great Pyramids at Giza

The Great Pyramids at Giza (fig. 2.18) were erected between 2601–2515 BCE, during the Fourth Dynasty, by the pharaohs Menkaure, Khafre, and Khufu. They commemorated the all-powerful pharaohs, provided a house for their spirit, called the *ka*, in the afterlife, and ensured the continuance of their cult as semi-divine figures. Their design suggests the culmination of two earlier funerary monuments, the **mastaba** and the step pyramid. The *mastaba* was a flat-topped trapezoidal structure of moderate height placed over a tomb chamber. Around 2675 BCE the priest-architect Imhotep built a tomb in the form of a step pyramid for the

pharaoh Zoser, comprised of six *mastaba*s set on top of each other. The great pyramids at Giza resulted when these steps were eliminated to realize a pure pyramidal form: Four triangular sides rising from a square base to converge at a point. The tomb chamber (fig. 2.19) was hidden inside, well behind false doors and passages built to divert grave robbers from finding the treasure that accompanied the pharaoh into the afterlife. The pyramids were faced with limestone, took years to complete, and have survived, almost intact, as one of the wonders of the ancient world.

The Temples at Karnak and Luxor

While the pyramids assured the continuance of the pharaohs' cult after death, massive temples emphasized their ties to the gods in this life.

During the so-called New Kingdom, the culmination of Egyptian power and wealth, the pharaohs identified their kingship with the creation god Amun, whose own identity they fused with that of the sun god Ra. The reigning pharaoh claimed Amun-Ra as his father, and reinforced such claims by building or adding to the great temple complexes dedicated to Amun-Ra at Karnak and Luxor (fig. 2.20). Unexpectedly, however, these monumental temple complexes increased the power of the priestly cast at the pharaohs' expense.

These New Kingdom temples consisted of three parts arranged along a central, processional axis (see diagram, fig. 2.21): An open outer forecourt (A) entered through a gateway (or **pylon**); a covered **hypostyle** hall (B) (filled with several rows of tall, thick, closely spaced columns); and an inner sanctuary (C) for the cult statue. To honor the deity, successive rulers added to the processional route courtyards, which were open to the public. Only select priests and the pharaoh could enter the small inner sanctum, however, which was reached by a series of small halls that extended beyond the larger hypostyle hall. The columns in these halls are divided into three sections: a round base, a cylindrical shaft (that might be carved or painted with images and inscriptions), and a capital, which is the top part of a column. The capitals were carved in the form of river plants such as the lotus, palm, and papyrus; the shaft could also take these forms.

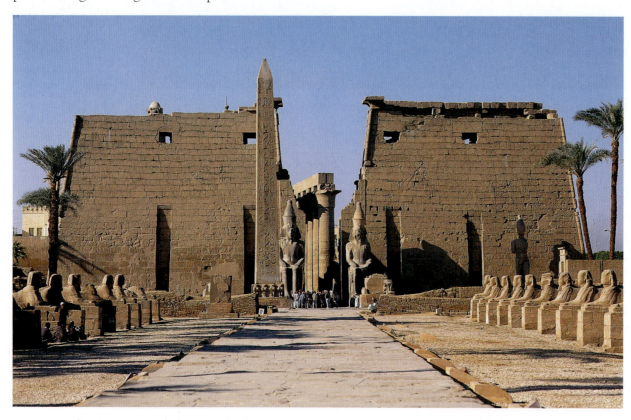

2.20 Temple of Amun-Mut-Khonsu, Luxor, with pylon of Ramses II. c. 1260 BCE

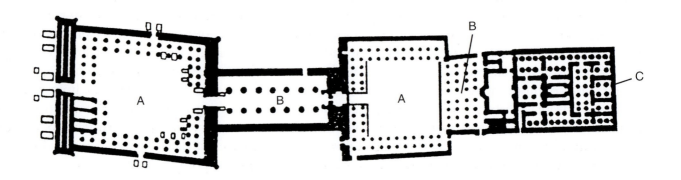

2.21 Plan of the Temple of Amun-Mut-Khonsu, Luxor (after N. de Garis Davies)

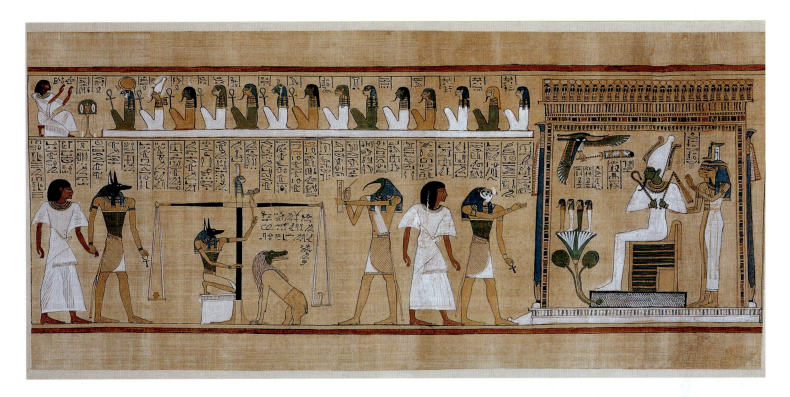

2.22 *Judgment before Osiris*, illustration from the Book of the Dead of Hunefer, Nineteenth Dynasty, c. 1285 BCE. Painted papyrus, height 15⅝". The British Museum, London

The temple of Amun-Ra at Luxor was begun under Amenhotep III around 1390 BCE, and extended by Ramses II about 1260 BCE. Two huge statues of Ramses II flank the entrance as did (originally) a pair of **obelisk**s—slender tapering shafts covered with inscriptions and culminating in a pyramidal shape. The message of the grand scale and richness of these temples is powerful and clear: they gave religious authority to the pharaohs' right to rule. At the same time, the temples helped the pharaohs gain support from the priestly caste.

In the objects and decorations carried with them to the grave, Egyptians brought together the concerns of this life and the next. As well as the custom of being buried with a supply of household goods, their desire to provide for the afterlife and their belief in a "last judgment" inspired a group of scrolls we know as "Books of the Dead." These written and illustrated papyrus scrolls, containing magic texts and prayers, were placed in the tomb or mummy wrappings of the deceased. A recurring image is this scene of *Judgment before Osiris* (fig. 2.22), painted for a man named Hunefer about 1285 BCE. As he waits, at left, his heart is weighed against an ostrich feather (signifying truth). A hungry monster, Ammit, "eater of the dead," waits as well, to devour Hunefer if he is found wanting. When Hunefer passes the test, he is presented—at right—before Osiris, who is worshiped by Egyptians

as god of the dead, king of the underworld, and giver of eternal life. The theme of this scroll predates by over a thousand years Christian images of the "weighing of souls," as does its combination of text and images in early book form. While the parallel is striking, there is no evident connection between the one and the other.

The Self

Like the Mesopotamians, Egyptian rulers used art and architecture to assert their power and authority. Art impressed subjects and enemies alike with images of a ruler's might, majesty, and military prowess. The baser aspects of power were hidden, and the sheer scale and magnificence of architecture surely instilled respect. Thus, art and architecture allowed even ancient kings to be a constant, powerful presence, just as modern politicians use the media to promote their own desired image. As we'll see below, the ancients also knew how to make a political message quite explicit.

The *Palette of King Narmer*

Carved from slate (about 3150–3125 BCE) during Egypt's First Dynasty, Narmer's palette commemorates the military victories that unified the kingdoms of Upper and Lower Egypt. (This palette is a ceremonial variant of an object used for mixing paint or eye shadow. It is carved in low relief on both sides.) On one side (fig. 2.23, left), the king, wearing the crown of Upper Egypt, stands under the protection of cows' heads (representing the goddess Hathor). He holds his enemy down, ready to strike him with his mace. The king's feet are bare, while an attendant holds his sandals and a ritual vessel, signifying that this scene is a sacred rite. On the reverse side (fig. 2.23, right), Narmer, wearing the crown of Lower Egypt and preceded by standard bearers, views his defeated enemies, who are represented by ten decapitated bodies. Look now at the lowest register, where a bull, again symbolizing Narmer's might and virility, gores an enemy and destroys his citadel. Notice, too, the concise diagram of the citadel walls, the earliest known city plan. (We do not know the meaning of the middle register.)

Menkaure and His Wife

Nothing is more imposing–if less personal–than the seated or standing portrait statues of the pharaohs. A fine example is that of *Menkaure and His Wife, Queen Khamerernebty* (fig. 2.24), of Egypt's Fourth Dynasty, carved from slate about 2515 BCE. Menkaure erected the smallest of the three great pyramids at Giza. Here we see him with his wife, both depicted a little under life size. They stand rigidly erect and frontal, distinct but immobile images of assured power. Each figure steps slightly forward, a posture which imparts life. Their proportions follow a standard formula used at the time and male and female are treated distinctly. His arms press firmly at his side, hands clasping scrolls. Her open hands gently enfold her husband. His

2.23 *Palette of Narmer* (two sides), from Hierakonpolis. First Dynasty, c. 3150–3125 BCE. Slate, height 25". Egyptian Museum, Cairo

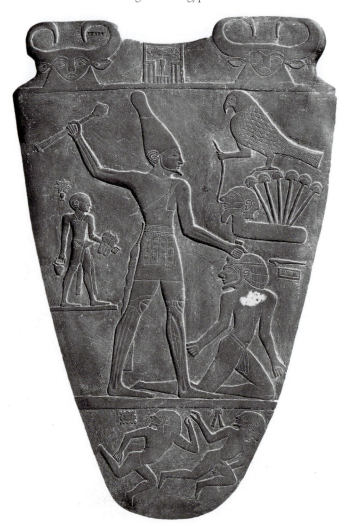

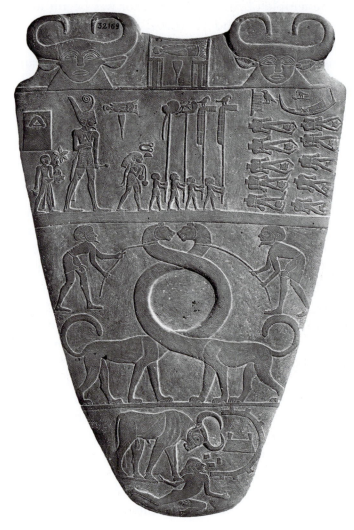

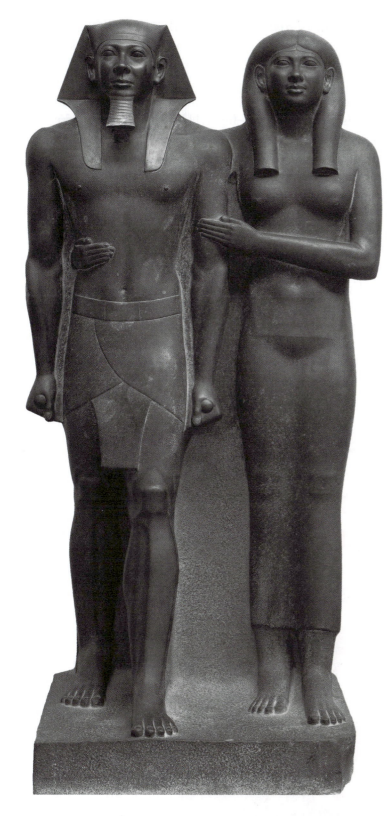

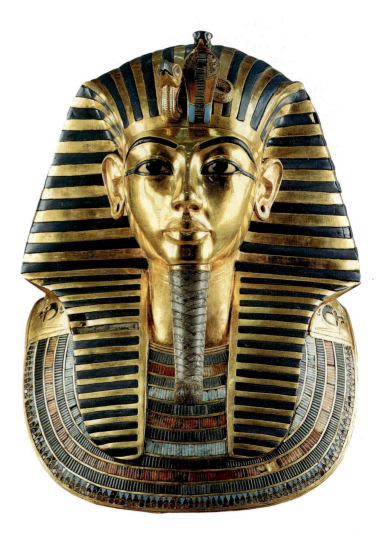

2.24 *Menkaure and His Wife, Queen Khamerernebty*, from Giza. Fourth Dynasty, c. 2515 BCE. Slate, height 54½". Museum of Fine Arts, Boston

features, but without the natural imperfections found in portraits of court officials. Pharaohs have to stand apart and instill a sense of majesty, which is what the sculptor has achieved.

Egyptian Funerary Art

Preoccupation with the afterlife inspired Egyptian artists to preserve the identity of the deceased in lavish portrait masks, attached to the wrapped, mummified body. An extraordinary example is the gold portrait mask of King Tutankhamun (fig. 2.25).

In the 1920s, when Tutankhamun's tomb was first opened, his mummy was found laid within three coffins—one inside the other—of which the innermost,

2.25 Portrait mask of Tutankhamun, from the tomb of Tutankhamun, Valley of the Kings. c. 1327 BCE. Gold inlaid with enamel and semi-precious stones, height 21¼". Egyptian Museum, Cairo

broad-set shoulders, heavy arms, and firm, pronounced legs contrast with the slighter, softer, and more rounded forms of his queen. His leading knee projects more than hers; his headdress is angular, hers curved. They are united as royal couple, but distinct in their gender roles. Both figures have somewhat individualized facial

Map 2.4 The Aegean: Ancient Greece, Crete, and the Cyclades

THE PREHISTORIC AEGEAN

Other major prehistoric cultures arose in the east Mediterranean in and around the Aegean Sea (see Map 2.4), on the island of Crete, among the Cycladic Isles to its north, and further north and west on what is today mainland Greece, in cities such as Mycenae, Tiryns, and Pylos in the Peloponnese. Each of these developed distinct, yet interrelated cultures. On the Cycladic Isles, small, sculpted figurines of nude women, with arms folded across their abdomens, have been found that date back to the middle of the third millennium BCE. As with Paleolithic fertility figurines, such as figure 2.2, their breasts and pubic area are well defined, but—lacking documentary or other evidence—the function of these figurines remains disputed.

During the second millennium BCE, the island of Crete rose in power and prosperity. Its prosperity derived not only from agriculture but also from sea-faring, trading with Egypt, the Near East, mainland Greece and elsewhere. In about 1620 BCE, a powerful volcanic eruption accompanied by earthquakes and possibly great tidal waves struck the island, leveling the buildings of a civilization that had flourished there since 3000 BCE. Surviving Cretan art is called Minoan, after the legendary King Minos, whose name archeologists associated with the most renowned palace on the island.

As Minoan culture declined, that of Mycenae, on mainland Greece, flourished, between approximately 1500 and 1100 BCE. The prehistoric art of the Greek mainland (*Hellas* in Greek) is called Helladic, although that of the second half of the second millennium BCE from the great citadel of Mycenae is usually called Mycenaean. Here, we will look at examples of both Minoan and Mycenaean art.

Spirituality

King Minos was said to have kept a monster—half man, half bull, known as the Minotaur—in a labyrinth, the Greek name for the king's palace at Knossos. According to Greek legend, each year King Minos would order fourteen young Athenian men and women to be sacrificed to appease the Minotaur—until, the legend says, the Athenian hero Theseus slew the monster.

Bull-vaulting Ritual

Whatever the relationship between fact and legend, when archeologists first excavated the buried ruins of the palace at Knossos between 1899 and 1935, they found vast, labyrinthine remains, containing both painted and sculpted images of bulls. A double ax (*labrys* in Greek) appears frequently as a decorative motif in the palace. In other Minoan art this image is associated with bull sacrifice. This and other evidence has led scholars to believe that bull-vaulting rituals, such as the one shown in figure 2.28, *Bull Leaping*, from the palace at Knossos, c. 1750–1450 BCE, took place in the central courtyard, around which the palace is built.

The religious significance of the bull-vaulting ritual shown in figure 2.28 remains a mystery, but the bull was a sacred animal in many ancient civilizations. As an embodiment of strength and virility, it was used elsewhere in ritual sacrifice, so it is likely that bulls carried ritual significance in Minoan civilization as well. The *Bull Leaping* **fresco** (a technique for painting with water-based pigment on a freshly plastered wall), now much restored, is the best-preserved of a group of bull scenes from the palace of Knossos. The elongated, sinuous outlines of both figures and bull typify the decorative nature of Minoan art. As in Egyptian art, male and female are silhouetted and differentiated by skin tone: darker reddish-brown for the boy vaulting over the bull's back, paler skin tones for the women at either end of the bull. The image appears to show

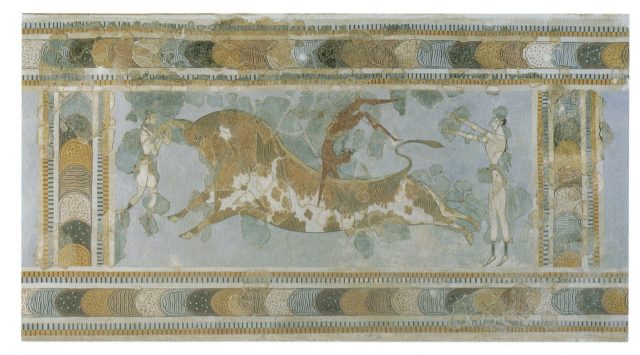

2.28 *Bull Leaping,* from the palace complex at Knossos, Crete. c. 1750–1450 BCE. Fresco with restored areas painted lighter, height approx. 24¹/₂". Archeological Museum, Iraklion, Crete

simultaneously three aspects of this dangerous ritual: Grasping the horns, vaulting the back, and alighting unscathed. Many believe that modern bullfighting has its origins in this Cretan ritual.

Fertility Statuettes

Archeologists working in Crete have found no temples and no large cult statues. But, as elsewhere in the ancient world, the Minoans may have revered a fertility goddess. Statuettes found in the palace of Knossos, such as the *Snake Goddess* (*Priestess?*) date from around 1800–1550 BCE (fig. 2.29). Though small, this female figure, bare-breasted, brandishing snakes, and with a cat perched on her crown, is a fearsome presence. Ritual figurines, wrapped in snakes, had been made in Crete for thousands of years; and throughout the ancient world, snakes and cats were both widely revered as sacred animals. The frontal stance, outstretched arms, pronounced breasts, and flashing eyes give the *Snake Goddess* a forceful presence, in whom the devotee is probably meant to see an embodiment of the regenerative power of a fertility goddess.

The Self

We may find the Cretan bull-vaulting ritual nerve-racking and the *Snake Goddess* fearsome, but Aegean art also has a lighter, more joyful side, in which we find representations of figures feasting, boating, and celebrating the harvest.

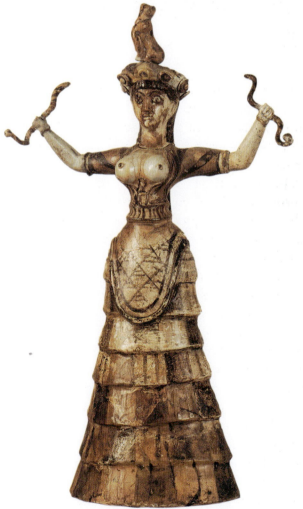

2.29 *Snake Goddess* (*Priestess?*), from the palace complex at Knossos, Crete. c. 1800–1550 BCE. Faience, height 11⁵/₈". Archeological Museum, Iraklion, Crete

Scenes of Ordinary Life at Akrotiri

Excavations of Akrotiri, on the Cycladic island of Santorini (ancient Thera), about sixty miles north of Crete and reflecting its artistic influence, have brought to light some beautifully preserved frescoes found in ordinary houses buried under the debris of volcanic eruption. One such detail is the *Young Fisherman with Catch*, a wall fresco from about 1650–1550 BCE (fig. 2.30). The red skin tones and the supple rendering of the body recall the color and fluid outline of the vaulting youth from the Cretan *Bull Leaping* fresco (see fig. 2.28). In contrast to the sharp, angular outlines of the Egyptian hunter (fig. 2.26), the curving forms and sinuous outlines of the fisherman's nude body are

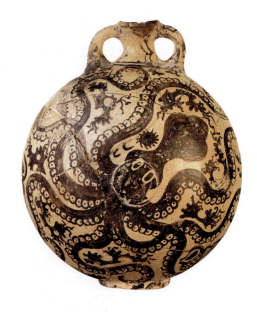

2.31 *Octopus Vase*, from Palaikastro, Crete. c. 1500 BCE. Ceramic, height 11". Archeological Museum, Iraklion, Crete

quite sensual. As with Cretan wall painting, the beauty of the image rests in the shape and outline of forms seen against a neutral ground. Its everyday theme, which seems free from any ritual significance, suggests the islanders' delight in seeing ordinary elements from their daily lives depicted on their walls. As such, this is a remarkable survival from ancient art.

Nature

Aegean artists, like those of Mesopotamia and Egypt, depicted dangerous and powerful natural forces and animals—such as snakes and bulls—as having spiritual or ritual significance (see figs. 2.17, 2.23, 2.28, 2.29). But they also expressed their love of the flora and fauna of their islands in wall paintings (see fig. 2.30), and on ceramic objects. A number of these carry lively images of marine life, such as the spherical vase in figure 2.31 whose surface is embraced by the wavy tentacles of an octopus. Its big eyes gaze out at us from a position slightly off-center, adding dynamism to an image of sea life whose design masterfully exploits the curvature of the vessel's surface. Working about 1500 BCE, the vase painter achieved this lively effect through the rhythm of shapes and outlines seen against a neutral ground, as did the artist of the *Bull Leaping* fresco (see fig. 2.28), which was made about the same time.

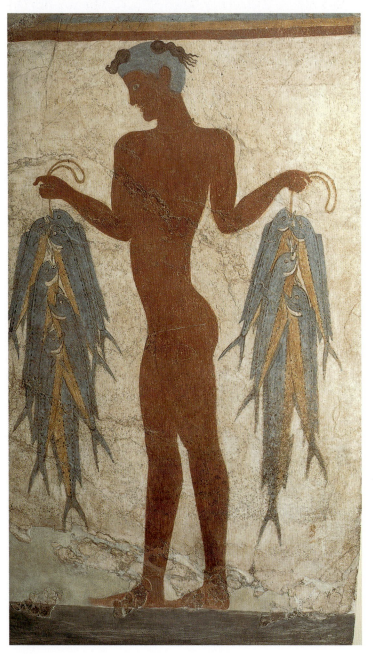

2.30 *Young Fisherman with Catch*, from Akrotiri, Thera (Santorini). c. 1650–1550 BCE. Wall painting, height 4'5". National Archeological Museum, Athens

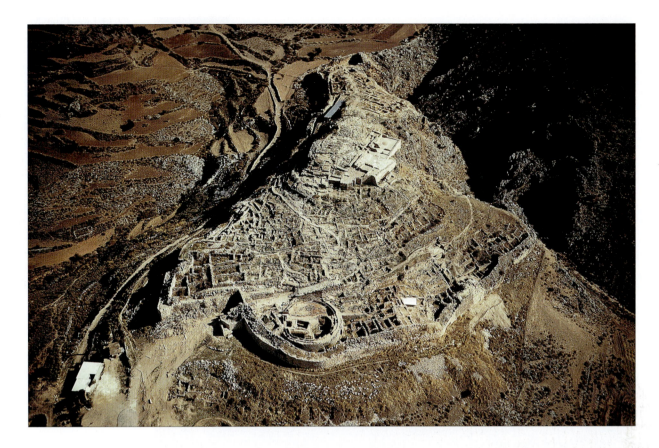

2.32 Aerial view of the hill-top citadel at Mycenae, Greece. c. 1600–1200 BCE

The City

Another side to prehistoric Aegean culture appears in the mighty hilltop strongholds built in the Peloponnesian mountains of mainland Greece, notably that of Mycenae. The Mycenaeans have passed through Homer's *Iliad* into Western consciousness as the fierce Greek warriors who sacked the famous city of Troy. They are named for the city of Mycenae, their citadel perched high in the mountains of southern Greece (the ruins of which are seen in this aerial photo, fig. 2.32), where they lived from between about 1600 and 1200 BCE.

Their visual art reflects Minoan influence, but their culture is otherwise quite distinct. From their hilltop stronghold the Mycenaeans overlooked the sea approach from Crete and the land approach from Corinth and the north. They surrounded their city with such massive walls (20 to 25 feet thick) made of such huge boulders that writers have described them as cyclopean, after the legendary race of giants.

Mycenae

The setting and city of Mycenae could not be more different than that of the Assyrian Sargon II's Dur Sharrukin or the Egyptian Sesostris II's Kahun (see figs. 2.16 and 2.27), although, like the former, it has

sculpted guardian figures to protect its entrance (see fig. 2.17). Both Dur Sharrukin and Kahun were built on flat ground and laid out on a regular, geometric ground plan. Mycenaean builders, by contrast, chose the jagged tops of the most rugged terrain and followed the natural contours of the site in laying out their city. Unlike Mesopotamian and Egyptian cities, Mycenaean cities show no monumental temples, only small shrines. Seen from above (as in fig. 2.32), Mycenae's plan follows what we call an organic as opposed to geometric design. Seen from below, as it would have been by approaching armies, its massive defensive walls offered a grim prospect for entry.

The city's entry gate (fig. 2.33) is framed by monoliths (single, massive rocks, also called megaliths for their great size), and a carved triangular limestone block is set above the convex lintel stone, so relieving the pressure from above. In the thirteenth century BCE, sculptors carved two lions flanking a downward tapering column into the limestone block, a motif reminiscent of Minoan art, and intended as guardian figures. Inside the gate an enclosed ramp led to the palace located on the highest ground. The circular walls to one side of the gates mark a grave circle enclosing shaft graves, where princes buried with golden face masks were discovered. (Mycenaeans may have been imitating the Egyptian

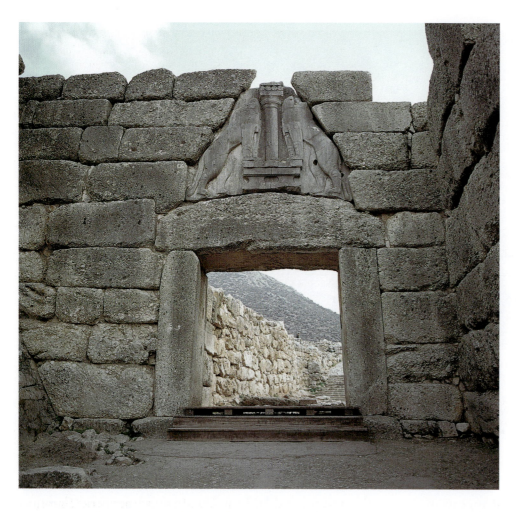

2.33 Lion Gate, Mycenae.
c. 1300–1200 BCE. Limestone relief, above
megalithic post-and-lintel construction,
height of sculpture approx. 9'6"

practice, perhaps observed by traders.) Even more impressive subterranean tombs, called beehive tombs for their shape, were built at a later date in the foothills below the city walls. These too were built of massive stone. Whether in life or death, the Mycenaeans took full precaution to protect themselves. Given their warlike reputation, they probably needed to.

PARALLEL CULTURES

The Indus Valley, Ancient China, and the Israelites

While societies were forming up in the fertile river valleys of Mesopotamia and Egypt, as well as the Aegean, other quite distinct urban cultures had emerged in the river valleys of China and India (see Map 2.5). Traces of the civilization of the Indus Valley were first rediscovered only in 1856 by workmen constructing a railway, and what was found evidenced trade between several cities in the Indus Valley and Sumerian Mesopotamia between about 2300 and 1750 BCE.

As for China, although, the Romans (much later in time, from the first to the fifth centuries CE) traded with China through middlemen, importing Chinese silks, yet the fabulous wealth of the Orient remained more fabled than known. Then, in the thirteenth century, the Italian merchant-adventurer Marco Polo visited the splendid court of the Emperor Kublai Khan in Beijing and returned to tell astonished Europeans what he had seen.

The Indus Valley

It is a marvel of art that one tiny image can suggest, like a visual DNA, the core identity of an entire civilization, its images recurring for centuries to come. When that civilization has left no written historical record, discovery of such an image is all the more exciting. This is the case with the image carved into a tiny steatite (a soft gray or greenish stone) seal, only 1³⁄₈" square (fig. 2.34). Carved between about 2300 and 1750 BCE, it was excavated, along with many other such seals, from the rubble of the long-lost city of Mohenjo-Daro, on the banks of the Indus (in modern Pakistan).

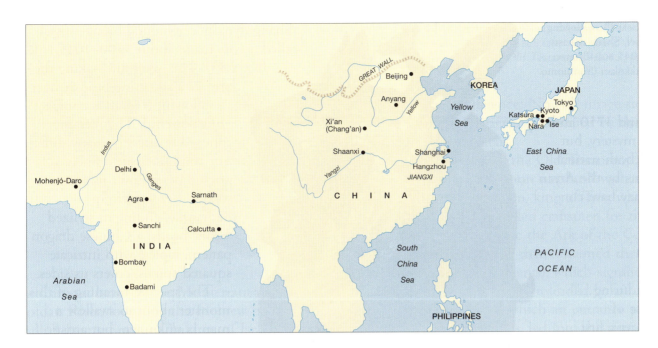

Map 2.5
India, China, and
Japan

Carved into this little seal is the image of a figure who appears to have three faces. He sits in a yogic position, arms extended to the knees and covered with bracelets, wearing a buffalo-horned, three-pointed crown and displaying an erect phallus. Animals surround him: A tiger, rhinoceros, buffalo, and two deer all face the crowned figure, and an elephant faces away. All are realistic portrayals, precisely carved. (The seal

2.34 Seal with ithyphallic figure, from Mohenjo-Daro, Indus Valley (modern Pakistan). c. 2300–1750 BCE. White steatite, height 1³/₈". National Museum, New Delhi, India

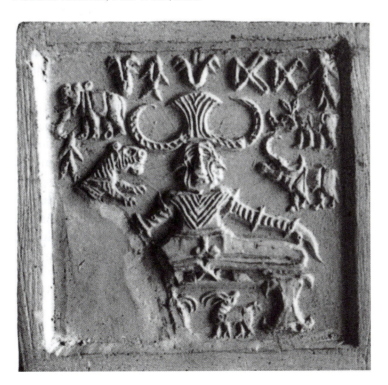

also includes two human figures and an indecipherable inscription.)

It is remarkable that an artist could compress so much of life into so little space. But it is also striking that many of these elements appear in the religious art and life of India over the subsequent millennia: The figure, almost certainly representing a deity, bears many of the characteristics of the Hindu god Shiva, the "Lord of the Animals." The trident headdress, the phallic fertility symbolism, the multiple identity (indicated by three heads), and the yogic position recur in Hindu art. The yogic position (see fig. 5.40) and the deer under the throne appear in Buddhist art. The horned crown worn by the god also recalls, in concept, the crown of the Babylonian sun god Shamash on the stele of Hammurabi from 1760 BCE, itself carved in the form of a phallus (see fig. 2.13). So this tiny seal carries not only the portent of future Indian religious art and life but also offers evidence of trade and perhaps other cultural links between this lost Indus Valley culture and ancient Mesopotamian civilizations. By associating powerful animals and fertility with the divine, the seal also attests to the continuity of beliefs even more ancient and widespread.

This and other such seals are a small part of the discovery of an ancient Indus Valley civilization. Excavation has also uncovered many sensuously carved figurines, as well as the foundations of whole cities such as Mohenjo-Daro, logically planned, centered on a great bath house, and with many houses equipped with plumbing. What brought this culture to

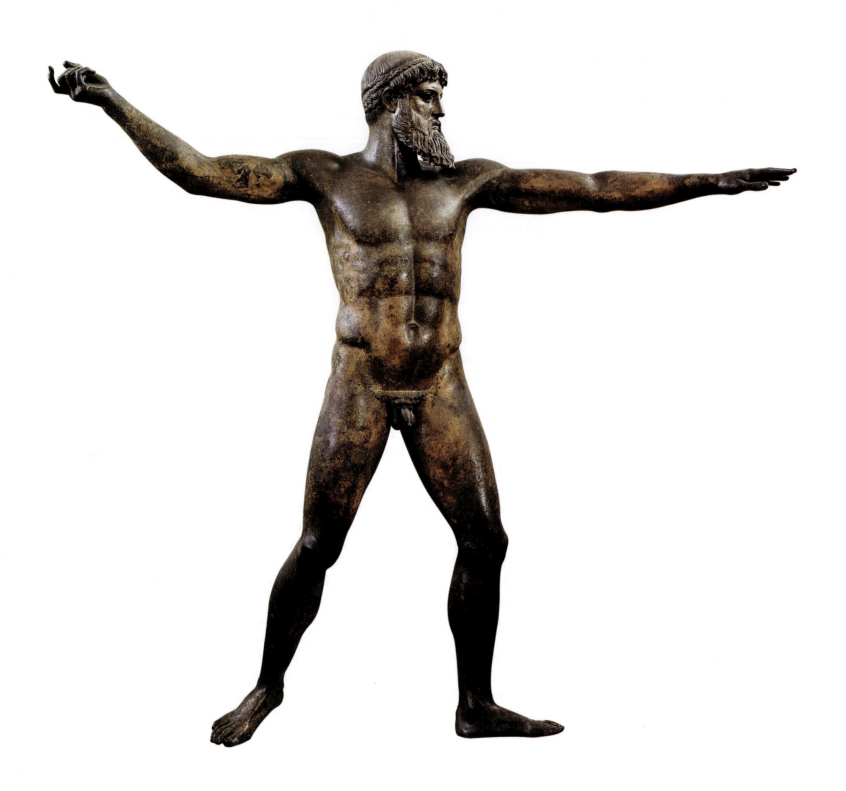

3 Greek Art

3.1 *Zeus (Poseidon?).* c. 460–450 BCE. Bronze, height 6'10". National Archeological Museum, Athens

The beautifully balanced, proportioned, and toned body of a bronze figure (fig. 3.1) of a Greek god, probably Zeus but perhaps Poseidon, embodies an ideal that has inspired many later generations: A supreme self-confidence in human potential to bring greater order to existence when human reason is balanced with self-discipline. The ideal of cultivating a disciplined mind and an athletic body can be traced back to the ancient Greeks, the originators of the Olympic Games. In this ideal, as well as in the artistic style that conveys it, lies one of the legacies of the Greeks to Western civilization.

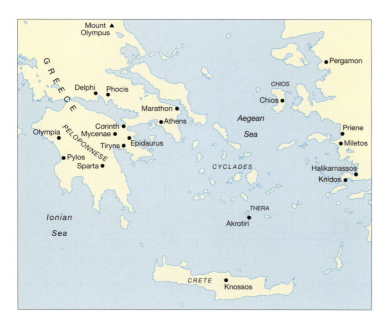

Map 3.1 Ancient Greece and Asia Minor

The Greeks, who called themselves Hellenes, lived in independent city-states, the most prominent of which were Athens, Sparta, and Corinth. Earlier Aegean civilizations, including Minoan culture on the island of Crete, and Mycenaean culture on the mainland (see Chapter 2), had been mostly destroyed or forgotten by the eighth century BCE. With little more than the older Aegean practices of bronzeworking and pottery on which to draw, the Greeks were left to start anew. The traditions they established—in art, architecture, literature, drama, science, and philosophy as well as politics, education, and athletics—have profoundly shaped Western civilization, and much of their legacy endures today.

Since farmland was sparse, the Greeks, like the Minoans and Mycenaeans before them, depended on trade. Crossing the Mediterranean, Greek ships carried goods to and from Egypt and Phoenicia, and with the exchange of goods came the exchange of ideas. In time, the Greeks would come to emulate the writing of the Phoenicians and the statuary of the Egyptians. In turn Greek painted pottery, as well as other elements of Hellenic culture, would be exported all around the Mediterranean (see Map 3.1). Their most far-reaching and enduring product, however, was an attitude toward the world.

Greek Rationalism and Humanism

At the core of Greek culture was a highly distinctive way of thinking about the world. Like all ancient peoples, the Greeks responded to fear of the unknown and the unpredictability of life through ritual and sacrificial offerings to the gods. But unlike other ancients, the Greeks trusted more to the potential of human reason and observation to know, explain, and bring order to existence.

Greek beliefs about the divine, the meaning of life, and the origins of the world were shaped by ancient legends and popular beliefs. In the eighth or ninth century BCE, Hesiod brought together a collection of these popular beliefs in his *Theogony*, and from Homer came two great epic poems, the *Iliad* and the *Odyssey*. From these combined sources the Greeks also developed a system of ethics based on four primary virtues: temperance, courage, justice, and wisdom.

From the time of Homer, poets and dramatists explored the nature of tragedy, the outcome of the actions of flawed heroes, who suffered retribution meted out by the gods. Dramatists set before their audiences tales of the unpredictable course of human destiny, seen against a backdrop of divine justice. For its part, the athletic arena provided a stage on which to honor virtue. Successful male athletes were living examples of the virtues of self-disciplined training, a temperate life-style, and sustained courage. A bronze sculpture of a young charioteer perfectly expresses these virtues through the calm restraint, alert gaze, and youthful beauty of his face and posture (fig. 3.2). The sculpture, which originally included horses and chariot, was offered as a gift to the god Apollo at his sanctuary at Delphi, celebrating a victory in the Delphic Games of 478 or 474 BCE.

While dramatists and athletes forefronted the virtues of justice, temperance, and courage, philosophers nurtured the pursuit of wisdom, especially the knowledge gained from human reason and observation. In the sixth century BCE, for example, Pythagoras discovered that musical intervals could be measured in exact mathematical ratios. The world itself, then, might be governed by laws of numerical harmony that people, through reason and observation, could discover. In the fourth century BCE, the philosopher Plato argued that all aspects of life might best be governed by reason.

Greek philosophers, most notably Socrates (469–399 BCE), championed reason as the way to overcome ignorance and discover the highest human goals: Truth, goodness, and beauty. Painters, sculptors, and architects, for their part, sought to point the viewer toward what is good, beautiful, and true by representing nature, not as it actually is, with all of its imperfections, but as they imagined it might be: In short, Greek

artists represented nature as an ideal, a model of perfection that could be achieved by combining reason with observation. So doing, their achievements complemented those of the dramatists, athletes, and philosophers and proved a source of recurring inspiration to later generations.

The Greeks' confidence in human potential and their pursuit of virtue led them to rationalize and humanize many aspects of life. For instance, in building libraries and gymnasiums within their cities, the Greeks made clear the value they placed on nurturing the mind and body. Just as many aspects of life were humanized, so Greek art is not only more rational but also more human in its orientation. Its enduring appeal attests the significance of their efforts.

Formal Qualities of Greek Art

Dominating Greek (Hellenic) art and architecture are the human figure and the temple. Both were conceived as ideal forms, their harmonious proportions derived from mathematics. Greek artists developed modular systems in which all parts are proportioned according to a basic unit of measurement: The size of a head might be related to a whole body, or the height of a temple to its length and width.

We will see, in the following pages, that Greek artists sought to create ideal forms by adjusting imperfect reality to conform to what they imagined were nature's essential, ideal proportions. Each artist adjusted these measurements to satisfy his own perception; reason was balanced by observation. Experimentation, in fact, was characteristic of Greek art. Egyptian art had remained static for long periods, but Greek art and architecture evolved, as artists sought increased technical refinement and expressive power. This quest for greater mastery and deeper understanding is rooted in the same spirit of inquiry that drove Greek philosophers in their pursuit of truth. The enduring fame of Classical Greek art is the measure of their success.

Over time, the artistic ideal of mimesis—the imitation of life—was interpreted in terms which included more action and a wider range of emotions. If idealism is the desire to represent the essential qualities of a form without imperfections, and if realism embraces those imperfections, then Greek artists reached from the one extreme to the other.

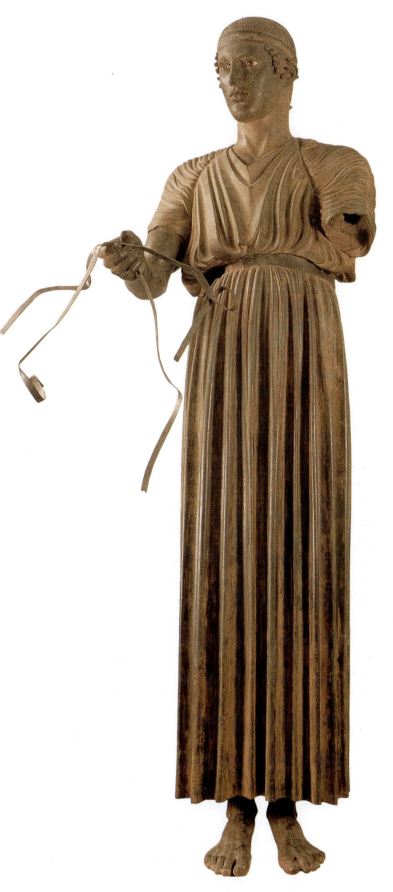

3.2 *Charioteer*, from the Sanctuary of Apollo at Delphi. c. 470 BCE. Bronze, height 5'9". Archeological Museum, Delphi

The development of Greek art is commonly divided into successive phases, listed below. We will consider works from the Archaic period onward.

- Geometric and Orientalizing, about 900–600 BCE
- Archaic, about 600–480 BCE
- Early Classical, about 480–450 BCE
- Classical, about 450–400 BCE
- Fourth century or Late Classical, about 400–320 BCE
- Hellenistic, about 320–31 BCE (the year Octavian, later Emperor Augustus, became sole ruler of the Greco-Roman world)

SPIRITUALITY

"Man," said the fifth-century BCE philosopher Protagoras, "is the measure of all things." Indeed, the Greeks tended to explain everything in human terms, including the actions of their gods. Like earlier civilizations, the Greeks looked to gods to help them make sense of an unpredictable world. But the Greeks invested their gods with more human characteristics than did the peoples of Mesopotamia, Egypt, and the Aegean (see Chapter 2).

As if taking "man as the measure of all things," the Greeks gave their gods human identities. Their twelve major deities embody human traits, concerns, and needs; they oversee specific departments of life and the natural world, and are swayed by all-too human passions. Human-looking (anthropomorphic) gods controlled the rivers and forests, the sea and the wind, making the natural world less threatening, more inviting. When an artist uses a human figure to represent a quality, idea, or non-human thing, we call this personification. Religious rituals, too, were humanized, sometimes even associated with athletic and dramatic events. The Greeks watched the athletic games at Olympia in the sanctuary of Zeus, the chief of Greek gods; Athenians saw plays in their theater of Dionysos, a sanctuary dedicated to the god of fertility and wine, abutting the sacred temple enclosure of the Acropolis (fig. 3.3).

The imagined power of gods and goddesses was enormous. Athens, for example, sought protection from Athena, goddess of wisdom and military victory. The temples dedicated to these gods were conceived as the highest architectural expression of Greek culture, and stood as symbols of collective values, group identity, and cosmic harmony.

Zeus and Apollo

The Minoans and Mycenaeans had worshipped a Great Goddess (see *Snake Goddess* from Knossos, fig. 2.29), who controlled fertility. For the Greeks, Zeus, a sky god, was the Great Father, supreme ruler of both gods and mortals. Along with other Greek deities, Zeus was believed to live with his wife Hera, goddess of marriage and protector of women, on the peaks of Mount Olympus in northern Greece. He imposed justice, but, like all Greek gods, Zeus was flawed, often using deceit to pursue his many romantic adventures. In his contradictory impulses, the Greeks saw their own, very human, contradictions and imperfections.

In the gods Apollo and Dionysos, the Greeks represented the two greatest opposites in human nature—lucid reason and passionate emotion. Though they believed that reason led the way to wisdom, they kept a mystical path open as well, sometimes traveling great distances to the sanctuary of Apollo at Delphi to consult the famous oracle, who delivered the god's messages in a trance-like state of hallucination.

The Temple of Zeus

Art, athletics, and religious ritual all combined to honor the Greek gods in the sanctuaries built for them. The great sanctuary of Zeus at Olympia, built 470–456 BCE and originally the site of the Olympic Games, is today in ruins. Originally, at each end of the temple, a monumental group of sculpture adorned its **pediment** (the triangular gable above the columns of each entrance **portico**). One was presided over by the figure of Zeus, the other by Apollo.

The relationship between the Greek athletic ideal and their concept of deity is beautifully expressed in the majestic bronze sculpture shown in figure 3.1. Cast in about 460–450 BCE, it was found on the sea bed near Cape Artemision. Its identifying attribute has been lost, but traditionally Zeus hurls a thunderbolt, Poseidon throws a trident. In either case the sculptor represented the god as an athlete. The figure is nude—the way Greek athletes competed—in the full strength of manhood. Poised, alert, controlled, and balanced, the figure suggests someone who is disciplined to endure with courage. It is poised on the ball and toes of one foot and the heel and edge of the other. Lithe and agile, it differs greatly from the rigidly posed Egyptian sculptures that had first impressed the Greeks. (See for example, fig. 2.24.)

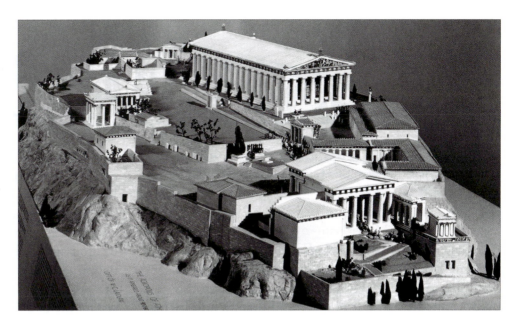

3.3 Reconstruction model of the Acropolis towards the end of the 5th century BCE. Royal Ontario Museum, Toronto

The supple pose of this bronze sculpture would be impossible to create in marble; its weight could not be so lightly supported, and the tensile strength of marble could not sustain the outstretched arms. Thus bronze fulfilled a Greek aesthetic ideal—facilitating life-like movement—and became their favored sculptural medium (see "Materials and Techniques: The Lost-wax Process," page 64 and fig. 3.6). Few Greek bronzes survive today: Melted down for other purposes, the original bronzes are mostly known through marble copies made by Romans, and some such copies required additional supporting props.

In the center of the west pediment at the Temple of Zeus stood the figure of Apollo, god of the sun, light, and truth. Embodying the ideals of measured order, temperance, youth, beauty, and reason, Apollo represented to the Greeks much that distinguished them from their neighbors. On his temple at Delphi were inscribed the famous sayings "Know thyself," and "Nothing in excess." Here, carved in marble (about 470–456 BCE), Apollo intervenes at a legendary wedding ceremony of the Lapiths—a fabled people from Thessaly (fig. 3.4). Drunken Centaurs (half man, half horse) had attempted to abduct the bride and her maidens (see reconstruction drawing, fig. 3.5, of the

3.4 *Apollo and the Battle of the Lapiths and Centaurs*, from the west pediment of the Temple of Zeus at Olympia. c. 470–456 BCE. Marble. Archeological Museum, Olympia

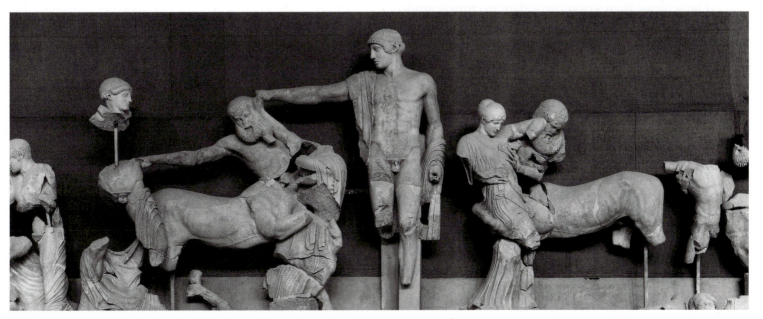

The Classical Orders

The Classical Greek architectural orders—Doric, Ionic, and Corinthian—were developed between the seventh and fifth centuries BCE. Together, they created a set of model proportions and architectural decorations to be used with the post-and-lintel construction typical of Greek temples. Each of these orders, or stylistic systems, organized the elements of the temple—the base, columns, and horizontal entablature above—to create visual harmony and unity. Each order is built according to a set of proportions for the height of the column relative to the diameter at its base. With the Doric order this varies from 4:1 to 6:1; with the slimmer columns of the Ionic, it varies from 7:1 to 8:1; and with the typically taller Corinthian column, it ranges from 8:1 to 9:1. The columns support the elements of the lintel that collectively make up the entablature. This consists of three horizontal layers: The lowest (the architrave), the center frieze, and at the top, a projecting cornice.

Each order treats the entablature differently, and, in each, a distinct form of capital separates the shaft of the column from the entablature above. The Doric order is the oldest (seventh century BCE), and is the simplest and most austere. It was used in the design of the Parthenon in Athens, built between 447 and 438 BCE (see fig. 3.8). The Doric column has a tapered shaft with flutes, or shallow grooves, carved into it. These flutes emphasize its height, while the play of light and shadow over the surface and grooves accentuates the impression of the column's roundness. Doric columns have no base decoration, and so stand directly on the stylobate, or top level of the platform on which the temple is built. The simple Doric capital (4) that separates the column and the horizontal entablature (6) is made up of an undecorated, cushion-like echinus (9) supporting a flat, slab-like abacus (10). This creates a simple transition from a round column to the straight entablature. The architrave (3) is a solid, undecorated band; the frieze (2) is made up of alternating triglyphs (11), carved with three vertical grooves, and metopes (12), which are square spaces, sometimes decorated with relief sculpture. A plain cornice (1) supports the triangular pediment characteristic of Greek temples.

3.7 Diagram of the Doric and Ionic orders

The Classical Orders

Greeks in Asia Minor were the first to use the Ionic order. More elegant and graceful than the unadorned Doric, it was generally used for smaller temples. A fine example is on the Temple of Athena Nike, Athens, built c. 425 BCE (see fig. 3.11). As shown in the drawing, Ionic columns are proportionally taller and thinner than Doric columns, and the fluting is deeper and closer, making the columns appear less massive. The columns have a richly worked base, and the capitals are embellished with a spiral, scroll-like motif called a volute (13). In an Ionic entablature, the architrave is subdivided into three horizontal bands, creating a more delicate effect than the plain Doric one. The frieze is a continuous decorated band of sculptural relief. (Compare this to the Doric triglyphs and metopes.) The Ionic cornice (1) is also more decorated than in the Doric order.

The Corinthian order is the most elaborate and was first used in fifth-century BCE Athens. It was originally only used in the interior of buildings because of its elegance. Beginning in the second century BCE, it became the favorite order of the Romans, who in turn enriched its details. In Chapter 4, we will see several examples of the Corinthian order in Roman architecture (see figs. 4.4, 4.29, and 4.30). The most characteristic element of the Corinthian order is its cylindrical capital (4) decorated with ornate acanthus leaves and often scrolls at the upper corners. Corinthian capitals may also be decorated with rosettes and, at the top center of each face, a projecting ornament, called a boss. Details of the entablature tend to be more elaborate than either the Doric or Ionic, especially on the cornice.

Each of these orders was described by the first-century BCE Roman architect and theorist Vitruvius, and during the Renaissance by the sixteenth-century Italian architect and theorist Serlio. Their influence in Western architecture has been vast since they were adopted, little changed, by the Romans, incorporated into Early Christian architecture, once again appropriated during the Italian Renaissance, and widely used ever since, especially in buildings meant to convey traditional values and permanence.

1 cornice
2 frieze
3 architrave
4 capital
5 column
6 entablature
7 stereobate
8 base
9 Doric echinus
10 Doric abacus
11 Doric triglyph
12 Doric metope
13 Ionic volute
14 continuous frieze

3.7 Diagram of the Corinthian order

of reason and observation, in pursuit of beauty. And in containing a colossal cult statue of the goddess Athena within such a rationally conceived structure, the Parthenon shows again the Greek tendency to marry reason and mystery, and to conceive of their divinities in amplified human form.

Adorning the Parthenon were sculptures by Pheidias and his workshop, made in about 438–432 BCE. Besides the colossal cult statue (also made by Pheidias), free-standing sculptures of the gods were placed on the triangular pediments of the roof gables at each end of the temple: Above the entrance to the cult cella, the Olympian gods witness the Birth of Athena, who emerged full-grown from the head of her father Zeus; on the treasury end, Athena triumphs over Poseidon for the patronage of Athens.

Look now at figure 3.9, the damaged remains of a group of three goddesses. Once located on the pediment depicting the Olympian gods, the remnant displays the sculptor's sensitivity to the female form,

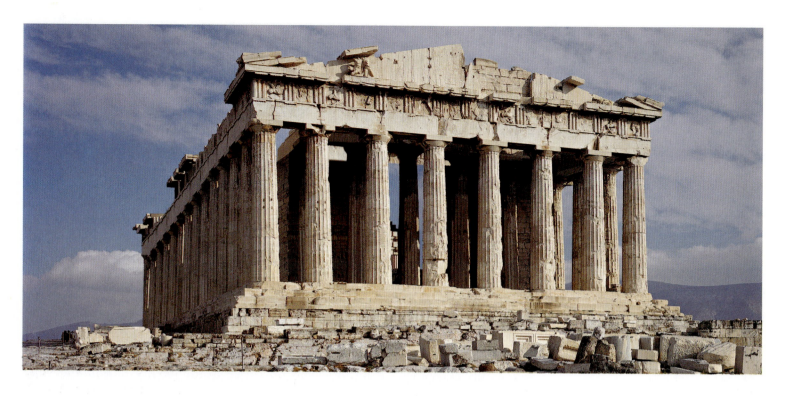

3.8 Parthenon, Acropolis, Athens. 447–438 BCE. View from the northwest

revealed through flowing robes. Because of the way the fabric appears to cling to the underlying body, this sculptural method is known as the "wet drapery" technique. It allowed the sculptor to reveal his own mastery of the varied and fluid movement of the human body, while upholding the modesty of the goddesses. Besides these free-standing sculptures, relief sculpture also adorned the Parthenon. The series of square **metopes**—the decorative panels below the **cornice** on the entablature—represented the battles between the gods and giants, and the Lapiths and Centaurs, as well as other episodes from mythology.

A lively sculpted frieze representing horsemen and walking figures, ran along the entire 525-foot length of the exterior wall of the cella. It may have represented the Great Panathenaic procession held every four years, when Athenian citizens presented a sacred robe to Athena. Only a few fragments remain, their ownership much disputed by the Greek government and the British Museum in London. In 1799, during the Turkish occupation of Greece, the British Lord Elgin removed the surviving sculptures to save them from destruction. He gave them to the British Museum, where they remain today.

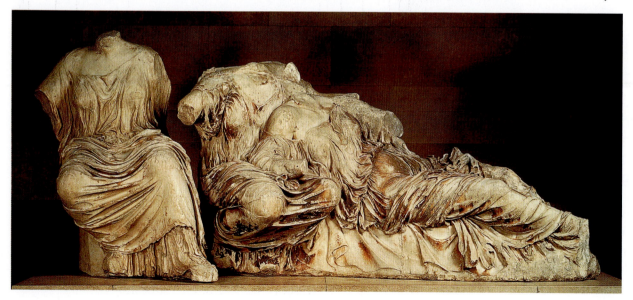

3.9 *Three Goddesses*, from the east pediment of the Parthenon, Athens. c. 438–432 BCE. Marble, greatest height approx. 4'5". The British Museum, London

3.10 School of Skopas (?), *Dionysian Procession.* Fourth century BCE. Marble. Museo Archeologico Nazionale, Naples

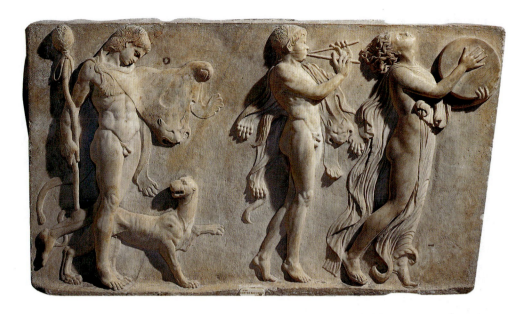

The Parthenon thus combines the severity of Doric architecture with the more graceful rhythm of an **Ionic** sculptural frieze on its cella wall. The figures in this frieze also exemplify Greek idealization of the human form, here rendered in relief, rather than as a free-standing sculpture.

Those graceful rhythms appear again in another small temple on the Acropolis, designed by Kallikrates in about 425 BCE, and dedicated to Athena Nike—Athena as goddess of victory (Greek *nike*) (fig. 3.11). At

3.11 Kallikrates, Temple of Athena Nike, Acropolis, Athens. c. 425 BCE

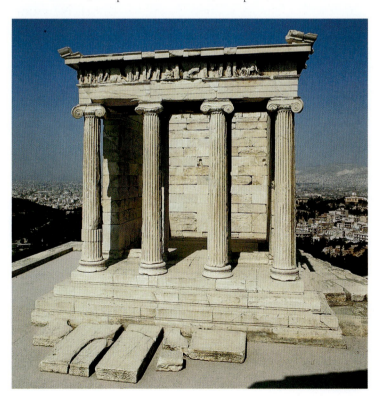

the top of the steep, narrow path to the Acropolis, just before the grand Propylaia, it stands to the right (see fig. 3.3). As in the Parthenon, the columns of the Temple of Athena Nike are fluted to create a play of light and shadow that emphasizes their roundness while also drawing the eye upwards. Unlike the Doric order of the Parthenon, however, its Ionic columns stand on decorative bases, have slender shafts, and support Ionic **capitals** with elegant **volutes**, rather than severe Doric ones. Overall the effect of the Ionic order, as seen on the Temple of Athena Nike, is light and graceful in comparison to the noble severity of the Doric. Besides these two contrasting orders, another order was developed later, the Corinthian, which we'll see in Chapter 4. All three orders have been imitated by Western architects down through the centuries, into our own time.

Dionysos

Although the Acropolis bears lavish testimony to the cult of Athena, in the fourth century BCE a theater was built into the side of its southern escarpment and dedicated to Dionysos, the patron god of drama. The cult of Dionysos represented the passionate, emotional side of human life, themes explored in the plays performed in his theater. In a fourth-century BCE relief sculpture of a *Dionysian Procession* (fig. 3.10), the freedom of rhythmic movement and sense of joyous abandon complement the noble gravity found in the cults of Athena and Apollo. Indeed, in Apollo and Dionysos we see two enduring and complementary principles of ordered reason and passionate emotion.

THE SELF

At the sanctuary of Apollo an inscription exhorted the Greeks to "Know thyself." Protagoras claimed that "Man is the measure of all things," and Socrates found the highest goals in pursuing truth, goodness, and beauty. The value placed on the individual led to the development of the earliest form of democracy, limited though it was. By the fifth century BCE, even though the Athenians kept slaves, and limited women's rights and roles to the home, political representation had been extended to those adult males who qualified as citizens. This contrasted strongly to Middle Eastern societies, where an absolute ruler claimed divine authority.

Perikles is recorded as boasting of the Athenians that "we cultivate the mind without loss of manliness." This Greek ideal of nurturing a sound mind in a sound body was exemplified in the self-disciplined athlete. Male figures were mostly represented nude, as they actually practiced in the gymnasium and competed in the games. The virile human body, in fact, became the prime focus of Greek artists, and since the Renaissance period in Europe, from the fifteenth to the nineteenth century, Greek ideals of beauty were an authoritative yardstick for Western civilization. (See "The Artist as Innovator," below.) Female figures were draped, at least until the fourth century BCE, when the first female nude was sculpted.

From the late fifth century BCE onward, reflecting their culture's interest in human character, Greek sculptors began to express the nuances of human thought, action, and emotion, as never before attained in visual art. We begin with the earliest known examples of large-scale Greek nudes, the *kouros* figures.

Archaic Kouroi: The Self-disciplined Athlete

The ideal of the self-disciplined athlete—combining physical beauty with the virtues of temperance and courage—appears early in the Archaic period, in life-size statues of naked youths known as *kouros* figures (plural *kouroi*). Like the statue in figure 3.12 (about 600 BCE), they stood at temple sanctuaries, where they were dedicated to the gods and also served as commemorative or funerary monuments.

Notice the stiff, frontal pose—arms by the sides, fists clenched, and left leg advancing. All of these elements reflect the tradition of Egyptian statuary (compare the sculpture of Menkaure, fig. 2.24). On the other hand,

❖ THE ARTIST as Innovator ❖

In ancient Greece, artists of exceptional ability were appreciated and remembered for their skill. Some artists signed their paintings and sculptures, asserting their desire to be acknowledged for their individual achievement. The fifth-century BCE sculptor Polykleitos wrote a treatise on ideal proportions, known as The Canon, which he demonstrated in a sculpture of a male nude (see fig. 3.16).

Greek artists had their own gods, such as the blacksmith god Hephaestus, maker of beautiful things, and their legendary heroes. Daedalus of Athens, for example, was a marvelously inventive blacksmith, bronze-caster, and architect, and the sculptor Pygmalion was said to have created a statue of such ideal beauty that the goddess Aphrodite brought her to life to marry its maker. These legends make clear the association of art with invention, ideal beauty, and the power to imitate life. In their works, Greek artists gave visual form to the ideals and mythology that guided public life, above all the temple service of its gods. In the next chapter, we'll see that Roman artists played much the same role, except that their efforts served the state, as propaganda, as much as the gods.

Throughout antiquity, even though artists were viewed as skilled artisans, gifted with skill at making things rather than with wisdom, the tasks assigned to them addressed the core of each society's religious, political, and social identity. In turn, their works shaped and reinforced society's values by making them publicly visible. This critical role endured throughout the centuries that followed.

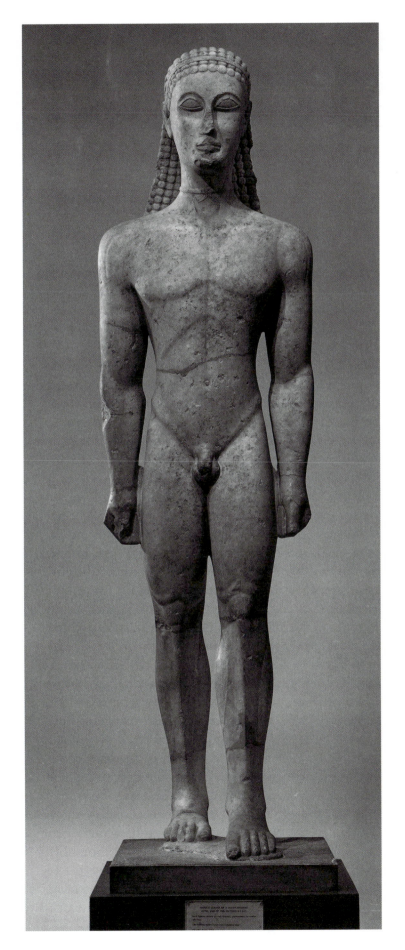

the *kouros*'s enlarged eyes and upward gaze, as if fixed on a deity, recall the reverent attitude of ancient Mesopotamian votive figures like those from the Abu Temple (see fig. 2.12).

As soon as the Greeks began to emulate monumental Egyptian sculpture, they began to refine it. First they released the form of the figure from the rigid constraint of the block of stone. Notice how, in the *kouros*, the sculptor has opened up the space between the sides and arms, and between the legs, liberating the figure from the block. His face is much more stylized than that of Menkaure, and the anatomy is schematic, but still, the nude *kouros* reflects the Greek athletic ideal. If, as you read the following pages, you refer back to the Egyptian works, you will see that the Greeks, whether working in stone or bronze, gave the human form the appearance of movement, self-mastery, and muscular beauty that embodied their own ideals. In the process, Greek sculptures began to convey a sense of self-conscious human dignity.

Early Classical: Human Choices and Consequences

From the Early Classical period onward, the anatomy of the *kouroi* became increasingly lifelike. For example, compare the the Archaic *kouros* of figure 3.12 to the body of Apollo (fig. 3.4) from the Temple of Zeus at Olympia. The Apollo is a more supple depiction of human anatomy, with more natural transitions between the torso and limbs. And with such lifelike renderings of the human body, sculptors began to express the complexity and depth of human emotions as well.

Look now at another sculpture from the Temple of Zeus at Olympia, the "*Old Seer*" (fig. 3.14). It comes from the east pediment, and was carved about 470–456 BCE. You can see the sculpture's original location and function in a reconstruction drawing (fig. 3.13), where it rests behind the chariot on the right. Pose, gesture, and facial expression all reveal the significance of this figure. The *Old Seer* is the wise poet or philosopher who observes the deceitful human choices about to unfold and anticipates their consequences.

3.12 *Standing Youth* (*kouros*). c. 600 BCE. Marble, 6'4".
The Metropolitan Museum of Art, New York

460–450 BCE (around the same time as the *Zeus* or *Poseidon*; see fig. 3.1), and salvaged from the sea off Riace in Italy in 1972. Its compelling naturalism is carried through into the veins on the hands, rippling locks of hair, and various colored details. The eyes are made of ivory, and glass paste; reddish copper accents eyelashes, lips, and nipples; the teeth are of silver. The principle of **contrapposto**, or weight shifted so that one part of the body turns in a direction opposite to the other, is less pronounced than in the *Doryphoros*, but it shares the contrasting raised and lowered arm. Like the *Doryphoros*, its power derives from the fusion of naturalism and idealism—of observation adjusted according to reason and harmonic proportion. The bronze original of the *Doryphoros*—made almost at the same time—must have been equally lifelike.

During the same period, the age of Perikles, the female figure appears at its most supple and fluent form in the three goddesses (see fig. 3.9) carved for the Parthenon by Pheidias or his collaborators. On a more intimate, personal level, the feminine form is featured on a number of gravestones, or **stele**. We see an example of this in the serenely beautiful *Grave Stele of Hegeso* (fig. 3.18), carved in the Pheidian manner in about 410–400 BCE. Here, the deceased chooses a necklace from a jewel box held by her servant. This image reveals the domestic role of women in Greek society; the deceased is commemorated in death as she might have been in life. Its

3.17 *Young Warrior* (front and rear views), found in the sea off Riace, Italy. c. 460–450 BCE. Bronze with bone and glass eyes, silver teeth, and copper lips and nipples, height 6'8". Museo Archeologico Nazionale, Reggio Calabria, Italy

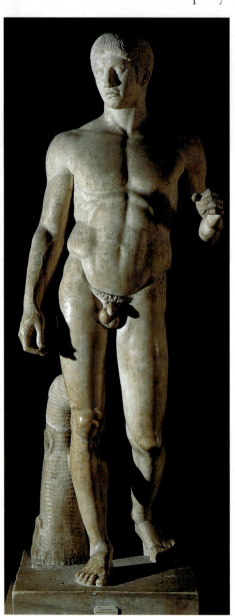

3.16 Polykleitos, *Doryphoros* (*Spear Bearer*), Roman copy after bronze original of c. 450–440 BCE. Marble, 6'2". Museo Archeologico Nazionale, Naples

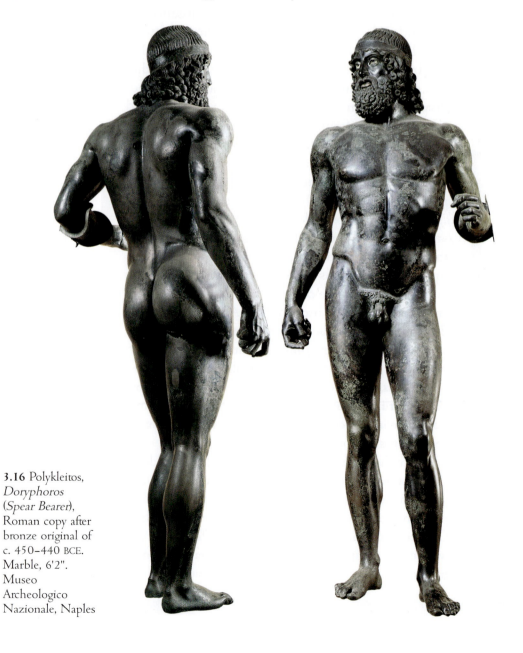

artists began to express a wider range of emotions in sculpture, including both pleasure and pain. The noble austerity of earlier art gave way to a more sensuous quality, opening the door to eroticism. This sensuous quality is first seen in the sculpture of Praxiteles, particularly in his unprecedented nude sculpture of about 350 BCE, the *Aphrodite of Knidos* (fig. 3.19).

The sensual qualities the Greeks ascribed to Praxiteles's *Aphrodite* (whom the Romans called Venus, goddess of love) are scarcely evident in the routine Roman copies, such as the one shown here, through which it is known today. Nevertheless, the contrast with the women portrayed in figure 3.18 is striking for the figure's nudity. The inhabitants of Knidos, a Greek colony in what is now eastern Turkey, set up the original in an open shrine so people could view it from all sides, and visitors traveled great distances to gaze on this goddess of love, whom they were to imagine as caught by surprise in the act of bathing. The Roman writer Lucian thought the protective

3.18 (left) *Grave Stele of Hegeso.* c. 410–400 BCE. Marble. National Archeological Museum, Athens

modesty, tenderness, and domesticity are in marked contrast to the *kouroi* and stele commemorating males. The carving of the stele is extraordinarily subtle in its gradations from high relief to almost imperceptibly low relief in the background. The graceful linear qualities of falling drapery and outline are comparable to effects found in Greek vase painting, which we will examine later in this chapter (see figs. 3.23, 3.25).

Fourth Century BCE: Love and Emotion

During the fourth century BCE, the images of women—and of men—in Greek art began to change. The first Greek female nudes were created, and at the same time,

3.19 Praxiteles, *Aphrodite of Knidos*, composite of two similar Roman copies after the marble original of c. 350 BCE. Marble, 6'8". Musei Vaticani, Rome

3.18), and the figures express greater emotional intensity. The deceased, in the prime of life, leans on a plinth with his left hand resting on his hunting stick. He appears wistful and pensive, characteristics also found in other sculptures of the period. The old man, perhaps his father, sadly ponders the youth's early death, and his stiff, frail body creates a poignant counterpoint to the supple curves and relaxed pose of the younger man. Between them the deceased's hunting dog lowers his head in sadness, and to the left a small boy—perhaps a younger brother or the man's son—buries his head in grief. The scene becomes a moving meditation on the fleeting quality of life, on the short passage from childhood, through maturity into old age and death.

Hellenistic Art: Violence and Tragic Fate

Fourth-century BCE Greece was a period of intense conflict among rival city-states, leaving them vulnerable to conquest by their northern neighbors, the Macedonians. After years of warfare, Philip II of Macedon decisively defeated the Greeks in 338 BCE. Philip's son, who would become known as Alexander the Great, led his armies to great victories across Asia Minor, into Syria, Phoenicia, Egypt, and Persia, spreading Macedonian dominance and Hellenic culture.

The art arising from this spread of Greek culture is known as Hellenistic, lasting from the time of Alexander, who died in 323 BCE, until around 31 BCE, when the Roman Emperor Augustus became sole ruler of the Greco-Roman world. In their portrayal of life, Hellenistic artists turned away from the poised confidence of the Periklean age. Perhaps in response to the new political climate, the emotional, melodramatic, and realistic qualities of fourth-century BCE art are intensified, as artists began to express emotions that were more violent than tender. We see, too, more works of sensuous eroticism.

So far we have seen no examples of Greek painting, which was famous in antiquity, but has scarcely survived, except on the small scale of vase paintings (see figs. 3.23, 3.25), and in the form of floor mosaics. Later copies and written descriptions

gesture of the hand suggested token modesty, but saw "the dewy quality of the eyes with their joyous radiance and welcoming look" as more provocative.

In the Athens of Perikles, women's lives had been strictly limited to the home; the wives of the well-to-do rarely even ventured onto the streets unaccompanied. While male nudity was admired, female nudes were shunned and associated with prostitution. In this light, Praxiteles's nude *Aphrodite* is all the more remarkable. It quickly became the prototype, or model, for hundreds of subsequent versions that in turn have influenced Western conceptions of female beauty.

While Praxiteles's *Aphrodite* aroused feelings of love and desire, sculptors also explored other private emotions. Mourning and grief are poignantly expressed in one of the finest and largest surviving grave stele from Athens, the *Grave Stele of a Youth, with Old Man, Weeping Boy, and Hound,* made about 340–330 BCE (fig. 3.20). Notice that it is carved in much higher relief than the fifth-century *Grave Stele of Hegeso* (see fig.

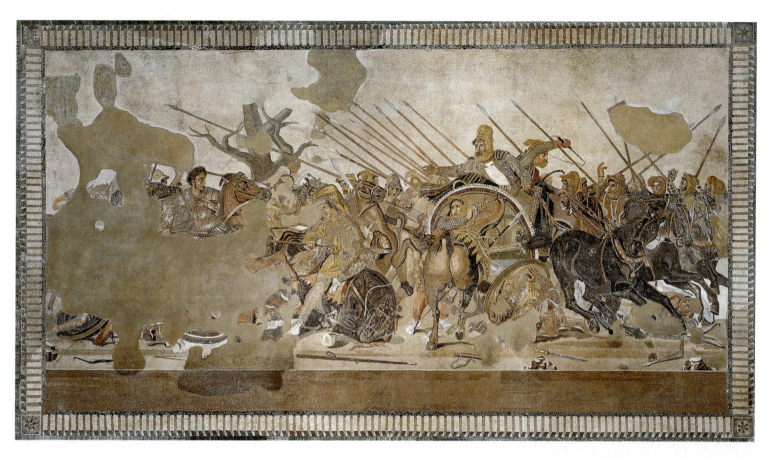

3.21 *Alexander the Great Routs Darius at the Battle of Issos*, Roman mosaic copy of first century BCE, after a Hellenistic painting of c. 310 BCE. 8'11" x 16'9¹/₂". Museo Archeologico Nazionale, Naples

also give us some sense of their beauty and its great loss, all the more tantalizing when confronted by the dramatic power of the huge floor mosaic of *Alexander the Great Routs Darius at the Battle of Issos* (fig. 3.21). (See "Materials and Techniques: Mosaic," page 78.)

Alexander the Great Routs Darius at the Battle of Issos

The Roman example shown here comes from a house in Pompeii, in southern Italy, from the first century BCE and is believed to be a copy of a Hellenistic original from the end of the fourth century. The first-century CE Roman historian Pliny the Elder attributed an original work of this description to Philoxenos of Eretria. The artist has imagined the dramatic moment when the Persian King Darius, (at the right), sensing defeat, gestures hopelessly toward the bare-headed Alexander (visible at left). While Darius's charioteer is turning to retreat, Alexander presses his advantage from the left, and spears a dismounted cavalryman. A Persian groom,

who is bringing up a spare mount for the cavalryman, looks on in horror. Above, the array of spears heightens the fierce rhythm of battle. The bare tree draws our gaze to Alexander. It also stands as a grim portent of death.

The dramatic power of this huge mosaic not only commemorates one of the turning points of ancient history, it also reveals the original Greek artist's astonishing mastery of movement and the foreshortening of figures, to indicate depth. This can be seen in all the horses, but look particularly at the relation of the head to the buttocks of the horse held by the frightened groom. The colors are limited to black, white, red, yellow, and brown—colors commonly used by fourth-century BCE mosaicists—and the figures are modeled with highlights and shadow to create the illusion of volume. But—as we'll see in Greek vase painting—the artist carries the entire drama and defines highly complex forms through the masterly control of line. (When art historians speak about "line," they refer to the defining outline of forms, whether of people, animals, or details of the harnesses of the horses.) The four turning horses drawing Darius's chariot epitomize the mastery of line. Through these means, the artist conveys the violent drama of battle with a power unprecedented among surviving ancient works of art.

Mosaic

Famous in their time, most ancient Greek floor mosaics have long since been destroyed. We can glean some idea of them from much later Roman works, since these often imitate Greek models, or were even created by Greek craftsmen working in Italy. *Alexander the Great Routs Darius at the Battle of Issos* (see fig. 3.21) is such an example.

Mosaic is comprised of many small pieces of colored glass, tiles, or stones (called tesserae), which are imbedded in mortar on the surface of a floor, wall, or ceiling to create two-dimensional images or patterns. Tile or stone mosaic was first used in ancient Greece and Rome on floors. Because these mosaics were walked upon, tile and stone, rather than glass, were used. (For an example of Greek pebble mosaic, see *The Stag Hunt*, fig. 3.27.) As we will see in Chapter 5, mosaic was later adapted for use on walls and ceilings in Early Christian and Byzantine churches, where it served both decorative and didactic purposes. By using colored glass, sometimes inlaid with gold leaf, church mosaicists created sparkling effects of light and color. To refer to the supernatural, artists used gold tesserae, made by pressing a piece of gold leaf between two layers of glass. Each tessera was carefully placed in the wet mortar so that its surface was at a slight angle to that of the next. When changing light shines on wall mosaics, the light reflects in varying directions, creating a rich, glittering effect within the church interior. (In Chapter 5, we'll see one of the greatest examples of mosaic, in the Church of San Vitale, fig. 5.11.) During the fourteenth century, mosaic was largely replaced by fresco, a much quicker and cheaper medium, but one that lacks the reflective qualities of mosaic.

Laocoön and His Sons

In the writhing *Laocoön and His Sons* (fig. 3.22), we reach the opposite end of the spectrum from the rigidly posed, emotionally controlled, Archaic *kouros* (see fig. 3.12). Intense pain and anguish exude from the contorted forms of this Hellenistic sculpture, especially from the surging mass of the main figure. His flesh is drawn tightly over his rib-cage; he grimaces and gasps in agony as coiled serpents attack him and ensnare his two sons. The subject is taken from an episode from the epic Trojan Wars. The Trojans' priest Laocoön warned his countrymen not to draw the wooden horse (secretly filled with Greek soldiers) into the city. In revenge, the gods supporting the Greeks sent serpents into Troy to consume Laocoön and his sons.

Scholars still debate the origin of this sculpture, which was excavated in Rome in 1506. Pliny the Elder named three sculptors from the Greek island of Rhodes as creators of the famed *Laocoön*. Today, some scholars consider this piece to be a Hellenistic original of the second or first century BCE, others an original of the first century CE, yet others a copy from about the same time. To the Greeks, the story of Laocoön signified the perils of defying the gods and the inevitability of fate.

To the Romans, who claimed Trojan descent, Laocoön was an example of heroic suffering in the face of uncontrollable forces. Like all great art, it is capable of arousing different responses from successive generations.

From the Archaic *kouros* to the *Laocoön*, the human figure came to express the virtues cherished by the Greeks as well as a wide range of emotions. So successful were ancient Greek sculptors that subsequent generations of artists from the Renaissance to the nineteenth century returned to them for inspiration.

NATURE

We have only a limited view of this theme in ancient Greek art, as nature, in the sense of natural scenery, lends itself to representation in painting rather than sculpture, and very few ancient Greek paintings and mosaics have survived. However, paintings and mosaics made by

3.22 Hagesandros, Polydoros, and Athanadoros of Rhodes, *Laocoön and His Sons*, perhaps the original of the second or first century BCE, or a Roman copy of the first century CE. Marble, height 7'. Musei Vaticani, Rome

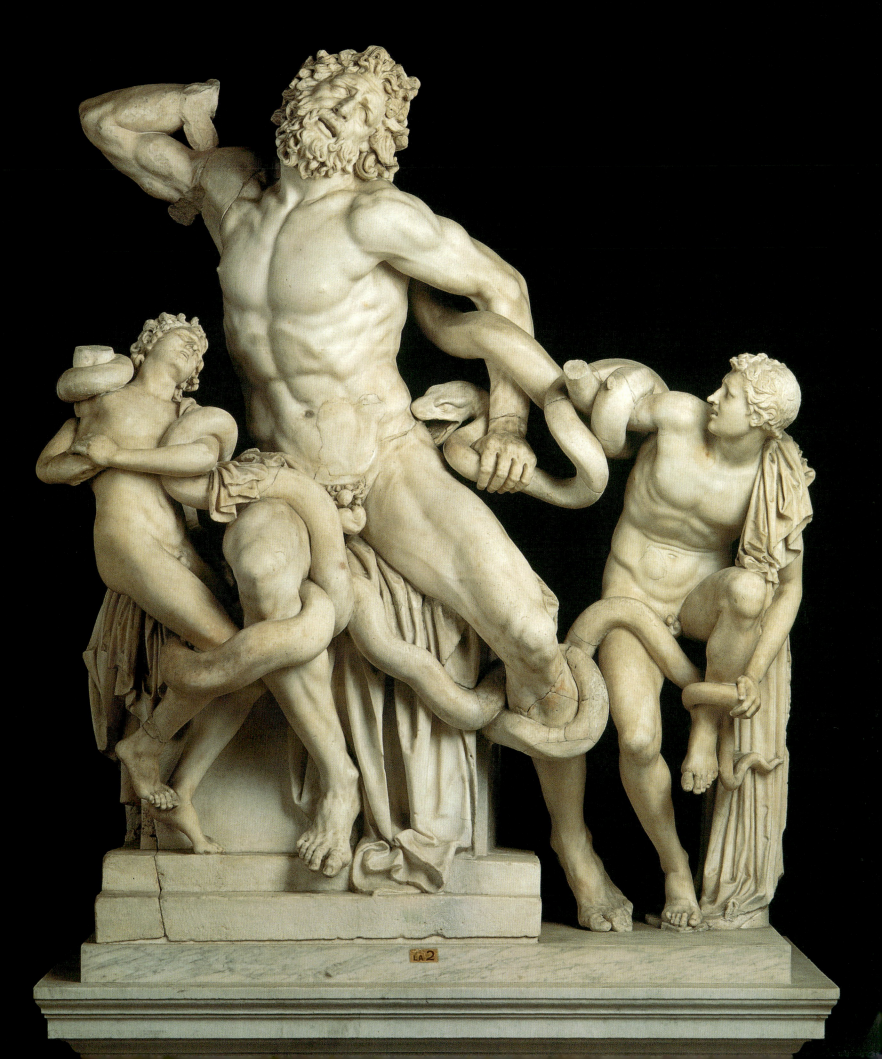

Hellenistic craftsmen for Roman patrons at Pompeii in southern Italy include many scenes from nature, perhaps reflecting ancient Greek originals (a Sacred-idyllic landscape in fig. 4.16 is one such example).

The Greeks certainly understood the evocative power of natural settings. They imagined their gods living on the remote summit of Mount Olympus, and established their most sacred sanctuaries in spectacular settings at Delphi, Olympia, and on the Acropolis at Athens. The hillside setting of the theater at Epidauros also testifies to their imaginative use of the natural environment (see fig. 3.30).

To explain the forces of nature, the Greeks looked to their gods and to other human personifications. Thunder and lightning might represent the anger of Zeus; at sea, the zephyrs (personified winds) sped their boats along; Poseidon, lord of the sea, controlled waves and storms, while tritons—pictured as having the head and upper body of a man and the tail of a fish—and sea nymphs, their female equivalents, might be sent to accompany them. Bountiful Demeter and Dionysos oversaw the harvesting of grain and grapes; nymphs and satyrs protected woodlands and streams; river gods watered their fields. But before the Greeks could humanize the forces of nature, they had to tame its demons.

Taming Nature's Demons

As in earlier cultures, the Greeks viewed nature as a demonic, threatening force to be overcome. But the Greeks went beyond ritual sacrifice to tame nature's power. In their myths and in their art, human will and courage vanquish nature's demons: the hero Herakles slew many dangerous monsters; Perseus slew Medusa, the terrifying snake-haired monster; and Theseus killed the Cretan Minotaur, to whom Greek youths and maidens had been sacrificed annually (as we noted in our discussion of Minoan art in Chapter 2).

Visual artists drew their inspiration from these heroic tales of Greek mythology. The earliest surviving examples appear in vase paintings, dating from the ninth and eighth centuries BCE. These early works are decorated with abstract geometric designs, with small, schematic human and animal figures painted in narrow encircling bands. Then, between about 700 and 600 BCE, the Greeks absorbed many motifs from the visual arts of their trading partners in Egypt and the Near

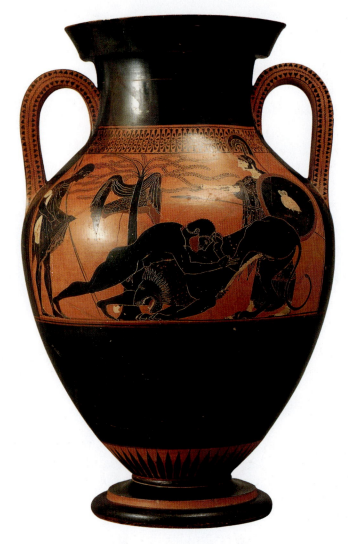

3.23 Psiax, *Herakles Strangling the Nemean Lion*, on an Attic black-figure amphora from Vulci, Italy. c. 525 BCE. Museo Civico, Brescia

East. Beginning around 600 BCE (the Archaic period) the Greeks transformed these sources, giving them a distinct identity of their own.

Herakles Strangling the Nemean Lion

A fine example of the heroic encounter with brute nature in Archaic vase painting decorates an Attic black-figure **amphora** (fig. 3.23) (see also "Materials and Techniques: Greek Vase Painting," page 81) of about 525 BCE, attributed to the artist Psiax. In one of his many celebrated feats, Herakles strangles the fierce and monstrous Nemean Lion. This subject, much like that of Theseus slaying the Cretan Minotaur, symbolizes human subjugation of the dangerous forces of nature (contrast fig. 2.15). The artist shows the hero, who has hung his cloak and armor on a tree, wrestling the wild beast as the goddess Athena and a young companion stand by. The scene is represented strictly

in silhouette, with the design blocked out in black against the reddish clay ground. Outline and internal details have been incised with a sharp tool, exposing the clay ground. When fired the body of the vase would turn reddish-brown, and the painted areas black. This technique depended on the artist's ability to incise into the clay an outline, thereby creating a silhouetted image. The spare, fluidly incised lines that evoke this scene characterize much of Greek vase painting and relief sculpture.

Analyzing Nature

Skilled in the use of line, Greek artists typically depicted figures in silhouette. But as interest in reason and observation of the natural world grew, Greek artists needed to find a way to present figures in space in a more natural way. As we saw in the large mosaic of *The Battle of Issos* (see fig. 3.21), they tried to create the illusion of three-dimensional figures situated in space. This quest led to the development of perspective (creating the illusion of depth on a flat surface) and illusionistic painting (painting that looks true to life). Artists sought to fool the eye by creating images so lifelike that they would appear real. Their success, and the value placed on illusionism by the Greeks (and Romans) is revealed by a story told by Pliny the Elder: In the fourth century BCE, the artist Zeuxis created a prized painting of grapes so true to nature that birds flew up to them. Whereas ancient Egyptian tomb painters had focused on the details of fauna and flora (compare fig. 2.26), the Greeks turned their attention to space.

❖ MATERIALS AND TECHNIQUES ❖

Greek Vase Painting

From around the eighth century BCE onward, the Greeks developed an active trade in pottery, and made a range of vases in varying shapes, for specific uses, and all made for both the home market and export. These vases stored wine, olive oil, and other products, and served many other purposes, from drinking vessels to grave markers. Typically, they were decorated with scenes from both Greek mythology and everyday life. Starting in the seventh century BCE, individual artists began to sign their works—something unprecedented in former cultures.

From the sixth century BCE onward, two styles emerged for creating Greek figurative vase paintings: In black-figure painting, a black image appears against a reddish-orange ground. Reversing the process produced a reddish-orange figure against a black ground, known as red-figure painting (see figs. 3.23, 3.25).

In both black- and red-figure vase painting, the artist would first seal selected areas of the clay surface with a glazed coating before firing the clay vessel. By mixing clay particles and water, sometimes adding wood ash, the painter created a slip. He would then paint with the slip wherever he wanted the final surface to appear black, either for figures or background. In black-figure painting, silhouetted figures were given internal features—details of eyes, hair, clothing, and the like—by incising fine lines through the slip to expose the underlying clay body, which would then remain reddish when fired. The area covered by the slip turned black.

In red-figure paintings, the image was achieved by reversing the way the figure and the background were treated. In this case, the internal features of the figures were painted onto the clay surface, rather than incised through the slip. After firing, reddish figures—having the color of the fired clay body—are seen in silhouette against the painted black background that was covered by the slip.

Using both techniques, Greek painters created a wide assortment of images of their gods, heroes, and daily life activities, in which lines and silhouettes were manipulated with great dexterity to create images of grace and beauty. Over the course of time, vase painters grew interested in representing the details of human anatomy and the way the body looks in action, despite the inherent limitations of the medium and technique.

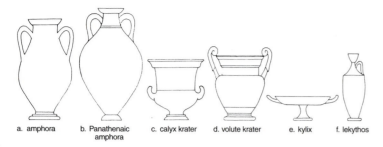

a. amphora b. Panathenaic amphora c. calyx krater d. volute krater e. kylix f. lekythos

3.24 Shapes of Greek vases: a, b for storing wine, olive oil, honey, water; c, d for mixing wine with water; e for drinking; f for holding olive oil

Orestes and Iphigeneia Among the Taurians

On a wine vessel or **krater** depicting *Orestes and Iphigeneia among the Taurians* painted in a Greek workshop in Apulia, southern Italy, in about 370–350 BCE (fig. 3.25), we see an early experiment in representing space with perspective. (The example shown here is a redrawing of the original work.) The vase painter has used a technique called red-figure painting, in which the process of black-figure painting is reversed: The figures are left in red, and the background and internal details are painted black. (See "Materials and Techniques: Greek Vase Painting," page 81; for the contrasting black-figure technique, see fig. 3.23.) In this scene the artist attempted to represent objects and buildings in perspective. Figures appear in a landscape,

in which successive overlapping folds of the hilly terrain convey the effect of space. This is a significant advance toward illusionism over the single-plane, silhouetted representation of *Herakles and the Nemean Lion* (see fig. 3.23).

The scene itself, showing figures near a temple set in a hilly terrain, is similar to the pastoral landscapes that became popular in Roman wall painting, as we'll see in Chapter 4. Such scenes were almost certainly copied from lost Greek originals, perhaps comparable to this early example.

Humanizing Nature

The Greeks, as we have noted, not only viewed nature as a force to be tamed, they also humanized it. This is seen in their representation of natural forces by means of personifications.

Hercules Finding His Infant Son Telephus in Arcadia

A striking use of personification appears in the scene of *Hercules Finding His Infant Son Telephus in Arcadia*, a wall painting of about CE 70 from Herculaneum in Italy (fig. 3.26). It is the work of a Roman painter but derives from Hellenistic sources, the most likely being second-century BCE Pergamon in what is now Turkey. This city's legendary founder was Telephus, and his father Hercules (the Greek Herakles) was the legendary founder of Herculaneum, creating interest in both cities for the subject. In the painting, the seated figure with a garland around her head and an overflowing basket of fruit at her side personifies the fertile land of Arcadia. Behind her, the smiling young Pan, shepherd god and protector of flocks, holds a shepherd's crook and his pan-pipes. In the upper right, a winged figure points Hercules towards the baby Telephus, who is

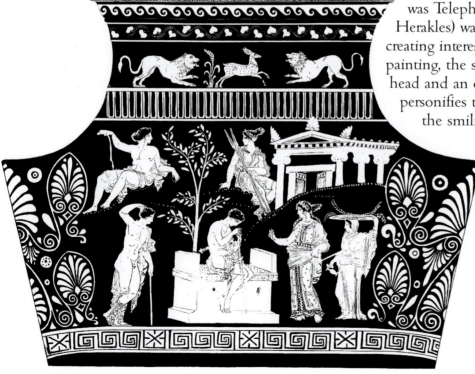

3.25 Redrawing of a scene on an Apulian red-figure krater depicting *Orestes and Iphigeneia among the Taurians*. c. 370–350 BCE. Museo Archeologico Nazionale, Naples (redrawn from Furtwängler-Reichhold, *Griechische Vasenmalerei*, vol. 3, plate 148, as reproduced in J.J. Pollitt, *Art and Experience in Classical Greece*, Cambridge University Press, 1972, page 163, fig. 71)

being suckled by a doe. As nature nurtures humanity, even the lion (and the eagle) are shown as domesticated symbols of Herculean strength. Though Hercules and Arcadia both resemble painted statues—the one of bronze, the other marble—the artist has modeled the forms with highlights and shadows to create the believable illusion of figures in a sunlit space.

Nature Domesticated

In the *Stag Hunt*, a pebble mosaic of about 300 BCE from the royal Macedonian capital at Pella (fig. 3.27), a lively decorative border of vegetation surrounds the scene (see "Materials and Techniques: Mosaic," page 78). A hallmark of Hellenistic decorative art, such borders appear in many surviving Hellenistic mosaics. Floral borders like this one provided the prototype for later Christian wall mosaics (see fig. 5.11), as well as for illuminated (or painted) manuscripts. Artists would use such borders as a decorative motif for centuries to come.

Within the scene itself, notice how the hunters and dog appear to surround the stag from behind and in

3.26 *Hercules Finding His Infant Son Telephus in Arcadia.*
c. CE 70, probably a copy after a Pergamene original of the second century BCE. Fresco. Museo Archeologico Nazionale, Naples

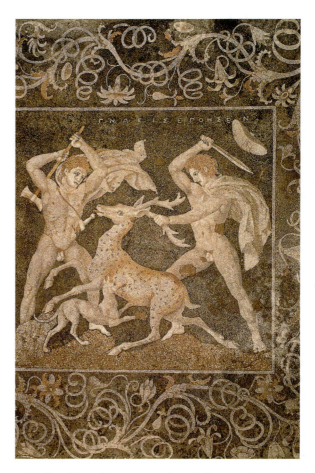

3.27 *Stag Hunt*, floor mosaic from Pella. c. 300 BCE.
Pebble mosaic, central area 10'4" sq. Archeological Museum, Pella

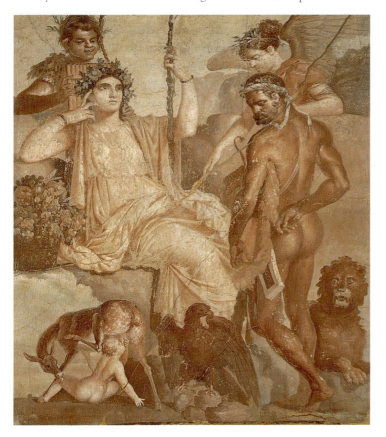

front, conveying an idea of three-dimensional space (achieved with even more dramatic effect in the mosaic of the *Battle of Issos*, see fig. 3.21). In this case, the varied colors of hundreds of tiny pebbles create the illusion, acting like the pixels on a modern television screen. When Greece was conquered by the Romans, such representations of nature conquered Roman hearts.

THE CITY

Beyond the temple precincts, honoring the gods who protected their cities, the Greeks created lasting buildings—libraries, gymnasiums, and public meeting places—to enhance the lives of ordinary citizens. In the development of Greek cities, we see again the ideals of rationality, order, beauty, and democracy. Democratic ideals turned the focus away from a ruler's palace toward the agora, where all the citizens assembled. Democracy also promoted egalitarian city plans, and rationality inspired the grid-like street pattern still used in many cities today.

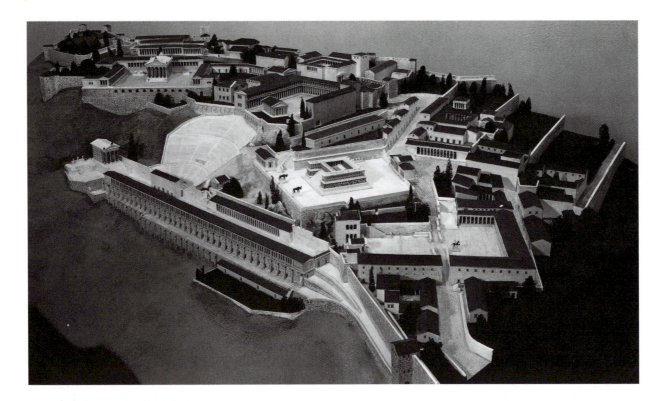

3.31
Reconstruction model of the acropolis, Pergamon. Antikensammlung, Staatliche Museen, Berlin

the central, steeply descending theater, with a great, long stoa as a footing for the entire composition. Such monumental effects, in which royal symbolism once more makes itself felt in monuments to the power and military victories of kings, proved irresistible to the Romans, who later emulated such monumentality on an even grander scale.

In Greek culture, the pursuit of democracy, rationality, and beauty humanized the city: The Greeks provided for human needs, building libraries, stoas, gymnasiums, and sports stadiums, as well as temples to honor the gods. At Pergamon the grandeur of royal symbolism once more asserted itself. In Roman cities, the cultural institutions that had remained separate in Greece—the temple and agora, the sacred and profane—were fused in the forum. Here, the profane came to dominate the sacred, and secularize it for political ends.

PARALLEL CULTURES
The Etruscans, India, and China

A trading people, the Greeks had regular contact with other Mediterranean cultures, and, as we've seen, were influenced by Egyptian, Phoenician, and Near Eastern peoples. In turn, their trading partners, notably the Etruscans in Italy, imported and emulated Greek ceramics and sculpture. With the conquests of

Alexander the Great, Greek cultural goods were widely absorbed by non-Greek peoples. When the Romans, in their turn, became masters of the Mediterranean world, they eagerly embraced the spectacular achievements of Hellenistic art and architecture.

The Etruscans

In central Italy, between the Arno and the Tiber Rivers, lived a people we call the Etruscans. Their origins are unclear, their language obscure, and their culture overshadowed by that of the Romans, who, having learned from them the skills of trade and civic organization, overthrew them. By 700 BCE the Etruscans were established in Tuscany (named for them) and traded throughout the western Mediterranean. Treasures found in their distinctive burial sites, in cities such as Cerveteri and Tarquinia (north of Rome), suggest they were a prosperous people. As rulers of Rome, between 616 and 510 BCE (when the Romans expelled them), the Etruscans drained the marshes in the heart of the city where the Romans would build their forum. From the Etruscans, too, Romans learned how to build temples and durable roads.

Today, the Etruscans are best known for their funerary art. Outside their cities they built expansive necropoleis (singular, necropolis) or cities of the dead, featur-

ing groups of circular burial mounds, or tumuli, that cover multi-chambered tombs below. The walls of the most lavish tombs are decorated with relief carvings or frescoes of people feasting, dancing, hunting, fishing, and swimming. These tombs also contained sculpted sarcophagi, made of terracotta and painted. The most distinctive, such as the example shown here from about 520 BCE, found in a tomb at Cerveteri (ancient Caere), feature a couple, reclining on a banqueting couch, as if participating in festivities (fig. 3.32).

The angular modeling of the facial features bears some similarities to Archaic Greek practice—and many other parallels between Greek and Etruscan art do exist—but the Etruscan conception of a funerary monument could not be more different from either typical Greek stele or Egyptian mummy masks (compare figs. 3.18, 2.25). Including a woman with her husband in a banquet setting is also unique to Etruscan culture. Indeed, several ancient Greek and Roman writers commented on the (to them assertive) presence of women in Etruscan public life. For today's viewer, what remains so striking is the sense of vitality that imbues this and many other examples of Etruscan funerary art, suggesting that they conceived of the afterlife as a continuation of the most joyful aspects of this life.

India

The armies of Alexander the Great reached India in 327 BCE only to turn back, and although trade contacts remained strong between the Hellenistic world and India, India maintained its ancient and independent cultural identity. As we saw in Chapter 2, a remarkable civilization had flourished in the Indus Valley from around 2500 BCE until about 1500 BCE, when it appears to have disintegrated, about the same time as Aryans from Iran infiltrated from the northwest. During the third century BCE, Indian religious life changed significantly.

Between 800 BCE and 500 BCE, Indian religious thinkers reacted against the Aryans' Vedic rituals, creating their own texts. Then, in the fifth century BCE, one dominant teacher, the Indian prince and sage Siddhartha Gautama, known as the Buddha, or Enlightened One, rose to prominence. His followers are called Buddhists. As Aryan beliefs blended with those of the indigenous population, Indian culture became the cradle of two world religions, Buddhism and Hinduism. Both inspired great and enduring artistic traditions whose history is as rich and diverse as that of Western art, spreading across continents and thousands of years. We'll look at an example of Hindu art in Chapter 5, but here we will briefly review the

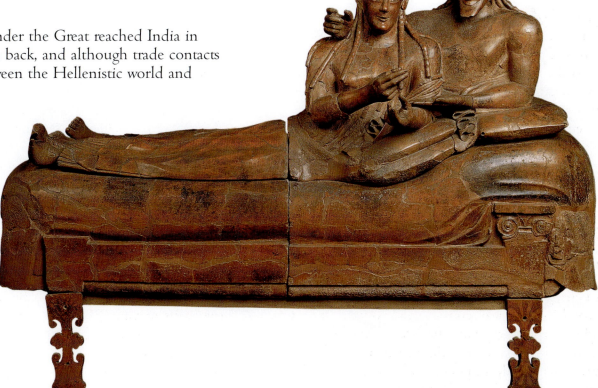

3.32 Sarcophagus from Caere (modern Cerveteri, Italy). c. 520 BCE. Terracotta, length approx. 6'7". Museo Nazionale di Villa Giulia, Rome

beginnings of Buddhist art and architecture, as manifest in an Indian Buddhist **stupa** begun about a century after Alexander the Great's armies had halted at India's frontier.

In the third century BCE, the first great Buddhist ruler, Ashoka, erected shrines, monasteries, and other monuments to Buddha throughout his empire, giving birth to religious art in India. The goal of Buddhism is release from human suffering, not by sacrifice to a god—as in many of the cultures we've discussed so far—but through personal enlightenment. Ideally, this is achieved by the obliteration of all desires, through meditation. In their art and architecture, therefore, Buddhists created settings for meditation and enlightenment, not for ritual or sacrifice.

When the Buddhist ruler Ashoka sought to spread his adopted faith, he had solid, hemispherical mounds, called stupas, built to enshrine the bodily relics of the Buddha. Perhaps the earliest surviving such stupa is the Great Stupa at Sanchi in central India (fig. 3.33). Begun in the third century BCE, probably by King Ashoka, it was expanded during the next two centuries. Its four monumental entrance gates are richly carved with stories from the life of Buddha, guardian figures, fertility gods and goddesses, and other sacred images.

The Great Stupa's four entrance gates are aligned with the cardinal points of the compass. When the devout pass through any one of these gates, the enclosing stone railing, which separates the sacred and profane, guides them to walk around the mound clockwise. Devotees thus symbolically make a path around the "holy mountain" that follows the course of the sun.

As a site for meditation, this early Buddhist stupa contrasts sharply with the temples of the Greeks, designed to house a cult image of the deity (see fig. 3.8), and Mesopotamian ziggurats, at the summit of which sacrifices were performed (see fig. 2.11). However, all three types evoke a cosmic symbolism: Both the stupa and the ziggurat are oriented to the points of the compass, and Greek temples were designed in accordance with mathematical ratios believed to signify cosmic harmony.

China

In the third century BCE, the Chinese also constructed a circular burial mound, yet on a far greater scale than either the Etruscan burial mound or the Indian Stupa. The mound was the royal burial site of the First Emperor of Qin (in Chinese, *Qin shi huang di*), a ruler who ruthlessly established the empire of China around 210 BCE. Yet only in 1974 did this burial mound and its astonishing contents become known.

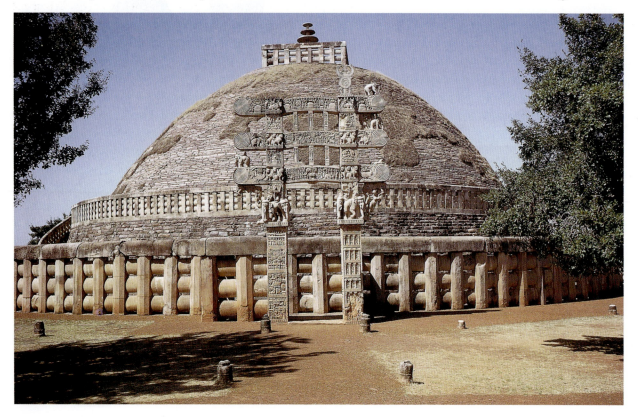

3.33 The Great Buddhist Stupa, Sanchi, India. Begun third century BCE, with additions of mid-first century BCE. Height of dome 54'

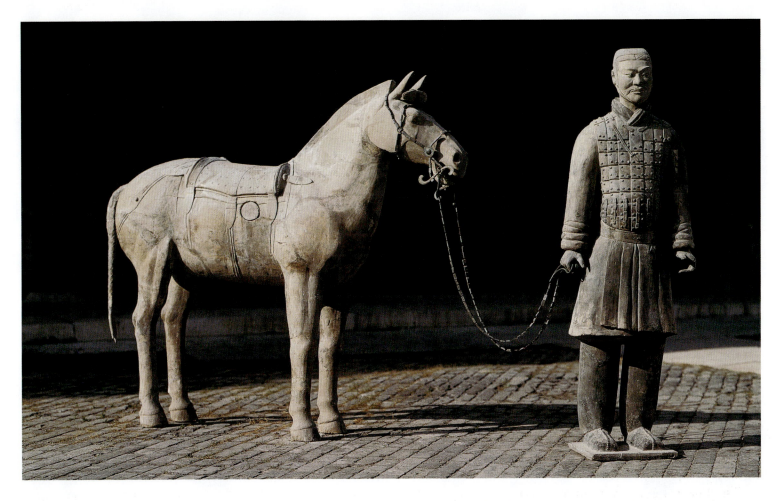

3.34 *Cavalryman and Saddle Horse* from earthenware burial army of the First Emperor of Qin, Lintong, Shaanxi, China.
c. 210 BCE. Terracotta, height of man 5'10½". Museum of Emperor Qin Figures and Horses, Lintong, Shaanxi

A *Cavalryman and Saddle Horse* (fig. 3.34) is just one set of more than six thousand life-sized terracotta statues of soldiers and two thousand horses, plus life-sized government dignitaries, that stand guarding the approach to the emperor's tomb. Closer to the tomb much smaller bronze images of horses, chariots, and charioteers have also been found. The giant tumulus, originally some 600 feet high and covering a large area, dominates a plain west of Mount Li near Xi'an.

The individual pieces of sculpture excavated from this burial mound reveal a sensitive realism, a striking contrast to the abstracted design of the much earlier Chinese bronze drinking vessel that we saw in Chapter 2 (fig. 2.35). The *Cavalryman and Saddle Horse*, like the Etruscan *Reclining Couple*, is made of terracotta, and, like it, was also originally painted. Traces of many different colors remain on the gray clay figures, suggesting their original lifelike appearance, and each statue is sculpted with individual features. Yet, compared with the fluid Greek treatment of both human figures and animals (compare fig. 3.4, *Apollo and the Battle of Lapiths and Centaurs*), it seems severe and rigid.

Four years after Shi's death invaders burned the posts supporting the roof over these sculptures, burying the statues in the dirt from above. Though much is still unexcavated, it is clear, that, like Egyptian pharaohs, a Chinese ruler such as Shi intended to be waited on in death as he had been in life.

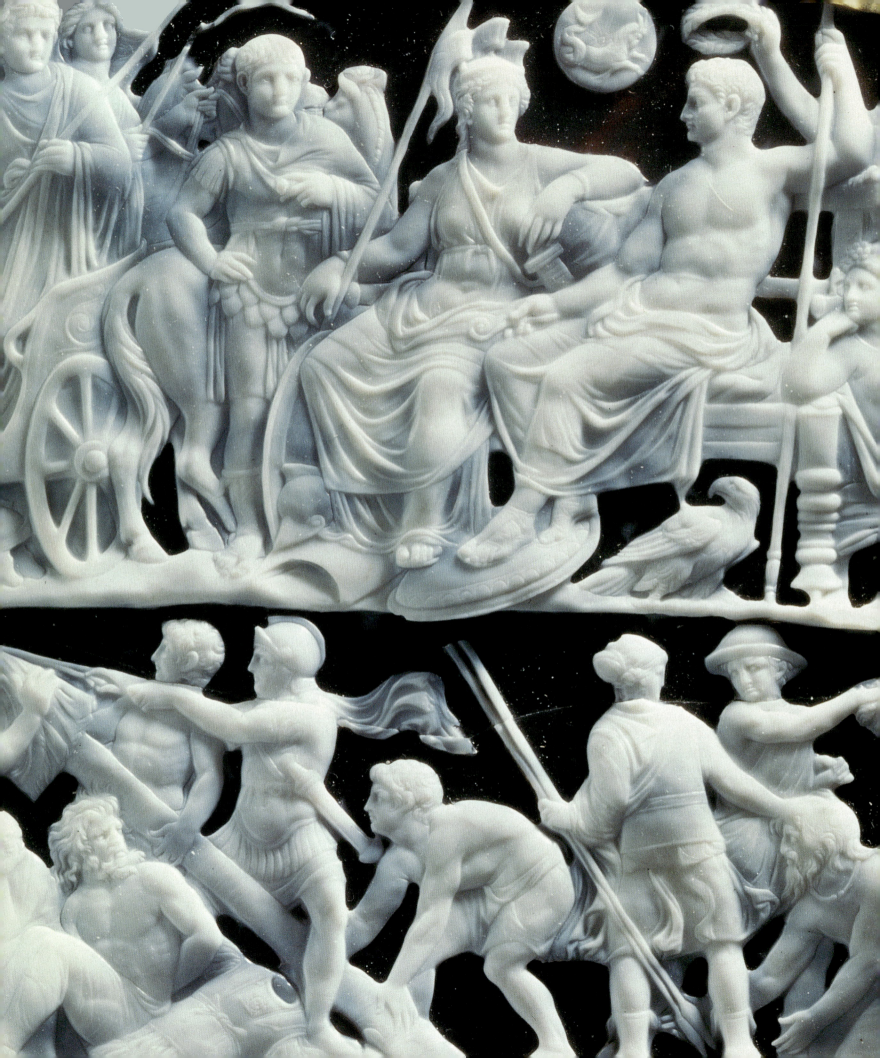

4 Roman Art

4.1 *Gemma Augustea* (detail of fig. 4.12). Early 1st century CE. Onyx, 7¹/₂" x 9". Kunsthistorisches Museum, Vienna

Until the fifth century BCE, the Romans were mostly farmers, ruled by a tribal king. Around 510 BCE, a republican form of government was established, with power vested in a senate, a council of leading citizens, and two elected consuls, the highest officials. From around 250 BCE onward (by which time they had conquered most of Italy), Rome began a period of conquests and overseas expansion, but the city of Rome itself was still far from grand. Visitors found its public and private buildings squalid and ordinary. It was the Emperor Augustus and his successors who would transform and aggrandize Imperial Rome. But, as any modern visitor can still see, the models for monumental Imperial Rome were distinctly Greek. Indeed, the fusion of Greek art forms and Roman subjects in an onyx cameo known as the *Gemma Augustea* typifies Roman admiration of Greek art (fig. 4.1).

Soon after Julius Caesar was assassinated in 44 BCE, his eighteen-year-old adopted son, Octavian, came to power. By age thirty-two, in 31 BCE, he ended republican rule and established the Empire, which lasted until 476 CE. Now known as the Emperor Augustus, he had become sole ruler of a vast empire and a unifying symbol of the Roman state, which reached from northern England to North Africa, and from Spain to Syria, encircling the entire Mediterranean world from the Atlantic Ocean in the west to the Euphrates River in the East (see Map 4.1). Without exaggeration, Augustus could claim to be master of the known world. His official image, in a slightly larger-than-life marble sculpture (see fig. 4.12), joins the ideal body-type of a Greek athlete (see fig. 3.16) with the uniform of the Roman emperor, complete with symbols of cosmic rule on his breastplate.

Under Augustus and his successors, the old, stern virtues of ancient Republican Rome were undermined by a life of wealth and luxury fed by the spoils of military conquest and sustained by a brilliant, pragmatic, imperial administration. From North Africa to Wales, the Romans masterfully organized people and

resources. So successful were they that Western culture still stands on models of Roman administration and law (see "The Founding of Rome: Legends and Gods," page 93).

The art and architecture of Republican Rome had long been influenced by the Etruscans, their more cultivated neighbors to the north (see Chapter 3), but when Rome conquered Greece, Greek art conquered Roman hearts. Romans imported Greek art by the ship-load, used the orders of Greek architecture in their own buildings, and hired Hellenistic artists and craftsmen, often to copy specific works of art. Most ancient conquerors laid waste the cities they captured, but Rome, despite the pillaging of its soldiers, so valued the older Mediterranean societies that it became, in effect, the preserver of ancient culture, by collecting it avidly. Today we would know little of Greek wall painting, mosaics, or sculpture, had the Romans not been so enamored of these arts.

If the Greeks were idealists, the Romans were pragmatists: Ideal Greek models would be adapted to fill Rome's practical needs. In meeting civic needs, Roman builders developed the technologies that changed the

Map 4.1
The Roman
Empire

The Founding of Rome: Legends and Gods

During the reign of Augustus, the poet Virgil wrote his *Aeneid*, an epic tale of Rome's legendary origins. The *Aeneid* tells of the Romans' descent from the Trojan war hero Aeneas, the mortal son of the goddess Venus. Jupiter (the Greek god Zeus) promised Venus that her descendants would rule the world. In the legend, Aeneas and his companions escaped from the burning city of Troy and, after long travels, settled in Latium in Italy. Another ancient legend attributes the founding of Rome itself in 753 BCE to Romulus and Remus, twin sons of Mars, god of war, by a Latin princess descended from Aeneas. For the Romans, these legendary links to Venus and Mars would explain their martial spirit and confirm their historic destiny.

The Romans adopted the Greek pantheon of gods, changing their characteristics to suit their needs (in this chapter, the Roman names are used). Jupiter, like Zeus, was supreme, and revered as protector of the city and the state. But for Romans the cult of Mars was more important. Significantly, the identity of Mars, their mythical ancestor, changed with the Romans themselves. Originally an agricultural deity, Mars became a god of war, just as the Roman citizen was first a farmer, and then a conqueror. Departing Roman legions made sacrifices to Mars; battles were won in his name; and war booty dedicated to his temple in Rome. Yet today, while Roman stone carvings graphically portray the oppression of Rome's enemies, statues of Mars are nowhere to be found. His great temple—once the pride of the Forum Augustus—is now a ruin, destroyed by those barbarians once crushed in his name.

look of Rome and became its lasting legacy. The ability of architecture to enclose huge spaces, which we take for granted today, for example, has its roots in the concrete vaulting designed by the Romans. Freed from post-and-lintel construction, builders could create vast interior spaces uncluttered by support columns.

As we'll see in the following pages, while the Romans were great innovators in the practical realm of building, in painting and sculpture they relied more on Greek prototypes, or models. And while the Romans esteemed earlier Greek art and artists, they thought little of their own contemporary visual artists, and treated them as humble artisans.

SPIRITUALITY

For the ever pragmatic Romans, even spirituality was political. From across their vast empire, they collected gods as well as plunder. Temples and shrines dedicated to an extraordinary array of deities—whether of Greek, Egyptian, Syrian, or Persian origin—were common in all Roman cities. In making allies of former enemies, the gods of conquered peoples were all tolerated and

absorbed, but on one condition: That all citizens—regardless of race or belief—first worshiped the Roman gods and burnt incense before the emperor's image. For this purpose, statues or busts of him were erected all across the Empire, as a symbolic embodiment of the unity of the state.

The Romans thus used religion as a unifying force, tolerating polytheism while insisting on the imperial cult. They expected their own deities to protect the state and its citizens, rewarding their temples with gifts in times of success, and, with characteristic pragmatism, withholding payment in times of failure.

Mars, God of War

In 186 BCE the Romans officially banned the public worship of the popular Greek god Dionysos (the Roman Bacchus). At the same time, they transformed Mars from an agricultural deity into a god of war, lavishing their greatest attention on his cult. This shift reflects Roman values: The cult of Dionysos, or Bacchus, invited a yielding to pleasure, passion, and irrationality, inconsistent with the traditional values of the Roman Republic: Piety, austerity, conquest, and

4.2 *Sacrifice of a Bull in the Forum of Augustus*, frieze from a Claudian altar. Mid-1st century CE. Marble, height c. 3'9". Villa Medici, Rome

frugal, efficient administration. By contrast, Mars, legendary father of Romulus and Remus, was their founding deity. To him, Rome traced its martial (literally Mars-like) spirit, and throughout the Empire, temples were built in his honor. The most famous one stood in the Forum of Augustus in Rome.

Though the Temple of Mars is now ruined, a carving of it forms the backdrop for this altar frieze from the mid-first century CE, depicting the *Sacrifice of a Bull in the Forum of Augustus* (fig. 4.2). As in Greek relief sculpture, the artist subtly conveyed depth by carving the figures in ever shallower relief, from the prominent servant holding down the bull's head to the successive images of people behind. (Recall the discussion of the Greek grave stelae in Chapter 3, and see figs. 3.18 and 3.20.) Some of the heads—depicted in profile or three-quarter view—appear to be individual portraits.

The Temple of Mars, as shown in the relief, stood on a high **podium**, or base, approached by steps from the front (not, as in Greek temples, on all four sides). Notice the crisply carved Corinthian order used for its portico (see Chapter 3, "The Classical Orders," pages 66–7). The sculpture standing in the

center of its pediment clearly represents Mars, with Venus—Rome's other founding deity—at his side, to our left. Bulls were offered to Mars because they were the most precious of farm assets. Their sacrifice also reflects Mars's origin as an agricultural divinity and recalls ancient fertility rituals (see Chapter 2, page 50 and fig. 2.28). The cult of Mars, then, served the Romans both as farmers and as conquerors.

Traditional Piety and State Religion

At the heart of Rome's ancient Field of Mars (Campus Martius), the Emperor Hadrian built a temple dedicated to the rituals of Roman traditional piety and state religion. The Pantheon (meaning "all the gods," CE 125–28) was named in honor of the Olympian deities (fig. 4.3). Statues of the seven planetary deities, including Venus and Mars, once stood in the Pantheon, their heavenly home symbolized by the building's great dome. This "dome of heaven" became the prototype for thousands of imitations, as did the building itself.

Greek and Roman temples were traditionally rectan-

gular, with wooden-beamed ceilings, so nothing prepared the visitor for the surprise of entering this vast, unobstructed, domed **rotunda**, or circular building. The surprise would have been all the more complete originally, when its portico was enclosed at the head of a rectangular forum. This hid the rotunda from view, framing a standard temple portico similar to that of the Temple of Mars (see fig. 4.2). (The Pantheon also stood on a raised podium, approached by steps, now buried under centuries of rubble and street paving.)

Of all surviving Roman monuments, the interior of the Pantheon best shows off the stunning effects achieved through innovative Roman engineering (see figs. 4.3, 4.4). By using concrete, Roman builders transformed arch and vault construction (see "Materials and Techniques: Arches and Vaults," page 114), and covered this raw shell with a strongly modeled surface

of rich and multicolored marble paneling, plinths, pilasters, columns, cornices, pediments, and statuary. The shell itself consists of a hemispherical dome set on a cylindrical drum (see "Materials and Techniques: Domes," page 97). Dome and drum are of equal height, and the diameter of the drum (143 feet) is the same as the height from the floor to the opening at the top, called the *oculus*, or eye. Thus all proportions are in harmony, framing the shape of a perfect sphere. Originally the sunken squares, or **coffers**, of the dome were gilded, and may have contained gilded bronze rosettes like twinkling stars, to suggest the vault of the heavens. Rich materials, united with the interior's geometric simplicity, yield the Pantheon's beauty.

The symbolism of the Pantheon was political as well as religious, since it contained sculptures of both

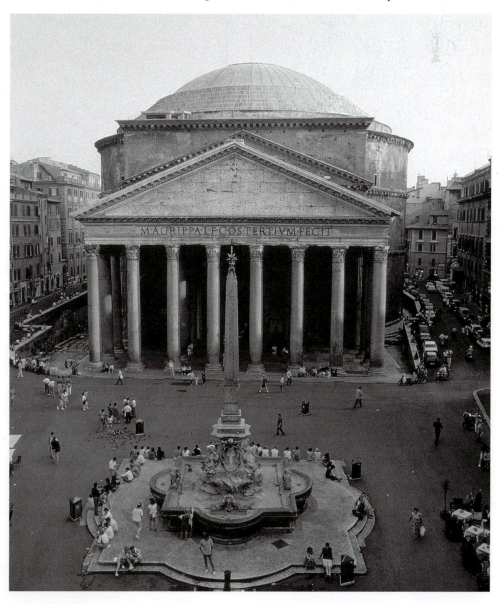

4.3 Pantheon, Rome. CE 125–28

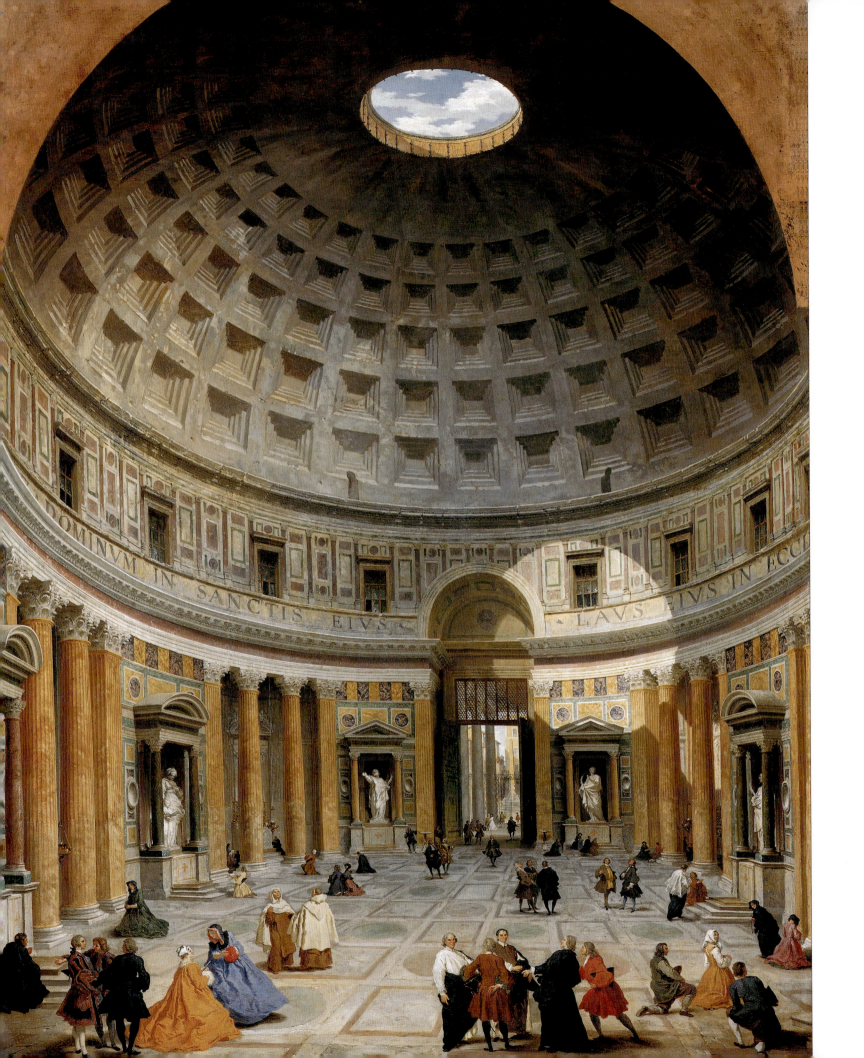

Domes

Picture an arch. Now imagine turning it 180 degrees on its axis. That creates a **dome**, a roofing structure in the form of a hemisphere. A dome must be buttressed around the entire circumference of its base, to prevent its outward pressure from causing collapse. Domes rest on a supporting structure, set either on a circular base, called a drum, as on the Pantheon (see fig. 4.3), or on a square base (see, for example, fig. 5.12, Hagia Sophia, Constantinople [Istanbul]). A dome may also be placed on a drum, itself raised above a square base (see fig 7.24, St. Peter's, Rome).

Light can enter a dome in several ways. At the Pantheon, it streams in through a single opening in the top, called an **oculus**. As the sun's angle changes throughout the day, so does the direction of the light coming into the Pantheon, rotating like a spotlight around its circular interior (see Panini's painting, fig. 4.4). In later architecture, windows were placed around the drum, as at St. Peter's, Rome (see fig. 7.23), creating a brighter and more evenly lit interior.

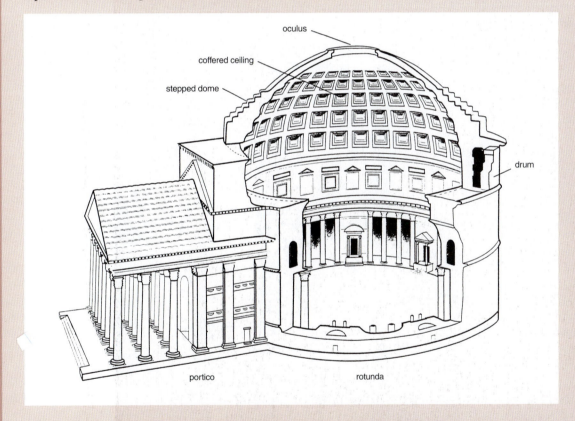

4.5 Reconstruction drawing of the Pantheon dome

oculus

coffered ceiling

stepped dome

drum

portico

rotunda

Augustus and Julius Caesar, and Hadrian himself presided there over a judicial court. Indeed, it has been suggested that its structural unity, containing many parts and diverse substances, implied that the cosmic symbolism of the Pantheon might equally be related to the Empire itself. Granites, marbles, porphyries and other materials display the wealth and vast geographical extent of the Empire, all joined under the single canopy of heaven. In this way, the Pantheon embodies a critical goal of Roman architecture—joining religious allegiance and symbolism to serve political ends.

4.4 Giovanni Paolo Panini, *The Interior of the Pantheon.* c. 1740. Oil on canvas, 4'2" x 3'3". The National Gallery of Art, Washington, D.C.

Mystery Religions

While the routines of state religion served political purposes, they did not satisfy more personal spiritual needs. To meet those needs, people throughout the Empire turned to an array of cults and mystery religions, many of them from the Near East and Persia. Few traces of their temples or shrines remain, but one outstanding cycle of wall paintings painted about 50 BCE and found in a large Pompeian villa depicts a cult initiation ceremony (fig. 4.6), apparently a Dionysian or Bacchic ritual. Almost life-size, some of the figures recall poses found in Hellenistic art. They are painted as if standing on a ledge in an extension of the viewer's own space. The action continues across the corners, so that a kneeling, bare-backed woman in one corner panel seems about to be struck by a flagellator raising her whip on the adjoining wall.

Unlike the Greek associations of Dionysos with dance and revelry, these scenes reveal the transformation of Dionysos into a suffering god who dies and is born again, and comes to symbolize immortality. Though once banned, the Roman cult of Dionysos, or Bacchus, became popular because of its promise of an afterlife of bliss and plenty. For the most part the state turned a blind eye to such mystery religions, so long as people honored the image of the emperor.

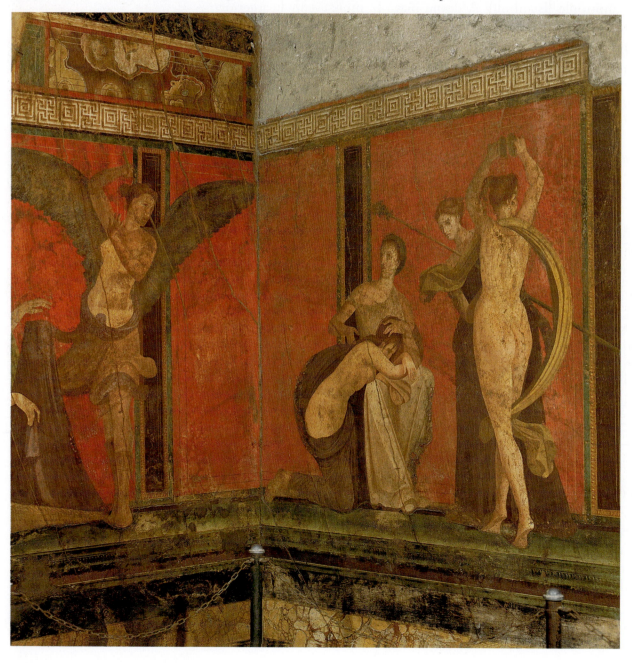

4.6 *Dionysiac Mystery Cult.* c. 50 BCE. Wall painting, 5'3¹/₄". Villa of the Mysteries, Pompeii

THE SELF

The ideals of patriotism, public duty, and self-discipline guided the old patrician families of Republican Rome, that is, members of the ruling, senatorial class. Wives were expected to be virtuous, obedient, chaste, and noble. Taking Greek Stoic philosophy as their model of virtue, the old patrician class maintained a public image of solemn dignity, with loyalty to the state and family valued above all else.

The Stoics had taught that a divine, controlling providence determines each person's life. Individuals were to accept misfortune with "Stoic" fortitude, acknowledging that health, fame, and riches were among life's uncertainties. These stern Stoic values were what Romans, hardened by foreign wars and bitter civil strife, were trained to embrace. Nevertheless, they preserved the more superstitious character of traditional religious practices, continuing to make sacrifices to the gods.

Ancestor Worship and Patrician Portraits

At a Roman aristocrat's funeral, his son would deliver a eulogy, praising the father's character and accomplishments. A wax mask of the dead man would then be displayed in his house, surrounded by a shrine. Family members would wear these masks at family funerals and at public sacrifices to represent the presence of honored ancestors. Because the wax images would not last, marble copies were made, and so the spiritual practice of honoring ancestors fostered the development of portrait sculpture.

A Roman Patrician with Busts of His Ancestors
A life-size statue from the late first century BCE (fig. 4.7) embodies the Stoic virtues and stern sense of public duty embraced by the Republican patrician class. The Romans are renowned for their portraiture, and for its hyper-realism, or "verism," as seen in this group's tight-lipped mouths, drawn faces, and grave bearings. Such realism also reflects Roman ideology, with certain facial characteristics accentuated to stress a long life of public service. The sculptor deliberately accentuated gravity of bearing, and a look of moral rectitude, clear-eyed pragmatism, and steely endurance—all appropriate

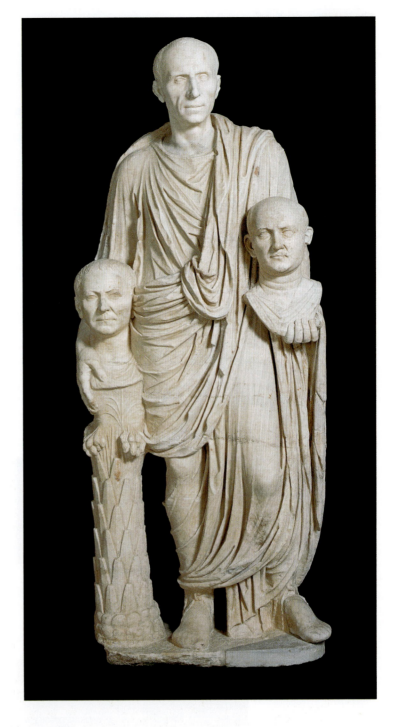

4.7 *A Roman Patrician with Busts of His Ancestors.* Late 1st century BCE–early 1st century CE. Marble, life-size. Capitoline Museums, Rome

attributes of a Roman patrician. The patrician's ideal was to serve one's country—whether in politics or the army—and then return to oversee the tilling of the fields of the family villa. Their example has inspired posterity, and was emulated by George Washington and Thomas Jefferson, both admirers of Roman patriotic virtue.

Domestic Life

On an August morning in CE 79, a violent volcano erupted at Mount Vesuvius, near Naples, burying the provincial cities of Pompeii and Herculaneum under layers of ash, lava, and mud. In the eighteenth century antiquarians excavating the cities and villas covered by the eruption unearthed unparalleled evidence of Roman domestic life at several different levels of society. Their discoveries revealed what kind of fruit Romans grew in their gardens, what foods they ate, and how their town houses, gardens, and villas were designed.

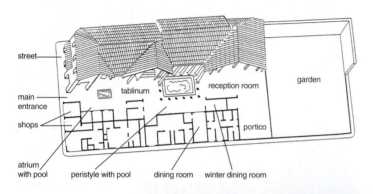

At Pompeii, as elsewhere in the Roman world, town houses were turned inward with their backs to the street, with no windows piercing their solid outer walls. These houses were designed around a central axis, which was aligned with the street entrance. This led to an **atrium**, an entrance court with a small pool at its center to catch rainwater from an opening in the roof. Directly beyond it was the tablinum, a reception room where ancestor busts were displayed, and directly beyond this again was an open peristyle courtyard, often with a larger pool and small fountains with statuettes and garden plants, surrounded by a colonnaded portico (figs. 4.8 and 4.19). The family rooms all looked onto the two courtyards aligned on the central axis.

Beautifully preserved wall paintings enhance our knowledge of these houses. The decorative scheme shown in figure 4.9, from the bedroom (or perhaps dining room) of a country villa at Boscoreale, near Pompeii, was painted in the mid-first century BCE. Particularly striking is the way the artist used the illusionistic effects of perspective to reverse the enclosed nature of a Roman house: Instead of turning inward, these paintings create the illusion that the room opens out onto an expansive

4.8 Reconstruction drawing and plan of the House of Pansa, Pompeii. 2nd century BCE

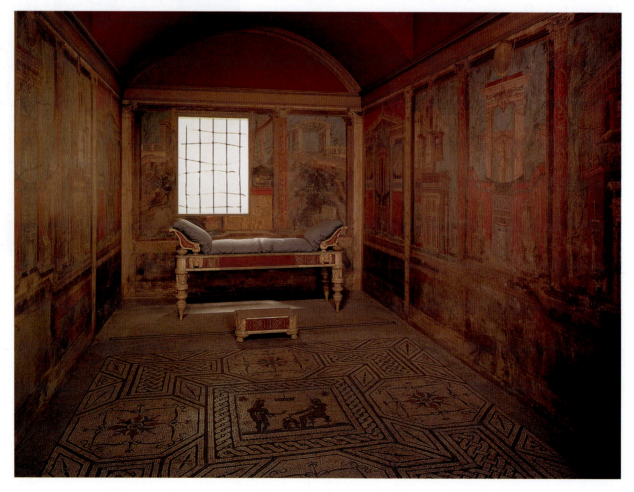

4.9 Bedroom of a villa from Boscoreale, near Pompeii. Mid-1st century BCE. Wall paintings. The Metropolitan Museum of Art, New York

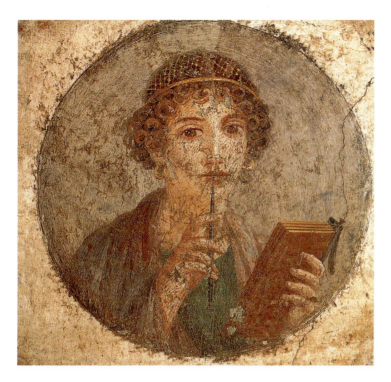

4.10 *Young Woman with a Stylus and Writing Tablet*, from Pompeii. 1st century CE. Fresco, diameter 11³/₈".
Museo Nazionale Archeologico, Naples

Family Portraits

Among the surviving wall paintings from homes in Pompeii and Herculaneum, a number include family portraits that were painted directly onto the wall, as if hung there as separate objects. A beautiful small portrait from a house in Pompeii, *Young Woman with a Stylus and Writing Tablet*, was painted in the first century CE (fig. 4.10). Conceived as if within a circular frame, called a **tondo**, it was painted in a quick, sketchy manner, using a technique called **buon fresco**. To paint in *buon fresco*, an artist mixes colored pigment with limewater, then applies it directly to the wall before its plaster coat has dried. As the plaster dries, the painting becomes one with the wall, conferring great durability.

The artist has achieved a pleasing formal harmony between the shape of the tondo and the pose of the sitter: The circular form echoes the shape of the golden net holding her curly hair, and the stylus she holds to her lips creates a central axis, against which the other elements are played off. As the writing tablet draws our eye to the right, her dreamy gaze is turned in the other direction, as if she is caught in thought.

Several portraits from Pompeii and Herculaneum, such as this one, are of middle-class or wealthy people. Some are crudely painted by local artists of limited talent, somewhat comparable to early American colonial portraiture in their directness and lack of technical refinement (see Copley's *Portrait of Paul Revere*, fig. 11.25). One such painting is of a young couple, a law student and his wife, who both bear the characteristic features shared by many Neapolitans today. The painting of family portraits directly onto a wall implies an expectancy of long-term residency in the same house, an expectation that is alien to our highly mobile society. Laws protected these home builders from having their family name and identity effaced by later

world. The views include a city seen beyond a majestic gateway, vistas through a portico onto a circular building, called a **tholos**—perhaps a shrine—and a garden scene with birds by a fountain in a grotto, plants twining on the arched trellis above. To the right of the real window is a painted bowl of fruits customarily offered to guests as a symbol of hospitality. Such scenes project a fantasy world of luxury far beyond the means of the villa's owner; they were perhaps inspired by accounts of the lavish pleasure villas and gardens built by the most wealthy Romans on the outskirts of Rome.

❖ MATERIALS AND TECHNIQUES ❖

Encaustic

Encaustic is one of the earliest painting methods, used by ancient Egyptians, Greeks, Romans, and early Christians. The artist mixes pigment with heated beeswax and then applies it to a surface, before it cools down. Encaustic can be applied to a variety of surfaces, such as panels or walls, and was also used by the Egyptians and Greeks to tint sculpture, making its hard, otherwise colorless surface more lifelike. Artists using encaustic have to work quickly, before the hot wax cools, and this quickness imparts a freshness to the image. Though it is a difficult medium to work with, encaustic is being used again. It is extremely durable and creates vibrant and luminous colors.

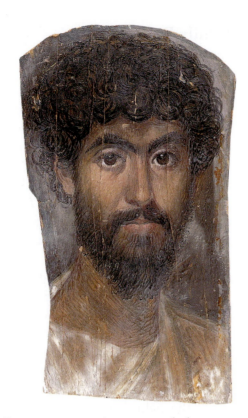

4.11 *Mummy Portrait of a Man*, from the Fayum, Egypt. 2nd century CE. Encaustic on wood, 14 x 8". Albright-Knox Art Gallery, Buffalo

owners. Ironically, at Pompeii, owners' tenure ended more abruptly that they could ever have anticipated. In a dramatic and strange way, we profit from their tragedy. In visiting Pompeii, we can enter the remains of their homes and find them much as they were in CE 79.

Egypto-Roman Mummy Portraits

The ancient Egyptian practice of mummy portraits (see fig. 2.25) continued during Roman rule in Egypt. Once reserved to rulers and court officials, this practice was now open to a wider class of people due to the development of a less expensive medium. By painting with **encaustic** on a wooden panel (see "Materials and Techniques: Encaustic," page 101), an artist could create a lifelike image of the deceased, heightened by modeling the face with highlights and shadows. Painted in the second century CE, the *Mummy Portrait of a Man* (fig. 4.11) is an excellent example of this technique. Modeling on the face creates the illusion of the third dimension even on a flat surface, preserving a very natural, vivid impression of the deceased.

Although the frescoed portrait from Pompeii was buried accidentally, and mummy portraits on wood panels were made for burial, in conception and technique such head-and-shoulder, or bust-length portraits provided the model for subsequent icons of Christ and the saints, as painted on both walls and wood panels. This desire to preserve identity is echoed in the Western practice of portrait painting.

Rulers

Throughout the far-flung Empire, statues of the emperor stood as powerful, daily reminders of Rome's rule and as calls to loyalty. When the rulers of the former Soviet Union erected monumental statues of Lenin and Stalin across eastern Europe to symbolize Soviet control, they were borrowing from the Romans. The practice of venerating the image of the emperor created a huge demand for state portraits.

Augustus of Primaporta

The most memorable of Roman state portraits is the statue of Augustus from the imperial villa at Primaporta, carved early in the first century CE (fig. 4.12). The idealized body-type and stance recall the Greek *Doryphoros* of Polykleitos (see fig. 3.16), from which it is derived. Augustus's right arm is raised in the conventional Roman gesture of public address. This gesture conveys authority, but it also implies a call to citizenship, a reminder of patriotic duty and public service. The portrait departs from the earlier hyper-realist conventions of Roman Republican portraiture (as seen in fig. 4.7). Augustus appears youthful and idealized, and in his perfected body and facial features, we see the Greek conception of noble beauty.

Breaking from past convention may have been intended to give Augustus a quasi-divine stature, while also identifying him as a symbol of peace, concord, and renewal after a century of bitter civil war and grueling foreign campaigns. The cupid at his right foot reminds viewers of Augustus's divine descent from Venus through Aeneas, marking his destiny to lead Rome to world sovereignty (see "The Founding of Rome: Legends and Gods," page 93). We can also see this theme of cosmic rule in the reliefs on his breastplate: Augustus's victory over the Parthians—avenging an earlier Roman defeat—is carved within a framework of cosmic symbols. Allegorical figures of the sun, the moon, and the sky god look down, while mother earth spreads out her bounty below.

The *Gemma Augustea*: Greek Techniques, Roman Themes

Augustus appears, again, as the divinely ordained ruler of the world in an onyx cameo barely nine inches wide (fig. 4.13, see also fig. 4.1). Known as the *Gemma Augustea*, the piece was carved for Augustus (or his family), probably by a Hellenistic artist. Again, the

Romans freely borrowed Greek techniques and images to serve their own distinct agenda.

In its upper register the semi-nude Emperor Augustus, feet resting on a shield, sits beside a figure who reminds us of Athena, divine protector of Athens, now transformed into Roma, protector of Rome. The eagle (a symbol for Zeus) shown at Augustus's feet was a Greek omen of good fortune in both war and peace. (This eagle, the symbol of the Roman Empire, was later adopted by countless political entities, including the United States.) In the background, allegorical figures (that is, human figures that represent a quality, idea, or natural phenomenon)—here signifying the earth's bounty—use a Greek laurel wreath (borrowed from Olympic ceremonies) to crown Augustus as ruler of the world. Such hubris, or excessive pride, would not have been tolerated in Periklean Athens, not even in royal Pergamon (see Chapter 3). Yet, ironically, the Greeks supplied virtually all the means by which such hubris could be expressed, down to almost every last detail.

Beside and below the allegorical figures, we can find more mundane elements: To the left, a contemporary Roman ruler (probably Augustus's successor, Tiberius) steps from a chariot driven by a Greek allegorical winged figure of "victory." Below, Roman soldiers, their uniforms accurately detailed, hoist a war trophy of captured arms, as two barbarian couples, stripped, bound, or pulled by their shaggy hair, await their fate. Besides the distinctly Roman subject, the precious quality of the object attests the Roman love for collecting all that is fine, well conceived, and exquisitely executed.

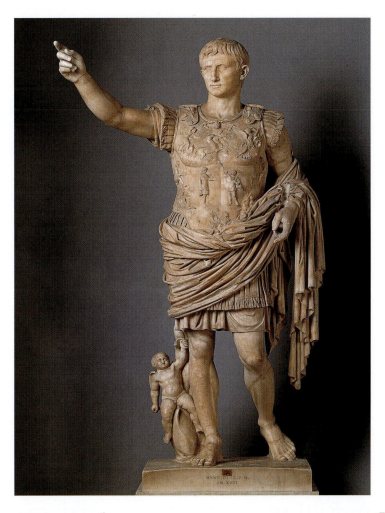

4.12 *Augustus of Primaporta.* Early 1st century CE. Marble, height 6'8". Musei Vaticani, Rome

4.13 *Gemma Augustea.* Early 1st century CE. Onyx, 7½" x 9". Kunsthistorisches Museum, Vienna

Equestrian Statue of *Marcus Aurelius*

One of the most celebrated, and emulated, monuments of ancient Rome is the large, bronze equestrian portrait of *Marcus Aurelius* (fig. 4.14). Created CE 161–80, and originally gilded, it stood in front of the papal Lateran Palace throughout the Middle Ages until Michelangelo made it the central focus of the Campidoglio (see fig. 7.00). (Today it is kept indoors in the Capitoline Museum to protect it from air pollution.) This equestrian portrait is the sole survivor of more than twenty such figures of emperors that once adorned the Imperial Forums of Rome.

The philosopher-emperor Marcus Aurelius is known for his *Meditations*, written during his military duty. They describe his struggles to rule as an emperor and live as a Stoic. The statue commemorates the

4.14 Equestrian statue of *Marcus Aurelius* (after restoration), CE 161–80. Gilt-bronze, height 11'6". Capitoline Museums, Rome

Roman virtues of martial strength (signified by his powerful horse straining at the bit) and clemency, conveyed in the calm poise and gesture of the emperor. This last quality would originally have been more evident, since, in the artistic convention of the time, a captured enemy (now lost) knelt in supplication before the horse's raised leg. This technical masterpiece was not matched in the West for almost 1300 years, when Donatello emulated it during the Italian Renaissance (see fig. 7.25).

Warriors

In a culture devoted to Mars, the god of war, a Roman commander was proud to be commemorated as triumphant in battle, even if it meant having images of Rome's wretched enemies strewn all over his **sarcophagus** or tomb. The *Battle between the Romans and the Barbarians* (fig. 4.15) memorializes such triumph and tragedy. This third-century CE relief sculpture is the front panel of the so-called *Ludovisi Battle Sarcophagus*, which was found near Rome. The writhing figures are woven into a surface pattern and piled on top of one another. The uppermost figures are slightly larger and more deeply undercut. This creates stronger modeling in light and shadow, and allows the Roman commanders literally to stand out as triumphant conquerors.

The panel was made at a time when the Roman army had great power and most of the emperors were tough military commanders. Its sculpture celebrates both the patriotic obligation of military service, and the moral virtue of clemency over defeated enemies. In the detail of the Roman soldier, at left, looking into the eyes of a barbarian captive pleading for mercy, there seems to be at least the potential for mercy. However, the overall scene is one of violence and death. Above, the memorialized commander rides triumphant on his splendid charger, crushing his enemy underfoot. The gesture of his outstretched arm may recall that of both Augustus and Marcus Aurelius, but the spirit of the action is unashamedly brutal. As a commemorative monument it is a far cry—in subject, spirit, and technique—from the graceful and tender Greek grave steles or the Etruscan couple we saw in Chapter 3 (see figs. 3.18, 3.20, and 3.32).

Thus, whether in funerary monuments, painted portraits, ancestor busts, or public statues of their emperors, the Romans inscribed their sense of public duty, family honor, and Stoic ideals in art—in all cases recasting Greek ideals in pragmatic Roman terms.

NATURE

While the Romans knew well the rigors of war, they also valued the solace of nature. Increasingly, the attractions of Roman cities turned this society of farmers into urbanites. And, somewhat as we do today, Roman city dwellers viewed nature through an idealized, nostalgic lens. Writers such as Horace, Pliny the Younger, and Virgil extolled country living as a way to retreat from the artificial life of the city, reconnecting with the rhythms of nature.

To the greed, ambition, vice, and clamor of the city, country life offered an antidote of innocence and purity. Roman city dwellers responded to such perceptions in two ways: many commissioned idyllic landscape paintings to decorate their town houses, and those who could afford it bought farms and villas in the country, where they lived for part of the year. Thus, in their art and in their lives the Romans enjoyed nature as a foil to the pressures and evils of the city.

4.16 A sacred-idyllic landscape, from the Villa of Agrippa Postumus at Boscotrecase, near Pompeii. CE 1–25. Wall painting. Museo Archeologico Nazionale, Naples

Landscape Painting

The Romans' attachment to the land became the backdrop for the development of landscape painting, as a specific **genre**, in the West. The earliest surviving examples (excluding some Minoan and Etruscan art) were created during the late first century BCE and the early first century CE. These works take three forms: first those with scenes inspired by literature, such as the *Odyssey Landscapes* (painted for a house in Rome and now in the Vatican). Second are those in which a garden is created as an extension of the real space of the room, as we saw in the Boscoreale wall paintings (see fig. 4.9). Third are those with rural temples and

shrines, called "sacred-idyllic landscapes," as seen in a wall painting from the Villa of Agrippa Postumus at Boscotrecase, near Pompeii, painted early in the first century CE (fig. 4.16).

The Sacred-idyllic Landscape

This sacred-idyllic landscape is presented as a framed view, creating the illusion of a separate painted panel hung against the wall, whose deep red color contrasts with the gentle, pastel tones of the landscape itself. This type of landscape, deftly executed in the same sketchy technique as the *Young Woman with a Stylus* (see fig. 4.10), takes its name from its subject, an idyllic landscape with a rural shrine. In this case a rocky outcrop serves as a sacred isle dedicated to a nature goddess (perhaps Ceres), whose statue is set before a sacred tree. Beside the tree stands a column draped with shields and topped by a commemorative urn. Beyond it we see a cylindrical tomb monument, and a shepherd tending his goats reclines on a further monument. As two women and a child cross a bridge, approaching the statue of the seated deity, the foremost figure extends her arms, suggesting veneration. Behind them is a phallic **herm** (a pillar terminating in a head) of the fertility god Priapus. In the background two small temples and a wall enclose a sacred grove, and two rocky hills close off the view. While the shepherd and goats introduce a rustic, agricultural element, the dominant association is nostalgic: Nature is a place to worship rural divinities and visit the tombs of one's worthy ancestors. This landscape evokes an imagined earlier age of rural prosperity, lived under the protection of nature gods, restoring the city dweller, who now lived under the shadow of the Temple of Mars, god of war.

Country Villas and Peristyle Gardens

Wealthier Romans could indulge their nostalgia for rural life by building country villas, typically with farms attached. As the Empire grew richer, the old Republican values of thrift and hard work gave way to a more Epicurean attitude (see page 113). In country living, Romans wanted leisure and luxury. (Pleasure and renewal were joined in a concept first coined by the Romans—"*otium*," meaning free-time, leisure, or ease. The mind and the spirits were to be renewed in the country, in a conscious act of recreation.)

4.17 J. Paul Getty Museum, Malibu, California

Pliny the Younger, an upper-class Roman, describes his own two villas, one for weekend recreational use by the sea near Rome, and the other, with working farm attached, for summer vacations on the southern slopes of the Apennines in Tuscany. Describing each of them, he pays particular attention to the pleasure derived from their spectacular views. Seaside villas like Pliny's are depicted in a number of Pompeiian landscape murals, but no actual seaside villas survive. The original J. Paul Getty Museum in Malibu, California, is itself a replica of an entire Roman villa and its garden (fig. 4.17).

Hadrian's Villa
Still partly surviving is the most ambitious of all villas, built around CE 135 by the Emperor Hadrian. This vast complex is spectacularly situated in the foothills of the Apennines east of Rome, near Tivoli. A variety of different buildings was spread over half a square mile, many offering expansive views of the Roman countryside. Hadrian had traveled widely and commissioned his architects to build this villa complex as a kind of "theme park" of buildings he admired from Athens and Alexandria and other parts of the Empire. These were replicated in concrete or brick, and faced with marble veneer. Today, one of the most scenic remnants

is the long pool framed by a colonnade with an alternating straight and arched entablature, interspersed with copies of admired Greek statues (fig. 4.18). The vast scale and luxury of Hadrian's villa are, however, inconsistent with the intrinsic villa ideal of a place for pleasure and renewal in contact with a working farm.

The Roman Peristyle Garden
While a villa provided the wealthy urban dweller with a place of periodic retreat to the country, the enclosed Roman peristyle garden, surrounded by a colonnade, such as those in the town houses of Pompeii, allowed a wider class of urban people to enjoy and cultivate a small enclosed space with fountains and fruit trees, flowers, and vegetables. These peristyle gardens (fig. 4.19) were the models for the monastic cloister gardens that were built throughout the Christian era. Their influence is felt far and wide, from the Islamic "Court of the Lions," of the Alhambra in Spain (see fig. 6.47), to the cloister gardens of the Franciscan mission churches of California built in the early nineteenth century.

4.18 The Canopus, Hadrian's Villa, Tivoli. c. CE 135

4.19 Peristyle garden, House of the Vettii, Pompeii. Mid-1st century CE

THE CITY

Despite the nostalgic allure of nature, the Roman city became an ever-more magnificent magnet. Again, Greek models inspired Roman designs, and with typical pragmatism, the Romans built an unprecedented network of roads, bridges, aqueducts, and sewers to enhance communication across their empire and efficiency within their cities. Stoic efficiency was combined with Epicurean luxury. The Macedonians who complained of Rome's squalor in the third century BCE would have been stunned by the grandeur of the Imperial city.

Efficiency and Spectacle

Unquestionably, Rome's greatest artistic legacy is architectural. Large, vaulted covered markets anticipated the modern shopping mall, and at stadium-like amphitheaters, as many as 50,000 people could come together to watch public spectacles. A Roman citizen could spend the day in monumental bath-houses, luxuriously appointed with hot, warm, and cold baths, exercise rooms, lounges, lecture halls, and libraries.

Three to six-story apartment buildings served as sturdy and efficient public housing, with inner garden courtyards and shops on the ground floor. All this construction was done in brick or concrete, with marble or other precious materials used to finish important public buildings. As we noted earlier, the development of arch and vault construction in conjunction with concrete enabled the Romans to span vast, uninterrupted interior spaces, surpassing the scale of anything built by the Greeks.

Rome itself, which for centuries had been poorly designed and only modestly constructed, became not only efficient and well-appointed, but also spectacular, as booty from foreign conquest filled its treasuries. Modeling public buildings on the stunning accomplishments of Hellenistic architecture, the Romans combined these with their innovative building technologies. Building on a large scale at a lower cost, they transformed their capital to spectacular effect.

The Roman Forum

When founding new cities, the Romans adopted a Hellenistic grid plan of the kind used in such cities as Priene (see fig. 3.28), and divided the town with two major intersecting thoroughfares: the *cardo*, a straight street running north–south, and the *decumanus*, also straight, running east–west. Their intersection marked the town center, where the **forum** (a rectangular, colonnaded public space adapted from the Greek agora) was located. In pulling the Greek agora's disparate elements into one unified, rectangular public space, the Roman forum set the precedent for later city squares. A **basilica** (an oblong, aisled hall for administrative and legal matters) abutted the long side of the forum, and a temple headed the narrow end. This formed the social, political, and religious heart of the town, while the theater and public baths were generally located further out. The Romans followed this pattern consistently in new towns, from Timgad in North Africa to Caerwent in South Wales.

When the Byzantine Emperor Constantinius II [of Constantinople] visited Rome in CE 356, the sight of the old Roman Forum left him speechless, but on arriving in Trajan's forum "he was stupefied." Even today, standing amid the extensive ruins of the Imperial forums laid out by Julius Caesar, Augustus, Vespasian, Nerva, and Trajan, it is hard not to be moved. Before us lies an expanse of space on which the dreams and ambitions, energy and sacrifices, pride and humiliation of a once great empire were focused. Looking more closely, one sees how successive generations have each stamped their identity on this symbolic public space (fig 4.20).

When the Romans designed their forums, they united what the Greeks had originally kept separate, the religious acropolis and the political agora (see Chapter 3). By incorporating the sacred temple into the political heart of the forum, the Romans would bend religion to serve the state: Now, loyalty to the state was expressed in religious terms. In a number of Roman relief sculptures, including the frieze of a *Sacrifice of a Bull in the Forum Augustus* (see fig. 4.2), the imperial family and ruling senators are closely identified with public religious ritual.

With the temple commanding the forum, the agora was moved out, gaining a separate identity as a market. Trajan's forum, with its adjacent markets, is the largest of all the Imperial Forums (fig. 4.21) laid out between about 46 BCE and CE 117. Like those of Julius Caesar and Augustus, it was a ceremonial space signaling political power. In Trajan's forum, power was figured in a gilt-bronze equestrian statue of the emperor, comparable in form to the statue of *Marcus Aurelius* (see fig. 4.14). At

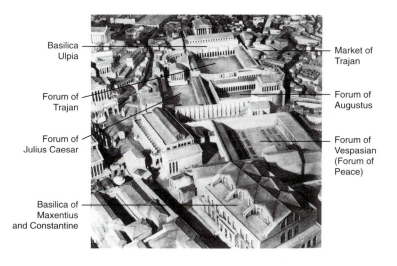

Basilica
Ulpia

Forum of
Trajan

Forum of
Julius Caesar

Basilica of
Maxentius
and Constantine

Market of
Trajan

Forum of
Augustus

Forum of
Vespasian
(Forum of
Peace)

4.21 Model of the Imperial Forums, Rome. c. 46 BCE–CE 117, with the early 4th-century CE Basilica of Maxentius and Constantine in the foreground

one end of the forum stood a huge basilica (the Basilica Ulpia), beyond which were two libraries, one each for Greek and Latin works, separated by Trajan's column. Its spiraling relief sculpture vividly portrays the emperor's military successes (see fig. 4.23). Beyond this the Temple of Trajan, high on a podium, stood at the end of the impressive sequence of spaces and structures.

In the foreground of a model of the Imperial Forums (see fig. 4.21), we see the larger Basilica of Maxentius and Constantine, completed in CE 313. Here, vast concrete vaulting enlarged and transformed the older basilican form. When Rome embraced Christianity it was the basilica, not the temple, that provided the model for Christian churches. This would prove to be one of Rome's greatest architectural legacies, one that endured long after their spectacular

bath-houses were no longer used. But for the Romans, the forum, with its temple and basilica, symbolized their Stoic patriotism, sense of public duty, and administrative efficiency.

Public Monuments as Propaganda

Architecture created the stage for Roman political propaganda, but specific agendas were made even more explicit through sculpture. Equestrian, full-length, and bust-sized statues of the emperors were placed in forums, temples, basilicas, and bath-houses. Other public monuments, such as sacrificial altars, memorial columns, and triumphal arches, were typically carved with narrative relief sculpture, commemorating military victories and celebrating the emperor's public piety. Such propaganda was heavily concentrated on triumphal arches, through which returning generals and their armies would pass. This example of sculpture from the Arch of Titus (CE 81), *Spoils from the Temple in Jerusalem* (fig. 4.22), celebrates the Palestinian campaign of Titus. The sculptural relief shows the seven-branched candlestick, or menorah, from the Jewish Temple being carried by a group of victorious Roman soldiers marching before a triumphal arch, seen in the right background.

4.22 *Spoils from the Temple of Jerusalem*, relief in passageway, Arch of Titus, Rome. CE 81. Marble, height 7'10"

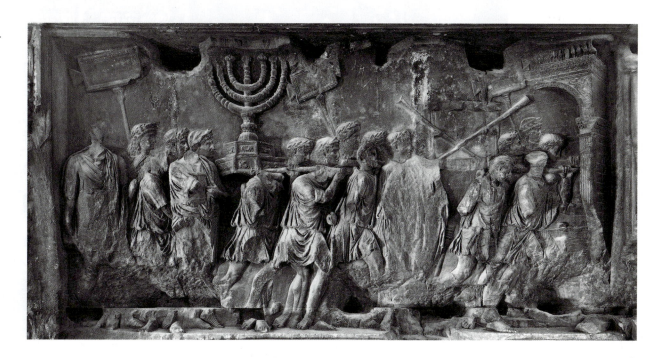

4.20 (left) The Forum, Rome

Arches and Vaults

The arch is one of the most fundamental architectural elements and is the basis for both vaults and domes. Unlike post-and-lintel construction, in which a horizontal crosspiece spans an opening (see "Materials and Techniques: Post-and-Lintel Construction," page 34), an arch is usually a semicircular structure, constructed of wedge-shaped elements, called **voussoirs**, often held together by mortar and capped by a **keystone**. Once installed, the keystone exerts a pressure that holds the voussoirs in place. The Canopus, at Hadrian's Villa in Tivoli, from about CE 135 (see fig. 4.18), provides a simple example. The point at which the arch begins to curve is called the springing. Because of the outward thrust or pressure created by the curved opening, the arch needs to be supported, or buttressed, by masonry. While it is being built, a wooden framework called centering supports the arch and is removed once the keystone is in place.

A **vault** is an extended arch that creates a passageway, for example in the Arch of Constantine, built CE 312–15 (see fig. 4.30). **Tunnel** or **barrel vaults**, used in constructing the Colosseum, are formed from multiple round arches. These vaults require continuous buttressing, making openings for windows in the vaults themselves structurally impossible, and limited even in the supporting walls below. This makes the spaces they cover fairly dark, since light can only enter from the ends and from small windows in the walls below them.

Another form of vault is the **groin** or **cross vault**, which is formed by two tunnel or barrel vaults intersecting at right angles. See, for example, the reconstruction drawing of the central hall at the Baths of Caracalla, CE 211–17 (see fig. 4.29). All of the outward thrust is concentrated on the corner piers, which are the only places buttressing is needed. The square space between these piers is called a **bay**.

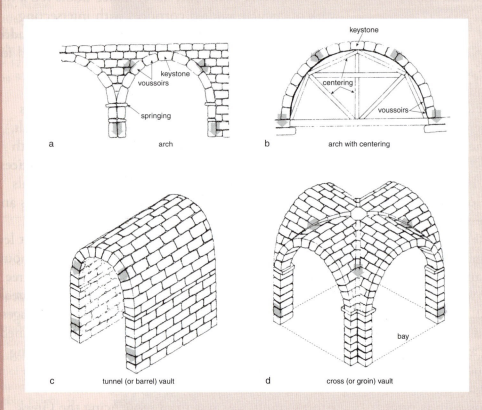

4.26 Diagrams of an arch
a. an arch with centering
b. a tunnel (or barrel) vault
c. and a cross (or groin) vault
d. The arrows indicate the outward thrust generated for these structures, which must be countered with masonry buttressing, as shown in diagram (a). See also figures 4.18 (arch with masonry buttressing), 4.30 (tunnel vault), and 4.29 (cross vault)

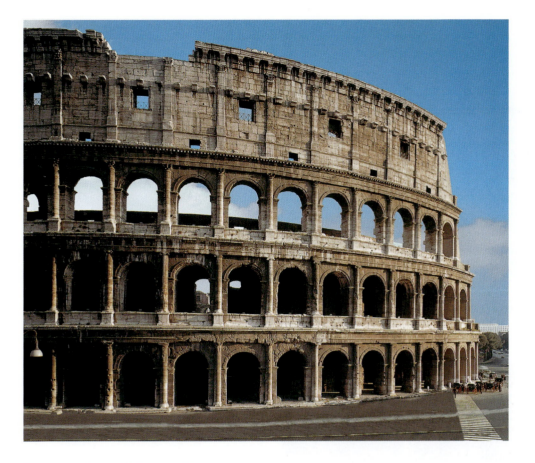

The Baths of Caracalla

The ready supply of water brought in on aqueducts made it possible for Rome to build vast and luxurious public bathing facilities (figs. 4.28, 4.29). Far more than a place to get clean, the baths served as community sports and recreational centers, complete with exercise rooms and library.

The same technology used to build the Colosseum was augmented by lavish interior finishing in the various public baths of Rome, such as the Baths of Caracalla. They were built by the Emperor Caracalla about CE 211–17, and ensured that, for all his brutality, he became a popular ruler, providing Rome's citizens with an ideal location in which

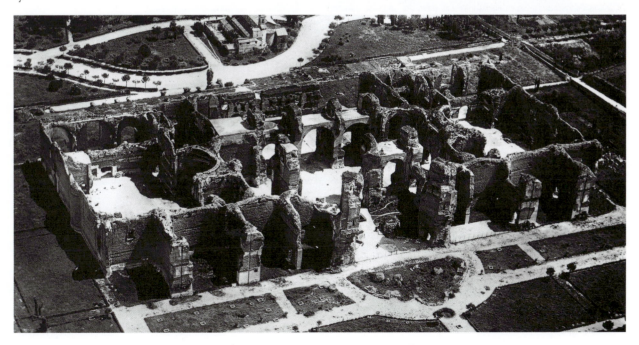

4.28 Aerial view of the Baths of Caracalla, Rome. c. CE 211–17

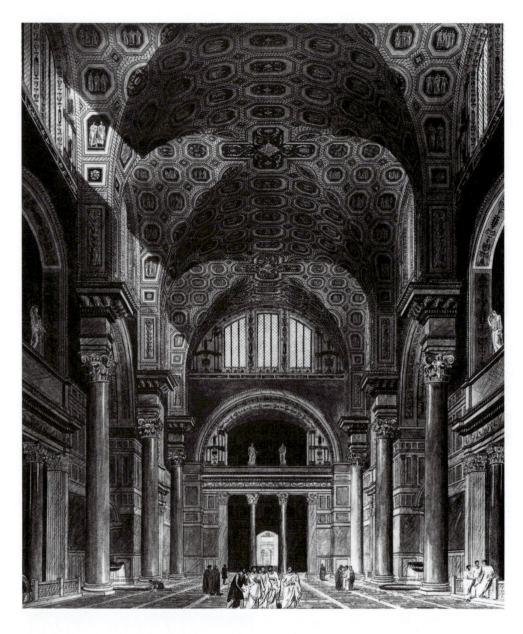

to idle away a day comfortably in the company of friends.

The interior of the surviving Pantheon (see fig. 4.4) gives us an idea of the richly faced marbles and multi-colored columns that once adorned the interior of these baths. Beyond this one has to imagine the profusion of Roman copies of Greek statues (many of the best of which were found here), the marble-lined pools, the circular hot tub in its domed rotunda, the mirrors, marbles, and mosaics, and the rich decorative finish of the vaults. Besides the lavish setting, one must then imagine the human spectacle—the young and old, male and female, enjoying themselves in various levels of dress and undress. Needless to say, the place held great potential for social encounters and romantic adventures. It is not hard to grasp that Roman emperors knew how to main-

tain good will, however much corruption went on backstage. For the history of Western architecture, however, it is the construction and finish of the central vaulted hall (see fig. 4.29), also emulated in the early fourth-century Basilica of Maxentius and Constantine, that caught the imagination of later generations and inspired Roman Renaissance and Baroque architecture.

Public Ceremony: The Triumphal Arch

Monumental entrances to cities, temple precincts, and palaces were common in the ancient world (see, for example, Mycenae, fig. 2.33; the temple complex at Luxor, fig. 2.20; and the Propylaia of the Acropolis,

Athens, fig. 3.3). But Roman triumphal arches were different. Free-standing monuments, they typically spanned a major thoroughfare, through which victory parades and other ceremonial processions would pass.

In CE 312–15, after Constantine defeated his chief rival Maxentius to become sole ruler of the Roman Empire, the Arch of Constantine (fig. 4.30) was built at one end of the Roman Forum, in his honor. Its triple-arched design imitated the triumphal arch of Septimius Severus, which stood at the other end. But on Constantine's arch the columns dividing its main mass also divide the attic, or top, storey. There statues of four captive barbarians (taken from a Trajanic monument) top the Corinthian columns. Because the Arch of Constantine was speedily built, its relief sculptures were mostly plundered from earlier monuments. Those made especially for it are of inferior quality.

The triumphal arch was another feature of Roman architecture to capture the imagination of later generations, and today is associated as much with Napoleonic Paris as with Rome. The Arch of Constantine unintentionally marks a quite different "triumph" in Roman history, since Constantine claimed that the victory he had won had been achieved in the name of Jesus Christ. Until this declaration, this name had been heard mostly on the lips of Christian martyrs exposed to wild beasts in the Colosseum; Constantine now placed it on the shields of his army, and used Christianity as a means to unify the Empire. Christianity won the support of the imperial household, and it was only two generations before Emperor Theodosius I in CE 395 forbade the worship of the ancient Roman gods, tore down their statues, and looted their temples for building materials for Christian churches. Rome's prosperity rapidly declined, and its monuments to Stoic efficiency and Epicurean luxury were no longer valued in a new ideological context. In the process, ancient Rome passed into history. Its glory turned to rubble, and something new arose in its place.

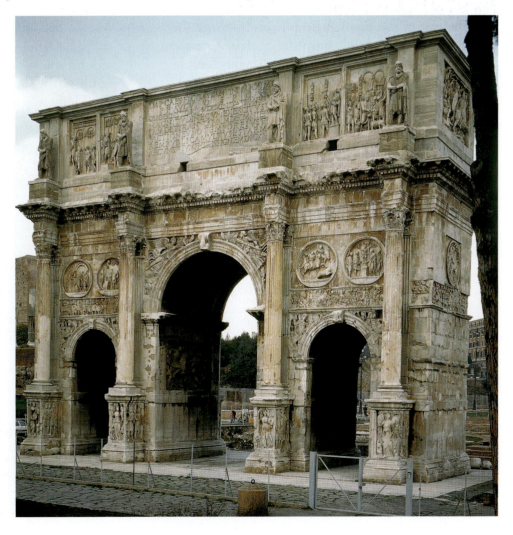

4.30 Arch of Constantine, Rome. CE 312–15

PARALLEL CULTURES

The Jews of Dura-Europos, Syria

The sheer expanse of the Roman Empire, extending, as we noted, from northern England to North Africa, and from Spain to Syria, encircling the entire Mediterranean world, meant that Rome was constantly in touch with many different peoples, each with their own customs, language, and religious practices. As we saw in Chapter 2, the Jews of the Near East were distinct from their neighbors in worshiping a single God as creator of the universe. The unrest this provoked in Rome's Palestinian province, though seemingly minor at the time, had consequences that permanently altered the course of Western civilization.

Since the time of Alexander the Great, the Jews of Palestine had been subject to first Greek and then Roman rule. In crushing the Jewish Revolt of CE 66–70, the Roman Emperor Titus destroyed the Jewish Temple in Jerusalem, ended Jewish statehood, and began the Jewish Diaspora, the movement of Jews into the rest of the Roman Empire and beyond. In figure 4.22, we saw spoils from the Sack of Jerusalem carried triumphantly into Rome. With the Temple destroyed, and the Jews dispersed, what became of Jewish artistic expression? Excavations in 1932 of

Dura-Europos, a Roman frontier post on the Upper Euphrates in Syria, uncovered the remnants of a Jewish synagogue built around CE 250. To the surprise of many, its walls were covered with Old Testament scenes.

The surprise was because the Jews are specifically forbidden by the second of their Ten Commandments to make and worship images, and their prophets repeatedly warned them not to imitate the idol-worship of their neighbors. Yet the Old Testament descriptions of Solomon's Temple indicate that, although the Jews were prohibited from worshiping carved idols, they were free to represent guardian angels, animals, and plants in both two and three-dimensional form as symbolic adornment for the Temple (see fig. 2.36).

The evidence of the Dura-Europos synagogue shows that by CE 250, if not earlier, Jews, while avoiding cult images, had incorporated visual imagery in their new places of worship. The walls of the synagogue were entirely covered with bands of symbolic narrative paintings representing the *Deliverance of the Israelites from Egypt*, the *Giving of the Law to Moses*, the *Consecration of the Tabernacle*, and other subjects (fig. 4.31). These wall paintings are centered around the niche in the west wall, where the sacred scroll of the Torah, containing the first five books of the Hebrew scriptures, was housed. Stylistically, these

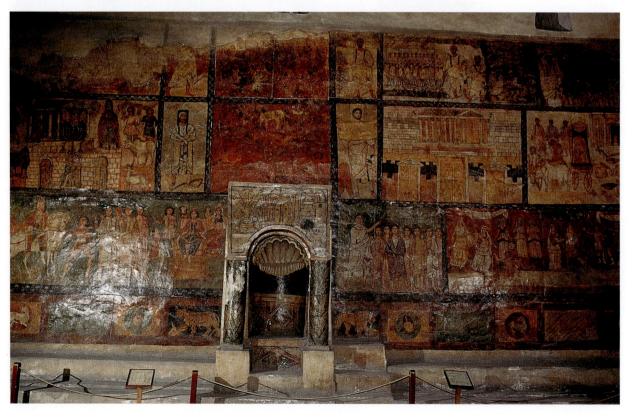

4.31 Wall paintings from the synagogue at Dura-Europos, Syria. c. CE 250. Tempera on plaster. National Museum, Damascus

paintings are simplified versions of both Greco-Roman and Near Eastern art, probably done by provincial craftsmen. By the standards of Greco-Roman art there is no depth, and no illusion of light or space. The figures, in flat relief, all face outward, reminding the worshiper of significant historical realities and religious beliefs.

In these Jewish wall paintings, both style and content reflect a mixture of sources. In the scene of the *Consecration of the Tabernacle*, above and to the left of the Torah niche, the sons of Aaron—identified by a Greek inscription—are dressed in Persian attire. The building beside them must signify the Tabernacle, which was a tent-like structure with poles and curtains. Yet it is depicted like a Classical temple, rendered with one side and one end both seen frontally, according to late Roman convention. The building below suggests the forecourt of the Temple in Jerusalem, built cen-

turies later than the Tabernacle. Intriguing for their hybrid imagery, these synagogue paintings are a rare survival. While some Hebrew manuscripts also contain illustrations, Judaism has remained an essentially **aniconic** religion, mostly rejecting figurative imagery in the context of worship. Thus Jewish artistic expression in the religious sphere has been chiefly limited to calligraphy and ornamentation of the Torah.

Judaism endures as a religion sustained primarily by the written, spoken, and sung word, comprising some of the most beautiful and inspiring literature ever composed. As a consequence of the Jewish Diaspora, Jews carried their faith and culture to the furthest reaches of the Roman Empire, and in time far beyond that. Meanwhile, from among the Jews of Palestine, a force had emerged that eventually transformed Rome itself. That force was Christianity; its influence on the art of the West is the subject of the next chapter.

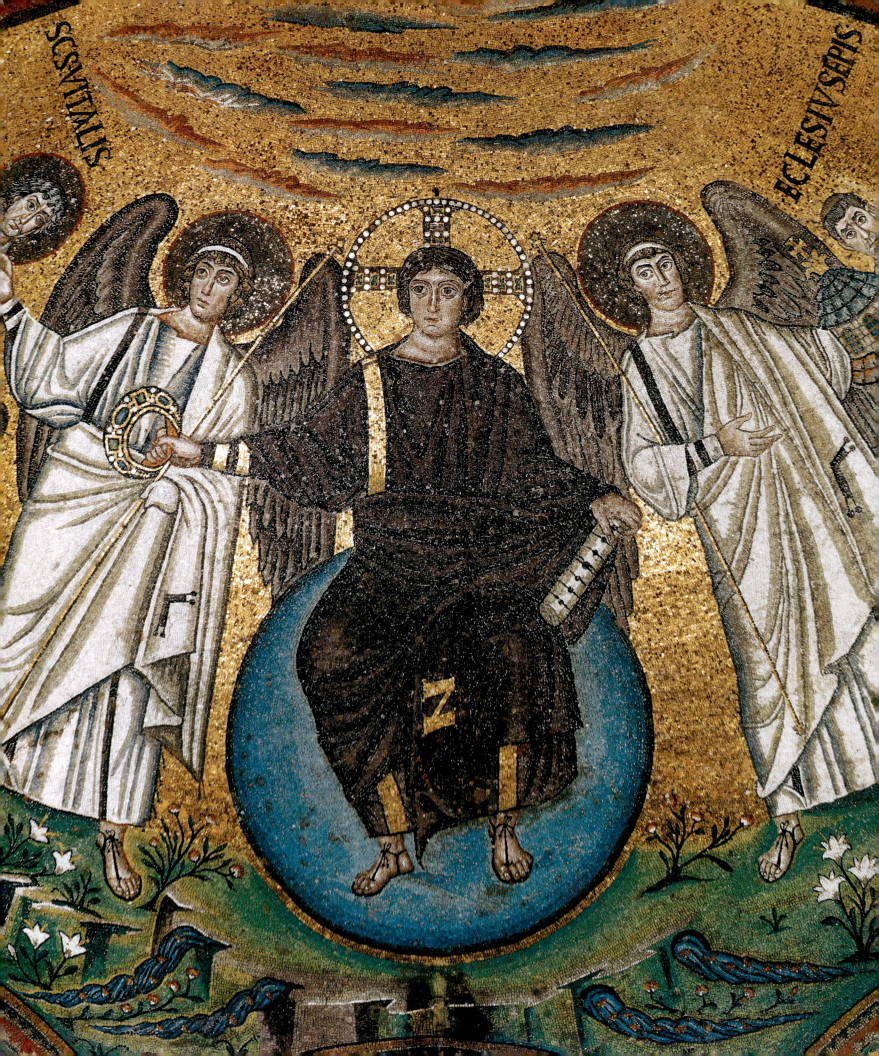

5 The Rise of Christianity

In 313 CE the Emperor Constantine formally recognized the Christian religion. Christianity's subsequent spread throughout the Roman Empire profoundly affected the way people thought about life and the way rulers viewed their power. In turn, these shifts influenced Christian art. Late in the fourth century, Emperor Theodosius I outlawed paganism and closed the Roman temples, often tearing them down to supply building materials for Christian basilicas. As this imperial support flowed into Christian churches, their interiors were adorned with glittering mosaics such as those at Ravenna (see figs. 5.1, 5.11, 5.26, 5.27). Many Roman aristocrats still clung to their ancient traditions, but as Roman military power weakened, the influx of northern European migratory tribes and their conversion to Christianity completed the shift away from ancient values.

The Greeks had emphasized mastery of the body and the mind. Classical Greek artists had accentuated the grace and beauty of women and the sensuality of the human body, both female and male. The Romans celebrated military might, physical comfort, and public entertainment. Now, Christianity emphasized the spiritual over the material, and with its spread over the next 1500 years, Western art turned to the life of the soul and the quest for immortality. Images of women would extol faith, devotion, virginity, and martyrdom. Male figures continue to show military might, but, more often, earthly power appears in a setting of divine authority. As a result, Christian artists renounced the vital naturalism of Greek and Roman art for more static, symbolic forms that concealed and denied the sensual appeal of the body.

How artists adapted the Greco-Roman heritage in art and architecture to serve Christian ends is the focus of this chapter. In it we will explore the great themes of art that developed in the Early Christian, Byzantine, and Early Medieval periods. The Roman Empire was divided into the Western Roman and Eastern Byzantine Empires. Early Christian denotes the art of the third to the sixth centuries in both areas; Byzantine art continued this tradition under the Greek Orthodox Church of the Eastern, Byzantine Empire. Early Medieval art was the art in the West up to the end of the tenth century that grew out of Early Christian art.

Church and State

Jesus Christ was born in Judea, an eastern province of the Roman Empire, during the reign of Emperor Augustus. Jesus's followers became known as Christians, because they considered him to be the Christ, literally the "Lord's anointed one" or Messiah (see "Christian Beliefs and Rituals," page 123). Since Christians acknowledged only one God, they refused to honor the divinity of the emperor, or reverence his image with incense and wine. As a result, the Roman state intermittently persecuted Christians, and put many of them to death. But in 313, by the Edict of Milan, as noted, the Emperor Constantine recognized Christianity as a legal religion. Thereafter, with the support of the Roman emperors, the Christian Church grew in the fourth and fifth centuries, spreading throughout the Greco-Roman world. In 395 Christianity was declared the official religion of the Roman state. Church and state were one. The Church adopted the state's model of centralized power. The emperors built sumptuous churches, especially in Rome, the Holy Land, and Constantinople.

Meanwhile the Roman Empire was collapsing in the west. In 330 Constantine founded a new imperial capital at ancient Byzantium, which he renamed Constantinople (today Istanbul) (see Map 5.1). In 476

Map 5.1 Europe in the Middle Ages

Christian Beliefs and Rituals

Sharing a belief in the sacred scriptures of the "Old Testament" with Judaism, Christians worship the same God, the creator and sustainer of the universe. But their belief that Jesus, born to Mary, a young Jewish woman whom they believe to have been a virgin, is the Son of God separates them from Judaism. For Christians, Jesus is the Messiah the Old Testament prophets had foretold. Christians believe that Christ rose from the dead, ascended into heaven, and will return to judge all people. During the first and second centuries, Christians worshiped in private houses. Their basic ceremony was a communal meal, the Eucharist, that involved breaking bread and drinking wine, to signify Christ's body and blood, sacrificed through his death by crucifixion (a standard Roman method of execution). Readings from the New Testament, prayers, and hymns accompanied the Eucharist.

the Roman Empire in the west came to an end, but the eastern Byzantine Empire, ruled from Constantinople, survived until 1453, when it fell to Islamic Ottoman Turks.

In the west, as their military might waned, the Romans could no longer withstand the "barbarian" tribes—Goths, Vandals, Saxons, Slavs, Lombards, and Franks—who migrated from their northern and central European homelands in waves from the late fourth to the seventh centuries. As they were converted to Christianity, their cultural and artistic traditions gradually fused with those of the Greco-Roman world and gave birth to the richness of medieval art.

Christianity and Art: West and East

The early church recognized art's power to inspire and teach. In the sixth century Pope Gregory the Great called images the "Bible of the illiterate." All Christians used art for religious purposes until the sixteenth-century Protestant Reformation, and outside some forms of Protestantism, most still do (see "Symbols and Subjects in Christian Art," page 128).

By the ninth century, the Western, Latin or Catholic Church, centered on Rome, and the Eastern, Greek or Orthodox Church, centered on Constantinople, had different views of ecclesiastical art. The Greek Orthodox church treats icons—that is portrait-like images of Christ, the Virgin Mary, and the saints—as

holy products of divine inspiration that serve a mystical function, to be venerated as objects of devotion. By contrast, the Roman Catholic Church considers religious images as products whose function is to instruct the faithful and honor God through their beauty and craftsmanship.

SPIRITUALITY

Christian artists rejected the classical regard for the ideal human body because they believed that flesh was impure, corrupting to the spirit. Instead of physical prowess, they accentuated spiritual aspirations, producing art that was rich in symbols and allegory. Christian faith, as we shall see, inspired a wealth of funerary art, a range of new building types, and paintings, mosaics, and sculptures. These gave visual form to biblical narratives and symbolic form to Christian beliefs.

Funerary Art: Catacomb Paintings

Many Christian sanctuaries were destroyed in the Roman persecutions, but early funerary art survived in the catacombs of Rome, the underground galleries and chambers that Christians used as cemeteries. They decorated many small chambers used as mortuary chapels with scenes and symbols from the Bible. These

5.2 *Good Shepherd, Jonah,* and *Orant Figures,* painted ceiling of the mortuary chamber in the Catacomb of Saints Pietro and Marcellino, Rome. Late 3rd century or early 4th

decorations express the faith of a persecuted Church and its hope for deliverance into eternal life.

The painted ceiling of the catacomb of Saints Pietro and Marcellino, Rome, from the late third or early fourth century (fig. 5.2) shows this theme allegorically. Decorative geometric patterns on a white ground frame images of intercession and deliverance. Christians adapted this decorative scheme, the sketchy, impressionistic style, and the pose and modeling of figures from contemporary Roman wall paintings. In their simple, economic execution, these figures are more like symbols than descriptive representations. The geometric framework is a cross form, contained within a dome, signifying the Dome of Heaven. In the central roundel, at the intersection of the cross pattern, a shepherd carries a lamb on his shoulders, an ancient image of protective guardianship that here alludes to Christ, the biblical Good Shepherd. Scenes from the Old Testament story of Jonah surround the Good

Shepherd. They show a ship with Jonah being cast overboard, swallowed by a whale, and then, after three days in the whale's belly, safely delivered onto dry land, where he rests under a gourd. Christians interpreted this imagery as foretelling Christ's death and resurrection after three days. It expresses the hope that Christ, the Good Shepherd, will safely deliver the souls of his flock from death, bringing them to rest in paradise. Between the scenes of Jonah, the artist shows orant, or praying, figures interceding for this deliverance.

Funerary Art: Sarcophagi

Telling stories through relief carving was an invaluable artistic legacy of classical antiquity to the Church. As Christians prospered, they applied this Greco-Roman technique to relief carvings on limestone coffins, called sarcophagi, and to small ivory plaques.

The *Sarcophagus of Junius Bassus*

Junius Bassus was a leading Roman official who was baptized a Christian on his deathbed in 359. His sarcophagus (fig. 5.3) is covered with carvings of the highest quality, befitting his rank. They express—in terms familiar from Early Christian funerary art—the belief that Christ delivers the believer from sin, suffering, and death itself. The artists conveyed this theme through ten scenes separated by Corinthian columns and spread over two registers. Grapevines that allude to the wine of the Eucharist encrust the central columns.

Other compartments of the sarcophagus depict deliverance from various trials, such as that of the prophet Daniel from the lion's den (second from the right in the lower register), suggesting that the believer would also be delivered from death. Also included are the arrests of the apostles Peter and Paul and Christ's interrogation by Pilate—figures brought before Roman courts. In the lower center section, Christ enters Jerusalem to face trial and death; in the scene above it, the resurrected Christ rules in majesty. His throne rests on a canopy supported by a Roman sky god, to personify Christ's heavenly dominion, the New Jerusalem. Beside him, Saints Peter and Paul each receive a scroll as a mark of their authority. The emphasis on Roman law and ecclesiastical authority may reflect the deceased's prominence as a Roman official. So, these carvings commemorate both his public role and his hope for eternal life. The little figures that narrate these themes are so deeply carved they seem almost free-standing. Despite their enlarged heads that allow us to read their expressions, their

5.3 Sarcophagus of Junius Bassus, Rome. c. CE 359. Marble, 4' x 8'. Grottoes of St Peter, Vatican, Rome

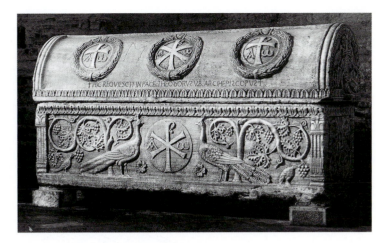

5.4 Sarcophagus of Archbishop Theodore, Sant' Apollinare in Classe, Ravenna, Italy. 7th century. Marble

poses and gestures recall their classical origin, as do the naked figures of Adam and Eve (second from the left in the lower register), here signifying Original Sin (that is, the Christian belief that human depravity originated in Adam and Eve's rebellion against God).

The increasing tendency for Christian art to emphasize the spiritual over the material, symbol over substance, can be seen when we compare this early sarcophagus of a Roman convert to that of a Christian bishop who died three centuries later. In marked contrast to earlier sarcophagi, the seventh-century *Sarcophagus of Archbishop Theodore* (fig. 5.4) has no figural representation. Instead, multiple symbols of salvation and immortality are carved in low relief, in static symmetry. This manifests a complete denial of classical naturalism, in favor of Christian symbols.

Places of Worship

The Emperor Constantine gave the Church massive financial support, with which it adapted various Roman building types for Christian use. Specific rituals—including public worship, private baptism, and the commemoration of martyrs—required new types of buildings, the predominant type being the basilican church.

Basilicas

Christians built large basilicas for public worship. The largest was Old St. Peter's, begun about 320 on a site in Rome on the Vatican Hill where tradition said that Peter, the first apostle, had been buried. The original T-shaped basilican church (fig. 5.5) was demolished in the Renaissance to make way for the present, much

grander structure. But even the original church was imposing, its interior enriched with marble pavement, columns, and mosaic wall decorations (fig. 5.6).

Old Saint Peter's Roman roots were everywhere, beginning with a ceremonial gateway, which led into an open, colonnaded, peristyle courtyard (see "Early Christian Architecture: Basilica-plan and Central-plan Churches," page 127). Though it was similar to the

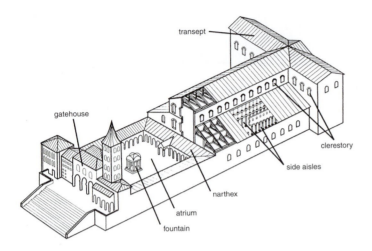

5.5 Reconstruction drawing of the exterior of Old Saint Peter's basilica, Rome. c. 320–27; atrium added in later 4th century

Basilica Ulpia in Trajan's forum, Christians modified the Roman design by placing the entrance on the short, rather than the long side. This created a long, open vista from the entrance down the central **nave**, ending in the semicircular apse (see fig. 5.6). A triumphal arch separated the nave from the apse. Such a design could provide a setting for spectacular processions. To accommodate the crowds of pilgrims visiting St. Peter's tomb, a transverse aisle, called a **transept**, set at right angles to the nave, separated the apse and nave. The transept extended beyond the side aisles, giving the building its characteristic T-shape. This design combined two major functions—a **martyrium**, commemorating the martyred saint, and a vast basilican hall to accommodate worshipers.

At St. Peter's, as in other basilicas, the worshiper looked toward the apse, where glowing mosaics or wall paintings created a focus for worship. In Roman basilicas, a statue of the emperor typically stood in the apse. Now, the emperor's free-standing statue was replaced by a wall painting or apse mosaic of Christ, the divine King of Kings (its two-dimensionality chosen to avoid

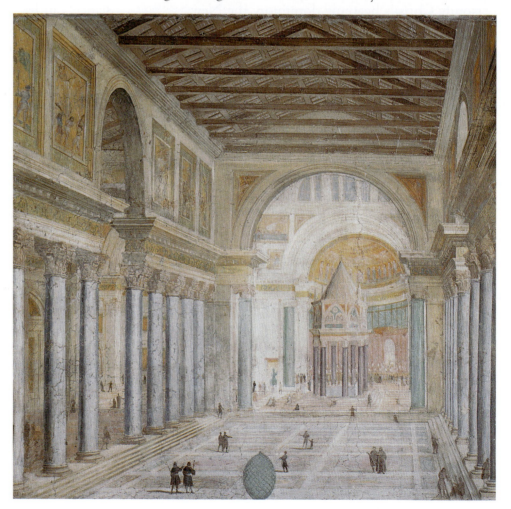

5.6 Interior of Old St Peter's in the 16th century. San Martino ai Monti, Rome. Fresco

Early Christian Architecture: Basilica-plan and Central-plan Churches

Early Christian churches were modeled on two classical types (fig. 5.7): rectangular, Roman basilicas, and circular, domed buildings, such as Greco-Roman tombs and public bathing-rooms.

Most Early Christian churches were built on a rectangular, basilican plan. One enters a forecourt, the atrium, which leads to a porch, the **narthex**, which runs along the building's short end. The visitor then enters the church interior through a doorway, sometimes triple doorways, known as portals. These open onto a long, central area, the nave. On each side of the nave, separated by a row of columns and lower in height, are one or two side aisles. The row of separating columns is called a **colonnade**, or, if supporting arches, an **arcade**. Light enters the nave through rows of windows along its upper story, the **clerestory**. Wooden-beamed roofs cover the nave and aisles. At the far end of the nave is a semicircular niche, the apse, the focus for worship and the site of the altar. As at Old St. Peter's, Rome, a cross-wing, called a transept, between the nave and the apse provided additional space. A **chancel** between the transept and the apse added space before the altar and accommodated the choir. By extending the line of the nave beyond the transept, the chancel and choir also completed the church's symbolic, cruciform shape. Christians also built central-plan structures, for use as tombs for martyrs, as places for baptism (called baptistries), and as churches. With a circular or polygonal central-plan design, worshipers could gather around a centrally located tomb or baptismal font, a basin. Often, in central-plan churches, two arms of equal length intersected at the center of the circular core (see fig. 5.19). This is called a Greek-cross plan, as the central plan design was used most often in Eastern Orthodox churches. A raised dome, symbolizing the "vault of heaven," crowned the central core and created a dual emphasis, the altar and the dome.

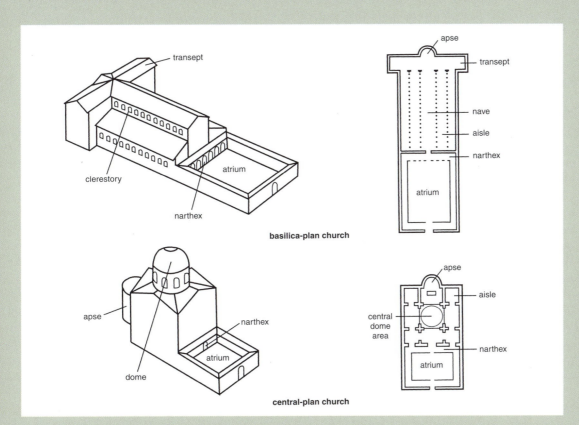

5.7 Two types of church plan: basilica plan and central plan

basilica-plan church

central-plan church

association with pagan idols). Below the image of Christ, in the apse, stood the throne, or cathedra, of the presiding bishop, from which the word cathedral is derived. The bishop's throne was the symbol of his authority to speak in the name of Christ, whose divine authority, in turn, the apse mosaic signified.

We can see the rich visual effect of such apse mosaics, as the climactic point of Early Christian basilican interiors, at Sant' Apollinare in Classe, near Ravenna, an important city in the Western Roman Empire, on the east coast of Italy (fig. 5.8). Built in 549, it originally contained the relics of St. Apollinaris, the martyred first bishop of Ravenna. The mosaics above the altar in the apse and on the surrounding triumphal arch are powerful examples of the Early Christian use of symbol and allegory. They offer worshipers an inspiring vision of Christ's divinity and, through the figure of the martyred St. Apollinaris, an image of triumph over death.

In this apse mosaic we can see many Christian symbols (see "Symbols and Subjects in Christian Art," below). St. Apollinaris appears in a paradisiacal garden as an orant, dressed as a bishop, interceding for his flock,

symbolized by the lower row of twelve sheep. Above him, in a star-studded blue aureole, or circle, a jeweled cross with a minute bust of Christ at its center signifies Christ's Transfiguration when, Christians believe, brilliant light transformed his appearance. The event was witnessed by three of his disciples, symbolized by the three sheep to the left and right of Christ's figure. Above them, emerging from the clouds, are the Old Testament figures of Moses and Elijah, who also miraculously appeared during the Transfiguration. At the crown of the semi-dome, the symbolic Hand of God extends through the clouds, alluding to the moment at the Transfiguration when, according to St. Matthew's Gospel, a voice out of the bright cloud proclaimed: "This is my beloved Son, in whom I am well pleased: hear ye him." Above, on the triumphal arch, a medallion image of Christ is centered between the symbols of the four evangelists (Matthew, Mark, Luke, and John).

The mosaicists of this Transfiguration used flat, symbolic forms and static symmetry to create an art form

5.8 Interior view toward the apse, Sant' Apollinare in Classe, near Ravenna. 549

Symbols and Subjects in Christian Art

Christian subject matter dominated Western art from the third to the seventeenth centuries. To instruct the faithful, the Christian Church developed visual ways of representing its faith. Artists have depicted the Christian belief in a God the Father, Christ his Incarnate Son, and the Holy Spirit in many ways. The table below identifies prominent Christian symbols that you will encounter in this chapter.

God the Father	A hand or light beam extending from a cloud: figs. 5.9, 5.32
Christ the Son	The initials XP, known as the CHI-RHO, the first two letters of the Greek word *Christos*: figs. 5.4, 5.26 Good Shepherd: fig. 5.2 Human and divine: figs. 5.8, 5.16 King of Kings: figs. 5.3, 5.11, 5.19, 5.25
The Holy Spirit	A dove: fig. 5.29
The Four Evangelists, authors of the four New Testament Gospels: Matthew, Mark, Luke, and John	As a winged man, a winged lion, a winged ox, and an eagle: figs. 5.8, 5.20, 5.21

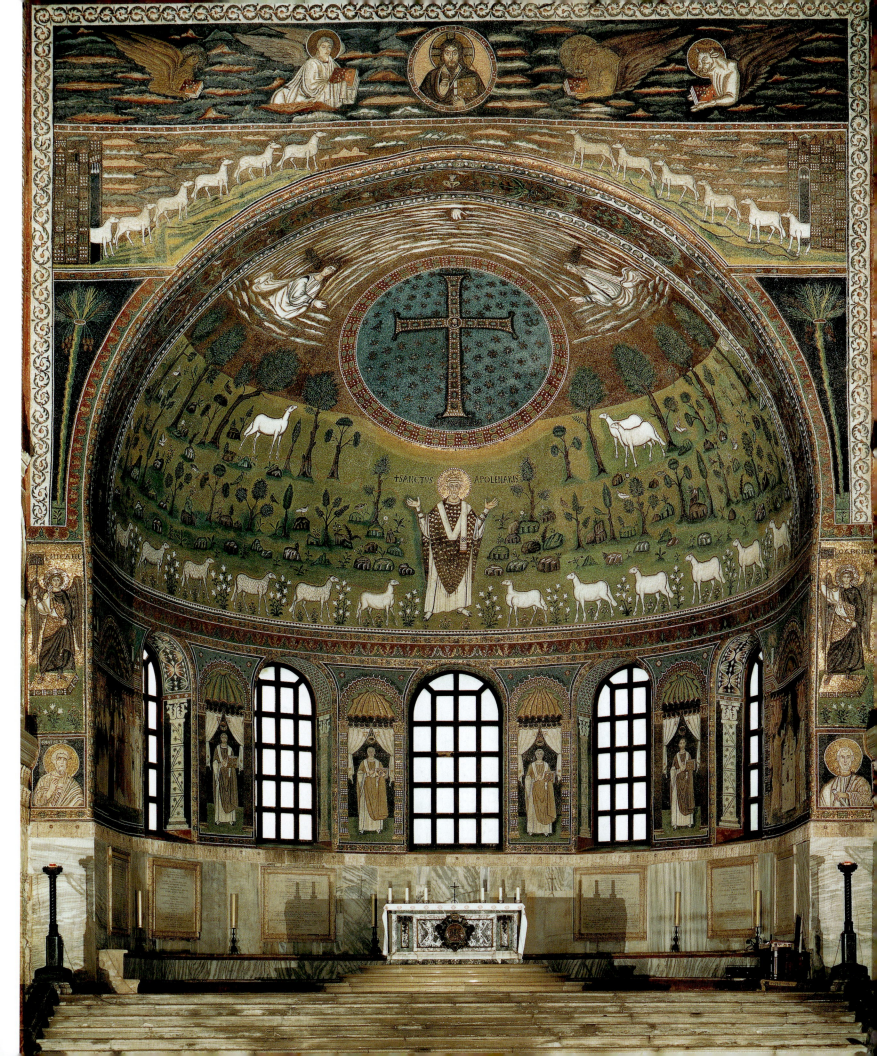

adapted to the symbolic expression of complex theological ideas. Myriad **tesserae** (small pieces of colored stone and glass, some backed by gold leaf) that catch the light at multiple angles comprise such mosaics (see "Materials and Techniques: Mosaics," page 78). Their lush, decorative beauty provides a climax to the worshiper's field of vision, and clarifies the meaning of the Eucharist celebrated below.

Central-plan Churches

While the basilica-plan church was favored by Western, Latin churches, Byzantine, Eastern Orthodox churches used another design, known as the central plan. A fine example is the church of San Vitale, also in Ravenna, which had become an important Byzantine outpost in Italy (see "Early Christian Architecture: Basilica-plan and Central-plan Churches," page 127).

San Vitale was completed under the Byzantine Emperor Justinian in 547. Reflecting its Byzantine inspiration, San Vitale's complex, octagonal design, with a domed central core, is unusual for a church in the Western Empire (figs. 5.9, 5.10). Its plain brick exterior offers no hint of the splendor within. The sumptuous interior underscores Ravenna's importance as a Byzantine outpost.

The domed octagonal core of San Vitale is surrounded by an octagonal, vaulted ambulatory, or passageway, with a gallery above reserved for women, following

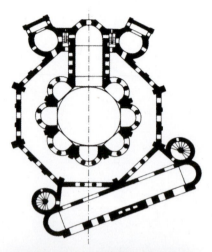

5.10 Plan of San Vitale, Ravenna

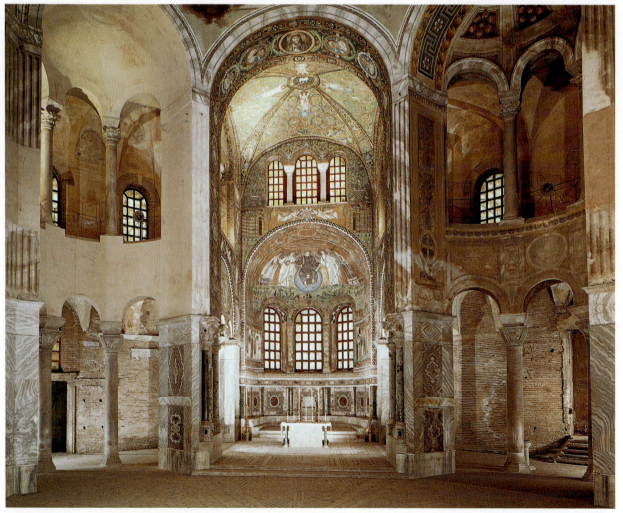

5.9 Interior view toward the apse, San Vitale, Ravenna. 525–47

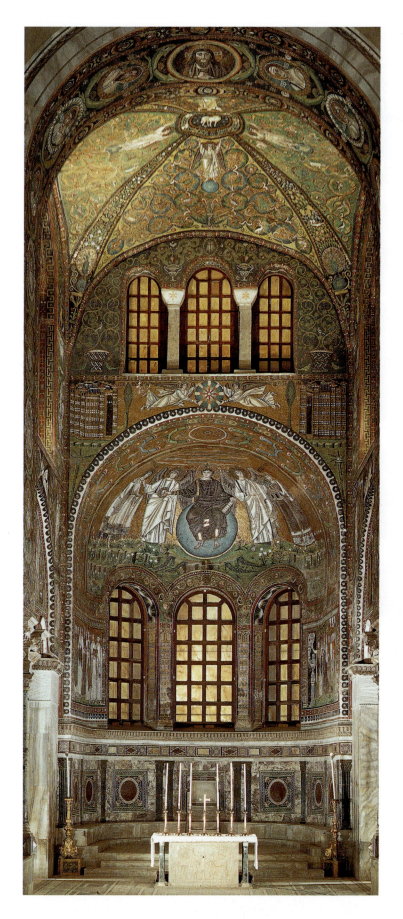

5.11 *View of apse mosaics, San Vitale, Ravenna. 525–47*

Byzantine practice. Semicircular columned niches, two stories high, each crowned by a semi-dome, link eight piers that support the dome. The interplay of curved, arching forms, the strong shadows, and filtered light passing through large alabaster window panes create a sense of lightness and mystery, enriched by the multicolored marble and mosaic surfaces, alabaster columns, and deeply drilled basket capitals (see fig. 5.9). Glowing mosaics cover the walls and vaults. Christ is given the youthful look of the Greek god Apollo, whose identity he thus takes on (fig. 5.11 and see 5.1).

The San Vitale mosaics express Christian allegory and symbol. The static, symmetrical, and conventionalized images of Christ and his retinue, set against the symbolic gold ground of eternity, evoke an unchanging, eternal reality. Below, on either side of the altar, are images of Justinian and his empress in the role of Christ's earthly vice-regents (see figs. 5.26, 5.27).

The glowing light in San Vitale and its design create a luminous, weightless effect. These innovations reflect the development of a Christian aesthetic theory, derived from the Greek philosopher Plato. In this theory, light, as transmitted through color, was deemed the most spiritual of all natural phenomena. At San Vitale, seemingly weightless architectural forms, translucent alabaster windows, and glittering mosaic surfaces transform interior space into something transcendent.

Hagia Sophia

In Constantinople itself, Justinian sought to outdo the fabled splendor of Solomon's Temple in Jerusalem, with the huge church of Hagia Sophia ("Holy Wisdom"), built between 532 and 537. Justinian commissioned it as a palace chapel, to symbolize the fused power of Church and state. Isidorus of Miletus, a professor of physics, and Anthemius of Tralles, a mathematician specializing in geometry and optics, designed it.

After the Turkish conquest in 1453, Hagia Sophia became a mosque, and four minarets were added (see fig. 5.35). It is now a museum. As at San Vitale, shimmering mosaics combined with architectural design evoke the mystery of Christian liturgy. The space itself, its grand scale and lighting, create a sense of majesty. A central dome appears to hover over the vast interior, floating on a rim of light-beams that pierce its base (fig. 5.12).

Hagia Sophia is a unique combination of the basilican and domed central plan. The longitudinal emphasis of the basilican plan here has a vertical accent (figs. 5.13, 5.14). On entering, an unbroken view ascends

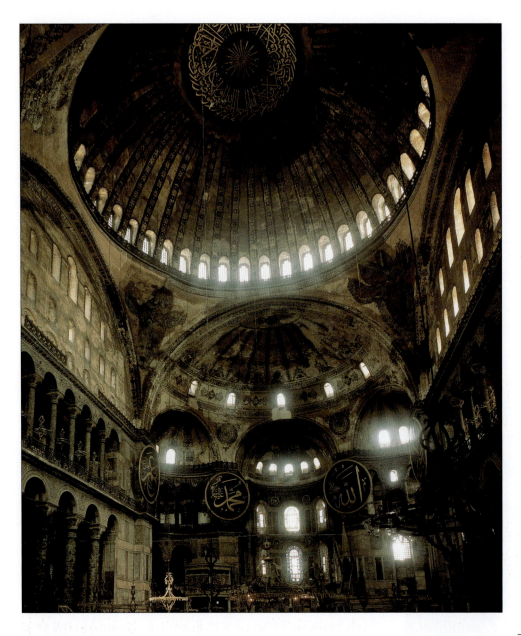

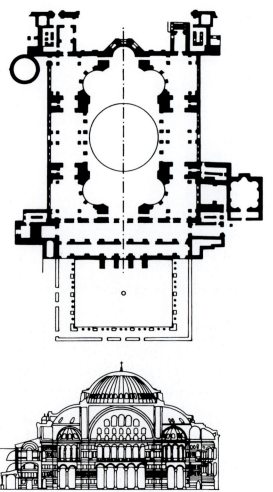

5.12 Interior view of Hagia Sophia, Constantinople (modern Istanbul, Turkey). 532–37

5.13 Plan of Hagia Sophia, Constantinople

5.14 Section of Hagia Sophia, Constantinople

through a semi-dome to the floating central dome and down again through the eastern semi-dome into the apse. Unlike a typical basilica, Hagia Sophia's upper structure transforms this long, broad open space—100 feet wide and 200 feet long, flanked by side aisles. The two semi-domes buttress the central dome, which is raised on spherical triangular segments, called **pendentives**, above four supporting piers below, which carry all the weight (see "Materials and Techniques: Dome Supports—Pendentives and Squinches," page 133). These piers, while supporting the dome, allow for the unbroken view from the entrance to the apse, the open arcades on either side, and the numerous windows above them, resulting in a vast, unobstructed, and luminous interior. While a traditional basilica draws attention to the altar and the eastern apse, here the eye

is also drawn upward, toward the luminous, floating, once gilded dome that reaches 184 feet high, symbolizing the canopy of heaven.

The interior of Hagia Sophia is lavishly finished (see fig. 5.12). Walls are faced with pieces of colored marble, cut and laid side by side to display their veining in symmetrical patterns. Two superimposed tiers of colored marble columns screen the side aisles, and deeply-drilled **basket capitals** of fine, white stone crown the columns. Originally, gold mosaic covered the dome; the furniture was plated in silver; and gold lamps illuminated the church by night.

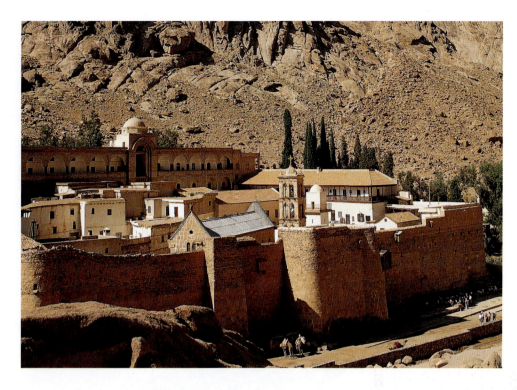

5.15 St. Catherine's Monastery, Mount Sinai, Egypt. Founded c. 548

Monasticism

Christian monasticism, which began in third-century Egypt, has played a major role in the cultural and spiritual life of both the Eastern and Western Churches. Western monasticism is divided into different orders, of which the earliest and most influential was the Benedictine. Monasteries were important centers for the production and preservation of knowledge and art.

St. Catherine's Monastery

Around 548, Justinian founded the Eastern Orthodox monastery of St. Catherine (fig. 5.15), at the foot of Mount Sinai in Egypt, where God was believed to have revealed himself to Moses. Like many monasteries of its time, St. Catherine's was surrounded by massive, fortified walls, which, along with its remote location, helped it to survive. The monastery consists of individual hermits' cells grouped around the church; it also contained housing for the soldiers that protected it. The

❖ MATERIALS AND TECHNIQUES ❖

Dome Supports—Pendentives and Squinches

Domes rest on a supporting structure, set either on a circular or a square base. At the Pantheon in Rome, the dome rests on a circular drum (see fig. 4.5 and "Materials and Techniques: Domes," p. 97). When it rests on a square base, making the transition from the square to the circle requires supports, called pendentives or squinches.

At Hagia Sophia, the great dome rests on a square base, supported by pendentives. In figure 5.12, notice that the pendentives are triangular sections rising from the four supporting corner piers. They curve inward until they meet up with the round base of the actual dome.

Squinches are arches, lintels, or **corbels** that stretch diagonally over the corners of the square space to create an octagonal or a circular base for the dome (see fig. 5.19). An alternative support system can be seen in the dome above the mihrab at the Great Mosque of Córdoba, where the dome is supported by eight interlacing arches spanning the corners (see fig. 5.46).

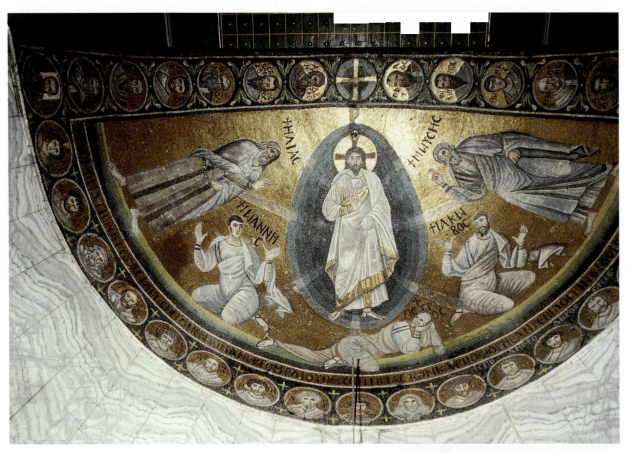

apse mosaic of *Christ's Transfiguration* (fig. 5.16) was the monastic community's focus for worship.

For Christians, believing that Christ is at once divine and human is fundamental. Symbolizing this faith is the Transfiguration, depicted at Sant' Apollinare (see fig 5.8), and here, somewhat differently, in the apse mosaic of St. Catherine's. Christ is surrounded by a blue **mandorla**, the almond-shaped radiance, set against a shimmering gold ground. Beams of light burst from his brilliant white garment, touching the stricken apostles and the calm, majestic figures of the heavenly witnesses, Moses and Elijah. Christ himself—following Greco-Roman practice, long-haired and bearded to indicate his divinity—raises his right hand in blessing and radiates supernatural light. Yet he retains his human form. Notice that he stands in classical contrapposto (see fig. 3.16), wearing sandals like the disciples.

St. Catherine's was also able to preserve several rare icons, including the *Blessing Christ* (fig. 5.17) and the *Virgin and Child Enthroned with Angels and Saints* (fig. 5.18) both from the sixth century. They are both painted in encaustic on panel, following the technique developed for Egypto-Roman mummy portraits from Fayum (see fig. 4.11). Like such ancient portraits, these icons invoke the authority of the figures represented:

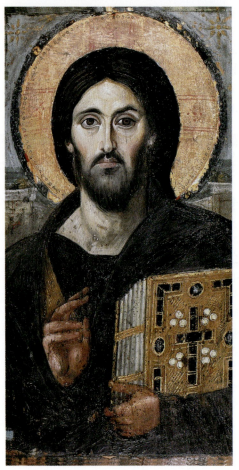

5.17 *Blessing Christ.* 6th century. Encaustic on board, 33" x 18". St. Catherine's Monastery, Mount Sinai, Egypt

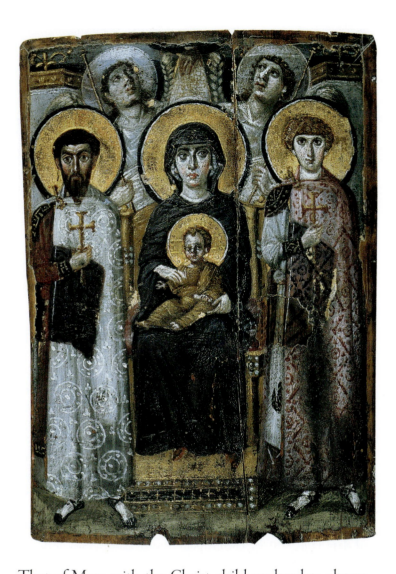

and the Virgin in these early icons to their mosaic counterparts in the dome and apse of the monastic church of the Katholicon, Hosios Loukas, Phocis, Greece, made four centuries later, in the early eleventh century (fig. 5.19). In an Orthodox central-plan church, an image of Christ as "Pantocrator" (or ruler and judge of all) was almost invariably placed in the central dome, to which all other spaces and images

That of Mary, with the Christ child on her lap, shows her as the "Mother of God"; that of Christ presents his humanity, while also functioning as an image of the deity. Both became widespread in Christian tradition. Worshipers address an icon with all the reverence meant for the one it represents, which may explain why the Virgin, the saints beside her, and Christ in these icons are posed frontally. Such a pose invokes a presence, and the icons' staring eyes invite worshipers to stare back. The image becomes an object of devotion, a substitute for the figure it represents.

The Eastern Orthodox Church developed a distinct theory of images, which had many implications for Byzantine art. To preserve continuity, artists were encouraged to depict figures in traditional poses, so that new images reflected earlier prototypes. That explains the similarity between the images of Christ

5.19 Interior view of church of the Katholicon, Hosios Loukas, Phocis, Greece. Early 11th century

were related. Together, architecture and images were designed to function in unison as a sequence leading the worshiper from the lowest to the highest, with all things centered on Christ.

Monastic Art in Northern Europe: The Book of Kells and Other Gospel Books

At the northern extremity of the Empire, the Celts of Roman Britain, who had also converted to Christianity, migrated to Ireland, where their culture and Church developed independently of the Romans. Irish missionaries then returned to northern England and founded monasteries that became major centers of English religious life and art. The fused art of Celtic Ireland and Saxon England is called Hiberno-Saxon.

The most richly illuminated Hiberno-Saxon manuscript (fig. 5.20) is the ninth-century Book of Kells. A page depicting *Christ with Angels and Peacocks* is embellished with a vibrant mixture of Hiberno-Saxon geometric patterns and coiling animals. The intense, staring figure of Christ, flanked by Nordic-

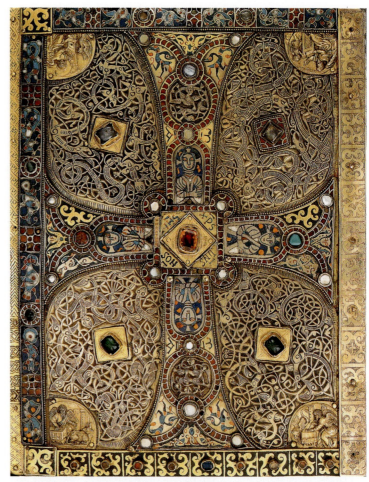

5.21 Back cover of the Lindau Gospels. c. 800. Silver gilt with enamels and glass, 13 1/8" x 10 1/8". The Pierpont Morgan Library, New York

style angels, is set amid this labyrinthine decoration. At his shoulders are two peacocks, emblems of immortality, with a cross-inscribed Eucharist wafer on their wings. They perch on vines sprouting from vases that symbolize the wine of the Eucharist. These images, like the figure of Christ, derive from Early Christian models, but they have been flattened and transformed, reflecting the Celtic artist's sense of surface pattern. Christ seems to float on the surface of the page, smothered in a decorative pattern of drapery folds.

In Hiberno-Saxon manuscripts, whirling animal forms elongate, transmute, and bite one another, evoking endless cycles of generation, violence, and regeneration. Combining images of this vibrant animal world with Christian symbolism suggests the authority of Christ over the natural world. But it is expressed in a manner foreign to the Greco-Roman world, in keeping

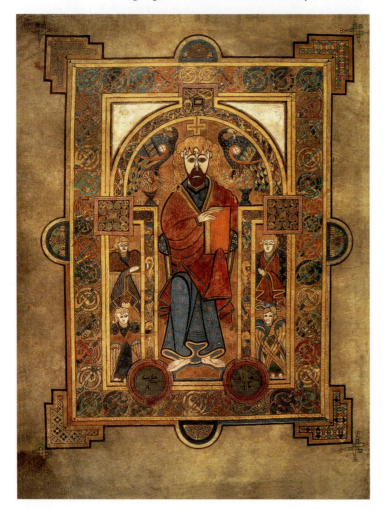

5.20 Christ and angels, with peacocks and grapes, and animal interlace, page from the Book of Kells. Late 8th–early 9th century. Vellum, 13" x 9 1/2". Trinity College Library, Dublin

5.22 Centula Abbey, St. Riquier, Picardy, France. Consecrated 799, now destroyed. Engraving by Petau, 1612, after 11th-century manuscript illumination

an ox, and a winged lion. This one surface thus combines two different artistic traditions—the Hiberno-Saxon and the classically derived Early Christian.

Carolingian Monasteries as Centers of Christian Culture

In 800 the pope crowned the Frankish king Charlemagne as Holy Roman Emperor. Scholars from all over western Europe were attracted to his court at Aachen (now in Germany), as a center of learning. Charlemagne fostered the arts, particularly book illumination, on a scale unprecedented in northern Europe. Monasteries thrived under his rule, including the abbey church of Centula (St. Riquier, Picardy, France), completed in 799, but long since destroyed (fig. 5.22). Centula's design was based on a T-shaped basilica, but the architect added a second transept at the west end and raised towers over both east and west crossings, flanked by smaller stair towers. The engraved view of the monastery also shows the large cloister, a standard feature of Benedictine monasteries, where monks could read, stroll, and grow herbs. The complex included two other churches, visible in the engraving, and other buildings that together formed a self-sufficient monastic community. Unlike St. Catherine's monastery at Mount Sinai, the complex was not fortified.

For several centuries, amid much political turmoil, further barbarian invasion (the Vikings), and warfare, rural monasteries like that of Centula preserved Christian—and ancient—culture, until cities began to thrive once again, in the twelfth century.

with the artists' own northern European traditions.

The covers of such gospel books reflect the value placed on them. To decorate these treasured objects, traditional northern metalworking skills were turned to new ends. The back cover of the Lindau Gospels (fig. 5.21), made around 800, perhaps on the Continent, is finely worked in silver gilt, with enamels and gems. Its overall design is similar to the decorative pages, resembling textiles (the so-called "carpet pages") of Hiberno-Saxon manuscripts, such as the Lindisfarne Gospels, with the cross form dominating fields of swirling animal interlace. The silversmith has included other types of decorative motifs, such as the small **cloisonné** enamel inlays, and classically derived, symbolic depictions of the four evangelists. They appear in the four tiny corner panels, with their respective symbols of a man, an eagle,

THE SELF

Since artists were patronized almost exclusively by the ruling elite—as throughout much of history—most surviving art from this period that is concerned with personal identity depicts rulers and leaders of state and Church—emperors, warriors, popes, and bishops (see "The Artist as Craftsman," page 138). The Roman cult of reverencing ancestors declined, and portraiture disappeared. Christian artists commemorated saints and martyrs for their exemplary lives, but their images were symbolic, rather than personal. Scarcely a glimpse of the personal remains, but the funerary art discussed above (see figs. 5.3, 5.4) shows how some individuals wished to be remembered by posterity.

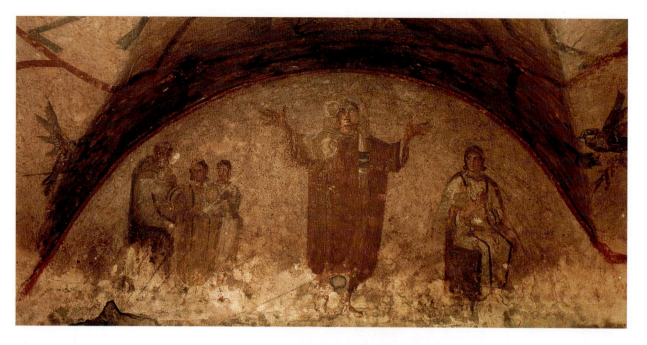

5.23 *Donna Velata* (*Veiled Lady*), catacomb of Santa Priscilla, Rome, 3rd century CE. Wall painting

The Expectant Soul

The funerary art of the catacombs preserves the spirit of the early Christians. The third-century orant figure, the *"Donna Velata"* (*"Veiled Lady"*), from the catacomb of Santa Priscilla, Rome (fig. 5.23) conveys their fearless spirit, disregard for earthly travails, and expectation of heavenly glory in the most rudimentary means. Barely delineating the physical form of the body, the artist accents the supplicant's upright bearing, outstretched hands, and her expectant, uplifted eyes. Her supplicating gesture signifies hope.

Domestic Life

In domestic life, some late fourth-century works of art, executed in a classical style, combine pagan and Christian motifs. Such is the partly gilded silver *Marriage Casket of Secundus and Projecta* (fig. 5.24). On it the bride, braiding her hair, is shown with a voluptuous nude Venus, goddess of love, who also combs her hair, attended by lesser deities. On the top of the lid is a double portrait of Secundus and Projecta, who are admonished in an inscription to "Live in Christ." Domestic pieces like this are rare, but more art survives commemorating rulers.

❖ THE ARTIST as Craftsman ❖

With the collapse of the Roman Empire, organizations of artisans disintegrated, professionalism among artists waned, and classical standards eroded. Masons, sculptors, silversmiths, mosaicists, and painters were all regarded as skilled workers. Those involved with construction moved from site to site, as did mosaicists, some traveling great distances. Charlemagne and other emperors summoned artisans from Italy to work in Germany, but monastic illuminators may have spent their entire lives working in the same monastery.

The patrons did not regard the buildings, sarcophagi, wall mosaics, and manuscript illuminations these craftsmen produced as works of art in our modern sense. As well-conceived buildings and objects —effective in fulfilling their function—they were valued for their beauty and craftsmanship, not for the personal view of the individual artist. The patron determined the iconographic program, or subject matter of art, and the requirements for a building. However, the success of a piece depended on the choice and handling of materials, and the artist's resourceful imagination. The master craftsman expertly manipulated all of these elements.

5.24 *Marriage Casket of Secundus and Projecta*, from the Esquiline Hill, Rome. Late 4th century. Gilded silver, 11" x 21½". The British Museum, London

5.25 *Triumph of Justinian*, the "Barberini Ivory." Mid-6th century. Ivory leaf from diptych, 14¼" x 11". Musée du Louvre, Paris

Rulers

Christian Roman emperors claimed the status of God's representative or vice-regent on earth, not unlike that of the Old Testament King David. While people no longer venerated the emperor's image, he now claimed authority not only on the basis of force of arms but also of the Christian God. The authority of the Roman and Byzantine Emperors was sanctioned by the Christian Church, and Church and state became intertwined in ways that have repercussions even today, with the state at that time using the Church as a seal of approval for its actions.

As art had once promoted Roman political propaganda, in the Christian era it reinforced the status of rulers in a different way. While few free-standing sculptures were produced, imperial authority made itself felt in architecture and church mosaic cycles, especially in the Byzantine world. Imperial power also impressed itself on smaller works in gold and ivory.

The Barberini Ivory

One surviving leaf of a mid-sixth century ivory **diptych** (a hinged, two-part relief), vividly expresses the notion of divine sanction for imperial rule. Known as the "Barberini Ivory" (fig. 5.25), it probably represents Emperor Justinian I. On the center panel the idealized emperor sits astride a rearing charger, and plunges his spear in the ground before a cringing barbarian. At his feet, the earth goddess Terra offers up her fruits, while a winged victory flies before him. In the left-hand panel, a Roman soldier proffers a statute of an allegorical figure, signifying victory. Below, on either side of yet another figure of victory, conquered people bring tribute of food, ivories, and native

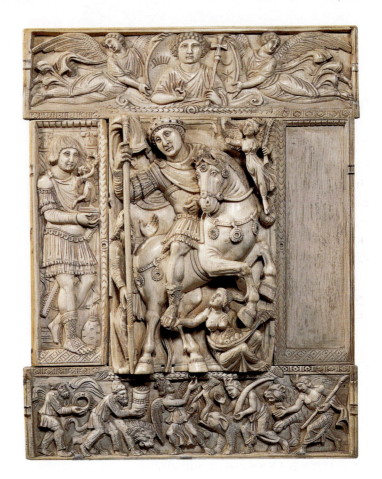

animals. Above, two angels—much like Roman personifications of victory—hold a medallion portrait bust of Christ, who gives his benediction, symbolizing divine sanction.

The central motif of this exquisite work recalls large-scale Roman equestrian sculptures, such as that of *Marcus Aurelius* (see fig. 4.14), but now on the miniature scale of a carved ivory. The diptych thus presents the combined views of sacred kingship of the Roman state and the Christian Church.

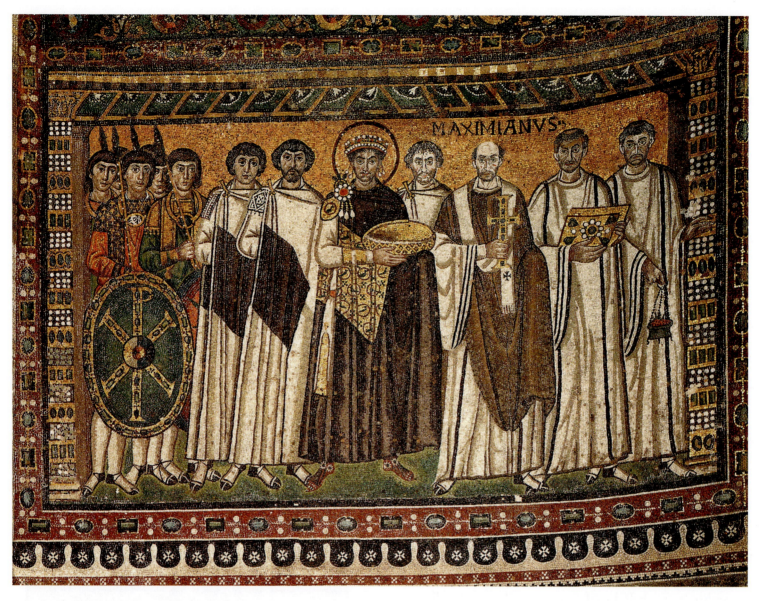

5.26 *Bishop Maximianus with Justinian and His Retinue*, in apse, San Vitale, Ravenna. c. 547. Wall mosaic

Justinian and His Retinue

The vision of sacred kingship is embodied on a much larger scale and in a more prominent context in two mid-sixth-century mosaics of Justinian (fig. 5.26), his empress Theodora (fig. 5.27), and their retinues at Ravenna on the chancel walls of the church of San Vitale. As we noted earlier, they are set on either side of the apse mosaic of Christ in Majesty (see figs. 5.9, 5.11). With subtle pictorial adjustments, the anonymous mosaicists evoked the presence of the royal entourage while preserving a sense of permanent order. The artists combined a penetrating and realistic characterization of the heads with an abstract flattening of the bodies into immobile patterns of ceremonial drapery. Justinian's placement, imperial purple and gold robes, crown, and halo assure his preeminence.

Justinian and his retinue appear as part of a sacred hierarchy comprising Church, state administration, and army. Opposite him is Theodora and her retinue. Above them in the semi-dome of the apse Christ extends his hand in benediction, conferring divine authority on the imperial retinue. This view of sacred kingship endured down the centuries of medieval culture and was immensely significant for the Byzantine world and later in the Russian Orthodox Church, until the overthrow of the last tsar in 1917.

Poets and Popes

In western Europe, the Church had consolidated its position as the most viable and enduring administrative structure after the disintegration of the Western Roman

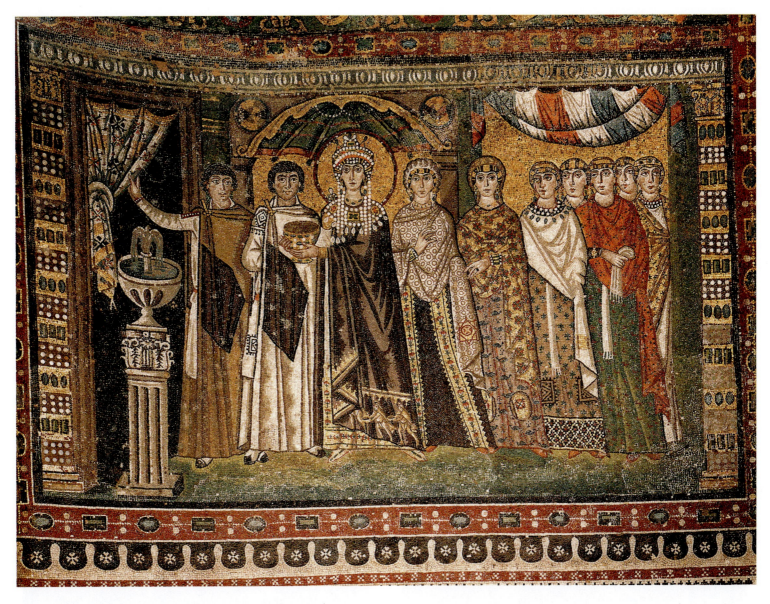

5.27 *Empress Theodora and Her Retinue,* in apse, San Vitale, Ravenna. c. 547. Wall mosaic

Empire in the fifth century. It was the unifying force in western Europe, or Christendom, for the next thousand years. Moreover, in a culture of farmers and marauding warriors, the monks and clergy preserved literacy and learning, and provided the great administrators of the so-called Middle Ages. In contrast to the world of the ancient Greek philosophers, thought was now guided by Church theologians, and recorded by monastic scribes.

Within the monasteries, monks specializing in calligraphy, and others in **illumination,** produced sumptuous gospel books and other liturgical works. But the most luxurious works came out of the workshops at the emperor's palace, known as **scriptoria.** It was through the monastic preservation and copying of texts—both sacred and secular—that the learning of the ancient world survived the turmoil of the Middle Ages.

The Poet and the Muse

The classical ivory diptych of *The Poet and the Muse* (fig. 5.28), carved about 500, echoes the literary culture of antiquity in its theme of poetic inspiration. Thus a beautiful, female Muse inspires the bare-chested classical poet—a theme that Christians transformed into the image of the gospel writer, or cleric, inspired by the Holy Spirit. The symmetrical composition, with two figures in a room, one active, the other passive, also provided Christians with a prototype for endless representations of the Angelic Annunciation to the Virgin Mary—the occasion when Mary is told that she will bear the Christ child.

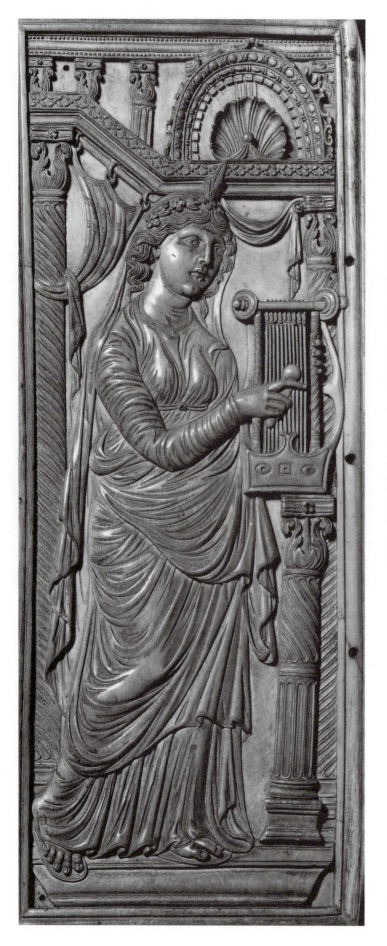

The Gregory Master

One of the most memorable depictions of clerical inspiration comes from northern Europe (fig. 5.29). It is an illustration from the late tenth-century *Registrum Gregorii* (*Letters of St. Gregory*), depicting Pope Gregory the Great dictating his *Homilies on Ezekiel* under the inspiration of the Holy Spirit, signified by a dove, as at Christ's baptism). The scene recalls the legend that the pope's secretary saw a dove with its beak placed on Gregory's lips. As the dove withdrew its beak, Gregory would dictate.

This image of the pope with his secretary is remarkable for its classical style, which we see in the modeling of the figure of the pope and the treatment of architecture. The gifted anonymous artist must have had access to Early Christian or Byzantine models. Yet, in contrast to the classical poet and his muse, Pope Gregory belongs to a world of clerics, monastic scribes, and spiritual mysteries whispered from the beak of a dove. Therein we see the impact of Christianity in transforming personal experience.

5.29 The Gregory Master, *Pope Gregory the Great and Secretary*, page from the *Registrum Gregorii* (*Letters of St Gregory*). 977–93. 10⁵/₈" x 7⁵/₈". Stadtbibliothek, Trier

NATURE

In their responses to nature, Early Christian artists transformed the conventions of classical antiquity. Wealthy Romans had sought peace and renewal in country villas, often commissioning artists to paint murals that included views of imaginary gardens with rustic temples and wayside shrines in landscapes of idyllic beauty (see figs. 4.16, 4.18). After the collapse of the Roman Empire, western Europe would see nothing like those villas or landscapes again for more than a thousand years.

Unlike the Romans, Early Christian artists did not depict nature for its own sake. Indeed, they distrusted sensory beauty. For them, earthly beauty was, at best, a window to the divine. They sought to create an art and architecture that served religious ideals and all but ignored the physical.

Such art would inspire men and women to imagine the perfect, spiritual world that no artist could actually depict. Christians did adapt motifs from the works of classical artists, including scenes that portrayed cupids amid clusters of grapes and vines. Such scenes of paradise were derived from pagan Dionysian, or Bacchic, scenes, which Christians could now associate with the wine of the Eucharist, and so with Christ (fig. 5.30).

Christian Landscape

With the decline of the Roman Empire, the ideal of an idyllic country villa disappeared. Roving bands of barbarian tribes made the countryside a rough, dangerous environment, not a place for renewal. Castles and monasteries with thick defensive walls took the place of unfortified pleasure villas, which would not be built again in Europe for a thousand years.

David Composing the Psalms

In the visual arts, the bucolic landscape associated with the villa ideal also passed into memory. It is recalled in a late ninth-century manuscript illumination of *David Composing the Psalms* (fig. 5.31). This image appears as

an "author portrait" at the front of the Paris Psalter and was probably produced in the imperial scriptoria, or workshops, in Constantinople. That would explain why both figures and space are much more naturalistic than in most Early Christian manuscript illuminations or mosaics that were produced in western Europe (see "Materials and Techniques: Illuminated Manuscripts," below).

This illumination takes its landscape and figures from classical models, including the red shroud tied around a commemorative column. The figure of David recalls the Greek myth of Orpheus playing music to the animals, with the graceful muse Melodia at his shoulder, and a river god lounges in the lower right corner. Although the scene is too crowded, the sense of space, mass, lighting, and depth, complete with architectural features, creates an illusion of a window on a world not seen since antiquity.

Byzantine Wilderness Landscape

More original and influential than the *David* scene is another type of landscape in Byzantine art, the wilderness landscape. Depicting the wilderness in art was a

5.31 *David Composing the Psalms*, page from the Paris Psalter. Late 9th century. Paint on parchment, 14" x 10¼". Bibliothèque Nationale, Paris

❖ MATERIALS AND TECHNIQUES ❖

Illuminated Manuscripts

During the Middle Ages, before the printing press was invented in the West (printing began earlier in China), scribes working in monasteries hand copied all texts and books. Elaborate copies of sacred texts, such as the Bible and prayer books, or Psalters, were made of parchment or vellum (specially treated sheep, goat, or calf skins). After the parchment was prepared, it would be brought to workshops, where the writing and decoration would begin. When decorated or illustrated, such manuscripts are called "illuminated."

Complicated images illustrating the text, often laden with symbolic meaning, were drawn in miniature, in the side margins and sometimes across the top and bottom of the page. The watercolor or gouache paint for decorating the parchment came from pigment (ground from minerals or other natural materials), moistened with water and then thickened with gum arabic, which served as a binder assuring the pigment would adhere to the parchment. Gouache is like watercolor, but mixed with chalk to make it opaque. With tools such as rulers and pairs of compasses, illuminators created complex, elaborate geometric designs that added to the manuscript's value. To protect them, other craftsmen created elaborately worked covers in leather and fine metalwork, sometimes studded with semi-precious stones. (See, for example, the book cover on the Lindau Gospels, fig. 5.21, crafted of silver gilt with enamels and gems.)

5.32 *Vision of Ezekiel in the Valley of Dry Bones,* page from the *Homilies of Gregory of Nazianzus.* 867–86. Paint on parchment, 16" x 11³/₈". Bibliothèque Nationale, Paris

Christian innovation; it did not derive from the classical tradition. Christians saw the wilderness as a setting for encounters with God: In the Bible, Moses, Ezekiel, and Christ himself had sacred experiences in the wilderness. This explains the remote countryside location, even in deserts, of monasteries such as Saint Catherine's, Mount Sinai (see fig. 5.15).

Early prototypes of the wilderness landscape appear in the sixth-century Ravenna mosaics at San Vitale, where, for example, Moses mounts a series of step-like diagonal rocks on Mount Sinai. This pictorial formula (as seen in fig. 5.32) survived for a thousand years, into the Italian Renaissance.

The *Vision of Ezekiel*

A wilderness landscape of this type is the subject of a full-page illustration in a book of the *Homilies of Gregory of Nazianzus,* made about 867–86 for Emperor Basil I in the imperial scriptoria. It depicts the biblical *Vision of Ezekiel* (fig. 5.32) and shows an angel leading the prophet Ezekiel into the Valley of Dry Bones. Beyond, in a second scene, Ezekiel stands at the foot of basalt-like rocks, which signify a mountain, as God commands him to prophesy the Resurrection.

Although narrative dominates the subject, the artist has attempted to animate the figures with suggested movement and bodily gestures. He has also placed the prophet, as realistically as possible, in a spacious mountain setting, bathed in the glow of a delicate pink sky. In settings for biblical narrative, artists came closer to treating landscape for itself, rather than as a mere symbol of a higher, spiritual reality. Even so, they conventionalized such landscapes, endlessly repeating the same formulas.

THE CITY

After Christianization and the political decline of the Roman Empire, many of the finest buildings in Rome were neglected or destroyed, as they were throughout the Empire. Temples were torn down, often to supply building materials for churches; the amphitheaters fell into disuse; and the bath-houses, which Christians associated with moral decadence, were closed. Urban populations plummeted as wars and pillaging by marauding barbarian tribes devastated the cities. For most of the Middle Ages, sheep and goats grazed in the once proud and populous forums of ancient Rome. In the West, rural monasteries, not cities, preserved what remained of the European cultural heritage. However, in the East, a lavish building program would transform the city of Constantinople.

Constantinople: The New "Christian Rome"

Situated at the crossroads of Europe and Asia, on the Bosporus, where the Black Sea meets the Mediterranean, Constantinople thrived as a hub of trade, art, theology, and diplomacy for over a thousand years, from its foundation in 330 until it fell to the Ottoman Turks in 1453.

Early plans of Constantinople give an impression of how the city appeared (figs. 5.33, 5.34), and can be compared with a photograph of modern Istanbul (fig. 5.35). Its designers adapted Roman town planning to express the ideal of sacred kingship. They also designed Constantinople to withstand repeated sieges. Water protected the city on three sides, and massive walls fortified the land side. A Roman-style aqueduct and vast cisterns supplied plentiful fresh water. Roman models inspired the buildings erected in Constantine's time, and many ancient statues were displayed in the city's public places.

The original city plan emulated the design of Rome, including its location on seven low hills (see fig. 5.33). Yet, since churches crowned the hills, the city's silhouette and symbolism were both imperial and Christian. A colonnaded, processional avenue, the Mesê, led to the sprawling palace complex, which was dominated by an arena used for chariot races, the grand, new Imperial Palace, and its chapel—the church of Hagia Sophia (see fig. 5.12). All three—stadium, palace, and palace chapel—opened onto the main public square, the Augustaeum. The Imperial Palace also included workshops for silk weaving and other crafts. Spread across the wooded slopes that ran down to the Sea of Marmara, the complex had an unrivaled location (fig. 5.35).

Although the original layout and buildings of Constantinople followed Roman precedent, the physical conjunction of palace and its church, Hagia Sophia—the crowning glory of the city and heart of the

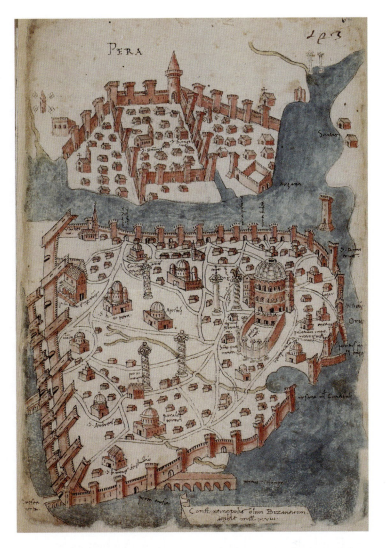

5.34 Christopher Buondelmonti, map of Constantinople. 1420. Ink on parchment. Biblioteca Marciana, Venice

5.33 Plan of early Byzantine and medieval Constantinople

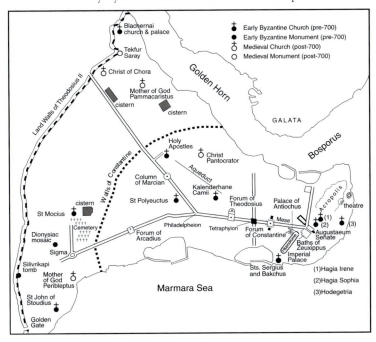

Byzantine world—carried new theocratic symbolism. Furthermore, Christian symbols, memorials, and relics were spread throughout the city. In times of crisis, the citizens carried these relics to the walls of the city, to invoke protection. Christian influence—both spiritual and artistic—extended far beyond Constantinople, to Ravenna, Venice, Russia, and the Balkans. Byzantine art proclaimed in stone and mosaic the ideal of sacred kingship, a theme that echoes down the centuries.

Aachen: Sacred Kingship in Northern Europe

The earliest monumental buildings in the much more modest city of Aachen show how sacred kingship was interpreted in the West. In the late eighth century,

the Frankish king Charlemagne chose Aachen as his permanent residence, hoping to reestablish a Western, Christian, Roman Empire. As at Constantinople, but on a much smaller scale, a palace complex with an adjoining chapel was erected. Western building standards had declined since the Romans, and nothing in northern Europe could compare to the splendor of ancient Rome, Constantinople, or any major Mediterranean city. Charlemagne's palace has disappeared, but his Palatine (palace) Chapel, begun in 792, still survives, as modified in later centuries. Although a comparatively modest achievement, northern Europe had nothing to rival it at the time.

Like Byzantine emperors, Charlemagne asserted his authority in both Church and state. In pursuit of Charlemagne's vision of sacred kingship, his architect, Odo of Metz, drew his models from Christian Rome and from central-plan Byzantine churches, such as San Vitale at Ravenna (see fig. 5.10). Materials salvaged from classical buildings were brought from Rome and Ravenna. The chapel faced the palace and audience hall at opposite ends of a long courtyard.

The Palatine Chapel of Charlemagne

Aachen's sixteen-sided, central-plan Palatine Chapel (figs. 5.36, 5.37) is reminiscent of San Vitale especially in its central core (see fig. 5.9). In both, a vaulted ambulatory, or passageway, surrounds a domed octagonal core, but Aachen also includes an entrance tower. This tower, flanked by cylindrical stair towers, and known as the "westwork," like that of centula (see fig. 5.22), became a feature of northern European architecture. Odo of Metz designed the chapel to reflect the Frankish kings' view of themselves as God's anointed leaders. The upper gallery of the chapel contained a throne, approached by the stair towers. From there, Charlemagne could follow the service and make public appearances from a balcony. The throne itself was symbolically mounted on six steps, like that of King Solomon in the Bible.

Architecturally, the chapel interior (see fig. 5.36) is more rigid, massive, and distinct in its parts than San Vitale. Eight massive piers support the dome, once covered with a mosaic of Christ. In place of San

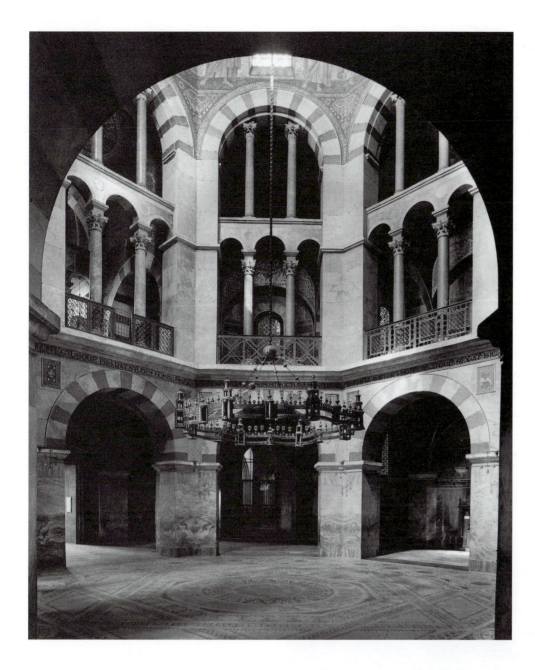

5.37 Plan of the Palatine Chapel

Vitale's curved, screening arcades that rise into semi-domes (see fig. 5.9), at Aachen the gallery arcades cut directly across the space in two tiers of classical columns. This confines attention to the severe vertical thrust of the central octagonal core. In place of San Vitale's fluid space and mysterious lighting, Aachen is angular and massive. However, as a piece of archi-tectural symbolism, its central plan was appropriate as a palace chapel and as Charlemagne's own **mausoleum**. Furthermore, his throne in the gallery, under the protection of the dome mosaic of Christ, reminded viewers of his sacred kingship. Even after Charlemagne's power waned, Aachen remained a symbolic center.

PARALLEL CULTURES
Mesoamerica, India, Japan, and the World of Islam

During the centuries that Christianity was becoming established in the former Greco-Roman world, quite different belief systems were shaping the art and archi-tecture of other great civilizations. Here we will encounter works of art from four cultures: Mesoamerica, India, Japan, and the world of Islam.

The following examples of the ritual art and archi-tecture of Mesoamerica, India, and Japan all reveal

human desire to come to terms with life's uncertainties and nature's power, and to do so through art and ritual. Their diverse responses to these shared concerns are evident in their art, and each can be compared to the rituals and responses expressed in the art of the West.

Mesoamerica

Europeans had no contact with Mesoamerica before the late fifteenth century and were unaware of the extraordinary urban civilization that flourished there during the early Christian era. Two salient examples of Mesoamerican architecture and art—one vast, the other small—express universal human concerns: Belief in the divine origin of the natural world, and an acute awareness of the uncertainty of human life. As we saw in prehistoric and ancient Near Eastern art (see Chapter 2), and in Christian art, many cultures have sought to allay the fear of natural disaster and death, and to ensure fertility, through ritual appeasement of divine forces. However, the vision of ritual and sacrifice expressed in Mesoamerican art could not be more different from that of the Christian West.

Mesoamerican civilizations believed that the sacrifice of the gods had brought about creation and human life, and that only blood-letting through human sacrifice could avert natural disaster and sustain life. Religious ceremonial sites, now in ruins, were built

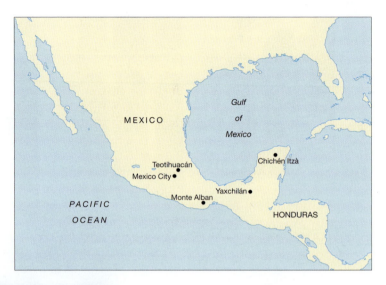

Map 5.2 Mesoamerica

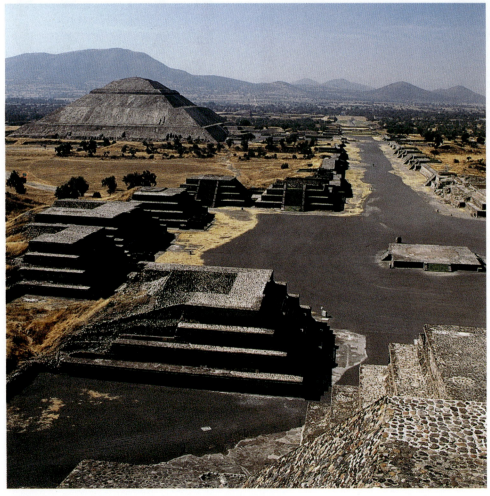

5.38 Temple of the Sun, Teotihuacán, Mexico. 1st–7th century

throughout Mesoamerica, stretching from central Mexico in the north to Guatemala in the south (see Map 5.2). They are strikingly similar to the ziggurats of ancient Mesopotamia, sites devoted to appeasing the gods and averting natural disaster (see figs. 2.10, 2.11).

Teotihuacán

Teotihuacán in Mexico is one of the most impressive Mesoamerican ceremonial sites. Laid out during the first to seventh centuries CE, Teotihuacán (fig. 5.38), meaning "birthplace of the gods," is northeast of modern Mexico City and covers nine square miles. At its height, Teotihuacán was far greater in scale than either Athens or Rome. At its core stand the Temple of the Sun and the Temple of the Moon.

The Temple of the Sun is aligned so that the sun sets directly in front of it at the summer solstice, evidence of the importance of appeasing the gods with sacrifice. Like the ziggurats of the ancient Near East, one reaches these temples after climbing a flight of ceremonial steps, a symbolic path reaching up to the heavens. These temples were the domain of a priestly caste, who, alone with their sacrificial victims, would have access to the shrine at the upper level. In this way, temple architecture reinforced the authority of a hierarchical society in which a privileged few held power over the many. As with the priest-kings of ancient Mesopotamia, their power was based on the knowledge of ancient ritual, which gave them authority to intercede with the gods.

Ritual Blood-letting

In Mesoamerica the ruling caste of kings and priests was set apart by their ability to control nature by communing with the gods and ensuring the provision of human sacrifice. While the Mesoamerican peoples fought wars to obtain captives for sacrifice, their kings and queens also sacrificed their own blood. A Mayan lintel relief from Mexico, carved about CE 725 (fig. 5.39) depicts a blood-letting ceremony. The richly robed Lady Xoc kneels before her husband, as she draws a rope spiked by thorns through her tongue. Her blood, which drips onto pieces of bark paper, will be burnt as an offering to the gods, accompanied by sacrificial victims, such as the one whose shrunken head forms part of the king's feathered headdress.

This relief, like much surviving Mayan carving, has a linear quality more like drawing than three-dimensional sculpture. Characteristically, too, it includes inscriptions.

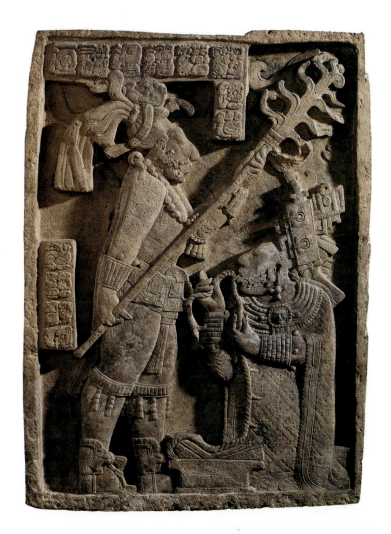

5.39 *Blood-letting Rite*, lintel from Yaxchilán, Mexico. c. 725. The British Museum, London

Such carvings were brightly colored (of which only traces remain), providing a brilliant, dense, and richly worked surface.

Indian Buddhism and Hinduism

Although, as we saw in Chapter 3, Buddhism arose in India in the fifth century BCE, the Buddha did not become an object of devotion until between about 100 BCE and CE 100. Thereafter, his image spread throughout the Buddhist world, into China, Japan, and Southeast Asia.

The *Teaching Buddha*

An outstanding example of a *Teaching Buddha* from the fifth century CE—the Gupta period—comes from Sarnath, in northeastern India (fig. 5.40). The Buddha is here represented as an otherworldly serene being of pure spir-

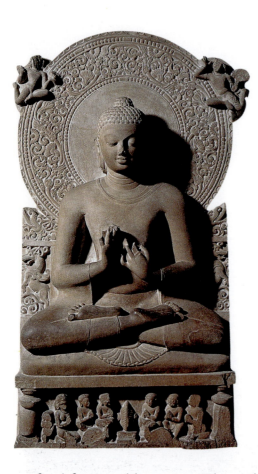

5.40 *Teaching Buddha*, stele from Sarnath, India. 5th century. Sandstone, height 63". Archeological Museum, Sarnath

Japanese Buddhism

Buddhism spread from China to Japan in the sixth century CE. The Horyuji Temple, at Nara (fig. 5.42) in Japan, dating from the seventh century, though periodically repaired, is the oldest surviving Buddhist temple in East Asia. It is a superb example of the simplicity and subtle asymmetry of later Japanese design. Nestled amid the natural vegetation, the upper tiers of the pagoda seem to float above the trees, lifting the spirit. Inside the main building, the **kondo**, or "golden hall," is a large bronze sculpture, made about 623 CE, known as the *Shaka Triad*, showing Buddha with two attendants (fig. 5.43). The Buddha's raised hand gesture is in the conventional position of reassurance, that means "fear not." This gesture is reinforced by the stability of the meditational pose and the figure's somewhat remote, but calm expression. (Compare the icon of Christ, fig. 5.17, also gesturing with his hand.)

5.41 *Dancing Shiva*, relief from cave temple, Badami, India. 6th century

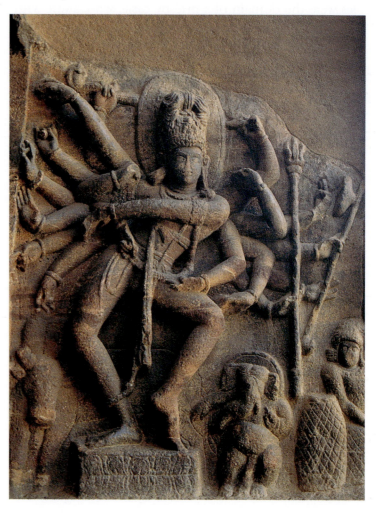

it, freed from earthly passion. The sculptor conveyed this serenity by creating a perfectly symmetrical, balanced body, eliminating naturalistic details. Compare the images of Christ we've seen, for examples in figures 5.16, 5.17 and 5.20. None of these is three-dimensional, but in most the eyes directly engage the viewer. By contrast, the downward gaze of the Buddha invites introspection.

The *Dancing Shiva*

Hindu art tends to be more sensuous than Indian Buddhist art. One of its most familiar images is that of the dancing god Shiva, whose lithe sensuality embodies an enduring quality of much Indian art. A *Dancing Shiva* from the sixth century CE is a relief carving located inside a cave temple in southern India (fig. 5.41). In it the deity shows his various attributes. The gesture of each arm and hand has a specific meaning. For example, the raised hand, with palm outward, means "have no fear." Shiva's dance is a cosmic dance; it embodies the idea that all life is engaged in a perpetual cycle of birth, sustenance, death, rebirth (or reincarnation), and liberation. Shiva's hand gestures are intended to liberate devotees from this endless cycle into a state of pure being. Hindu art serves, therefore, as a catalyst through which worshipers may find spiritual rest from life's trials.

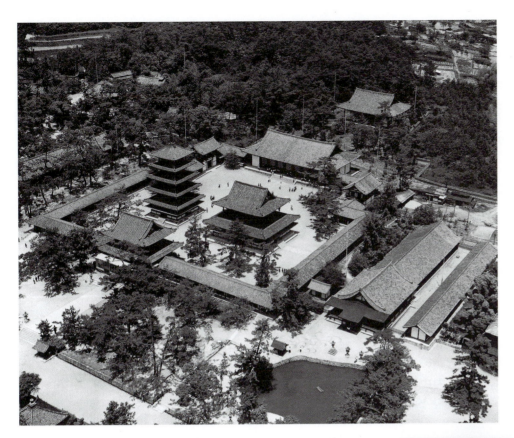

5.42 Horyuji Temple, Nara, Japan. Asuka period, 7th century.
Stone, wood, plaster, and tile

5.43 Tori Busshi, *Shaka Triad*, in the Golden Hall (*kondo*), Horyuji, Nara. Asuka period. c. 623. Gilt bronze, height of seated figure 34¹/₂", height of whole sculpture 5'9¹/₄"

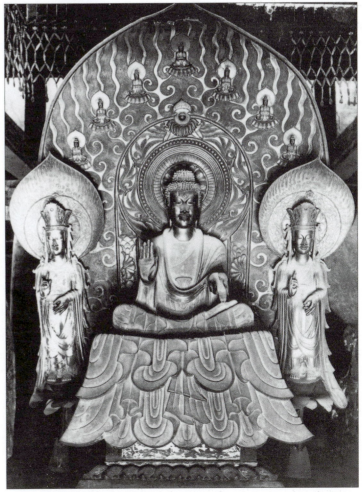

The harmony of buildings and their setting among trees at Nara echoes the Buddhist goals of simplicity and submitting the self to the greater whole. It also reflects the Japanese tendency to build structures that harmonize with their natural environment.

Compare the temple to the Early Christian monastery of St. Catherine, Mount Sinai (see fig. 5.15). Both seek the serenity of a natural setting, but their differences are striking. At Nara, wooden buildings rise within a landscape of trees, creating a feeling of calm and peace. St. Catherine's site is forbidding. At the foot of rocky Mount Sinai, stone walls surround stone buildings.

Islam

Mesoamerican, Indian, and Japanese cultures developed in complete independence from the West. In the seventh century, another spiritual and cultural force, Islam, arose in the Near East and in time penetrated to the heart of Eastern Christendom.

Islam arose amid the nomadic Bedouin people of Arabia. Its founder, Muhammad, was born in Mecca (now in Saudi Arabia) about 570. He believed himself a prophet of divine revelation, and called people to the worship of Allah, the One and Only God, the God of

Abraham. After his death in 632, Islam spread rapidly through Arabia, the Eastern and North African provinces of the former Roman Empire, eventually reaching from Spain to northern India. Its militancy driven by the desire to bring the whole world under Islam presented a long-term threat to Christendom, and Constantinople itself fell to the Islamic Turks in 1453.

Islamic Decoration

Muslims believe that God dictated their Scriptures, the Koran, to Muhammad in Arabic; the Koran provides comprehensive rules and laws governing Islamic life. It condemns the worship of idols, and later Islamic writings explicitly condemned representational religious art. As a result, by the eighth century Islamic decorations were aniconic, that is, without figurative elements. Instead, the Arabic script of the Koran became itself the pictorial symbol of the faith. Calligraphy combined with complex geometric and vegetal designs became the signature art form of Islam. Our use of the term "arabesque" to describe elaborate floral and geometric patterns acknowledges this art.

5.44 Dome of the Rock, Jerusalem. 691

The Dome of the Rock

Jerusalem is a holy city for Muslims, the place from where Muhammad was carried to heaven. Arab rulers built the Dome of the Rock in Jerusalem (fig. 5.44) in 691 on the site of Solomon's Temple (see fig. 2.36) as a commemorative shrine to enclose the rock where legend said that Abraham had prepared to sacrifice his son, Isaac. Its octagonal design, with a domed central space over the rock, surrounded by two ambulatories, was modeled on Early Christian martyria. The interior is decorated with veined marble and mosaics of Byzantine-style plant ornamentation, as well as Koranic inscriptions. However, its exterior embellishment is more distinct from Christian monuments, and its richly gilded, slightly pointed wooden dome and colored ceramic tiles dominate the skyline of Jerusalem.

The Great Mosque of Córdoba

More typical of Islamic architecture, however, is the mosque, meaning "a place where one prostrates oneself." Islam has no priesthood, and little ritual, so mosques need only accommodate the faithful as they assemble to pray, prostrating themselves toward Mecca.

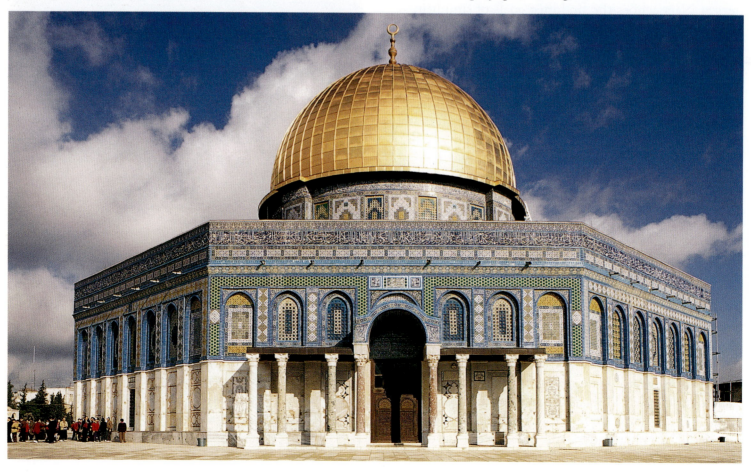

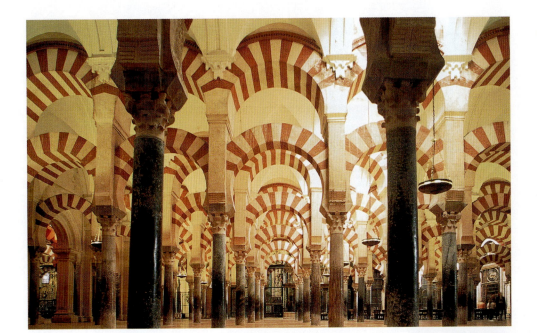

5.46 Dome above the *mihrab*, Great Mosque, Córdoba, Spain. c. 961–76

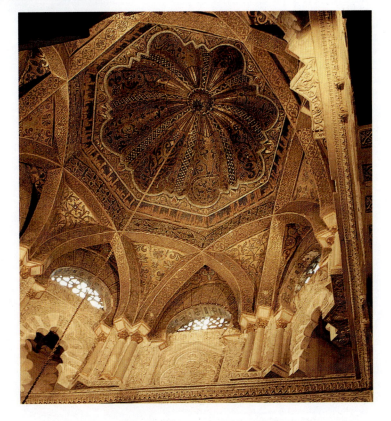

Where the design of Christian churches is hierarchical—the apse houses the bishop's throne, the chancel is reserved for the clergy, and the nave for the laity—a mosque reflects the equal access of all to God in prayer. It consists of an open, rectangular hall orientated toward Mecca, the direction in which Muslims pray. An adjacent feature is the **minaret**, a tower used to call the faithful to prayer.

At Córdoba, the capital of Muslim Spain, in 784 the emir, or ruler, built the Great Mosque. In the ninth and tenth centuries the mosque was enlarged (figs. 5.45, 5.46), and attached by a bridge to the royal palace, linking spiritual and temporal authority, as at the Hagia Sophia in Constantinople and the Palatine Chapel in Aachen. But the Great Mosque is much larger than both.

The interior is a hypostyle hall, with a roof supported by rows of columns salvaged from earlier Roman and Christian buildings. The effect is of a forest of columns extending limitlessly in all directions. The repetitive pattern of red-and-white striped, horseshoe-shaped arches accentuates the effect. Perhaps to admit more light in the low, wide hall, the architect raised the roof above two superimposed tiers of these arches. This also multiplies the pattern of receding arched forms. Such geometric complexity was taken even further in the tenth century with a triple-domed enclosure reserved for the caliph, the supreme ruler, literally the prophet Muhammad's successor. Its richly decorated and gilded central dome (see fig. 5.46), with an exposed structure of eight interlacing arches—typically concealed in Roman and Byzantine domes—further reflects Islamic love for geometric patterns combined with plant ornamentation and inscriptions in elaborate Kufic script.

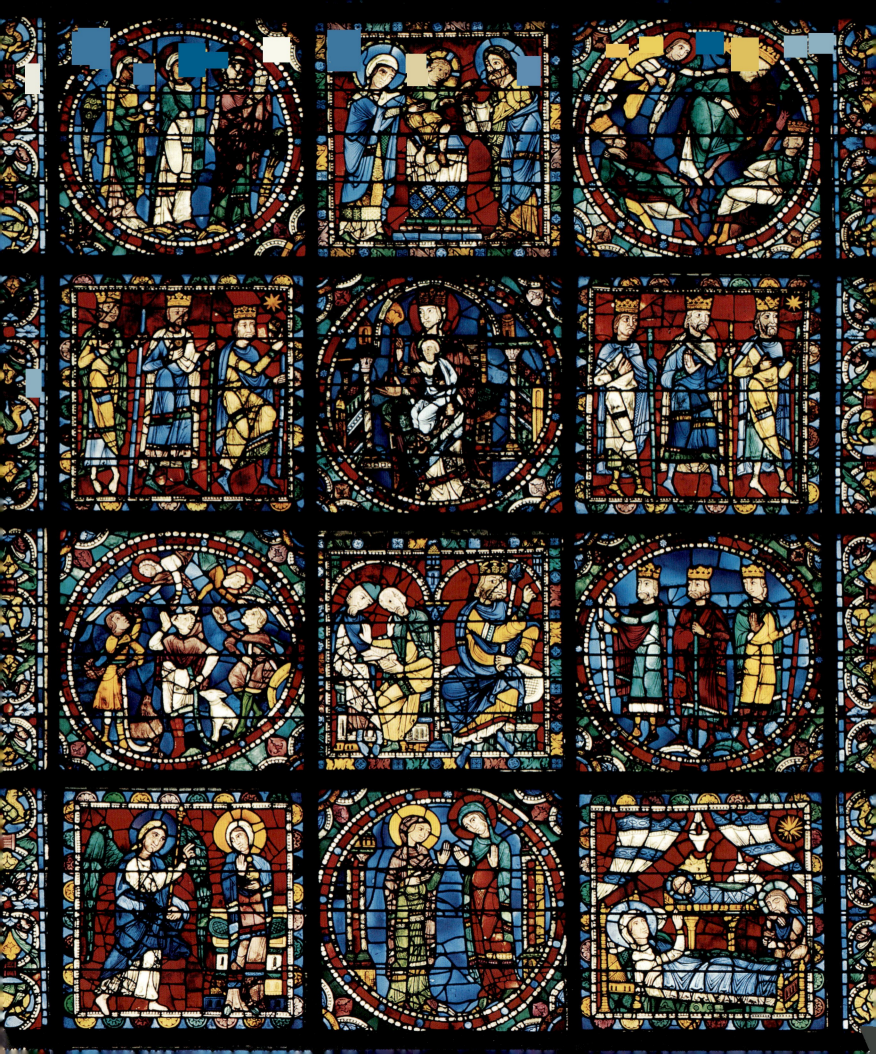

6 Medieval Art

6.1 Scenes from the Life of Christ (detail of fig. 6.15), stained glass windows on west façade, Chartres Cathedral. c. 1150–70

The centuries between the fall of Rome in the fifth century and the Italian Renaissance in the fifteenth are called the medieval period or Middle Ages. Our focus here is on the art and architecture that developed in western Europe from the eleventh to the early fifteenth centuries, known as the Romanesque and Gothic styles (see Map 5.1). During this period, Christians built vast abbeys and soaring cathedrals, many adorned with richly-colored, stained-glass windows, in which color, light, and glass were transformed into a radiant medium to illuminate the stories of the Bible's Old and New Testaments (see figs. 6.1 and 6.15).

6.2 Reconstruction of the third Abbey Church of St. Pierre, Cluny, France. c. 1085–1130 (after Kenneth John Conant)

images of the self and nature, and forms of urban life. Finally, in the section on "Parallel Cultures," we will focus on the contributions of Islam.

SPIRITUALITY

In their work, medieval artists and stone masons expressed Christian preoccupations with the purpose of life, the worship of God, the reality of sin and death, and the desire for eternal salvation. In art and architecture they created forms that expressed those spiritual concerns and provided settings for Christian life as pursued in monasteries, city cathedrals, and churches.

A Romanesque Abbey: Cluny

As we saw in Chapter 5, monasteries or abbeys were located in the country, away from the world. A Benedictine abbey such as Cluny (fig. 6.2), founded in 910 in Burgundy, southeastern France, like that of Centula (see fig. 5.22), was designed to support a contemplative life centered on study and prayer. The elaborate liturgy developed for worship there also provided a focus for music, art, architecture, and scholarship. In effect, Cluny served as both the conscience and the cultural center of society and spearheaded spiritual renewal of European monasticism.

Its layout was similar to the Carolingian monastery of Centula (see fig. 5.22). On the south side of the abbey clusters of buildings housed the dormitory, **refectory** (dining hall), library, scriptorium (where the monks produced manuscripts), and other service structures. These buildings were grouped around two **cloisters**, like open peristyle courtyards, to the south of the abbey church. The relation of cloister to abbey church was derived from that of a Roman forum and adjacent basilica, as first adapted to monastic use by St. Benedict at Monte Cassino in 529 CE. The monastery also provided hospitality to visitors. Through its interaction with the feudal nobility, Cluny grew in wealth and size. Under St. Hugh of Semur (abbot 1049–1109), the monastery housed 300 monks. This growth prompted him in 1088 to build a much larger abbey church that was completed in 1130 (see fig. 6.2). We will now consider its design, and how that reflected the requirements of the monastic liturgy.

Art historians first used the term "Romanesque," literally "in the manner of the Romans," to describe the architecture of western Europe of the eleventh and twelfth centuries, because its rounded arches, stone vaulting, and massive walls were based on Roman architecture. "Gothic" architecture was, in its own time, referred to as *opus francigenum* (Frankish work), because it originated in France. Only in the Renaissance did scholars start to apply the word "Gothic," as a derogatory term based on a mistaken association of such architecture with the Goths (one of the migratory tribes of northern Europe), whom they blamed for destroying classical art. The interior of Chartres Cathedral (see fig. 6.14) captures well the soaring religious aspirations of the builders of Gothic cathedrals (see also figs. 6.8–6.15).

In this chapter we will discuss how medieval art expressed the interests of three powerful elements in medieval society: the Church, the feudal nobility, and the bourgeoisie or townspeople (from the French word *bourg*, meaning town). In the eleventh century, the centers of artistic production were in rural monasteries and pilgrimage churches, but in the twelfth century, with the revival of trade after centuries of political instability, the initiative passed to towns, which began to rival one another in the scale and magnificence of their cathedrals. We will consider how the art and architecture of first the rural monasteries, then the city cathedrals, and finally the churches of new preaching orders, especially the Franciscans, reflect varying expressions of Christian spirituality and forms of religious devotion. We will also explore different medieval

6.3 (far left)
Reconstruction of the
nave at Cluny (after
Kenneth John Conant)

6.4 (left) Plan of the
third Abbey Church of
Cluny (after Kenneth
John Conant)

The Abbey Church as a Stage for Liturgy

Romanesque churches such as Cluny have a distinct,
blocky appearance, made up of groupings of well-
defined geometric forms, with clusters of projecting
chapels at their east ends. Cluny's new abbey church
had to accommodate the elaborate liturgical ceremonies
for which it was famous. To do so, its design included
the usual elements of a Christian basilica (compare the
Early Christian St. Peter's, Rome, fig. 5.5). However, the
growing practice of venerating individual saints, and of
every priest celebrating the Mass of the Eucharist daily,
called for many additional altars set in subsidiary
chapels grouped around the unusual double transepts
and behind the main altar at the east end. It was
Hugh's ambition to outshine other monasteries,
however, that dictated the new abbey's vast size.
Cluny was 555 feet long, and its barrel-vaulted nave
98 feet high (fig. 6.3). Transverse (or crossing) arches
reinforced these stone vaults. The stone vaults were
less vulnerable to fire than earlier wooden ceilings,
and they enhanced the acoustics for Cluny's renowned
musical liturgy. Cluny also had expansive double
aisles and transepts that crossed the nave at right

angles to make a cross (fig. 6.4). A cluster of towers
that rose above its east end were exterior symbols
of the heart of the building, where the Mass was cele-
brated, and marked the intersections of its cruciform
nave and double transepts (see fig. 6.2). When complet-
ed, Cluny was the largest church in the Christian world.

With the demise of monastic culture, what typically
remains today of monastic abbeys is the bare, architec-
tural shell of a once richly appointed fabric, designed to
inspire and sustain faith and house the sacrament of the
Eucharist. The massive walls, overarching barrel vaults,
and small windows of Romanesque churches create an
atmosphere of shadowy mystery, which we must imagine
as once filled with the sound of chanted music and the
scent of incense. Silver candelabras, golden vessels, glint-
ing crucifixes, cult images of saints, and bejeweled
shrines for relics glimmered in the half-shadows.

Besides offering such sensory stimulation, painting
and sculpture articulated the meaning of the Christian
liturgy. At Cluny, as at other Romanesque abbeys, on
entering, a visitor's line of vision culminated beyond the
main altar in the semicircular half-dome of the apse,
where an image of Christ in Majesty dominated the

interior. Already on entering such abbeys, worshipers had passed under tympanum sculptures representing the Last Judgment, where Christ separated the saved from the damned. Such visual effects inspired awe and fear, preparing medieval Christians for penitential acts, and for celebrating the Eucharistic sacrament of bread and wine, which symbolize the body and blood of Christ, through which believers hoped to be delivered from sin.

A Pilgrimage Church: Vézelay

The generation of masons and sculptors who were trained at Cluny built and adorned other churches in France, such as the church of Vézelay, a Cluniac monastery in northern Burgundy. Cluny thus acted as a model for later developments in French architecture and sculpture. Pilgrimages to Jerusalem, or to the shrines that honored the earliest Christian martyrs and apostles, or preserved some relic of them, were part of Christian tradition. Their popularity increased when the Church promised that a pilgrimage would shorten punishment for sin in purgatory after death. Relics were also believed to have miraculous healing power. Churches competed for such relics and were enlarged to house the many pilgrims that visited them.

One prominent gathering point for pilgrims was Vézelay, perched on a hill in southeast France. Its Abbey Church of Sainte Madeleine claimed to possess the relics of Mary Magdalene. After a fire in 1120, the nave (fig. 6.5) was rebuilt in the Romanesque style. Vézelay is a fine example of a Romanesque pilgrimage church that incorporated significant architectural innovation.

Vézelay's Romanesque Interior

Vézelay's interior was designed to accommodate and inspire both the resident monastic community and visiting pilgrims. Its bright, clearly defined spatial divisions result from features that distinguish it from the heavy, dark interiors of Cluny and from other pilgrimage churches that were barrel-vaulted and thus lacked clerestory windows—that is, windows piercing the upper level of the nave wall. At Vézelay, by contrast, a groin or cross vault crowns each bay of the nave. Since, as we saw in the box "Materials and Techniques: Arches and Vaults" on page 114, and in figure 4.26, a groin vault only needs support at its four corners, the builder can insert high clerestory windows into the vaults between these supports (compare figs. 6.3 and 6.5). Groin vaults also unite each bay—the space from supporting pier to supporting pier—into a distinct unit. Engaged columns attached to the piers separate each bay from its neighbors. The piers at Vézalay support transverse arches of alternating reddish-brown and white stones, perhaps inspired by Moorish architecture, as in the Great Mosque at Córdoba (fig. 5.45). The widely spaced

6.5 View of the nave and choir of Sainte Madeleine, Vézelay. 1120–32; choir of later date

Together, these sculptures signify the power of Christ to transform and heal his followers, including the visiting pilgrim. Below, on the **lintel** (the horizontal beam above the portals), the heathen nations are represented, including men with dogs' heads or huge ears and pygmies using a ladder to mount a horse.

Such figures reflect medieval Christian ignorance of non-Western peoples—peoples whom crusaders sought to convert or submit to Christianity. In 1095, Pope Urban II chose Vézelay as the ideal site from which to present the First Crusade to reconquer the Holy Land from the Muslims as a reiteration of the mission of the first apostles, even though their mission was backed by the word of the gospel, not the sword of the crusaders. Vézelay's tympanum sculpture (1120–32) perpetuated that vision. Vézelay was not only a starting-point for pilgrims and crusaders. The dramatic impact of such richly carved entrance portals as Vézelay's also led to a revival of large-scale sculpture.

St. Denis and the Gothic

At the royal Benedictine abbey of St. Denis, near Paris, Gothic architecture was first conceived. St. Denis was the shrine of St. Denis, the patron saint of France, martyred in the third century, whose relics it held, and later became the burial place of French kings. Abbot Suger wanted to create a monument at St. Denis that would symbolize French royal power, and be the spiritual center of France, thus reaffirming the Christian ideal of sacred kingship.

Suger found the old Carolingian structure in poor repair; he also considered it too small. As councilor and friend to kings Louis VI and Louis VII, Suger secured the funds to renovate the abbey. He summoned craftsmen from many regions, and rebuilt the west front entrance, and then, in 1140, the choir at the east end. The **ambulatory** (the passage behind the main altar and choir), with its radiating chapels strung around the apse, is all that remains of Suger's choir (fig. 6.7), a testimony to the innovations of his architectural program. It is a graceful, open, airy structure, filled by the glowing light of large stained-glass windows. The fluid spatial rhythm, the vertical thrust of pointed arches and ribbed vaults, and the lightness are in

piers, colored transverse arches, and brighter lighting create the lucid, rhythmical effect of Vézelay's innovative interior.

Missionary Ideals in Stone

Vézelay was embellished with a wealth of sculptured capitals on the nave arcades (the arches separating nave and side aisles). These vividly depict demons, temptations, moralizing stories, and biblical allegories that were intended to move and instruct viewers. At Vézelay, the portals in the narthex (the entrance hall preceding the nave) are also sculpted (fig. 6.6). These climax in the **tympanum** (the semicircular area above the central portal, between the door lintels and the arches above), which depicts the *Mission of the Apostles*. Because there was little recent precedent, other than Cluny, for such high-relief stone sculpture, manuscript illuminations may have inspired their graphic style, with elongated bodies wrapped in swirls of drapery.

The larger-scaled figure of Christ that dominates this scene is surrounded by a mandorla, an almond-shaped form that denotes his divinity, and here indicates his Ascension to heaven. Rays emanate from his hands to signify the spiritual power he gave the apostles, who extend their gospel books to proclaim their message. On the inner band of **archivolts** (the moldings on the face of the arch) images of the lame, the crippled, and the leprous surround this scene.

marked contrast to the heavy walls and dark, compartmentalized chapels of earlier choirs, such as Cluny's. This luminous, fluid space was soon imitated in other religious buildings in the region around Paris, the Île-de-France. The style it inspired is known as Gothic.

The Birth of Gothic Architecture

In contrast to Romanesque monastic abbeys, whose massive, austere forms suggest the rugged discipline of monastic life in service of a seemingly severe God, Gothic abbeys like St. Denis and later cathedrals like Chartres are delicate, skeletal structures, with soaring vaults, and walls of brilliantly colored translucent glass. They are lofty, luminous, and uplifting. Gothic cathedrals present God through luminous glass as the Light of Lights, and in sculpted stone as the great orderer of history. Christ is portrayed as teacher and king; and the serene figure of the Virgin Mary is given unprecedented prominence.

Elements of Gothic architecture were already present in the Romanesque. But the prevalence of pointed arches, **ribbed vaults** (narrow four-part vaults built on a framework of pointed-arch ribs that support their cells), and large stained-glass windows distinguished the Gothic. Gothic builders replaced the massive walls supporting barrel vaults in Romanesque buildings with a skeletal structure of slender **piers**, and external **flying buttresses** upholding the pointed arches and ribbed vaults (see "Materials and Techniques: Gothic Engineering," page 166). This supple structure accentuates the effect of airy lightness. Pointed arches also enabled the builder to vault bays of various shapes (not only square-plan). Thus, St. Denis's east end radiates out from the center in a web of seven wedge-shaped units, articulated by the columns, pointed arches, and rib vaults (see "Materials and Techniques: Gothic Engineering," page 166). This spatial fluidity complements the luminosity provided by the glass. Gothic churches were also typically enriched by extensive sculpture and surface decoration around their portals.

The essence of Gothic architecture is the symbolic value attributed to light that floods into the buildings' interiors through vast, richly colored windows and the architectural features designed to make this possible. At St. Denis, sheets of glowing stained glass hang between a framework of buttressed piers. The radiance of colored light passing through these windows symbolized the splendor of God, as "the True Light," passing into the church. As at San Vitale, Ravenna (see fig. 5.9), for Suger, light, the most immaterial of substances, was the ideal means for moving worshipers from the material world to the spiritual.

City Cathedrals and Universities

In the twelfth century, the rise in the wealth and power of towns undermined previous centers of power in the rural territories of the feudal lords and monasteries. It also fostered a great surge of cathedral building in cities, which continued into the thirteenth century and beyond. Initiatives in education also passed from the monasteries to the cathedral schools. Out of these grew the new universities, the most notable located in Paris, Oxford, and Bologna.

The cathedral, the center of both religious and civic life, was located at the heart of medieval towns, and the main market flourished in its shadow. Aside from its religious function, the cathedral provided education, a place for public assembly, and a setting for drama and music. Each city sought to outdo the next in the height of its cathedral's vaults and the majesty of its towers, which could be seen for miles. The city's cultural life revolved around the Christian calendar, while the cathedral's liturgy and rituals, combined with the biblical events depicted in its sculptures and stained glass, defined the framework of life. The cathedral of Chartres, southwest of Paris, exemplifies these functions.

Chartres: A Paradigm of Gothic Architecture
In 1145 the Bishop of Chartres, a friend of Abbot Suger, rebuilt his cathedral in imitation of St. Denis. In 1194 a fire destroyed most of it, but its most sacred relic, the mantle of the Virgin Mary, survived. This inspired the clergy and citizens to rebuild the cathedral, which was largely completed by 1220. Its design was modeled on the example of other cathedrals that had refined Suger's work at St. Denis. As a result, Chartres is a paradigm of Gothic architecture, enhanced by sculpture and stained glass. Like other cathedrals, Chartres inspired all classes of medieval society, which contributed financially to its

construction. Windows were donated by the monarchy, nobles, merchants, and artisans, each group of whom had their coat of arms, patron saint, or trade depicted in the stained glass. Nearly all this stained glass remains intact today (see figs. 6.1 and 6.15).

An aerial view (fig. 6.8) reveals Chartres's intricate structure, the strong verticality of its elements, and its cruciform shape. As at St. Denis, the string of radiating chapels at Chartres's east end is integrated with the main structure. Unlike St. Denis, Chartres also has elaborate portals opening onto the north and south transepts (fig. 6.9).

Elaborate sculptures, whose subjects manifest divine order in the cosmos and over history, embellish all three portals—north, south, and the main west ones. These sculptures are organized according to a sense of symbolic geography: On the north portals, which remain in shadow, are mostly Old Testament subjects, conceived as a lesser light, foreshadowing the brighter light of the New Testament. New Testament subjects, therefore, are clustered around the sunlit south portals. The main west portals, lit by the setting sun, reiterate elements from both Testaments, and depict the end of time. Inside the cathedral, the altar, where the life-renewing sacraments are received, is at the east end, where the sun rises.

Christian History in Stone

The sculptural program of Chartres Cathedral presents historical events as having ultimate meaning within a theological framework that links the creation of the world, the fall of humankind into sin, their redemption through Christ, and the Last Judgment. This view of history pivots on the Incarnation of Christ—in Christian belief, the Son of God.

As befitting the main entrance of the cathedral, the sculpture on the west portals of Chartres represents key elements of this vision of history (fig. 6.10). These sculptures (c. 1145–70) are the earliest such cycle at Chartres, and part of the older building that survived the fire in 1194. In contrast to the swirling movement of the Romanesque sculpture at Vézelay (see fig. 6.6), the figures at Chartres are presented in static, ordered clarity and are attached to the **jambs** (the vertical elements on either side of a door, or portal). These unbending, elongated figures adhere stiffly to their architectural support. In projecting out from it as three-dimensional volumes, they herald a revival of sculpture in the round. These jamb figures represent the Old Testament kings and queens of Judah, to signify the generations that awaited the Incarnation of Christ. They support and prefigure the events of the New Testament carved above.

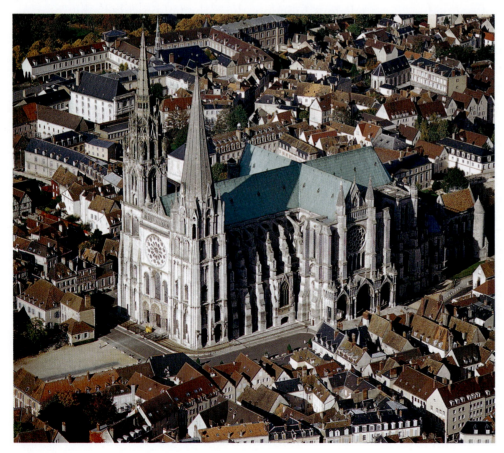

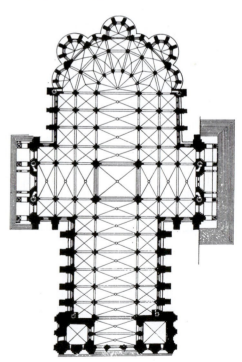

6.9 Plan of Chartres Cathedral

6.8 Aerial view of Chartres Cathedral. Mainly 1194–1220

The tympanum sculptures above each side portal of the west entrance of Chartres symbolize the beginning and end of Christ's earthly life, and frame the promise of his second coming to rule in majesty, depicted on the center tympanum. The tympanum of the right portal depicts the birth of Christ and his presentation in the Temple, where he is set on an altar in prefiguration of his sacrifice. Above, the Christ child sits in the lap of the solemn and majestic Virgin Mary, whose form makes a kind of throne for her child. In the archivolts of the surrounding arch, depictions of the seven liberal arts symbolize knowledge and wisdom, attributes of both Christ and the Virgin Mary. The sculptures of the right tympanum thus signify the meaning of Christ's birth: as teacher, sacrificial lamb, and king.

The tympanum of the left portal depicts the end of Christ's earthly ministry, with his Ascension into heaven in a cloud, as angels assure the apostles that he will return. The tympanum of the central portal proclaims Christ's cosmic rule. Its sculpture shows the serene and majestic Christ surrounded by the four symbolic beasts that identify the Evangelists of the four gospels. In the surrounding archivolts, the twenty-four elders of the Apocalypse, described in the Book of Revelation,

comprise Christ's heavenly court at the end of time. In its entirety, Chartres's sculptural program relates the meaning of all existence to the Incarnation of Christ.

The Cult of the Virgin Mary at Chartres

Chartres Cathedral was also a major center for the cult of the Virgin Mary, whom the medieval Church venerated as pure virgin, Mother of God, Queen of Heaven, and humanizing intercessor with Christ. The center portal of the north transept reinforces the importance of her cult. On the lintel above are scenes of her death (fig. 6.13). In capturing the emotions of the grieving apostles around her, the sculptor uses a graphic realism not seen since classical art. Above these scenes, the heavenly Coronation of the Virgin fills the tympanum.

In developing this complex sculptural program, the north portal sculptors, working around 1204–10, strove for more lifelike effects than those on the main west portals, which were carved at least a generation earlier. The figures on the south portals carry this tendency to greater realism further. This trend humanizes the individual prophets and saints within the cosmic vision of the complete sculptural cycle (see figs. 6.16, 6.26).

Gothic Engineering

The builders of Gothic cathedrals such as Chartres were driven by two major goals: To create soaring vaults over the central nave and choir, and to provide the largest possible openings in the walls for stained-glass windows.

Romanesque churches such as Cluny (see figs. 6.2–6.4) were built with stone barrel vaults. We saw in Chapter 4 that, in such vaults, the load is spread continuously on either side along its full length (see "Materials and Techniques: Arches and Vaults," page 114). This meant that the size of the window openings in the walls supporting those vaults was severely limited. Wide windows would have made the walls too weak to support the vaults above. Gothic church builders wanted to maximize the potential beauty of stained-glass windows. To do this, they had to reduce the bulk of the walls to the absolute minimum. They also wanted to raise the stone vaults much higher than Romanesque builders had done, without risking collapse. To achieve these ends, Gothic builders developed a new form of vaulting that only needed support from piers at the four corners from which each section rose.

The new vaults were based on a pointed, rather than a rounded, arch. Arched ribs rose from the corner piers, meeting at the topmost center point of the vault (see diagram). With this skeletal structure in place, the space between the vault ribs could then be filled in with lightweight masonry, so reducing the weight of the vaults. Unlike rounded arches, pointed arches can rise to any height regardless of the width of their base (see, for example, the vaults of the ambulatory of the Abbey Church of St. Denis, Paris, fig. 6.7). Pointed arches also allow for greater variation in the width and shape of each bay and allow stained-glass windows to rise high into a vault. Additionally, a ribbed vault creates less sideward thrust. With less pressure pushing out, less buttressing was needed to counterbalance it. A ribbed vault, therefore, allows the builder to reduce the bulk of the vertical supports, or piers. The space between the piers could then be filled with glass (see view of the nave, Chartres, fig. 6.14). Gothic builders also developed a system to transfer the sideward thrust of the stone vaults away from the walls onto massive external piers. These external supports were linked to the internal supporting piers by what are called flying buttresses (seen in the aerial view of Chartres, fig. 6.8, and figs. 6.11 and 6.12).

These three innovations—pointed arches, ribbed vaults, and flying buttresses—allowed Gothic church builders to move away from massive, dark Romanesque buildings. Now, delicate, luminous, and intricate skeletal structures would create the impression of vertical thrust more than weighty mass, and inside these soaring cathedrals, colored light would glow under high, graceful vaults.

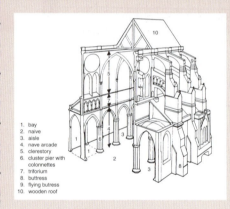

1. bay
2. naive
3. aisle
4. nave arcade
5. clerestory
6. cluster pier with colonnettes
7. triforium
8. buttress
9. flying butress
10. wooden roof

6.11 Isometric projection and cross-section showing the structure and parts of Chartres Cathedral

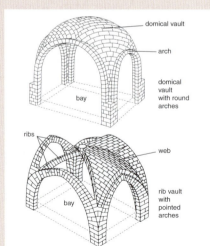

6.12 Vaults constructed using round and pointed arches

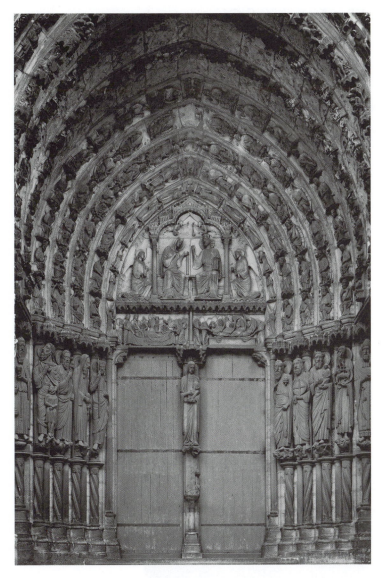

6.13 Coronation of the Virgin, north centre portal, Chartres Cathedral. 1204–10

The Cathedral as House of God

When medieval worshipers passed through the portals of a Gothic cathedral, they symbolically entered the house of the King of Kings, a prototype of the city of God, the heavenly New Jerusalem. The scale, proportions, lighting, and beauty of the structure expressed this exalted vision, while supporting the meaning of the liturgy. The soaring height, repeated vertical elements, and richly colored stained-glass windows express majesty and focus attention heavenward. The height of Chartres's nave relative to its width increases the sense of height, while the engaged columns, dividing the bays, and pointed arches accentuate the vertical accent (fig. 6.14).

6.14 View of nave and choir, Chartres Cathedral. 1194–1220

Passing down the nave at Chartres, the worshiper would also sense a quickened rhythm from bay to bay toward the altar, as well as an impression of extreme lightness. Effectively, colored glass and vertically accented, ribbed vaults have replaced the massive walls and barrel vaults of Romanesque structures. Each bay spans a shorter length. The walls of these narrower bays are also articulated more delicately: piers support a three-stage elevation, comprised of the arcade, a **triforium**—screening the roof of the side aisles—and a clerestory, almost equal in height to the arcade. Use of pointed ribbed vaults, as opposed to Romanesque rounded ones, allows glass to extend to the peak of the vault. Thus, the walls are dissolved into colored glass and delicate stone tracery, while the vaults soar overhead. A system of exterior flying buttresses which counteract the weight and outward thrust of the vaults (figs. 6.11, 6.12) makes this skeletal structure possible. The majestic interior that results provides a worthy setting and perfect acoustics for the Eucharist's liturgical celebration in word and music (see "Materials and Techniques: Gothic Engineering," page 166).

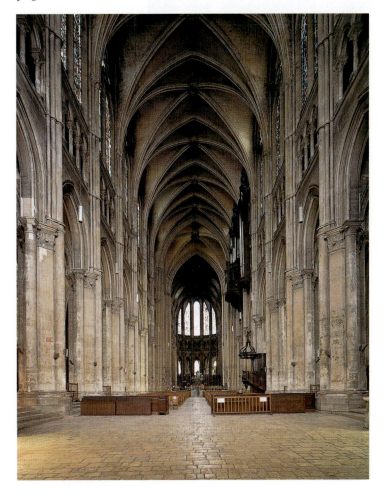

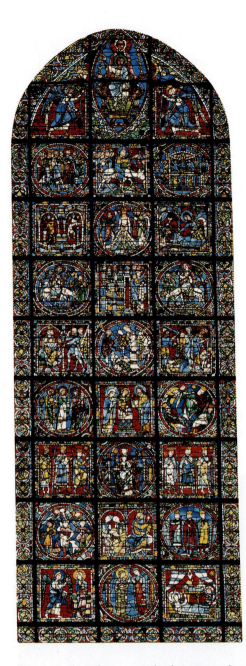

6.15 Scenes from the Life of Christ, stained glass windows on west façade, Chartres Cathedral. c. 1150–70

The Image of Christ in Art

Among the different roles of Christ figured in medieval art—as priest, king, sacrificial lamb, and judge—two in particular have impressed later generations: teacher and savior. Three images representing these roles stand out: one in sculpture, another in manuscript illumination, and a third in fresco from Constantinople.

Sculpture: Christ as Teacher and Savior

When Christ's figure is placed on the central portal **trumeau** (the stone post supporting the lintel) of Gothic cathedrals, he symbolizes the door through which one must enter to be saved. Such is the handsome figure on the trumeau at Amiens Cathedral, known as *Le Beau Dieu* (or beautiful God) (fig. 6.16). Carved around 1220–35, this figure of Christ stands between the doors and tramples underfoot a lion and a basilisk (the mythical king of serpents) who signify the

Stained Glass and the Symbolism of Light

Chartres's structural and aesthetic innovations fully realize Suger's ideal of light as the symbol of God's radiance. With a circular **rose window** crowning each portal, and the upper level wrapped in stained glass, soft, colored light glows in the vaults and animates the lower stonework with warm spots of color (fig. 6.15) (see "Materials and Techniques: Stained Glass," page 169). Besides these sensory qualities, the primary meaning of the windows is more essential and symbolic. A popular mystical analogy compared light penetrating and tinted by the glass to the Immaculate Conception of Christ in the womb of the Virgin. Gothic cathedrals such as Chartres are the climax of a long tradition of creating space to express Christian faith in material form.

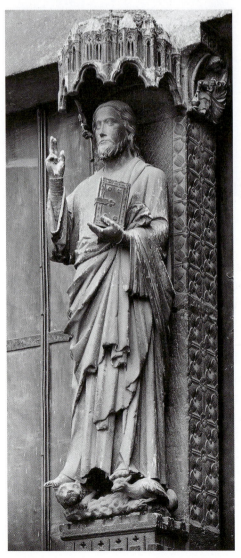

6.16 Christ (*Le Beau Dieu*), trumeau of central portal, west façade, Amiens Cathedral. 1220–35

Devil and the Antichrist. As teacher, Christ holds the Gospel in one hand, while raising the other in benediction (compare fig. 5.17, in the dome of 5.19, and 5.20). Whereas most figures at Chartres seem frozen to their columns, *Le Beau Dieu* at Amiens is more fully modeled. Strong contrasts of light and shade fall over the folds of his garment, creating a sense of volume. His handsome features and grave expression beckon the citizens to enter by his door. This captivating image has been imitated into our own time.

Manuscript Illumination: Christ's Crucifixion

Another memorable image of Christ from Gothic art is of his Crucifixion (fig. 6.17). This example illuminates a liturgical book, called a missal, made in Paris about 1314–28 for use in celebrating the Mass. As is common in Gothic painting, the Crucifixion is depicted symbolically against a flat, checkered ground; the only characters are Christ, Mary, and the Apostle John. Above them, two small figures contrast the Jewish Synagogue and the Christian Church. The Synagogue's tablets of law, representing the Ten Commandments,

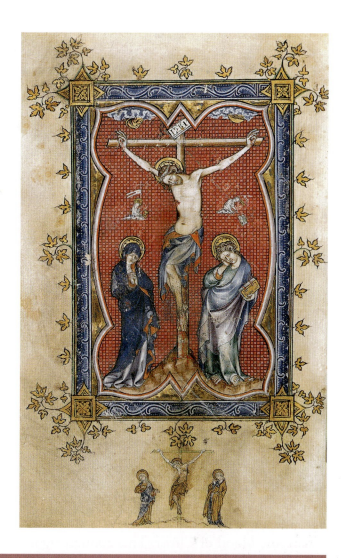

6.17 *The Crucifixion*, page from the *Missal for the Use of Paris.* c. 1314–28. Illumination on parchment, 11³/₄ x 8¹/₄". Paris, Bibliothèque Nationale, Ms. Lat. 861, fol. 147v

❖ MATERIALS AND TECHNIQUES ❖

Stained Glass

Colored glass or thin stone windows were used in Early Christian and Byzantine churches. But stained-glass windows first became prevalent in the Romanesque period and thereafter developed into a major expressive element of Gothic religious architecture. Large windows were filled with imagery and symbols from the Old and New Testaments, intended to instruct worshipers through their narrative and to inspire them through their radiant beauty.

Gothic stained glass is famous for its deep reds and blues, contrasted with touches of yellow and green. The colored, translucent glass glows like precious jewels—evoking biblical images of the Heavenly Jerusalem—while radiating beams of colored light throughout the church interior.

There are two types of stained glass. Pot metal glass is made by adding metallic oxides to molten glass, whereas flashed glass is made by fusing colored glass onto clear glass. Details, such as facial features, are painted on with black enamel and then fused to the glass by firing. To make a stained-glass window, the design is first drawn on a flat surface. The glass is cut to fit the shapes, and the pieces are joined together with lead strips. When completed, the entire piece is encased by a grid-iron armature for stability and then installed in the window, creating an incomparably brilliant, glowing effect.

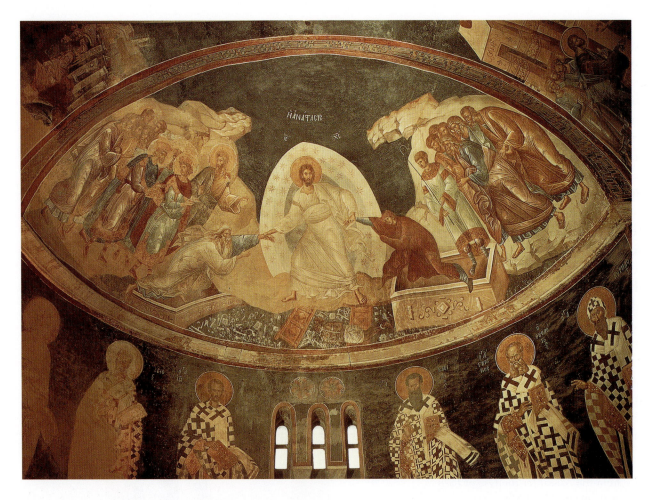

6.18 *Anastasis* (Resurrection or "The Harrowing of Hell"), apse fresco in the Church of Christ in Chora (now Kariye Camii Museum), Istanbul. 1315–21

are cast down, while the Church extends a chalice to receive the blood of Christ. This contrast signifies Christian belief that Christ's sacrifice on the cross established a new era of freely given grace that delivers believers from the condemnation of breaking the Ten Commandments. As with sculpted scenes of the life of the Virgin at Chartres, in the way the figures are depicted, the painter has attempted to fuse religious belief with emotion.

Fresco: Christ's Resurrection

Christians believe that Christ rose from the dead three days after he was crucified, and for them, his resurrection provides the basis of hope for their own. One of the most powerful artistic expressions of this hope was made at almost exactly the same time as the Parisian *Crucifixion*, but in the very different cultural context of an Orthodox Byzantine monastery in Constantinople: the *Anastasis* (Resurrection, also called "The Harrowing of Hell") (fig. 6.18) was painted around 1315–21 as the focus for worship in the apse of a monastic funerary chapel. It represents the risen Christ, as humankind's deliverer through his triumph over death. Christ's radi-

ant garments contrast with the darkness of hell and signify his divine authority to restore life to Adam and Eve. He draws them up from their tombs, canceling out the consequence of their original sin. Old Testament kings and prophets witness this fulfillment of their prophecies. In the foreground, amidst a pile of broken locks, Satan lies bound, prostrate across the shattered gates of hell. This vivid scene represents through the action depicted what is conveyed in figure 6.16 through the image of Christ trampling on a lion and a basilisk.

Franciscan Churches and Christian Humanitarianism

While ever more elaborate cathedrals in the Gothic style were built throughout Europe, patrons and architects in Italy chose instead to build large churches more like Early Christian basilicas, but in Gothic style. The Franciscan order, in particular, which was founded in the thirteenth century to minister to the spiritual needs of the cities, designed its churches as preaching halls to

accommodate the crowds that preachers attracted in the poorer areas of cities. Their church interiors were covered with frescoed wall paintings that complemented their preaching. The style of these frescoes recalls the Byzantine tradition, as seen in the *Anastasis* (see fig. 6.18), surviving Early Christian art, and contemporary Gothic works.

The Franciscans' founder, St. Francis of Assisi (1182–1226), was known for his devotion to Christ as the loving, suffering savior. Franciscans imitated Christ's care for the poor, emphasized the humanitarian side of the Gospel, and fostered appreciation for God's creation. Around 1300, the mother church of the Franciscans in Assisi in central Italy attracted artists whose work led to new directions in painting. Their focus on the expression of human feeling and the immediate human environment anticipated the Italian Renaissance. Where Gothic cathedrals display a vision of the cosmic purposes of God, the painted fresco cycles of Franciscan churches in Italy present a vision of the earthly ministry of the compassionate Christ to inspire service to the poor and needy. In locating their churches in the poorer areas of towns, Franciscans strove to emulate this ideal. They expressed through architecture, art, and even location a humanitarian outlook that challenged the cosmic vision, lofty architecture, and central urban location of French Gothic cathedrals.

Santa Croce

The Franciscan church of Santa Croce ("Holy Cross") in Florence was begun in 1294, probably to the designs of Arnolfo di Cambio (1232–1301) (fig. 6.19; see also fig. 6.44 for an aerial view of Santa Croce and its setting), a prominent sculptor and town planner, as we'll see in the section on Florence. Santa Croce is essentially a large, open preaching hall, with a cluster of private chapels flanking the main altar at the back of which stands a painted **altarpiece**, with sacred figures set against a gold ground, typical of the period (see plan, fig. 6.20, and fig. 6.21). Besides the timber roof, low clerestory, and the wide spacing of the nave arcade, it differs from French Gothic architecture in the predominance of wall painting over stained glass. These wall frescoes cover not only the triumphal arch, but the apse, and the transept chapels too (see fig. 6.21). This profusion of frescoes, painted by Giotto di Bondone (c. 1267–1337) and his pupils (discussed below) focuses attention on the humanity of Christ, and also shows exemplary saints and Franciscan monks emulating Christ's acts of love and mercy.

Imitating Christ was central to the Franciscans' mission. Thus, a large painted crucifix hangs in the apse, similar to the *Crucifix* by Coppo di Marcovaldo (active 1260s–70s) from the second half of the thirteenth century (fig. 6.22). Its subject is the suffering Christ, who served as a model for St. Francis. By emphasizing the humanity and suffering of Christ, such a crucifix highlights the meaning of the other imagery at Santa Croce.

6.19 Arnolfo di Cambio, Santa Croce, Florence. Nave and choir, begun 1294

6.20 Plan of Santa Croce, Florence

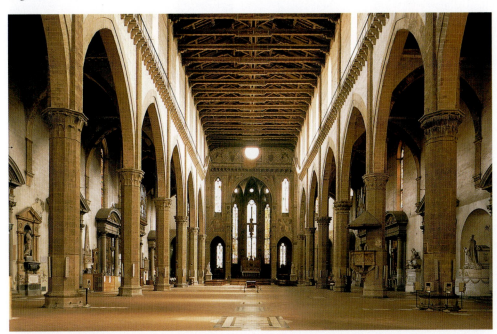

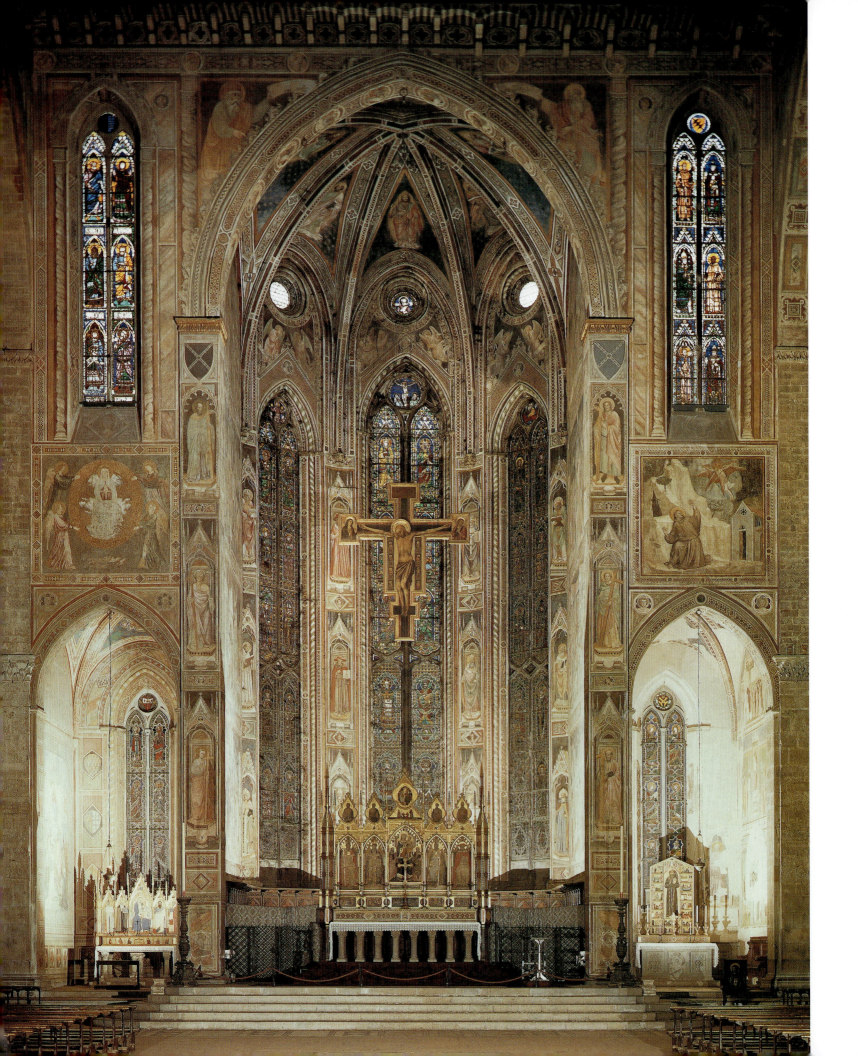

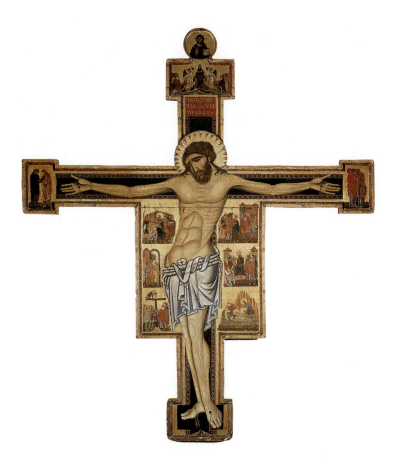

saints traditionally identified as the parents of the Virgin Mary.

Giotto's vivid narrative approach called for new artistic forms to convey personal sorrow or joy, rather than mere types and symbols, as found in much medieval art. This emphasis on individuality yields a robust, three-dimensional treatment of the human figure, that builds on the most realistic aspects of Gothic sculpture. Giotto's Christ figure in the Arena chapel, for example, recalls the handsome *Beau Dieu* at Amiens Cathedral (see fig. 6.16). Giotto's depiction of personalized human actions required a fitting setting, thus initiating the rebirth of pictorial space in Western art. This led to the abandonment of the gold ground of Byzantine art (seen in the *Transfiguration*, fig. 5.16), and the flat checkered ground of Gothic manuscript illuminations (seen in the Paris *Crucifixion*, fig. 6.17).

The new elements Giotto developed appear in his scene of *The Meeting of Joachim and Anna at the Golden Gate*, in the Arena Chapel cycle (fig. 6.25).

Giotto and the Arena Chapel

The art of the Florentine Giotto is imbued with the humanitarian vision of the Franciscans. He may have worked for them at Assisi, and certainly did in Florence. Not only was Giotto's style in keeping with the Franciscans' humanitarian outlook, it also changed the course of Western art. His best-preserved legacy is the cycle of frescoes he painted between 1304 and 1306 for the private Arena Chapel, Padua, built for the palace of a wealthy citizen, Enrico Scrovegni (fig. 6.23) (see "Materials and Techniques: Fresco," page 174). While the fresco cycle was painted for a private citizen, it is exemplary of Giotto's artistic and spiritual outlook.

Giotto's Arena frescoes depict with dignified but lifelike simplicity the lives of the Virgin and Christ, plus one large scene of the Last Judgment. In the Franciscan spirit, Giotto's depiction of individual human dramas reveals God's compassion. In the Arena frescoes, he embroidered the Gospel account with stories that had not been recorded in accepted biblical texts, such as that of Joachim and Anna, the

6.23 Interior of Arena Chapel, Padua, frescoes by Giotto. 1304–06

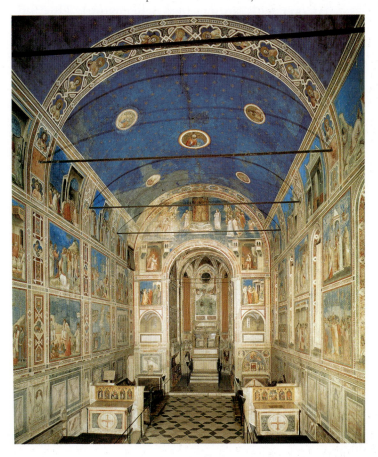

6.21 View of apse, with altarpiece, crucifix, and frescoes, Santa Croce, Florence

Fresco

The origins of fresco date back to antiquity. However, from the time of Giotto, the technique became popular again and was refined during the Italian Renaissance by Masaccio and Michelangelo. Frescoes are large-scale paintings executed in a broad, dramatic style on plaster, often on the walls or ceilings of churches or private buildings. A fresco must be carefully planned out in advance, since execution of each section must be completed before the plaster sets (fig. 6.24). It is done in sections with only enough plaster applied at a time that can be finished in one day's work. These patches of plaster are called "giornata," after the Italian word for "day." The artist tries to arrange these giornata so that the seams are not obvious.

To paint a fresco, first a layer of rough plaster, called "arriccio," is applied to the wall. The center of the wall, as well as the horizontal and vertical axes are established and the composition is drawn onto the arriccio in charcoal, which is then painted over with sinopia (red ocher paint). This full-scale underdrawing is called the sinopie. A final layer of thin plaster (intonaco) is applied each day. Since the day's intonaco covers that part of the sinopie, the image must either be painted from memory or the design transferred onto the fresh plaster from a preparatory drawing, called a cartoon. This was done by pricking the outlines of the drawing with small holes through which powdered charcoal was dusted onto the fresh plaster. This technique of painting into wet plaster is called *buon fresco*. The pigments are suspended in a water base and applied to the new plaster, which absorbs the color. When it has set, the colors are almost as permanent as the wall itself. Fine details and colors such as blue (which do not bind well with the plaster) are often added as *fresco a secco*, which is painting on the already set plaster with pigment in an eggwhite or lime binding vehicle. However, since these details do not penetrate the plaster in the same way as *buon fresco*, they often flake away over the course of time.

6.24 Drawing of the stages in the execution of a fresco: a. masonry wall; b. arriccio; c. painted intonaco of upper tier; d. new intonaco ready for color; e. previous day's work; f. underdrawing in sinopia

The scene represents the climax of the story, when the once-disgraced Joachim and his barren wife Anna were said to have been reconciled at God's command, and, according to legend, the Virgin Mary was immaculately conceived at the moment of their embrace. Giotto uses the architectural framework to define the setting, and draw the eye to the climactic point of both the main event and the sub-theme. The couple's tender embrace is centered on the edge of the tower. In the sub-plot behind, the line of the door-post draws the eye to the point of exchange between Anna's companion, and the sinister woman in black, who would be barren Anna's tormenter. The gestures and expressions of these large-scale figures convey poignant human drama to which we can personally relate. They also speak of a God of compassion and mercy.

Giotto's fresh, humane style transformed Western art and inspired the artists of the Italian Renaissance. It thus also helped to transform Western people's vision of God and opened the way to the modern world.

6.25 Giotto, *The Meeting of Joachim and Anna at the Golden Gate*, Arena Chapel, Padua. 1304–06. Fresco

THE SELF

Medieval Christians conceived of themselves as members of a fixed social structure. An eleventh-century bishop, Gerard of Cambrai, clearly expressed this concept: "From its very origin the human race had been divided into three classes, all of which aid each other: the men who pray, the fighting men, the tillers of the soil." It is a predominantly masculine world, even though its citizens venerated the Virgin Mary and knights paid homage to the noble's wife according to the code of medieval chivalry (see page 177). Medieval society did not distinguish the bourgeoisie from "the tillers of the soil"; however, with the rise of the cities and the social upheavals of the fourteenth century, the bourgeoisie gained a prominence that disrupted the established social order, and ultimately changed its balance in their favor.

Medieval art rarely represents individuals. More commonly, people were depicted as representing their social roles. Furthermore, since the clergy, "the men who pray," were the primary patrons of art, they also controlled the terms on which art represented both sexes and all classes. The art of the Church offered people role models for the active or contemplative life, but provided women with few opportunities for self-representation, and "the tillers of the soil" with even fewer.

The knights and lords, in pursuing the active life of the "fighting men," were disdainful of education.

Although nobles used the arts for display, much of the money they spent on art went to monasteries and cathedrals, and so passed through the hands of the clergy. Even when the bourgeoisie began to prosper, in the twelfth and thirteenth centuries, they were slow to patronize the arts. They usually did so through municipal channels or through guilds (associations of craftspeople and professionals), to express an institutional rather than a personal voice, reinforcing a view of society based on fixed types and classes of people, within which the individual had his or her allotted place. Thus the clergy ultimately controlled the role models of society in the form of the saints, the Virgin Mary, Christ, and other exemplary figures, such as the "Nine Worthies," mentioned below.

Warriors and Saints: The Active and Contemplative Life

In medieval society, warriors and saints filled complementary roles: Ideally, they were both perceived as serving Christ, whether wielding the sword or a gospel book, and each offered a vocation to those best suited for the active or contemplative life. The Church tried to direct the nobles toward the crusades, holding out to them the model of the Christian knight.

As in antiquity, people thought of medieval artists as skilled manual workers. And, as we've seen throughout this chapter, their works reflected and reinforced society's values by giving them concrete, visible forms. But, with the building of the great cathedrals in the eleventh and twelfth centuries, their status changed.

At the construction site of every great cathedral was a masons' lodge, overseen by a master mason, who was responsible for all aspects of the cathedral's construction and decoration. During the twelfth century, as cities grew richer and more powerful, painters and sculptors broke off from these lodges to form their own guilds, which were similar to modern trades unions. Artists' guilds oversaw the education of artists by master artists, who took on apprentices in their workshops. Guilds also enforced professional standards, controlled work conditions, and promoted the spiritual and material well-being of members. Nevertheless, their members mostly worked as anonymous artisans.

On the eve of the Renaissance, however, some established individual reputations that raised their status above that of a guild craftsman. Arnolfo di Cambio, for example (see page 186), was a sculptor and architect who became general overseer of works for Florence. The public recognition that went with such responsibilities signaled a more prominent role for artists in Italian culture. In northern Europe this prestige came later.

Social upheavals in the fourteenth century brought further change. The Black Death of 1348–50 and subsequent epidemics cut Europe's population in half; greater wealth was concentrated in fewer and newer hands. With the growth of trade came the growth of cities, and the bourgeoisie escaped further from the grip of the nobles. At the same time, education spread outside the clergy, allowing literature and art to reach a wider and more secular audience. These trends also signal the emergence of individual identity: Artists were sought after and remembered by name, and portraiture reemerged. Such changes heralded the world of the Renaissance, in which individuality was vigorously asserted.

love face arrows from Cupid's bow. On the right, a victorious knight rides away with his lady.

Both the subject and style of this medieval jewelry casket contrast strongly with the fourth-century *Marriage Casket of Secundus and Projecta*, with its mythological figures in a Late Antique style (see fig. 5.24). The surface of the ivory casket is densely covered with figures, brought together without regard to spatial continuity or depth, as in contemporary manuscript illuminations. The finely worked detailing reflects the aristocratic taste for small, refined objects. It was made to contain a lady's jewels, and carved to arouse her fantasies of love and courtship.

The "Nine Worthies"

While the rituals of courtly love diverted the feudal nobility, another set of ideals can be seen in series of tapestries, to be hung on castle walls. The images depict the so-called "Nine Worthies," or Paladins. Each series

6.32 The Limbourg Brothers, *January*, page from *Les Très Riches Heures du Duc de Berry*. 1413–16. Illumination on parchment. 9½" x 6". Musée Condé, Chantilly

(fig. 6.31) comes from a series perhaps designed by Nicolas Bataille (fl. late fourteenth century) about 1385. In it, the king is enthroned under an elaborate Gothic canopy; small figures of bishops and cardinals stand in surrounding niches. Their smaller scale implies the subordination of the Church to the state, while their presence gives the monarchy religious sanction. The series is emblazoned with the French royal arms, as well as those of the Dukes of Berry and Burgundy, which indicates its original use in a royal household, where warm, thick-textured tapestries not only covered the vast, bare walls, but, because they were expensive, also signaled the status of their owners. Such tapestries would have inspired the nobles with the example of eminent historical figures, while at the same time covering their otherwise bare walls with spectacular displays of wealth.

Feudal Display: The Nobleman's Banquet

Wealth and power were also on display at the sumptuous banquets given by feudal lords, occasions created to appeal to the loyalty of their followers. A richly embellished manuscript made for Jean, Duke of Berry, brother of the king of France, illustrates such a banquet with lavish tapestries on the wall behind (fig. 6.32). The manuscript is itself an outstanding example of the works of art through which nobles displayed their wealth. The Duke of Berry was a lavish patron of arts and letters, collecting tapestries and manuscripts for his various residences. Among his manuscripts, the Book of Hours known as the *Très Riches Heures*,

typically consisted of nine males or nine females: three respected pagans from antiquity, three eminent Jews, and three notable Christians. All the male Worthies, who lived by the sword, were known for their might and valor. The tapestry detail of King Arthur shown here

6.31 Nicolas Bataille (?), *King Arthur*, from Nine Worthies Series. c. 1385. Tapestry, height 11'6½". Cloisters Collection, The Metropolitan Museum of Art, New York

6.35 Rhenish
Master, *Garden
of Paradise.*
c. 1410–20.
Tempera on wood,
$10^3/8''$ x $13^1/2''$.
Städelsches
Kunstinstitut,
Frankfurt/Main

surrounded by symbols of her attributes—the lily and
fountain for purity, and the rose for suffering.
Accompanying her are female saints, one of whom lets
the Christ child play her zither, while another picks
cherries, the fruit of paradise. The archangel Michael
confers with his earthly counterpart, the knight St.
George, dressed in chain mail. The angel and knight
signify the overthrow of evil, embodied by the tiny
slain dragon.

The multitude of flowers in this paradise garden also
evokes its popular secular counterpart, the garden of love.
We see this subject in *millefleurs* (thousand-flowers) tap-
estries of about the same date, which resemble this
painting in color and detail. Both types evoke a secure
world of reverie, where flowers are plentiful, trees are
laden with fruit, and a pure fountain sustains life. Storm,
destruction, time, and death are banished. Medieval
gardens were turned inward to exclude external disorder,
as is the paradise garden painted by the anonymous
Rhenish master. While this artist paid great
attention to natural detail, he still did so within
a protected space.

The Noble View: Nature as Property

While the clergy read nature as a "book of symbols,"
medieval nobles dominated it, and their artists represent-
ed it to them as a possession and a stage. For the nobles,
nature was an arena in which to fight, hunt, or court a
lady. They hung their walls with tapestries that idealized
all three pursuits. But above all, nobles saw land as some-
thing to possess and dominate. In art commissioned for
nobles, nature first appeared in the highly schematized
illuminations of secular manuscripts made by lay artists
working within the city guild system, rather than by
monastic artists. By the mid-fourteenth century, artists
gave nature a fuller treatment, though restricted to the
lush gardens beside a castle, bordered by dense forest.

Seasonal Activities

Vivid representations of nature as a stage for the sea-
sonal activities of medieval nobles first appear in man-
uscript illuminations and in the calendar pages of
Books of Hours. In an early example, painted about
1370 (fig. 6.36) a noble and his followers set out to

go hawking. They pass through a flat, schematic landscape of trees and rocks, filled with birds. The artist accurately depicts more than a dozen species of birds. Yet, for all its lively details, the image lacks any spatial depth, and the figures are represented in silhouette against the neutral ground of the manuscript page.

A generation later, the Limbourg brothers depicted similar subjects in even more lifelike terms. In the *Très Riches Heures* of the Duke of Berry, discussed above, seasonal activities are set within a believable space containing many lively details. We see realistic details of the court's outdoor activities, including peasants working the fields, even swimming nude in a river. For August (fig. 6.37), the Limbourgs painted nobles and their ladies dressed in rich apparel, setting out on a hawking expedition. Beyond them, under the duke's castle walls, peasants harvest wheat and load a cart. Further back, dominating the skyline, is the duke's Château d'Etampes, parts of which still stand today. The Limbourgs captured the contrast between the nobles and the deferential falconer who precedes them on foot. They also observed how water distorted the

appearance of the swimmers' bodies and caught the sensuous effects of light, weather, space, and buildings. Their innovative portrayal of nature laid the foundations for landscape painting in northern Europe.

The Bourgeois View: Rural Plenty

Meanwhile, in Italy, about seventy years earlier, in a civic commission for Siena's city hall, the Sienese artist Ambrogio Lorenzetti (fl. 1319–47) was given the opportunity to represent a bourgeois view of nature—something that had not been done since ancient Roman times. As we saw in Chapter 4, Roman writers such as Virgil viewed nature as a place for renewal from the pressures of city life, and a source of bounty to be cultivated by farmers. Lorenzetti, in his revolutionary fresco painting of 1338–39 (fig. 6.38), represents it much the same way, in showing the effects of good and bad government in city and country (see also fig. 6.46).

Lorenzetti's expansive vision of the actual countryside around Siena is one of the most innovative landscapes of its time, in creating the illusion of looking out over a vast

6.36 (right)
Hawking scene with birds in margins, page from a Genoese treatise on the seven vices. c. 1370. Illumination on parchment, 6¹/₂" x 4". The British Library, London

6.37 (far right)
The Limbourg Brothers, *August*, page from *Les Très Riches Heures du Duc de Berry*. 1413–16. Illumination on parchment, 9" x 5¹/₂". Musée Condé, Chantilly

expanse of space, as if seen from Siena's city walls. The specific qualities of Siena's actual countryside express the ideal of a bountiful, well-ordered land. The artist has delighted in the expanse of a particular view, and also devised the means to represent it in painting. Lorenzetti's work marks the end of the medieval style of allegorical landscape. In the future, artists would emphasize the sensuous qualities of nature. Here, Lorenzetti depicts the countryside around Siena as seen by its bourgeois citizens. We see their interest in the produce that is brought to market and the prosperous burgher pursuing country sports once practiced only by the nobility. His vivid landscape goes beyond Giotto (or the St. Francis master) (see fig. 6.34), for whom landscape remains a stage for religious narrative, and preceded the Limbourg brothers by some seventy years in creating the illusion of an expansive space in which figures move freely. Lorenzetti's novel landscape also signifies the bourgeoisie's new prominence within the changing social structure.

6.38 Ambrogio Lorenzetti, *Allegory of Good Government: The Effects of Good Government in the Country.* 1338–39. Fresco, Sala della Pace, Palazzo Pubblico, Siena

THE CITY

The twelfth and thirteenth centuries saw a great reawakening of European cities, especially those on the major trade routes. At the heart of all medieval cities were market squares for the exchange of goods. They were typically located near the cathedral or larger city churches and served many of the same functions as the Greek agora and Roman forum. The main market square was the mercantile, political, and spiritual center. Ideally both cathedral and city government were located there, and festivals, tournaments, and mystery plays, that is, dramatic representations of biblical events, were performed in its open space. The major streets ran from this central market to the city gates and provided the most profitable locations for trade. Towns were enclosed by protective walls, strengthened by defense towers, especially at the city gates.

While most secular medieval buildings are long gone, we can still see the core patterns of urban life established so long ago. The form of medieval cities expressed the presence, power, and priorities of the dominant social groups: the clergy, the feudal lords, and the bourgeoisie. Throughout the Middle Ages, cathedrals and castles, symbols of the power of Church

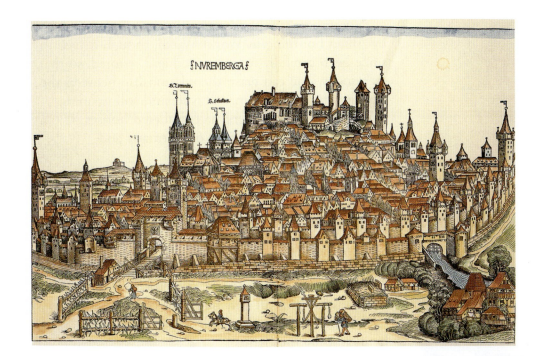

6.39 *View of Nuremberg*, woodcut from Hartmann Schedel's *Chronicle of the World*. 1493

6.40 Tiergärtnertor Square, with the Pilatushaus, from the southwest, Nuremberg

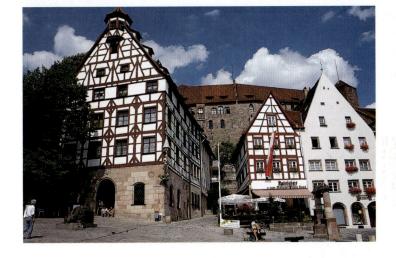

and state, dominated European cities. By the late Middle Ages, however, great trading centers such as Florence and Siena in the south, and Brussels and Bruges in the north, were given a third symbolic crown, large city halls that signified the rising power of the bourgeoisie. Besides these city halls, which served as centers of civic government, merchants and craftsmen also expressed their place in the civic structure through guild halls. By the late Middle Ages, two types of cities existed: One dominated by the castle of a feudal lord, under whose protection it had first arisen; the other, more independent of feudal control, dominated by the town hall of a ruling oligarchy of merchants. In both types the Church helped provide social cohesion.

Nuremberg: Clustered Around a Castle

Nuremberg in southern Germany typifies a city that grew up around the castle of the ruler who protected and controlled it. In the eleventh century, the Holy Roman Emperor Henry III built the castle at Nuremberg above the Pegnitz River. The town grew up below the castle and became a self-governing city under the emperors. It is a classic example of a city dominated by its castle, with mercantile life centered round its two main parish churches. At the crossroads of important trade routes in the late Middle Ages, Nuremberg was also a thriving cultural center.

The colored woodcut *View of Nuremberg* of 1493 (fig. 6.39) is drawn from the south, and shows the castle and the two main churches, Sankt Lorenz and Sankt Sebald, located on either side of the river, dominating the skyline. Packed in behind the city walls are the spires of smaller churches, a number of prominent citizens' stone tower houses, and the half-timbered burghers' houses that were the envy of their day. The large Pilatushaus under the castle walls is characteristic of medieval German domestic architecture (fig. 6.40). It was built in 1489 using a timber framework with plaster in-fill, set above a stone ground floor for protection against fire. The lively black-and-white pattern of its upper timber frame and plaster in-fill is typical of the region.

Another feature of medieval Nuremberg was the beautiful fountain (the so-called Schöner Brunnen)

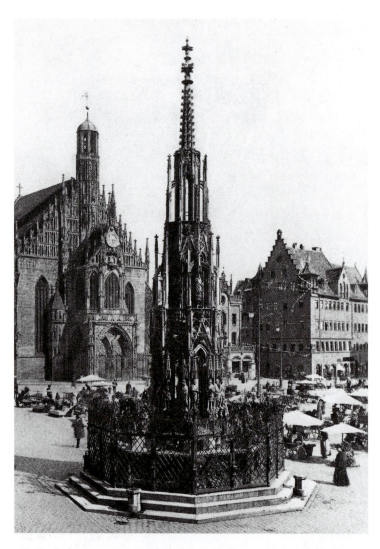

6.41 Hauptmarkt, with the Schöner Brunnen and the Frauenkirche (restored after World War II), Nuremberg. Fountain, a replica of 1879–1902; original in the Germanische Nationalmuseum, Nuremberg

built in 1385–96 in a new market square (fig. 6.41). This tall, ornate structure was painted, gilded, and designed like the spire of a Gothic cathedral, with arches, flying buttresses, and decorative finials. It was adorned with forty figures–including the "Nine Worthies"–to symbolize justice, and the religious sanction of secular rulers. Such fountains served a practical, aesthetic, and symbolic function, while also demonstrating the skill of the city's leading sculptors and masons.

However, the beauty of this fountain, the surrounding square, and the Frauenkirche church beyond it covered over a darker side to medieval culture–the marginalization and persecution of Jews. In 1349, under the Emperor Charles IV, Nuremberg's Jewish quarter had been violently destroyed to make way for this new market; the Frauenkirche was built where the synagogue had stood.

Nuremberg survived largely intact until devastated by Allied bombing in World War II, though it has since been carefully reconstructed and restored, so that, even today, one can grasp the relationship between the city and its once-dominant castle, and still examine examples of the burghers' half-timbered houses that were once characteristic of Germany and the Rhinelands.

Florence: Communal Buildings and City Hall

While Nuremberg represents a city dominated by a nobleman's castle, the layout and civic buildings of late medieval Florence in Italy reflect its citizens' desire to establish an independent, self-governing republic, ruled by its leading merchants.

The Pursuit of Civic Liberties
Florence, located in Tuscany on the banks of the River Arno–as seen from the southwest in a panoramic woodcut view of about 1471–82 (fig. 6.42)–was the cradle of the Renaissance. Originally a Roman city, Florence had expanded many times beyond its ancient core as it prospered in the Middle Ages on the strength of its wool trade and banking. By the late thirteenth century, it extended to the city walls seen in the woodcut view. In their struggle for political control of the city, two rival factions–the pro-papal, mercantile Guelfs, and the Ghibellines, feudal supporters of the Holy Roman Emperors–built networks of houses with fortified towers. After 1250, when the Guelfs and the merchants took control of the city, they erected civic buildings to signify their freedom from feudal control. In 1293 the city outlawed the building of private towers, and wide streets were driven through formerly obstructed neighborhoods. The Florentines shaped their city according to mercantile ideals of civic liberty.

The Bargello and "Palazzo Vecchio"
The building of the Bargello in 1255 for the *podestà*–the judicial head of Florence's self-governing commune–and of a city hall, the Palazzo della Signoria, today called the "Palazzo Vecchio" (the Old Palace)– reflect the new regime. The city also appointed a municipal architect, Arnolfo di Cambio (see page 178), who laid out two broad parallel streets to link the new civic buildings–the

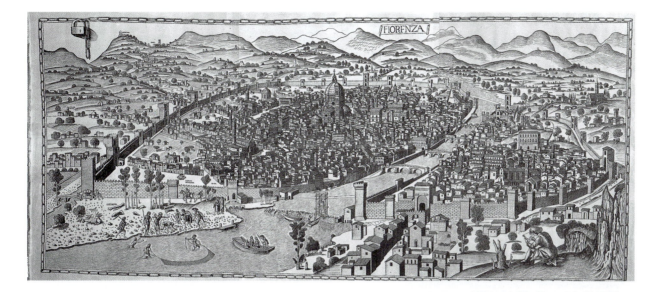

6.44 (below) Aerial view of the Piazza della Signoria, with the Palazzo Vecchio in the foreground, and the church of Santa Croce beyond, Florence

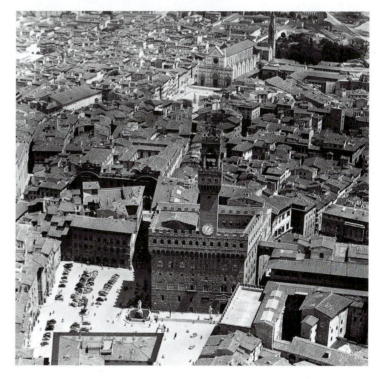

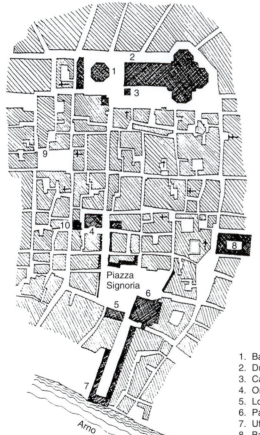

1. Baptistery
2. Duomo (Cathedral)
3. Campanile of Giotto
4. Orsanmichele
5. Loggia dei Lanzi
6. Palazzo della Signoria
7. Uffizzi (built 16th century)
8. Bargello
9. Market square
10. Wool Workers Guild Hall

6.43 Map of the center of Florence, after the interventions of Arnolfo di Cambio. Late thirteenth century

Bargello, Palazzo Vecchio, and the Duomo, or cathedral (fig. 6.43). He also cleared a large open public space—the Piazza della Signoria—to serve as a stage for civic ceremony in front of the new city hall (fig. 6.44). An aerial view of the center of Florence, from this piazza toward the Duomo, shows these streets, spaces, and buildings (fig. 6.45), which can be related to their locations on the map. On the left, one of the new streets links the Piazza della Signoria, seen in the foreground, with the octagonal Baptistery and the new Duomo. It also passes the rectangular Orsanmichele—a guild hall and communal granary—seen on the left of this street, rising above the

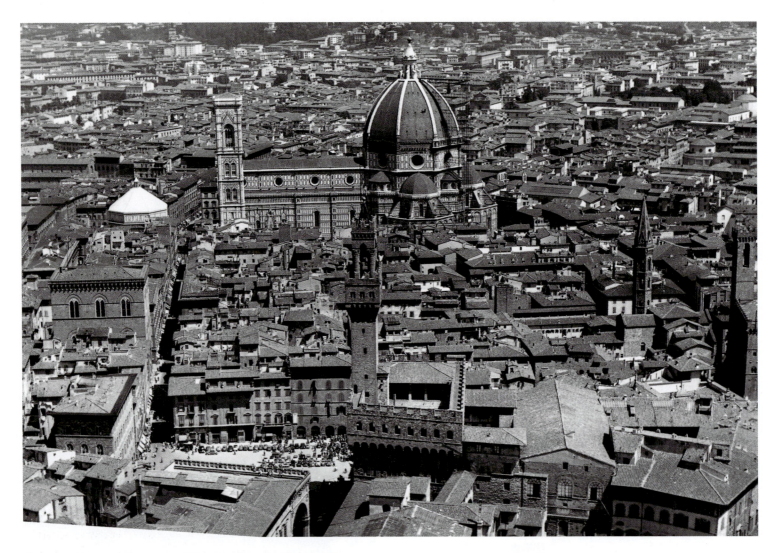

6.45 Aerial view of the center of Florence, from the Piazza della Signoria toward the Duomo (Cathedral)

other buildings. To the right of the Duomo, the other new street curves round to the back of the Palazzo Vecchio, passing the Bargello, whose tower is just visible on the extreme right.

The Palazzo Vecchio itself was begun in 1298, to Arnolfo di Cambio's designs. Its fortress-like structure was built of rough-hewn stone, like the Bargello. It is crowned by battlements, from which rises the fortified look-out tower, symbol of the commune's power. The stark, grim, embattled mass of this administrative center stands in contrast to the serenity of the cathedral complex at the other end of the central axis. Here, all is finished in smooth, white, green, and pink marbles; and here Giotto's graceful **campanile** (cathedral bell tower) answers to the mighty tower of the Palazzo Vecchio, together signifying the spiritual and secular heart of Florence's civic life.

Siena's City Hall

Another city hall like the Palazzo Vecchio dominated the main piazza of Siena, not far to the south. For its interior the city elders commissioned fresco cycles from leading Sienese artists. Among them was Ambrogio Lorenzetti, who in 1338–39 painted a panoramic fresco in the city hall's Chamber of Peace. Its subject, covering three walls, is an *Allegory of Good and Bad Government* that contrasts the effects of good and bad government in the city and country (for discussion of the country, see page 183 and fig. 6.38). In choosing this theme, the bourgeoisie revealed their preference for peace, freedom, and justice, and appealed to their councilors to weigh the effects of their actions. The section shown here depicts *The Effects of Good Government in the City* (fig. 6.46). An unprecedented rendering of ideal city life, set amid buildings modeled on Siena itself, it manifests peace and prosperity. At top left, the cathedral, with its striped campanile, rises above a city

6.46 Ambrogio Lorenzetti, *Allegory of Good Government: The Effects of Good Government in the City*. 1338–39. Fresco. Sala della Pace, Palazzo Pubblico, Siena

sparkling with life. The scene is rendered in warm rose and tan, contrasted with light grays and pale greens. Using rudimentary perspective, Lorenzetti creates the illusion of a space more substantial than anything seen since Roman times, then fills it with bustling activity. Produce arrives in the market; children are taught in school; young women dance in the street; even a swallow finds a haven under a balcony. By contrast, the opposite wall depicts bad government: soldiers seize a woman, whose companion lies dead in the street.

Lorenzetti's vivid representation of Siena also gives an idea of the comparable houses, shops, and street life of fourteenth-century Florence. In contrast to Nuremberg's narrow, vertical buildings, with their steep-pitched roofs, Florentine and Sienese houses are lower and wider, and have low-pitched roofs. The tower houses, seen in figure 6.46, remain from feudal times. While imperial Nuremberg is dominated by its castle and two main churches, the skylines of republican Florence and Siena were pierced by the towers of their town halls. Even today, the major civic buildings at the core of both cities recall their prosperity and priorities in the late Middle Ages.

PARALLEL CULTURES
Islamic Art

The leaders of the medieval Church held a view of history, and of their own place within it, that generally disregarded the religions and cultures of others. The crusades had exposed the West to Islamic culture, but Christians and Muslims remained fundamentally at odds. Within Europe itself, non-Christians, especially Jews, were subject to persecution, as happened in Nuremberg. And in representations of the betrayal and flagellation of Christ, artists portrayed Jews as hideous stereotypes. Nevertheless, through trade, warfare, and other openings for cultural exchange, medieval Europe received influences from outside the sphere of western Christendom.

Islamic Art in Spain: The Alhambra

In Spain the interminable efforts to recapture Moorish-held territories from the ninth to the fifteenth centuries were sometimes relieved by cultural coexistence. Through this exchange, Europe once again came into contact with classical traditions of literature, science, and medicine. Córdoba, for instance, prospered greatly as a center of wealth, art, and scholarship, attracting scholars from all over Europe. The writings of Arab scholars working in Córdoba such as Averroës (1126–1198)—noted for his commentaries on Aristotle—stimulated renewed European interest in ancient Greek philosophy. Islam developed a rich culture that also

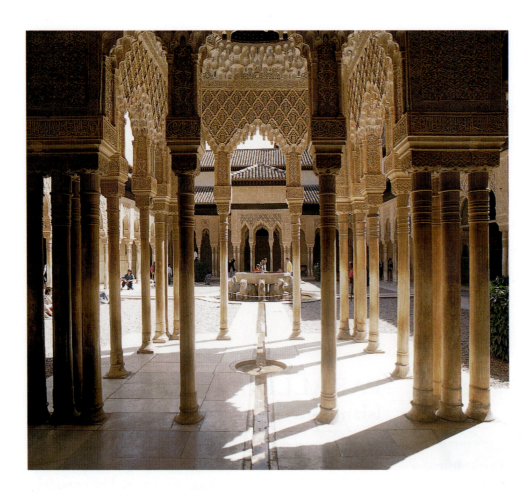

benefited the Christian West, especially in astronomy, optics, mathematics, and medicine. Yet great rivalry between the two faiths persisted. Beyond this religious rivalry, the existence of opposing faiths in one country was perceived as undermining the stability of the Spanish realm. In 1236 Córdoba was reconquered, and its great mosque converted to Christian use. This cultural diversity came to an end in 1492, when the Spanish Catholic monarchs Ferdinand and Isabella—desiring political, religious, and cultural unity—expelled both Muslims and Jews.

In 1492, Granada, the last Moorish stronghold in Spain, fell to Ferdinand and Isabella. With Granada came the palace of the Alhambra. Built 1354–91, it is an exquisite example of Spanish Moorish architecture. Where the castles of Western feudal lords were military strongholds, the Alhambra was designed for the comfort and luxury of a Muslim ruler. Set on a fertile hillside, surrounded by protective walls and towers, it contains a labyrinth of luxurious rooms. They are exquisitely decorated with Moorish **filigree**—delicate, lacelike ornamentation—stucco, and patterned, colored tile, and open onto secluded, watered courtyards, of which the most famous is the Court of the Lions (fig. 6.47).

The Court of the Lions, which is modeled on Greco-Roman peristyle courtyards and gardens (compare fig. 4.19) enriches such examples with the lightness and delicacy of narrowly spaced slender columns and Islamic detailing. The filigree decorations of the arcades capture little pockets of light and shadow in a delicate honeycomb effect, which corresponds to the network of colored tile on the walls. The courtyard was once filled with flowers, plants, and aromatic herbs, whose lushness and scent would have complemented the architecture and water. The Lion Fountain provides the central focus. From it, rivulets of water trickle toward the four sides. This fountain, which is characteristic of Moorish courtyards, suggests that a central fount nourishes life and offers a symbolic foretaste of the sensuous paradise that the Koran (in the Muslim tradition, the revealed word of God) says awaits the faithful.

The Alhambra palace complex is set among gardens. Further up the hill are the Generalife gardens, with secluded arcaded courtyards. They were once filled with fragrant myrtle and orange flowers (fig. 6.48). These gardens are designed to be slowly savored, absorbing the nuances of light, shade, shape, pattern, color, texture, aroma, and the quiet murmur of fresh water.

Italy and Islamic Pleasure Gardens

The Islamic taste for paradisiacal gardens left a lasting imprint in the West. The princely pleasure gardens of Islamic rulers in Palermo, Sicily, first rekindled European taste for such gardens, unmatched since those of the Romans (recall fig. 4.19). When the Normans conquered Muslim Sicily in the eleventh century, they emulated these Islamic pleasure gardens, creating a model that spread to central Italy and even to France.

During the Renaissance, similar gardens would become a feature of Italian country villas, reviving a way of life that Italians had not enjoyed since antiquity.

Persian Manuscript Illumination

Persia, at the other end of the Islamic world, was the inspiration for such paradisiacal gardens as those of the Alhambra complex, as this image from a Persian illuminated manuscript of 1494–5 shows (fig. 6.49). Despite differences of time and place, it manifests an ideal way of life and an aesthetic sensibility similar to that of the Alhambra.

Colorful patterned wall tile, intricate and richly colored carpet, and delicate, honeycomb-patterned screens adorn the room in the scene, which opens on to a paradisiacal garden filled with flowers and blossoms.

We saw in Chapter 5 that figurative imagery was originally excluded from Islamic art. Manuscript illuminations, such as figure 6.49, then, signal a major change toward a new, secular, court tradition. Herat (in modern Afghanistan), where this manuscript was painted, became a major center for such illuminated manuscripts.

6.49 *Iskander and the Seven Sages*, probably by Bihzad, from a Khamseh of Nizami, Herat. 1494–5. The British Library, London

7 Italian Renaissance Art

7.1 Andrea Mantegna, *Lodovico Gonzaga, His Family and Court* (detail of fig. 7.28). 1465–74. Camera degli Sposi, Palazzo Ducale, Mantua

In Italian cities such as Florence, Rome, and Venice, as well as at regional courts, such as Mantua's, wealthy merchants joined aristocrats and the Church in patronizing learning and the arts with a fresh vigor and outlook on life. Patrons and artists derived renewed inspiration from ancient, classical culture, which they sought to combine with the Christian tradition. As a result, they paid more attention to themselves and the world around them than had their medieval counterparts, laying new foundations for the art and culture of early modern Europe. Andrea Mantegna's (c. 1431–1506) sumptuous frescoes of the elegant court life of the ruling Gonzaga family in Mantua exemplify the urbane, worldly, and human-centered culture that developed in fifteenth-century Italy (see 7.1 and also fig. 7.28).

7.2 Simone Martini, *Annunciation with Two Saints*. 1333.
Tempera and gold leaf on panel, 10' x 8'9".
Galleria degli Uffizi, Florence

In Chapter 6, we saw that the Italian artist Giotto had
turned away from the otherworldly, symbolic emphasis
of medieval art, creating more lifelike figures interacting
with each other (see figs. 6.23, 6.25). After Giotto's time,
and notably after the Black Death of 1348, as if trauma-
tized by this widespread catastrophe, many Italian artists
continued to paint in the traditional mixture of Gothic
and Byzantine styles, representing sacred figures against
flat, gold grounds, especially for altarpieces. An altarpiece
by the Sienese artist Simone Martini (fl. 1315–44),
painted for Siena Cathedral in 1333 and representing
the Annunciation to the Virgin Mary, exemplifies this
fusion of Gothic and Byzantine styles (fig. 7.2). It is also
typical of fourteenth-century Italian altarpieces.
Renaissance artists abandoned such traditional practices
and instead looked back to Giotto, whose more lifelike,
humanized figures were a harbinger of Renaissance art.

Renaissance as Rebirth

In the late fourteenth and fifteenth centuries, Italian
thinkers began to reject what they considered medieval
"barbarism" in favor of classical values—the styles, work-
ing methods, and intellectual and cultural assumptions
of classical antiquity. A return to those values is reflect-
ed in the term Renaissance, which means "rebirth."

The term "renaissance" is widely debated, and its
implications and impact differ significantly from region to
region. But the term is generally associated with European
culture from c.1400 to 1600. Art historians use the term
proto-Renaissance to describe fourteenth-century Italian
art; the term Early Renaissance to differentiate fifteenth-
century Italian art from that of the late fifteenth and early
sixteenth century, which is called the High Renaissance;
and the term Mannerism of sixteenth-century art, emerg-
ing in the 1520s and overlapping that of the High
Renaissance. (The Renaissance beyond Italy will be treat-
ed in Chapter 8, and Mannerism in Chapter 9.)

The new view of history implied by the term "renaissance" encouraged artists to study classical architecture and sculpture and attempt to outdo it. Although artists did not have access to actual examples of classical paintings at the time of the Renaissance, they read about them in ancient literature. To emulate these paintings, they had to study the natural world, including human anatomy, which medieval artists had neglected. Renaissance humanists and artists also wrote about art, architecture, and artists themselves. These writings promoted the ideals of classical art and encouraged artists to compete with each other to produce the most humanly expressive work. In turn, art patrons valued originality in works they commissioned. The notion of a "Renaissance" thus sparked artistic innovation.

Observing Nature

The humanitarian vision of the Franciscans and late medieval interest in the natural world (seen, for example in the art of Giotto, Lorenzetti, and the Limbourg Brothers, figs. 6.23, 6.25, 6.38, 6.37), combined with a renewed interest in classical antiquity, inspired artists to depict people, nature, and even religious subjects in more lifelike ways. To paint nature more realistically, artists began to study and observe it more carefully. Artists also scrutinized people, especially for the way facial expression and body position can reveal emotions. Artists such as Antonio del Pollaiuolo (1433–98), Leonardo da Vinci (1452–1519), and Michelangelo Buonarroti (1475–1564) were so eager to study the human body that they dissected cadavers,

Map 7.1 Renaissance Italy

breaking the law to do so. Renaissance artists also studied a wide range of natural phenomena: Plants and animals, flowing water, and curled hair, how the wind blows drapery and distance mutes color, and how light and shadow affect all we see. The quest to discover new territory for art paralleled the development of new navigational instruments, more accurate maps, and the European voyages of discovery to the Americas, Africa, and Asia.

Perspective

For Renaissance thinkers, mathematics was a fundamental source of knowledge and truth, and, for some, the most adequate symbol of God. Artists were encouraged to ground their work on the mathematical certainties of **linear perspective**, an optical theory based on geometry (see "Materials and Techniques: Methods of Perspective," page 194). The Florentine Renaissance architect Filippo Brunelleschi (1377–1446) developed this system based on the assumption that all parallel lines running into space from the picture plane converge on a single vanishing point on the horizon that corresponds to the viewer's eye level. This meant that artists could create the illusion of three-dimensional space on a two-dimensional surface by using mathematics to determine how big objects in a painting were relative to each other.

Pietro Perugino's (c.1445–1523) painting *Christ Giving the Keys to St. Peter* (1482) is a fine example of this system of perspective (fig. 7.3). The vanishing point is located in the center of the door of the octagonal church, and the figures are scaled according to their relative location in space. The relative size of each figure is determined by its location in space, as defined by the grid of receding lines converging on the vanishing point. The smaller size of the background figures relative to the foreground figures creates the illusion of distance. Mathematics guaranteed the "truth" of the image. Perspective, combined with empirical observation of natural phenomena, enabled artists to create the illusion of a lifelike image of reality. Renaissance viewers accepted such images as not only more "true" than the symbolic forms of medieval art, but also as more like the descriptions of classical art in ancient literature. Indeed, Perugino's treatment of the figures, buildings, and space exemplifies the fusion of the classical and Christian traditions that characterizes the Italian Renaissance.

Methods of Perspective

Linear perspective was developed during the Renaissance to create the illusion of space on a flat surface. Although perspective had been developed in classical antiquity, it was neglected by medieval artists, who focused more on spirituality than on the physical world.

Early in the fifteenth century Filippo Brunelleschi conceived of the picture plane as if it were a window between the viewer and the subject. Working from that assumption, he developed a geometric system of linear perspective that was further refined by other artists. His method is founded on two basic observations: First, as objects recede into the distance, they become proportionally smaller in direct relation to their distance from us. And second, parallel lines receding from us seem to converge diagonally toward one point on the horizon (the vanishing point). Thus, using one-point perspective, any lines perpendicular to the picture plane are drawn diagonally to converge at a single vanishing point. This also determines the changing scale of objects. Using a system of two-point perspective, two sets of parallel lines converge at two points on the horizon, and so on. By using this method of depicting objects in space, artists were able to create an illusion of depth similar to that which our eyes perceive.

Artists usually use the technique of aerial, or atmospheric, perspective combined with linear perspective. Aerial perspective is based on the observation that the form and color of increasingly-distant objects become less distinct because of haze in the atmosphere. To imitate this effect, artists define distant objects with fainter lines and paint them with a bluish cast and more subdued colors in comparison to the bolder, brighter foreground objects.

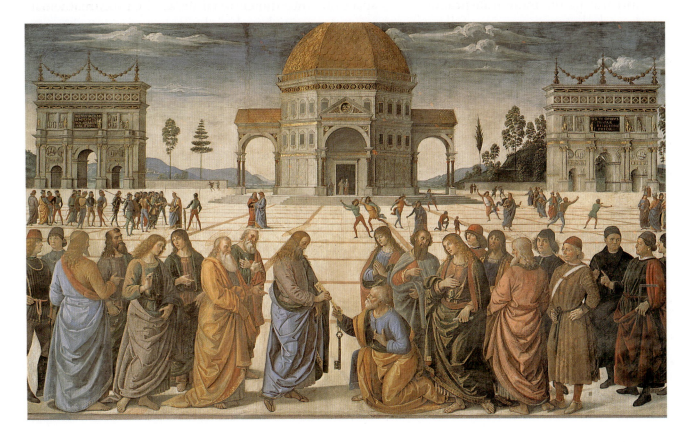

7.3 Pietro Perugino, *Christ Giving the Keys to St Peter*. 1482. Fresco, 11'5 1/2" x 18'8 1/2". Sistine Chapel, Vatican, Rome

Humanism

By the end of the fifteenth century, Renaissance artists pushed beyond this initial interest in observation inspired by an exalted vision of human dignity. Scholars developed a world-view known as humanism, which focused less on otherworldly, medieval religious concerns, and more on human potential in the here and now. They inspired artists and their patrons to value artistic virtuosity, individual invention, and imagination. Humanists such as Marsilio Ficino and Gianozzo Manetti emphasized the potential of the human mind and the beauty of the human body, complementing the traditional religious outlook on life by encouraging a focus on this world as well as the next. Writing in the 1450s, Manetti exclaimed: "What harmony of limbs, what shapeliness of figures, what figure, what face could be or even be thought of as more beautiful than the human?" The Greeks portrayed the gods in the likeness of man, Manetti went on to say, and now some wish to depict God in the image of man, as a means to divine contemplation.

These ideas had the power to liberate people from the medieval vision of a static, class-based society, in which each person had to stay within his or her allotted place. Instead, the humanists nurtured a new optimism about human potential and promoted the classical ideal of the well-rounded person who develops both mind and body. Nevertheless, the influence of humanism coexisted with traditional religious beliefs. The religious orders, such as the Franciscans, were highly active throughout the Renaissance, and continued to commission religious art for their meeting places and churches.

Centers of the Renaissance

The earliest full-blown manifestations of the Renaissance occurred in Florence in the early fifteenth century. In contrast to the anonymity of medieval art, Renaissance art is the achievement of a succession of outstanding individuals. And where medieval artists had received their prime commissions from kings and bishops, in Florence, the city government, the merchant guilds, and prominent individual merchants were the first to commission new art.

The political liberties of the Florentine city-state fostered both commercial initiative and artistic individualism. The leading Florentine merchants enjoyed great wealth, derived from the wool trade and banking. They also had a sense of religious and civic responsibility. The leading Florentine merchant family, the Medicis, who later became Grand Dukes of Tuscany, were lavish patrons of art and scholarship. Cosimo de' Medici and his grandson Lorenzo the Magnificent created in Florence a great library, opened the Platonic Academy, supported the monastery of San Marco, funded the church of San Lorenzo, and patronized the leading artists of their day. Other Florentine mercantile families followed their lead. Thereafter, Renaissance ideas spread elsewhere, notably to Rome and Venice, as well as to the noble courts of Mantua, Urbino, and Milan. Thus, across Italy, merchants, civic leaders, provincial rulers, the Church, and the all-powerful papacy patronized Renaissance artists. In creating the illusion of life-likeness, Italian Renaissance artists transformed the style as well as the subjects of art. For their part, sculptors and architects, by reintroducing classical principles to their work, transformed these media. Together, they shaped the look of the modern Western world.

SPIRITUALITY

Humanism was an elite culture that influenced many artists and their patrons, but the Church continued to be both a significant patron of the arts and a major voice in the popular outlook on life. As artists and their patrons, desiring to revive some of the virtues and values of the ancient world, sought to combine the Christian and classical traditions, they transformed religious art. Architects turned once more to the classical tradition for inspiration in designing churches, while painters and sculptors sought to humanize the sacred by abandoning the schematic figures and flat, gold grounds of medieval art for more lifelike representations. The challenges of combining the classical and Christian traditions reached a climax in the paintings, sculpture, and architecture that Michelangelo created for the papacy in Rome.

Renaissance Churches: Balance and Harmony

Renaissance church designs reflect the interest of architects and their patrons in classical architecture. Stimulated by renewed study of ancient Roman buildings, architects such as Brunelleschi, Leon Battista

Alberti (1404–72), and Michelangelo considered medieval architecture, and especially Gothic, to be unruly, impure, and barbaric. These architects sought to revive the use of the classical architectural orders (see Chapter 3, "The Classical Orders," pages 66–7), including a sense of harmonic proportions and lucid geometry.

Brunelleschi's San Lorenzo

The Florentine parish church of San Lorenzo, begun around 1425, with funding from the Medici family, is a stunning example of the new humanistic sensibility (figs. 7.4, 7.5). Wealthy individuals, like the Medici, were motivated to finance the building and embellishment of churches as a form of religious "good works," that also provided them with social prestige and a lasting memorial. With San Lorenzo, Brunelleschi changed the environment for worship, evoking classical serenity and harmony, rather than a medieval atmosphere of mystery and miracle. Its various elements are

precisely proportioned in relation to the square crossing of the nave and transept. The ordered consistency between the parts and the whole renders the church's design as rational as Brunelleschi's system of perspective. Like lines of perspective, receding toward their vanishing point in a painting, the lines of the entablature of the nave arcade, of the side aisles, and of the flat, coffered ceiling draw the eye toward the altar. White-painted walls offset the well-proportioned, classical detailing of the gray stone, Corinthian columns, and pilasters, and the fluid ease of the rounded arches give the interior a sense of clarity and ordered harmony.

San Lorenzo is strikingly different from the medieval Florentine church of Santa Croce (see figs. 6.19–6.21); measured architectural order rather than narrative fresco sets the tone. The absence of Gothic pointed arches and stained glass is as striking as Brunelleschi's allusions to the simplicity of Early Christian and classical basilicas (see Chapter 5). His style evokes a soothing sense of

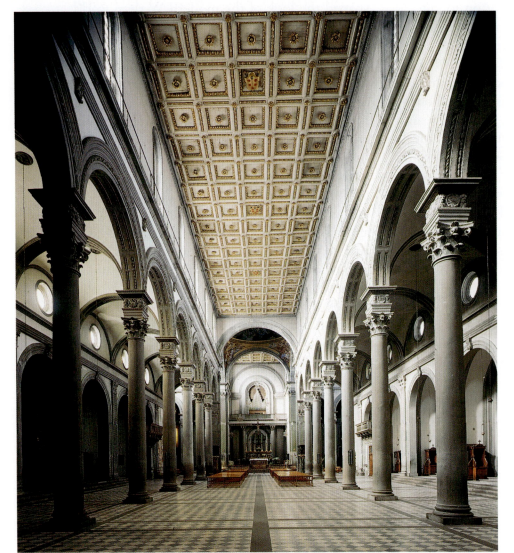

7.4 Filippo Brunelleschi, nave and choir, San Lorenzo, Florence. Choir and transept begun c. 1425; nave designed 1434 (?) and constructed 1442–1470s

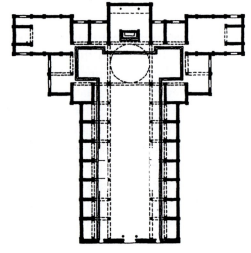

7.5 Filippo Brunelleschi, plan of San Lorenzo, Florence

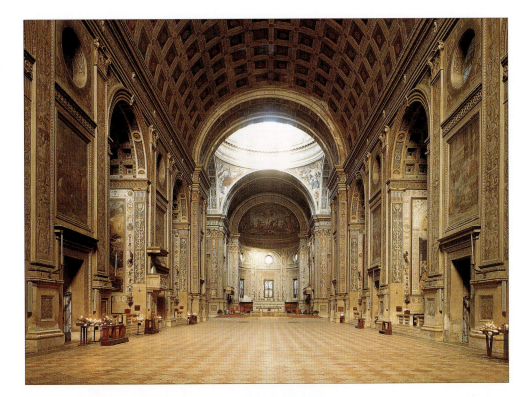

7.6 Leon Battista Alberti, nave of Sant'Andrea, Mantua. Designed 1470

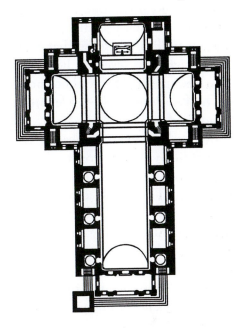

balanced harmony, in which the spare, geometric pattern of squares, circles, and semicircles symbolizes the perfection of God. The scale of the building, proportionate to the human body in its size and its classical architectural elements, allows the worshiper to feel in harmony with the church.

Alberti's Sant'Andrea

The humanist scholar, art theorist, and architect Alberti promoted a different interpretation of the heritage of antiquity. Inspired by Roman Imperial architecture, his churches are massive and grandiose, and in the long term even more influential than Brunelleschi's. Alberti's design (1470) for the church of Sant'Andrea in Mantua manifests this grandiose vision (figs. 7.6, 7.7). Alberti had studied the writings of the Roman architectural theorist Vitruvius, and admired the grandeur of Roman Imperial architecture, especially its use of massive piers to support huge, coffered barrel vaults (like those of the Roman Basilica of Maxentius and Constantine, discussed in Chapter 4). Citing Roman precedent, Alberti insisted that arches should rise from solid piers, not free-standing columns. Columns, he thought, should be a decorative element attached to piers, as in Roman Imperial architecture.

In Sant'Andrea, Alberti emulated these Roman ideas. He replaced side aisles with barrel-vaulted side chapels, set between the massive piers, overturning centuries of Christian tradition. The result was a large, unobstructed central space, similar to the interior of Roman bath-houses, such as the Baths of Caracalla (see fig. 4.29). His church façade also broke with tradition, combining two Roman motifs, the temple front and triumphal arch. Sant'Andrea created a precedent followed by Bramante and Michelangelo at St. Peter's, Rome, and in many later Baroque churches (see, for example, Sant'Ignazio, fig. 9.14). Its environment is intimidating, suggesting power and grandeur more than mercy and grace.

Humanizing the Sacred

During the early fifteenth century, artists in Florence transformed religious art, picking up where Giotto had left off a century before (see figs. 6.23, 6.25). Stimulated by classical sculpture and by rediscovery of the power of perspective (lost since antiquity) to create the illusion of figures set within an extension of the viewer's own space, they portrayed Christ, the Virgin Mary, and the saints as lively emotional beings in everyday settings. Their art gave biblical figures and narratives a sense of immediacy.

Donatello's Humanized Prophet: *Lo Zuccone*

The Florentine sculptor Donatello (Donato Bardi, c. 1386–1466) was one of the first to humanize sacred subjects. His statues reflect his study of classical sculpture, as well as the sense that he is portraying a particular model. This gives his figures psychological depth. A fine example is the prophet known as *Lo Zuccone* ("The Big Pumpkin")–a reference to his stark, bald head–sculpted in 1423–25 (fig. 7.8) for the cathedral in Florence. The grave demeanor, deep-set eyes, and broad, heavy mouth convey an intense individualized expression, with no concession to conventional notions of beauty. The stance and anatomy of the figure reveal an interest in human form not seen in sculpture since antiquity. Abandoning the elegant drapery patterns of Gothic sculpture, Donatello exploited the effects of light and shadow falling across the heavy folds of the drapery to reinforce the prophet's serious air. Even more than Giotto's figures, Donatello's are striking for their individualized features and psychological depth. These qualities render them more human and more realistic, compared with the stylized, impersonal types of Gothic sculpture (compare figs. 6.13, 6.16, and 6.26).

Masaccio's Brancacci Chapel

The Florentine painter Masaccio (1401–28) conveyed a similar sense of an individual's presence in painting. Learning from Giotto's and Donatello's lifelike figures and Brunelleschi's development of linear perspective, Masaccio's Brancacci Chapel frescoes, at Santa Maria del Carmine, probably painted about 1425, are fresh, vivid, and immediate (fig. 7.9). The figures pulse with life, and appear to be standing right there, in Florence. Masaccio achieved lifelikeness in a number of ways. He used perspective to relate the size of the figures to their setting and to create the illusion that they are standing within the viewer's own space, as if seen through a window. He also used a technique known as **chiaroscuro**, modeling the figures with light and shadow to give them volume and substance, as seen in the nude Adam and Eve (at the top left of fig. 7.9). A single light source that seems to come from the chapel's actual window illuminates the figures. The contemporary setting also

7.8 Donatello, *Prophet* (*Lo Zuccone*), from the Campanile, Florence Cathedral. 1423–25. Marble, height 6'5". Museo dell' Opera del Duomo, Florence

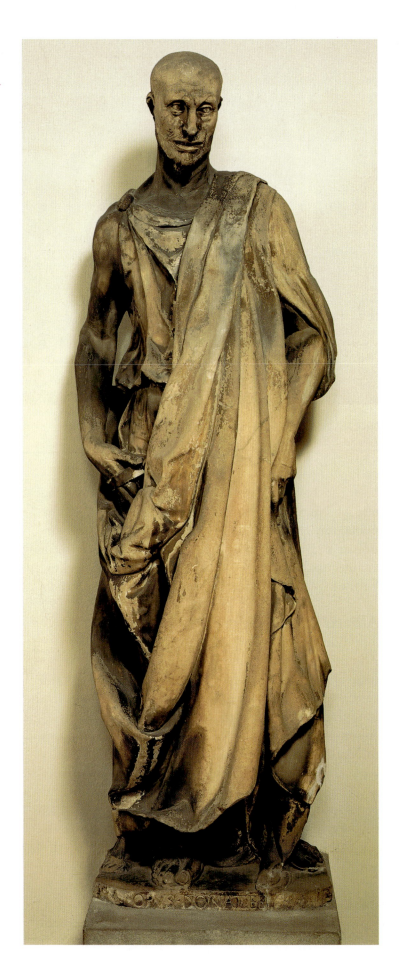

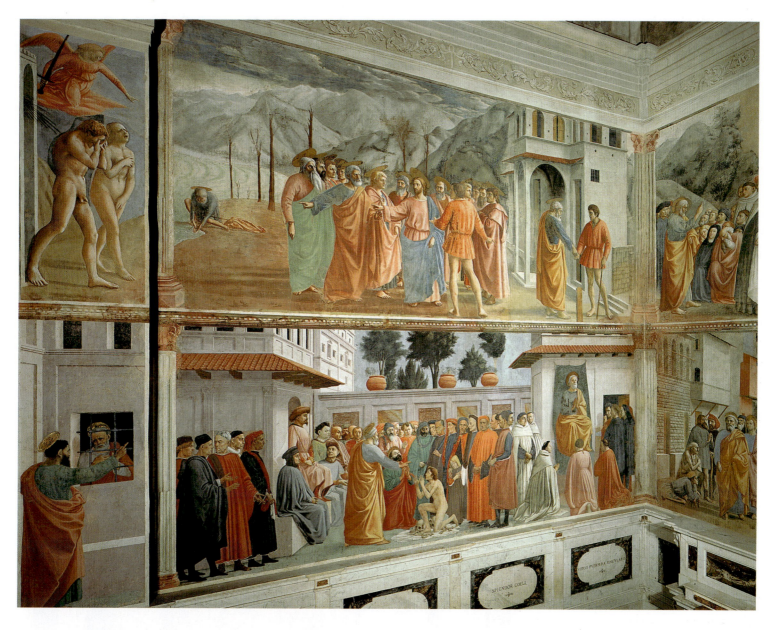

adds to the illusion of reality; biblical characters share the stage with portraits of Florentine citizens.

Whereas medieval artists had used stylized figures set against gold grounds to present the Christian faith, Masaccio made the biblical stories visually immediate and believable (compare figs. 6.22 and 7.2). Like Brunelleschi's church of San Lorenzo, his vision is less mystical and more lucid.

Ghiberti's *Gates of Paradise*

By the time Masaccio painted the Brancacci Chapel frescoes, the Florentine sculptor Lorenzo Ghiberti (1378–1455) was working on a set of sculpted portals for the Baptistery of Florence Cathedral. Their beauty moved Michelangelo to declare them "fit for the gates of paradise," a tribute that became their popular title.

7.9 Masaccio, *The Expulsion from Eden, St. Peter in Prison, The Tribute Money,* and *St. Peter Raising a Boy from the Dead,* left wall of the Brancacci Chapel, Santa Maria del Carmine, Florence. c. 1425. Fresco, the two major scenes: 8'1" x 19'7"

Ghiberti's *Gates of Paradise* are divided into ten square gilded panels that depict Old Testament scenes. Among them, *Jacob and Esau* (fig. 7.10), executed about 1435, shows Ghiberti's response to the innovations Masaccio had brought to painting. Like Masaccio, Ghiberti presents biblical subjects in a lifelike manner, using linear perspective and subtle sculptural relief to create the illusion of nimble figures moving freely in clearly defined spaces. And, as Alberti had urged, he depicted a variety of figures in graceful poses, paying careful attention to anatomy. According to Alberti, the figures should reflect

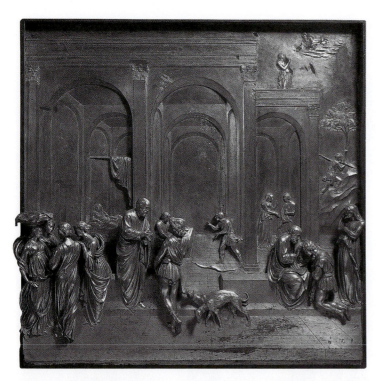

7.10 Lorenzo Ghiberti, *Jacob and Esau*, panel on the Gates of Paradise, Bapistery, Florence. c. 1435. Gilded bronze, 31¼" square

Fra Angelico's *Descent from the Cross*

Dubbed "the angelic painter" by his contemporaries, Fra Angelico (Guido di Pietro, d. 1455) was a devout Dominican friar in Florence. In painting the *Descent from the Cross*, probably completed in 1434 (fig. 7.11), Fra Angelico applied the innovations developed by Masaccio, Donatello, and Ghiberti. But, as a more conservative individual, he developed the lifelikeness seen in Masaccio's works more than the classicizing grace seen in Ghiberti's. Working in tempera Fra Angelico used the techniques of illusionism to evoke a mood of religious devotion, focused on the body of Christ (see "Materials and Techniques: Tempera Painting," page 202). Like Masaccio, Fra Angelico included contemporary figures in his painting. For example, the bearded man dressed in blue, with a black headdress, standing behind Christ, is

7.11 Fra Angelico, *Descent from the Cross*. 1434 (?). Tempera on panel, 9'1¼" x 9'4¼". Museo di San Marco, Florence. (Frames and pinnacles by Lorenzo Monaco)

the dramatic action and be in proportion with the surrounding space. These goals are fully realized in Ghiberti's *Jacob and Esau* panel.

Ghiberti's figures express self-assurance and ease, a vision of humanity not seen in medieval art. Notice, for example, the lithe figure of Esau returning from the hunt, the noble bearing of his father Isaac, and the elegant movement of the women in the left foreground. Their graceful forms represent Ghiberti's ideal of infusing the Christian tradition with classical dignity to celebrate, as Manetti put it, the image of God as seen in the beauty of the human body. This Christian humanist ideal was pursued by many other Renaissance artists, including Donatello, Sandro Botticelli (c. 1445–1510), Michelangelo, and Raphael (Raffaello Sanzio, 1483–1520).

believed to be Michelozzo di Bartolommeo (1396–1472), the architect of San Marco and the Medici Palace (see figs. 7.45 and 7.46). But Fra Angelico went beyond Masaccio, re-creating the local Tuscan landscape with unprecedented realism, detail, and depth. Fra Angelico's exceptional delicacy of coloring adds to the painting's serene mood. Through all of these devices, Fra Angelico imparted fresh, lifelike qualities to a traditional religious subject. If we compare this painting to the *Crucifixion* in the Paris Missal of the early fourteenth century (see fig. 6.17), we see that Fra Angelico's Christ is a man of flesh and blood. His sacrifice, while conveyed with grave dignity, has material substance and immediacy.

Fra Filippo Lippi's *Annunciation*

A similar sense of immediacy appears in the religious art of the Florentine Fra Filippo Lippi (c. 1406–69). In the *Annunciation*, painted around 1440 (fig. 7.12) for the Medici parish church of San Lorenzo (and still there today), Lippi humanized the moment when an angel tells the Virgin Mary that she will miraculously bear the Christ child by locating the event in the courtyard of a contemporary Florentine monastery, witnessed by angels who look like thinly disguised Florentine youths. If we compare Lippi's humanized *Annunciation* to Simone Martini's treatment of the same subject (see fig. 7.2), we see that naturalism was gained at the expense of the majesty, awe, and sense of the supernatural, evoked by the earlier work.

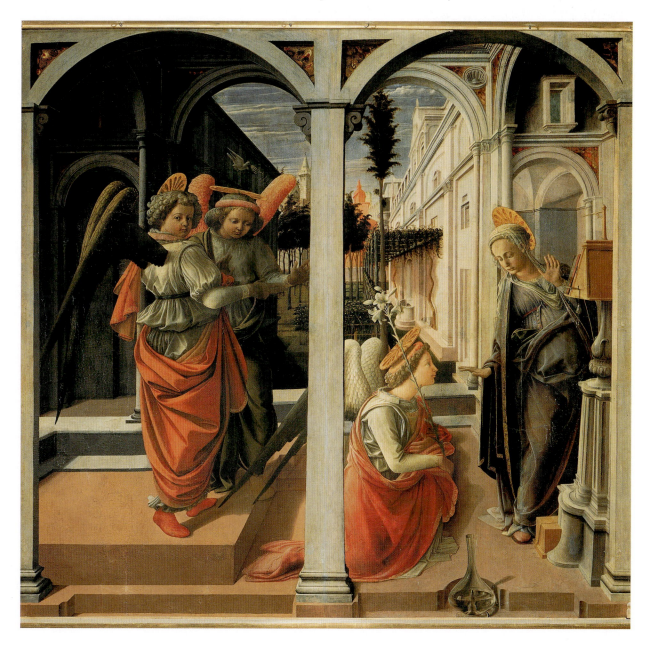

7.12 Fra Filippo Lippi, *Annunciation*. c. 1440. Tempera on panel, 69" x 72". San Lorenzo, Florence

Tempera Painting

Tempera is a painting technique, dating back to the Greeks and Romans, that was used extensively in the Middle Ages and Early Renaissance. To paint in tempera, pigment is mixed with a vehicle of egg yolk and water. It is a durable medium that produces rich colors, but unlike oil paint, tempera does not blend well and dries very quickly. Accordingly, artists working with tempera lay small brush strokes of colors side by side, a technique which allows the artist to achieve fine detail, and, by building the color up in layers, creates intermediate tones.

To prepare for a tempera painting, the artist or an assistant covers a wood or canvas support with gesso (1, 2) (a primer made of powdered plaster or chalk mixed with animal glue) and then sands it to a smooth finish so that it will easily accept paint. The underdrawing is then scratched into the surface of the gesso (3). Many medieval and Early

Renaissance painters then glued gold leaf to the background (4), creating a rich glow that suggests heavenly light. Next, the artist applies the underpainting (5), a preliminary lay-in of green or brown paint. Finally, the actual tempera paint, in finer shades of color, is applied over the underpainting (6), providing detail and the illusion of volume.

The effect of finished tempera paintings is rich and luminous, its colors brighter than fresco. But tempera cannot be easily reworked, nor can it produce the subtle tonal gradations of oil painting. When, in the fifteenth century, oil paint was developed, most painters abandoned tempera for this new, more flexible medium.

7.13 Diagram of layers in a tempera painting.
1 Wood panel
2 Gesso and perhaps linen reinforcement
3 Underdrawing
4 Gold leaf
5 Underpainting
6 Final tempera layers

Piero della Francesca's *Baptism of Christ*

Christ's humanity is the primary theme of Piero della Francesca's (c. 1420–92) *Baptism of Christ* (fig. 7.14), painted around 1450. The artist represented Christ's baptism as if it were taking place amid the Tuscan hills, including a glimpse of the artist's home town of Borgo San Sepolcro. While a stylized dove, signifying the Holy Spirit, hovers above Christ's head, and three human-looking angels attend him, the painting emphasizes the physical beauty of Christ's half-naked body, not his divinity.

Transcending the Human

Early Renaissance artists tried to humanize the sacred, accenting the humanity rather than the sacredness of the biblical figures they sculpted or painted. But as the Renaissance progressed in the period we call the High

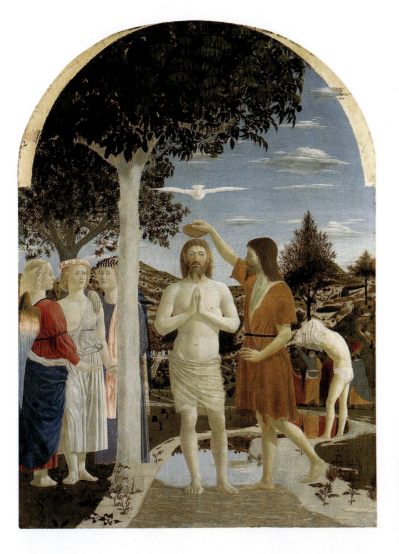

7.14 Piero della Francesca, *Baptism of Christ.* c. 1450.
Tempera on panel, 5'6" x 3'9¾". The National Gallery, London

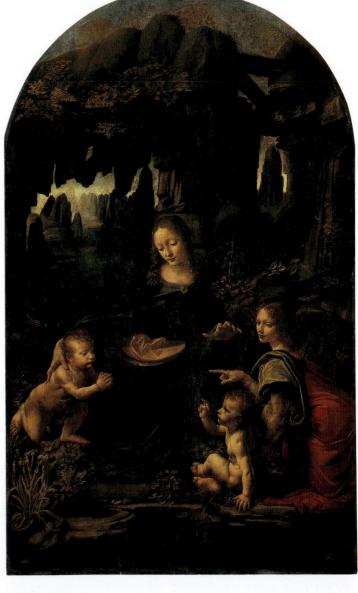

7.15 Leonardo da Vinci, *Madonna of the Rocks.* Begun 1483. Oil on
panel, transferred to canvas, 6'6½" x 4'. Musée du Louvre, Paris

Renaissance, artists such as Leonardo da Vinci,
Michelangelo, Raphael, and Titian (Tiziano Vecelli,
c. 1490–1576) sought to infuse naturalistic religious art
with a sense of the transcendent—to portray human beings
and nature in a way that would evoke the divine (recall the
ideas of Manetti, p. 197).

Leonardo da Vinci: The Natural and the Sublime

The Florentine artist Leonardo da Vinci moved reli-
gious art in this direction by imparting to his subjects a
sense of the sublime. Florentine artists of the early
Renaissance, such as Fra Filippo Lippi (see fig. 7.12),
had portrayed the Virgin Mary as a human mother,
inhabiting the everyday world. By contrast, Leonardo,

in his *Madonna of the Rocks* (fig. 7.15), begun in
1483, raised her above the ordinary world, suffusing
her with idealized grace as the sublime Mother of
God. Leonardo's serene Madonna watches over the
infant Christ and John the Baptist, attended by a
dreamy-eyed angel. A soft diffused light plays
over the figures' heavy eyelids and rippling curls,
while the shadows of a dark grotto bathe the scene
in an atmosphere of mystery. At the same time,
Leonardo used the devices of Renaissance naturalism
to make the Virgin and Child accessible to
the viewer.

No artist was more exact than Leonardo in his observations of natural phenomena nor more poetic in channeling these into the realm of the imagination. From his childhood, Leonardo had explored the hills, caves, and rivers of Tuscany with the curiosity of a scientist and the sensitivity of an artist. His desire was to discover, record, and understand the marvels of the natural world. His unbounded curiosity prompted him to scrutinize and draw a wealth of natural phenomena, from rocks to flowing water, from plants to thunder clouds.

Leonardo's responses to natural phenomena went far beyond collecting data in response to scientific curiosity. As a visual artist, he processed his findings in the imagination, as we'll see in portraits such as that of *Ginevra de' Benci*, with its dreamy background of a shady woodland pool, sheltered amid hills and trees (see fig. 7.27). Likewise, Leonardo's imaginative transformation of his observations accounts for the visual power of his *Madonna of the Rocks*. He painted this work in oils, a technique developed by Netherlandish artists (see Chapter 8, "Materials and Techniques: Oil Painting," page 246). This technique allowed him to build his imagery with successive layers of translucent color and also pick out the tiniest details. Leonardo renders every plant and rock believable, while bathing the figures in a glowing light. In the process, he channeled his careful observations into a work of poetic imagination.

Leonardo sought an idealized perfection that went beyond the crisp, linear, mathematical qualities of fifteenth-century Italian art—the quality of "*grazia divina*," or divine grace. The term implied a delicacy of blending light and shadow, a softness of color, an originality of mind, and a facility of execution, as seen in his *Madonna of the Rocks*. Other artists of the High Renaissance, such as Raphael, Michelangelo, and Titian, soon reached for a comparable level of idealization.

In another famous work, the *Last Supper*, painted in 1495–97 (fig. 7.16), Leonardo used gestures and facial expressions to convey the thoughts and emotions of the figures in the painting, thus engaging the viewer. This fresco is also an early example of how High Renaissance artists infused Renaissance naturalism with a sense of the transcendent. Leonardo painted his *Last Supper* on the end wall of a monastic dining room.

7.16 Leonardo da Vinci, *Last Supper*. 1495–98.
Oil, tempera, and varnish, on plastered wall, 15'1 1/8" x 28'10 1/2".
Refectory, Santa Maria delle Grazie, Milan

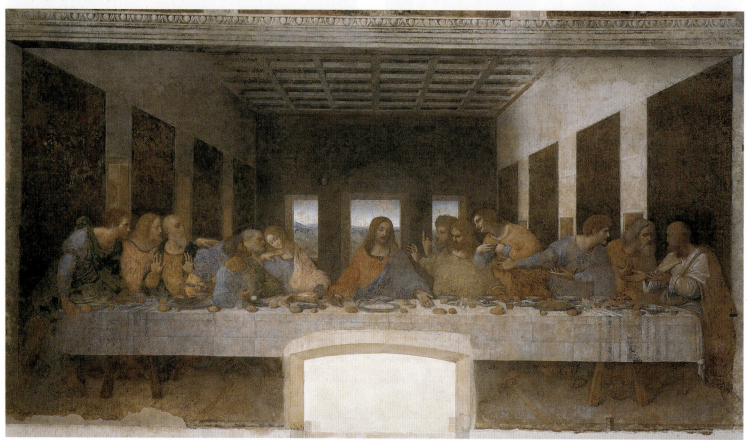

He worked on a damp wall and used an experimental medium that would allow him time to create a more nuanced, detailed, and finished effect than is possible with fresco. The experiment was disastrous and later restoration has only compounded the damage. Nevertheless, though its color and detail have suffered from the effects of Leonardo's technique and subsequent deterioration, the original conception can still be grasped. The painting depicts Christ's last meal with his disciples when he instituted the Mass on the night before he was betrayed and crucified. Leonardo presents this scene as a human drama that unfolds as Christ declares that one of his disciples in the room will betray him. Leonardo groups the twelve disciples into four groups of three, leaving Christ separated, alone, the still point amid their commotion. His centralized, triangular form anchors him as the sublime, unmoving center around which human actions turn. Leonardo uses the setting, perspective, and lighting to emphasize the religious significance of Christ's isolation. Christ sits at the center of the table, precisely placed so that the lines of perspective converge behind his head. The natural light from the window behind him acts like a halo, suggesting his divinity. Around him, each disciple reacts, showing his own personality. Only Judas, fourth from the left, is plunged in shadow, his singular, defiant pose, staring at the one he will betray, revealing his sinister intention.

In the *Last Supper*, Leonardo fulfills his ideal, as expressed in his notebooks, that the gestures and expressions of the figures in a painting should reveal their thoughts. What earlier artists had sought to do with symbols, Leonardo achieved through his astute study of people and their interactions.

Raphael's *Transfiguration of Christ*

Another artist of the High Renaissance, Raphael, melded the natural and the supernatural into a seamless dramatic unity. In his monumental altarpiece the *Transfiguration of Christ*, painted in Rome in 1517–20 (fig. 7.17), Raphael portrayed both the humanity and divinity of Christ and suggested that human beings, created in the image of God, have elements of both within themselves.

To depict this idea, Raphael combined two levels of reality into one field of vision. At the top of the painting he surrounds the transfigured yet full-bodied Christ with a circle of radiant clouds that fuse into the sky. Below this scene of transendence he fills the fore-

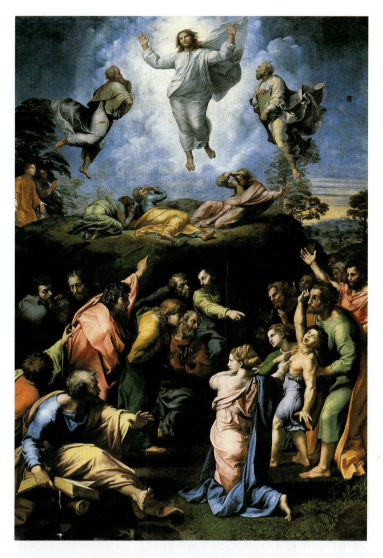

7.17 Raphael, *Transfiguration of Christ*. 1517–20. Oil on panel, 13'5 1/2" x 9'2". Musei Vaticani, Pinacoteca, Rome

ground with a group of excited disciples. Raphael painted these figures to engage the spectator by making them appear physically near us and by enlarging those features–hands, arms, legs, feet, eyes, and mouths–that convey emotion. Raphael thus sought to render humanity larger than life and give human beings something of the divine qualities of Christ. This vision resonates with the core of Renaissance beliefs: "God became man, that man might become god." (Compare the Mount Sinai monastery *Transfiguration* (fig. 5.16), where the gold ground suggests a reality beyond this world rather than, as with Raphael, within it.)

Titian's *Assumption of the Virgin*

While Raphael was working in Rome on his vast *Transfiguration*, in 1516–18 Titian was painting an even larger altarpiece in Venice, the *Assumption of the*

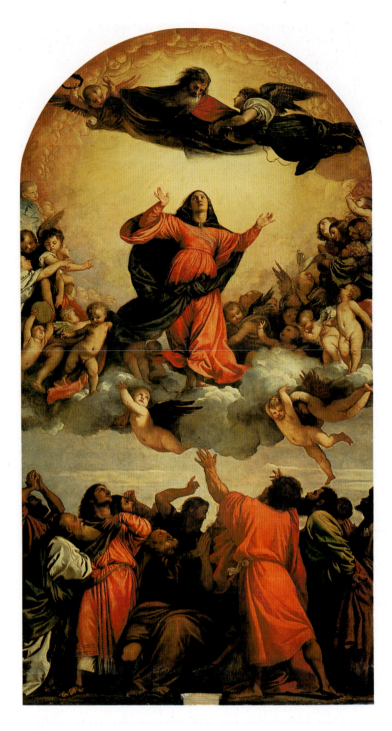

as epoch-making in the history of European altar painting.

The influence of Titian's great altarpiece lies in a number of factors, including the painting's integration with its space; its lucid composition; its brilliant, luminous coloring; and Titian's masterly use of principles similar to those used by Raphael in his *Transfiguration*. By melding the realms of heaven and earth into a seamless whole, Titian suggests to the viewer that heaven is within human reach. He flooded the scene of the *Assumption* with two distinct qualities of light—the radiant golden light of the heavenly sphere, shining around the Virgin; and the cooler light of earth. The apostles' proximity to the picture plane allows worshipers to feel as if they too can reach the Virgin, as she ascends into heaven and is greeted by God. In this painting, Titian, like Leonardo and Raphael, engaged the viewer and infused Renaissance naturalism with a sense of the transcendent.

Michelangelo and the Papacy

During the Renaissance, the popes used art to reestablish the prestige of Rome as the center of the Western Church. When the Florentine Michelangelo emerged as the outstanding artist of the age, successive popes pressed him to work on their various projects, demanding that he paint and sculpt, as well as design buildings.

As a young man living in Florence, Michelangelo was inspired by the works of masters such as Donatello and Masaccio. Living for a time in the Medici household, he was exposed to the humanist ideas of Ficino and his circle. Michelangelo was inspired by these Florentine humanists to see in the ideal beauty of a perfect human form a vehicle for imagining the divine, and, as noted above, to master human anatomy, he dissected cadavers.

After the Medici, his patrons, were expelled from Florence, and the influence of the Dominican monk Girolamo Savonarola undermined the arts in Florence, Michelangelo, in 1496, moved to Rome. Developers there were unearthing classical sculptures, and Michelangelo was quick to grasp their muscular idealization of the human body. He was commissioned in 1498 to carve a *Pietà*, showing the dead Christ on the knees of his mourning mother. Sculpted in 1498/99–1500, when Michelangelo was between twenty-three and twenty-four years old, the *Pietà*

7.18 Titian, *Assumption of the Virgin*. 1516–8. Oil on panel, 22'7¹/₂" x 11'9³/₄". Santa Maria Gloriosa dei Frari, Venice

Virgin (fig. 7.18). Made for the high altar of the Franciscan church of the Frari in Venice, it remains there to this day, dominating the interior. The huge size of the apostles is said to have shocked the friars, despite Titian's assurances that they had to be proportional to the enormous space in which they would be seen. Never before had such a vast scale been used for a Venetian altarpiece, and the result has been described

7.19 Michelangelo, *Pietà*. 1498/99–1500. Marble, height 5'8½". St. Peter's, Vatican, Rome

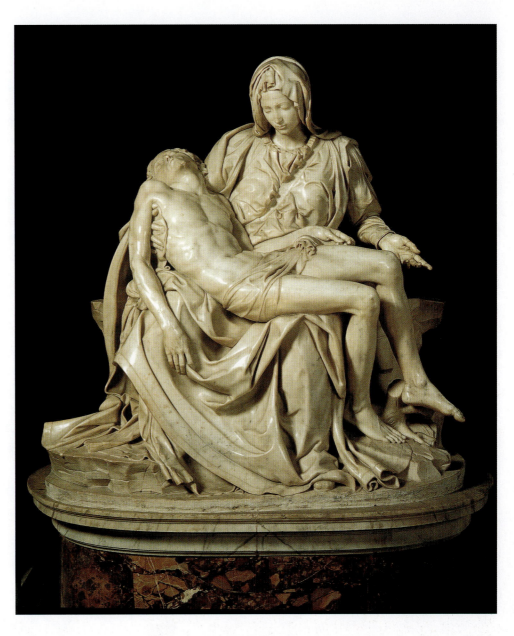

(fig. 7.19) blended the style of antique sculpture with the ideals of Christian humanism, presenting the Son of God as embodied in a beautiful human form.

Michelangelo extended the classical tradition through his detailed rendering of muscles, tendons, and veins. Helped by his intimate knowledge of human anatomy, Michelangelo was able to make his figures seem perfect yet real. His Madonna maintains an expression of composed serenity, but she is not emptied of vitality; in sculpting the folds of her drapery, Michelangelo conveyed a sense of an animate body beneath. But he was not a slave to anatomy. To contain the forms within a balanced triangular shape, Michelangelo made Christ smaller than his mother. The grace and beauty of the whole expresses Michelangelo's belief that in earthly beauty we catch a glimpse of our divine origins. The *Pietà* brought Michelangelo to the attention of the papacy, in whose service he realized some of his greatest works, including the painting of the Sistine Chapel and the rebuilding of St. Peter's, Rome.

The Sistine Chapel

In 1508 Pope Julius II demanded that Michelangelo, a sculptor, paint the ceiling of the Sistine Chapel, the pope's chapel in the Vatican. Michelangelo covered the vaulted ceiling, an area of about 133 by 43 feet, with biblical subjects from the Creation to the time of Noah (fig. 7.20).

Michelangelo divided the huge surface into three major zones and used simulated architecture to further

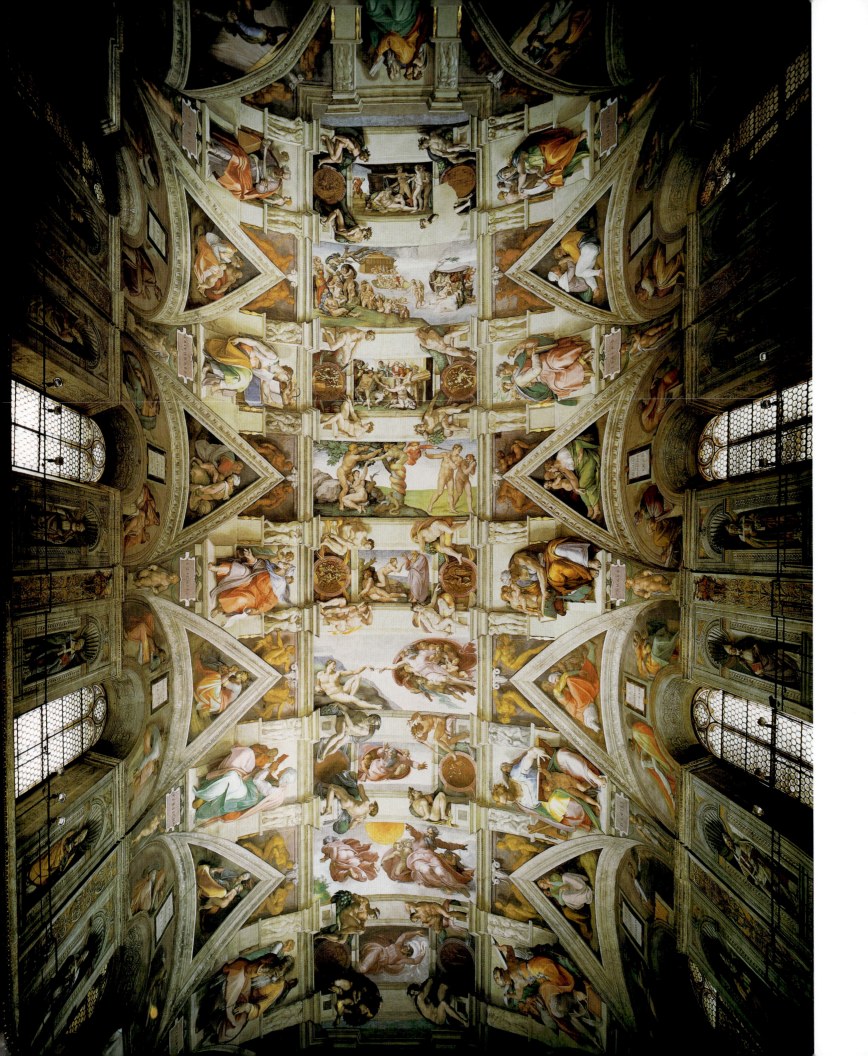

subdivide it. In the lowest zone, he depicted figures from the Old Testament, the ancestors of Christ. In the middle zone, enthroned in architectural niches, seven Hebrew prophets alternate with five pagan sibyls (female seers), who, humanists believed, all foretold the coming of Christ. The prophets and sibyls are absorbed in their writings and look out from their lofty thrones. The climactic central zone shows the origins of the universe, humankind, and sin.

In probably the best-known scene, God stretches forth his hand to impart life to Adam (fig. 7.21). Adam's muscular body epitomizes the way in which Michelangelo adapted classical art to celebrate humanity as the summit of God's creation. Michelangelo believed that Adam was the progenitor of all humanity, carrying within him the potential of all other humans. Notice that around the inert body of Adam, Michelangelo covers the rest of the ceiling with energized figures who express all the human passions and possibilities latent in

this one figure. While his prophets and sibyls brood and debate, twenty nude youths, the *ignudi*, twist and turn. Together, these figures carry within them all the passions of the human soul.

In each of the figures he carefully analyzed the body's anatomical structure, used line to define its contours, and light and shadow to reinforce the sense of three-dimensional form. This reliance on drawing strongly influenced later artists, but few have been able to articulate the human figure as effectively as Michelangelo did to express such diverse human emotions or such an exalted vision of human history—and one so characteristic of Renaissance humanism.

Michelangelo worked on the Sistine Chapel ceiling paintings for four years. Laborious cleaning (completed 1989) has removed centuries of dirt, grease, varnish, and candle smoke, and brought out the intensity and vibrancy of his palette: Pale violet contrasts with luminescent green, interspersed with pink, orange, and yellow. A gray architectural framework and the repeated flesh tones of the human body unify the whole. Although Michelangelo favored a vibrant palette, he, like his contemporary Raphael, never allowed color to obscure, or bleed over, his line drawing, which formed the foundation of his art.

7.21 Michelangelo, *Creation of Adam*, detail of ceiling, Sistine Chapel, Vatican, Rome. 1508–12. Fresco, 9'2" x 18'8" (after cleaning 1989)

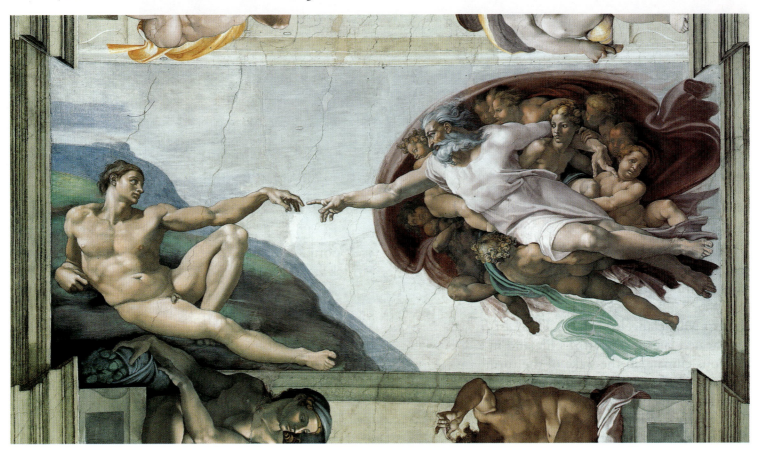

THE SELF

During the Renaissance, the artistic representation of personal identity went far beyond the impersonal representations of class and social roles found in medieval art. Portraiture and sculpture celebrated the individual likeness not only of princes, but also of soldiers of fortune and merchants and their families. In their works, Renaissance artists also expressed the desires and ambitions of their patrons who were pursuing fame, power, virtue, and beauty.

The Pursuit of Fame

The humanists' celebration of the heroes of antiquity stimulated a spirit of self-reliance and individualism that fed the pursuit of fame. Public monuments and private portraits alike embody that pursuit.

Donatello's *Gattamelata*

Nowhere is the Renaissance ideal of self-determination more apparent than in the soldiers of fortune, the *condottieri*, who contracted the services of their private armies to cities and states, and whose victories brought

them fame and fortune. One such commander was the Venetian general Erasmo da Narni, nicknamed Gattamelata ("Honeyed Cat," or "Slick Cat"). He left money to the Venetian state to commemorate him with a large bronze equestrian statue, which Donatello finished in 1453. It was set up in the square of Sant'Antonio in Padua, where it still stands (fig. 7.25).

Donatello's monument recalls the bronze equestrian monument to the Roman emperor Marcus Aurelius, which the sculptor must have seen when visiting Rome (see fig. 4.14). Inspired by this classical precedent, Donatello created an image of strength and determination. The posture and powerful facial features of the general, and the animated appearance and confidant stride of his horse convey the sculpture's vitality.

Donatello enhanced the effect of forward motion through the descending diagonals of the general's baton and sword, which play against the curves of the charger's reaching foreleg, arched neck, and raised tail. This energizes the horse's massive bulk to create an effect of unflinching strength. The fame, courage, and will of the general is thus preserved for—or impressed upon—posterity. In ways not seen since antiquity, art celebrates individual fame through a life-size statue in bronze.

Ghirlandaio's *Sassetti Chapel*

The use of art to pursue fame took a different form for wealthy merchants. They spent money on art and architecture for themselves and the Church because, as the prominent Florentine merchant Giovanni Rucellai put it, such spending gave him "the greatest contentment and the greatest pleasure because they serve the glory of God, the honor of the city, and the commemoration of myself." Probably for similar reasons, the wealthy Florentine banker Francesco Sassetti, an associate of Florence's dominant family, the Medici, commissioned Domenico Ghirlandaio (1449–94) to create the frescoes and altarpiece for his family chapel in the church of Santa Trinità, Florence, painted in 1483–86 (fig. 7.26). Ghirlandaio was then the leading painter in Florence and appealed to the vanity of the Florentine mercantile class by including them and their daily environment in his detailed, lifelike works.

Thus, Ghirlandaio placed within the Sassetti Chapel's religious scenes, portraits of the family's associates in specific Florentine street scenes that record the

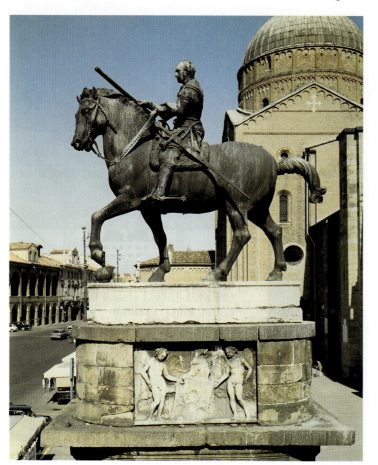

7.25 Donatello, *Equestrian Monument of Gattamelata*. 1445–53. Bronze, height 12'2". Piazza del Santo, Padua

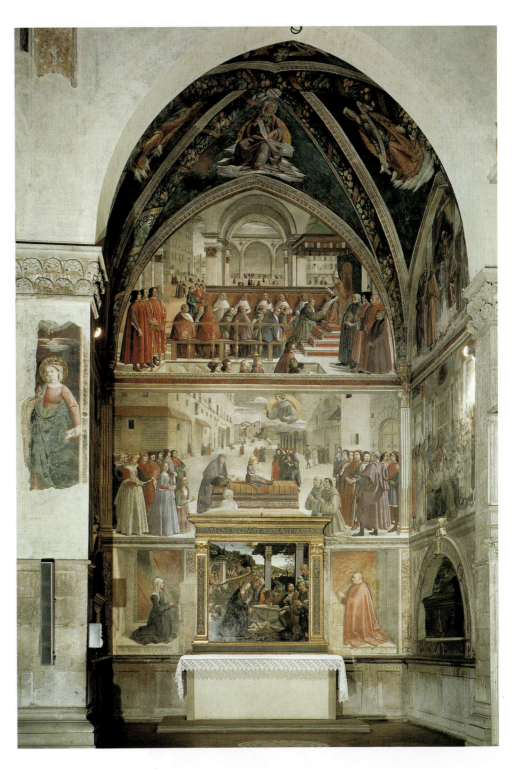

7.26 Domenico Ghirlandaio, frescoes in Sassetti Family Chapel. 1483–86. Santa Trinità, Florence

social connections of the Sassetti family. In the upper register, to the right, Lorenzo de' Medici stands to the right of Francesco Sassetti and his son, while the boy's tutor, the humanist poet Angelo Poliziano, climbs the stairs toward them. Sassetti and his wife appear, prominently, on the lowest register, kneeling on either side of the altarpiece. Above the altarpiece, in the middle register, Ghirlandaio has included, on the extreme right, his self-portrait.

Complementing these portraits, black marble tombs of the Sassettis, carved with classical motifs, are set in niches in the side walls, while four pagan sibyls look down from the vaults. The memorial chapel's focus on social setting and family connections contrasts sharply with the way the English prelate William of Wykeham was commemorated in Winchester Cathedral less than a century earlier (see fig. 6.33).

Portraiture

The pursuit of fame also stimulated the development of portraiture, which thrived on Renaissance naturalism. Artists not only incorporated portraits within public religious art—as in Ghirlandaio's Sassetti Chapel—they also painted and sculpted them for private settings. Portraits commemorated both women and men, young and old, and were no longer restricted to rulers. Artists rendered most early Renaissance portraits in profile, like commemorative medals, which themselves followed classical precedent. But in the second half of the fifteenth century, artists showed the face in three-quarter or full view, which allowed the viewer to make eye contact with the portrait, and enabled the artist to portray a subject's personality.

Among the most famous Renaissance portraits is Leonardo da Vinci's *Mona Lisa*. But a much earlier painting attributed to him, the portrait of *Ginevra de' Benci*, painted in the late 1470s (fig. 7.27), set the precedent. The sitter, a member of the cultivated de' Benci family of Florence, was a woman of renowned beauty and a poet. In this subdued but acutely sensitive portrait, Leonardo depicts the young poetess as a woman of great poise and dignity. She is posed in three-quarter view, and behind her head is a juniper bush, *ginepro* in Italian—an allusion to her name. In this painting we find many of Leonardo's stylistic traits, including a deep penetration of human personality, a dreamy landscape, and exquisitely rendered curls of

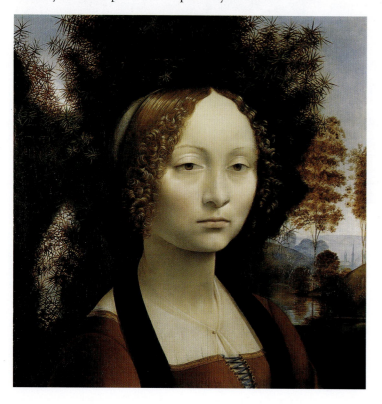

hair, which, in his notebooks, Leonardo compared to the effect of the movement of swirling water. With such means, Leonardo created a study of personality, beauty, and mood, reinforced by its landscape setting.

The Pursuit of Power: The Princely Court

During the Renaissance, Italy was divided into a patchwork of city-states and princely courts, as it had been for centuries. Eager for recognition, the rulers of these small states understood the power of art to burnish their splendor and prestige. They were also eager to secure a humanist education for their children and to retain the best artists in their service. Thus, Renaissance court art often embodied humanist themes.

Notions of the ideal courtier were expressed by humanists such as Ficino and Alberti. Reviving the ancient Greek ideal of the trained mind in a sound body, they believed that only the best should rule. From this notion of ideal aristocratic qualities the Renaissance ideal of the courtier emerged. Lorenzo de' Medici was an early example. De' Medici was versatile, well-read, an accomplished poet, and a capable public figure—a different character altogether from medieval feudal lords, who, as we saw, were not intellectuals. Renaissance rulers were similarly cultivated; Federico da Montefeltro, first Duke of Urbino, for example, was as well-versed in the classics as he was adept with a sword. Subsequently, the court of Urbino provided the model for Baldassare Castiglione's *The Courtier*, which propagated these new ideals.

The palace of the ruling Gonzaga family at Mantua in northern Italy shows the most vivid pictorial representation of a humanist court. For almost fifty years Mantegna was the Gonzagas' official court painter. In the palace's Camera degli Sposi ("Marital Chamber"), painted between 1465 and 1474 (fig. 7.28 and see also fig. 7.1), he showed Marquis Lodovico Gonzaga, his family, and entourage in all their studied elegance. In one scene, on an enclosed terrace, the marquis leans back to receive a messenger, as his court assembles. Mantegna's painting captures well the ideal of the Renaissance courtier—agile, self-aware, and consciously aristocratic. To the left, before

7.27 Attrib. Leonardo da Vinci, *Portrait of Ginevra de' Benci*. c. 1475–76. Oil on panel, 15¼" x 14½", cut down on bottom edge. National Gallery of Art, Washington, D.C.

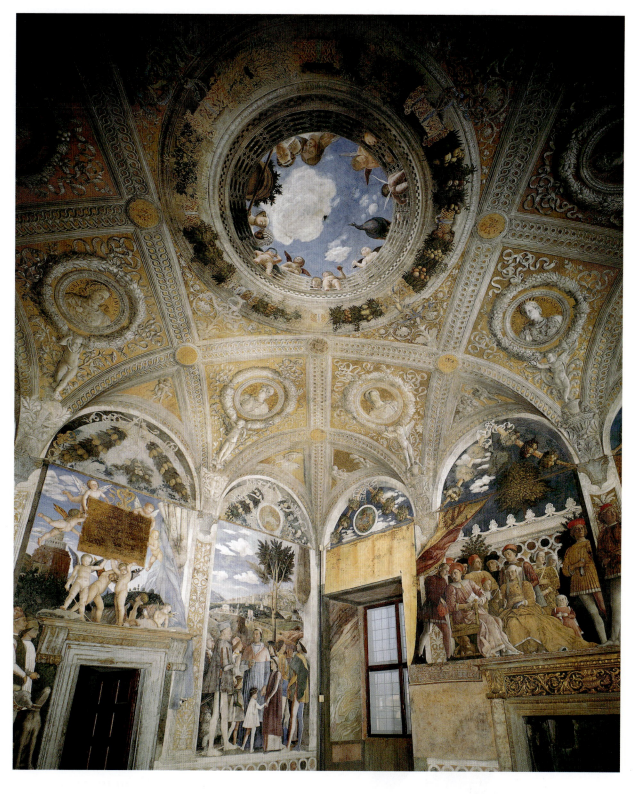

an expansive, imaginary landscape graced by classical buildings, the marquis receives the Bishop of Mantua, who is accompanied by the marquis's thirteen-year-old son, Francesco. Mantegna used classical motifs to create a sumptuous portrayal of court life that magnifies the Gonzaga family's prestige. A vaulted ceiling rises above the wall paintings. Mantegna painted it to resemble clas-

sical reliefs with Roman rulers, garlands, and nude putti. The ceiling culminates unexpectedly in the illusion of a central oculus, through which we apparently see open sky, with figures gazing down, provocatively, from a balcony. Visiting dignitaries, when shown Mantegna's painted room, considered it the most beautiful room in the world.

The Pursuit of Virtue and Beauty

With the term *virtù*, the Italians implied a quality of strength, excellence, and adroitness in human affairs. Renaissance artists celebrated such *virtù*, as well as the beauty, agility, and expressive power of the human body in terms that had not been seen since classical antiquity. Recall Manetti's words, noted on page 197: "What harmony of limbs, what shapeliness of figures, what figure, what face could be or even be thought of as more beautiful than the human?" In the works of Donatello, Botticelli, Michelangelo, Raphael, and Titian we see many different expressions of that idealized conception of human beauty.

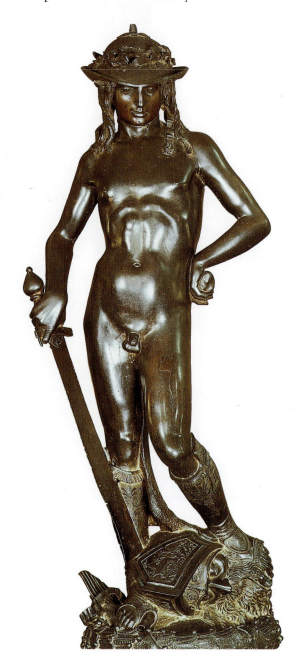

Donatello's *David*

Already earlier in the fifteenth century, in his free-standing, life-size bronze sculpture of the nude *David* of about 1440, Donatello had taken a lead in articulating a radically new sense of self-esteem (fig. 7.29). Not since the Romans had art celebrated youth, grace, and sensual beauty. In this work, while seeming to represent the Old Testament David's triumph over Goliath, the sculptor evokes the presence of a particular adolescent, posing nonchalantly, with eyes cast down, toying with the decapitated head of his conquest. The figure is modeled with sinuous line, and finished with smooth, reflective surfaces. Offsetting the sensual quality of the boy's smooth body is the crisper texture of the hair, the wide-brimmed hat crowned with laurel, and, at his feet, the finely carved helmet and severed head of Goliath. The beauty of the slight adolescent body overshadows the traditional significance of its biblical subject.

Other Renaissance artists looked beyond the biblical sources that had characterized medieval Christian art. In classical history and mythology, they found fresh forms for expressing a wide range of human concerns. At the same time, they reached beyond the naturalistic depiction of beauty to portray the human longing for ideal beauty.

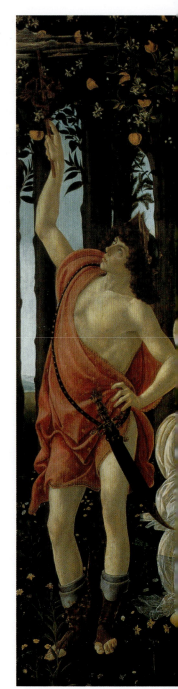

Botticelli's *Primavera*

An early example of this idealizing tendency is the Florentine Botticelli's *Primavera* (*Spring*) (fig. 7.30), painted about 1482, probably for a Medici family marriage. It is a complex allegory of beauty, virtue, and love—

7.29 Donatello, *David*. c. 1440. Bronze, 5'2½". Museo Nazionale del Bargello, Florence

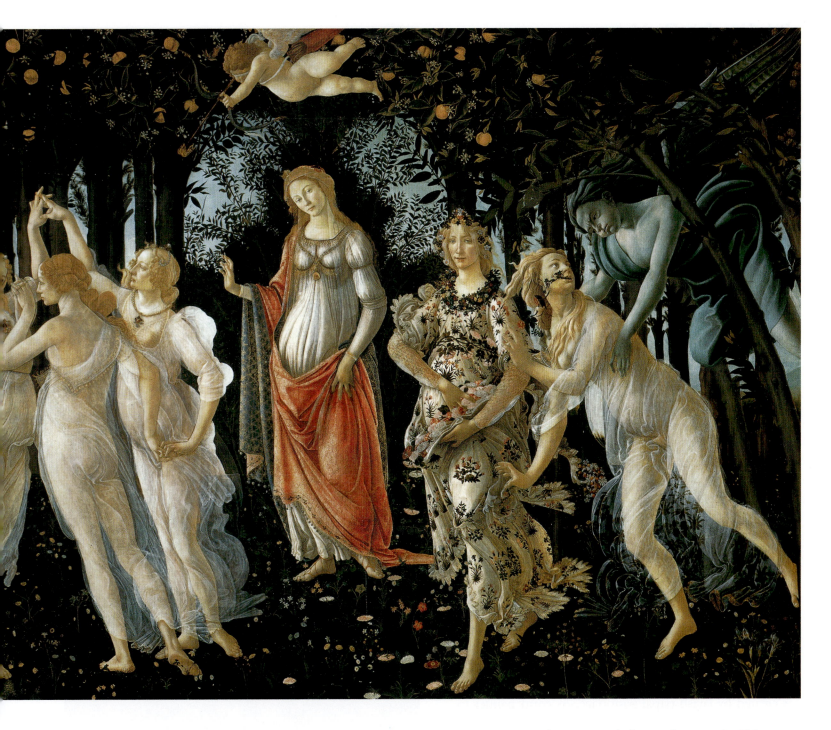

7.30 Sandro Botticelli, *Primavera*. c. 1482. Tempera on panel with oil glazes, 6'8" x 10'4". Galleria degli Uffizi, Florence

both sacred and profane—appropriate for a newly wed couple. Botticelli delineated his figures with an extraordinarily graceful line and painted them with scarcely any shadow. The result is figures of unprecedented elegance that glide over a shimmering carpet of flowers screened by orange trees. His basic theme is human response to earthly beauty. Venus, goddess of love, presides in the center of the painting. To the right Zephyr, the wind of

spring, swoops down toward the earth-nymph Chloris, transforming her into Flora. From her lap tumble spring flowers, a metaphor for love transforming chastity into beauty. To the left of Venus are the Three Graces, at whom Cupid shoots his love-dart. Further to the left the messenger god Mercury points toward the heavens, the divine source of this earthly love and beauty. Taking his subject from classical mythology, Botticelli thus celebrates the beauty of both humanity and nature, while also presenting earthly beauty as a vehicle through which to contemplate the divine.

Michelangelo's *David*

What Botticelli achieved in painting, Michelangelo pursued in sculpture. Michelangelo carved his more than twice life-size *David* between 1501 and 1504, from a block of flawed marble (fig. 7.31). The Florentine authorities placed it before the Palazzo della Signoria, the seat of government, in the city's main square (it was later moved indoors and replaced outdoors by a copy). It stood as a symbol of civic liberty and republican triumph over tyranny, for David's victory over Goliath was compared to Florence's 1494 expulsion of the Medici, who had become tyrannical rulers of the city, undermining its republican form of government.

Michelangelo depicted David ready for battle, with the sling over his shoulder and a stone in his right hand. He appears calm, strong, and self-assured, in control of his own destiny. However, while David was a biblical figure, Michelangelo reconceived him in classical, Herculean terms. With its powerful and majestic frame, rippling muscles, large hands, and confident gaze, Michelangelo's *David* carries to heroic proportions the sculptor's vision of man as the ideal embodiment of divine perfection. Although it became a civic symbol, Michelangelo had first conceived the *David* as his ideal vision of humanity, in which to glimpse the divine. Michelangelo's heroic conception is matched by his mastery of human anatomy and his technical feat in drawing forth this Herculean figure from a block of flawed marble. No such commanding nude sculpture had been seen in a public space since antiquity.

Raphael's Vatican Frescoes

Michelangelo's exalted vision of humanity as the crown of creation and a reflection of divinity has its counterpart in the frescoes Raphael painted around 1510–11. Raphael had been attracted to Rome by the opportunities created by lavish papal patronage. As court painter to the papacy from 1508 until his early death in 1520, Raphael painted a magnificent series of frescoes in the Vatican that project the humanistic ideals of the papal court, values most dramatically displayed in his *School of Athens* (fig. 7.32). Pope Julius II commissioned these frescoes for the Stanza della Segnatura, a room where the pope signed important documents, in the Vatican. On each wall, Raphael depicted one of the four branches of human wisdom: Theology, Law, Poetry, and Philosophy.

7.31 Michelangelo, *David*. 1501–04. Marble, height 13'5 1/2".
Galleria dell'Accademia, Florence

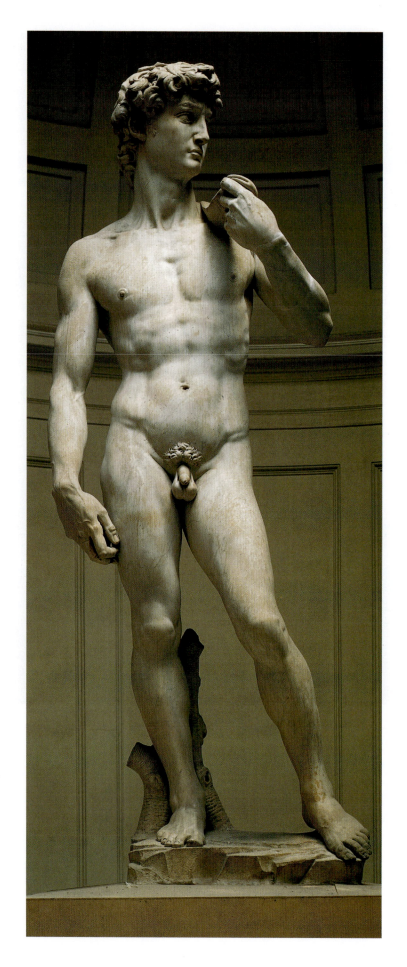

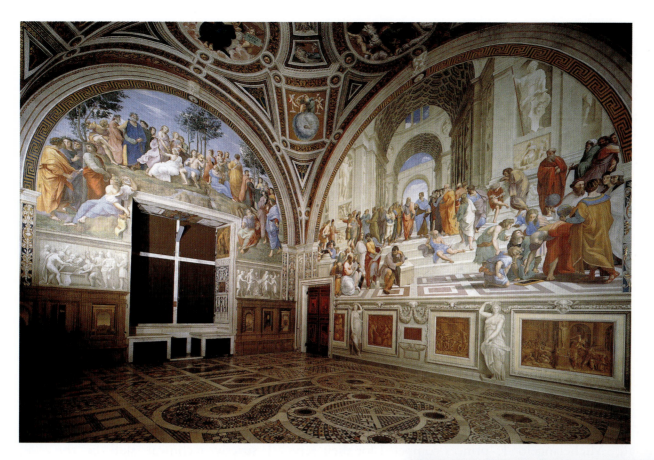

7.32 Raphael, *Mount Parnassus* (left); *School of Athens* (right). 1510–11. Fresco, height 19'. Stanza della Segnatura, Vatican Palace, Rome

7.33 Raphael, *Pope Leo X with Cardinals Giulio de' Medici and Luigi de' Rossi.* c. 1517. Oil on panel, 5'5⅝" x 3'10⅞". Galleria degli Uffizi, Florence

In the *School of Athens*, he created a grandiose architectural stage to surround the central figures of Plato and Aristotle with groups of ancient philosophers of noble bearing talking among themselves. The grand architectural style, derived from ancient Rome, reflects Bramante's design for St. Peter's. Following the example of Leonardo da Vinci and Michelangelo, Raphael used each figure's pose, gestures, and facial expression to suggest the potential of the human mind to discover truth and master nature. Raphael includes the Renaissance artist in such company, leaving us in no doubt about his view of artists' elevated status (see "The Artist as Scholar," page 222). At the center of the fresco, the long-bearded Leonardo stands in for Plato. Michelangelo leans on a marble block in the foreground. To his right, the bending figure of Euclid may be a portrait of the architect Bramante. On the far right stands Raphael himself.

Raphael's Portrait of the Pope

While Raphael's Vatican frescoes project the ideals of the papal court, the psychological depth of his group portrait of *Pope Leo X with Cardinals Giulio de' Medici and Luigi de' Rossi*, painted about 1517, exposes a harsher reality (fig. 7.33). Pope Leo X was the son of Lorenzo de' Medici, in whose intellectual world he was

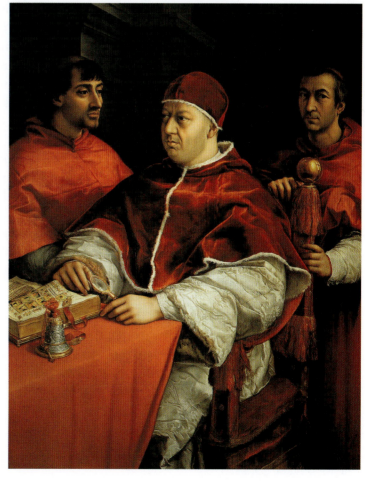

During the Renaissance, in the course of the fifteenth and sixteenth centuries, the professions of architect, sculptor, and painter were all significantly transformed by emphasizing their gift of *sophia* (wisdom), or intellectual invention, as much as *techne* (skill), or technical virtuosity. Brunelleschi, Alberti, and Michelangelo brought the architect's role out of the mason's lodge, and into the intellectual arena. Increasingly, mastery of practical construction was delegated to others, while architects concentrated on mastery of design and classical learning.

Similarly, Ghiberti, Donatello, and, above all, Michelangelo transformed the sculptor's identity. Once, strictly a highly-skilled bronze caster among blacksmiths or the master stone-carver among other masons, the sculptor now also possessed knowledge of human anatomy, classical art, philosophy, and psychology. As for the painters, a desire to emulate the legendary representational skills of their classical forebears inspired artists such as Masaccio, Leonardo da Vinci, and Raphael to master a similar breadth of knowledge as Renaissance sculptors.

The focus of Renaissance artists on classical learning, mathematics, and scientific observation, combined with their sheer ambition and achievement, elevated figures such as Leonardo da Vinci, Raphael, and Michelangelo above the control of the medieval guild system.

Their higher level of learning also began to reverse the prejudice against their form of manual work. Because of their extraordinary technical and intellectual accomplishments, Italian Renaissance artists enjoyed an elevated social standing. Kings and princes competed for their services, and, in time, their example transformed the outlook and identity of artists and architects throughout Europe.

The accomplishments of Italian Renaissance artists also precipitated further developments: Until the late fifteenth century, commissioning patrons —whether from the Church, state, or noble families—had sought out the services of the most technically-competent artists' workshops to execute specific public works, whether religious or secular. Contracts between the parties specified details as to the overall scheme, subjects, and figures to be represented, the quality of materials to be used, and the time allowed for completion. During the Renaissance, however, patrons increasingly desired works of art from the hand of a specific artist and permitted that artist more latitude in conceiving and executing the subject.

This shift of interest from the function of the image to the form of the artist's invention signaled a new respect for the conceptual as opposed to the strictly technical skill of the artist. It also meant that objects, such as painted altarpieces or sculpted saints, came to be viewed less exclusively as devotional objects and more as works of art from the hand of a noted artist. This new perception of both art and artist also led to the emergence of a commercial art market driven by art dealers. Ultimately it marks the beginnings of the relative autonomy of modern art and artists.

nurtured. As pope he pursued his humanistic interests, and Raphael shows this pleasure-loving prince of the Church with a richly illuminated manuscript open on the table before him, attended by two cardinals, both his cousins. Raphael used a strident combination of purplish crimson and bright "cardinal" red, combined with figure placement, gesture, and gaze, all heightened with deep shadows, to suggest a poisonous atmosphere of dependency, manipulation, and intrigue.

Mythology as an Expression of Virtue and Beauty

Not only in Florence and Rome, but also in Venice, artists were attracted to humanistic themes derived from classical mythology. In painting such subjects, artists both displayed their humanistic learning and, as we noted earlier, expanded the subject matter of Western art beyond the religious concerns seen in medieval art. The Venetian painter Titian, in a series of paintings on

themes from Ovid's *Metamorphoses*, exemplifies this trend. Painted about 1559 for Philip II of Spain, one of these works, the *Death of Actaeon* (fig. 7.34), depicts the myth of Diana and Actaeon. While out hunting, Actaeon inadvertently came upon the goddess Diana bathing naked, but could not divert his eyes from her radiant beauty. Outraged, Diana turned him into a stag, and his own hounds devoured him.

In Titian's painting, the vengeful goddess assails the wretched hunter, while the foreboding mood and muted color of the landscape foreshadow his tragic fate. The *Death of Actaeon* also exemplifies Titian's mastery of a novel way of painting. Where Raphael used line to define figures, for example, in the *School of Athens* (see fig. 7.32), Titian relied on color and light to create form and carry the image's expressive power. With incredible freedom of execution, Titian invoked figures and landscape with swatches and daubs of color, which he worked up in layers of glazes and further color. His manner of suggesting forms with richly charged color, rather than defining them with line, enhances the power of his imagery to stir the viewer's emotions. In so doing, Titian paved the way for many later artists—among them Rubens, Rembrandt, Watteau, Delacroix, and the Impressionists—to explore further such sensuous effects of color and light.

With such works, Titian and other Renaissance artists gave form to a wide range of aspirations. They not only served individual patrons in their pursuit of fame, power, virtue, and beauty, but, by embracing themes from classical history and mythology, Renaissance artists inspired their viewers to reflect on human action and desire from fresh perspectives beyond the confines of medieval Christian tradition—namely those derived from classical antiquity. These perspectives would prevail in Western art for centuries.

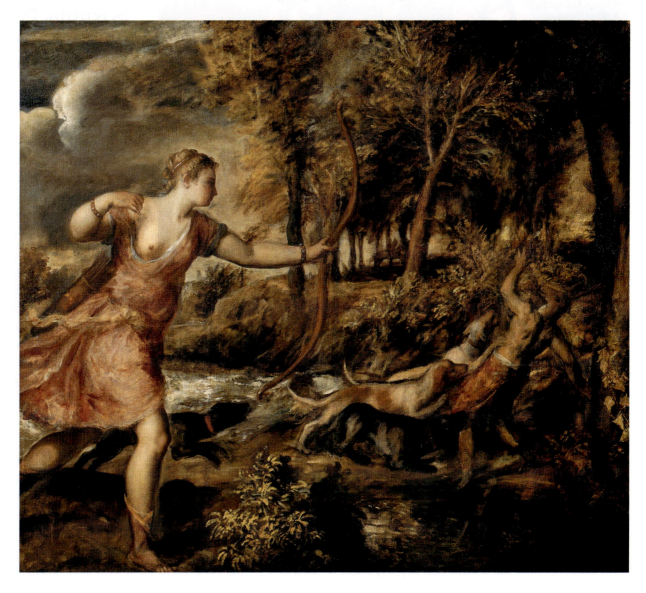

7.34 Titian, *Death of Actaeon*. c. 1559. Oil on canvas, 70¼" x 78". The National Gallery, London

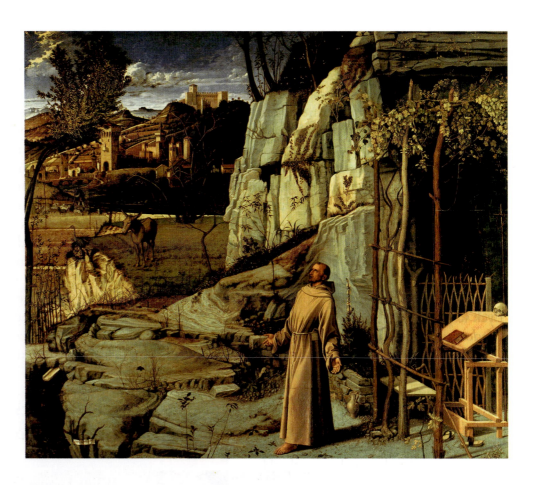

7.37 Giovanni Bellini, *St. Francis in Ecstasy.*
Late 1470s. Oil and tempera on panel,
4'1" x 4'7⁷/₈". The Frick Collection,
New York

to St. Francis's *Hymn to the Sun*, which praised all of God's creation. Bellini patiently depicted all the little cracks and crevices of the rocky outcrop, the plants, trees, and meadows, and the river, hillside, and walled city beyond. The artist transports St. Francis's hillside retreat to the fertile Venetian hinterland, where the saint stands, awed by a vision of (the unseen) Christ and by the boundless beauty of God's creation. Bellini alluded to the vision in the brilliant light illuminating the clouds in the upper left corner of the painting. Bellini's successors, Giorgione and Titian, evoked a more secular dream of life in harmony with nature.

Giorgione's *Three Philosophers*

Giorgione's *Three Philosophers*, painted about 1506–08 (fig. 7.38), like Bellini's *St. Francis*, represents figures in a landscape, deep in contemplative wonder. Giorgione's philosophers hold instruments with which to study the world, perhaps pondering its mysteries. The artist gave the scene its own mysterious, moody atmosphere through the use of shadow, color, and light. While shadow covers much of the scene, soft side-lighting plays over the buildings nestled amid trees and highlights the warm tones of the distant landscape.

Beyond these distant hills the sun spreads a warm, joyous light. But the painting has a second, mysterious light source. Notice the light that comes in from the side and falls over the mouth of the cave, illuminating the philosophers. Could this light, the object of the youngest philosopher's intent gaze, be the light of the miraculous star that the Three Wise Men saw over Bethlehem? (In another painting, Giorgione sets the scene of *The Three Shepherds Adoring the Christ Child* in front of the mouth of a cave.) Whatever his specific intent, Giorgione has created a poetic landscape in which the mystery and beauty of the natural world absorb the figures, and in which the urban viewer can find a peaceful escape.

Titian's *Bacchanal of the Andrians*

Titian, Giorgione's younger contemporary, evokes a more jubilant and sensuous mood in his *Bacchanal of the Andrians*, painted about 1522–23 (fig. 7.39). It depicts revelers on the fabled island of Andros. Titian conjures up a dream of harmony between men, women, and nature, where all is fertile, lush, and plentiful. The sea is calm, the trees provide shade, and nature freely gives its bounty. The child urinating beside the reclining

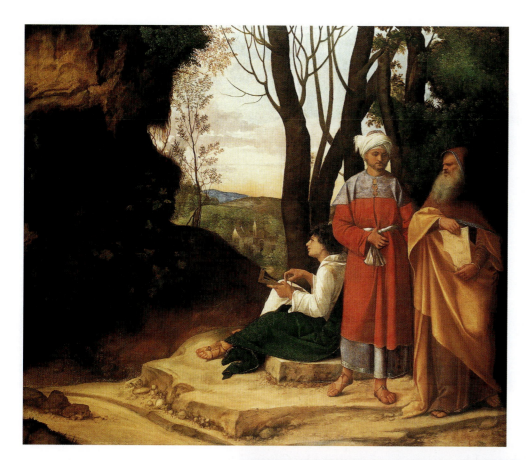

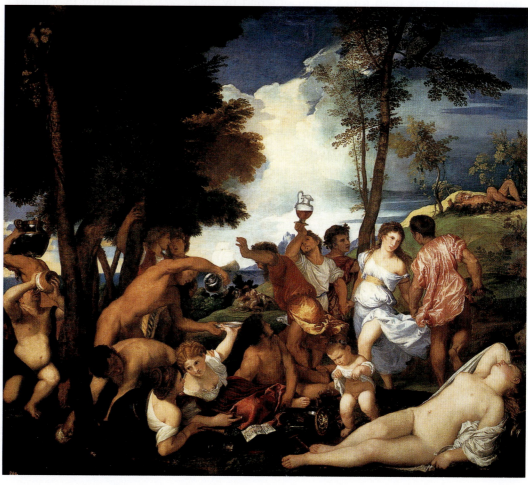

7.39 Titian, *Bacchanal of the
Andrians.* c. 1522–23.
Oil on canvas, 5'8⅞" x 6'4".
Museo del Prado, Madrid

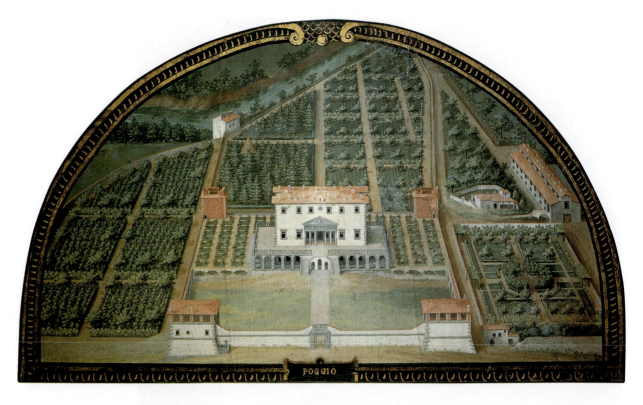

7.40 Lorenzo de' Medici and Giuliano da Sangallo, Villa Medici, Poggio a Caiano. Begun 1485; painting by Giusto Utens, 1598/99 (also showing the layout of the formal gardens and orchards). Museo di Firenze Com'era, Florence

nude woman on the right signifies fertility and abundance. Titian's colors intensify the poetic reverie of his theme: Warm pink flesh tones are heightened by areas of blue and red, and complemented by the cool tones of the landscape. Exuberant paired figures twist, turn, reach, and recline, as they talk, drink, and dance in harmony, enfolded in the abundance of nature. The guardian spirit of the place, the god of the river of wine, who lies prostrate on the hillside above, oversees them. Only the storm clouds and a rigged ship hint at the harsher reality beyond the horizon of the world in which we actually find ourselves. The theme attests our insatiable desire to recover the limitless bounty of the Garden of Eden which Titian evokes as much through the lush landscape as by the reveling figures.

Nature as Solace: The Renaissance Villa

The Renaissance villa was essentially a place of pleasure where the privileged city dweller could enjoy fresh food, breathe clean air, entertain friends, and enjoy beautiful views of ordered gardens, fertile fields, hills, streams, and woodlands.

A fine early example of a Renaissance villa is the Villa Medici at Poggio a Caiano, near Florence (begun 1485), whose elevated setting was designed to express

humanity's dominance over nature, as well as the desire to capitalize on a site with an expansive view. As seen in a painting by Giusto Utens (fl. late sixteenth century) of 1598–99 (fig. 7.40), it stands on the hills above the valley of the River Arno, commanding a view similar to that in Pollaiuolo's *St. Sebastian* altarpiece (see fig. 7.35).

The ordered gardens combine with the elevated villa to emphasize a deliberate contrast of culture to untamed nature, underscoring humanity's dominion over nature. Disorderly vegetation appears only on the far river bank, beyond the villa precinct, as seen in Utens's painting.

Palladio's Villa Rotonda

The Renaissance villa reached its definitive form in the plans of the architect Andrea Palladio (1508–80), who designed many fine villas in the region around Venice. The most famous of them is the Villa Rotonda (Villa Capra), near Vicenza, begun in 1550 (fig. 7.41). Its fine views inspired the villa's unique architectural feature: Four symmetrical porticoes, one on each façade, that allow the visitor to look in all directions from a dominant vantage point. The villa's plan also exemplifies the humanistic architectural principles we saw in Renaissance churches: Ordered geometric symmetry, harmonic mathematical ratios, and designs centered on a circle inscribed within a square (fig. 7.42). The villa is centered on a domed circular hall inscribed within a

square, and each unit of portico and steps repeats, on a reduced scale, the square of the house itself. By basing his architecture on harmonic mathematical proportions, Palladio believed that the scale of all the elements in a building—rooms, halls, doorways, and windows—would be in harmony with each other and with the building's occupants. It was an ideal that sought to bring humanity, culture, and nature into delightful accord.

Palladio's Villa Rotonda, and others like it, inspired a number of later buildings, particularly country house designs for eighteenth-century English aristocrats and for gentlemen farmers in colonial America, such as Thomas Jefferson (see Chapter 11). Palladio's design provided a dignified simplicity, implying class without ostentation. His trademark classical temple porticoes enhanced a building's grandeur as well as providing a welcome spot to enjoy the view, screened from sun and wind.

Since gardens were inherent to Renaissance villa culture, the building of villas also stimulated a burst of new interest in landscape gardening. The designs of both the villas and gardens reflected Renaissance humanist taste through imitation of classical precedents and the creation of formal order, based on geometry. With the spread of villa culture, the Renaissance urbanite's ideal of life in harmony with nature seemed complete.

THE CITY

Renaissance artists and architects conceived of the ideal city in classical terms: It would be laid out on a centralized plan, with a palace or church at its center, surrounded by other buildings of uniform design, creating harmony between the parts and the whole. Perugino's painting *Christ Giving the Keys to Saint Peter* shows us a Renaissance artist's vision of the ideal city, a vision shared by Renaissance architects and theorists (see fig. 7.3). Given the density of the late medieval cities in which they lived, however, architects had to apply these classical principles to existing public spaces and, where possible, insert new buildings into them.

Public Space and Civic Buildings

Despite the difficulties of working within dense spaces, prominent merchants, churchmen, and other civic leaders adorned cities such as Florence and Rome with classically inspired churches, palaces, and civic buildings, and enriched public spaces with statuary and fountains. Brunelleschi in Florence and Michelangelo in Rome attempted to mould public spaces into something recalling the regularity of a Roman forum. As with so much in Renaissance art and architecture, what was born with

7.41 Palladio, Villa Rotonda (Villa Capra), Vicenza. Begun 1550

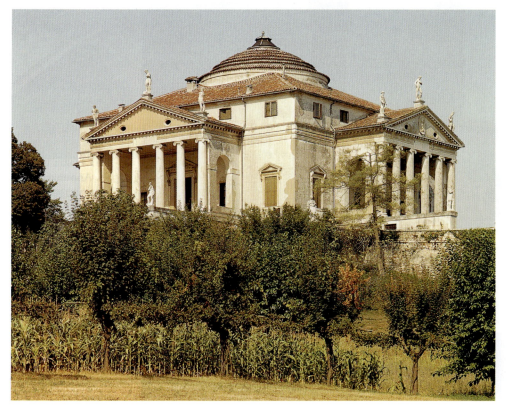

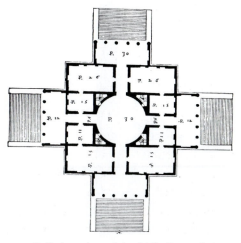
7.42 Palladio, plan of the Villa Rotonda

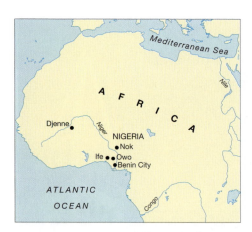

Map 7.2
West Africa

PARALLEL CULTURES
West Africa: Ife and Benin Art

The Renaissance spirit of self-assurance and adventure, the desire to explore and master the world, and the quest for commercial gain led to intensified and unprecedented contact with non-Western cultures, including those previously unknown to Europeans. More than the Italians, the Portuguese and the Spanish took the leading initiatives in this exploration.

The first of these encounters took place in Africa as a result of the Portuguese search for a southern passage to the East. This quest took the Portuguese down the west coast of Africa and led to the first direct contact between the cultures of Europe and sub-Saharan Africa in the 1470s and 1480s (see Map 7.2). In what is now southwestern Nigeria, the Portuguese encountered long-established city-states in Ife and Benin, cultures that produced great art. We will look at two examples. Both were designed to uphold royal authority, a function of art that we have encountered often in the past, and both examples display the artists' skill in metal-casting. One comes from Ife, the other from Benin.

Ife, the most important religious center of the Yoruba people of West Africa, had been producing figurative sculpture for centuries. To Western eyes, the magnificent life-size brass heads of Ife rulers, or Oni, such as the example shown here, which dates from between the twelfth and fifteenth centuries (fig. 7.48), combine naturalism and stylization: The features are lifelike, yet not individualized. These qualities, together with the figure's poise and expression, give it a commanding dignity. Little holes in the figure allow ceremonial elements, such as a crown, beard, veil, or necklaces, to be attached, which indicates that the Yoruba used such brass heads in their rituals, perhaps in burial and coronation cere-

monies, to symbolize the continuity of the royal office and identify a new king with the powers of his ancestors.

By the 1480s, when the Portuguese arrived, Ife's power was in decline, and the Portuguese traded with the Bini, the people of Benin. The Portuguese exchanged copper and brass for gold, ivory, and slaves that the Bini took from their enemies. The Bini were a wealthy, highly organized society. Their ruler, the *Oba*, was an absolute monarch who claimed divine origin by descent from the kings of Ife. The *Oba* had the sole right to use brass sculpture: Metalsmiths and ivory carvers worked exclusively for him. According to local tradition, they derived their metal-casting skills from the older Ife culture. But to Western eyes, their art is more stylized—the features on their sculpture are less natural than those of the Ife. Since the king held a monopoly on sculpture in brass, surviving work glorifies the divine status of Bini rulers.

The palace at Benin was an elaborate complex filled with works of art accumulated over centuries. These

7.48 Head of an *Oni* (king) of Ife, Yoruba. 12th–15th century. Zinc brass, height 12³⁄₆″. Museum of Ife Antiquities, Ife, Nigeria

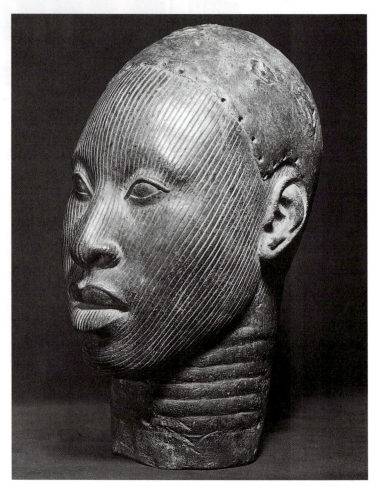

7.49 *The Oba of Benin in Divine Aspect.* 16th–17th century. Bronze, 16" x 12¹/₂". The British Museum, London

were later seized by the British in a punitive expedition in 1897 and auctioned off in London. This sixteenth-century bronze plaque, *The Oba of Benin in Divine Aspect* (fig. 7.49), went to London's British Museum. It presents the king as a divine figure, exercising power over nature. Posed frontally against a flat, patterned ground, he swings two leopards by their tails. In place of legs, his body terminates in two fish, a reference to the sea god Olokun and thus to the royal family's claim to divine origins.

At the time, the Portuguese West African encounter did not result in any significant creative exchange between Western and African art. Some West Africans, notably the Bini, produced art for export, such as ivories that fused African skills with European motifs and found their way, as curiosities, into European princely collections, including that of Grand Duke Cosimo I de' Medici of Florence in 1553. But Westerners did not grasp and appreciate the expressive potential of African art until the early twentieth century.

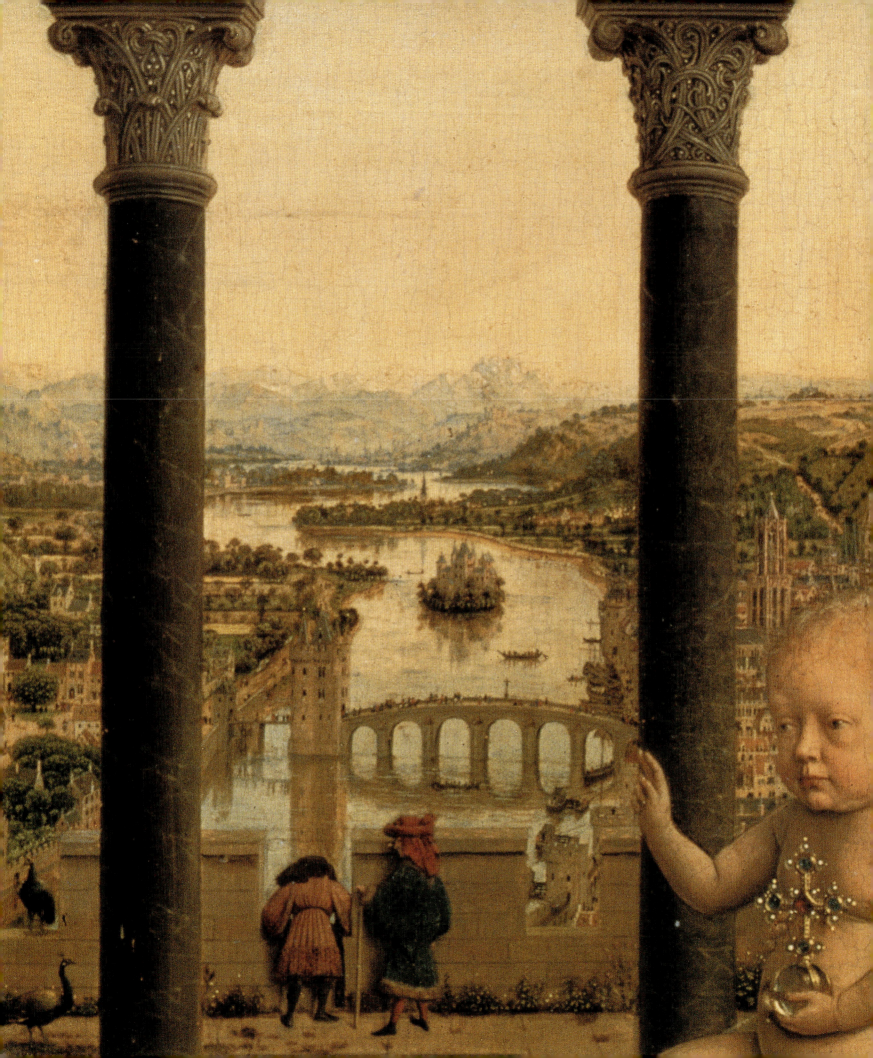

8 Northern Renaissance Art

8.1 Jan van Eyck, *Madonna and Child with Chancellor Nicolas Rolin* (detail of fig. 8.18). c.1435. Oil on panel, 26" x 24¾". Musée du Louvre, Paris

The Northern Renaissance occurred during the years 1400–1600, a period of revolutionary social change, marked by a shift from feudalism to a capitalist economy, increased commercial prosperity, and mounting criticism of the corruption of the Church of Rome. The Protestant Reformation erupted in 1517, a movement which would fragment forever such spiritual unity as had existed in medieval Europe. During this tumultuous time many of the social, economic, spiritual, and artistic features of early modern Europe took shape.

Map 8.1 Northern Renaissance Europe

For northern European artists, these revolutionary social changes would have profound effects. The term "Northern Renaissance" refers to the art of this period in the Netherlands, Germany, France, and England (although our focus will be on the first two regions; see Map 8.1). A detail from a painting by Jan van Eyck (c. 1390–1441) (fig. 8.1, see also fig. 8.18) masterfully displays a Netherlandish artist's scrupulous eye for the smallest detail, whether of jewels, flowers, stone-carvings, human flesh, or a distant landscape bathed in radiant light. With works like this, the Northern Renaissance was launched.

Social and Economic Contexts

A thriving money economy, centered on Flemish cities such as Ghent and Bruges, provided northern artists with a new source of significant patronage. "Flemish" refers to the art and culture of Flanders, the most prosperous province of the Netherlands. In northern Europe, medieval artists had served the Church and the nobility; now they received commissions from civil servants, wealthy merchants, and the intellectual elite as well. With the rise of capitalism, fed by expanding overseas markets, a strong mercantile class had money to spend on art, and as economic power shifted from Italy to the Netherlands, northern artists profited.

In the sixteenth century, Antwerp replaced Florence as the financial center of Europe and the hub of international commerce, attracting publishers, cartographers, and artists. Amidst this vital activity, artists absorbed the latest ideas current in such circles. They were also influenced by independent humanist scholars, such as Erasmus and

Sebastian Brant, who openly criticized corruption in the Church. The newly invented printing press would spread their ideas, influencing artists and their patrons.

Society and Art

Around 1400, artists found most of their work in creating altarpieces, both painted and carved, manuscript illuminations such as those of the Limbourg Brothers (see figs. 6.32 and 6.37), and occasional portraits, plus all the decorative trappings of court life. Between 1520 and 1550 commissions for religious art in Protestant Germany and the Netherlands dried up (see discussion of Protestantism, page 247). Instead wealthy merchants wanted smaller-scale art to decorate their homes, such as Petrus Christus's (d. 1472/3) *Saint Eloy in His Studio* (fig. 8.2). This change inspired the development of new types of paintings, especially portraiture, landscape, still life, and satirical scenes of daily life, known as **genre** paintings. The printing press brought **printmaking** into vogue, effectively ending the craft of manuscript illumination.

As for sculpture, when Protestants changed the focus of worship from image to word, the demand for sculpture—which had been the pride of late medieval religious art—dried up, and many sculptors found themselves out of work. Thus painting and printmaking form the core of Northern Renaissance art. The commercial life of sixteenth-century Antwerp launched the beginnings of a modern, commercial art market that catered to the middle class. In turn, this new art market provided the vital foundation for the flowering of Dutch art and culture in the next century, as we'll see in Chapter 10.

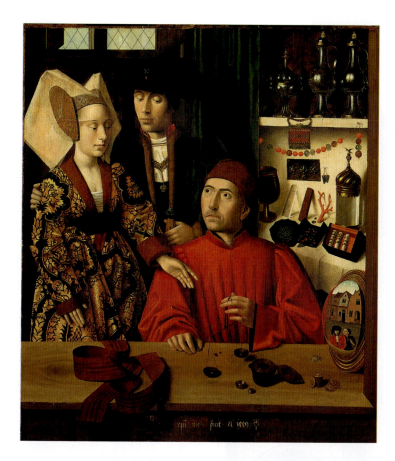

8.2 Petrus Christus, *Saint Eloy in His Studio.* 1449. Oil and tempera on panel, 39" x 33½". The Metropolitan Museum of Art, New York

Italy and the North: From Idealism to Realism

Italian Renaissance artists—inspired in part by the classical tradition—had tended to create an idealized image of humanity, purified of the incidental features and imperfections of everyday reality (see figs. 7.10 and 7.29–7.32). By contrast, northern artists, and their patrons—at least during the fifteenth-century—showed little interest in classical idealism. Like their Italian counterparts, they were keenly interested in the natural world, but northern artists favored scrupulously observed, finely crafted, and minutely detailed representations of individual people and things, with all their idiosyncrasies. For example, Petrus Christus's painting of Saint Eloy depicts a bridal couple negotiating the purchase of a ring in a goldsmith's workshop, in which the goldsmith's wares are all carefully rendered (see fig. 8.2). Northern artists of the fifteenth century onward, especially in the Netherlands, took pride in creating a form of visual realism, in which they used the potential of **oil paint** to create the illusion of the specific texture, detail, color, and surface qualities of material objects.

Yet, for all the visual realism they valued, Northern Renaissance artists also perceived the material world in traditional Christian terms, as a mirror of spiritual reality, and so endowed their art with religious meaning. Humanistic scholars in the north drew on lessons from the Bible and theology to encourage ethical behavior. Similarly, Northern Renaissance painters infused their art with moral themes. In the sixteenth century, interest in Italian Renaissance art complemented these traditional concerns. Albrecht Dürer (1471–1528) was the first of a succession of northern artists to respond to the classical dimension of Italian Renaissance humanism. This resulted in a hybrid form of art that blended elements of both traditions.

At the same time, northern rulers, such as Francis I of France, who admired Italian Renaissance architecture, lured Italian artists and craftsmen to the north, opening a new chapter in northern architecture. Though the Northern Renaissance began as a movement distinct from that of Italy, over time it absorbed some of its principles, just as Italians adopted some of the innovations of northern artists, notably the technique of oil painting.

During this period the arts in Spain and Portugal (which are outside the scope of this chapter) maintained their own distinct traditions, while influenced by both Italian and Netherlandish masters. But it was Spain and Portugal, not Italy or the Netherlands, who led the initiative in world exploration. With Spain's and Portugal's overseas expansion, new commodities entered the European market, including Chinese porcelain, oriental fabrics, and other works of art. We close this chapter with a look at the art of two cultures the Portuguese encountered, China and Japan.

SPIRITUALITY

In the century preceding the Protestant Reformation, one of the most prevalent art forms in northern Europe was the painted or carved altarpiece that supported the traditional liturgy of the Catholic Mass. Now, outside Italy, especially in Germany, criticism of the corrupt Church of Rome ran high, particularly the sale of indulgences (the remission of punishment for sin), the use of Church funds to support the lavish tastes of the Renaissance papacy, and other issues. At the same time, in the Netherlands and the German

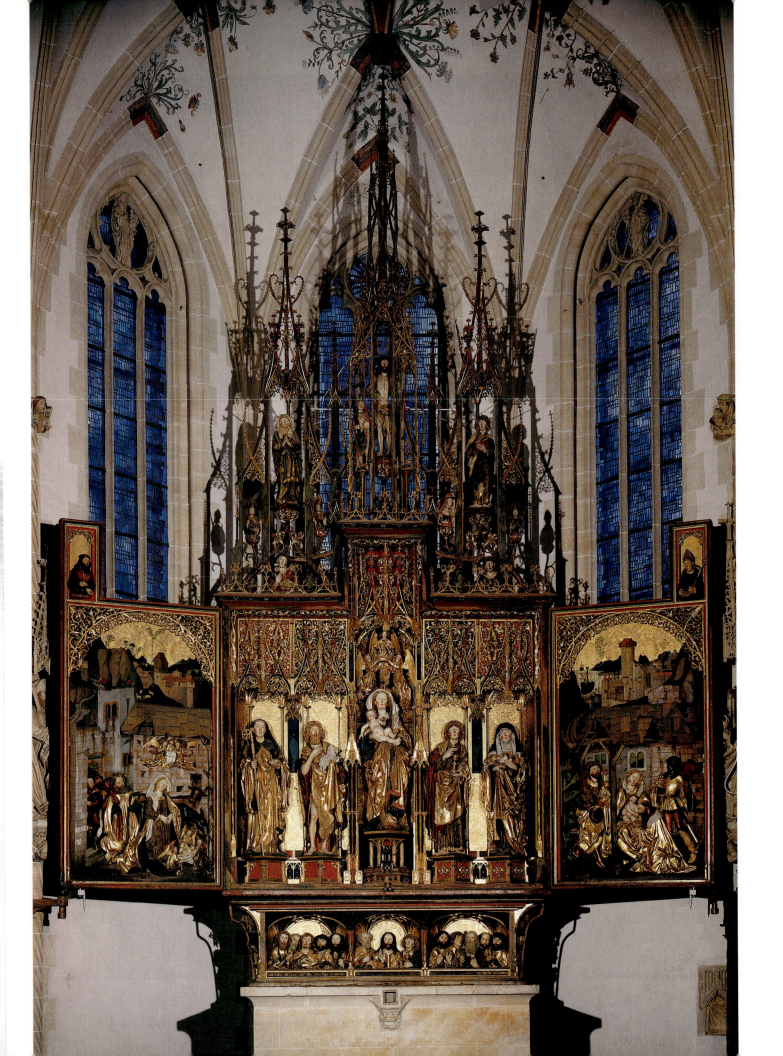

Pre-Reformation German Altarpieces

As well as the many painted altarpieces produced at this time, sculptors in the Netherlands and Germany were producing some of the most elaborate wood-carved altarpieces ever made. Many of these were destroyed during the **iconoclasm** of the Protestant Reformation, leaving sculptors throughout Germany and the Netherlands unemployed. Michel (fl. 1469–1522) and Gregor Erhart's (c. 1465–1540) carved and painted *Blaubeuren Altarpiece* is an exemplary surviving work (fig. 8.7). It was made for the Benedictine abbey of Blaubeuren, near Ulm, about 1493–94.

Altarpieces such as this, whether painted or carved, were designed for display at the back of an altar. The main body of the *Blaubeuren Altarpiece*, together with its hinged wings, horizontal base, and elaborate, pinnacled canopy, rich in decorative carving, shows off the range and virtuosity of the Pre-Reformation German wood-carvers' art. The row of figures on the main body, representing various saints, is painted to look lifelike. The scenes on the wings are carved in low relief and also painted. A typical feature of such altarpieces is the pinnacled canopy. While the rich, decorative frame elevates the images of the saints above ordinary life, their lifelike presence makes them accessible to the worshiper.

Such altarpieces were intended as an aid to devotion, but Protestant reformers feared that their lifelike qualities, frontal poses, and engaging facial expressions also nourished the veneration of the Virgin and saints, at times blurring the distinction between the images themselves and the figures they represented. Alleging that such images were idolatrous, Protestant iconoclasts destroyed many fine examples of the carver's art.

The Isenheim Altarpiece

While the *Blaubeuren Altarpiece* connects with its intended audience through the realism of its figures, another remarkable altarpiece that survived the Protestant Reformation, *The Isenheim Altarpiece*, addressed its specific audience—the diseased—through identification with the sufferings of Christ. Mathis Neithardt, known as Matthias Grünewald (d. 1528), conceived of *The Isenheim Altarpiece* between 1510 and 1515 as three successive layers of carved and painted panels. It is best known for the somber painting of the agonized *Crucifixion of Christ* seen on the exterior when closed (fig. 8.8).

8.7 (left) Michel and Gregor (?) Erhart, *The Blaubeuren Altarpiece.* 1493–94. Painted wood (figures limewood), overall height, approx. 39'; width, open, approx. 26'10". Klosterkirche, Blaubeuren

8.8 (right) Matthias Grünewald, *The Isenheim Altarpiece*, closed. 1515. Oil on panel (with framing), 9'9½" x 10'9". Musée d'Unterlinden, Colmar

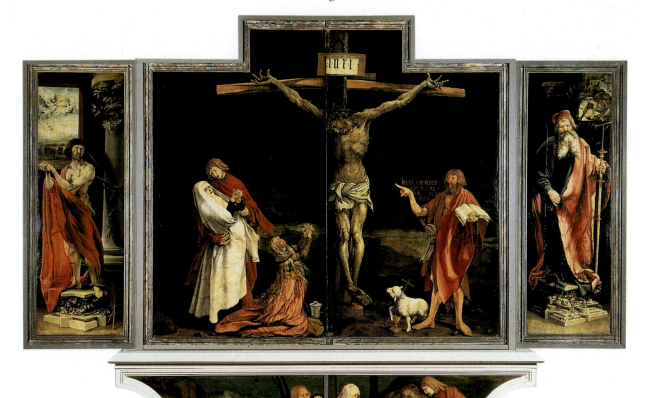

Oil Painting

Jan van Eyck, Robert Campin, and Rogier van der Weyden are widely acknowledged as founders of the Netherlandish school of oil painting. Early in the fifteenth century, they transposed a vital tradition of manuscript illumination and stained-glass onto the scale of large panel painting. At the same time, they developed the technique of oil painting and exploited its potential to capture everything from the fine texture of gold threads in a rich fabric to the most subtle reflections of images and light off metal or glass surfaces.

Oil paint is made of a mixture of ground pigment and linseed oil. Previously, artists had mixed their pigments with egg **tempera**, which dries within minutes, and is opaque (see Chapter 7, "Materials and Techniques: Tempera," p. 204). Oil, by contrast, dries slowly, and can be applied in successive, translucent glazes. Glazing is a technique by which an artist applies thin, transparent layers of oil color over a solid one. The base color is then subtly changed by the glazes laid over it, without losing color or brilliance. The glazing also imparts a glowing luminosity to the painting. By using oil instead of egg tempera as the binding medium, artists could thus gradually build up their image to create an astonishing and detailed illusion of reality. With this medium, they evoked the effects of light playing on the surface textures of materials, which could be rendered in brilliant, translucent colors (see, for example, Van Eyck's *Ghent Altarpiece*, fig. 8.3). The powerful visual appeal of their technical innovations swept all before it, being imitated throughout Europe, even in Italy.

Oil paint can be applied not only in fine, transparent glazes, but also in thick deposits of luscious paint, called **impasto**. When applied with a brush, palette knife, or even the finger, each mark becomes part of the surface texture of the painting. It can be layered over existing paint, allowing some of the undercolor to show through, a technique known as scumbling. Or, it can be applied over still-wet paint, so that the colors of each layer blend. Titian was one of the first to apply paint in a thick impasto with broad, painterly brushstrokes that remain visible as part of the painting's surface texture (see his *Death of Actaeon*, fig. 7.34).

As we noted in Chapter 2, much later, when chemical pigments were introduced in the nineteenth century, paint both became more affordable and created more brilliant and durable colors which the French Impressionists used to full advantage. Tubes of premixed paint also allowed artists to paint outdoors (see, for example, Monet's *On the Seine at Bennecourt*, fig. 13.24). The medium of oil painting continues to be widely used right up to the present. Its tactile potential has been wide exploited by twentieth-century artists. For example, Willem de Kooning's (1904–97) *Woman and Bicycle* (see fig. 15.10) offers an excellent example of scumbling and painting wet-on-wet.

This polyptych was made for the hospital chapel of the monastery of St. Anthony at Isenheim in Alsace. The hospital treated diseases of the blood and skin, including ergotism, or so-called St. Anthony's Fire, which produced gangrene. The themes of the polyptych, built around the sufferings of Christ and of those saints who endured great physical and spiritual torment, St. Sebastian and St. Anthony, present inspiring figures with whom the patients could identify.

On the exterior, Grünewald's Christ hangs from the cross in a bleak landscape shrouded in utter darkness. His emaciated, bloody, deathly green body is lacerated from flagellation, and his contorted fingers extend wretchedly against the desolate sky. Grünewald's colors—deep crimson robes offset by cold blacks and grayish green on the exterior—heighten the emotional intensity of this devotional image.

When these somber, exterior panels are opened, the viewer sees instead joyfully-colored, music-making angels, and bursts of supernatural light, radiant with red, pink, yellow, and blue, to celebrate scenes of the Nativity and Resurrection. As a whole, the altarpiece offered comfort and hope to the sick and dying.

The Protestant Reformation in Sixteenth-century Germany

When Zwingli, Calvin, and other reformers broke with the Catholic Church, they also rejected the images and the uses of traditional religious art. Protestants emphasized that faith comes from hearing, not from seeing. Art should be secular, or, if religious in subject, it should function outside the Church, in the home.

Only Luther wanted art in churches, but even he rejected images that encouraged veneration, particularly depictions of the Virgin Mary. He called for works that would clearly promote Protestant teaching, ideally supported by a written text. Effectively, Protestants shifted the focus of worship from the altar and the image to the pulpit and the word, and Protestant churches became physically bare.

While the work of such artists as Lucas Cranach the Elder (1473–1553) (see below) embodied Luther's desire to preserve a role for religious art, his emphasis on the church as a place to hear clear preaching undermined the imaginative qualities of visual art. By reducing art to the level of mere visual aid, even in Lutheran communities the demand for Church art radically diminished.

Protestantism had particularly severe consequences for northern European sculptors. Their prime work had been the creation of carved altarpieces (such as fig. 8.7). Now, secular commissions for fountains, statuettes, and ornate domestic carvings were a poor substitute. Painters adapted more easily, as the market for **history painting**, portraiture, landscape, and genre painting grew.

Artists in areas of the Netherlands controlled by Protestants fared better than their German counterparts because there was already a well-established mercantile clientele for art such as Petrus Christus's *Saint Eloy in his Studio* of 1449 (see fig. 8.2). Thus, when Lutheranism and then Calvinism spread through society, the consequences for artists, although significant, were not devastating. In the Iconoclastic Riots of 1566, artists saw most of their work done for the Church destroyed. Yet alternative private commissions were more readily available than in Germany, and so, while the visual arts suffered in Protestant Germany, they continued to flourish in the Netherlands.

Lucas Cranach the Elder's *The Wittenberg Altarpiece*

One artist functioning close to the heart of the Protestant Reformation was Lucas Cranach the Elder. While working as court painter to the electors of Saxony at Wittenberg, he met Luther who became his life-long friend. Besides the secular work Cranach produced as court artist, he also created propaganda woodcuts, biblical illustrations, and a few altarpieces intended for Protestant use. Most notable is *The Wittenberg Altarpiece* (fig. 8.9), installed in the city church of Wittenberg in 1547. Far more austere than his work for the court, it embodies Luther's conception of the Church and the sacraments with characteristic Protestant directness.

Thus, on the base, Cranach depicts Luther plainly preaching "the purity of the gospel" before members of the Wittenberg court. On the three panels above, the sacraments are administered to members of the

8.9 Lucas Cranach the Elder, *The Wittenberg Altarpiece*. 1540s. Oil on panel, center panel, 8'4³/₄" x 7'11¹/₄". Town Church, Wittenberg

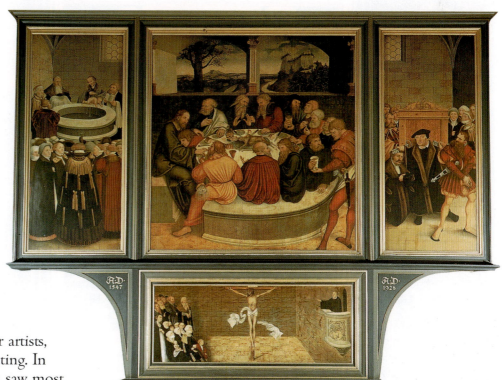

Printmaking:
Woodcut and Engraving

Woodcut is the oldest form of printmaking and was first developed in China around 200 BCE for printing patterns onto textiles. It was not until the fifteenth century that European artists began using this technique. Most of these early prints were book illustrations or religious images. They began to have a significant cultural impact in northern Europe in the sixteenth century, as the printing press made prints widely available at relatively low cost.

Woodcuts are a form of the relief process, in which lines and areas to be printed remain raised above the areas that are to stay white (fig. 8.12). A design is drawn onto the surface of a woodblock that has been sawn along the grain. The non-image areas are then carved away with a knife or gouge. As a result, these areas are shallower, and will not pick up ink when it is applied to the wood with a roller. The ink adheres only to the raised surface of the drawing. The image is printed when paper is laid on top of the woodblock, either by hand or with a printing press. Up to a thousand good prints can be pulled before the block starts to wear.

Lucas van Leyden's *A Tavern Scene* of c. 1518–20 (see fig. 8.11 and detail, 8.14) is characteristic of sixteenth-century northern European woodcuts. The artist uses series of parallel lines, called **hatching**, as well as two layers of such lines, one crossing the other at an angle, called **crosshatching**, to create shading, imitating the effect of ink drawings. The large size of this particular print ($26^3/_8$" x $19^1/_8$"), in which two blocks were used to print on four sheets of paper, suggests that the image was designed to be displayed on a wall, rather than preserved in a portfolio of fine prints.

Artists also used woodcut to achieve quite different effects. Much later, the German Expressionists of the early twentieth century emphasized the roughness and sharpness of edges that come from gouging out wood, as we can see in Käthe Kollwitz's (1867–1945) print *Memorial Sheet for Karl Liebknecht* (see fig. 14.19). The print is much bolder and lines are used for expressive purposes rather than detailed representation of natural forms.

8.12 Diagram of woodcut technique

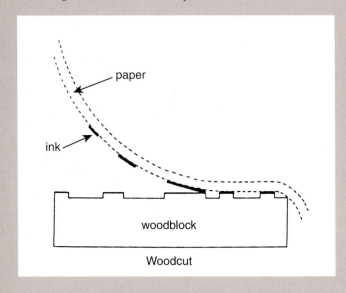

Woodcut

8.13 Diagram of engraving technique

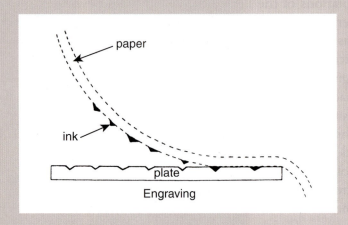

Engraving

To make a color woodcut, such as Hans Burgkmair's *Lovers Surprised by Death* (see fig. 8.20), a separate block has to be made for each color. These blocks must be precisely matched and lined up on the paper by cutting registration guides into the corners beyond the edges of the print. Starting with the lighter colors, each block is printed one after the other on the sheet of paper, so that the final print is made of a layering of colors. Burgkmair's *Lovers Surprised by Death* is a type of chiaroscuro (light-and-shadow) woodcut, popular in Europe in the sixteenth century, in which the inks are different values of the same color, rather than a range of local colors, that is the actual colors of objects. The effect of a chiaroscuro woodcut is to emphasize highlights, shadows, and contour lines.

Color printing using a full scale of local colors was developed by Japanese woodblock printers of the eighteenth and nineteenth centuries. An example is Suzuki Harunobu's (1725–1770) *Courtesan on Veranda* of the late 1760s, in which flat areas of color are bounded by crisp and fluent contour lines (see fig. 13.43).

Intaglio is the opposite of relief: the image is incised into the surface of a metal printing plate, so that the removed areas are printed, instead of those left remaining, as in relief printing. The incised lines are printed by rubbing the plate with ink until it fills the grooves, and then wiping off the excess ink from the surface. A sheet of dampened paper is laid across the plate and the pressure of the printing press forces it to pick up the ink from the grooves. The pressure causes the plate to make an impression on the paper and the lines to be slightly raised.

Engraving is the earliest of the intaglio processes. The material generally used is copper plate, into which lines are cut with a sharply pointed steel tool, called a burin (fig. 8.13). This technique creates extremely fine, precise lines by which subtle shading and modeling of forms can be achieved by laying multiple lines next to each other through hatching and cross-hatching. Usually several hundred good prints can be made before the lines start to wear down.

Albrecht Dürer is one of the masters of engraving. *St. Jerome in His Study* (see fig. 8.23 and detail, fig. 8.15) is one of Dürer's "Master Engravings," which—in contrast to his popular woodcuts—were designed for a more exclusive audience, made up of humanist scholars, fellow artists, and print collectors. The medium of engraving enabled Dürer to render precise detail and textures, as well as subtle variations in light and darkness.

8.14 Lucas van Leyden, *A Tavern Scene*, detail of figure 8.11. Woodcut

8.15 Albrecht Dürer, *St. Jerome in His Study*, detail of figure 8.23. Engraving

Pieter Bruegel the Elder's *Massacre of the Innocents*

In the Netherlands by the mid-sixteenth century, conflict between the local inhabitants and their Spanish overlords turned the religious and political climate into a tinder box, causing artists to treat religious subjects cautiously. The risk of censorship and oppression from their Catholic Spanish overlords caused Bruegel to instruct his wife, for her safety, to destroy certain works at his death. In this context artists devised indirect pictorial strategies (much as dissident artists and writers have done under more recent oppressive regimes).

Under the guise of biblical narrative, Pieter Bruegel the Elder's *Massacre of the Innocents* (fig. 8.16) alludes to a highly sensitive political issue, the threat of oppression from the troops of the Duke of Alva, sent by Philip II of Spain to crush the religious and political revolt in the Netherlands. (The resultant Dutch War of Independence is treated in Chapter 10.) Bruegel painted the *Massacre of the Innocents* in about 1566, when Alva's troops were expected. The painting can be seen as an indirect plea for religious tolerance. Protecting himself behind a New Testament story, Bruegel can address this issue, since his potential accusers would not want to admit that their oppression could be likened to the brutality of Herod's massacre of young children in his attempt to destroy the Christ child. Furthermore, the white-bearded general leading the troops might only coincidentally resemble the duke—a resemblance Bruegel, for his own safety, kept deliberately ambiguous.

Characteristically, Bruegel recasts the religious narrative in a contemporary Flemish context, as Lucas van Leyden did with the parable of the Prodigal Son (see fig. 8.11). Here, Bruegel poignantly contrasts the pure, freshly fallen snow with the brutal massacre. Similarly, the blond tones of the cottage walls exude a warmth, contrasting with the cold steely grays of the menacing troops that shatter the tranquillity of a Flemish village. The graceful bare trees silhouetted against the heavy winter sky mockingly echo the soldiers' lances.

By the late sixteenth century in Protestant areas, explicitly religious art for churches was defunct. But from the art of Bosch, van Leyden, and Bruegel evolved the satirical paintings of everyday life, known as genre, which became immensely popular in the following century, in both Flanders and Holland.

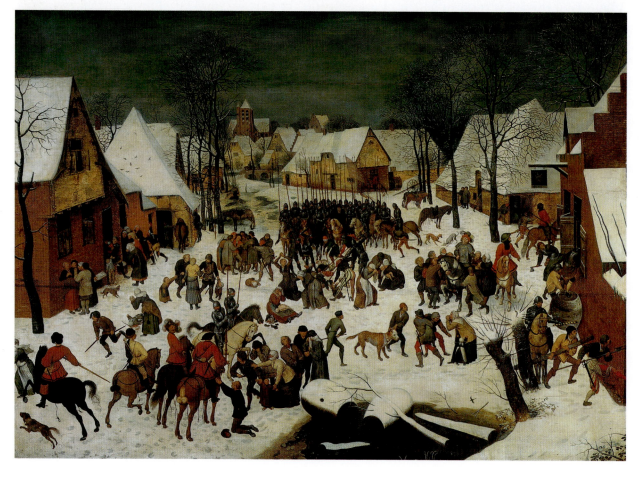

8.16 Pieter Bruegel the Elder, *Massacre of the Innocents*. c. 1566. Oil on panel, 45¹/₂" x 63". Kunsthistorisches Museum, Vienna

THE SELF

During the late fourteenth century, Northern European feudal aristocrats, such as the Duke of Burgundy, ruler of the Netherlands, commissioned artists to paint their portraits. By the early fifteenth century, portraiture began to flourish across Europe, and in time a rising middle class exploited its possibilities—taking advantage of the visual realism characteristic of northern art. Newly successful groups—government officials, merchants, humanist scholars, and publishers—also became active collectors of the graphic arts, stimulated by the growth of printmaking. Now too, images of women begin to reflect the social changes sparked by the Protestant Reformation and the spread of education, as fostered by the widespread availability of printed books. Overall, though, northern artists drew on more traditional Christian attitudes toward life than their Italian counterparts, showing little interest in the classical tradition.

Portraits: The Feudal Tradition

Realistic portrait images first appear in art produced for the nobility. Between 1385 and 1393, Claus Sluter (fl. 1379–1404), a native of Haarlem in the Netherlands, executed the sculptural group of *The Duke and Duchess of Burgundy Adoring the Virgin Mary* for the portals of the Chartreuse de Champmol in Dijon (which was to be the duke's family mausoleum). In doing so, he set a new standard of vivid realism for court portraiture. In the detail shown here (fig. 8.17), the duke is a believable individual, not just a symbol of his rank. His broad, set features—his sunken but alert eyes, big nose, a slight smirk—are individualized, and the deep folds of his robes give his presence substance. To make them look even more lifelike, Sluter's figures were originally colored by painters. This prominent sculptural commission became a model for representing less prominent people in the cheaper medium of painting.

8.17 Claus Sluter, *The Duke and Duchess of Burgundy Adoring the Virgin Mary*, detail of the duke from the portal of the Chartreuse de Champmol, Dijon. 1385–93

Portraits: Court Officials

One of the first to apply this vivid realism to portraits in oils of non-royal individuals was Jan van Eyck, Court Painter in Bruges. As well as independent portraits of court officials and diplomats, a fine example is his *Madonna and Child with Chancellor Nicolas Rolin*, painted about 1435 (fig. 8.18). Strictly speaking, it is an altarpiece that includes an unusually prominent portrait of the donor.

8.18 Jan van Eyck, *Madonna and Child with Chancellor Nicolas Rolin*. c. 1435. Oil on panel, 26" x 24³/₄". Musée du Louvre, Paris

Van Eyck's *Madonna and Child with Chancellor Nicolas Rolin*

Nicolas Rolin was the Chancellor of Flanders. He came from a notable family of vintners in Autun, to whose church of Notre Dame the painting was donated. Van Eyck's painting offers a vivid portrait of the ruthless and ostentatious Rolin, who had become the most powerful man in the Burgundian court. In van Eyck's painting, he appears, audaciously, directly before the Virgin and Child, without the customary mediation of a patron saint. He is seen kneeling in prayer in an imaginary and sumptuous audience hall, with an intricately inlaid marble floor and marble columns with finely carved capitals, opening onto an enclosed terrace graced by flowers and peacocks. From the terrace, two figures gaze down from its imaginary height. They look out over a crystalline landscape that extends along a winding river to a distant range of mountains. Rolin thus dominates this world, while appearing to seek benediction for the next.

In this virtuoso display of oil painting, the architectural details of the cities on each river bank are as distinct as the golden threads on the chancellor's robe, and the illusion of diffused light is as palpable in the shadows under the bridge as in the leaded glass of the windows. Van Eyck likewise enables us to scrutinize the features and expression of the shrewd chancellor, illuminating his identity with small details. Rolin's family background is suggested by the vineyards on the hillside beyond his face. Above his head, the carved relief on the capital depicts the drunkenness of Noah, the first recorded vintner. Above the Virgin, van Eyck portrays the priest Melchizedek bringing bread and wine to Abraham, prefiguring the sacrament of the Eucharist. Through these two images, van Eyck suggests that wine is an element both of debasement and of redemption. Confessing within this setting, Rolin would have us believe in the sincerity of his penance, and the certainty of his receiving Christ's blessing. Here, Christ holds an orb, denoting his world dominion, while raising his right hand to bless the intrepid chancellor. In van Eyck's hands, such is the power of portraiture to project personal identity.

Portraits: The Bourgeoisie

Although portraits of the wealthy Flemish bourgeoisie had already appeared in religious art (see figs. 8.3, 8.5), Jan van Eyck's full-length *Arnolfini Marriage Portrait* (fig. 8.19) is unprecedented.

Van Eyck's *Arnolfini Marriage Portrait*

Van Eyck painted this portrait in 1434 to commemorate the union of Giovanni Arnolfini, a wealthy Italian merchant from Lucca and resident of Bruges, and Giovanna Cenami, the daughter of another powerful Lucchese merchant. The young couple exchange vows in a nuptial chamber, and through van Eyck's skillful illusionism, they appear to stand before us, as well as before the artist, who includes himself and another court functionary in the mirror on the back wall. Above it the inscription "Jan van Eyck was here" (in place of his usual "Jan van Eyck made this") bears witness to the couple's vows.

As noted in Chapter 1, the composition of the *Arnolfini Marriage Portrait* is divided down its center, underscoring the distinct roles of man and wife. The husband stands next to the window, with outdoor shoes beside him, linking him with the outside world. His fur-trimmed gown denotes his status. On the wife's carpeted side is the marriage bed, with a duster hanging from the chair finial, which is carved into a figure of St. Margaret, patron saint of childbirth. The colors of the bride's elaborate costume—blue dress, white headdress, and green mantle drawn up in an exaggerated manner over her womb—are symbolic. Blue was associated with the Virgin Mary, and thus with submission and fidelity; white signified purity; and green the (as yet unfulfilled) hope for fertility.

The separate worlds of man and wife are joined down the central axis of the painting, marked by the brass candelabra, the mirror, and the dog. These centering devices are also symbols for contemporary ideals of marriage: Dogs represent fidelity, the spotless mirror purity, and the single candle denotes the "marriage candle" customarily placed in a nuptial chamber to burn until the marriage was consummated. Finally, the small convex surface of the mirror—which reflects more of the room and the view beyond it than the rest of the painting shows—is surrounded by ten minuscule scenes of the Passion of Christ. This invokes the traditional Christian analogy between the union of man and wife and that of Christ and his followers.

Van Eyck's illusion presents the Arnolfinis, their understanding of their respective roles, and the Christian significance of their vows. As such, it would function as an eye-catching reminder in their home.

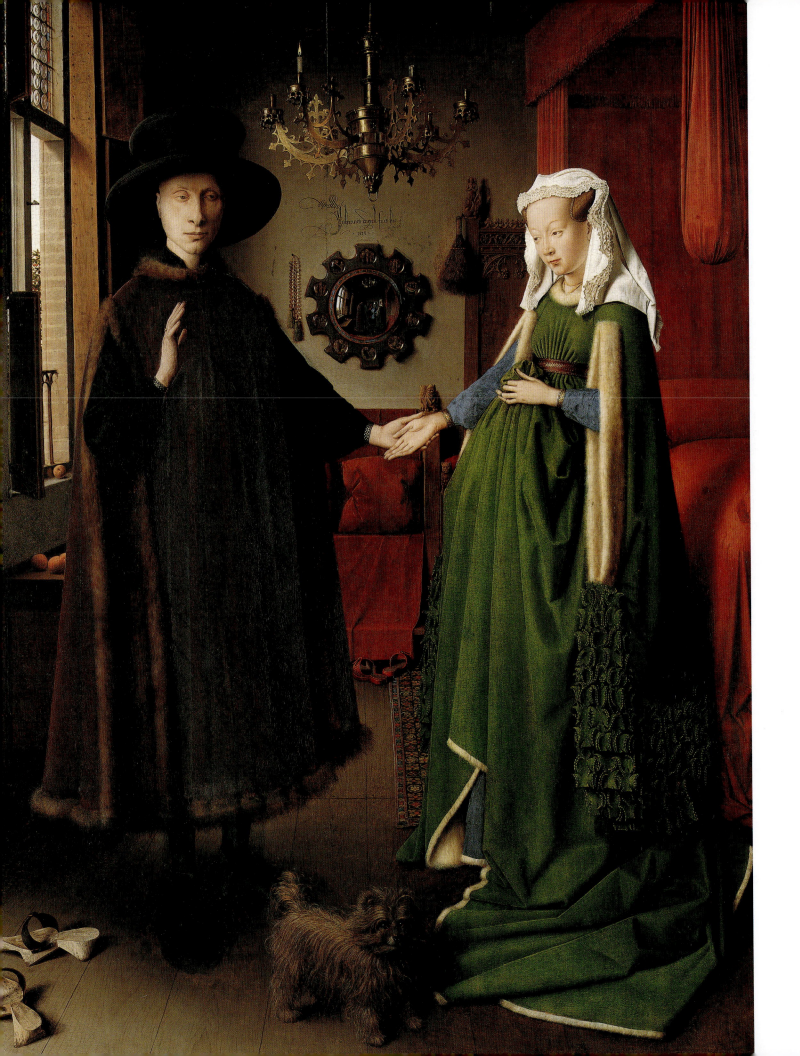

Models of Virtue

In creating art for people's homes, northern European artists and their patrons were as interested in the pursuit of virtue as in commemorative portraits, and valued graphic art as well as oil painting. While some Italian Renaissance artists explored classical sources for inspiration (as seen in Chapter 7), northern artists generally preferred more traditional Christian sources.

A common theme of such Northern Renaissance art is the deceptive and fleeting nature of earthly desires, worldly goods, and life itself. This theme underlies various characteristic motifs, including that of lovers surprised by Death, the allure of money, and the vanity of knowledge and fame.

Hans Burgkmair's *Lovers Surprised by Death*

A horrific and moving image of the fleeting nature of life is the German Hans Burgkmair's (1473–1531) woodcut *Lovers Surprised by Death* of 1510 (fig. 8.20). Set within the most fashionable Italian Renaissance architecture, the cruel figure of untimely death reaches into a soldier's mouth to pluck out his life. His horrified young lover flees, while her robe is locked firmly in Death's jaws.

In this woodcut, the artist suggests a number of ideas popular at the time: A soldier is at greater risk in the arms of a woman than on a battlefield; and Death is a mocker, who strikes at the most unexpected hour. In Death's striking at young lovers in the heat of their desire, the artist evokes a long association between lust and death, based on medieval Christian views of the (supposedly sexual) temptation and fall of humanity in the Garden of Eden. By superimposing skull and cross-bones over the fashionable Italianate architectural setting, the German artist also signals the vanity of worldly magnificence. Wealth and power are no defense against death.

Quentin Metsys's *The Banker and His Wife*

The dangers of avarice and the vanity of worldly goods are themes interwoven into a double portrait of Metsys's *The Banker and his Wife* (fig. 8.21), painted in 1514 by Quentin Metsys (1464/5–1530). At the time, Metsys was

8.19 Jan van Eyck, *Arnolfini Marriage Portrait*. 1434. Oil on panel, 32¹/₂" x 23¹/₂". The National Gallery, London

8.20 Hans Burgkmair, *Lovers Surprised by Death*. 1510. Chiaroscuro woodcut, printed in black, green, and yellow on red-brown paper, 8⁵/₁₆" x 5⁷/₈". The National Gallery of Art, Washington, D.C.

the leading painter of Antwerp, the financial center of the Western world. We don't know whether he was portraying specific individuals or generic types here, but the couple are occupied with one of the most pivotal, and also much-criticized, professions of their time and place—money-changing. While the banker carefully weighs coins in a balance, his wife flips the page of her illuminated Book of Hours, diverted from her prayers by the allure of money.

The painting's original frame is reported to have borne an inscription from the Judaic law: "You shall have just balances and just weights" (*Leviticus* 19.35). This admonition would serve as a reminder to bankers that, while it is now coins that are weighed in the balance, at the Day of Judgment it will be their souls. The painting, then, contrasts two modes of life and their eternal consequences: The hard business of the

8.21 Quentin Metsys, *The Banker and His Wife*. 1514. Oil on panel, 28" x 26³/4". Musée du Louvre, Paris

day, with its inherent temptations to injustice and avarice, and the path of virtue, signaled by the woman's prayer book. Each choice has its consequences, as the scales of justice underscore.

Dürer's *Hercules at the Crossroads*

Another type of moral choice, that between luxury and virtue, appears in the graphic art of Albrecht Dürer of Nuremberg (1471–1528). Dürer was the most prominent German artist of the late fifteenth and early sixteenth century, and was widely known through the multiple copies of his woodcuts and engravings. More than any other northern artist, Dürer attempted to assimilate the humanistic ideals of the Italian Renaissance, including its reliance on classical sources. A long-standing symbol of the active life was Hercules, who early in his career was forced to choose between the ease of luxury and the harder way of virtue. It is this moment of choice that Dürer addresses in one of the finest mythological engravings to result from his two stays in Venice, *Hercules at the Crossroads*, engraved about 1498/99 (fig. 8.22).

Dürer depicts Hercules at the moment of his

encounter with two women. One, an elaborately coiffeured nude, represents Pleasure and sits in the lap of a satyr, who signifies sensual luxury and uncontrolled self-gratification. The demurely dressed Virtue wields a club with which to chasten Pleasure. Hercules, grasping a tree stem in both hands, mediates between them, without yet siding with either.

Behind the protagonists Dürer creates a landscape whose contrasting features symbolize virtue and ease either side of the central figures. On our left, a high, stony road leads to Virtue's strong castle. On the right is the soft, easy countryside of a watered plain. Hercules must chose between these, as he must between Virtue and Pleasure.

In this engraving, Dürer also displays his skill in representing the human figure in a variety of ways, clothed and naked, seated and standing, from the front and back. Dürer's treatment of the nude—a subject typically ignored by northern artists—reflects his attempt to assimilate the humanistic ideals of the Italian Renaissance, and specifically shows off his knowledge of the anatomical studies of the Italian artists Mantegna and Pollaiuolo (see Chapter 7). The technical brilliance

of Dürer's engravings served to spread his reputation, inspire other northern European artists such as Lucas van Leyden to attend to Italian figure studies, and also held out a humanistic model of virtue.

Learning and Diplomacy

After his second visit to Venice in 1514, Dürer explored the theme of *St. Jerome in His Study* (fig. 8.23). He would include this image in his series of three "Master Engravings," named for their exceptional technical qualities, but also for their focus on significant aspects of human experience. While the other two Master Engravings represent the active life (*The Knight*) and the creative life (*Melencholia I*), *St. Jerome* suggests the contemplative life.

8.22 Albrecht Dürer, *Hercules at the Crossroads.* c. 1498/99. Engraving, 12³/₄" x 8³/₄"

8.23 Albrect Dürer, *St. Jerome in His Study.* 1514. Engraving. 9⁵/₈" x 7⁵/₈"

Dürer's *St. Jerome in His Study*

Traditionally, the fourth-century scholar-saint Jerome, who translated the Bible into Latin, was portrayed as a hermit dwelling in the wilderness. Dürer, however, depicts the saint as a humanist scholar working in an orderly and well-appointed study. As a learned Church father, fluent in many languages, Jerome had become the patron saint of humanist scholars, such as Erasmus, who likewise mastered languages as a foundation to their critical reexamination of ancient texts. The popularity of Dürer's engraving served to spread this ideal.

Not only did Dürer understand the humanists' world, he related it to his own pursuit of the mastery of perspective and human anatomy. Both were attempts to recover the wisdom of the ancients, reapplying it in the present to overcome the "ignorance" of intervening centuries. Thus, in his *St. Jerome*, he rigorously applies the principles of geometric perspective. He constructs the space so that the receding lines, called orthogonals, converge on a vanishing point at the extreme right edge

of the print. The effect emphasizes the direction of the warming rays of sunlight penetrating the scholar's study through the lattice window, leaving a soft play of light and shadow in its path, especially on the slanted window opening. The rays of light may also be intended as a metaphor for spiritual illumination, for, prominent among the objects surrounding the saint are an hour-glass, skull, and crucifix—all intended to direct the scholar's attention to the things of God.

Holbein's *The French Ambassadors*

Knowledge of a more secular kind, as well as manipulation of perspective, features prominently in Hans Holbein's (1497–1543) double portrait of *The French Ambassadors* (fig. 8.24), painted in 1533. Holbein was a German artist who, suffering lack of employment for religious art in the wake of the Protestant Reformation, had found work at the English court, as a portraitist. It was there that *The French Ambassadors* was painted. This large, full-length double portrait celebrates the friendship of two successful young representatives of the state and the Church. On the left, richly dressed, with the Order of St. Michael around his neck, stands Jean de Dinteville, at age twenty-nine a wealthy landowner and French ambassador to England. To the right is a clerical ambassador, Bishop Georges de Selve, aged twenty-five, in London visiting his friend. The men lean on a two-tiered table filled with objects that reflect their intellectual interests, both earthly and

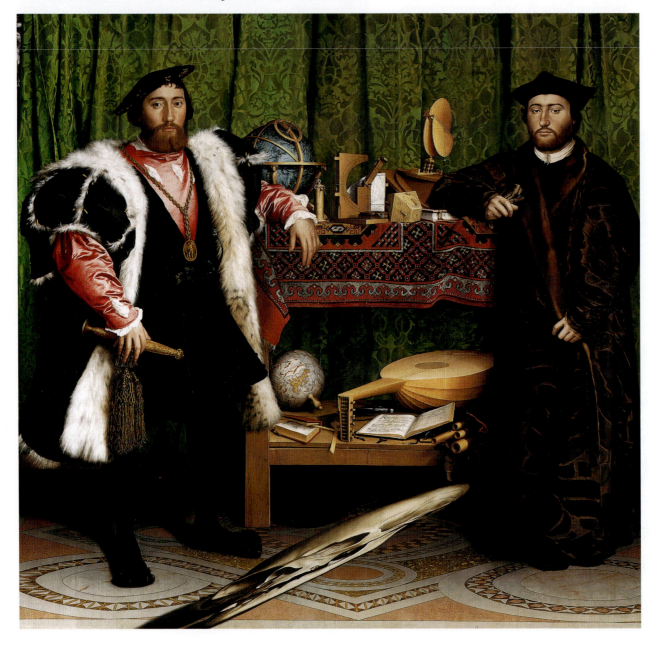

8.24 Hans Holbein, *The French Ambassadors*. 1533. Oil on panel, 81 1/8" x 82 1/4". The National Gallery, London

celestial. These objects also allow Holbein to display his illusionistic skills in painting still life. Among the earthly objects on the lower shelf is a globe that marks both the course of Magellan's voyage around the world and de Dinteville's estate, a lute with one broken string, and a Lutheran hymn book. On the upper shelf Holbein includes a celestial globe, and various instruments for measuring the positions of celestial bodies.

Yet Holbein has also superimposed across the foreground of *The French Ambassadors*, in acute foreshortening, an object that, when seen from a different perspective, from below and to the right, has the perfect form of a skull, such as Dürer placed in St. Jerome's study. With this image, Holbein offers a contrasting perspective on the display of human knowledge and accomplishment that fills the painting. Furthermore, from the same angle, one also sees, at the upper left corner, almost covered by the curtain, a crucifix. These two objects—skull and crucifix—place human accomplishment, literally and figuratively, in a different "perspective." Seeing them, humanists such as Sir Thomas More, Holbein's court patron, and their mutual friend Erasmus would wryly observe that death is the great leveler, consuming not only earthly desires and worldly goods but also knowledge; only virtue endures. This moralizing perspective, characteristic of Northern Renaissance artists, also distinguishes their version of Christian humanism from the more idealized and self-confident vision of Italian Renaissance artists.

Changing Roles and Images of Women

The Protestant Reformation had far-reaching effects on the lives of women. With the convents closed in Protestant regions, marriage and the home became the only acceptable sphere for women in such areas. Accordingly, role models shifted from the religious to the domestic—the Madonna and female saints gave way to the virtuous wife and mother.

Protestantism promoted the spread of literacy, also among women, and as women gained literacy, they were also expected to take up the moral education of their children. Preachers and conduct books, for example, pointed to the scriptural model in the Old Testament Book of Proverbs (31.10–31) of the ideal woman, wife and mother, praising her skills at a variety

8.25 Maerten van Heemskerck, *Portrait of Anna Codde*. 1529. Oil on panel, 33¼" x 25⅝". Rijksmuseum, Amsterdam

of domestic tasks. Among sixteenth-century artists in northern Europe, domesticity offered a rich source of images.

Maerten van Heemskerck's *Portrait of Anna Codde*

One widely popular domestic image was that of the virtuous wife diligently spinning wool. An early example of this subject, which clearly signifies the woman's virtue, is Maerten van Heemskerck's (1498–1574) *Portrait of Anna Codde* (fig. 8.25). It was painted in 1529 as a counterpart to the portrait of Codde's husband, Pieter Bicker, who is portrayed as the vigilant businessman, tending his account book. Painted within two decades of Quentin Metsys's *Banker and his Wife* (see fig. 8.21), Heemskerck's couple are distinct individuals. The wife appears on a separate panel, her features far more specific than the stereotyped images of queens, countesses, and nuns of medieval art.

NATURE

The love that Netherlandish artists had for rendering fine detail in combination with perspective to create the illusion of reality (what we call verism), extended to their treatment of nature. As we saw in Chapter 6, the Limbourg brothers' innovative illuminations of a Book of Hours (see fig. 6.37) captured the sensuous effects of light, weather, space, and local detail. Soon, such artists as Jan van Eyck, Robert Campin, and Rogier van der Weyden would assimilate their innovative achievement, working on the larger scale of oil painting on wood panels. These artists typically set the figures in their altarpieces against detailed, expansive panoramas (see, for example, the detail of van Eyck's *Rolin Madonna* of about 1435 on page 236). Equally detailed city views appeared in the background of Rogier van der Weyden's *St. Columba Altarpiece* (see fig. 8.6) and even, glimpsed through a window, in Robert Campin's *Mérode Altarpiece* (see fig. 8.5). Many other Netherlandish artists celebrated the beauty of countryside and city in the backgrounds of such altarpieces.

In all of these works, the predominant subject was still divine and human activity. During the sixteenth century, however, the landscape itself began to be treated as a sub- ject worthy of painting in itself, though still perceived primarily as a setting for human actions. Artists such as Joachim Patinir (d.c. 1524) and Pieter Bruegel the Elder (along with the Venetians considered in Chapter 7) laid the foundations for a new vein of artistic expression. Their landscape paintings express relationships between humanity and nature inspired by Christian and human- istic thought that are distinctly Western.

Among the first northern European artists to treat nature as a significant subject for study was Dürer. While the human figure would dominate his work, he believed that artists should also pay attention to nature. Indeed, even in a work such as *Hercules at the Crossroads* (see fig. 8.22), where human action is central, an array of natural details enhances the vitality of the setting. Throughout his career, Dürer made studies of specific locations and of animals, flowers, and plants. He even used an astronomer's drawings to chart the northern and southern skies.

Dürer's *The Wire-Drawing Mill*

Many of Dürer's studies were painted in watercolor, including his early rendering of *The Wire Drawing Mill* (fig. 8.26). He may have painted this study of a mill on the banks of the River Pegnitz, important to

8.26 Albrecht Dürer, *The Wire-Drawing Mill.* c. 1489 (?). Black ink, water- color, and tempera on paper, 11¹/₄" x 16³/₄". Staatliche Museen zu Berlin, Preussischer Kulturbesitz, Kupferstichkabinett

8.27 Joachim Patinir, *Landscape with St. Jerome*. c. 1520. Oil on panel, 30" x 54". Musée du Louvre, Paris

Nuremberg's metalworking industry, in 1489, when he was only eighteen, or a few summers later, in 1494. Its color structure conforms to the traditional tones and organization of earlier religious images: Horizontal layers of warm brown tones appear in the foreground; cool green makes up the mid-ground; and blue-grey colors the distant hills. Dürer's interest in the mill and its rural setting for their own sake, however, was unprecedented. Indeed, *The Wire-Drawing Mill* is considered the first color landscape of a particular site to stand on its own—though Dürer himself probably treated it simply as a study from life.

Dürer's watercolor creates a vivid impression of Nuremberg's half-timbered and plaster-filled domestic and industrial architecture with its steep pitched roofs, as well as the meadows, wooden fences, and hamlets scattered through the countryside. Remarkably for Dürer, or artists of his time, he ignores human activity and the workings of the mill itself, focusing only on the buildings and their natural surroundings.

World Landscapes

For Joachim Patinir, working in Antwerp at about the same time as Dürer, landscape became a specialty. He painted so-called "world landscapes," in which vast reaches of terrain are seen from an imaginary, elevated foreground. He often included a fertile river valley, as van Eyck did in his *Rolin Madonna*. But while van Eyck reveals nature from the secure vantage point of civilization, Patinir looks down on human culture from remote rocky outcrops, sometimes inhabited by a hermit saint.

Patinir's *Landscape with St. Jerome*

We can see this reversal of viewpoint in his *Landscape with St. Jerome* (fig. 8.27), painted about 1520. Patinir divides his world landscape into a mountainous wilderness on one side and a fertile plain on the other, with the hermit's shelter in the center. Divergent pathways lead through each type of terrain, recalling the schema of Dürer's *Hercules at the Crossroads* (see fig. 8.22), though here the chief interest is not the human figure but the landscape. One path descends to the fertile plain; the other leads up a steep road to a remote monastery. St. Jerome,

prosperity, abandoned its local traditions for the allure of Italian Renaissance architecture.

By 1500 Antwerp had become the commercial and financial center of northern Europe. We can get some idea of Renaissance Antwerp from a sixteenth-century bird's eye view map of the city (fig 8.29). The city lies to the east of the River Schelde, which drains into the North Sea. An old Flemish proverb states that Antwerp owes the Schelde to God and all the rest to the Schelde, a reality that is confirmed by both its history and this artist's vision. We can imagine the city's streets, market squares, churches, and houses from those in Flemish paintings. Indeed, the wharves along the river bank backed by the city walls closely resemble those of the city in van Eyck's *Rolin Madonna*.

Behind the walls the city opens up, its heart centered around the cathedral, and the almost adjacent Grote Markt, its market square. Here, between 1561 and 1565 a monumental Town Hall (fig. 8.30), designed by Cornelis Floris (Cornelis Floris de Vriendt II, c. 1514–1579), was built according to Italian architectural principles. Around this core were grouped the Bourse (the financial exchange), commercial houses, and homes of the wealthy merchants.

Antwerp's massive Town Hall, a symbol of civic power, combines the horizontal emphasis and classical detailing of a Renaissance palace with the vertical thrust of Flemish step-gabled architecture. It is topped by a steep-pitched roof typical of northern Europe. In the vertical accent of the Town Hall's central bays, Floris acknowledges the Gothic heritage of the city halls of Bruges and Brussels.

Cornelis Floris probably learned about the classical orders of architecture from the widely published illustrated architectural treatises of the time, which included many Italian Renaissance architectural designs. Notice the horizontal divisions of the elevation, the rectangular (rather than Gothic arched) window frames, the rustication of the base, and the arches set between paired columns in the three central bays—all used in correct classical sequence, with Doric supporting Ionic, and Corinthian above that.

Also following the Italian Renaissance ideal, Antwerp's physical expansion during the sixteenth century was based on a rational plan. Zones were laid out in an orderly, geometric pattern, each designated for a distinct need. To the north lay an industrial, working-class quarter, with a residential area in the east. There, houses were widely spaced out and surrounded by gardens, a concept similar to the modern suburb.

Antwerp's huge Town Hall dominated the surrounding city and symbolized the secular power held by the burgomasters and aldermen, all drawn from the urban upper class. Its Renaissance style also became prevalent in the architecture of northern Europe.

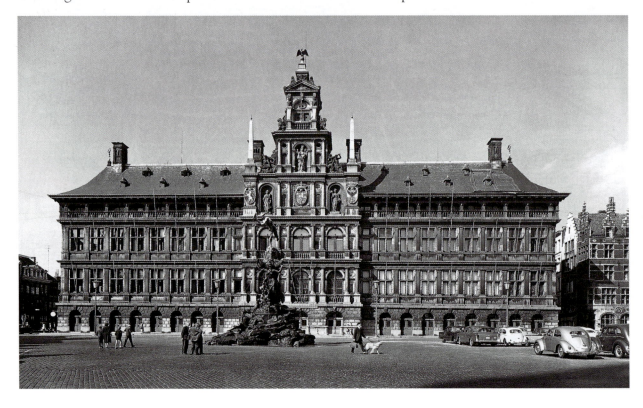

8.30 Cornelis Floris, Antwerp Town Hall. 1561–65

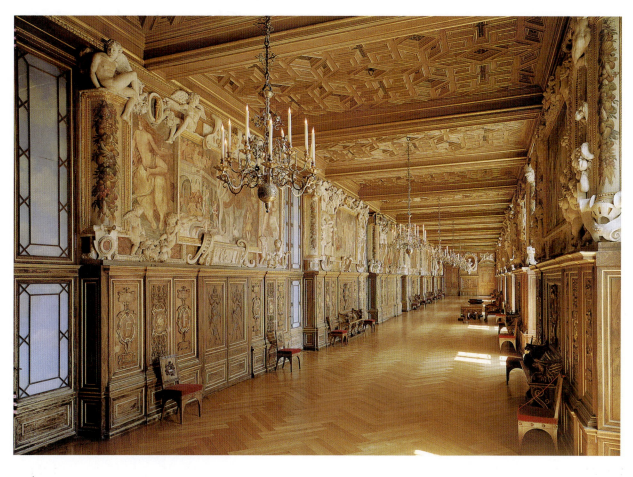

Renaissance Architecture in France

Although architects in Renaissance Antwerp retained some of their Gothic traditions, in France the monarchy encouraged their architects—and those brought from Italy—to abandon the Gothic outright and follow Italian Renaissance conventions, based on the classical architectural orders.

To this end, king François I summoned the Italian artists Rosso Fiorentino (Giovanni Battista Rosso called "Rosso Fiorentino" 1494–1540) and Francesco Primaticcio (1504/5–1570) to decorate the interior of Fontainebleau palace, which they did between 1533 and 1540 (fig. 8.31). These Italian artists practiced a complex and highly ornate form of late Renaissance art known as Mannerism. Their work in the Galerie François I at Fontainebleau, intended for festive state occasions, is a refined combination of paintings, raised **stucco** work, and richly carved wood paneling. The raised stucco frames sport a series of elegant, elongated, and erotic nude figures, encased in architectural orna-

ment. Although the specific work of these Italian artists was interior decoration, Fontainebleau became the center from which Italian architectural ideas spread widely.

With the arrival in 1540 of the Italian architectural theorist Sebastiano Serlio (1475–1554) as architect to the king, the future course of French architecture—in adopting variants of the classical architectural orders—was set. Serlio's influence can be seen in another

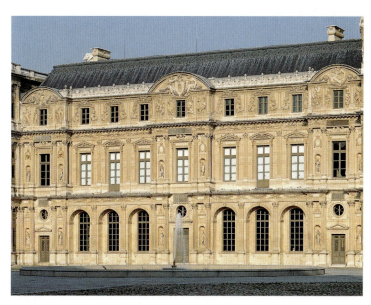

8.32 Pierre Lescot and Jean Goujon, detail of the Cour Carrée, Musée du Louvre, Paris. Begun 1546

trend-setting project, Pierre Lescot's (1500/15–78) design for the Cour Carrée of the royal palace of the Louvre, in Paris (fig. 8.32), begun in 1546, with sculptural decoration by Jean Goujon (c. 1510–68). This elegant design, more restrained than the lavish decorative work at Fontainebleau, is distinguished by the use of paired columns separated by niches on the projecting pavilions, as used later on the center of Antwerp Town Hall. While Lescot's classical orders, differentiated stories, and projecting cornices are indebted to Italian precedent, the elegant use of decorative sculpture on an exterior, and the curved, crowning segmental pediment breaking the roof line above each of the three projecting bays, became hallmarks of French architecture.

Lescot was an intellectual, not a working mason, and his work epitomizes the shift in French architecture at this time away from the Gothic style that had been passed down through generations of medieval master masons. Lescot's Louvre likewise marks the beginnings of the French taste for learned classicism, which in time transformed not only Paris but also London and other northern cities. As a result, variants of the classical architectural orders came to dominate the Western world, both in the north and the south.

PARALLEL CULTURES
China and Japan in the Age of Exploration

Although trade with China and Japan had long been carried out across indirect and dangerous land routes, it was during the Renaissance that European sailors first reached the Far East. By 1550 the Portuguese had established trading stations in Japan and China, and Spanish and Italian missionaries zealously explored both countries. Now, direct exposure to Chinese and Japanese art was possible.

European missionaries encountered two ancient, highly cultivated civilizations, with long, unbroken traditions of literacy, art, and learning. Here, we glimpse one small aspect of the artistic traditions of China and Japan that the Portuguese and the Jesuit missionaries encountered: The responses of the Chinese and Japanese to the forces of nature.

Chinese Landscape Painting

By the time the Portuguese arrived, the Chinese had been practicing landscape painting for well over a thousand years. Landscape was highly esteemed by the Chinese, since it expressed their enduring sense of the relation of humanity to nature. In nature, they found their highest spiritual ideal: To yield to

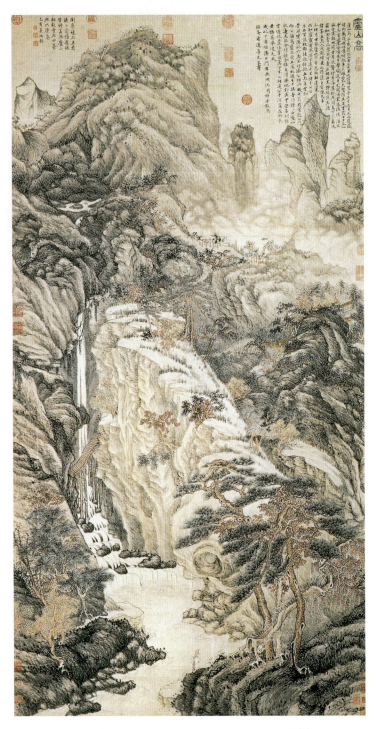

8.33 Shen Zhou, *Lofty Mount Lu*. 1467. Hanging scroll. Ink and color on paper, 76¼" x 38⅝". National Palace Museum, Taipei

Chinese artists have specialized in landscape painting for more than fifteen hundred years. In the past, the most prized were the landscapes of the literati (*wen ren*). Though trained for government service, these gentleman scholar-artists were also masters in calligraphy, poetry, and painting. The literati considered themselves the guardians of China's cultural values, and believed that the highest function of painting was to express the artist's emotional response to the mystical essence of nature—its life-force.

The philosophical and religious tradition of Confucianism encouraged the civil servant to find renewal for the duties of state in the calm contemplation of landscape. For its part, Chan (or Zen) Buddhism taught that one could find enlightenment through nature or art.

In their style and subjects, the paintings produced by the literati often recall the works of earlier masters. In these landscapes, artists seek to honor an enduring Chinese vision of the human relationship to the life-forces of nature (see, for example, fig. 8.33).

the life-force, which they believed dwelt in the natural environment.

This desire to evoke the mystery of the life-force believed to inhabit the natural environment inspired the landscape paintings of the most noted Chinese literati painter in the age of European exploration, the artist Shen Zhou (1427–1509) (see "The Artist as Chinese Scholar-Artist," above). A fine example of his work is the hanging scroll landscape *Lofty Mount Lu*, dated to 1467 (fig. 8.33). Its subject, dedicatory inscription, and style also exemplify Chinese reverence for tradition. The subject, the famous Mount Lu, located near Lake Poyang in Jiangxi Province, is associated in the artist's dedicatory inscription with his literary teacher, Chen Kuan, whose family had lived for generations at the foot of the mountain. The intricately worked surface, built up with a myriad of twisting, curling, and spiky brushstrokes, has been seen as a stylistic tribute to an artist of the previous century, Wang Meng (1308–1385), the artist's favorite source of formal inspiration, and a friend of Chen Kuan's grandfather.

Tradition, both literary and artistic, thus infuses Shen Zhou's vision of *Lofty Mount Lu*, in which the minuscule figure of a scholar is seen standing alone by the water's edge at the foot of the waterfall. In contrast to a European hermit saint, who dominates the landscape (see fig. 8.27), this scholar is enveloped in nature. He is a speck, absorbed in a mist-shrouded world, almost unapproachable in its majesty. The only other signs of human encroachment are a small shrine on the upper right, and the precarious footbridge over the falls. Evocation of the life-force of nature is all. With the rhythm of brush and ink, and soft touches of color, the artist strives, like his respected predecessors, to capture the spirit that animates both nature and artist. Chinese landscape painting provides an illuminating glimpse into a culture whose spiritual and artistic values differed markedly from those of the West during the Renaissance.

Japanese Garden Design and Landscape Painting

Much as the Romans had admired and emulated the art of Greece, sixteenth-century Japan esteemed the literature and art of China. Buddhism spread from China to Japan via Korea in the sixth century, and with it came Chinese traditions of calligraphy, poetry, art, and architecture. In Chapter 5 we discussed the oldest surviving Buddhist temple in East Asia, the seventh-century Horyuji Temple at Nara (see fig. 5.42). Later, from the twelfth through the fourteenth centuries, Chan Buddhism spread to Japan, and was completely assimilated into Japanese life, becoming known as "Zen." Zen Buddhism thrived without scriptures, dogma, or cult images, promoting a life of severe self-discipline and self-knowledge, and cultivating utter simplicity and avoidance of sensuality. We find these values expressed

8.34 The Silver Pavilion, Ginkaku-ji, and its water garden. Muromachi period, completed 1489. Kyoto, Japan

not only in Japanese art but also in many other aspects of Japanese culture, even to this day.

Perhaps the greatest expression of Far Eastern sensibilities toward nature appears in the art of garden design. A Western visitor exploring Japan in the sixteenth century would have been struck by the complete contrast between Eastern and Western sensibilities and practice. In Japan, Zen Buddhism profoundly influenced garden design, and the most famous examples are Zen temple gardens. The Silver Pavilion, Ginkaku-ji (fig. 8.34), was built as a retreat for the military governor, called the shogun, at Kyoto. Surrounded by a water garden, it was completed in 1489. The two-story pavilion, which was to have been faced with silver leaf (but never was), provides both a temple worship hall and an austere room for meditation and the ritualized

tea-drinking ceremony. The design of the pavilion as well as the sand and water gardens reflect Zen notions of simplicity and restraint.

The deliberate asymmetry and the rhythm of carefully chosen and deftly placed rocks recreate in miniature the bold irregularity of nature's forms, while the static water and sand gardens invite steady contemplation. Such gardens were also intended to evoke the Pure Land of Amitabha (or Amida in Japanese), ruler of the Western Paradise, which is imagined as the ultimate destiny by most East Asian Buddhists. Zen rock and water gardens, or the more austere rock and sand gardens, such as the famous temple garden at Ryoanji, in Kyoto, also constructed in the 1480s, inspired notions of the relation of the individual (the large rocks) to the larger whole (sand or water). Such gardens thus suggested an endless cycle of time and the impermanence of all things.

The deferential attitude toward nature seen in Zen gardens, in the quiet understatement of Japanese tem-

8.35 Sesshu Toyo, *Ama no Hashidate*. c. 1503. Hanging scroll. Ink and notes of color on paper, 35 1/4" x 66 3/4". Kyoto National Museum, National Treasure

ple architecture—and seen also in Shen Zhou's Chinese landscape *Lofty Mount Lu* (see fig. 8.33)—is expressed differently by Shen Zhou's Japanese contemporary, the famous Zen monk, painter, and traveler, Sesshu Toyo (1426–1506). His panoramic hanging scroll landscape *Ama no Hashidate*, painted about 1503 (fig. 8.35), represents what is still today a famous Japanese beauty spot, the "Bridge of Heaven" near Miyazu, in the northern Kyoto Prefecture. This beauty spot is notable for the pine-clad, sandy spit of land extending like a bridge across the water, for the views, and for the two temple complexes—one nestled at the foot of Mount Nariai, the other to the left of the sand spit. In Sesshu's rendering, the wooden temples and villages beyond them appear to have a tenuous hold on existence, tucked among the trees and perched between great expanses of water and lofty, mist-shrouded mountains. How different is Sesshu's rendering of the world than Joachim Patinir's panoramic vision, painted at almost the same time (see fig. 8.27). Whereas in the Western vision humanity dominates nature, in the Eastern vision we are subsumed within it.

9 The Counter-Reformation and the Aristocratic Baroque

9.1 Gianlorenzo Bernini, *Ecstasy of St. Teresa*. 1645–52. Marble and bronze, height of figures approx. 11'6". Cornaro Chapel, Santa Maria della Vittoria, Rome

During the first half of the sixteenth century, the Catholic Church was in disarray. Troops of the Holy Roman Emperor, Charles V, had sacked Rome in 1527, humiliating the Renaissance papacy and spreading insecurity among the artistic community as much as among the Roman clergy. Faced with widespread protests against a variety of Church abuses—as well as Protestantism's outright challenge to papal authority— Pope Paul III appointed a commission to recommend reforms. Meeting over the course of nearly twenty years, the Council of Trent (1545–63) set policies that would dominate Catholicism for the next four hundred years.

The reforms begun by the Council came to be known as the Catholic Counter-Reformation. Its reach would extend into the artistic community as well. The power of Gianlorenzo Bernini's (1598–1680) *Ecstasy of St. Teresa* (1645–52) to make the visionary and miraculous appear real exemplifies the art and spirituality inspired by these reforms (fig. 9.1, see also fig. 9.13).

Sixteenth-century Mannerism

The artistic atmosphere of late Renaissance Italy was highly competitive. In the sixteenth century, wealthy patrons commissioned artists who showed the greatest virtuosity and invention, and artists responded by articulating the human figure in ever more complex poses and actions. While inspired by the refinement, grace, and accomplishments of earlier Renaissance artists (see Chapter 7), a new generation carried their preoccupation with personal style and ingenuity to an

extreme. What resulted were works of art that placed style above subject; elegance and polish were combined with bizarre distortions of accepted practice. This trend, which affected all the visual arts and architecture, has been labeled "Mannerism." In the words of one observer, Mannerism develops where style becomes the goal, rather than the servant, of emotion and subject. Indeed, one contemporary churchman protested that Mannerist artists preferred figures that struck poses rather than expressed devotion, and put art before decency.

One of the earliest artists to adopt Mannerist traits was the Florentine painter Giovanni Battista Rosso (called Rosso Fiorentino (1495–1540)), who was later to work for the king of France at Fontainebleau (see Chapter 8). In his *Moses Defending the Daughters of Jethro* (fig. 9.2), painted in 1523, he used an obscure Old Testament incident as his subject (Moses fending off rival shepherds, Exodus 2:16–19), to pack his canvas with charging, bending, twisting, writhing nude forms, a few passive sheep, and a vulnerable shepherdess. As his figures cut through the visual space at varying angles, Rosso shows off his mastery of complex poses, illustrating muscle and bone structures from all sides. Never mind that shepherds didn't usually water their sheep in the nude. Fellow artists and the patron would more likely have judged the painting against the benchmark of Michelangelo's nudes on the Sistine Chapel ceiling (see fig. 7.20), and commented on the draftsmanship, the modeling of form, and the complex **foreshortening** required of the poses. Art rather than necessity justified their nudity, providing a fine opportunity for the artist to display his virtuosity.

The complaint that Mannerist artists prefer figures that strike poses rather than express devotion, putting art before decency, is even more understandable in the face of Parmigianino's (Francesco Mazzola, 1503–40) *Vision of St. Jerome* of 1527 (fig. 9.3), intended for a family chapel in a Roman church. The artist devised bizarre variations on acknowledged masterpieces of both contemporary and ancient art. In the pose of the impudent Christ child, viewers would have recognized echoes of Michelangelo's work, but recast in terms that are provocatively erotic. Likewise the pose of the dreaming St. Jerome recalls sleeping figures from classical art,

9.2 Rosso Fiorentino, *Moses Defending the Daughters of Jethro*. 1523. Oil on canvas, approx. 63" x 46". Galleria degli Uffizi, Florence

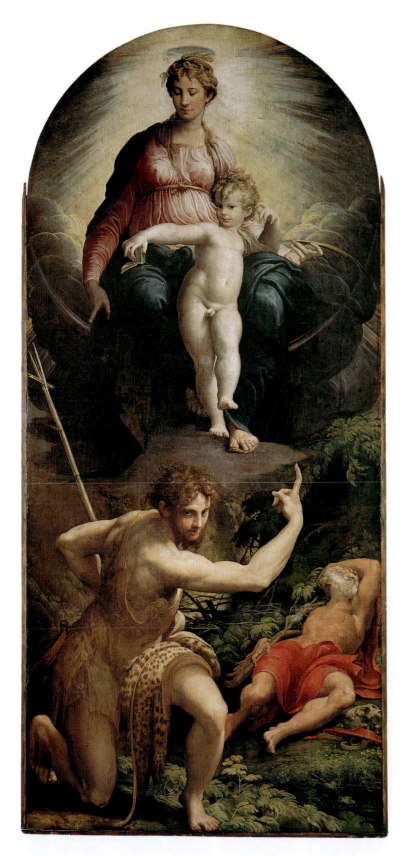

9.3 Parmigianino, *Vision of St. Jerome.* c. 1526–27. Oil on panel, 11'3" x 4'10". The National Gallery, London

here set ambiguously in space and rendered with acute foreshortening to suggest a delirious dream, which forms the subject of the painting.

For Parmigianino, St. Jerome's vision is a far cry from those depicted by Dürer and Patinir (see figs. 8.23 and 8.27). Here, seated on clouds and framed by flashing rays of light, the visionary figure of the Madonna—with elongated arms and the fabric of her garment clinging tightly to her breasts—is an extraordinary mixture of visionary eroticism and elegant refinement. As for the foreground figure of St. John the Baptist, who mediates this vision for the viewer, the artist has twisted his body into a combined frontal and side view in which the right arm is greatly exaggerated relative to the right leg, while over the left leg lies a leopard skin associated with the ecstatic wine god, Bacchus, rather than the ascetic desert saint. Taken as a whole, the work treats a religious theme more with artistic virtuosity and erotic suggestion than with devotion.

The Mannerist taste for complexity and extreme virtuosity also appears in the work of a Franco-Flemish sculptor active in Florence, Jean de Boulogne, Italianized as Giovanni da Bologna (1529–1608). The most significant sculptor of his time, he adapted Michelangelo's figure style, infusing it with the suggestion of dynamic movement. His *Rape of the Sabine Women* of 1583 (fig. 9.4), though intended for a secular rather than a sacred context, is a fine example of the Mannerist attempt to outdo existing artistic achievements by adding complexity of figurative composition and viewpoint. Borrowing gestures of agonized grief from the famous ancient triad of the *Laocoön* (see fig. 3.22), Bologna recalls the motif of one figure carried by another, found in the work of Raphael and Michelangelo, to produce a spiraling tier of three interlocking figures.

Furthermore, this group was designed as the first large-scale sculptural group intended to provide visual interest from multiple viewpoints, not just one, as Michelangelo intended with his *Pietà* (see fig. 7.19). It is only as the viewer walks around Bologna's sculpture that the interplay of solids and voids, of gesture, muscle tension, direction of gaze, and overall expression of each of the figures coiled in this vortex is fully revealed. While the sculpture's form aptly fits the drama of Sabine fathers losing their daughters to plundering Romans, its subject mattered far less to the sculptor than its ambitious complexity. Its title, in fact, was

The Rise of the Baroque

The origins of the term "Baroque" imply irregularity and complexity. But rather than identifying a well-defined style, the term is now used to designate European art, and its New World extensions, from about 1590 to 1750.

Baroque artists adopted the technical innovations of Renaissance and Mannerist art and put them to new uses. These artists are known for their dramatic manipulation of space, strong contrasts of light and color, exaggerated gestures, and lively rendering of human expression. Many Baroque artists favored intense emotion, dynamic movement, and complex, ornate forms, often using these means to overwhelm the viewer with the dramatic, emotional impact of their works. Baroque art embraced many different artistic strategies. Whatever unity the period has comes from an underlying world view and a resulting tendency to fuse opposites: The immediate and the infinite in space and time; naturalism and allegory; the natural and the supernatural. Baroque artists melded these contrasting elements into a seamless whole, often suggesting the presence of the spiritual within the natural world. This is the case in such works as Annibale Carracci's *Assumption of the Virgin* (see fig. 9.6) and Gianlorenzo Bernini's *Ecstasy of St. Teresa* (see fig. 9.13).

In architectural terms, at least in Italy, the Baroque is associated with fluid forms, richly-modeled, undulating surfaces, and pronounced projection and recession of masses in space. Examples are Orazio Grassi's Sant'Ignazio and Francesco Borromini's Sant'Agnese, both in Rome (see figs. 9.14 and 9.38). Typical of Italian Baroque is also the combination of painting, sculpture, and architecture, acting together to stir the viewer's emotions, as at Sant'Ignazio (see fig. 9.14) and in Bernini's *Ecstasy of St. Teresa* (see fig. 9.13). Outside Italy, a more restrained classicism developed, as at Versailles (see fig. 9.21), and, in Chapter 11, we will also see a more restrained Baroque in London's St. Paul's Cathedral (see fig. 11.5).

faculties, directing the devotee to use all his or her senses to imagine the depth of human depravity, the intensity of Christ's Passion, and the vividness of the trials and ecstasies of the saints. This highly sensory process may have inspired artists such as Rubens and Bernini to devise comparably vivid artistic strategies. The subjects and styles of both these Catholic artists typify a period of art that has come to be called Baroque (see "The Rise of Baroque," above).

The Aristocracy and Baroque Art

The artistic strategies that Baroque artists devised to serve the needs of the Catholic Church were also exploited by rulers and aristocrats to serve their own interests and trumpet their power. The Counter-Reformation arose at a time when European rulers wielded almost unlimited power. Spain, profiting in the sixteenth century from the abundant wealth of the New World, dominated Europe, and at times had significant influence in papal Rome. Spanish monarchs saw themselves as the supreme champions and defenders of the Catholic faith, and several notable Spaniards (St. Ignatius Loyola, St. Francis Xavier, St. Teresa of Avila, and St. John of the Cross) influenced the reform of the Church. The Spanish introduced Counter-Reformation doctrines, practices, art, and architecture not only at home but also throughout their overseas dominions, with lasting consequences for Latin American culture (see pages 309–11).

However, in the seventeenth century, as Spain's European influence waned, French power grew. The

French monarchy, through skillful political maneuvering, justified by invoking the divine right of kings to dominate their subjects, gained centralized control of power. Under the monarchy, the arts became, in effect, an instrument of the state. Architects, artists, and landscape designers gave visual expression to the absolute supremacy of Louis XIV, the "Sun King," in the Palace and gardens of Versailles, which became the model for all other rulers who strove to imitate the splendor of his court and impress their own subjects. Such royal use of the arts as an instrument of power was imitated on a smaller scale by members of the court and the aristocracy, both within France and throughout much of Europe.

Rome, the Papacy, and Catholic Kings

While the monarchies of Spain and then France dominated Catholic Europe, Rome remained the center of the visual arts, attracting artists from far afield to learn from its past achievements and current practices. In the heyday of Pope Urban VIII (1623–44), the Catholic hierarchy revived the worldly lifestyle of their Renaissance predecessors, and once more lavishly patronized the arts. When the French established an Academy in Paris to nurture the arts under state control, the Academy's best students were sent to study in Rome. Other nations followed suit, and continue to do so even today.

The Flemish painter Rubens, for whose services kings competed, built a successful career by combining his prodigious talent with eight years of study in Italy. He then used his influence to persuade the Spanish king to permit his court painter, Diego Rodríguez de Silva y Velázquez (1599–1660), to study in Italy. Many others followed this pattern.

In the rest of this chapter we will look at the work of seventeenth-century artists and architects who worked within the context of the Counter-Reformation movement, in Italy, Spain, France, the Southern Netherlands, and the New World, while also serving the monarchies and aristocracy of these Catholic countries. Whether working for the Church or the state, these artists were often obliged to be propagandists. Yet, in meeting their patrons' requirements, they also expressed distinct artistic identities, thus preserving their artistic integrity.

SPIRITUALITY

By the 1580s the concerns of the Counter-Reformation began to have profound effects on the form and content of religious art. Artists such as Tintoretto (Jacopo Robusti, 1518–94) and El Greco (Domenicos Theotocopoulos, 1541–1614) adapted Mannerist strategies to express mystical religious intensity, but a younger generation of artists—here represented by Caravaggio (Michelangelo Merisi, 1571–1610), Rubens, Bernini and others—abandoned Mannerism for an emotional directness and visual naturalism associated with the Baroque.

The themes we will explore all treat subjects that were intended by the Catholic reformers to inspire renewed devotion among the faithful and loyalty to the Catholic Church. In their treatment of these themes, artists strove to fuse the natural and the supernatural through dramatic visual effects that made the encounter between heaven and earth a vibrant visual reality.

Encounters Between Heaven and Earth: Tintoretto and El Greco

Two of the earliest and most notable artists influenced by the Counter-Reformation are the sixteenth-century Venetian painter Tintoretto and the Greek artist Domenicos Theotocopoulos, known as El Greco ("The Greek"), who settled in Spain in 1577 after working for about ten years in Venice and Rome. In different ways, each adapted the artificial and restless idiom of Mannerist art to infuse earthly events with an aura of the mystical and supernatural.

In 1594, at the end of a long career as Venice's leading religious artist, Tintoretto completed a painting of *The Last Supper* for a church in Venice (fig. 9.7). His treatment of the subject contrasts strikingly to the work of his fellow Venetian, Veronese's *Christ in the House of Levi* (see fig. 9.5), as well as to the Renaissance standard of Leonardo da Vinci's *Last Supper* (see fig. 7.16). Veronese created a lavish and colorful spectacle, whereas Leonardo used geometrical structure to focus on Christ's unique identity. Tintoretto, by contrast, employed an unusual viewpoint and the illusion of plunging into space to draw the viewer into the dramatic scene. Luminous colors, infused with the glow of a

supernatural light, emanate from Christ and from the ethereal transparency of hovering angels, introducing an otherworldly dimension.

Departing from tradition by placing the table on an acute diagonal, Tintoretto dramatically contrasted the principal action, Christ's offering of spiritual sustenance, with the servants' foreground preoccupation with physical sustenance. The artist thereby conveys the spiritual mystery of the Eucharist, in which the material world is infused with spiritual life. Tintoretto's evocation of the unseen, heavenly realm of angels reinforces the reality of this encounter between heaven and earth, which became a recurrent element of subsequent Catholic art.

While Tintoretto evoked the presence of the spiritual within the physical world, El Greco informed all of reality with spiritual energy, almost to the point of dissolving matter. With his painting of the *Martyrdom of St. Maurice and the Theban Legion* (fig. 9.8), El Greco hoped to secure the patronage of Spain's "most

Catholic king," Philip II. El Greco painted it in 1580–82 for the Chapel of St. Maurice at the Escorial palace, near Madrid, where the king was engaged on a vast artistic project (see fig. 9.18). The painting treats the theme of a Roman legion and its commander, St. Maurice, who, after converting to Christianity, refused to worship the Roman deities, and chose martyrdom instead. In the right foreground, El Greco signals the choice of St. Maurice and his officers by their commander's heavenward gesture. To the left, in greatly reduced scale, St. Maurice is seen again, comforting his loyal soldiers as they submit to execution. Angels swirl overhead, extending the martyr's crowns that they will soon receive, while others sound the heavenly music that awaits the legion. El Greco's unique style renders the immaterial realm more believable than the material, which seems appropriate, given the soldiers' convictions. His colors and forms are bathed in a surreal light that electrifies the scene. The flesh tones are ashen, the physical setting spare, and the sky unnatural and agitated. While El Greco's scene of martyrdom may have appealed to Church reformers as an inspiring model of loyalty, Philip II, accustomed to the robust art of Titian,

9.7 Jacopo Tintoretto, *The Last Supper*. 1592–4. Oil on canvas, 12' x 18'8". San Giorgio Maggiore, Venice

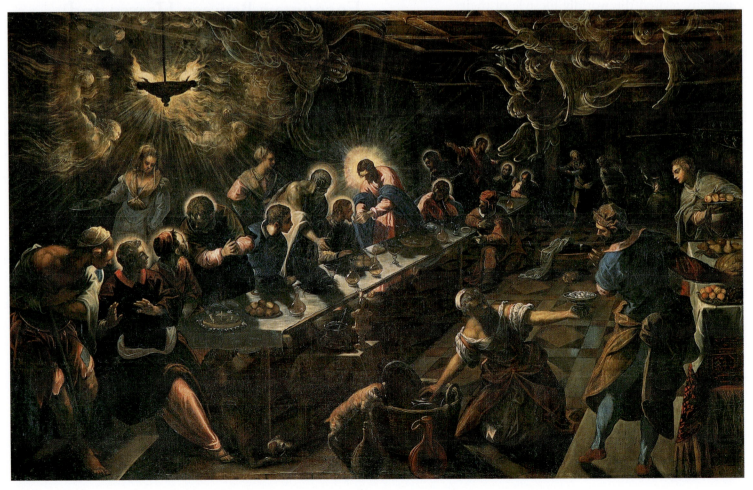

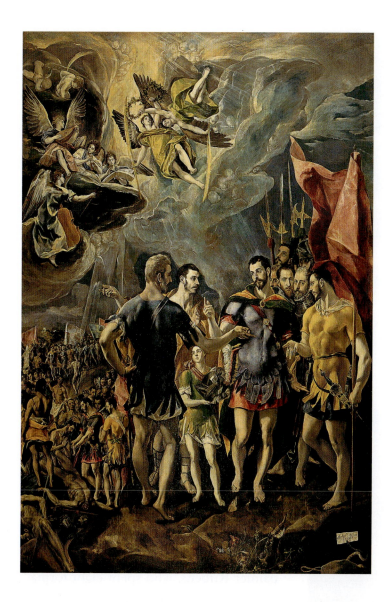

didn't like the result, and thereafter El Greco painted almost exclusively for the Church.

Both El Greco and Tintoretto adapted the idiom of Mannerism to infuse earthly events with an aura of the supernatural. The artists that followed broke with Mannerism to cultivate a greater degree of naturalism, which appears to conform more closely to the call of Church reformers such as Cardinal Paleotti for more realistic interpretation of religious subjects.

An "Unveiled Display of Truth": Caravaggio

As we've seen, Church reformers demanded that artists treat traditional religious subjects with a directness and clarity that would serve as an emotional stimulus to

piety. One artist, Caravaggio, responded so radically to such notions that his pictorial interpretations of religious subjects stunned viewers but struck Church authorities as too direct and down-to-earth. Caravaggio arrived in Rome in the 1590s as an obscure and independent artist from northern Italy. He stripped religious subjects of all idealization and treated them as if he had witnessed these events on the back streets of Rome. This disregard for traditional ideals of beauty or artistic decorum shocked the establishment, but opened the eyes of other artists.

With the same directness that he rendered his subjects, Caravaggio reputedly worked directly on the canvas from the model. The stunning effect of his radical approach can be seen in his *Entombment of Christ* (fig. 9.9), painted around 1602–4 for the Oratorian church of the reformer St. Philip Neri in Rome. Caravaggio's treatment of the subject is designed to engage the worshiper as directly as possible. The artist represents the moment when Christ's body is laid down before burial, and mourned by Mary Magdalene, Mary Cleophas, and the Virgin Mary. This tumbling crescendo of grieving figures is brought closer to the viewer by the shallow pictorial space and the surface detail of the projecting corner of the tomb slab, brushed by the punctured right hand of Christ. His limp body is as near and real to us as to those who prepare it for burial. They, in turn, appear to be ordinary people, which heightens the viewer's sense of identification with them. The Virgin could be any grieving mother in Italy, the Magdalene a girl of the street. Only Mary Cleophas directs us beyond this deeply human moment of silent grief, as she raises her eyes and hands to God.

The intense visual response provoked by this solemn and humble group is also a result of the painting's unusual lighting. Borrowing from works such as Leonardo da Vinci's *Madonna of the Rocks* (see fig. 7.15), Caravaggio's forms emerge from deep shadow, illuminated by side-lighting that models the forms in sharp relief, with bright highlights and few half-tones. The striking effect of this method, known as **tenebrism**, was widely emulated by later artists such as Rembrandt van Rijn (1609–69), and has also inspired modern theatrical lighting techniques.

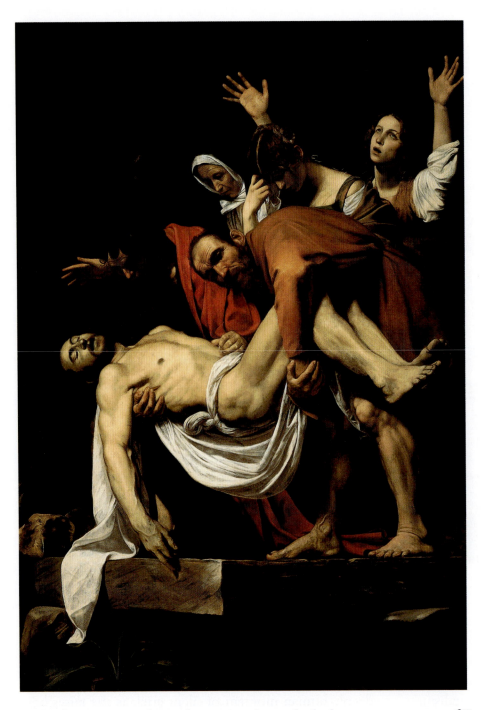

religious values, undermining the elevated status of the Virgin Mary and the saints. Many of his other paintings were rejected by the churches for which they had been commissioned, but his *Entombment* remained in place until plundered by Napoleon in 1797.

Caravaggio offered a radical alternative to Mannerism. Other seventeenth-century artists learned from the irresistible freshness of his paintings, but moderated his realism by studying more traditional artists, such as Titian and Raphael (see Chapter 7). In so doing, they achieved the delicate balance of tradition and renewal that reformers desired and thus became champions of Catholic reform.

An "Unveiled Display of Truth": Rubens

Prominent among these was the Flemish painter Rubens, who spent eight formative years in Italy, from 1600 to 1608, before settling in Antwerp in the Spanish-ruled, Catholic Southern Netherlands (see Map 9.1). When in Italy, Rubens studied not only the most significant work of Carracci (and his circle) and Caravaggio, but also the master-

Preferring an earthy realism to traditional ideals of beauty and artistic decorum, Caravaggio presented biblical figures as humble working people, smeared with dirt and sweat. His work is forthright and direct, without ornamental frills or unnatural grace. His directness and expression of the passions, in this case, grief, parallels the Catholic reformers' desire for clarity in art, and an "unveiled display of truth," which will elicit the viewer's emotional response through a strong sense of identification with the subject. Yet ironically, because of this very directness, Caravaggio's art was perceived by the Church as a threat to traditional

pieces of Renaissance art and surviving classical sculpture. He filled sketchbooks with gestures and poses derived from these works, and creatively mined this ore of pictorial ideas for the rest of an exceptionally productive career.

A widely read humanist, Rubens was also a devout Catholic, with close ties to the Antwerp Jesuits. Rubens painted many altarpieces to replace those destroyed by the Protestant iconoclasm of 1566 and 1581. One of the most profound of these is his *Descent from the Cross* (fig. 9.10), commissioned by the Spanish Governor of the Netherlands for Antwerp Cathedral

and executed in 1611–14. It shows the influence of Rubens's studies in Italy. Christ's Passion is expressed with a vibrant, palpable reality, whose **naturalism** (that is, art based on the ways things look naturally) is charged with a moving emotional directness.

On the two wing panels, tender themes and rich, warm tonality reinforce the central panel's expression of devotion to Christ. The focal figures of the center panel of the *Descent* are enshrouded by a dense night sky, against which a brilliant white sheet surrounds the ashen-gray body of the dead Christ. Rubens draws our eyes to this central figure by boldly contrasting Christ's deathly pallor with rich reds, mauves, deep blues, and greens in the costumes of the surrounding figures. Mary Magdalene's serene beauty only heightens by contrast the unsparing realism with which Rubens has rendered the fresh blood running down Christ's limp body on to his white loincloth. The overall mood of the painting is one of quiet pathos and reverence for Christ's suffering.

For the figure of Christ, Rubens reversed the pose of the statue of *Laocoön* (see fig. 3.22), thus transposing that ultimate classical expression of pathos and suffering to serve a Christian theme. This is typical of the way Rubens capitalized on the fruits of his studies in Italy. He had also studied numerous Italian Mannerist paintings of the Descent from the Cross in planning

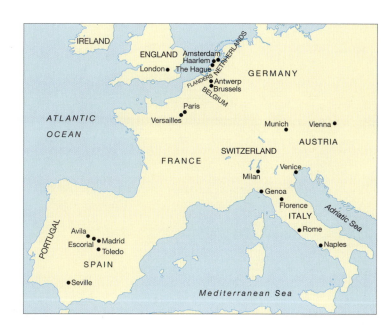

Map 9.1 Europe in the Seventeenth Century

his own more naturalistic version. Of few other versions of this subject could it be said, however, as it was of Rubens by the discerning French critic Roger de Piles in 1677: "The painter has entered so fully into the expression of his subject that the sight of this work has the power to touch a hardened soul and to cause it to experience the sufferings that Jesus Christ endured in order to redeem it." Could the Church ask more of a painter?

9.10 Peter Paul Rubens, *Descent from the Cross* (central panel), *The Visitation* (left panel), and *The Presentation in the Temple* (right panel). 1611–14. Oil on panel, central panel 13'9" x 10'2"; each wing 13'9" x 5'1". Antwerp Cathedral

Art Bolsters Church Authority

As we've seen, since ancient times, both secular and religious rulers used the power of art to bolster their authority (see especially Chapters 2 and 4). Now, faced by the challenges of Protestantism, the Catholic Church commissioned artists to create works that would reinforce its own historic tradition and authority. The papacy found a bold artistic advocate in the sculptor and architect Bernini, who emerged on the Roman scene at a propitious moment. He was only twenty-five at the beginning, in 1623, of the papacy of Pope Urban VIII, a man whose architectural and artistic ambitions were equaled only by Bernini's talents. This prodigious artist went on to serve two more popes, Innocent X and Alexander VII. Like Rubens, Bernini was a devout Catholic and like Rubens, too, his work was vigorous

and exuberant. Its confident spirit matched the optimism now felt by the leaders of the Catholic Church.

Bernini's Baldacchino, Rome

Bernini's first great commission from Urban VIII was for a monumental bronze **baldacchino**, or canopy (fig. 9.11), rising approximately 93 feet (28 m) (about the height of an eight-floor building) above the tomb of St. Peter and the main altar in the central crossing of St. Peter's, Rome. Executed between 1624 and 1633, it was designed to celebrate the historic authority of the Church of Rome, whose foundation went back to Christ's words to Peter, that he was the rock (*petros*, in Greek) on which Christ would build his Church. Its forms and images evoked these historical associations, and its scale declared their present authority. The giant corkscrew columns recall those of the fourth-century

shrine of St. Peter, from the original Basilica of St. Peter's, Rome. Four angels look out to the four corners of the earth, while on top, the cross is raised triumphantly over a globe. Centered above the canopy, two **putti**, one seeming to hover in space, display the attributes of papal authority—the three-tiered tiara and the two keys of St. Peter. Pope Urban VIII, who commissioned this lavish work, is signaled as well by the display of his coat of arms on the canopy and is further alluded to by another symbol of his family, laurel vines on the great columns (which also carry other symbolic meanings).

During the papacy of Alexander VII, Bernini further trumpeted papal authority with a theatrical ensemble of stained glass, bronze sculpture, and molded stucco, which glorifies the symbolic throne of Peter. This was installed in the apse of St. Peter's, where traditionally the bishop's throne or cathedra (hence the word "cathedral") is located. This glorified throne can be glimpsed beyond Bernini's baldacchino. Above the throne a white dove appears to hover in a radiant light, surrounded by ecstatic angels and putti. The throne is raised aloft, attended by four founding Fathers of the Eastern and Western Church, and once again the papal tiara and keys of Peter are prominently displayed. Christians believe that the Holy Spirit in the form of a dove hovered over Christ at his baptism, confirming his authority as the Son of God. Here, Bernini causes it miraculously to reappear, confirming the historic authority of the popes.

9.12 Peter Paul Rubens, *Miracle of St. Ignatius*. c. 1617–18. Oil on canvas, 17'6³/₅" x 12'11¹/₂". Kunsthistorisches Museum, Vienna

Miracles, Visions, and Church Authority

Challenges to Church authority were also met by commissioning artists to depict the alleged miracles and visions of its leaders. Such works, Church leaders thought, would offer evidence that their ministries were divinely blessed. Again, Rubens and Bernini richly imagined and vividly treated such themes.

They and other talented artists serving the Catholic Church effectively transformed the techniques of Renaissance and Mannerist art to inspire renewed devotion and bolster Church authority. They evoked a sense of the supernatural penetrating the natural world, gave fresh life to traditional religious themes such as the Passion of Christ, rendered the traditional practices and authority of the Church credible to the eye, and set before the faithful images of the miracles and visions of the leaders of Church reform.

Rubens's *Miracle of St. Ignatius*

Painted about 1617–18 as an altarpiece for the new Jesuit church in Antwerp (fig. 9.12), the *Miracle of St. Ignatius* was designed to be displayed alternately on the high altar with another of Rubens's altarpieces. Painted before St. Ignatius, one of the founders of the Jesuit order, was canonized (declared a saint) in 1622, it can be seen as publicity for his alleged miraculous deeds.

Rubens's *Miracle of St. Ignatius* celebrates the power of Ignatius to cast out evil spirits, a subject that allows the artist to exercise his gift for rendering extreme states of being, seen here in the prostrate figures of those from whom demons have been expelled. His taste for vivid naturalism appears, too, in the lower right corner, where a mother calms her frightened child. Over the commotion, Ignatius, decked out in all the finery of his clerical vestments, stands as an unshakeable pillar of strength. This reassuring image both promotes the reputation of Ignatius and confirms the power of the Jesuits to drive

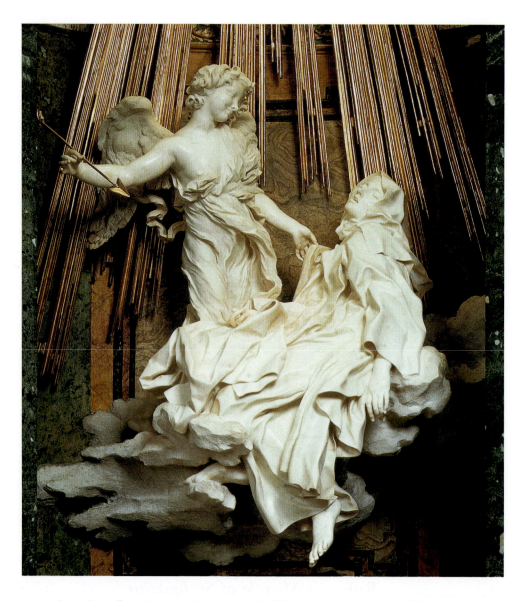

9.13 Gianlorenzo Bernini, *Ecstasy of St. Teresa*. 1645–52. Marble and bronze, height of figures approx. 11'6". Cornaro Chapel, Santa Maria della Vittoria, Rome

chapel in the church of Santa Maria della Vittoria, Rome. Nowhere in Catholic art was sensuality used with greater effect to evoke religious ecstasy. St. Teresa had described her experience of the all-consuming love of God in erotic terms, expressing the entry of the spirit as a penetration of the flesh. Representation of the saint's rapture gave Bernini occasion to exercise his gift—like that of Rubens—for rendering extreme states of being in ways that would engage the viewer's emotions.

Like Rubens, too, Bernini drew inspiration from classical sculpture, from Michelangelo, and from Carracci's fusion of tradition and naturalism, and Caravaggio's vital realism. Drawing from these sources, Bernini gives the illusion of life to the flying angel and the swooning saint. His capacity to make marble appear to pulse with life appears equally in the flowing fabric and in the softness of skin that it covers. He created this illusion from cold, white marble through the use of such techniques as deep undercutting of the stone resulting in a rich play of light and shadow. This accents the texture of the angel's wings and hair and of both figures' garments, offsetting their smooth skin. The folds of the angel's wind-swept garment evoke the speed of his descent, contrasting with the heavy folds of drapery that fall from the inert saint. Life pulses from the angel's alert, gleaming eyes, while Teresa's open mouth and closed eyes register her intense inner focus and feeling.

The figures are backed by sumptuous multicolored marble wall panels and bathed in a hidden source of light (from a window behind the projecting pediment) that bounces off the gilded rods to suggest divine light illuminating the saint. The entire chapel ensemble includes sculpted members of the Cornaro family

out what they feared as an "evil spirit" of heresy (Protestantism) from the Church. For the faithful, Rubens's compelling naturalism makes the miraculous believable, reinforcing the role of Church leaders as earthly mediators of heavenly power.

While the artistic depiction of miracles bolstered the authority of Church leaders, representation of their visions supported the notion that their teachings and actions were divinely inspired. With the exception of Rubens, no artist made this more credible than Bernini.

Bernini's *Ecstasy of St. Teresa*

Bernini drew on his inventive and theatrical fusion of sculpture, architecture, manipulated light, and even painting to conjure up before the eyes of church-goers the ecstatic vision of the Spanish mystic St. Teresa. His *Ecstasy of St. Teresa* (fig. 9.13, see also fig. 9.1) was created between 1645 and 1652 in the Cornaro family

leaning out of illusory theater boxes in rapt wonder, encouraging believers to yield to the illusion of an ecstatic encounter with the divine.

The Church of Sant'Ignazio, Rome

The taste for spectacular illusions of heavenly visions was carried to an extreme in the vaulted ceiling of the nave of the church of Sant'Ignazio at the Jesuit College in Rome, from where students and missionaries were sent out all over the world. The design of the church (fig. 9.14) is an example of a type that was widely imitated throughout the Catholic world. In its main features, as designed in 1626 by the Jesuit Orazio Grassi (1583–1654) (a professor of mathematics at the Jesuit College), it follows the earlier Jesuit church of Il Gesù, in Rome (figs. 9.15 and 9.16), begun in 1568 to the designs of Giacomo Barozzi da Vignola (1507–73). The interior of the church of Sant'Ignazio, like that of Il Gesù, comprises a single wide barrel-vaulted nave,

9.15 Il Gesù, Rome. Interior by Giacomo da Vignola, begun 1568. Façade by Giacomo della Porta, c. 1575–84. Engraving by Joachim von Sandrart

9.16 Plan of Il Gesù, Rome

9.14 Orazio Grassi, interior of church of Sant'Ignazio, Rome. Begun 1626

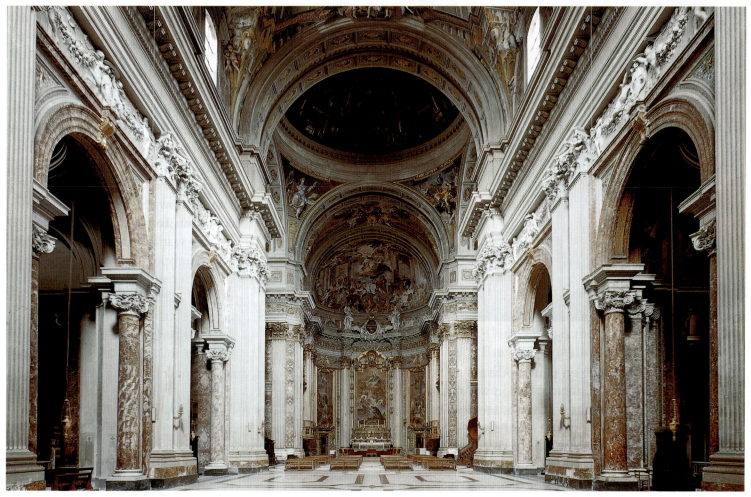

9.19 Diego de Velázquez, *Las Meninas* (*The Maids of Honor*). 1656. Oil on canvas, 10'5" x 9'1½". Museo del Prado, Madrid

on the rear wall of the studio. This device is a brilliant reversal of Jan van Eyck's earlier representation of himself in the rear-wall mirror of his *Arnolfini Marriage Portrait* (see fig. 8.19). Now the artist steps into center stage, relegating his patron to the background.

Velázquez's painting proudly displays the power of the painted image to evoke many layered illusions, pictures within pictures, spaces beyond spaces, and mirrored spaces; indeed mirrored spaces within mirrored spaces, for the artist must himself be gazing into a large mirror, behind the royal couple, in order to paint the princess and her maids of honor. All told, the resultant painting reflects more on the power of art than on the power of the monarchy.

Art Bolsters Royal Authority: The "Sun King"

Louis XIV of France would not have allowed his image to appear as a misty, mirrored reflection on the back wall of an artist's studio. Nor did he build an austere monastery/palace complex, like Philip II's. Through commissions given to artists and architects, this monarch projected a radically different view of self, power, and public relations.

Louis XIV understood the power of art to shape opinion and mold history as well as any political "spin-doctor" manipulating today's media. Hence his lavish expenditures on art and architecture, and the efforts of his ministers to use their newly founded Academy of Art to keep the arts under the firm control of the state. As the self-proclaimed "Sun King," Louis would need an image to match. This he found in Hyacinthe Rigaud's (1659–1743) portrait of him and in the design of the Palace of Versailles.

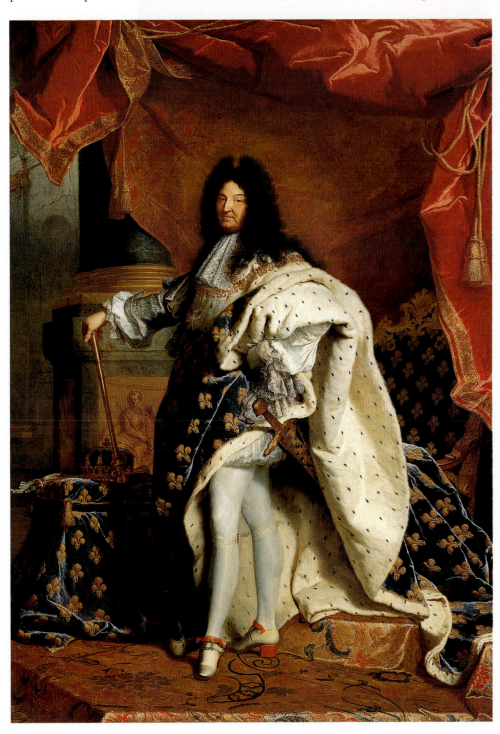

9.20 Hyacinthe Rigaud, *Portrait of Louis XIV in His Coronation Robes*. 1701. 9'2" x 7'10¾". Musée du Louvre, Paris

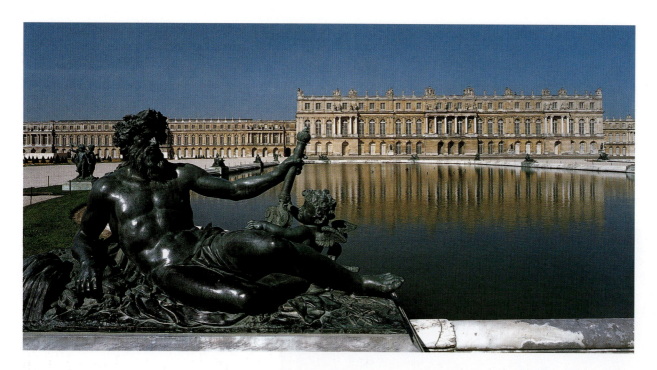

Rigaud's *Portrait of Louis XIV in His Coronation Robes* (fig. 9.20), painted in 1701, offers unstinting support for the aggrandized self-image of France's most dominant and powerful king. Rigaud's success as a court portraitist no doubt rested on his ability to conjure up all the trappings of absolute power, and render them too gorgeous to resist. What could a contemporary do before such an image as this, except gape in awe, which of course is exactly what the king wanted. As for posterity, the image remains emblematic of the centralized, political power claimed by the "Sun King."

The Palace and Gardens of Versailles

The display of power manifest in Rigaud's royal portrait, designed to mesmerize both the king's subjects and foreign diplomats, was embodied even more potently in Louis XIV's grandest building project, the rebuilding of his palace at Versailles, outside Paris (figs. 9.21 and 9.22). Versailles started out as a royal hunting lodge until Louis XIV paid a visit to the spectacular château of Vaux-le-Vicomte, recently built by his Minister of Finance, Nicolas Fouquet. Shocked to find his minister better housed than he, the king sent Fouquet to prison and shipped the minister's army of architects, stone masons, decorators, and landscape designers off to Versailles to transform his own modest hunting lodge into a grand palace. Louis XIV had Versailles rebuilt on a scale not seen since the Rome of the caesars, and its surroundings landscaped so that wide avenues converge on it, and pathways, fountains,

and gardens emanate from it, spreading like the rays of light from a brilliant center. This radiant plan symbolized the monarch's chosen identity as the Sun King, an image reinforced by references to the Greek sun god Apollo in the building's architectural decorations and its garden statuary.

The long, sprawling palace of Versailles—in contrast to the self-contained, fortress-like Escorial—is open-faced and opulent. Its lavish design is centered on the bedroom of the Sun King, whose ceremonial rising and resting set court rhythm for the day. From his bedroom window, Louis could see expansive, landscaped vistas opening up in every direction, as far as the distant horizon.

From an architectural point of view, the finest exterior aspect of Versailles is the central section of the garden façade, designed and built by Louis Le Vau (1612–70) and Jules Hardouin-Mansart (1646–1708) between 1669 and 1685. Its design echoes several earlier French buildings, including Lescot's Cour Carrée of the Louvre from the previous century (see fig. 8.32). This influence can be seen especially in Versailles' projecting pavilions with paired columns and richly ornamented upper levels. Versailles' three-story elevation rises from a lightly rusticated base (that is, with deep joints giving a bold texture) pierced by arched window recesses. The main level, or *piano nobile*, picks up the arched window motif, and is embellished with Ionic pilasters, and by Ionic columns on the pavilions—all crowned by a heavy cornice. This accentuates the horizontal spread of the building, while its rhythm is regulated by the richly

decorative statuary projecting above the balustrade of the attic (or top) story. Together, these features achieve an expansive, open, and opulent effect.

The absence of a steep-pitched roof—so typical of earlier French buildings—signals complete assimilation of the principles of classical architecture. Versailles' grand scale, decorative richness, and relation to its expansive site is in sharp contrast to the self-contained restraint and religious focus of Philip II's Escorial (see fig. 9.18). Instead, Versailles' every note expresses the absolute secular power of the Sun King.

The formal gardens at Versailles, designed and laid out by André Le Nôtre (1613–1700) between 1662 and 1688, act as an extension of the principles governing the entire complex (see figs. 9.22 and 9.23). They are organized around a central axis, so that order is imposed from a central point over the entire field of vision, as far as the horizon, signifying dominance and control. The rigid geometry of straight paths lined by decorative statuary and tightly clipped hedges, bending nature to human will, is relieved by an array of fountains, ingeniously conceived and operated so that the waters rose and fell as his majesty passed.

This triumph of the gardener's art was crafted from a marshy swamp previously inhabited by deer and wild boar, a site as unpromising as that of Philip II's Escorial. Each king, however, had the power and will to import what nature failed to provide. Their resolute imposition of culture over nature thus came to symbolize political absolutism.

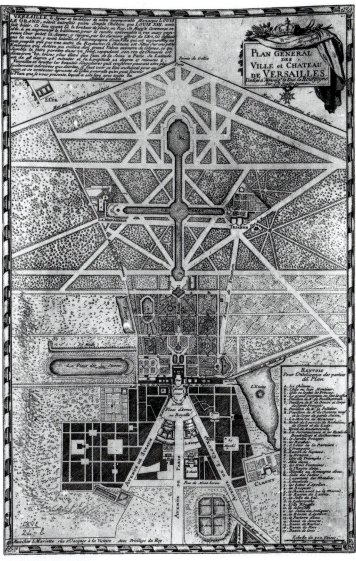

9.23 André Le Nôtre, plan of the gardens and park, Versailles. Designed 1661–68 and laid out 1662–88

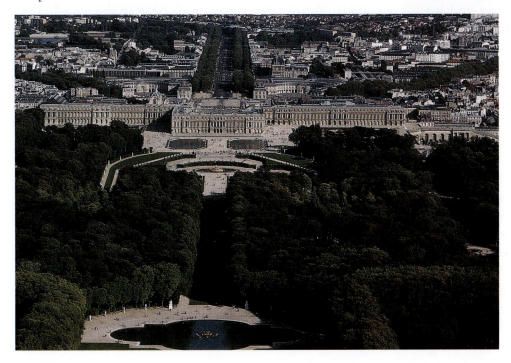

9.22 Louis Le Vau and Jules Hardouin-Mansart, Palace of Versailles, 1669–85. Aerial view of palace and garden

Aristocratic Pomp and Display

During the Baroque period (about 1590–1750), almost as much art patronage came from a privileged aristocracy as from absolutist monarchs. As in works made for the monarchy and the Church, artists drew on classicism, naturalism, and allegory to express the self-assurance, pleasures, and ideals of these aristocrats.

Carracci's Ceiling Fresco for the Palazzo Farnese, Rome

One of the leading initiatives that set the tone for such art was a commission from Cardinal Odoardo Farnese given to Annibale Carracci to paint the ceiling of the gallery of the grand Palazzo Farnese (Farnese Palace) in Rome (fig. 9.24). Painted between 1597 and 1601, this ceiling fresco is Carracci's undisputed masterpiece. Its overarching theme, that love conquers all, is derived from classical mythology. In festive scenes of the loves of the gods and the triumph of Bacchus and Ariadne, the nude human figure is freely displayed, which may seem remarkable in the most public space of a cardinal's palace. The whole ensemble exudes an air of confident sophistication, in which mythological allusions are playfully rendered. Visitors would be reminded of similar Renaissance cycles by Raphael in the Villa Farnesina, also owned by the family.

Carracci's technical mastery in modeling the human figure, the clarity of his disciplined drawing, and his ability to fuse lessons learned from the study of classical sculpture, Renaissance masters such as Michelangelo and Raphael, and renewed study of the live model made his ceiling a feasting ground for younger artists (Rubens was one of the first to learn from it). Its visual impact was such that it sounded the death knell to Mannerism, and its figure style was frequently imitated. Indeed, it remained until the nineteenth century a paradigm of what is known as academic art. Such art, as taught in Europe's newly founded academies, follows Carracci's example in studying the live model and yet idealizing it, reflecting the styles of classical sculpture and Renaissance masters such as Michelangelo and Raphael.

The way Carracci presented this sea of amorous figures also set a precedent for the Baroque love of eye-fooling illusionism. To achieve this, he adapted the simulated architectural framework of Michelangelo's Sistine Chapel ceiling (see fig. 7.20). Like Michelangelo, Carracci juxtaposed simulated sculptural caryatids (human figures holding up the illusionary architectural cornice) with "real" figures, that is youths painted in lifelike flesh tones. But Carracci strove for a greater degree of illusionism. Thus he placed the main subjects in simulated frames: Four of them, in gold, appear to be superimposed over the other decorations, while the one at the end of the vault seems to cast a shadow from the light of the windows. The visual appeal and sophistication of this ceiling fresco made the patron, Cardinal Farnese, the envy of his peers, setting a precedent that was soon followed by artists working for other Roman aristocrats.

Van Dyck's *Portrait of the Marchesa Elena Grimaldi*

Two other media that lent themselves to aristocratic aggrandizement and commemoration were painted portraits and sculpted portrait busts. Anthony van Dyck (1599–1641), the brilliant pupil of Rubens, became a popular portrait painter with the European aristocracy for his ability to convey the elegance of their privileged status. Following the example of Rubens, this Flemish artist spent four years in Italy, making his mark with portraits of the Genoese aristocracy. Among them is his stately *Portrait of the Marchesa Elena Grimaldi* of 1623 (fig. 9.25). Van Dyck depicts her stepping out from the columned portico of her palace on to an elevated terrace that symbolically dominates the surrounding landscape. The obsequious pose of the page boy, who holds a brilliant red parasol over her head, underscores her rank and haughty demeanor. The viewer looks up at her from a viewpoint even lower than the page boy's.

The vertical thrust of the fluted columns with their richly turned Corinthian capitals reinforces the image of the marchesa's elevated stature, while Van Dyck's saturated colors project luxuriousness. The rich red of the parasol, the cuffs of her sleeves, and her lips and cheeks is offset by the deep green dress edged in gold trim. These opulent colors are perfectly balanced by the somber tones of the architecture and the overcast evening sky. The overall effect is one of haughty elegance, which, through portraits such as this, has come

9.24 Annibale Carracci, ceiling fresco in the Palazzo Farnese, Rome. 1597–1601. 65' x 20'

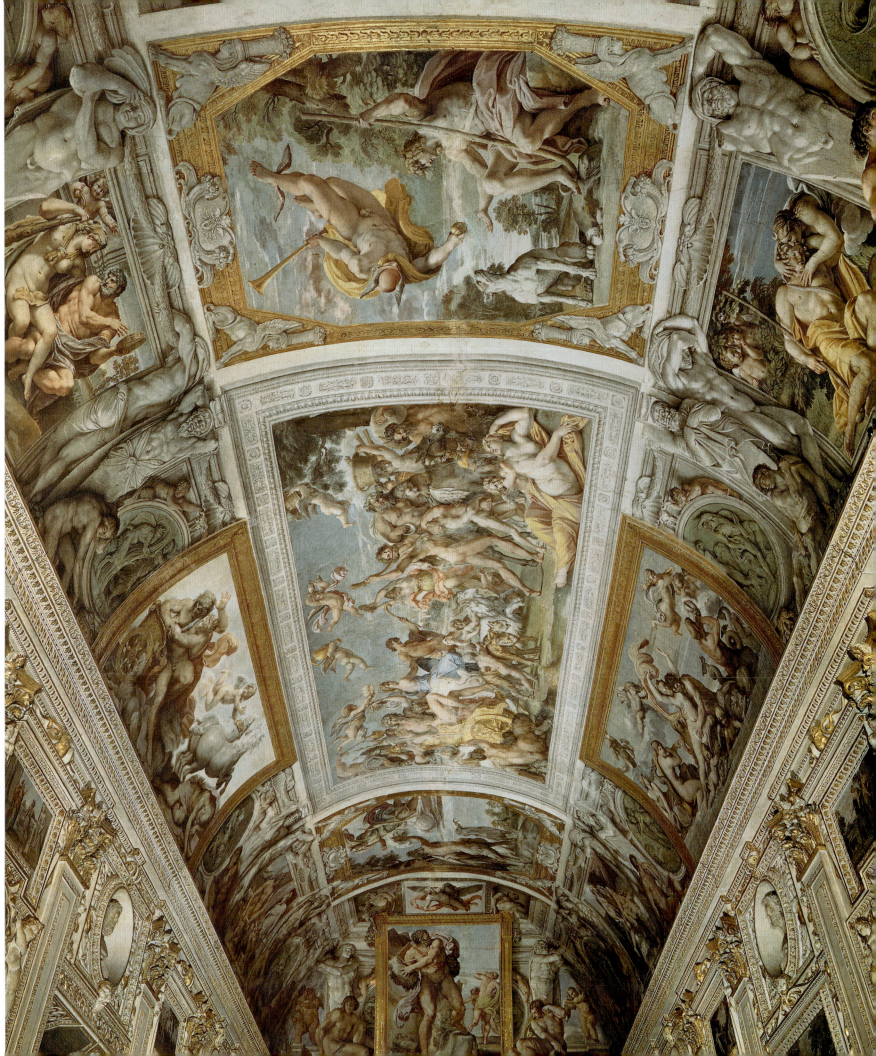

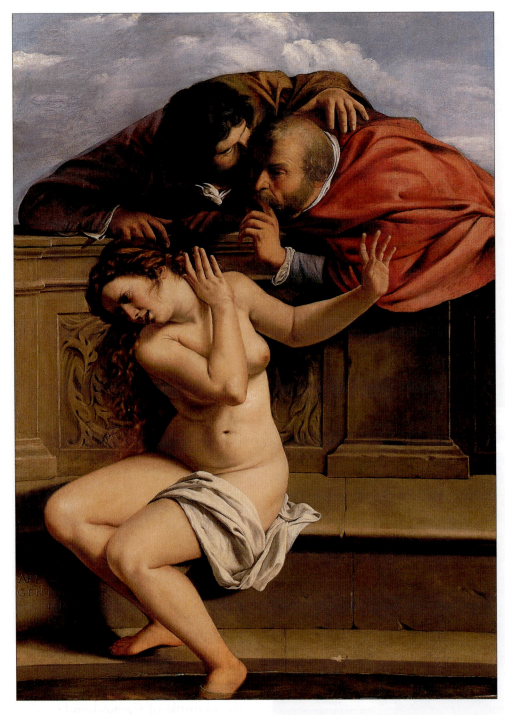

9.28 Artemisia Gentileschi, *Susanna and the Elders.* 1610. Oil on canvas, 67" x 47⅝". Schloss Weissenstein, Pommersfelden, Collection Graf von Schönborn

wife of a leader of the Jewish community in Babylon. She was desired by two old and influential men, but, after she rejected their advances, they falsely denounced her as an adulteress, a charge which carried the death penalty. The wise young prophet Daniel discerned the men's perjury, and Susanna's virtue was exonerated. Traditionally, the story was made into a piece of lewd and sensual voyeurism, set in a lush garden to accentuate the element of exotic sensuality, but Artemisia Gentileschi (1593–1652) offered a different, female interpretation. Gentileschi was a noted woman artist during a time

when women were generally excluded from the formal study of art. In her painting *Susanna and the Elders* (fig. 9.28), she portrays a virtuous woman resisting the advances of two lewd and treacherous older men. Painted in Rome in 1610, when the artist, the daughter of an established master, was just seventeen years old, the work shows that she knew her subject well. Gentileschi herself was experiencing sexual harassment from two men, the painter Agostino Tassi (c. 1580–1644), hired to teach her perspective, and his accomplice, Cosimo Quorli, who raped her the following year.

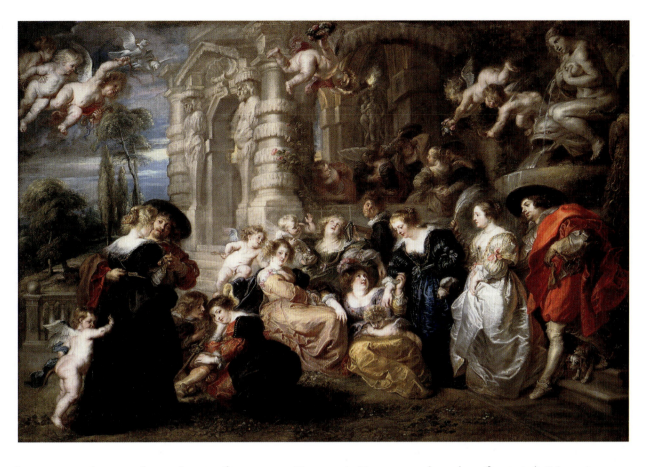

9.29 Peter Paul Rubens, *The Garden of Love*. c. 1632–5. Oil on canvas, 6'6" x 9'3½". Museo del Prado, Madrid

In her painting she reverses the usual emphasis of the subject. While continuing to depict the beauty of the female body, Gentileschi gives us men who look like lecherous schemers. Susanna appears in a spare, protective setting; her pained gestures, bent pose, and expression of revulsion highlight her vulnerability. While this painting may be seen as a plea from a position of weakness, Gentileschi went on to paint, with great power, various versions of the Old Testament story of the righteous Judith beheading the mighty general Holofernes, enemy of her people (Judith 13:4–12). She might be said to have taken her artistic revenge through these paintings, while also displaying her ability to rival both Caravaggio and Rubens in treating scenes of violence.

Rubens's *The Garden of Love*

Love's pleasures are celebrated in a full-blown Baroque style by Rubens in his painting *The Garden of Love*, painted around 1632–5 (fig. 9.29). The subject of lovers in a garden dates back to medieval art, and was currently popular in the Netherlands. Out of this stock theme, Rubens weaves a dense allegory of love that takes place under the auspices of a statue of Venus, from whose breasts spout the waters of a fountain. As in Carracci's Farnese ceiling (see fig. 9.24), Venus's presence announces that "Love conquers all." Rubens expounds the theme in more naturalistic terms, as represented by contemporary Flemish couples enjoying love within the bounds of marriage (signaled by the paired doves leading a putto grasping the yoke of wedlock in the upper left corner). The main action shows four couples, two on either side of the central group of young women, who represent the Three Graces. Each couple suggests a different attitude toward love, from gently coerced hesitancy on the extreme left—perhaps a self-portrait of Rubens and his second wife—to comfortable satisfaction on the extreme right; the other two men are shown responding to the despondency and indifference of their partners. Through Rubens's naturalistic figures and opulent costumes, architecture, and landscape, the viewer is presented with a complex allegory of love, including its progression from hesitation to fulfillment.

Poussin's *The Death of Germanicus*

In contrast to Rubens's opulent Baroque style, others developed a restrained classicism from the example of Annibale Carracci (see "Materials and Techniques: The Uses of Color and Line," page 300). Notable among

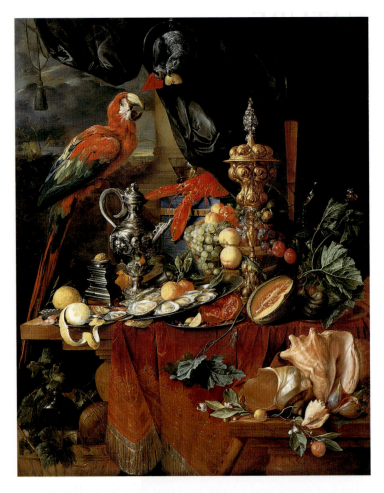

9.31 Jan Davidsz. de Heem, *Banquet Still Life with Parrots*. Late 1640s. Oil on canvas, 59¼" x 45½". The John and Mable Ringling Museum, Sarasota, Florida

In De Heem's *Banquet Still Life with Parrots*, the sensory appeal of the painting's vivid naturalism supports layers of cultural and religious allusions. The natural wonders signifying nature's bounty are complemented by artificial ones, like the silver ewer, the gilt goblet, and glass roemers (large drinking glasses)—all associated with wealth, luxury, and feasting. De Heem intended to display aspects of the four elements—earth, air, fire, and water—to delight the viewer, while inspiring wonder and awe for their Creator.

Many of the depicted objects were also associated with the ideal of balancing excess with moderation, and material and spiritual satisfaction. For example, oranges and figs were associated with the Fall of Man and thus with human temptation; grapes and wine symbolized the Eucharist, and peaches and pomegranates suggested Resurrection and paradise. Visual nourishment from naturalistic representation of the wealth of the material world thus also contained allegorical references to spiritual nourishment intended to sustain the viewer for eternity.

Rubens's *Autumn Landscape with a View of Het Steen in the Early Morning*

For De Heem's senior Antwerp colleague, Rubens, this vision of nature's bounty evoked other connotations. At different times Rubens, as an artist favored by the rulers of the Southern Netherlands, had expressed, both in art and through official acts of diplomacy, his desire to see the Southern Netherlands return to peace and prosperity, freed from the ravages of civil war. He had also expressed a personal desire to live in peace, freed from his court obligations. In his later years, Rubens found the opportunity to realize these desires at least in part when, in 1635, he purchased a country house and estate, the château of Steen. There, Rubens's interest in landscape painting intensified; he could now celebrate in painting the humanistic ideal, described in the Roman poet Virgil's *Georgics*, of finding renewal in country life from the pressures and corruption of the city.

Rubens's vision of country life and its benefits was embodied in two exceptionally large landscape panels, his *Autumn Landscape with a View of Het Steen in the Early Morning* (fig. 9.32), painted about 1636, and its **pendant** (that is, a companion piece), the *Landscape with Rainbow* (now in the Wallace Collection, London), which perfectly balances it from

a grand scale, and also painted many works that centered around the symbolism of the sacrament of the Eucharist. These were intended—like Rubens's religious works—to address the spiritual through the senses, thereby serving the agenda of the Counter-Reformation.

Jan de Heem's *Banquet Still Life with Parrots* (fig. 9.31) exemplifies the sumptuous still lifes he painted in the late 1640s for the wealthy Antwerp bourgeoisie. A rich array of natural and artificial wonders is conjured up before our eyes in a brilliant juxtaposition of colors. Contrasts of scale, shape, and texture add visual richness to its varied elements. There's a tiny shrimp and a gleaming lobster, geometric and organic forms, soft feathers and hard, shiny metals, with succulent melon, pomegranate, gleaming oysters, and peeled lemon crammed in between. A scarlet macaw from Brazil and an African gray parrot, as well as nautilus and other shells from the East and West Indies represent some of the exotic natural wonders recently brought home by travelers to distant lands.

the right. Painted with exceptionally vivid naturalism, it depicts Rubens's country house, warmed by the first rays of morning light, overlooking the rolling Brabant countryside that unfolds before it in an expansive panorama that extends as far as a city glimpsed on the far horizon. Our eye is drawn diagonally through the landscape of *Het Steen* from the dark shadows in the left foreground through the progressively brighter midground to the brilliant, warm glow of the rising sun on the far right.

In the foreground, a peasant couple takes produce from the estate to market; to their right a hunter stalks a covey of partridges, and on the far right cattle are being milked. On the left, by the château, a well-dressed couple strolls with a nurse and child. Besides these signs of human activity, suggesting rural plenty and personal renewal, all Rubens's attention is given to the detail, color, light, and space of the fertile countryside. The shapes, rhythms, and textures of the trees, bushes, and wayside flowers, the refreshing water, and the life of the sky are all rendered with vibrant Flemish naturalism. In depicting Virgil's vision of renewal through country living, Rubens also expressed his desire to see peace and prosperity return to his country, freed from the turmoil of civil war (the Dutch War of Independence).

Ordered Measure: Restraint of Style and Subject

Classical tradition influenced seventeenth-century artists' expressions of nature in different ways. Whereas Rubens could relate to Virgil's idyllic view of the benefits of country life, for Nicolas Poussin, the ancient Greeks influenced his method rather than his perception. The Greeks had invented diverse "Modes" or styles of musical expression, each internally consistent as to form and content. Poussin sought to adapt this ideal to visual art. Writing in a letter in 1647, he described "the Dorian Mode [as] stable, grave, and severe," to be applied to "subjects which are grave and severe and full of wisdom."

Poussin's view was that artists must choose noble and serious subjects, as he did in *The Death of Germanicus* (see fig. 9.30). Yet in the 1640s he also painted landscapes, applying to them the same rational principles he used with historical subjects, perfecting nature's impurities in accord with an ideal form in the artist's mind.

9.32 Peter Paul Rubens, *Autumn Landscape with a View of Het Steen in the Early Morning.* c. 1636. Oil on panel, 51⅝" x 90¼". The National Gallery, London

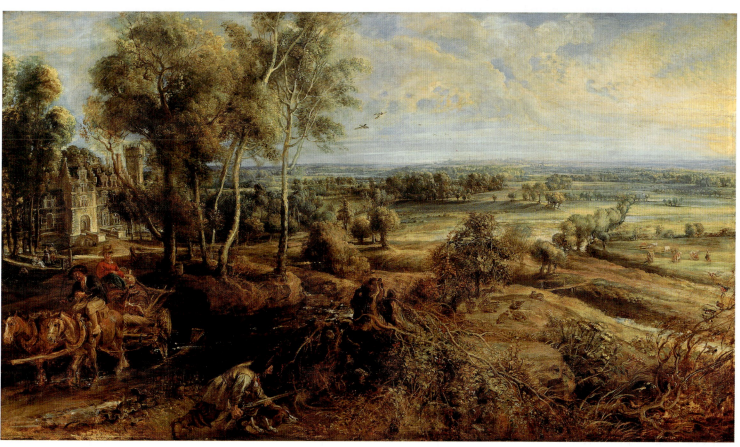

9.37 Piazza Navona with the Fountain of the Moor (renovated by Bernini, 1653) in the foreground, Rome

9.38 Piazza Navona with Bernini's Fountain of the Four Rivers (1648–51) and Borromini's church of Sant'Agnese, Rome, façade, 1653–57

world. Above this sumptuous base, Bernini installed an ancient obelisk, whose severe lines contrast with the florid and irregular play of forms below.

On the west side of the Piazza Navona, facing Bernini's great fountain, Pope Innocent X commissioned the architect Francesco Borromini (1599–1667) to complete the façade of the pope's family chapel, the church of Sant'Agnese (see fig. 9.38); the work was carried out between 1653 and 1657. Borromini, who had been Carlo Maderno's assistant at St. Peter's, created a dynamic composition by using his favorite undulating and contrasting concave and convex forms, here played off against the static obelisk. His design draws the eye in toward the center of the concave façade, while providing a counter-thrust with the convex dome above. This model of the Baroque principle of dynamic composition also realized for the first time the motif of a central dome and flanking towers, imitated in churches as far afield as Austria, England, and Mexico.

PARALLEL CULTURES
Counter-Reformation Art in Mexico and New Mexico

Following on the heels of the army of the Spanish conquistadors in Mexico and the New World (Map 9.2) came the missionary arm of the Counter-Reformation Church. Franciscan, Dominican, Augustinian, and Jesuit missionaries came to the New World to convert the native inhabitants to Christianity. The Spanish crown and the colonial administration supported the missionaries' goals, seeing in them an effective way to subdue and control their conquered subjects. But the brutality and callousness of the Spanish colonial administration toward Native Americans seriously compromised this missionary activity, and, while local beliefs and practices were suppressed, the hold of Christianity declined with that of Spanish colonial rule.

Map 9.2
Mexico and
New Mexico in
the Seventeenth
Century

has been described as being like a miraculous grotto (fig. 9.40). Local artists decorated the entire chancel and dome, probably after 1700, with painted and gilded stucco and wood decor. All its relief sculpture and ornament is the work of Native American artists, who gave the characteristic facial features of their own people to the angels that gaze down on the worshiper from gilded vaults. These vaults are completely overlaid with a maze of carved foliage, teeming with angelic, Indian faces. No surface is left without carving, molding, or color, providing a wealth of imagery to stimulate the imagination, and bear testimony to the fruitful collaboration between European designers and Indian artists.

Such colonial control extended to artists as well. Spanish padres directed Native American artisans to blend Indian decorative traditions with European Christian iconography and architectural forms. The style of the Counter-Reformation was thereby recast in new hybrid forms, laying the foundations for a long tradition of Catholic art in Mexico, Latin America, and the American Southwest. We will consider early examples of this hybrid art from Mexico and New Mexico.

Mexico

The city of Puebla, Mexico, has been called the cradle of "exuberant Baroque" architecture in the New World. A number of its churches display lavish ornamentation that fuses Baroque and older Spanish Christian elements derived from Spanish Muslim architecture, known as Mudéjar. On the outskirts of Puebla, native Indian artisans using local materials built two churches in a hybrid form of "Spanish Baroque." One, the church of San Francisco, Acatepec, is remarkable for its exterior, the other, the church of Santa María, Tonantzintla, for its interior.

Around 1750 the façade of the church of San Francisco, Acatepec, was completely covered with richly colored glazed ceramic tiles, known as *azulejos*, the predominant color being azure (fig. 9.39). These tiles have been cut and fashioned into the capitals, columns, moldings, and volutes of the Baroque repertory of forms to create a novel and refreshing effect. Nearby is the church of Santa María, Tonantzintla. It is faced with a more modest combination of glazed and unglazed tile. Its cruciform interior, however, is spectacular. Such a profusion of relief ornament covers the interior that it

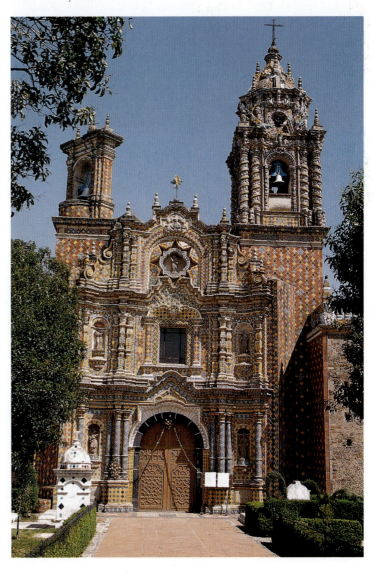

9.39 Church of San Francisco, Acatepec, Puebla, Mexico. Begun late 17th century; façade c. 1750

New Mexico

Spanish missionaries and Native American artists achieved another creative synthesis of their artistic traditions in the churches of New Mexico. Using ancient techniques of the Pueblo peoples, artisans freely interpreted Spanish styles. The Pueblo peoples built a unique form of flat-roofed communal dwellings, made of wood and **adobe**–a mixture of clay, sand, and water.

The church of San Estéban, at Ácoma, New Mexico, completed by 1644, is an early surviving example of the Franciscan missionary stations that were built in the hot, arid regions of the Southwest (fig. 9.41). Its twin bell towers preserve a faint echo of European Baroque churches (see fig. 9.38) as realized within the limitations of locally available resources. The smooth surfaces of its adobe walls are punctured only by the projecting roof timbers and minimal window openings. Its severe sculptural forms, flat roof, and plain, thick adobe walls are characteristic of the region and harmonize with the baked earth and dry austerity of the surrounding landscape.

The interiors of these mission churches could not offer a stronger contrast to their exteriors. Coming in from the hot, dry outside, one enters a cool, dimly lit interior, often animated by the most vivid decorations. Typically, a carved and painted assemblage known as a

9.40 Interior of Santa María, Tonatzintla, Puebla, Mexico. Probably after 1700. Painted and gilded stucco and wood

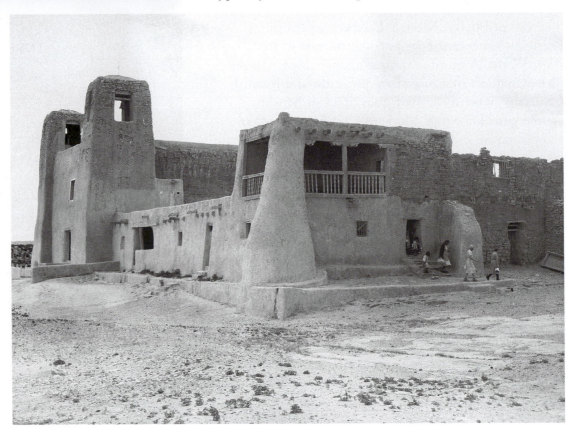

9.41 San Estéban, Ácoma, New Mexico. Completed before 1644

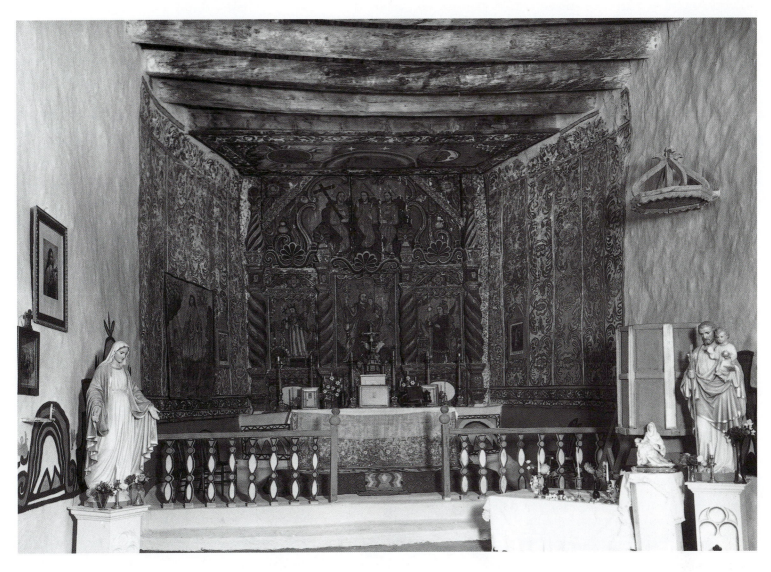

9.42 Interior of San José, Laguna, New Mexico. 1699–1706

reredos rises above and behind the altar. These were derived from the intricately carved and figuratively decorated reredos altarpieces of Spain.

In the New World, a vivid example of a rustic reredos altarpiece executed in 1699–1706 by Native American artists decorates the interior of the church of San José, at Laguna, New Mexico (fig. 9.42). On the reredos above the altar the artist has produced a provincial version of a typical Baroque display of Christ and the Saints, with, on the upper level, a triad of figures with triangular halos to signify the Trinity. On the ceiling and nave wall Pueblo Indian religious symbols of sun, rain, thunder, and vegetal motifs mix with further Christian subjects. In the eighteenth and early nineteenth century missionaries built similar churches in Texas, Arizona, and California, some on a much more elaborate scale. Many such mission churches still bear traces of the architectural style that originated in Europe with the Counter-Reformation, as modified by indigenous building practices and local conditions.

So it is that, in the American Southwest, Mexico, Latin America, and indeed many other parts of the world, there remain standing to this day many traces of the missionary zeal inspired by the Catholic Counter-Reformation. The belief in the power of images to inspire devotion, confirmed at the Council of Trent in 1563, had repercussions that can be seen as much in the grandeur of Bernini's baldacchino for St. Peter's, Rome (see fig. 9.11), as in the vivid decorations carved and painted by American Indian artists for the mission churches of the New World. The expansive range of such artistic activity attests the power of the Counter-Reformation Church to reach across continents using art in the service of its vision and purposes.

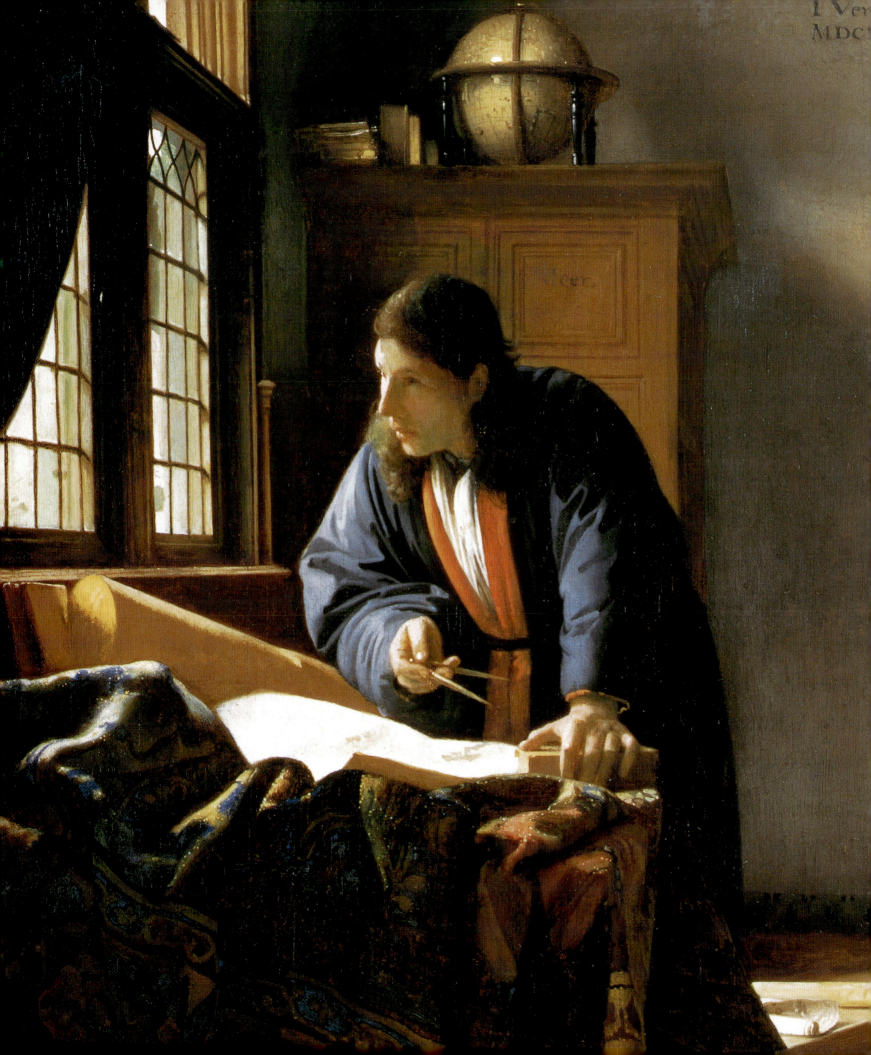

10 Seventeenth-century Dutch Art

The Dutch artist Johannes (or Jan) Vermeer of Delft
(1632–75) floods his painting of *The Geographer*, dated
1669 (fig. 10.1), with a light that streams into a modestly
furnished room, illuminating a scholar reflecting on the
knowledge embedded in his maps. As a small painting
(20³/₄" x 18¹/₄"), made for a merchant's home, not a
king's palace, both its size and subject belong to the dis-
tinct cultural milieu of seventeenth-century Holland.

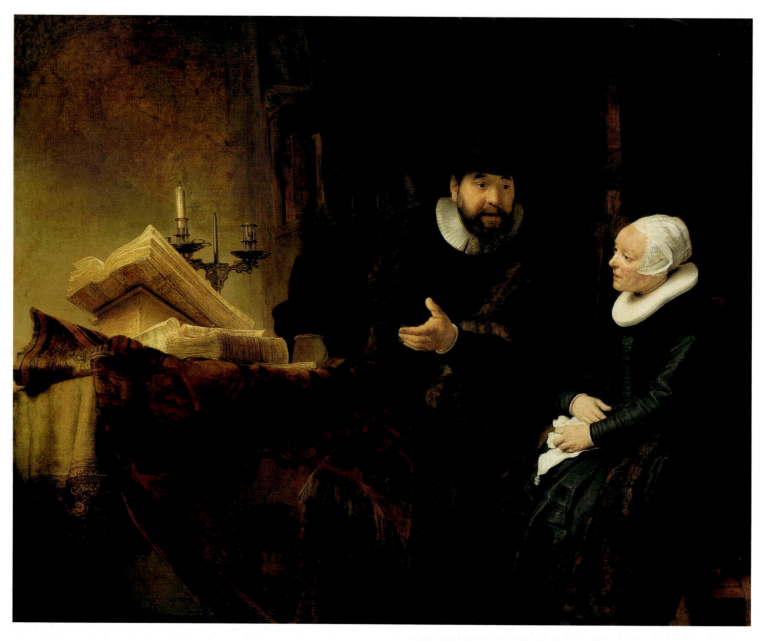

10.4 Rembrandt, *The Mennonite Preacher Cornelis Anslo and His Wife, Aeltje Gerritsdr. Schouten.* 1641. Oil on canvas, 69$^{1}/_{4}$" x 82$^{1}/_{2}$". Staatliche Museen zu Berlin

head, her concentrated facial expression and the gestures of her hands, one holding a handkerchief, suggest her calm attentiveness. Rembrandt reveals, through the combined poses and facial expressions of each, the power of words to reach the heart through the mind.

The Dutch poet Joost van den Vondel, once a member of the same Mennonite community as Anslo, paid tribute to Rembrandt's "speaking portrait" and Anslo's gifts in an epigram:

That's right, Rembrandt, paint Cornelis' voice!
His visible self is second choice.
The invisible can only be known through the word.
For Anslo to be seen, he must be heard.

Rembrandt's "speaking portrait" of Anslo and his wife uses exterior gesture to convey interior feeling, but the painting's pensive mood and emotional impact are also carried by the artist's handling of light and color. Large areas of shadow suggest the uncertainties of human life, while softly glowing light plays over the biblical text, illuminating the faces and hands of the couple. The atmosphere evoked by this play of light and shadow is complemented by the contrast of the mellow golden-brown tones of the illuminated Bible and the deep, warm red hues of the table covering, offset by the black

costumes. Rembrandt intensified such effects in the religious paintings of his maturity, such as *The Denial of Peter* (1660) (see fig. 10.7).

Early in his career, Rembrandt's ambition prompted him to emulate the flamboyant work of Rubens (see Chapter 9). But, as his artistic and spiritual vision matured, Rembrandt shunned such grandiose, outward gestures in his art. He became even less concerned with the external signs of dramatic events, drawn toward evoking the deeper, personal responses to experience. Nourished by his own reading of the Bible and the teaching of the Mennonites, and mellowed by a succession of personal tragedies, Rembrandt in his maturity plumbed the depths of the human soul. In emphasizing the inner life, his artistic and religious vision focused on human frailty as met by divine compassion.

Rembrandt's *Christ Healing the Sick* (the *Hundred-Guilder Print*)

Rembrandt richly expressed his religious vision in both paintings and graphic art, especially in etchings. The last supplemented his income while spreading his ideas widely. One of the most memorable of these etchings is *Christ Healing the Sick*, made around 1648–50 (fig. 10.5). Its popular title, the *Hundred-Guilder Print*, is derived from the high price once placed on an impression of the print, supposedly fixed by Rembrandt

himself. The price could be justified both by its technical accomplishment and by the way the artist has compressed several biblical events into one compelling and unified narrative.

Technically, the power of the *Hundred-Guilder Print* rests in the work's rich range of lights, shadows, and mid-tones that Rembrandt has employed, together with his ability to animate an array of figures with a minimum of deft, sketchy lines, while modeling others with a denser body of light and shadow. Rembrandt's manipulation of line, and the atmosphere he creates with the range and subtlety of his tonal gradations, are widely acknowledged as a high point in graphic art, both in technique and profundity of expression (see "Materials and Techniques: Etching and Drypoint," page 320).

The theme of the *Hundred-Guilder Print* is drawn from the Gospel of Matthew, which addresses Christ's compassion for the powerless and the sick. Ignoring the protest of one of his disciples, Christ welcomes a mother bringing her child to receive his blessing. On the left, skeptical Pharisees turn away, engrossed in dispute among themselves; on the right, emerging from shadow, the sick prostrate themselves before him, eager for attention. Rembrandt contrasts their desire for help to the skepticism and self-sufficiency of the Pharisees. Amid all the jostling of the crowd, Christ stands out as a serene, radiant presence illuminating the surrounding darkness.

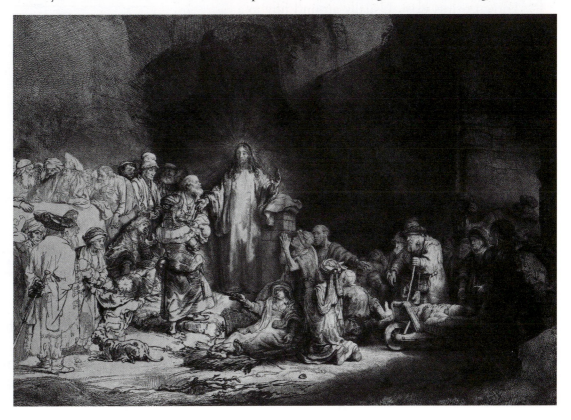

10.5 Rembrandt, *Christ Healing the Sick* (the *Hundred-Guilder Print*). c. 1648–50. Etching, drypoint, and engraving, 10½" x 15". The British Museum, London

among his contemporaries may have shared his beliefs, but they lacked Rembrandt's capacity to reach into the invisible places of the heart, and to express its profoundest spiritual experiences. Most of all, they lacked his technical mastery of the art of painting and his ability to experiment boldly with novel methods of oil painting. This included not only great freedom in building up his surface with a multi-layered, rich impasto, but even smearing the wet paint with his fingers.

THE SELF

Given the nature of Protestant worship, it is not surprising that, beyond Rembrandt's profound personal exploration of biblical subjects, there was little public demand for religious art as such. However, Protestantism penetrated to the consciousness of the nation in other ways. Its preoccupation with moral instruction in domestic contexts affected the tone of portraiture and still-life painting, and fueled the Dutch love for satirical genre paintings that amuse, delight, and at the same time indirectly instruct their domestic viewers.

There is perhaps no other society, before the invention of photography, which created such an all-pervasive representation of itself in art. The proliferation of portraiture and genre scenes in seventeenth-century Holland lets us into the world of the baker, the fish-vendor, and the tailor, as well as that of the housewife, merchant, scholar, and artist. The openness of the Dutch art market, directed toward a mercantile population, stimulated Dutch artists to depict people of all classes and ages, all trades and professions, as never before. Furthermore, their scrupulous attention to setting and detail creates the illusion that we can enter these various worlds, and know the people and their environment. Although an image may approximate our sense of reality, however, it is never a direct, unedited transcription of life, but always a selective interpretation based on the values and conventions of the time.

As we encounter the people who stare out at us from the canvases of Frans Hals (c. 1581/5–1666), Rembrandt, Vermeer and others, the apparent directness of their images can deceive us into overlooking the artistic and cultural conventions that determine the way we perceive them. Among the varied images of Dutch personal identity, we'll focus on community, family, and professional identity as representing the egalitarian nature of Dutch society and the special attention given to children and the home.

The Community: "Sovereign Lords Miller and Cheeseman"

The commemoration of community identity in art took many forms, most often group portraits of officers of local militia companies (a home guard, with a largely social function). A fine example from the early seventeenth century is Frans Hals's *Banquet of the*

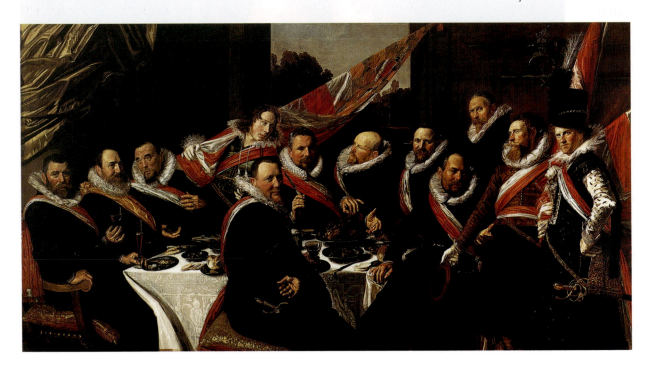

10.8 Frans Hals, *Banquet of the Officers of the Haarlem Militia Company of St. George.* 1616. Oil on canvas, 5'6" x 10'5". Frans Halsmuseum, Haarlem

Officers of the Haarlem Militia Company of St. George (fig. 10.8), painted in 1616 for the company's headquarters. Hals was born in the Southern Netherlands and came as a child to Haarlem as part of the Protestant immigration (see Map 10.1). He was himself a militia man as well as an artist. In painting the officers of the Company of St. George, Hals might have lined them up in rows—as others did—but instead he created the illusion that the viewer has stepped into their banqueting room, interrupting a meal. Within this room, the twelve officers turn in their seats, as if acknowledging the intrusion, some gazing at the viewer, while others continue their conversations. Hals used the brilliant reds and whites of their flags and sashes to further break up the monotony of the black-costumed group. He enlivened these potentially dull areas with deep, shimmering blacks, richly contrasting with the officers' white ruffs, colored sashes, and the sparkling damask tablecloth. Hals executed the painting with an unerring quickness of touch, whose freshness matches the spontaneity of the action portrayed. This virtuoso illusion of spontaneity combined with the painting's sparkling surface texture inspired many later artists, notably Édouard Manet (1832–83), as we'll see in Chapter 13. Thus, with the astute eye of a brilliant portraitist, Hals invested these lusty, ruddy-cheeked Dutch burghers with a vivid sense of individual identity. By showing them as prominent equals celebrating their community identity, he immortalized some of the "sovereign lords miller and cheeseman" who formed the core of Dutch society.

Within the egalitarian context of seventeenth-century Holland, even portraits of the most prominent members of society show restraint and modesty, especially when compared to court portraiture elsewhere in Europe. (Recall, for example, van Dyck's *Portrait of the Marchesa Elena Grimaldi* of 1623, fig. 9.25.) We see this in Thomas de Keyser's (1596/7–1667) small-scale portrait of *Constantijn Huygens and His Secretary* (fig. 10.9), painted in 1627. Huygens was a diplomat, secretary, and advisor to the Princes of Orange. He was also a noted literary figure and, as an astute connoisseur of art, was the first to note the young Rembrandt's potential. Thomas de Keyser was a noted Amsterdam portraitist, known for small-scale full-length portraits like this one. Its highly finished, fine detail contrasts markedly with the broad strokes of Hals's canvases, and reflects De Keyser's admiration for the high finish of Netherlandish masters of the Northern Renaissance

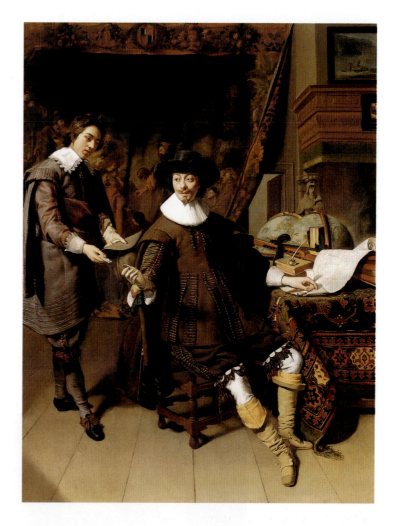

10.9 Thomas de Keyser, *Constantijn Huygens and His Secretary*. 1627. Oil on panel, 36³/₈" x 27¹/₄". The National Gallery, London

(see Chapter 8). De Keyser's attention to the surface texture of materials—notice the sleeves of the clerk's jacket, the table cover, Huygens's leather boots, and the tapestry on the rear wall—renders each element almost palpable. This love for creating the illusion of life by treating detail with a precision that conceals the artist's brushwork became a hallmark of much Dutch painting and is especially pronounced in still-life painting.

In his portrait of Huygens, De Keyser used these techniques to create what is known as a milieu portrait, which—like De Keyser's technique—had been common among Northern Renaissance artists. The artist presents the sitter as if in the midst of some familiar occupation, as in Rembrandt's portrait of Cornelis Anslo and Hals's militia piece (see figs. 10.4 and 10.8). In this case, De Keyser shows Huygens, as a clerk brings him a note, sitting at a table strewn with objects that allude to his interests in the arts and the sciences. These include a pair of terrestrial and celestial globes,

as also seen in Holbein's *The French Ambassadors* (see fig. 8.24). Above the fireplace hangs a stormy seascape. Its subject, a storm-tossed ship, was then seen as an allegory of human life. Thus, while the technique and approach create the illusion of immediacy, the painting's conventions allow the artist to present the sitter and his values in a particular way. The appeal of such works assured the popularity in Holland of painted portraits, rather than tombs or sculptural busts, as the preferred visual means for self-commemoration.

The Family: Orderly Living and Human Folly

A vast amount of Dutch literature and art concentrated on maintaining family relationships and responsibilities from the birth to the grave. In no other culture did home life and children feature so prominently in art—

not surprisingly, considering the high regard paid to the domestic realm, which the dutiful housewife presided over, while her husband made his way in the business world. Artists in Amsterdam, Haarlem, Leiden, Delft, and elsewhere all painted domestic interiors, focusing on the virtues and vices to which members of a household are exposed. Mothers and female servants are repeatedly depicted preparing food, nurturing the young, spinning yarn, scolding idleness, pondering over love letters, given over to sloth, or being seduced.

Frans Hals's *Isaac Massa and Beatrix van der Laen*

Many couples commissioned artists to commemorate their marriage and family, sometimes in family group portraits, often with paired portraits of man and wife, and occasionally in a double portrait, such as Hals's remarkably informal painting of the prominent Dutch merchant *Isaac Massa and Beatrix van der Laen*, probably

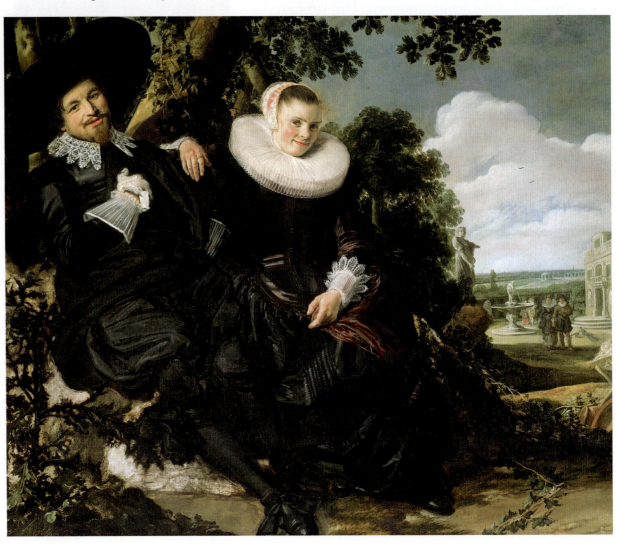

10.10 Frans Hals, *Isaac Massa and Beatrix van der Laen*. c. 1622. Oil on canvas, 54" x 62". Rijksmuseum, Amsterdam

10.11 Judith Leyster, *Boy Playing a Flute.* c. 1630–5. Oil on canvas, 28⁴/₅" x 24²/₅". National Museum, Stockholm

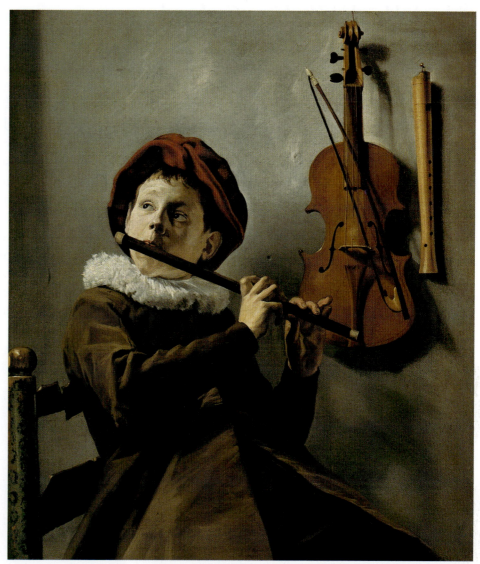

done for their wedding in 1622 (fig. 10.10). Today everyone is asked to smile for the camera, but in the early seventeenth century there was little precedent for the casual pose, smiles, and directness through which Hals suggests that theirs was a marriage based on love and not just on shared social standing. The theme of love is reiterated in the background lovers' garden, a stock motif that Rubens later elaborated in his *Garden of Love* (see fig. 9.29). Besides these love motifs, Hals also included such conventional marriage symbols as the vine wrapped around the tree and the trailing ivy—both representing female dependency. This is also suggested by the bride leaning on her husband's shoulder. The prominent thistle in the left foreground introduces a jarring note, as it was commonly associated with the curse pronounced against Adam and Eve because of their sin, and therefore serves as a reminder of earthly toil, sorrow, and death.

This jolt back to reality that Hals gave Massa and his wife reveals a matter-of-factness still typical of Dutch culture. Because of it, Dutch artists also succeeded, where few others have, in depicting children without sentimentality. One finds them in Dutch art fighting and stealing, imitating the worst habits of their parents, and having their bottoms wiped. They are also seen doing their homework, and occasionally, as in Judith Leyster's *Boy Playing a Flute,* practicing their musical instruments.

Judith Leyster's *Boy Playing a Flute*

Painted around 1630–5, when the artist was in her early twenties, this work (fig. 10.11) lies somewhere between portraiture and genre. The daughter of an emigrant from Antwerp, Leyster had been exposed to the art of Caravaggio's Dutch followers in Utrecht, and had also been a pupil of Hals in Haarlem. This background shows through both the form and content of

the painting. Leyster's *Boy Playing a Flute* takes its cue from paintings of a single musician, rendered close up with striking immediacy, which Caravaggio and his followers had popularized. The vitality derived from this sense of spatial immediacy, already emulated by Hals, is also evident in Leyster's painting. The shallow space and side-lighting, which accentuates the sense of volume in the figure and objects, are also derived from Caravaggio and his followers. Leyster enhances this practice with the distinct quality of her lighting, her subtle, almost monochromatic grays, browns, and olive greens—offset by the boy's red hat—and her more detailed characterization of the boy and his musical instruments. These are rendered with eye-fooling, or **trompe l'oeil**, illusionism. As with the portraits of both Hals and De Keyser, the effect is of immediacy, and also in this case of intimate informality—a characteristic found in other domestic interiors she painted.

Pieter de Hooch's *The Linen Cupboard*

Domestic life is also the theme of Delft artist Pieter de Hooch's (1629–after 1688) *The Linen Cupboard* (1663), in which he depicts the serenity of a household run by virtuous and orderly women (fig. 10.12). De Hooch's painting includes three women, representatives of the three stages of life. The oldest, wearing a widow's peak on her hair, stands at the linen chest and passes clean, neatly folded linen to a younger woman, who wears a jeweled headband and earrings to signify her married state. Beyond, in the doorway, a young girl plays with a *kolf* stick (the forerunner of golf). While the clean linen signifies the virtues of domestic order, the widow models diligence for the young wife, who must pass this example on to the playing child. Above the child, over the pilastered doorway, a statuette of Mercury, god

of commerce, suggest the prosperous trade pursued by the husband in the world glimpsed beyond the street door.

In De Hooch's *Linen Cupboard* the diligent activity of the women and the rhythmic order and clarity of the setting together embody the Dutch ideal of sober, proper, orderly living. De Hooch's interest in perspective and optical illusion—conceived in terms of figures set within a succession of domestic spaces, sometimes, as here, opening on to a street beyond—was characteristic of the painters of the small town of Delft. His pictorial fascination with geometric pattern and crisp, clean lines—as seen in the shiny tiled floor and the outlines of the windows, doors, and furniture, and echoed on the sunlit façade of the house across the street, perfectly mirrored the Dutch ideal of a well-ordered household.

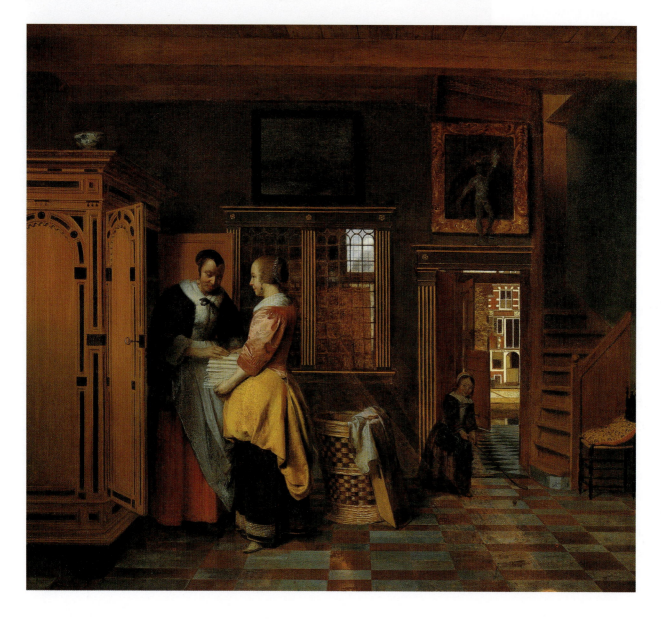

10.12 Pieter de Hooch, *The Linen Cupboard*. 1663. Oil on canvas, 28$^{1}/_{3}$" x 30$^{1}/_{2}$". Rijksmuseum, Amsterdam

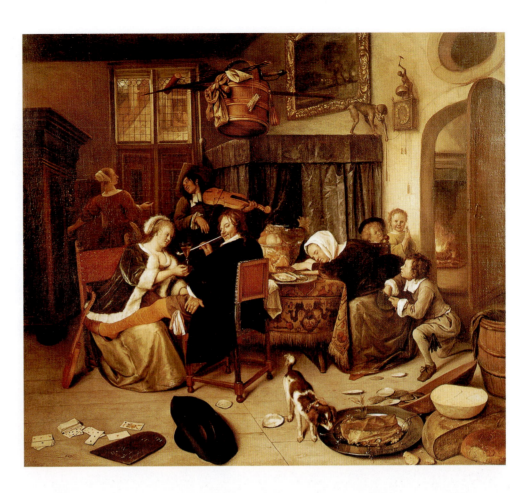

10.13 Jan Steen, *The Disorderly Household.*
1668. Oil on canvas, 31³/₄" x 35".
Wellington Museum, London

Jan Steen's *The Disorderly Household*

While Pieter de Hooch praised the virtue of orderly
living, Jan Steen (1625/6–79), a Catholic artist from
Leiden, good-humoredly poked fun at Protestant
demands for sobriety and delighted in exposing the
spectacle of human folly. Steen was a versatile story-
teller, who drew at times from the stock characters of
contemporary theater. He is known for his satirical
domestic scenes, such as *The Disorderly Household* of
1668 (fig. 10.13). In contrast to De Hooch's stiff,
impersonal figures, Steen gave full play to the depravity
of his characters, blatantly exposing a household's sur-
render to vice. He included himself amidst this scene
of neglect and carousing, his leg slung over the lap of
the flirtatious young woman who offers him a glass of
wine as he puffs merrily on his pipe. Steen's satiric
view shows that as the master lets down his guard and
the mistress falls asleep, vice invades through each of
the five senses and rules the home.

The objects strewn about Steen's imaginary house-
hold offer clues—some blatant, others subtle—to the dire
consequences of exchanging virtue for vice. As an ape
draws attention to the passage of time, a basket, brim-
ming over with threatening objects—including a sword,

a crutch, and a birch-rod—is suspended precariously
above the artist's head. Taken together, these elements
suggest that calamity can strike the careless at any
moment. As in other paintings by Steen, many ele-
ments make allusion to Dutch proverbs, aphorisms,
and emblems that would be familiar to his contempo-
rary viewers, such as the saying that the lap of a whore
is the devil's boat. With his typical good humor, Steen
makes himself the butt of the moral.

Professional Identity: Artists and Scholars

Besides portraying the worlds of merchants, courtiers,
housewives, and children, Dutch artists represented
their own roles and identities. In Chapter 1, we
encountered Johannes Vermeer's vision of the artist,
in his painting, *The Art of Painting* (fig. 1.1). Lacking
revenue from Church commissions or aristocratic
patronage, many Dutch artists worked as self-employed
craftsmen in an open market, a context in which art
dealers first emerged. Artists became specialists,

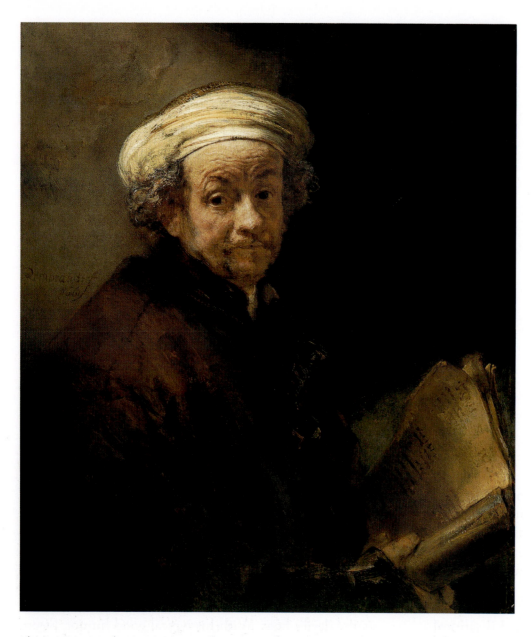

choosing a niche among a wide range of genres: Portraits, genre, landscapes, marines, still life, and, more occasionally, historical subjects.

In constructing images of self-identity, Dutch painters represented a society regulated by a traditional sense of morality, which at the same time embraced the empirical methods of early modern science. Above all, as we have seen, their paintings manifest a pervasive desire for portraits of a well-to-do, bourgeois society, in which family life was prized and even children were deemed worthy, independent, subjects for art.

Rembrandt's Self-Portraits

Rembrandt's gifts and ambition rose far above that of the local artist-craftsmen producing their specialty products. His grander vision prompted him to produce an unparalleled series of self-portraits, which capture a wide range of moods, from the buoyant self-confidence of his youth to the pensive inner reflection of his maturity. In one of the last of these, *Self-Portrait as the Apostle Paul*, painted in 1661, the artist presents himself in a dark, shallow space with the hilt of a sword (Paul's identifying symbol) tucked under his sleeve (fig. 10.14). Including the sword is more understandable in light of the inscription on the papers he holds. It refers to the Apostle Paul's Letter to the Ephesians, which ends with the exhortation to be armed "with the sword of the Spirit, which is the word of God." A shaft of light, falling obliquely over Rembrandt's turbaned head, furrowed brow, and bulbous nose, illuminates these words.

Rembrandt's self-portraits project his vision of the artist as an interpreter of profound human experiences,

in the tradition of other Baroque painters of historical and religious themes (such as Rubens). His late self-portraits, for example, do not hide or romanticize the effects of age and financial loss. He went bankrupt in 1656, yet he presents himself bearing this and other set-backs with profound dignity. Rembrandt's mature artistic vision—nourished by a lifetime of painting religious subjects that treated the mystery of divine grace poured out on vulnerable mortals—enabled him to see himself in a similar existential light, physically and materially weaker, yet spiritually stronger than earlier in life.

Johannes Vermeer's *The Geographer*

Vermeer took the world of discovery and science as the subject of two related paintings: *The Astronomer* (1668) and its companion, *The Geographer* (1669) (fig. 10.15). As Thomas de Keyser did in his painting of *Constantijn Huygens* (see fig. 10.9), appropriate "props" signify the sitter's scientific interests. Here, a globe sits prominently atop the chest behind the geographer, indicating his scholarly interest.

Vermeer's scholar leans over a chart, dividers in hand, as he pauses to ponder the data he studies—a pose and subject evoking the spirit of inquiry then engaging Dutch society. The artist implies that the geographer's mind is enlightened by the same clear, natural light that illuminates the chart before him and which plays across the orderly space of his study. Vermeer's technique harmonizes with this lucid spirit of investigation, for he effectively renders the texture of the rug draped over the table, the surface of the globe, and the modulation of light throughout the room by

10.15 Johannes Vermeer, *The Geographer*. Bears date 1669. Oil on canvas, 20³/₄" x 18¹/₄". Städelsches Kunstinstitut und Städtische Galerie, Frankfurt

applying the same careful scrutiny as the geographer directs to his cartographic calculations.

Other aspects of Vermeer's technique suggest that he was interested in advances in Dutch science and technology. With newly improved lenses, for example, observers could see the natural world in sharper detail than ever before. For Vermeer, such new inventions would influence his rendering of space and light. For example, dappled specks of light, called *pointilles*, shimmer over the surface of objects in Vermeer's paintings, and, in some works, a notable "wide-angle" perspectival distortion can be observed. Art historians commonly attribute both of these novel phenomena to the impact on the artist of looking through the lens of a *camera obscura* (Latin: "dark room"), a viewing device with a lens that projected the image before it on to a sheet of paper or glass, somewhat like a modern camera.

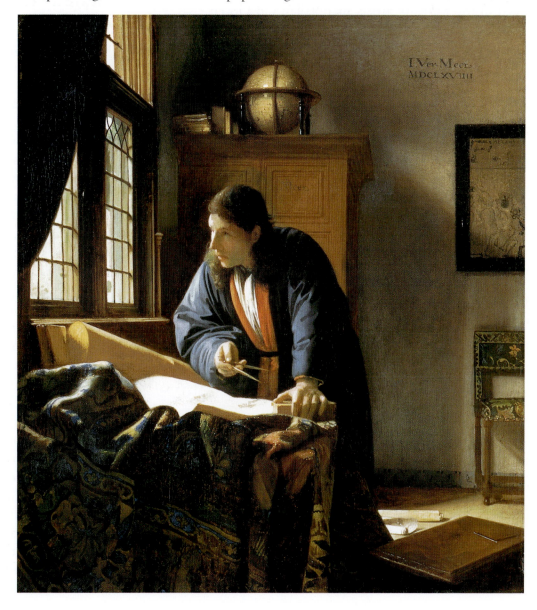

NATURE

Building on the heritage of Pieter Bruegel the Elder (see fig. 8.28), around 1611 the Amsterdam printmaker C.J. Visscher issued a set of landscape prints entitled *Pleasant Places*. These comprised local scenes so unpretentious that elsewhere in Europe they would not have been thought worth the paper they were printed on. But their commercial success in Holland was such that others began to draw and paint the local Dutch landscape in a similar manner. This prompted even cultivated literary figures, such as Constantijn Huygens, to write with enthusiasm of the marvels of the Dutch countryside, with its sand dunes, dikes, and winding country roads. Likewise Huygens, despite his cosmopolitan taste, expressed enthusiasm for the "naturalness" seen in the works of artists such as Jan van Goyen (1596–1656), in which "nothing is lacking ... besides the warmth of the sun and the movement caused by cool breezes."

Art for Delight and Contemplation

The motivation for this enthusiastic embrace of the local landscape is suggested by another Dutch poet, H.L. Spiegel, who expressed preference for naturalistic, Dutch landscape over classical, mythologized Arcadia on the grounds that one need not look elsewhere to see the hand of God in creation. Both Spiegel and Huygens refer to the natural world as "God's second book," finding in the local landscape plenty to delight the eyes, ease one's cares, and arouse contemplation of the Creator. Contemporary commentary shows that Dutch artists consciously sought naturalness of effect, not through mindless topographical imitation (in a strictly scientific sense), but rather through a process of selective naturalness.

For the Dutch, selective naturalness implied representing selective features of imperfect reality, according to their regional characteristics, rather than tidying it up to erase the ravages of time, wind, and weather, as in the classical humanist tradition. The Dutch (like their predecessors, such as van Eyck; see Chapter 8) perceived the visible world as inherently meaningful, and thus valued it the way it is, rather than as an imagined perfection. This inspired voracious visual curiosity in Dutch artists—comparable to that of Dutch scientists

such as Antonie van Leeuwenhoek, who developed microscopes that revealed things not previously seen by any human eye. This visual curiosity also generated novel forms of aesthetic satisfaction. The Dutch developed pictorial motifs traditionally given little or no attention, such as local coastal waters, beaches, sand dunes, inland waterways, and flat, panoramic landscapes. They gave equal attention to painting every flower and sea shell then known, as well as a vast inventory of food and tableware—fruits, pies, cheeses, glass, pewter, and silverware—which they viewed with a pleasure qualified by a concern for ostentation, as a delight to the eye and cause for contemplation.

Inland Waterways and Panoramic Views

Two innovative Dutch landscape painters, both of whom painted scenes from the environs of Haarlem, are Jan van Goyen and Jacob van Ruisdael (1628/9 –82). Each had an eye for different qualities in the Dutch landscape and each expressed their vision through contrasting techniques: Van Goyen developed a quick, sketchy technique to evoke the predominance of sky and water over slivers of land; van Ruisdael captured in greater detail the drama of storm-clouds and sunlight playing over the expansive low-lying landscape. Both artists manifest acute powers of observation as well as technical and compositional originality.

Jan van Goyen's *View of Haarlem Lake*
In his *View of Haarlem Lake: Evening Calm*, painted in 1656, Jan van Goyen represented the serenity of sailing Holland's inland waterways on a calm evening (fig. 10.16). He evokes, above all, the sensuous beauty of the local scene, using a predominantly monochrome palette, which he lays on with the lightest and deftest of touch, scarcely covering the wood panel on which it is painted. Here is no allusion to a lost classical Arcadia with idealized shepherds, but an everyday landscape populated by ordinary Dutch fishermen and comprised for the most part of air and water. A mere strip of land supports a farm and a windmill, while two church spires and further windmills dot the long, low horizon. The freshness and originality of van Goyen's vision is less obvious today when we are familiar with

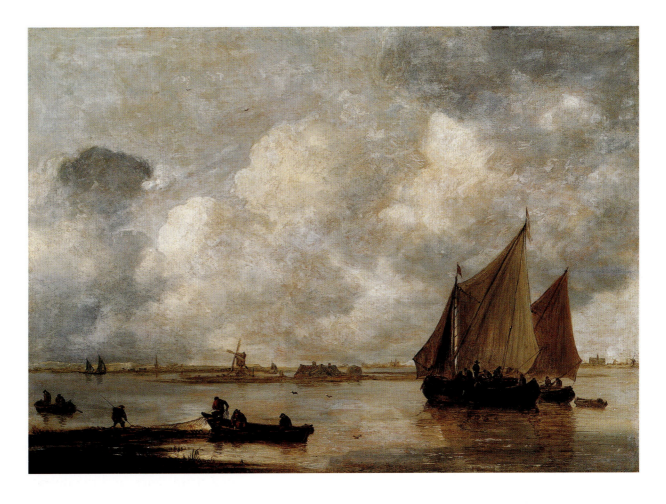

10.16 Jan van Goyen, *View of Haarlem Lake: Evening Calm.* 1656. Oil on panel, 15 1/2" x 21 1/4". Städelsches Kunstinstitut und Städtische Galerie, Frankfurt

nineteenth-century Impressionist paintings, but in their own time they were a significant departure from long-standing conventions in both subject and technique. This resulted from a desire to depict the unheroic, matter-of-fact elements of the immediate environment, using new technical means to convey a sense of immediacy. The artist rendered the light, atmosphere, and beauty of the local Dutch landscape for its own sake, as inherently significant, and perhaps also of heightened significance to the local citizens who bought them, given the country's recently-won independence.

Jacob van Ruisdael's *View of Haarlem*

The Haarlem-born painter Jacob van Ruisdael drew inspiration from the local sand dunes and low-lying lands, or polders—rather than the inland waterways favored by van Goyen—for paintings such as his *View of Haarlem*, which was painted in the late 1660s (fig. 10.17). In such works van Ruisdael perfected a new type of panoramic landscape, in which the flat local countryside is viewed from a high vantage point. In this case, the view is from the sand dunes that hold back the North Sea, sheltering on their lee side a network of

polders that spreads out toward Leiden and Haarlem. (A "polder" is low-lying land reclaimed from inland lakes and peat bogs.) Even standing on the slight elevation of the sand dunes above them offers a long prospect. In van Ruisdael's *View of Haarlem*, one has the impression of looking out from these dunes over the peat bogs and polders toward Haarlem, whose massive church of St. Bavo rises above the rooftops of the town. Its spire leads the eye up into the expansive sky, in which layer upon layer of cumulus clouds roll across the countryside, casting most of it in shadow. Van Ruisdael shows the sun breaking through above the white strips of linen laid out in Haarlem's famous linen-bleaching fields that resulted from the land reclamation. By including these bleaching fields, van Ruisdael proudly acknowledged both the Dutch engineers' feat of land reclamation and a flourishing local industry.

Unlike van Goyen's sketchy, monochromatic style, Ruisdael's favored greater detail, descriptive local color, and a firmer compositional structure, all wrought with the eye of an acute observer. Departing from the schematic treatment of skies characteristic of all earlier art, even in the naturalistic Netherlandish Renaissance

paintings ignore classical notions of ideal order, celebrate the beauty of the everyday world, and allude to the metaphysical. The prevalence of this metaphysical dimension in their still lifes also reveals a characteristic Dutch cultural tension between enjoying the world and its wealth and a moral duty to practice restraint.

THE CITY

Dutch cities are distinctive for their modest scale; for their narrow, red-brick houses with stepped or curved gables and steeply-pitched, red-tiled roofs; for the round towers of their city gates, and for their medieval church spires. With the exception of a few churches, town halls, and other public buildings built in an ornate, late Renaissance or Mannerist style, these more traditional characteristics—glimpsed in the background of fifteenth-century Netherlandish paintings such as Robert Campin's *Mérode Altarpiece* (see fig. 8.5)—generally prevailed into the early seventeenth century. At that time, the princes of Orange introduced an adapted form of French classicism for their country palaces and town houses. Only gradually, and then mostly in Amsterdam, did wealthy merchants begin to build wider houses in a classical style that broke with the traditional Dutch, narrow-fronted, stepped-gable designs. Even then, merchants mostly built in brick, rather than stone, which helped preserve the warmth and intimacy of scale characteristic of Dutch cities. These qualities can still be enjoyed in some measure today, but the lively interest of seventeenth-century Dutch artists also allows us to see how they viewed their own cities.

City Views

During the sixteenth century, prints of city views, seen in silhouette, began to appear on the edges of Netherlandish maps (see, for example, the old map hanging on the wall of Vermeer's *Art of Painting*, fig. 1.1). In the seventeenth century, a number of artists took up this motif in both printmaking and oil painting. Local pride no doubt contributed to the popularity of Dutch city views, some featuring prominent buildings in the heart of town, others, following the cartographic tradition, featuring the city in silhouette, rising from a thin strip of land under an expanse of sky. An outstanding example of the latter is Vermeer's *View of Delft*, painted about 1658–60 (fig. 10.20) and widely admired for the subtlety of its suffused light and warm colors. Vermeer's masterly handling of light and color transforms the conventional city profile. It is as if we view the city of Delft from the south bank of the River Schie, overlooking people conversing beside a barge. Nestled behind its city walls, Delft is seen at first light under an overcast sky. The city's stone bridge and gates are rendered in subdued tones of red, brown, and blue, animated by the flickering beads of Vermeer's characteristic *pointillé* highlights (see fig. 10.15), while bright shafts of early

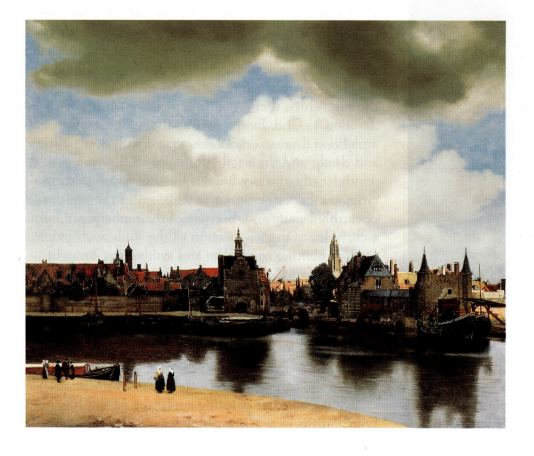

10.20 Johannes Vermeer, *View of Delft*. 1658–60. Oil on canvas, 38½" x 46¼". Mauritshuis, The Hague

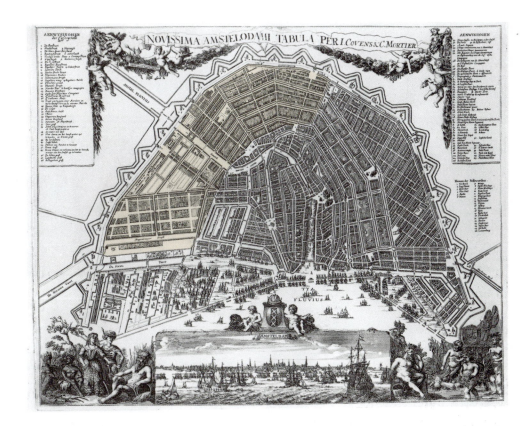

morning sunlight catch the gothic tower of the Nieuwe Kerk and cause some of the red-tiled roofs of the background buildings to shimmer in brilliant contrast to those on the waterfront. All is still and quiet, and the reflections of the buildings stretching across the sheet of water are undisturbed by wind or shipping.

The way Vermeer conjures the illusion of the city of Delft bathed in a warm morning light is captivating. Equally vivid is the texture of the wooden boats and the old brick walls. Vermeer has underscored the sense of tranquillity with the rhythms of his composition: Successive horizontal bands of sand, water, brick, sky, and cloud are played against the lateral rhythm of red roofs and towers. A sequence of vertical accents provided by the towers of the churches and city gates, quietly echoed by the succession of windows, chimneys, and ships' masts, modulates the lateral rhythm. These rhythms, combined with the warm tonalities and the rich texture of the buildings, suspended between air and water, provide an aesthetic satisfaction that goes far beyond the work's appeal as either description or illusion, evoking a sense of peace, stability, and well-being.

The Expansion of Amsterdam

Delft and other smaller cities managed to preserve the modest, intimate scale and historic identity that Vermeer captures in his *View of Delft*. But for Amsterdam, the vast expansion of the Dutch economy in the seventeenth century and the sheer influx of people brought a massive expansion of the city. The result was a complete transformation of its scale and civic identity. This ambitious piece of town planning was begun in 1613 and took more than fifty years to complete. A crescent-shaped extension, comprising a series of three canals laid out in concentric rings, was wrapped around the old center, as shown in this city plan (fig. 10.21). These new canals were lined with wide quays and faced by elegant houses that served as the wealthy merchants' residences and places of business. The wider and grander buildings were designed in the newly fashionable classical style, with horizontal cornices and/or triangular pediments, which broke with the traditional narrow, stepped-gable designs. The radial streets intersecting the three grand, concentric canals were reserved for the property of artisans and smaller tradesmen.

During the expansion of Amsterdam, the city also built churches to serve the residents of the new areas. This gave architects an opportunity to experiment with designs fitted to the simpler needs of Protestant services, while also augmenting the city skyline with decorative bell towers. Jan van der Heyden's *View of the Westerkerk, Amsterdam* (fig. 10.22), painted in the 1670s, depicts the most notable of these churches, which the architect-sculptor Hendrick de Keyser (1565–1621), the father and teacher of Thomas de Keyser, had designed in 1620 to face the majestic new, tree-lined Keizersgracht. De Keyser's Westerkerk is an early example of new Protestant church designs. In this case, the architect translated older basilican models in terms of restraint and clarity. Its modest scale and red brickwork harmonized with traditional Dutch architecture, but the city magistrates' budding interest in clas-

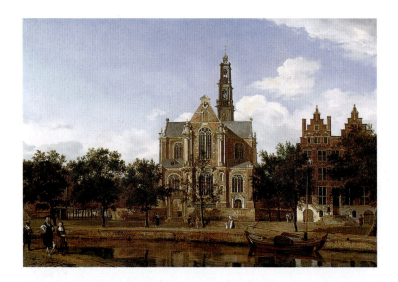

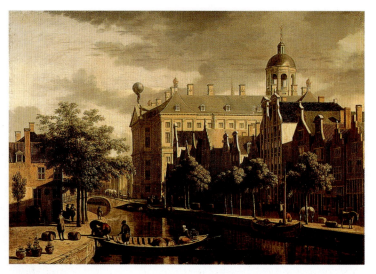

10.22 Jan van der Heyden, *View of the Westerkerk, Amsterdam.* 1670s. Oil on panel, 16"x 23". Wallace Collection, London

10.23 Gerrit Berckheyde, *The Flower Market in Amsterdam.* 1670s. Oil on canvas, 17³/4"x 24". Amsterdams Historisch Museum, Amsterdam

sicism is reflected in the classical detailing of the stone bell tower, which became a key landmark of the city.

Dutch independence from Spain, granted in a 1648 peace treaty, ushered in a swell of national pride. In Amsterdam, the city magistrates commissioned a colossal new town hall, which is now a royal palace. Jacob van Campen (1595–1657) designed it in 1648 in a classical style that carried a wealth of sculptural decorations proclaiming Dutch domination of world trade. Crowned with an Italianate cupola, this symbolic feature claimed for Amsterdam the glory that once was Rome's. However, the town hall's monumental scale and cupola may seem out of place in Amsterdam. It certainly overshadows the surrounding buildings and signals the triumph of classicism over existing Dutch traditions as well as a new taste for grandeur, in which older notions of restraint are set aside.

Gerrit Berckheyde's (1638–98) painting *The Flower Market in Amsterdam* (fig. 10.23), probably painted in the 1670s, captures the ambitious scale, overbearing mass, and classical style of the new town hall in contrast to the older town houses around it. Amsterdam's expansion, and the building of the new town hall, marks the erosion of local building styles in face of the by then widely accepted authority of classicism—especially for architecture. As the vertical accents of traditional construction gave way to the horizontal emphasis of classical cornices, the regional distinctiveness of Dutch domestic architecture yielded to the rule of classicism. By contrast, Vermeer's *View of Delft* shows the regional style intact.

PARALLEL CULTURES
The Dutch in Brazil

As we've noted, Dutch merchants plied the world's oceans in pursuit of trade, from the Baltic to the Mediterranean and from the East Indies to the West Indies. They brought home exotic goods. Chinese porcelain, Persian carpets, Asian mahogany (used for

10.24 Albert Eckhout, *Tapuya Woman.* 1641. Oil on canvas, 8'5"x 5'3". Nationalmuseet, Copenhagen

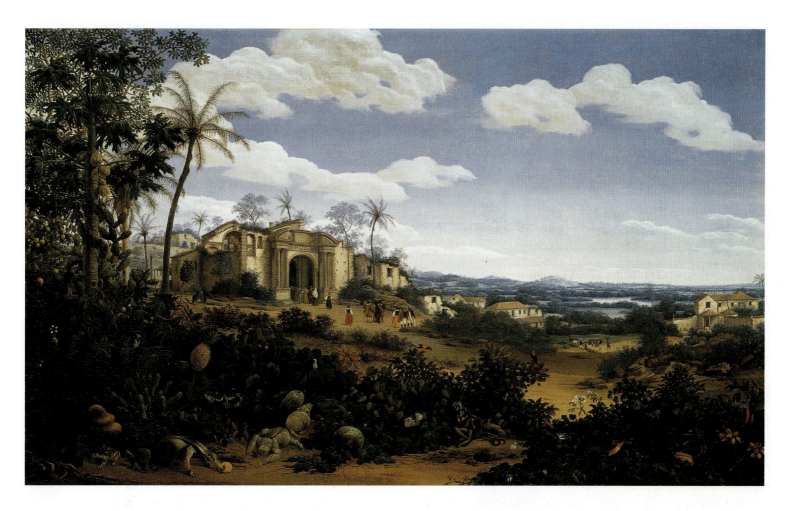

10.25 Frans Post, *Ruins of the Cathedral of Olinda, Brazil.* 1662. Oil on canvas, 42"x 68". Rijksmuseum, Amsterdam

fine furniture and picture frames), rare sea shells—many of which can be seen in their still-life paintings. Dutch shipping features prominently in seventeenth-century painting (see fig. 10.2), and some artists recorded Dutch colonial life in remote trading stations.

When Prince Johan Maurits of Nassau led an expedition to Brazil, lasting from 1636 until 1644, two artists accompanied him: Albert Eckhout (c. 1610–65), who made paintings of the local people and wildlife; and Frans Post (c. 1612–80), who was employed to depict the Brazilian landscape. Eckhout's 1641 painting of a *Tapuya Woman* (fig. 10.24), standing amid exotic vegetation, holding a severed human hand, and carrying a human foot in her shoulder bag, appears to perpetuate myths of widespread cannibalism among the indigenous population. It thus acted as a form of justification for Dutch colonization.

For its part, Frans Post's *Ruins of the Cathedral of Olinda, Brazil* (fig. 10.25), painted in 1662, long after he had returned to Holland, provided the home market with a crisp, detailed depiction of Brazilian flora and fauna, including an anteater and an armadillo. The work also includes a reminder of Dutch imperial prowess in the New World, shown by Dutch presence in the Brazilian landscape, and by the ruined Portuguese cathedral of Olinda, which the Dutch had wrested from the Portuguese in a much-publicized battle in 1630. Frans Post provides a synthesis of artistic imagination and detailed scientific information. The picture's scientific credibility is underscored by the artist's clarity and precision in presenting the foliage of exotic plants splayed out against the sky. In such works, painting serves as a counterpart to the pictorial information provided by contemporary Dutch cartographers. It remains, inevitably, a European's view of the New World. The life of the indigenous population is scarcely registered, except in the derogatory terms that justified colonization.

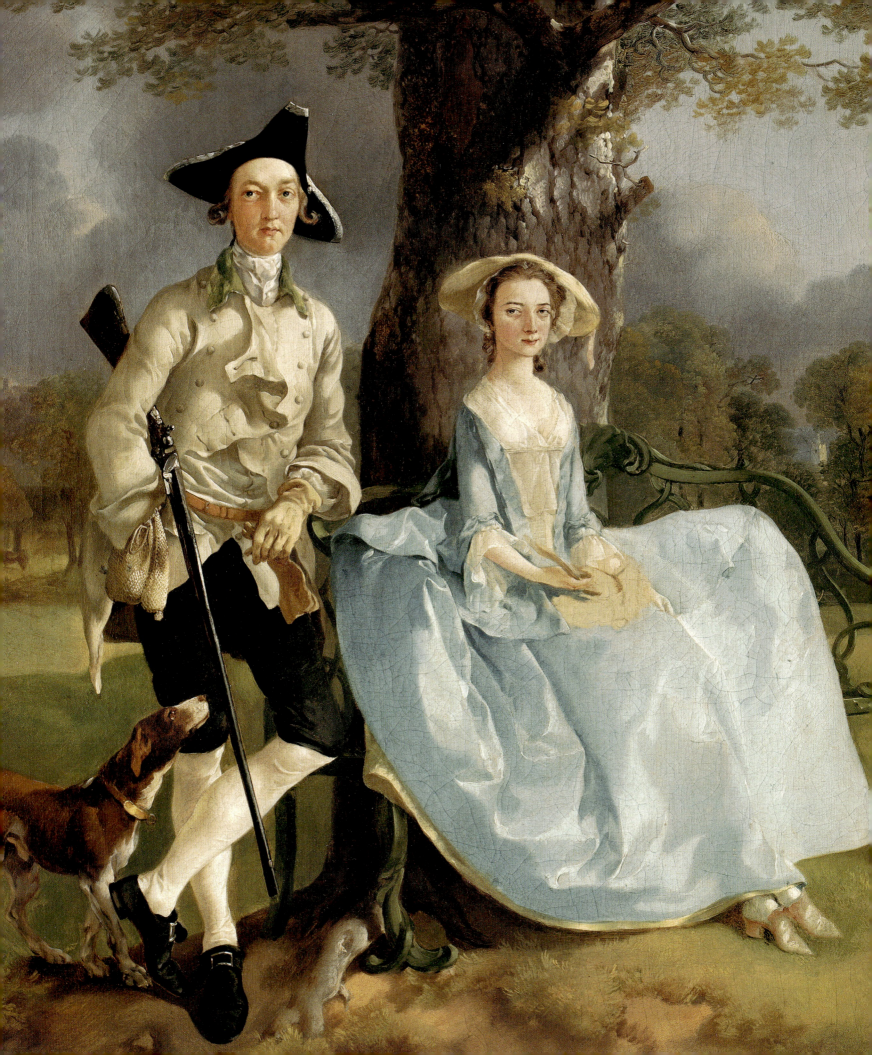

11 English Baroque and Eighteenth-century European and American Art

Early in the eighteenth century, the sun set forever on the "Sun King," that proud, absolutist monarch, Louis XIV of France. By the end of the century, the old political order that had sustained the monarchs and aristocrats of Europe since the Renaissance had been swept away. The American colonists had fought the British for independence, and in France the monarchy had been violently overthrown by the French Revolution. Out of these two revolutions, ignited by the clash of powerful, opposing ideas, came the beginning of the modern age.

Natural Science, Reason, and Progress: Enlightenment Ideals for a New Age

Enlightenment thinking had its roots in the wave of advances made in the natural sciences through the use of reason. As earlier figures such as Galileo, Johannes Kepler, and Isaac Newton had applied reason to uncover the laws of nature, philosophers such as John Locke and David Hume in Britain, and Voltaire, Montesquieu, Rousseau, and Diderot in France applied the same logical principles to human affairs. As scientific thinking had transformed our understanding of the natural world, so too, they believed, it would free society from its "unnatural" superstitions and injustices. The alert and quizzical expression on Jean-Antoine Houdon's (1741–1828) 1781 bust of Voltaire (fig. 11.2) brilliantly captures the spirit of inquiry driving such free-spirited individuals.

The Enlightenment love of reason and the natural shaped the vision of a new, more just age. Achieving this vision demanded that existing institutions be destroyed and rebuilt, based on a new set of principles known as "natural law." In France, Voltaire's *Philosophic Letters on the English*, published in 1734, discreetly (and anonymously) introduced these ideas, derived from the English philosopher Locke. Revolutionary in its time, natural law justified the protection of individuals and their property from the tyranny of absolutist monarchs. Rousseau went even further in his *Social Contract* of 1762, advocating human equality and a state based on the General Will of the people. All three attacked established politics as obstacles to natural human liberty. The prime engine for reconstruction was the publication, between 1751 and 1772, of the *Encylopédie*, edited by Diderot. Filled with articles and illustrations describing technological innovations, it was a veritable manifesto for rational Enlightenment and offered its readers the practical means by which to achieve progress.

In the religious sphere, intellectuals' skepticism grew, fed by continued Church corruption and increased exposure to non-Western religions. Some thinkers even speculated about a natural religion based on universal religious principles. Many Christians turned to Deism, which attributed to God a limited role as the creator of a mechanical universe, which has subsequently followed its own laws, independent from its original creator. Intellectual appeals to nature and reason also tended, therefore, to undermine traditional Christian beliefs.

Ultimately, Enlightenment ideals of liberty and justice underlay the American Declaration of Independence of 1776 and the French Revolution of 1789. With them, a new social order began to take shape, in which individuals were guaranteed a set of "natural rights" and were freed from the absolute power of Church and state.

11.2 Jean-Antoine Houdon, *Voltaire*. 1781. Marble, height 20". Victoria and Albert Museum, London

The old social order or *ancien régime* of the Church, absolute monarchs, and an aristocracy had rested on its assumed right to inherited privilege. Disputing these assumptions, writers and philosophers in Britain and France attacked the foundations on which the old order rested. In place of inherited privilege, they championed natural, human rights. Human affairs, they urged, should be governed by rational thinking based on a scientific approach to all problems. Together, their ideals and the time in which they wrote became known as the Enlightenment. Once described as a "solvent of the old order," it was a time when a just world based on human reason seemed possible.

In the life and art of the British painter Thomas Gainsborough (1727–88), we find the conflicting

values and sensibilities of both the old order and the new. In his portrait of *Mr. and Mrs. Andrews* (figs. 11.1 and 11.27), painted about 1749, the couple appear proud and nonchalant against the backdrop of their property. The subject—especially for the modern viewer—evokes a world of class privilege. Yet these are provincial country landowners, not absolutist monarchs, prelates, or titled aristocrats (compare them, for example, with Rigaud's Louis XIV and Van Dyck's Elena Grimaldi, figs. 9.20, 9.25). While Gainsborough's subject suggests privilege, his approach to it owes more to the spirit of the Enlightenment. He ignores approved academic convention and rejects classical idealism. Gainsborough observes the English countryside in its natural state, and renders it freshly and directly. While Dutch art pointed Gainsborough in this direction, it was in England and France that Enlightenment thought was first nurtured (see "Natural Science, Reason, and Progress: Enlightenment Ideals for a New Age," page 340).

British Power and the Industrial Revolution

As the revolutionary ideas and events of the eighteenth century unfolded, Britain, which had undergone revolution in the seventeenth century, emerged to challenge France as a world power and Holland as a commercial power. As the cradle of the Industrial Revolution, Britain also prospered from improvements in agriculture, brought about by land enclosures. At the same time, farm workers, displaced thereby, sought work in the urban mills and factories now fueling Britain's economy and its imperial expansion. Britain would come to dominate India, and ultimately displaced France in North America. Britain's economic and political prominence stimulated grand architectural projects, as well as leading to the founding in 1768 of the British Royal Academy of Arts.

Privilege, Enlightenment, and Art

Eighteenth-century artists and architects were caught in the ideological clashes of their age. By training and professional association their sympathies would lie with Enlightenment ideals, yet most of their patrons came

from the old social older. Amid this very real, personal conflict, the most striking artistic contrasts appeared—ranging from the sumptuous to the severe in architecture; from pleasure to self-denial in representing the self; from artifice to naturalness in relation to nature; and from the theatrical to the rational in the design of public spaces. In the non-Western world, this contrast took on ironic proportions as Neoclassical architecture found its way to the streets of India (see "Clashing Values, Clashing Styles: Rococo and Neoclassicism," page 342).

We will examine some of these contrasts, as found in the arts of late seventeenth- and eighteenth-century France, England, and Germany, as well as North America, and end by briefly examining the art and architecture of India prior to British colonial domination.

SPIRITUALITY

In an age of reason, beset by religious skepticism and a tendency toward Deism (see "Natural Science, Reason, and Progress: Enlightenment Ideals for a New Age," page 340), Christianity was supported by two fresh, contrasting forms of architectural expression. In southern Germany and Austria, architects working for the Catholic Church designed ornate churches in a Rococo style that completely overwhelms the senses. In England, starting in the late seventeenth century, Protestant architects designed some of the least decorated, most geometrically rational churches in a classical style ever conceived. The former evoke, with effusive visual stimulation, the sensuous mystery of the Catholic liturgy. The latter support, with matter-of-fact rationality, a Deist's notion of a reasonable God, to be presented through a clear-headed, logical sermon.

Catholic Rococo Extravagance

After almost a century of economic stagnation following the devastation of the Thirty Years War (1618–48), a European conflict that set Catholics against Protestants in Germany, the Catholic Church in southern Germany and Austria commissioned a spate of new churches. Their architects reinterpreted the idiom of Italian Baroque architecture (see Chapter 9) with

Clashing Values, Clashing Styles: Rococo and Neoclassicism

The clash of ideals is reflected in the two dominant artistic styles of the eighteenth century—the flamboyant late Baroque works, generally called Rococo, and the various restrained forms of classicism, generally called Neoclassical. Rococo, meaning "shell work," refers to a style of architecture and decoration that developed in France from the Baroque and is characterized primarily by elaborate and often delicate ornamentation that imitates shells, foliage, and other natural forms. Its ornate forms are curvilinear, its colors pastel, and its effects are often light and playful.

Classicism refers to a return to the principles of Greek or, more often, Roman art and architecture. Classical revivals, which have occurred at various times in history, imply a return to the rule of artistic law and order, as well as evoking the memory of antiquity. Neoclassicism refers to a particular movement in art and architecture that arose in the 1750s, partly in reaction to Rococo, as a conscious imitation of the serenity, harmony, and at times severity of the classical art of Greece and Rome. In contrast to Rococo, its forms are typically geometric and plain, its lines straight and sharp, its colors cool. Neoclassicism is found in various forms, from opulent to austere, and its style, too, evoked a range of associations—"good taste" and political freedom (as seen at Kedleston Hall, fig. 11.16); austere, Stoic virtue (as used by Jacques-Louis David, fig. 11.21); and patriotism and democracy (as with Thomas Jefferson, fig. 11.23).

flair and fantasy in a Rococo style. Among the most spectacular is the church of Vierzehnheiligen ("Fourteen Saints") in Bavaria, designed by Johann Balthasar Neumann (1687–1753) for the Bishop of Bamberg, and built between 1743 and 1772 (fig. 11.3).

Vierzehnheiligen stands on a hillside, and its twin bell towers with onion-shaped domes serve as a beacon to approaching pilgrims. Its interior defies all expectations. Its plan (fig. 11.4) is conceived as a succession of fluid, interlocking oval spaces, surrounded by columns that screen the side spaces. Overhead, figures in the delicately frescoed vaults float toward heaven in an airy expanse, surrounded by ornately worked and gilded stucco (plaster-based ornamentation). The irregular, curvilinear forms of the decoration—freely derived from shells, bark, and spiraling plant tendrils—are characteristic of Rococo, as are the delicate ornamentation and luminous tonal range of white, gold, and pastel colors.

In the midst of Vierzehnheiligen's light, airy interior and framed by the central oval of the nave, an altar in the form of an ornate, fairytale canopy marks the site where, Catholics believe, a vision occurred. Its evocative,

exotic splendor serves to this day as a focus for believers' prayers. The elliptical form of the central spaces, cushioned from the exterior by amorphous side aisles, draws the eye forward and upward through this dreamlike space.

Beyond, in the **apse**, the main altar is surrounded by a lively array of painted and carved saints and flying angels. Their upward gestures lead the eye toward the brilliant burst of light that breaks in through the clerestory windows above, evoking a seamless fusion between earthly and heavenly spheres. Space and decoration are thus perfectly harmonized to evoke a flight of religious fantasy arising from the church's two centers of worship, the altars in the nave and the apse.

Art historians have noted that the joyous fantasy of such Bavarian Rococo churches, with their mixture of escapist dream and ravishing spectacle, would in time be echoed in the opera houses of Europe. As if in compensation for a loss of mystery before the onslaught of rationalism, the liturgical spectacle of the Catholic Church, with its drama of suffering and redemption, could be experienced in secularized form in opera, acted out in an aesthetic setting comparable to an enchanted Rococo church.

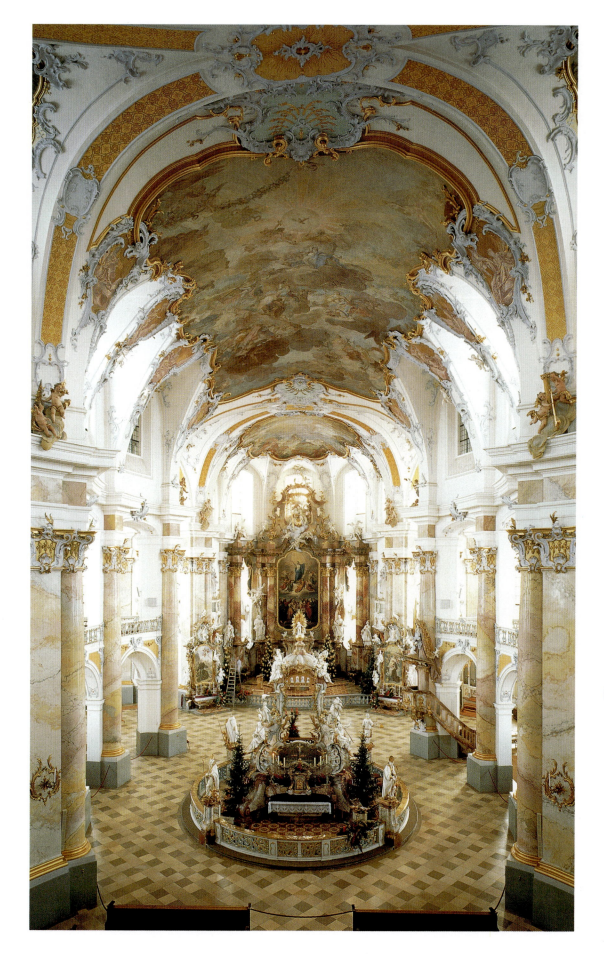

11.3 Johann Balthasar
Neumann, interior of the
church of the Vierzehnheiligen,
near Staffelstein, Germany.
1743–72

11.4 Johann Balthasar
Neumann, plan of the church
of the Vierzehnheiligen, near
Staffelstein, Germany. 1743–72

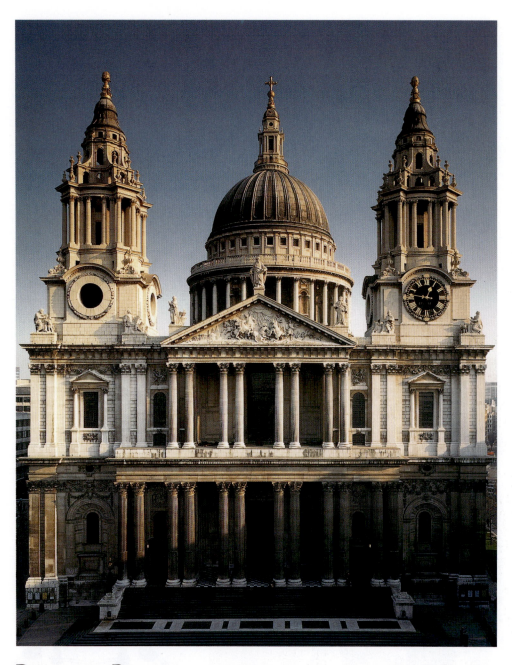

Protestant Baroque: St. Paul's Cathedral, London

The origins of what became a characteristically Protestant form of church architecture lie in the late seventeenth century. At that time, Continental Baroque grandeur—of a type seen in churches such as St. Peter's (see fig. 9.36) and Sant'Agnese in Piazza Navona (see figs. 9.37, 9.38), both in Rome, as well as various Parisian buildings—was emulated in Britain by Sir Christopher Wren (1632–1723) in rebuilding London's St. Paul's Cathedral (fig. 11.5). Built between 1675 and 1710, after the existing gothic church was destroyed in the Great Fire of London (1666), its massive size, twin

towers, and majestic dome dominated London's skyline until skyscrapers rose alongside it.

While its towers recall those of Borromini in Rome (compare figs. 9.37, 9.38) and its dome reminds the viewer of St. Peter's, Rome, the façade's superimposed porticoes with paired columns echo buildings Wren had seen in Paris (such as the newly rebuilt east façade of the royal palace of the Louvre). In his design for St. Paul's, Wren joined elements of Italian Baroque with a more restrained French classicism to create a monumental and unified whole. In so doing, he gave London a cathedral whose architectural symbolism broke completely with England's long tradition of ecclesiastical gothic architecture.

Protestant Classical Restraint: St. Stephen, Walbrook

The restrained classicism (rather than the Baroque features) seen in St. Paul's is even more pronounced in the many smaller parish churches Wren designed to replace those destroyed in the 1666 Fire of London. Significantly, Wren was by training a mathematician and a scientist, who became a professor of astronomy and was admired by Sir Isaac Newton for his skill in geometry. He brought this modern, scientific outlook to the practice of architecture. For these churches, Wren also found inspiration in the Dutch Protestant churches designed by Jacob van Campen (architect of Amsterdam's town hall, see fig. 10.23). From these sources, he developed a rational new Protestant aesthetic.

A fine example is the church of St. Stephen, Walbrook, in London, built between 1672 and 1687 (fig. 11.6). The chief feature of its exterior is a tall steeple with classical detailing, designed to rise above the adjoining buildings. As with Vierzehnheiligen (see fig. 11.3), the surprises are in the interior; but in all other respects the two churches couldn't be more different. In St. Stephen, a complex geometry, devoid of any imagery, surrounds the worshiper. The church is comprised of a short, plain rectangle, in which the sparest of classical architectural elements are organized with subtle mathematical calculation to create varied interlocking effects.

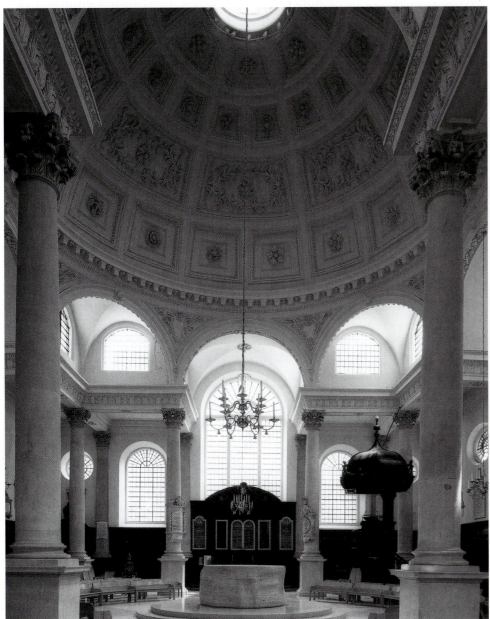

11.6 Christopher Wren, interior of the church of St Stephen, Walbrook, London. 1672–87

11.7 Christopher Wren, plan of the church of St Stephen, Walbrook, London. 1672–87

11.8 James Gibbs, church of St Martin-in-the-Fields, London. 1721–6

At Vierzehnheiligen the worshiper is invited to travel in the imagination through time and space accompanied by an array of saints and angels. But at St. Stephen, Walbrook, it is the rational clarity of mathematics and geometry in which the pulpit, Ten Commandments, and the sign of the cross are set. In Wren's church we see a more chaste and rational sensibility that turned from the extravagance of the old order toward the Enlightenment vision of an impersonal, mechanistic universe.

James Gibbs's St. Martin-in-the-Fields

Wren's London churches laid the foundations for subsequent Anglican church architecture. Among these, the church of St. Martin-in-the-Fields (fig. 11.8), facing on to Trafalgar Square, London, and built between 1721 and 1726, became the most widely emulated of all Protestant church designs, especially in North America. Although it is a Protestant church, it was designed by an Italian-trained Catholic architect, James Gibbs (1682–1754). Its beautiful exterior design, which repetition has made familiar, was unusual at the time. Its steeple, similar in design to Wren's at St. Stephen, rises unexpectedly through the roof of the church, directly behind the classical pediment of a columned temple portico. The interior is a large, open auditorium, with balconies running along both sides. But where Vierzehnheiligen climaxes in the lavish imagery surrounding the high altar, here a plain glass window closes the field of vision. Just as the design of the former supports the sensuous mystery of the Catholic liturgy, that of St. Martin, like St. Stephen before it, serves Protestant worship through the rationality of its design, and the absence of figurative art to distract attention from the spoken word.

On entering St. Stephen, the first impression is of a negligible nave and side aisles preceding a spacious, domed central space, containing the pulpit, with the altar beyond, and the text of the Ten Commandments displayed behind it. On looking up into the dome, however, and tracing the relation of its supports to the surrounding space, one discovers the ingenuity with which these elements interlock.

Eight slender **Corinthian** columns support the dome. These columns are linked by right-angled cornices to four more identical ones, which together form a circle within a square. The spacing of the columns and the vaulting above them, with an arch on each side of the square, creates the form of a cross, which can also be seen on the plan (fig. 11.7). Through this play of forms, Wren inscribes a circle within an octagon, itself within a square, itself within a rectangle, while also marking out the form of a cross.

THE SELF

Since artists and architects received most of their commissions from members of the higher aristocracy, their art inevitably reflected their patrons' values, power, and pleasures. However, some aristocratic patrons embraced aspects of the Enlightenment outlook. By training, too, eighteenth-century artists and architects were strongly influenced by a rational approach to art, promoted by art academies (see "The Artist as Academician," page 354).

Given the sometimes conflicting values of their patrons and their training, some of the period's artists celebrated the power, pride, elegance, and pleasures of the privileged old order; some expressed a desire for reform—be it artistic, political, or moral—modeled on the virtues of classical antiquity; and, finally, a small minority broke with tradition, attracted instead to nature, science, and progress.

Privilege, Pleasure, and Glory

Nowhere better did an architect and an artist succeed so brilliantly in enshrining the values, power, and pleasures of the old social order than in the vast sprawling Residenz of the Prince-Bishop in Würzburg, Germany. And nowhere is the attempt to translate the grandeur of Versailles into the new Rococo style more evident. The wealthy Prince-Bishop's architect was Johann Balthasar Neumann, who subsequently designed the church of Vierzehnheiligen for the neighboring Bishop of Bamberg (see fig. 11.3); and the artist was the Venetian Giovanni Battista Tiepolo (1696–1770), the leading Italian fresco painter of the era.

Residenz of the Prince-Bishop, Würzburg, Germany

Begun in 1720, the Würzburg Residenz unashamedly imitated the grandeur of Louis XIV's Versailles in its conception and scale. Neumann's lavish interior decoration—enriched by Tiepolo's dazzling paintings—employed the techniques of German Rococo, as later seen at Vierzehnheiligen, to trumpet the secular glory of the Prince-Bishops. The Residenz's main state reception room, the Kaisersaal (Imperial Hall) (fig. 11.9), is located on the central axis of the building and is reached by a ceremonial staircase of unprecedented elegance. This staircase rises and doubles back on itself to either side, with each flight eased half-way by a landing, which gives the whole a graceful, undulating rhythm. It is contained in a large vaulted hall, which is sumptuously decorated with pilasters and sculptures on the stair balustrades as well as above the doors and windows. The entire space is crowned by a vast ceiling fresco, painted by Tiepolo, that allegorically trumpets the glory of the prince-bishops to the four corners of the earth.

The dramatic conception of this approach not only displays princely magnificence; its grandeur is also a fitting prelude to the great oval Kaisersaal. Neumann

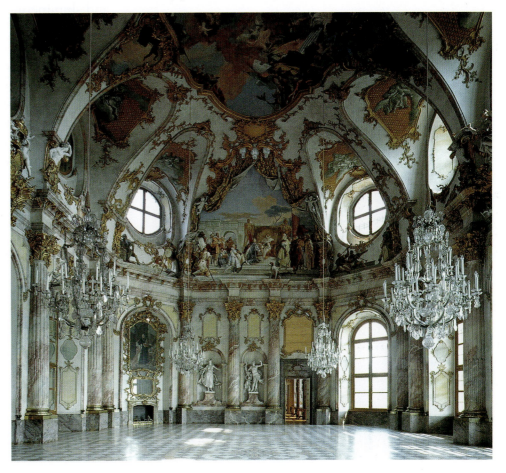

11.9 Johann Balthasar Neumann, interior of Kaisersaal (Imperial Hall), Residenz, Würzburg, Bavaria, Germany. 1720–44. Frescos by Giovanni Battista Tiepolo. 1750–53

surrounded this vaulted state reception room with luxurious, multicolored, **engaged columns** (that is, attached to the wall and supporting the cornice) and decorated the entire space in a characteristic Rococo color scheme of pastel white, pink, and gold. In the vaults above the cornice, with a theatrical gesture of illusionism, Tiepolo painted between 1750 and 1753 an imaginary spectacle of court pageantry from an earlier age, as if unveiled beyond a lavish curtain drawn aside by flying putti. This and the other scenes he painted, both in the Kaisersaal and above the monumental staircase, are fine examples of Tiepolo's dashing style: He conjures up elegant figures in lavish costumes, painted in brilliant, glittering colors and set in airy spaces.

To connect the viewer to this festive world Tiepolo typically added playful details—such as the dog, and the two trumpeters on the right, who appear to be sitting on the cornice. Visually these details create a transition between real and illusory spaces. In churches, such techniques were used to lead the viewer's imagination into the heavenly realm. Here, the scenes that unfold commemorate majestic events from the lives of the prince-bishop's ancestors, reinforcing their authority and prestige in the present.

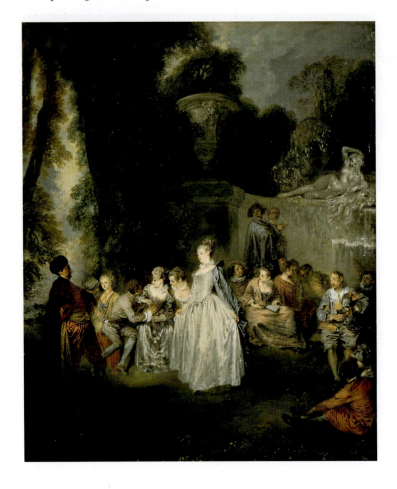

Watteau's Paintings of *Fêtes Galantes*

Rococo ornamentation, such as Neumann used in the Würzburg Residenz, had originated in Paris in the early eighteenth century and soon became the decorative hallmark of elegant Paris salons (drawing rooms). These French salons and boudoirs (a woman's private sitting room) were smaller rooms where aristocrats and intellectuals met to read together, exchange ideas, enjoy music, and flirt. Their smaller scale and delicate decor called for a more intimate type of painting than had previously been commissioned by Church or state. The painter Antoine Watteau (1684–1721) was one of the first to respond to this call with lyrical paintings of music-making, dancing, and courtship, set in dreamlike settings. Known as *fêtes galantes* ("amorous parties"), they were widely imitated and perfectly suited the settings for which they were made.

Watteau's *The Dance* (*Les fêtes vénitiennes*) (fig. 11.10), of about 1717–18, echoes Rubens's robust *Garden of Love* (see fig. 9.29) from the previous century, but Watteau's mood is more whimsical. His hopeful couples flirt in a dreamlike environment that excludes life's harsh realities. Watteau heightened the poetic allure of this enchanted world with his delicate palette of colors and shimmering rendering of silks and satins. The bagpiper on the right is believed to be a portrait of the artist in the role of discerning onlooker. His stare directs the viewer to consider the poignant spectacle of human courtship taking place at the foot of a reclining statue of Venus, goddess of love. That love is sought in this realm of fantasy only heightens the poignancy of its absence in the everyday world. Watteau's painting fits in perfectly with the style and mood of Rococo interiors. It is also an early example of art that does not even try to express morally uplifting themes, but whose emotional and aesthetic satisfactions are enjoyed as ends in themselves.

Artists of the Commonplace and Common Sense: Jean-Baptiste-Siméon-Chardin and William Hogarth

The French artist Jean-Baptiste-Siméon Chardin (1699–1779) and the English artist William Hogarth (1697–1764) offer a striking contrast to the lyrical escapism of Rococo art.

11.10 Antoine Watteau, *The Dance* (*Les fêtes vénitiennes*). c. 1717–18. Oil on canvas, 21½" x 17¾". National Gallery of Scotland, Edinburgh

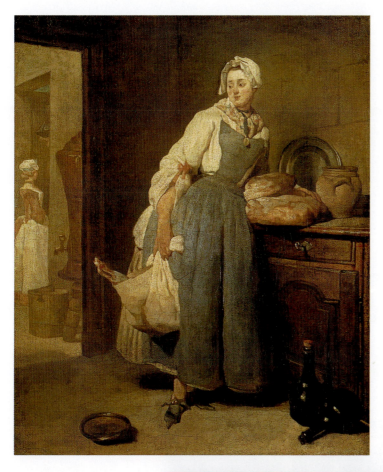

Chardin's paintings, typically depicting scenes or objects from ordinary life, recall the themes of Dutch genre painters such as Vermeer and De Hooch (see fig. 10.12). In such paintings as *Back from the Market*, 1739 (fig. 11.11), he focuses on the everyday environment of ordinary people, often drawing attention to the virtues of diligence, frugality, and domestic order. His modest themes harmonized with his muted, restrained style and quiet color harmonies. Together, themes and style conferred a sense of substance on ordinary objects and ordinary people. Here, his treatment of the bread, bottles, and sideboard—as well as the rosy-cheeked servant—affirm the integrity of the commonplace. Chardin's work contrasts strikingly to the light touch and easy elegance of Rococo art (see figs. 11.10, 11.13, and 11.26), inspiring the Enlightenment thinker and art critic Denis Diderot to praise him for his "excellent common sense" and naturalism.

The enlightened, commonsense outlook is also seen in the work of the English artist William Hogarth. In the tradition of Dutch genre painters such as Jan Steen (see fig. 10.13) and even Lucas van Leyden (see fig. 8.11), Hogarth is known best for his series of satirical paintings exposing human folly. In *Marriage à la*

11.11 Jean-Baptiste-Siméon Chardin, *Back from the Market*. 1739. Oil on canvas. 18½" x 14¾". Musée du Louvre, Paris

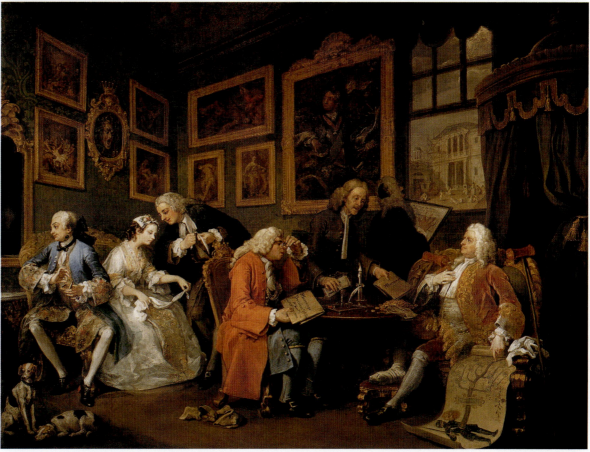

11.12 William Hogarth, *The Marriage Contract*. c. 1745. Oil on canvas, 27½" x 35¾". The National Gallery, London

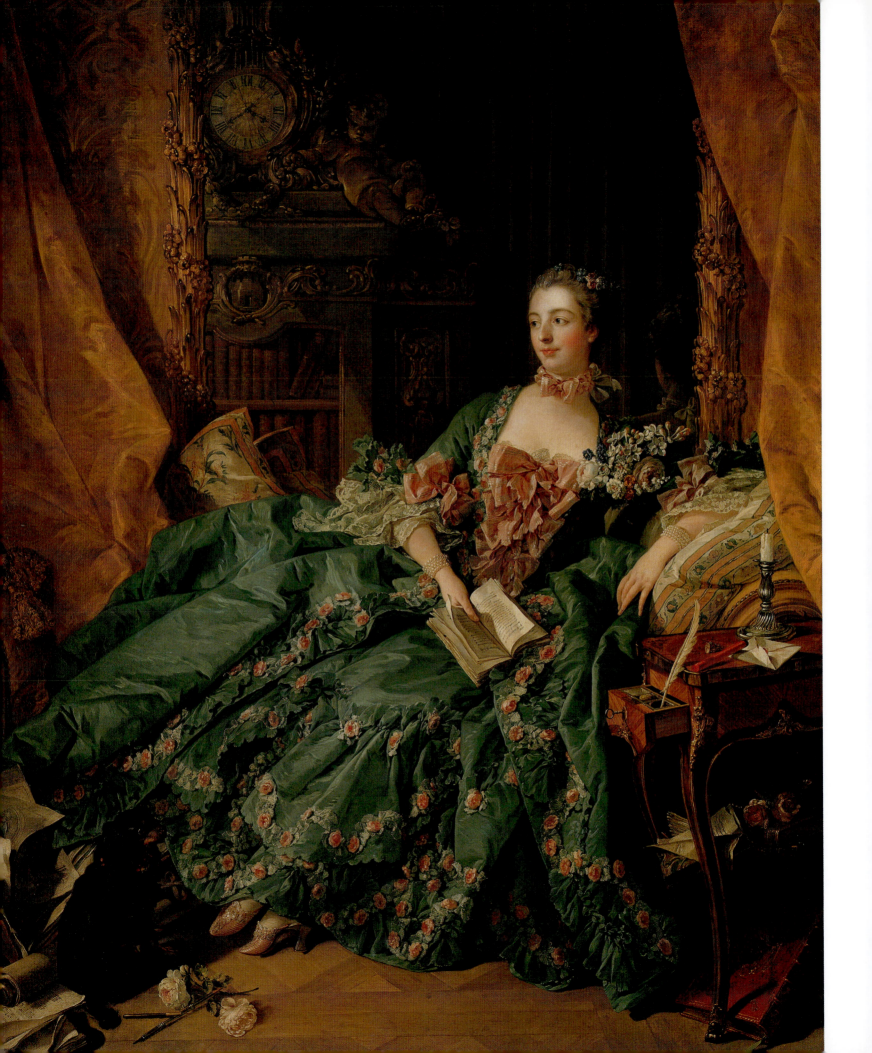

11.13 François Boucher, *Madame de Pompadour*. 1756. Oil on canvas, 79" x 61⁴/₅". Alte Pinakothek, Munich

Mode, of about 1745, Hogarth's social target is the upper classes. In this six-part series, he exposes the destructive consequences of using marriage as a cynical means to obtain wealth or social status. In the first scene, *The Marriage Contract* (fig. 11.12), the groom's father, an impoverished nobleman, points to his family tree, while the bride's father, a newly rich merchant, examines the contract. On the left, the foppish groom ignores his miserable bride-to-be, who leans for solace toward her attractive young lawyer, who has brokered the contract. In subsequent scenes, things move from bad to worse, as the lawyer kills her husband before escaping through the bedroom window. As in Dutch genre paintings, Hogarth uses paintings within the painting, as well as a view through the window, to elaborate on the main theme and drive home his moral. Hogarth's financial success in publishing etchings from this and other series suggests that their topics rang true.

Feminine and Masculine Ideals under the *Ancien Régime*

While Chardin praised simplicity and Hogarth played the scold, the French artist François Boucher (1703–70) painted lighthearted pastoral scenes that conveyed the feminine ideal under the *ancien régime* (old order), before the French Revolution of 1789. In his pastoral and mythological scenes, treated in a frivolous, and often erotic manner, Boucher gave free rein to the gaiety and playful luxury of the Rococo style. This may be seen, in part, as a reaction to the pompous grandeur of Versailles. Rococo reached its zenith in France at the court of Louis XV, under the patronage of his intelligent and resourceful mistress, Madame de Pompadour. Madame de Pompadour was a great patron of the arts, and the primary patron of Boucher. The painter's friends compared his colors to rose petals floating on milk; Diderot, however, lamented Boucher's corrupting moral influence. His art had everything, he commented—facility, variety, fresh lush color, fertile imagination, wit, elegance—everything, that is, except the truth.

11.14 Jean-Baptiste Pigalle, *Monument to Maréchal Maurice de Saxe*. 1753–76. Marble. Church of St. Thomas, Strasbourg

François Boucher's *Madame de Pompadour*

As a portraitist, Boucher offers more substance than in his mythological paintings. In his painting of *Madame de Pompadour* (1756), she reclines gracefully in her boudoir, wearing an elaborate blue dress covered with ribbons and roses (fig. 11.13). Underlining her alert expression, Boucher surrounds her with books, sheets of music, engravings, and writing instruments—the evidence of her literary and artistic interests. Behind her, a mirror reflects a richly carved and well-stocked bookcase topped by an elaborate clock flanked by a carved cupid. This allusion to the theme that love triumphs over time may be a reference to her constant efforts to divert a bored king. Boucher captures the qualities of a woman who was admired by the establishment for her grace and beauty, and respected by the literary world for her intelligence and wit. It is also a fitting visual tribute to the most influential woman at the French court.

Jean-Baptiste Pigalle's *Monument to Maréchal Maurice de Saxe*

Just as the feminine ideal was portrayed in boudoir portraits like that of Madame de Pompadour, the old order's French masculine ideal was embodied in the military hero and celebrated in a number of extravagant tomb monuments. One of the most notable of these commemorates the French military commander, the Maréchal Maurice de Saxe, in the church of St. Thomas, Strasbourg (fig. 11.14). The sculptor was Jean-Baptiste Pigalle (1714–85), who is better known for smaller-scaled works executed for Madame de Pompadour and her circle.

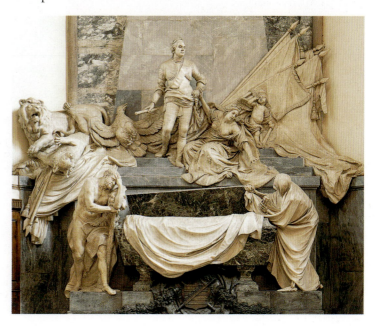

In an age when most sculpture was conceived on an intimate scale to harmonize with Rococo interiors, Pigalle's monument to Marshal Saxe (erected 1753–76) evokes fame and immortality by means of allegory on a grand scale. The marshal stands proudly before a pyramid that suggests his immortality, as the nations who shrunk before him in the War of Austrian Succession (1740–48) are signified by the cowering lion, leopard, and eagle. As he advances fearlessly toward a tomb opened by Death, an allegorical figure of France tries to fend Death off. At one side of the tomb Hercules, representing the French armies, mourns. Above, to the right, backed by lowered military banners, a weeping infant's down-turned torch signifies extinction of the spirit of military genius. Notice that Christian symbols are no longer used to give meaning to life and death. Now, in a period of religious skepticism, the sculptor conveys meaning through secularized symbols, borrowed from antiquity.

Marie Louise Élisabeth Vigée-Lebrun's *Self-Portrait*

Under the *ancien régime*, while artists endowed men such as Marshal Saxe with the symbolic attributes of power, women were typically represented more informally, even when the subject was a member of the nobility or royal family. One of the leading painters of such female portraits was herself a woman, Marie Louise Élisabeth Vigée-Lebrun (1755–1842), shown here in her lively *Self-Portrait* of 1790 (fig. 11.15). In 1779 Vigée-Lebrun was appointed official painter to the French queen Marie Antoinette, and in 1783 was awarded one of the four positions in the French Academy allowed to women. Because of her royalist connections, she fled France in 1789, on the eve of the Revolution, and continued her practice at the aristocratic courts of Italy, Austria, Russia, and elsewhere, only returning to France in 1802, after many fellow artists had petitioned for her right to return. Her female portraits were admired for their freshness and informality, evident even in her treatment of hair. As seen in her *Self-Portrait*, this hairstyle—typically parted at the center of the forehead and arranged in irregular curls—initiated a new, widely adopted fashion for less formal, more natural styles. Effectively, Vigée-Lebrun set out a new model for feminine beauty, perfectly embodied in her own *Self-Portrait*. In this painting she also displays her self-assurance, a quality that ensured her continuing success, even when political events turned against her.

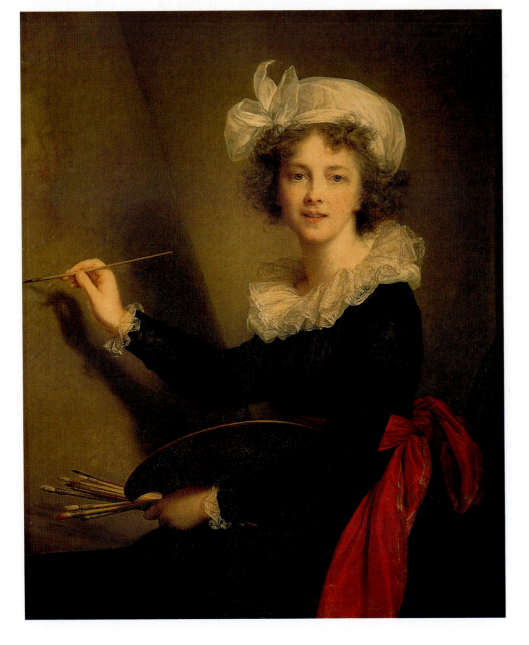

11.15 Marie Louise Élisabeth Vigée-Lebrun, *Self-Portrait*. 1790. Oil on canvas, 8'4" x 6'9". Galleria degli Uffizi, Florence

Neoclassicism: A Model of "Good Taste"

During the eighteenth century, in various parts of Europe, late Baroque and Rococo art and architecture became identified with the political tyranny and excessive luxury of the old social order. The English, who had experienced political reform in the wake of the civil war of 1642–51, largely abandoned the Baroque. Instead, they looked to the Italian Renaissance architect Palladio (see fig. 7.41), whose architectural simplicity and purity suited their need for a style that denoted good sense, political liberty, and a Protestant desire for restraint. But as the English aristocracy flocked to Rome on the "Grand Tour" that was considered an essential part of their education, they and their architects became intoxicated with Palladio's source, the grander architecture of ancient Rome. In classical art and architecture they found enduring principles of good taste and beauty as well as solemn dignity. From then on, in England, Neoclassicism became the hallmark of what the eighteenth-century English aristocracy considered "good taste" and a symbol of political and religious liberty.

Robert Adam's Kedleston Hall

These lofty ideals found their most complete expression in the country houses of the English landowning class, such as at Kedleston Hall, Derbyshire, rebuilt between 1760 and 1770 by the Scottish architect Robert Adam (1782–92) for Nathaniel Curzon, 1st Lord Scarsdale. The entrance front had already been built before Adam was involved, but his Neoclassical taste shaped the south, garden front (fig. 11.16) and the interior. While both the exterior and interior of Kedleston may strike the modern viewer as ornate and self-aggrandizing—which they are—to the architect and patron the style was intended to project cultivated civility and good taste, informed by the best classical sources.

The central axial core of the building is comprised of a long, columned entrance hall leading to a saloon, a large reception room for entertaining, in the form of a domed rotunda, which on the south front is seen as a combination of elements from two of Rome's most famous monuments, the Arch of Constantine (see fig. 4.30) and the Pantheon (see fig. 4.3). The Marble Hall and Saloon (fig. 11.17) were conceived in terms of the *atrium* (inner courtyard) and *vestibulum* (sanctuary of the gods) of a Roman villa, with state rooms on either side

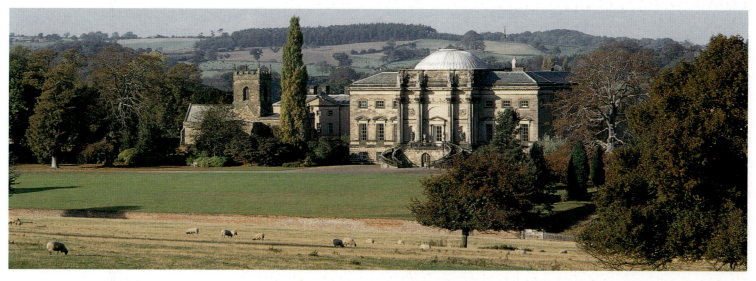

11.16 Robert Adam, the south front of Kedleston Hall, Derbyshire. 1760–70

11.17 Robert Adam, cross-section design of the Marble Hall and Saloon of Kedleston Hall. 1760. Sir John Soane's Museum, London

❖ THE ARTIST as Academician ❖

During the seventeenth and eighteenth centuries, the transformation of artists' social and professional status that began in the Renaissance was completed, as the medieval guild system (see Chapter 6, "The Artist: The Transition from Artisan to Artist," page 380) gave way to government-supported academies of art. Some Baroque artists were knighted by kings for their service to the state, but with the state's support came the academy's regulations. The academy dictated the content of the artist's education, putting the study and emulation of classical and Renaissance art at its core. To succeed, an artist had to conform to the academy's standard, since it controlled major public commissions. So, while the guilds fell away, restrictions on artists remained, and a new kind of conformity replaced the regulations of the old guild system.

Students in the academies of Europe and, later, in North America, were taught to represent the human figure by using a quasi-scientific system of rules and procedures based on classical and Renaissance models. Architecture was similarly constrained. By these means, artists were expected to discover the timeless, underlying principles of beauty in nature much as an Enlightenment scientist or philosopher sought to uncover fundamental principles in nature, or "natural laws" for human affairs. When applied to subjects that promoted the ideals of Stoic virtue, also derived from the classical tradition, the content and form of such art reflected the spirit of the Enlightenment rather than that of the privileged old social order. Despite subsequent challenges, the academic association of artists survives today in the integration of artists within the intellectual life of modern universities where, however, the emphasis is on experimentation rather than conformity.

(compare fig. 4.8). The Marble Hall is lined by giant alabaster columns that recall the opulence of Imperial Rome. It is enriched by statues of pagan gods and heroes in wall niches, as well as other features, all inspired by classical art. This classical theme is continued in the domed Saloon beyond, which was inspired by the Pantheon and includes paintings of Roman ruins to heighten the theme of association with the ancient world.

Finally, to give Kedleston Hall a more "natural" setting, Adam and his patron remodeled the formal gardens of a previous generation—now associated with Versailles and absolutism—and displaced an entire village and its inhabitants to create an unbroken expanse of lawn, water, and tree-studded parkland. However full of irony, given the opulence of the architectural decor and the displacement of people, both the building and its setting were intended to show off Lord Scarsdale as a model of good taste, who valued political liberty and classical virtue.

Sir Joshua Reynolds and Neoclassical Ideals
The Enlightenment frame of mind and the ideals associated with Neoclassicism became more firmly established in British artistic life when, in 1768, the painter Sir Joshua Reynolds (1723–92) became the founding president of the Royal Academy of Arts. He modeled the Academy's teaching on the theory and curriculum of the already well-established French Academy, and thereby promoted within the English-speaking world principles of art and Neoclassical ideals similar to those celebrated at Kedleston Hall (see "The Artist as Academician," above). Reynolds's own work was largely confined to portraiture, but even within such limits, he presented his sitters in an idealized, classical form, as in his portrait of *Lady Sarah Bunbury Sacrificing to the Graces*, 1765 (fig. 11.18). In such portraits of society women, Reynolds generalized their features rather than individualizing them. Indeed, his subjects often resemble an ideal, mythological figure. Reynolds even posed them like ancient statues, sometimes against a background of classical architecture. In this case, he posed Lady Bunbury as a Roman priestess burning incense on a Roman tripod altar before a marble sculptural group of the Three Graces.

11.18 Joshua Reynolds, *Lady Sarah Bunbury Sacrificing to the Graces.* 1765. Oil on canvas, 7'10" x 5'. The Art Institute of Chicago

By such means, Reynolds sought to elevate portraiture to the ideal level of history painting, which was seen as the highest form of art. By rising above mere "face painting," Reynolds claimed intellectual dignity for the artist and offered the viewer an exemplary model of human conduct, conceived in Neoclassical terms.

J.H.W. Tischbein's *Goethe in the Roman Campagna*

The allure of the ancient world for the eighteenth-century German intellectual is artfully inscribed in Johann Heinrich Wilhelm Tischbein's (1751–1829) portrait of *Goethe in the Roman Campagna* (fig.

11.21 Jacques-Louis David, *Oath of the Horatii*. 1784–5. Oil on canvas, 14' x 11'. Musée du Louvre, Paris

sounded the death knoll of the world of Rococo art. He challenged the decadence of the *ancien régime* and presented the public with an image of human responsibility that indirectly found its political expression in the bloodbath of the French Revolution. As the events of the Revolution unfolded, David's Stoic vision of rugged resolve proved terrifyingly pertinent.

Jean-Antoine Houdon: Naturalism and Virtue

The French sculptor Jean-Antoine Houdon found a different means for expressing Diderot's ideal of art promoting moral virtue. Whereas strict academicians like Reynolds and David pursued an idealized beauty,

Houdon attempted to be true to nature in his work.

As a student of the French Academy in Rome, Houdon had studied ancient and Baroque sculpture as expected, but he had also learned anatomy by studying corpses in a hospital. This led him to develop a more scientific approach to representing individual character, an approach he exercised in his vivid head-and-shoulder busts of French Enlightenment philosophers such as Diderot, Voltaire (see fig. 11.2), and Rousseau, all of whom praised the artistic integrity of his naturalism. When Houdon was invited to North America to make commemorative sculptures of the leaders of the newly independent nation, his pursuit of truth to nature carried over even into his most official public monuments, such as the life-size, full-length marble of *George Washington*, carved in 1785–96 for the State Capitol in Richmond, Virginia (fig. 11.22). In sculpting this

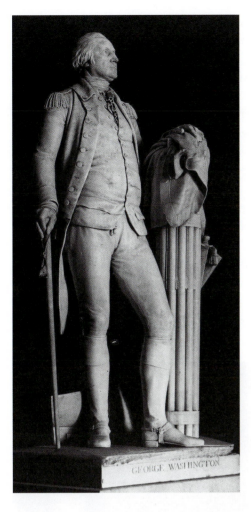

11.22 Jean-Antoine Houdon, *George Washington*. 1785–96. Marble, height 6'2". State Capitol, Richmond, Virginia

monument, Houdon resisted the temptation to follow academic convention by dressing Washington in a Roman toga, as was originally planned, to give him the status and dignity of a Roman senator. Instead, Washington appears in modern dress. There are, however, two subtler Neoclassical features in this sculpture: Washington is shown resting his left hand on a bundle of thirteen rods or "fasces," which are an ancient Roman symbol of authority now used to represent the original states of the union. Also, with his sword slung from the fasces, and a plowshare at his feet, Washington is presented as the citizen-soldier, on the model of the Roman general Cincinnatus, who after securing his country's future is able to beat his sword into a plowshare, and return to the land for which he has fought—as Washington himself wanted to do.

Although Houdon's monument to George Washington commemorates a great military leader, the way Houdon presents him as a virtuous citizen-soldier is a far cry from Pigalle's monument to Marshal Saxe (see fig. 11.14). In place of the old social order's ideal of military glory as an end in itself, Houdon's Washington

monument proclaims the Enlightenment ideal, placing love of liberty and country before all else, as modeled on the Stoic virtue of self-denying public service.

Thomas Jefferson's Monticello, Charlottesville, Virginia

The American statesman and amateur architect Thomas Jefferson had long admired Palladian architecture (see fig. 7.41) and, as minister to France (1784–89), he had studied French Neoclassicism and its ancient Roman prototypes. Like others of his time, Jefferson associated Neoclassicism with democratic civic virtues, order, and rationality, and promoted it as the preferred style for the new republic. He began with his own home, Monticello (built 1770–84 and modified 1796–1806).

On returning to America, Jefferson rebuilt Monticello according to Neoclassical principles (fig. 11.23). With its octagonal core, symmetrical wings, and temple portico, Monticello combines Palladian and Neoclassical elements, interpreted in brick and wood rather than stone. In materials, scale, and choice of plain Roman Doric rather than lavish Corinthian columns, its modesty contrasts strongly to the opulent version of Neoclassicism at Kedleston Hall in England (see fig. 11.16). Through Monticello, Jefferson intended to present himself as dutiful citizen in the Roman Republican mold, rather than hereditary aristocrat, in the British sense.

Science, Industry, and Progress

Artists such as Reynolds, Kauffmann, and J.-L. David expressed Enlightenment values abstractly on an ideal plane, as did Neoclassical architects. In contrast, the

11.23 Thomas Jefferson, Monticello, Virginia. 1770–84, modified 1796–1806

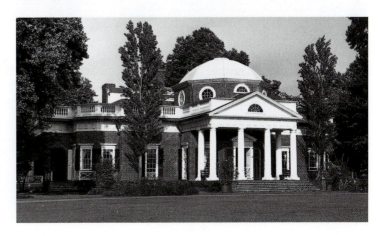

English artist Joseph Wright (1734–97) expressed the scientific side of the Enlightenment quite literally. Practicing his art in the Midlands town of Derby, in an area where the Industrial Revolution was taking hold, Wright moved in the circles of those such as Richard Arkwright and Josiah Wedgwood, who pioneered the alliance of science and industry that launched the Industrial Revolution. In a number of paintings Wright attempted to capture the spirit of enquiry that inspired his friends. One of the best-known is *Experiment with the Air Pump* of about 1768.

Joseph Wright of Derby's *Experiment with the Air Pump*

In this painting, Wright depicts a group of people representative of his circle gathering to watch a scientific experiment in which air will be sucked out of a glass globe containing a dove (fig. 11.24). The dove,

emblematic of innocence and purity, is sacrificed to scientific progress. While two young girls express grief at the bird's inevitable death, they are reassured by an adult that the experiment is worthwhile for the sake of science. Indeed, the image of the presiding scientist has great intensity: Light shines from below, dramatically emphasizing his gaze and furrowed brow. For Wright's scientist there is no doubt that nature is there to be measured and mastered, at any cost. Yet on the extreme right another adult, head lowered pensively, appears to ponder the implications of such an experiment. The distress of the two young girls, and the adult's reassurance of the value of scientific enquiry, poignantly reflect the growing tension of the age between reason and feeling, between the mind and the heart. Wright's precision

11.24 Joseph Wright of Derby, *Experiment with the Air Pump.* c. 1768. Canvas, 6' x 8'. The National Gallery, London

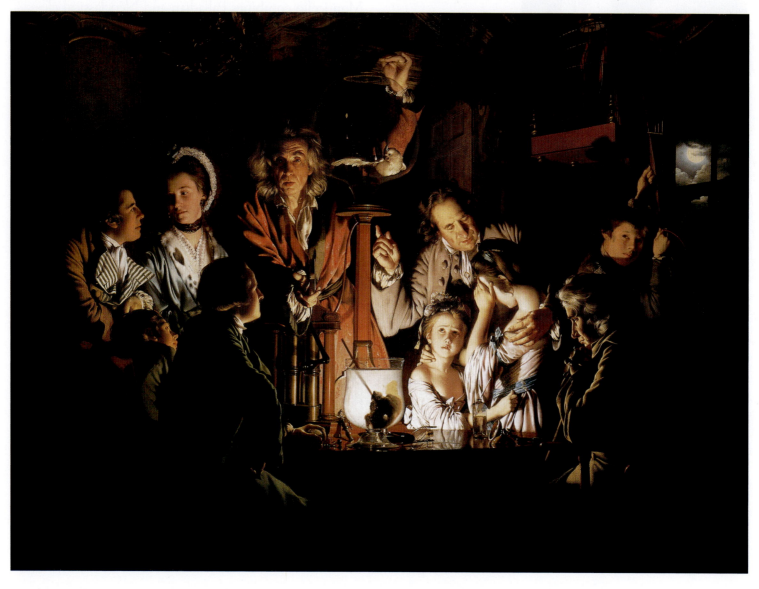

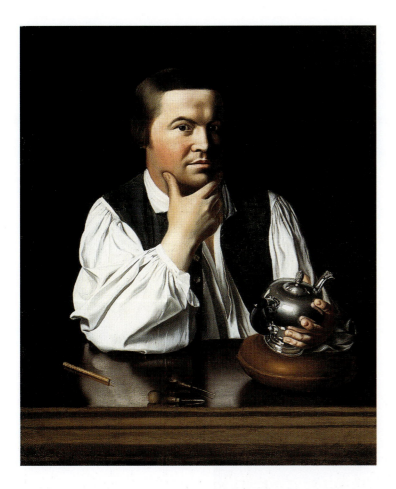

in observing the manner in which the artificial light source strikes each of the protagonists shows that he was as keenly observant as the scientist he portrays.

John Singleton Copley's *Portrait of Paul Revere*

In a more modest, plain-spoken style the Boston painter John Singleton Copley (1738–1815) honored Paul Revere, who had not yet become the popular hero of the American Revolution, as a master of his profession as a Boston silversmith and engraver.

In his *Portrait of Paul Revere* of about 1768–70 (fig. 11.25), the artist presented his subject with a no-nonsense directness: Without a wig, dressed in his shirtsleeves, Revere appears with his tools on the table before him and a product of his craft, a gleaming teapot, in his left hand. Copley describes Revere's shirtsleeves and face with the same matter-of-factness as the teapot in his hand. In this early work, the artist also captured something of the middle-class admiration for hard work and plain manners that characterized American Colonial society at that time. While this work is far less sophisticated than Houdon's sculpture of Washington, Copley shared with Houdon, as with Wright, high esteem for truth to nature of a plainer

tone. In this sense, form and content are once again in harmony here, paying tribute to an ethic of simplicity and hard work.

In viewing Copley's guileless portrait of Paul Revere, we sense a great distance—ideological and artistic, as well as geographic—from the world of Tiepolo's historical fantasy painted for the prince-bishops of Würzburg (see fig. 11.9). Their differences also attest the eighteenth century's vast contrasts and revolutionary transformation: Some artists had celebrated the privileges of the *ancien régime* in a Rococo style; others had turned to antiquity for models of reform; and yet others abandoned tradition in the name of science and progress.

NATURE

In many ways, images of landscape in eighteenth-century art parallel the diverse concerns expressed by artists who represented "the self." Thus, some artists created a Rococo landscape of privileged pleasure addressed to the aristocracy of the old social order. Others sought greater substance, looking either to the authority of the classical tradition or to that of nature, as exemplified by the Dutch landscape tradition (see Chapter 10). The Enlightenment admiration for naturalness also had far-reaching consequences for landscape gardening.

The Landscape of Pleasure: Fragonard

Much as Reynolds had emphasized the ideal over the real in academic portraiture, many eighteenth-century European landscape painters sought to depict nature free from irregularities and imperfections. Academicians scorned the Dutch artists, whose canvases had reflected nature's realities. Instead, they favored an idealized image of nature, based on classical principles of beauty and ideal form. The landscapes of Nicolas Poussin and Claude Lorraine, painted in the previous century (see figs. 9.33, 9.34), were held up as models to follow. In 1770, the Swiss poet-painter Salomon Gessner (1730–88) described the qualities of Poussin and Claude which his contemporaries were to emulate:

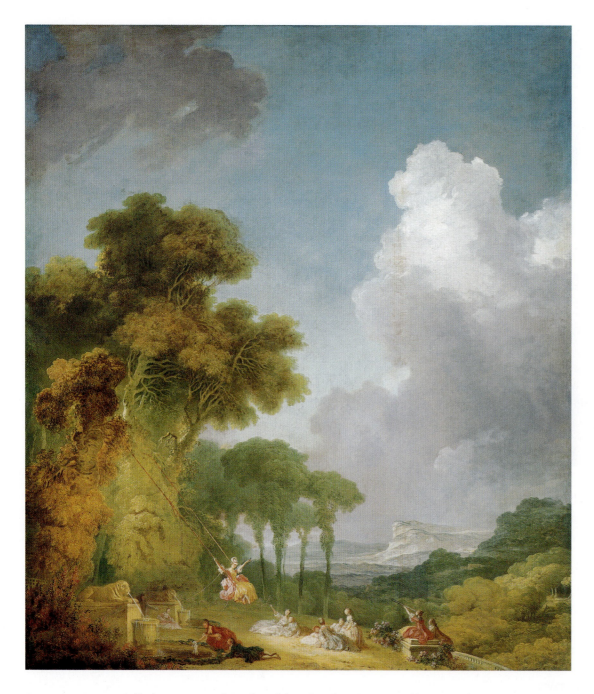

Poussin "unites all that is grand and noble;" his landscapes "transport us into ... countries where nature is not wild ... and where, in a benign climate, every plant attains its healthiest perfection." Claude, he wrote, creates a world where "grace and contentment prevail ... a happy land in which men live in abundance."

A more original, Rococo interpretation of the theme of creating "a world where grace and contentment prevail" is seen in the dreamy landscapes of Boucher and those of his virtuoso pupil Jean-Honoré Fragonard (1732–1806). In the late 1760s, Fragonard painted *The Swing* in delicate, pastel tones to harmonize with the Rococo interiors for which such paintings were destined

(fig. 11.26). In this and related paintings, Fragonard placed contemporary figures in park-like settings, as Watteau had done (see fig. 11.20). The original viewers could identify with these figures, secure in the bosom of a benign, untroubled world (just two decades before the French Revolution), who had nothing to do but amuse themselves with harmless games. The artist used enough realism to render this dream-world believable, but brushed it in with a lightness of touch, a softness of form, and a delicacy of tonality that lend a reassuring tenderness to the whole. Seen as if through a veil, only the gentlest of sensations reach the viewer's eye.

In 1789, the French Revolution cut down Fragonard's playful world of careless recreation, and with it his patrons, leaving Fragonard himself in abject poverty. But the technical virtuosity of his fluid handling of paint has remained much admired, outliving the vision it sustained.

The Illusion of Naturalness: Gainsborough

The English artist Gainsborough reflected in the tensions of his life and work the conflicting sensibilities of the eighteenth century with respect to nature and landscape painting. By inclination, Gainsborough was attracted to the Dutch school, particularly to the freshness and naturalism in the paintings of artists like Jacob van Ruisdael (see fig. 10.17). However, since Dutch landscapes were looked down on by the Royal Academy, if Gainsborough were to earn an income from his paintings, he would have to look elsewhere for inspiration. He found it in the ready market for elegant, Rococo-style portraits, and in what were termed "fancy" pictures—whimsical rustic scenes of the rural peasantry, rendered with the kind of dreamy unreality and fluid brushwork with which Fragonard had depicted a world of upper-class privilege.

In retrospect, though, many would consider that Gainsborough showed greatest integrity when he followed his natural inclinations, as he did especially in his youth. At that time, as a provincial portrait painter in his native Suffolk, he liked to include characteristics of the local landscape, rendered with a fresh naturalness. Thus, in his vivid portrait of a newly-wed local country squire and his wife, *Mr. and Mrs. Andrews* (fig. 11.27), painted about 1749, he placed the couple to one side under a tree in their own park, with their farmland extending beside them, and the spire of the village church just visible beyond a clump of trees. In such a work, Gainsborough's vision owes much to the Dutch school, nothing to the classical tradition, nor to Rococo flights of fancy. Its fresh naturalism captures the values of the English gentry: Their love for country sports, their hunting dogs, and the local landscape (compare figs. 9.20, 9.25).

11.27 Thomas Gainsborough, *Mr. and Mrs. Andrews*. c. 1749. Oil on canvas, 27$^{1}/_{2}$" x 47". The National Gallery, London

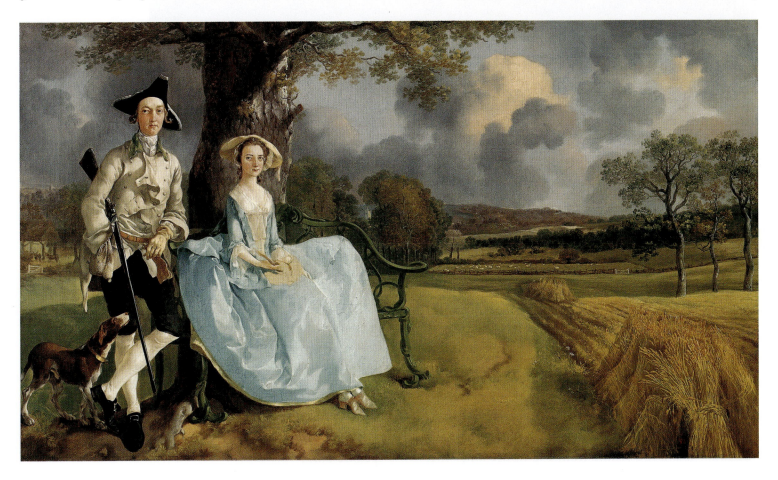

buildings, which in reality would be blurred by haze, are distinctly defined and in sharp focus. His paintings offer an extraordinary wealth of information, recorded with the scrupulous care of an Enlightenment scientist. As in all of his paintings, the scene we see here is bathed in a bright, clear, warm light. This created a cheerful atmosphere for his intended public, but it also lent credibility to the wealth of architectural detail he provided.

In creating an ideal pictorial souvenir for tourists, Canaletto also reflected Enlightenment beliefs in the application of ordered, human reason to uncontrolled nature. Venice itself—an improbable city seemingly floating on the sea and brimming with human activity—perfectly expressed the bending of nature to human will.

11.30 Christopher Wren, Royal Naval Hospital, Greenwich, facing the River Thames. Completed 1705

Urban Design: London

Seventeenth-century London was hardly a modern city. Medieval churches and cathedrals were surrounded by a dense "rabbit-warren" of essentially medieval buildings of half-timbered wood-and-plaster construction, as well as red-brick buildings in the Dutch style with pointed gables and mullioned windows. The classical ideals introduced in Renaissance Italy, and later in France, had scarcely penetrated the city, except in isolated instances. Then, in 1666, much of the City of London was destroyed by fire, creating an unprecedented opportunity for modernization.

Responding to this opportunity, Sir Christopher Wren produced for King Charles II a plan designed to link some of the key monuments of London's spiritual and economic life, much as the popes had done in Rome. Recalling the long, straight streets radiating from the Piazza del Popolo (see fig. 9.35), he combined this "bird's foot" plan with the star-shaped radiating avenues of Le Nôtre's Gardens at Versailles (see fig. 9.23). Each of those models displays a characteristically Baroque spatial sensibility: Long, straight vistas extend through space, ending, in a visual climax, at a significant public monument. Through such perspectives disparate elements of a city became part of a unified scheme. At the same time, such plans created a visual hierarchy, relating subordinate parts to the dominant climax, typically a church or a palace. But in seventeenth-century Britain, which had limited the absolute power of the monarchy, private property rights prevailed over royal prerogative, and Wren's plan was not realized. He did find more limited

opportunities, however, to introduce the grandeur of Continental Baroque to England's public spaces, first at St. Paul's Cathedral, London, (see fig. 11.5) and later on royal land at Greenwich, the gateway to London for river-borne traffic (see fig. 11.30). As for the rebuilding of the city of London, it went forward piecemeal, without the benefit of a master plan to coordinate its separate parts into a coherent whole.

Christopher Wren's Royal Naval Hospital, Greenwich

Wren's Royal Naval Hospital at Greenwich, completed in 1705, marks England's rise as a world maritime power (fig. 11.30). Its grand scale, twin domes, and colonnades, organized with rational symmetry around a central axis, were inspired by Continental Baroque spatial sensibility. Obliged to keep open a vista of the earlier Queen's House beyond, Wren had to forego plans for a monumental Baroque, centralized domed structure. Instead he created a twin feature by narrowing the courtyard between the second range of buildings and enriching their short ends (facing the river) with colonnades below and prominent domed towers above. He repeated the twin motif in the doubled porticos of the waterfront blocks, creating a dramatic stepped-back ensemble as seen from the river. The Queen's House served as the point of visual convergence in the background. All this was a striking departure from existing English architecture and spatial sensibility. With this architectural ensemble Wren transformed the idiom of British vernacular architecture and gave London a grand river entrance equal to its rising place in international politics.

Urban Design: Paris

A distinguishing feature of seventeenth-century Paris had been its enclosed royal squares, typically centered on an equestrian statue of the monarch and surrounded by elegant private houses. These were built to uniform design, consistent with the classical ideal of achieving unity through regular, balanced symmetry. As a result, the most beautiful spaces in the city were associated with the authority of the monarchy—a pattern that was imitated throughout the major cities of the French provinces, continuing into the eighteenth century.

In the eighteenth century though, an age when the French Academy defined beauty in terms of classical principles, it was logical to apply those principles to public

Indian culture was anything but monolithic, with Hindu, Buddhist, and Islamic elements reflecting the long history and the outside influences to which the land had been subjected (for the ancient Buddhist and Hindu art of India, see Chapters 3 and 5). From around 1000 CE, Hindu architecture and sculpture declined under the effects of a series of Muslim conquests, which saw the development of an Indo-Islamic culture that reached its apogee under the Mogul emperors. This art-loving dynasty brought the taste of Islamic rulers for monumental mausoleums to the height of refinement, as can be seen in the Taj Mahal at Agra in north-central India (fig. 11.34). It was built between about 1632 and 1648 by the fifth Mogul emperor, Shah Jahan, as a tomb for his favorite wife, Mumtaz Mahal, and for himself.

With its central plan, domed cube, and symmetrical secondary elements, flanked by four minarets, the Taj Mahal follows an established design for tombs of Islamic rulers, though here interpreted on a colossal scale. The main features of each side of the cube are derived from mosques: At the center is a large vaulted entrance portal, called an *iwan*; this is encased in a decorative rectangular frame, flanked on either side by superimposed smaller *iwans*; and a dome, rising to a point, crowns the central *iwan*. Four small, domed corner pavilions soften the transition between the vertical lift of the bulbous dome and the horizontal spread of the base, and are themselves echoed in the yet-smaller pavilions that crown the flanking minarets. The Taj Mahal's white marble surface is accented with delicate inlaid colored marble **arabesque**, contributing to the overall effect of lightness.

The Taj Mahal is built near the Yamuna River, and is set amidst formal walled gardens, with four intersecting channels of water alluding to descriptions of the Garden of Paradise in the Koran. The water mirrors the gleaming white building which is silhouetted against the sky, with nothing to interrupt its harmonious forms. It is also raised on a podium, whose white marble reflects more light on to the building, so that it appears to float weightlessly, seeming to echo the desire to pass from death into the Paradise alluded to by the waters around it.

The refinement seen in the detail of the Taj Mahal is also found in Indian manuscript illumination (hand-painted book illustration), to which the Mogul emperors also gave a great boost. One of them, Humayun, spent time in exile in Persia and developed such a love for Persian miniature painting (see fig. 6.49) that on return to Delhi in 1555 he brought two Persian artists with him. Thus began a great Mogul school of Indian miniature painting, which flourished for several centuries. His son Akbar, the next emperor, though himself a Muslim, established a state atelier in which a multitude of artists, mostly Hindu, produced illuminated manuscripts. From there the love of miniature painting spread to lesser feudal courts in India, so that by the time

11.34 Taj Mahal, Agra, India. c. 1632–48

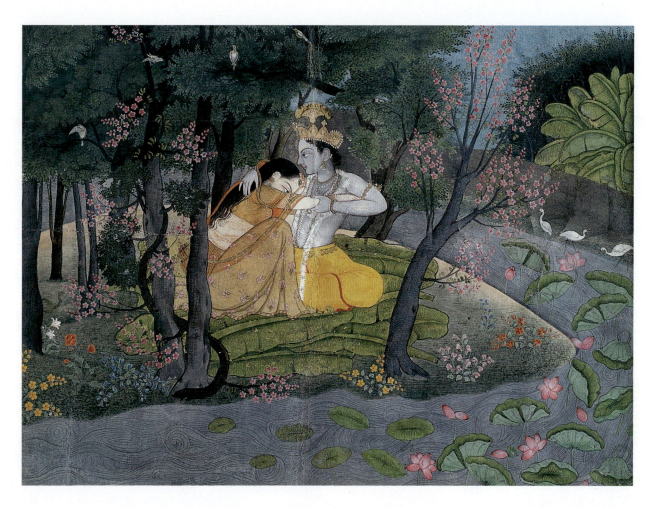

11.35 *Radha and Krishna in the Grove*, Pahari, Kangra. c. 1780. Paint on paper, 5⅛" x 6¾". Victoria and Albert Museum, London

British influence reached inland in the late eighteenth century, there were many local schools. It was at Hindu courts in the Himalayan foothills that the last genuine Hindu art flourished before British dominance took root.

Characteristic of such late Hindu art is a miniature of *Radha and Krishna in the Grove* (fig. 11.35), painted about 1780 in the hill state of Kangra in northern India. The cult of Krishna (the most human and charming of the incarnations of the god Vishnu) is known for the erotic mysticism of its love poetry, the *Gita-Govinda*, in which those who seek Vishnu find the ecstasy of love and liberty. The subject of this miniature, and many like it, is the trysts between Krishna and Radha, his favorite among the shepherd girls who danced with him. Here they meet in a grove amidst lush blossom trees, a carpet of leaves for their bed. Intense pink lotus flowers waft up and down on the surface of the swelling river, alluding to their passions. Likewise the tendril entwined around the tree trunk echoes the couple's embrace, and the landscape's pink and gray-blue tonality harmonizes with the contrasting tones of Krishna, the "Blue God," and his human lover. Every element expresses the passion of physical union between two lovers.

The clash between the sensual world evoked in this Indian miniature and Enlightenment rationalism as expressed by British Neoclassical architecture symbolizes the discord between the two cultures. While this eventually led to the ousting of the British, it was not before the vitality of much Indian art had been drained. The loss of a genuine Indian aesthetic sensibility is poignantly registered in the comment in a late nineteenth-century English journal that "the most advanced [Indian] artists have taken to clothing the gods in European costume with similar surroundings; thus Shiva is shown sitting in a hall lighted by candles in glass shades, and Krishna drives a Phaeton [a European carriage]." Perhaps the deeper irony is that, in Europe itself, greater exposure to other cultures and religions was causing at least some "enlightened" thinkers to question the validity of their own Christianity.

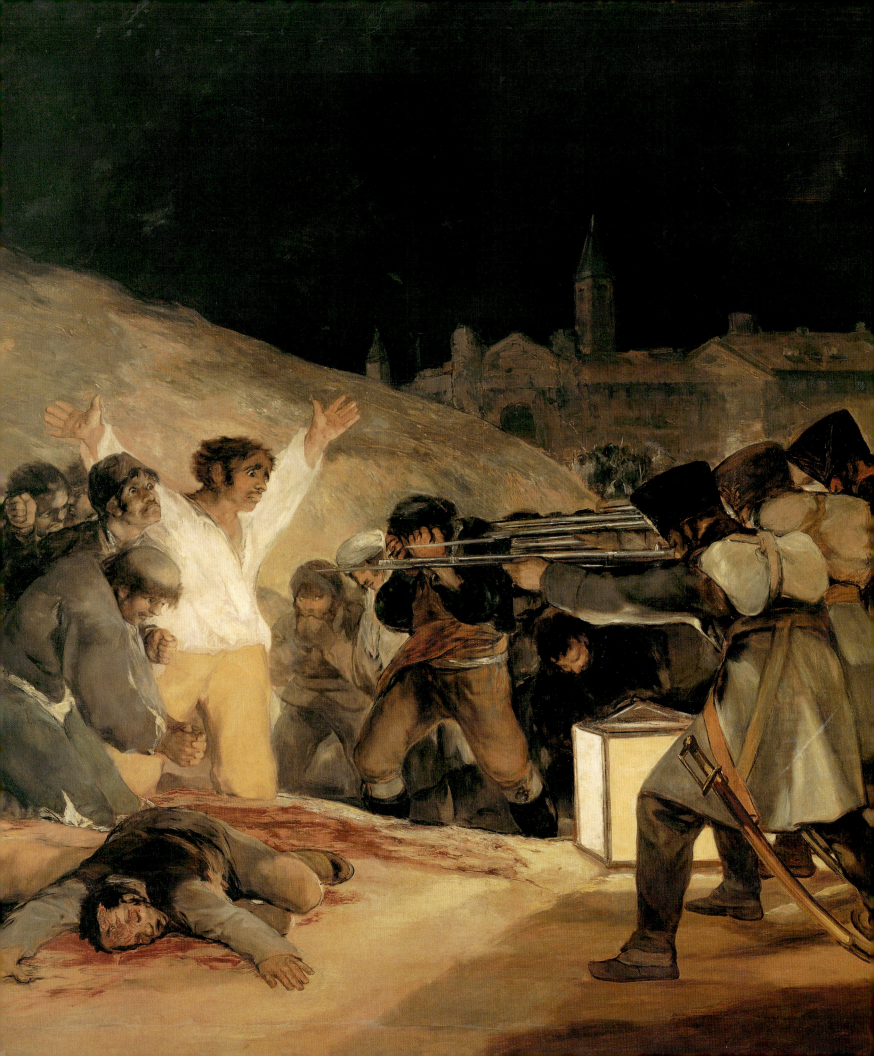

12 Art in the Romantic Age

The Spanish artist, Francisco de Goya y Lucientes (1746–1828) movingly protested the violent tenor of the age of Romanticism (late eighteenth to mid-nineteenth century) in his painting *The Third of May, 1808* of 1814 (fig. 12.1; see also fig. 12.9). Goya graphically contrasts the individual expressions and gestures of horror, fear, and incredulity of the victims to the rigid anonymity of the firing squad. By so doing, Goya powerfully represented the perspective of the individual, rather than authority. It was a perspective shared by many Romantic artists.

❖ THE ARTIST as Visionary Romantic ❖

During the eighteenth and nineteenth centuries, the artistic establishment or academy set the standards for European artists. As government sponsored entities, European states used national academies to centralize and control the arts. The themes, models, and rational techniques for rendering them were regulated by the academy. Academicians studied the formal conventions of art according to preconceived standards, pursuing what they considered timeless beauty and universal truth. In such a climate, tradition prevailed over innovation (see Chapter 11, "The Artist as Academician," p. 354).

Critics of this system argued that it stifled individual vision. Art flows, they argued, from an inner vision and depth of feeling that cannot be taught. The French philosopher Jean-Jacques Rousseau lent support to these ideas, as he encouraged his readers to trust their innate feelings and intuition, as opposed to cultivated thought and reason. In turn, the German philosopher Immanuel Kant, writing in the 1790s, redefined the aesthetic experience. It was not, he argued, a quality inherent in things; instead, the aesthetic response was subjective—a view that others took as support for a subjective view of artistic creativity. Such ideas inspired the Romantics in their opposition to the rules of the academy.

Thus, in time, innovation—rather than the technical mastery promoted by academies—became a defining characteristic of artists, encouraging them to nurture their own vision. As a result, artists functioned less as conservers of established aesthetic values and focused more on using art as a means of personal expression.

As Kant and others defined fine art in terms of innate genius, inspiration, and subjective expression, rather than technical mastery, the artist's personal, unconventional vision would be prized over conformity, and taken as a sign of genius. The modern notion of the artist as rebel derives from this distaste for tradition, encouraging artists to turn against the past and discern the future. From these beginnings arose the identity of modern, **avant-garde** artists (literally, in the vanguard of change). It also gave birth to the concept of the art museum as a modern temple of the arts, at whose shrine a new, secularized form of inspiration could be found.

Europe in Turmoil

Enlightenment ideals dissolved in the carnage of the French Revolution and in its wake, as Napoleon's ambitions spread war across early nineteenth-century Europe. Politically and socially, nothing was the same again. Monarchies, the aristocracy, and the clergy survived, but their power was now sharply diminished. In the nineteenth century, the tensions that had been evident in the eighteenth century between the old social order and the rising middle class resulted in a decisive shift in the balance of power in favor of the middle class. The old union between Church and state was effectively broken.

Economically, as the middle class prospered from the rise in commerce that accompanied the Industrial Revolution, the rural working classes suffered. Displaced from their land and traditions by the new agricultural machinery and farming practices, they were pressed into factories and slum housing. They formed the new class of an uprooted urban proletariat, living in poverty, in greater misery than ever.

Artists were also affected by these enormous social changes. A diminished aristocracy and Church left them with greater creative freedom but less financial security. To earn a living, they needed the attention and support of the monied middle classes. In effect, they eventually had to learn to relate in new ways to a modern market economy, much as Dutch artists had done in the seventeenth century. Nineteenth-century French artists could exhibit in the state-sponsored annual

Salons, which attracted a large public, increasing exposure to their work and stimulating sales. This was the prime outlet for their art. Not only would markets change, but the very concept of what it meant to be an artist would also be profoundly altered (see "The Artist as Visionary Romantic," page 374).

Romanticism: Passion and Escape

Out of this tumultuous time, an artistic movement known as Romanticism arose. Far from its popular association with sentimental love, Romanticism in art, as found from the late eighteenth century to the mid-nineteenth, expresses the heights and depths of human aspirations and fears. It is not so much an artistic style as a state of mind, an attitude toward creativity, and an expression of a range of concerns that accompanied the political and social upheavals of the period. Romanticism marks the collapse of Enlightenment idealism and expresses the mix of passion, violence, cruelty, disillusionment, spiritual yearning, and desire for escape that replaced it.

We cannot define Romanticism in terms of a unified style, because the very notions of creativity adopted by the Romantics encouraged individual vision rather than conformity to any given standard. Romanticism is best understood as a byproduct of a new cultural force. The Romantics' willingness to plumb the depths of human consciousness and to explore the darker side of human passions was the opposite of Neoclassicism, which, in its quest for ideal beauty and noble virtue, sought to avoid all the passions that the Romantics went on to embrace. Where Neoclassicists valued measured order, balanced harmony, and stability, Romantic artists acknowledged spontaneous intuition, dissonance, and instability, responding with passion rather than cool reason. Romanticism marks a shift from reason to feeling, from imitation of tradition to personal expression.

Of course, the preoccupation with the dark side of human nature neither began nor ended with Romanticism. Those who first used the term "Romantic" in relation to their own work were concerned that their art should address the realities of the day, and that they, as artists, would serve as the conscience of their age. The Romantic idea that artistic souls should express their feelings and their inner vision also gave birth to the modern notion of the artist as a suffering and melancholy individual, even inspired and prophetic. The new Romantic outlook was expressed well by the landscape painter Caspar David Friedrich (1774–1840) when he wrote that "the artist's feeling is his law," and that if a painter sees nothing within himself, he should not paint what he sees in front of him. The intensity of the gaze in Friedrich's *Self-Portrait* (fig. 12.2) of about 1810 registers something of this sensibility. Likewise, the works of the Spanish artist Goya reveal the phantoms of his haunted imagination, and the highly individualistic English poet and painter William Blake (1757–1827) exemplifies the inspired, prophetic artist. If Romanticism eludes precise definition, it has certainly nurtured an emphasis on imagination and individual expression as hallmarks of artistic creativity that have endured to the present.

The Themes of Romanticism
Romantic artists, while typically committed to the realities of their day, were attracted to extremes—to the

12.2 Caspar David Friedrich, *Self-Portrait.* c. 1810. Black chalk, 9" x 7¹/₅". Staatliche Museen zu Berlin, Preussischer Kulturbesitz, Kupferstichkabinett

revolutionary melodrama of the age, to the violent and macabre, as well as to the sublime. In their art, they expressed two continuous, intertwined themes—the discord in human experience and the desire for escape. As we explore the larger themes of Spirituality, the Self, Nature, and the City, as well as in the section on Parallel Cultures, we'll see that much of Romantic art took one of two directions: On the one hand, human suffering, violence, and despair; on the other the desire to escape—whether back into an idealized past, forward to a longed-for freedom, deep into an idealized, comforting nature, or far into the exotic and primitive. We will focus on these two intertwined threads—discord and escape—that inspired the creators of nineteenth-century Romantic art and architecture.

SPIRITUALITY

With the decline of Church authority, and commissions for religious art in sharp retreat, artists expressed their spirituality in various forms. Some expressed a profound sense of disillusionment with established beliefs; others expressed yearning to find God in fresh ways, notably in nature; and still others reached back to an idealized past, a world of secure faith symbolized by Gothic cathedrals.

Disillusionment and Protest: Francisco de Goya

In 1799 Francisco de Goya, court painter to the Spanish king, published a series of eighty **aquatint** prints, *Los Caprichos* (*The Caprices*). They marked a watershed in his career and indeed in the history of art. The series is a biting social satire directed against ignorance, folly, superstition, magic, and sorcery. Through it Goya expressed a mocking repugnance for the evils of the day, among them religious fanaticism and bigotry. While addressing a wide array of social ills, the prints reveal a society riddled by spiritual malaise and bereft of any moral compass.

In producing these plates Goya turned his back on the lighthearted, Rococo scenes he had made earlier for the royal court, refusing to ingratiate himself to the

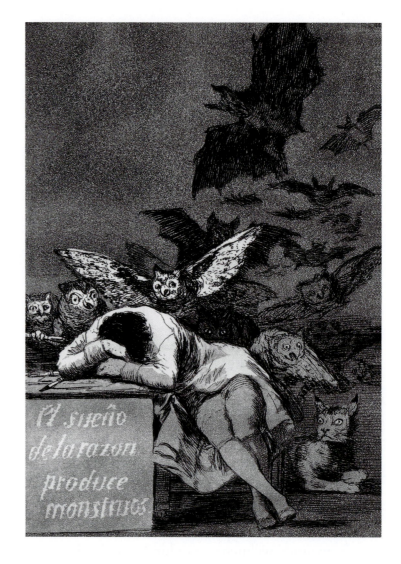

12.3 Francisco de Goya, *The Sleep of Reason Produces Monsters*, plate 43 of *Los Caprichos*. c. 1798. Etching and aquatint, 8½″ x 6″. The Metropolitan Museum of Art, New York

social hierarchy, its art patrons, and the Catholic Church. Instead he manifested a radical commitment to telling the truth as he saw it, however abrasive, bitter, or ugly. He resolved to be true to his own conscience, as a counter-cultural voice, rejecting a universal standard of beauty and replacing it with images derived from his own, personal vision. This radical posture came to define the artistic attitude first associated with Romanticism, which later became a benchmark of Modernism (see "The Artist as Visionary Romantic," page 374).

Goya had originally intended the famous print entitled *The Sleep of Reason Produces Monsters* as the opening plate of this series (fig. 12.3). Although he ultimately gave it less prominence, it was a fitting prelude to the series. It shows the melancholic artist at his drawing

table, head buried in his arms, with a menacing owl, eyes flashing, itself holding the artist's drawing chalk in readiness, to symbolize the artist's source of inspiration. This creature of the night, a symbol of wisdom but also the portent of evil, who symbolizes Satan, the Prince of Darkness, is here accompanied by other creatures of the night–a wild cat, menacing owls, and bats–that descend on the artist like the evil visions that have invaded his mind and fill the pages of *Los Caprichos*.

Goya's inscription, "The Sleep of Reason Produces Monsters," has many implications, among them the artist's sense of the evils rampant in a society in which the light of reason failed to shine. Goya had begun working on these prints after a slow recovery from a severe illness that had left him permanently deaf. It was the turning point in his life. His hearing gone, Goya's inner vision grew more acute. As Spain's ruling élite, reacting to the revolutionary terrors of France, retreated from liberal Enlightenment ideals, Goya's satirical prints proved too threatening. Under pressure from the Catholic Inquisition and the political right, he was forced to suspend sales of *Los Caprichos* and seek personal protection from the king.

But censorship could not repress Goya's compulsion to expose irrationality and religious superstition as reigning evils in Spanish society. Although early in his career he had produced religious paintings for churches on commission, in later years he revealed his personal abhorrence of religious fanaticism and hypocrisy in a number of small, dark oil paintings made for himself or for those who shared his views. Whereas Goya's earlier state and Church commissions were full of brilliant color and light, these later, private works, such as the chilling *"Auto-da-fé" of the Inquisition*, painted around 1815–19, are executed in a sober palette of black and muddy brown (fig. 12.4).

In this particular panel Goya elaborated on one of his themes from *Los Caprichos*: The blind complacency, dark cruelty, and cold injustice with which the religious establishment, through the instrument of the Inquisition, passed judgment on those they deemed to be heretics and who they condemned to be burned at the stake. Goya mustered his powers of satirical caricature to capture the well-fed faces, self-absorption, and cold indifference of the clergy. They sit securely in their musty halls, complacent within the darkness of their deliberations.

In contrast, Goya presents the accused with compassion, as the wretched victims of a sinister system that thrived on persecution of the downtrodden. The similarity of Goya's treatment of such brutal inhumanity in the religious establishment to his scenes of witchcraft implies that he saw the one as being as evil as the other, both feeding off darkness and superstition.

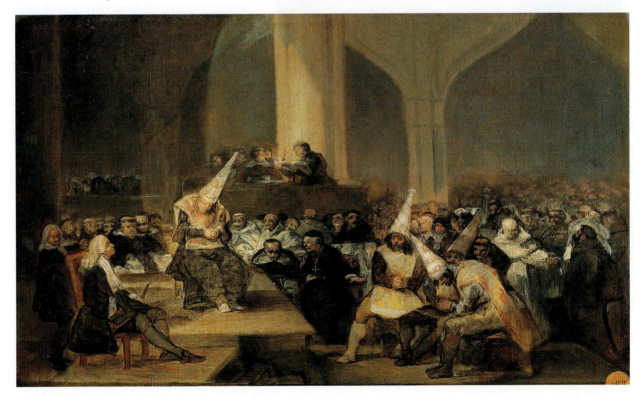

12.4 Francisco de Goya, *"Auto-da-fé" of the Inquisition*. c. 1815–19. Oil on panel, 18¼" x 28¾". Museo de la Real Academia de Bellas Artes de San Fernando, Madrid

Prophecy and Spiritual Renewal: William Blake and Caspar David Friedrich

While Goya so forcefully exposed what he perceived as the utter corruption of established religion, others dreamed of a revitalized spirituality. This would be either born of the imagination or drawn out of the sublimity of nature and mediated by the visionary artist of genius. The English poet and artist William Blake was a prime practitioner of the imaginative approach, while the German landscape painter Caspar David Friedrich sought the mystical within nature. Although the artistic approaches of these two artists were far apart, both were concerned with looking beyond the natural to the supernatural.

When Blake treated biblical themes, he interpreted them in a characteristically Romantic way: in terms of his own highly subjective and potent imagination. Blake did make use of contemporary and historical art forms, but he ultimately claimed that visionary imagination,

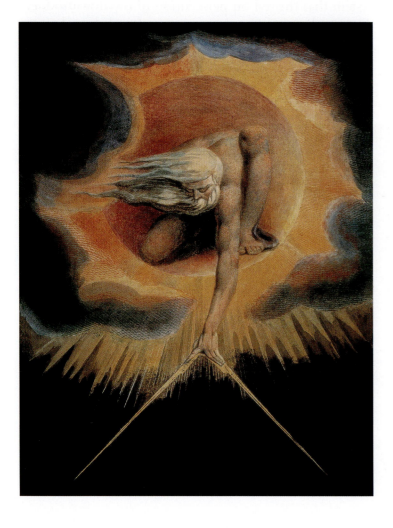

not conformity to tradition, was the source of inspiration with the greatest integrity. He deliberately avoided drawing from nature, trusting rather in his inner vision.

Blake's color print *Ancient of Days*, executed in 1794, exemplifies such artistic strategies (fig. 12.5). His figure recalls those of Michelangelo and his Mannerist successors (see Chapters 7 and 9), but the flat composition and blaze of brilliant color offset by black are peculiar to Blake. Blake saw himself as reviving the art of medieval manuscript illumination, and produced books of his own illustrated poems. His spiritualizing tendencies led him to reject the viscous substance of oil painting for the floating translucency of watercolor. Similarly, he avoided a naturalistic use of color, favoring a form of color symbolism. Thus his use of red and yellow, associated with fire and heat, suggests the spiritual energy of the creator of the universe. Blake visualizes the creator in terms of a divine geometer, with compass stretched across the heavens. Blake associated this image, derived from medieval art, with the seventeenth-century scientist Isaac Newton's concept of a mechanistic universe (a universe whose parts fit together like the workings of a clock). Indeed, Blake had represented Newton in a similar way, compass in hand, to symbolize the dominance of reason over the physical world, though Blake viewed this as a blight on artistic imagination. By contrast, with his image of the *Ancient of Days*, Blake seeks, as a visionary artist, to reveal a transcendent reality that science cannot reach.

While artistic imagination was for Blake a means to evoke a transcendent spirituality, for Friedrich it served to reveal the spiritual dimension within nature. Friedrich was disenchanted with traditional religious art and strongly attracted to tendencies within German Protestant pietism that laid more emphasis on personal religious experience than on traditional Church dogma or liturgy. Like many German artists and writers of his generation, Friedrich looked to nature as a source for religious experience. His art characteristically evokes the supernatural through the natural. His so-called *Tetschen Altar* (*Cross in the Mountains*), painted in 1808, was destined for use as an altarpiece in a private chapel (fig. 12.6). Traditional Christian symbols—such as the Eye of God and the Eucharistic wheat and grape vine—adorn its frame, but the treatment of the crucifixion motif is unprecedented in Christian art.

12.5 William Blake, *Ancient of Days*. 1794. Engraving touched with pen and watercolor, 9" x 6³/4". The British Museum, London

12.6 Caspar David Friedrich, *Tetschen Altar* (*Cross in the Mountains*). 1808. Oil on canvas, 45 1/5" x 43 3/10" (without frame). Gemäldegalerie, Dresden

In the *Tetschen Altar*, Friedrich replaced the historic subject of the Crucifixion as event with a series of "natural" symbols, including a carved hilltop crucifix, which itself denotes the Crucifixion. This crucifix, standing high on a rock, wrapped by ivy and surrounded by evergreen trees, is silhouetted against the last rays of a setting sun. Friedrich represented nothing that couldn't be empirically recorded in the natural order by a modern observer. Yet through these natural elements he intended to reveal spiritual truth, using the traditional Christian symbols of rock, cross, light, ivy, and evergreens. In the Christian tradition, trees were associated with the cycle of human life, the evergreen (which retains its foliage through the dead of winter) with immortality, ivy with fidelity (since it adheres relentlessly to things), rocks with steadfastness, and rays of light with divine presence. The crucifix, as a physical object in the landscape, refers to Christ as mediator between the divine and human.

Friedrich renders each detail with the technical precision of an accomplished landscape painter, yet the result is consistent with own belief that the artist who does not first look inside himself should not paint what he sees outside. In seeking to transform landscape painting by treating nature as a catalyst for religious experience, Friedrich, like other Romantics, sought to escape the confines of a mechanistic universe as conceived by Enlightenment thinkers.

Looking Back: Gothic Revival

While Goya reacted to the instability of Europe after the French Revolution and the Napoleonic Wars with increasingly dark satire and horror, and artists like Blake and Friedrich sought spiritual renewal through nature and imagination, another widespread tendency was toward retrospection, that is, looking back to an earlier time.

In England as well as in Germany, many cultural leaders looked back with nostalgia to medieval Christendom as an era of political stability, religious certitude, social cohesion, and national well-being. Gothic revivalists deplored the dehumanizing effects of modern industrialization and the mediocre craftsmanship that resulted. They admired anew the richly wrought, hand-crafted objects of medieval culture, epitomized by Gothic cathedrals. For them this style represented honest workmanship and aesthetic integrity, as well as symbolizing a form of religious certitude and political stability that was missing in their own time.

As a result, in the 1830s the British architect and theorist A.W.N. Pugin (1812-52) began to advocate Gothic architecture as a distinctly Christian form. In contrast to what he perceived as the cold intellectualism of Neoclassicism, he believed that Gothic architecture was more emotive and spiritual, due to its rich detailing, surface texture, varied articulation of volumes and towers, and the silhouette these created against the sky. Pugin's ideas were taken up by others, including the English writer and artist John Ruskin (1819-1900), through whom they had wide circulation in England, America, and throughout the British Empire. This yearning for an idealized Christian past stimulated a revival in Gothic architecture—particularly for churches, colleges, and universities.

A sumptuous early example of Gothic Revival architecture is All Saints' Church, Margaret Street, London, built 1849-59 by William Butterfield (1814-1900) (fig. 12.7). The building is striking, both on its exterior and interior, because of its Pugin-inspired interpretation of Gothic forms in terms of an extremely rich use of patterned brickwork and other decorative detail, evoking the idealized world of medieval craftsmen. Thus, the entire surface of the red-brick exterior is enriched with various patterns and horizontal bands of black brick, and the interior is a riot of geometric patterns spread across the floor and walls in a variety of richly colored materials. Every surface and support is densely worked, creating an overall effect of abundance that expresses the ideal of revived medieval craftsmanship. For Butterfield and his contemporaries this surfeit of ornamentation may have embodied Pugin's idealized vision of medieval Christendom; yet, ironically, because of the time in which it was built, the modern viewer tends to associate it with the material prosperity of Victorian England.

THE SELF

Neoclassical artists had championed ideals of beauty, good taste, and Stoic virtue, but the Romantics plunged headlong into the passions of the age. Their work reveals a pervasive sense of oppression—whether political, social, or spiritual—and a yearning for liberty. Such concerns were expressed in images of violence, misery, and despair; hopes for deliverance; and, for some, the relief found in feminine grace and beauty.

Napoleon: A Secular Hero

Romantic themes of conflict and deliverance centered on the French military leader and later Emperor Napoleon Bonaparte, who emerged as the single most charismatic figure of his age. He was also a man who understood the propagandistic power of art to transform the ugly reality of warfare into heroic myths of glorious conquest or noble gestures of charity. Napoleon found creative propagandists in the leading French painters of the day, Jacques-Louis David (1748-1825) and his most talented pupil, Antoine-Jean Gros (1771-1835), both of whom succumbed to the aura of the victorious general.

After Napoleon's Near Eastern campaign of 1799, for example, Gros submitted the painting *Napoleon in the Plague House at Jaffa* to the Paris Salon of 1804 (fig. 12.8). This work put a positive, mythical spin on a sordid incident: After bubonic plague had broken out among both Arab prisoners and French soldiers, Napoleon had ordered the prisoners poisoned. Napoleon had then entered the plague house and mixed fearlessly with the soldiers in an attempt to assuage the fears of his troops.

Raising this event to mythic proportions in his painting, Gros presents Napoleon as Christ-like, illuminated amid the surrounding darkness, as a secular redeemer who reaches out to touch (and perhaps heal) the sick. To stimulate the imagination of the viewer in Paris, Gros set the scene within the exotic architectural features of a Middle Eastern mosque, a gloomy sky providing further atmosphere.

With a mastery of human anatomy learned from his teacher David, the rich colors of Rubens, and the dramatic lighting of a Rembrandt or Caravaggio, Gros creates a scene of wretched suffering. In the filtered light under the arcades we gaze at colorless bodies, sick and dying, slumped across the shadowed foreground. Exotic

figures in turbans are seen to the left and right, while the suffering crowd parts in the center to reveal Napoleon, the majestic hero in his plumed hat. He strides confidently toward the plague-stricken as his adjutant cowers behind him, drawing a cloth over his mouth to obstruct the stench and the disease, at which Napoleon doesn't even flinch. Thereby, Gros transformed a gruesome event into an inspiring image of deliverance.

Oppression and Despair

Eighteenth-century artists had typically treated contemporary military heroes as ideal historical figures, which Napoleonic artists made even more acceptable. But the brutal realities of widespread war in Europe and the devastation it caused now provoked counter-images of violence, misery, and despair.

Goya Protests War's Brutality

Goya, in particular, with his devotion to truth, transformed this practice by treating contemporary subjects in memorably un-idealized ways. Thus, in 1814, he painted *The Third of May, 1808*, a powerful protest against the brutality caused by such "heroes" as his Napoleonic contemporaries had celebrated (fig. 12.9; see also fig. 12.1). The intensity of Goya's painting was perhaps fired by the fact that he and his progressive friends had once looked to the ideals of French Enlightenment philosophers as a lamp of liberty for their own country. But such hopes were extinguished by Napoleon's invading armies, who brought with them destruction and misery rather than social reforms.

In *The Third of May, 1808* Goya commemorates the Spanish resistance to the French occupation of Madrid. After rioting occurred between French troops and Spanish civilians, hundreds of civilians—mostly innocent—were rounded up at night and shot. Goya organized his subject so that it has the directness of reportage while also containing a series of ironic allusions to earlier historical subjects. The gesture of the white-shirted victim echoes the frequently painted scene of Christ's sacrifice, with hands outstretched on the cross. But in Goya's scene no cause is served as innocent civilians are shot. The opposition is between light and darkness, and between an anonymous firing squad and individual civilians, whose humanity Goya drew out with the same searching eye and understanding that he brought to his engravings. Goya divided the victims into three groups—those already shot, those

12.8 Antoine-Jean Gros, *Napoleon in the Plague House at Jaffa*. 1804. Oil on canvas, 17'5" x 23'7". Musée du Louvre, Paris

waiting their turn, and wedged helplessly between them, those at the ultimate moment of death. Through their diverse gestures and the looks in their eyes, Goya conveys the dread and pathos of those who can't look, the terror of those who look despite themselves, and the climactic burst of humanity emanating from the

white-shirted man, on whom Goya has concentrated all the color, light, and action of the painting. Goya overturned tradition to mourn the anonymous victim rather than celebrate the famous hero.

In Goya's painting the "lamp of reason" has become the accomplice of destruction, and the church stands in darkness, in the background, under a starless night sky. Goya subverted the ideal moral drama of traditional history painting to present instead the mechanized execution of the innocent by the forces of organized oppression. What dies under the cruel glare of this night lamp is individual human dignity.

12.9 Francisco de Goya, *The Third of May, 1808*. 1814. Oil on canvas, 8'9½" x 11'4½". Museo del Prado, Madrid

12.10 Francisco de Goya, *Why?* (*Por Qué?*), plate 32 of *The Disasters of War*. 1812–15. Etching, 5³⁄₈" x 7½"

Between 1810 and 1820 Goya produced a series of prints known as *The Disasters of War* in which he revealed his despair in response to the atrocities of the Napoleonic Wars. They were not published in his lifetime due to their inflammatory political and moral content. In one plate, entitled *Why?*, Goya depicted a man—presumably a Spanish patriot—tied by a rope to a tree being strangled by three soldiers who pull at his limbs (fig. 12.10). The subjects of many of the plates are even more sadistic, covering themes of mutilation, rape, and carnage.

In this series Goya not only protested the senseless horrors of war, but he also implied that evil is the ultimate human condition, violation and degradation the universal fate, with no deliverance in sight, neither from man nor God. Indeed, he followed a plate captioned "Truth has died" with another that asks, "Will she live again?" Goya himself retreated to his country house, on the walls of which he painted some of the most disturbing images ever to come from the hand of an artist. Painted with great breadth of execution in a sober palette, their nightmarish subjects (such as *Saturn Devouring His Children*) combine the grotesque, the violent, and the macabre. The aesthetic distance between the joyous, colorful Rococo scenes he

painted in his youth for the royal court and these "black paintings" epitomizes the willingness of Romantic artists to address the darkest chasms of human experience.

Théodore Géricault's *The Raft of the "Medusa"*

As Goya was completing his *Disasters of War*, a young French artist, Théodore Géricault (1791–1824), submitted to the Paris Salon of 1819 a painting of monumental dimensions (16 feet by 23 feet 6 inches) on a subject of his own choosing, *The Raft of the "Medusa"* (fig. 12.11). The painting was epic in scale, but its subject was suffering, not glory, and its theme human cruelty and misery.

The painting treats the aftermath of the recent shipwreck of a French government frigate, the "Medusa," off the coast of Africa. The captain and officers had made off in a lifeboat, after callously cutting adrift a makeshift raft they were towing, which carried 149 passengers and crew. Of these only fifteen survived the horrific ordeals of sweltering heat, thirst, starvation, murder, and cannibalism before they were rescued. Preparing for his painting, Géricault interviewed survivors, studied corpses, and made painstaking studies to grasp the nature of the experience and render it with

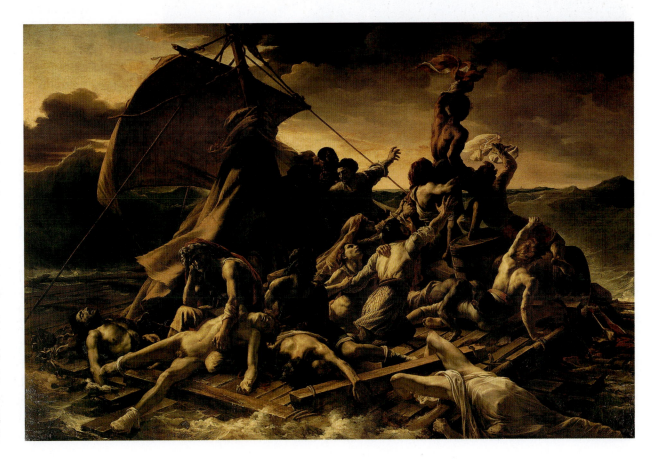

12.11 Théodore Géricault, *The Raft of the "Medusa."* 1818–9. Oil on canvas, 16' x 23'6". Musée du Louvre, Paris

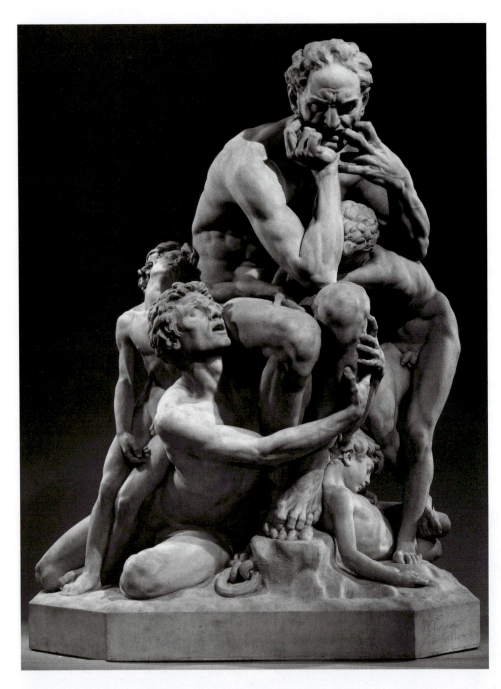

12.12 Jean-Baptiste Carpeaux, *Ugolino and His Sons*. 1865–7. Marble, height 6'5". The Metropolitan Museum of Art, New York

symbolized divine deliverance from life's perils. But Géricault shifted the focus to a darker theme that is conveyed with unprecedented power. It was immediately acknowledged as a rallying point for Romanticism, as David's *Oath of the Horatii* (see fig. 11.21) had been for Neoclassicism. It signified the conviction that the anti-heroic, discordant, and destructively passionate were more compelling and true to life than the noble idealism, harmonious forms, and enduring principles of beauty espoused by the adherents of Neoclassicism.

Jean-Baptiste Carpeaux's *Ugolino and His Sons*

Later in the nineteenth century the anti-heroic theme of human misery and despair, and even the motifs and style of Géricault's *Raft of the "Medusa"* were taken up in a masterpiece of sculpture. Since most sculptors had pursued a hackneyed Neoclassicism for most of the century, Jean-Baptiste Carpeaux's (1827–75) life-size sculpture *Ugolino and His Sons* of 1865–7 is all the more remarkable (fig. 12.12). Its subject is the dreadful story, taken from Dante's *Inferno* (Canto XXXIII, 58–75), of Count Ugolino, interred with his sons in a tower for betraying his city and left to starve. Biting his hands in despair, which his sons took for hunger, they offered him their own flesh.

both art and fidelity. He eventually depicted this desolate event as a pyramid of carefully placed and masterfully drawn figures that rises from a base of the dead and dying, through the desperate to a summit of the hopeful, who wave their clothes aloft as they gaze at the mast of a ship on the distant horizon.

Whatever Géricault's painting may have contributed to public outrage at the naval scandal, its enduring power is as an image of human misery, adrift at the mercy of the raging elements, menaced by heat, storm, and engulfing waves. Shipwreck as a metaphor of human wretchedness is a recurrent Romantic theme, derived from earlier Christian images of seafaring that

In its artistic conception, Carpeaux's complex figure group immediately invited comparisons with the ancient *Laocoön* (see fig. 3.22), as well as Michelangelo's sculptures. But it also recalls Géricault's figure in the *"Medusa"* of a pensive man, head on his hand, holding the body of a dead youth (see fig. 12.11). Carpeaux raised this motif to a heightened level of intensity, and the resulting work is a *tour de force* of sculptural complexity. Male bodies, in five different stages of

maturity, are intertwined into a dense pyramid of twisting limbs, turned heads, expressive hands, bent knees and elbows that climax in the clawing hands and tormented expression of the father. Its Romantic theme of torment and despair has since been revisited by modern artists.

The Struggle for Liberty

When Géricault died from complications following a fall from a horse, aged only thirty-three, his younger friend and admirer Eugène Delacroix (1798–1863) became the torchbearer of French Romanticism. He is known for his large, ambitious history paintings, whose subject matter was inspired by both literature and contemporary events. Delacroix's themes also reflect a Romantic preoccupation with passionate tragedy, commemorating the anti-heroic rather than glory. But in more than one instance he responded to the vital events of his day—notably the "July Revolution" of 1830—to depict the pervasive aspiration for liberty that ran through all the violence of the age.

Eugène Delacroix's *The 28th July: Liberty Leading the People*

This painting, completed in 1830, immediately became the definitive image of the struggle for liberty, and perhaps the most memorable of all revolutionary images (fig. 12.13). Its conception and style pay tribute to several sources, and also make clear the contrast between Romantic and Neoclassical art. Like Géricault, Delacroix recast contemporary events in epic terms. In fact, he paid tribute to his deceased friend's *"Medusa"* in the positions of the two dead bodies on the barricades. In forging his own style, Delacroix turned to the same Baroque sources Gros had used for his *Plague House at Jaffa*—such as Rubens and Rembrandt. These were also Delacroix's sources for pictorial qualities, such as dramatic contrasts of highlights and murky shadows, deep colors, and swirling forms. But Delacroix used them to create a more immediate and melodramatic effect than Gros's more static painting (see fig. 12.8). As a result, Delacroix's Romantic melodrama stands in even greater contrast to the

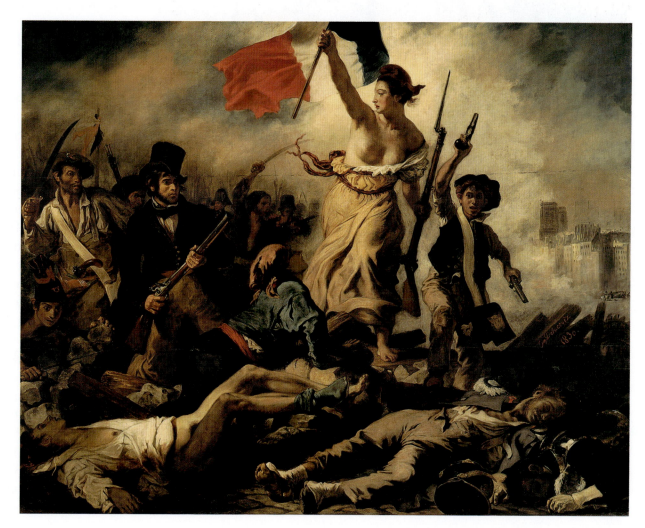

12.13 Eugène Delacroix, *The 28th July: Liberty Leading the People.* 1830. Oil on canvas, 8'6" x 10'7". Musée du Louvre, Paris

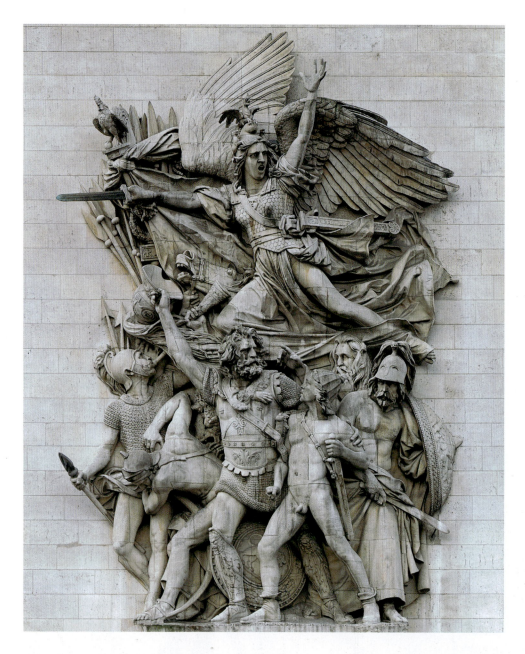

open-shirted proletarian waving a cutlass. A kneeling figure, dressed in the three colors of liberty, looks up at her hopefully from among the dead of both sides. But only the youth seems able to bound forward with a bravado born of innocence. With this mixed assortment of street characters, Delacroix created an inspiring image of the quest for liberty, in which the hope for freedom is carried in the hands of the common people. Its power was so great that it was put away in storage by government officials, and brought out again only after the next major political uprising, in 1848.

Francois Rude's *La Marseillaise*

The struggle for liberty is also the theme of François Rude's (1784–1855) relief sculpture *La Marseillaise* (*Departure of the Volunteers in 1792*) of 1833–6 (fig. 12.14), which makes for an interesting comparison with Delacroix's *Liberty Leading the People* (see fig. 12.13). Although, like most French sculptors, Rude conformed to many of the formal conventions of Neoclassicism, the dynamic and emotional power of his sculpture is more in keeping with Romanticism. Commissioned for Napoleon's Arc de Triomphe de l'Étoile, in Paris, its subject commemorates the events of 1792, when the French populace had rallied to defend the Republic against attack from abroad.

In contrast to Delacroix's use of contemporary dress on ordinary people, Rude, following the conventions of Neoclassical sculpture, cast the event in ideal terms. Thus, some of his figures are heroic nudes, others—of equally Herculean physique—are dressed in Roman armor, symbolizing strength and military courage. The mood is less ambivalent than in Delacroix's painting.

Neoclassical standard of David's *Oath of the Horatii* (see fig. 11.21). Delacroix's forms melt into deep shadow, whereas David's figures are crisply defined. The action in David's *Horatii* is self-contained, to be contemplated from a position of safety, but with Delacroix the passionate drama seems about to spill out into the viewer's space. What Delacroix sought with these effects was a carefully calculated appearance of spontaneity that would arouse the viewer's imagination.

Delacroix portrays "Liberty" as a hybrid allegorical female figure, naked to the waist, wearing the symbolic red cap of liberty, bearing a bayoneted gun in one hand, and the tricolor flag in the other. She strides on to the barricades accompanied by a pistol-brandishing youth, a top-hatted bourgeois bearing a musket, and an

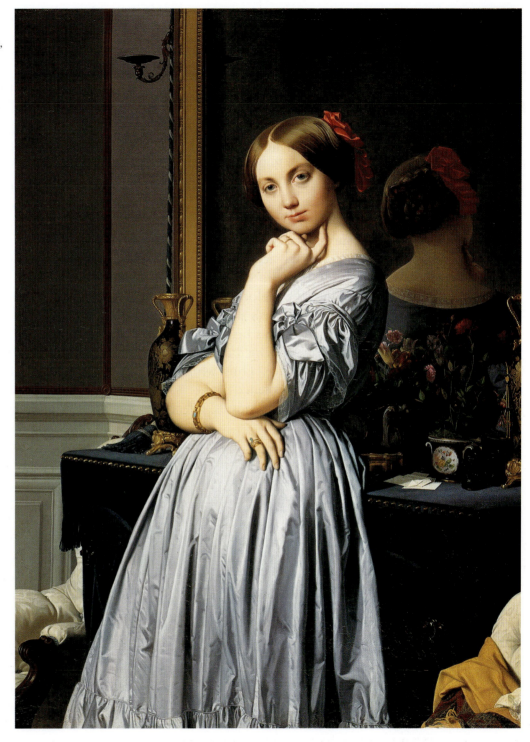

12.15 Jean-Auguste-Dominique Ingres, *Comtesse d'Haussonville*. 1845. Oil on canvas, 53¼" x 36¼". The Frick Collection, New York

Rude's muscular figures surge forward with confidence, inspired by the winged spirit of Liberty, who is bolder than Delacroix's figure of Liberty. Whereas Delacroix's group advances towards us, Rude's ensemble, in keeping with the conventions of classical relief sculpture, sweeps across the field of vision. Rude's deep, energized carving creates an intense drama of highlights and shadows in contrast to the smooth stone surface of its support, heightening its emotional impact. With its rousing, heroic spirit, it came to be identified with the French national anthem, *La Marseillaise*, that celebrates the ideals of liberty, equality, and fraternity.

Images of Female Beauty: Jean-Auguste-Dominique Ingres

The side of Romanticism we have been exploring was a distinctly masculine world of warfare and violence, in which the sole feminine presence we've seen was in the allegorical figure of Liberty. However, the French artist Jean-Auguste-Dominique Ingres (1780–1867), a contemporary of the Romantics, stands out for his adherence to Neoclassical principles, for his opposition to his long-standing rival Delacroix, and for his serene paintings of women. One such is his portrait of the *Comtesse d'Haussonville*, painted in 1845 (fig. 12.15).

Ingres, who had studied with David, championed the lucidity of line and drawing as the foundation of art. He was scornful of the way Delacroix obscured

forms in indefinite shadows, composed with color more than line, and created dynamic, energized figures that were intended to evoke passion and stir the imagination. In contrast to the soul-stirring subject matter of the Romantics, Ingres was at his best in cool, almost detached paintings of the female figure, including some memorable portraits such as that of the *Comtesse d'Haussonville*. In these portraits, however, we do not encounter the mood and personality of the sitter, as in

Romantic art, but the outward form, adjusted to the most judicious pictorial balance, with a refined control of line, and a crystalline purity of color.

In his portrait of the *Comtesse d'Haussonville*, Ingres's stable, orderly composition is deftly calculated to maximize the balance between the figure and the setting. As in Boucher's portrait of *Madame de Pompadour* (see fig. 11.13), Ingres includes a mirror image of his sitter. But in contrast to Boucher, Ingres uses it to juxtapose the graceful curving rhythms created by the doubled outline of his sitter's tilted head. The carefully calculated pose, the purity of form, and the contrast of smooth, spare surfaces with lucid, colorful details are fused into an exquisitely refined image.

Although some may find Ingres's refined sensibility to be cold, it can be a relief from the melodrama of French Romantic history painting. Ingres's skillful compositions bring as much rest to the eye as his images of female grace and beauty, which are presented as a source of comfort in a world of violence. Thus, while most Romantic artists expressed the violence of the age, Ingres, remaining true to Neoclassical ideals, offers a serene element of relief.

NATURE

In a time of political and cultural instability, nature captured the Romantic imagination. It seemed to offer protection and escape from the turmoil of the modern city as well as a glimpse of the infinite. But artists also saw, in the violent and destructive power of nature, an echo of the dark side of the human soul. For the Romantics, nature was to prove both sweet and sour. Romantic landscape painters, such as the English John Constable (1776–1837) and Joseph Mallord William Turner (1775–1851), the German Caspar David Friedrich, and the American Thomas Cole (1801–48), observed nature with great care and even greater passion. Many among them used sight as the means to insight, drawing attention to aspects of nature that, for them, evoked humanity and spirituality within the material environment. The impact of their work raised the stature of landscape painting and inspired other artists to find in nature an arena for significant artistic innovation throughout the nineteenth century.

Landscape: "Another Word for Feeling"

The English landscapist John Constable once described painting as "but another word for feeling." The lush detail and rapturous mood of many of his landscape paintings, such as his *Dedham Vale* of 1828 (fig. 12.16), epitomize the Romantic desire to escape the industrial transformation of town and country as well as the political and social turmoil of the age.

Early in his career Constable consciously rejected the academic practice of striving for an ideal beauty inspired by other paintings more than by the actual, physical experience of nature. Instead he sought "a pure and unaffected manner," more in keeping with Dutch landscape painting, confident that only "truth" so conceived would endure.

John Constable's *Dedham Vale*

The approach that Constable adopted is exemplified in several paintings inspired by the East Anglian landscape of his childhood. In *Dedham Vale*, he presents the fertile, watered meadows of the Stour Valley looking toward Dedham, with Harwich harbor beyond. In rendering the vivid details of this scene, Constable wanted to represent his love for the "Light-dews-breezes-bloom-and-freshness," with a vital naturalism, never before seen. To record his sensations, Constable made oil sketches on the spot. Trying to retain the freshness of his sketches in the finished paintings, he built up his canvases with flecks of lighter colors laid over darker ones. This method created a visually rich surface texture that also resolves into the appearance of woodland plants, bark, and foliage. When one of his paintings was exhibited in Paris, these technical qualities impressed Delacroix and others, anticipating Impressionism by some forty years (see Chapter 13).

Constable's conviction that in landscape paintings, sky is the "chief organ of sentiment," led to careful study and spectacular results. His skies were unmatched since Ruisdael's (see fig. 10.17). Indeed, the heavy storm-clouds, wind-swept trees, and overgrown tree stump on the left in *Dedham Vale* introduce a melancholy, almost menacing tone, casting a shadow over this world of rural well-being. This sense of loss and foreboding—in contrast to the cheery optimism of his earlier works—may signal the artist's own displacement from the landscape of his childhood. The shadows of the foreground also strike a darker note, where, sheltered under a bank, Constable has included a vagrant mother with her child, a pot of

12.16 John Constable, *Dedham Vale.* 1828. Oil on canvas, 57¹/₈" x 48". National Gallery of Scotland, Edinburgh

food cooking over a small fire beside her makeshift shelter—a motif that underscores his rejection of academic idealism. As Constable aged and suffered, his vision of nature darkened further, in both subject matter and technique. He exchanged a loving attention to natural details for a coarser, more tormented application of paint, attesting to his continuing conviction that, painting is "but another word for feeling."

The Sublime

For other Romantic landscape painters, such as Friedrich and Turner, those feelings were often the sublime emotion aroused by nature's extremities: Great mountains, vast oceans, endless spaces, wild storms, avalanches, volcanoes, and other violent elements. Whereas Constable mostly celebrated the intimacy of

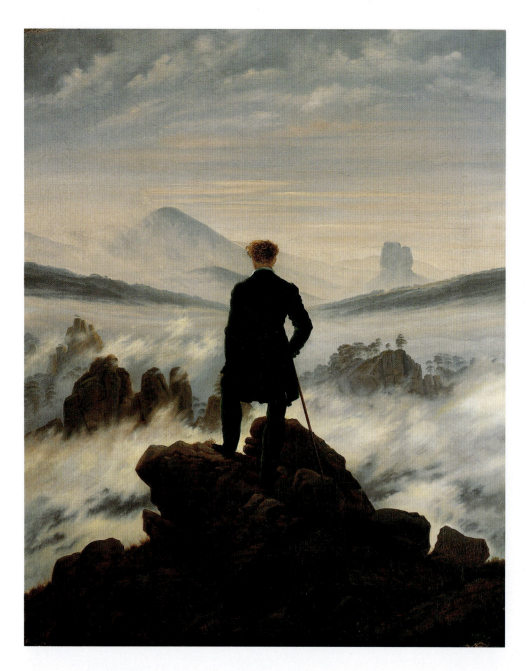

12.17 Caspar David Friedrich, *Wanderer Above the Mists*. c. 1817–18. Oil on canvas, 29½" x 37¼". Kunsthalle, Hamburg

the eye and the imagination beyond them. Thus, much as in his *Tetschen Altar* (*Cross in the Mountains*, see fig. 12.6), Friedrich evoked an awareness of the eternal from elements within the natural order.

Like other Romantics, he capitalized on nature's tendency to stir our emotions and inspire awe. Therefore, he typically painted those elements which lead the viewer's imagination from a place of security to the brink of infinite time and space—ships viewed through a window, the sea viewed from the beach, ancient trees set in great spaces, ancient ruins in dead of winter, or the moon in the night sky. For Friedrich, these awe-inspiring subjects were sublime rather than beautiful, in the sense intended by the eighteenth-century British essayist Edmund Burke. Burke had described the sublime as a pleasing terror that moves the emotions and causes astonishment, overwhelming one's rational faculties. Naturally, this was very appealing to the Romantics.

the much-loved local scene, Friedrich, in paintings such as his *Wanderer Above the Mists* of about 1817–18, often evoked a distinct sense of separation and yearning (fig. 12.17).

Caspar David Friedrich's *Wanderer Above the Mists*

In contrast to traditional practice, Friedrich's figures are typically disengaged from the landscape. Like the traveler in this painting, they gaze toward the distant horizon, leading the viewer in a similar direction. By building up his landscape from carefully rendered natural phenomena, Friedrich invited the viewer to dwell on particular aspects of the world, while also drawing

In Friedrich's painting *The Wanderer*, an elevated viewing point provides an awe-inspiring vista of rugged mountain-tops, while mist hanging over the valleys blots out all familiar elements of the everyday world. So isolated, the traveler is left to confront the infinite. Friedrich's friend, the physician and painter Karl Gustav Carus, in writing about landscape painting, commented that "[humanity] sensing the immense magnificence of nature, feels his own insignificance, and feeling himself to be in God, enters into this infinity." Since Carus was a friend and disciple of Friedrich, we may take this as a fair reflection of the artist's intent with such a painting.

Turner and the Sublime

Like Friedrich, the English artist J.M.W. Turner was attracted to the sublime in nature, but he also saw, in its destructive power, an image of the darkness of the human soul. Turner was a painter of greater emotional range and invention than either Constable or Friedrich, and, in the breadth of his technique, he would influence later modern abstract painting. Turner's landscapes were at once more sublime, original, and at times more disturbing than anything seen before. He eventually abandoned all existing artistic conventions to create unprecedented pictorial effects of atmosphere, light, and color, in which a whole spectrum of sensations are released.

While Turner, like Constable and Friedrich, keenly observed natural phenomena, he focused primarily on the effects of colored light filtered through mist or haze, or reflected off water, and on the interplay of sea, surf, and sky. Turner experimented boldly with the potential of color, light, and atmosphere, transforming his observations into great swatches of radiant color. His paint application was so thick, and its intent so much more emotive than descriptive, that his contemporaries, accustomed to high

definition and fine finish, found his imagery incoherent. They derided his effects as "tinted steam."

While Turner's great washes of color have been seen as precursors of modern abstract art, his paintings retain the naturalistic observation which inspired them. Even his most original compositions, in which water, spray, and air are caught up in a swirling vortex of color and light, cohere into recognizable imagery.

J.M.W. Turner's *The Slave Ship*

Turner evoked both dreamlike scenes of utter tranquillity and turbulent images of natural and man-made disasters. Such is his painting of 1840, *The Slave Ship*, in which nature "red in tooth and claw," as the poet Alfred Tennyson later put it, leaves humanity helpless before its forces of destruction—forces Turner represents as equally present in ourselves (fig. 12.18).

The subject of Turner's painting recalls the age-old theme of the storm-tossed ship, buffeted by the elements. But his pictorial effects, as well as his specific subject, are unprecedented, as the painting's full title makes clear: *Slavers Throwing Overboard the Dead and Dying–Typhoon Coming On*. Amidst the swirling waves

12.18 Joseph Mallord William Turner, *The Slave Ship*. 1840. Oil on canvas, 35 3/4" x 48 1/4". Museum of Fine Arts, Boston

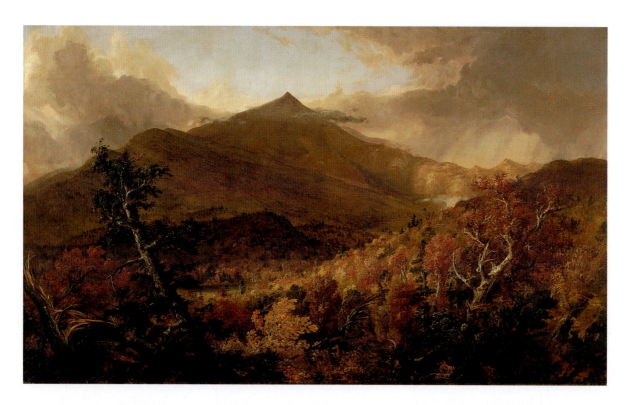

12.19 Thomas Cole, *Schroon Mountain, Adirondacks.* 1838. Oil on canvas, 39³/₈" x 63". The Cleveland Museum of Art

and hungry circling predators, the shackled limbs of the slaves underscore their final moments of struggle against inevitable death. From an early painting of a crushing avalanche in the Alps to this later painting, Turner created a series of potent images in which each of the fundamental elements of earth, air, fire, and water rise against humanity as forces of destruction rather than sustenance.

While the forces of nature were for Friedrich, Constable, and other Romantics, a source of comfort, for Turner they are deeply disturbing. Constable was able to portray nature as benign because, as he wrote in a letter to his wife, he felt the animating presence of God in the surrounding landscape. Turner was unable to muster such faith, and often exhibited his works accompanied by excerpts from his own unfinished epic poem *The Fallacies of Hope.* The German philosopher Immanuel Kant, whose ideas about art are touched on in "The Artist as Visionary Romantic" (page 374), observed that contemplation of nature brings the deepest moments of self-discovery—for we see in nature reflections of our own souls. Thus Turner has us gaze into the vortex of a typhoon, and see therein not only the forces of destruction, but also an image of the unsparing brutality of humanity. Nature, reduced to empirical fact by the Enlightenment, was seen by the Romantics, and later by such artists as Vincent van Gogh, Paul Gauguin, and Edvard Munch, as rife with the passions of the human soul (see figs. 13.3–6 and 13.41).

American Landscape Painting: Thomas Cole

In America, the English-born Thomas Cole translated the Romantic view of the sublime into the idiom of the vast American landscape. In *Schroon Mountain, Adirondacks*, painted in 1838, Cole envisions the untamed American wilderness (fig. 12.19) as a modern garden of Eden. American settlers like Cole perceived the landscape of the "New World" as distinct from European landscape for its vastness and natural grandeur, in which one could contemplate the works of God without interruption from the works of man. In Cole's painting, the form of the distant mountain, framed by two storm-struck trees, rises to a sharp point, where it is silhouetted against an opening in the storm-cloud. A burst of sunlight illuminates the transient fall colors of the trees. Above these trees, the mountain stands as an image of majestic strength, unshaken by storm or time. Its tip points toward the source of light and, metaphorically, that of life itself.

In other works, Cole responded to the American demand for morally elevating art by using landscape as a vehicle for allegories on such themes as the progress of civilization and the stages of life. In seeking to define a distinctly American landscape aesthetic, Cole pointed to the uncultivated scene as holding the promise of the future, writing that "Where the wolf roams, the plough shall glisten."

Thus Thomas Cole, who founded the Hudson River School of landscape painting, managed to define an American version of the Romantic landscape aesthetic. Its dimensions embraced a sense of inhabiting a God-given paradise, and, at the same time, a vision of unlimited future development. It thus contained the promise of untapped resources and boundless liberty that had attracted many of Europe's oppressed to leave their ancient roots.

THE CITY

The Romantic desire to escape from the stresses of modern life influenced urban development in at least two critical ways: By relating new luxury housing developments to park-like settings, and in the design of buildings in styles associated with an idealized past, remote from modern mills and factories. As cities such as London and Paris underwent vast changes, traditional architectural styles masked the social hardships caused by modern technology. By providing reassuring signs of historic continuity, architecture, too, expresses the Romantic desire for escape.

The Garden City Ideal: Regent's Park

As cities such as London spread out in all directions, swallowing the countryside, town planners responded to the growing desire for a rural escape (a desire probably as old as cities themselves). In the midst of the city, they developed (where possible) town housing in park-like settings. One of the first to do so was John Nash (1752–1835). His designs of 1811 for Regent's Park in London (fig. 12.20) continued the city's transformation into the grand capital of an expansive empire that had started a century earlier with Wren's ambitious projects (see figs. 11.5 and 11.30).

In his plan for Regent's Park, in north-central London, Nash combined elements of town and country. Nash planned this luxury housing development as a natural-looking, country house park (compare the park of Blenheim Palace, fig. 11.28). He achieved this with the curving lines of a serpentine lake, long sweeping lawns, and scattered clumps of trees surrounded by grand terraced houses and some smaller villas. Nash's inspiration for placing buildings in an informal, landscaped setting came from the eighteenth-century

English picturesque garden aesthetic (see fig. 11.28). Like a country mansion in its private park, each building at Regent's Park was situated so that, looking out from the windows, one had the illusion of living within a tranquil country park. It had the added benefit that the fashionable shops and business offices of the metropolis were just a few streets away, since the park and London's fashionable West End were linked by a new, ceremonial street (Regent Street), which Nash lined with imposing Neoclassical buildings.

Looking Back: Gothic Revival

Besides bringing the country into the city, the desire to escape the present also rekindled interest in the architectural past. In urban design, nostalgia ruled. Architects created a medley of historical styles, each with their own set of cultural associations—Neoclassical, Neo-Gothic, Neo-Renaissance, or Neo-Baroque, even an eclectic Orientalism known as Indian Gothic. Regardless of a building's function or underlying structure, one or other of these styles was chosen, according to the desired set of associations it evoked. This need to borrow an identity from the past suggests that, besides the bold innovation of a few, the wish to escape the present was stronger than the will to forge a modern identity.

12.20 John Nash, Regent's Park, London. 1811–30. Aerial view

By the 1830s the one conviction shared by many architects was that pre-industrial architecture—of whatever period—was better than industrial designs. Ironically, they failed to realize the architectural potential of the iron and steel of their own industrial age—on which the wealth of expanding cities was built. Indeed, the architect George Gilbert Scott (1811–78) had declared that the great principle of architecture is "to decorate construction"—in other words, to hide the evidence of the iron and steel of new building technology. In turning away from the present, architects echoed, on their terms, the Romantics' aversion to modernity and the desire for escape that, as we've seen, inspired other aspects of Romanticism. The result was an eclectic historicism, in which styles of the past were studied and recycled, much as the new museums, founded by national governments, were classifying the past for contemplation in the present.

London's Houses of Parliament

The rebuilding of London's Houses of Parliament, 1839–52 (fig. 12.21), after a fire in 1834, underscores the extraordinary eclecticism of nineteenth-century architecture, as well as the desire to use a particular style for its symbolic historical associations, regardless of the nature or integrity of the structure itself. The commission to design the new Houses of Parliament went to Sir Charles Barry (1795–1860), a classicist. Caught up in the spirit of Romantic revivalism, the authorities preferred English Gothic for its associations with Christianity and a great era of British history. For this they turned to A.W.N. Pugin, who favored Gothic

architecture's textural richness and varied forms over classical restraint and symmetry.

So, while Barry designed the shell of the structure, Pugin oversaw design of all the Gothic detail of its exterior and interior. Barry's classicism appears in the symmetry of the wings and corner pavilions on either side of the building's long, central range, while Pugin's asymmetrical towers and spires gave the Houses of Parliament a Gothic silhouette against the sky. As Pugin himself acknowledged, the design was effectively an English Gothic skin covering a classical body.

London's definitive landmark, Parliament's silhouette contrasts strikingly to the domes and other Baroque features of Wren's Naval Hospital, built a century earlier at Greenwich, further down the River Thames (see fig. 11.30). Today, given the accessibility of their respective locations, there is little doubt about which of the two sticks in the memory of visitors to London. They might, however, wonder which was built first.

Buildings for Public Entertainment

Europe's expanding industrial economy created enormous wealth for the bourgeoisie, who now wanted to enjoy what had been the private reserve of princes and aristocrats. Demand from the bourgeoisie for access to cultural and leisure activities resulted in several new kinds of buildings. In London, Paris, and elsewhere civic leaders

12.21 Sir Charles Barry and Augustus Welby Northmore Pugin, Houses of Parliament, London. 1839–52

began building public museums, art galleries, theaters, concert halls, opera houses, libraries, and luxurious private clubs—all typically built in eclectic, historical styles.

J.L. Charles Garnier's Paris Opéra

The masterpiece of nineteenth-century decorated construction and stylistic eclecticism was Jean-Louis-Charles Garnier's (1825–98) Paris Opéra, built 1861–75 (fig. 12.22). Spectacularly located at the place where several wide boulevards converge, Garnier's Opéra was built as a pleasure palace for the rich Parisian bourgeoisie. Its opulent Neo-Baroque style completely masks its modern industrial steel supports (see fig. 1.11). Behind its richly decorated façade—dripping with paired columns, sculpted festoons, swags, portrait busts, and figurative groups—stands the grandest of ceremonial staircases (see fig. 12.22). Richly decorated and illuminated by lavish candelabras, the staircase rises majestically through the center of a great vaulted hall flanked by paired columns and divides half-way to the left and right to reach the arcaded balconies above. The theatrical fantasy of this space matches that of opera itself. Perhaps for the bourgeoisie, the evening's real spectacle took place not on the stage, but on this grand, sumptuous staircase. In any event, both the building and its operatic function offered an appealing form of escape from the industrialized and commercialized city around it.

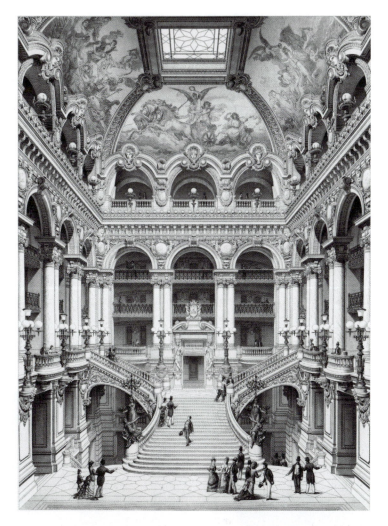

12.22 J.-L.-Charles Garnier, the Grand Staircase of the Opéra. 1862–75. Engraving of 1880 from C. Garnier, *Le Nouvel Opéra de Paris*, Paris, 1880, Vol. 2, pl. 8

PARALLEL CULTURES
Orientalism: Romantic Fantasies of Escape

The Romantic desire for escape also nourished exotic fantasies about alternative lifestyles. Typically, these fantasies were embodied in non-Western peoples, whom Romantics imagined as natural and free from their own feelings of malaise. The Romantics in France and elsewhere were fascinated by so-called Orientalist subjects that offered enchanting glimpses of an exotic, non-Western lifestyle. This interest was stimulated successively by Napoleon's Egyptian campaign of 1798, the Greek struggle for independence from Turkish rule in the 1820s, and a French campaign in Algeria, North Africa in the following decades.

In practice, Oriental subjects meant scenes from North Africa or the Holy Land that typically evoked Bedouin camps, the exotic world of Arab mosques and markets, and, most of all, beautiful women in the lush, exotic settings of imaginary Turkish harems. For the European public, Orientalist subjects were a means of imaginative escape, whose appeal lay precisely in the exotic "otherness" of the Arab, Islamic world, whose climate, dress, habits, and culture provided, at a comfortable distance, an alluring alternative to their own existence.

Most of the artists who worked in this genre, such as Ingres, had never been to the Near East or North Africa. They painted an Orient of the imagination that offered, above all, an erotic sensuality. We will consider two contrasting examples of this genre, one painted by Ingres, the other by Delacroix. The two artists are often compared, as here, for the marked differences in their technique: Ingres, the Neoclassicist, was the master of

line, and Delacroix, the Romantic, of color (see Chapter 9 "Materials and Techniques: The Uses of Color and Line," page 300).

Ingres's *Odalisque with a Slave*

Ingres's *Odalisque with a Slave* of 1842 offers a voluptuous sensuality rendered with the cool, precise construction and drawing characteristic of academic Neoclassicism (fig. 12.23). Ingres applies color with such steady, detached precision, that, despite its saturated intensity, the cumulative effect is still of passion, dispassionately rendered. Ingres's painting epitomizes a European male's fantasy of an Oriental potentate's life of exotic luxury and soothing refreshment.

Ingres evokes this through the languorous beauty of the odalisque (a woman in a harem), reclining amidst

12.23 Jean-Auguste-Dominique Ingres, *Odalisque with a Slave*. 1842. Oil on canvas, 28" x 39⅜". Walters Art Museum, Baltimore

rich silks and satins. He intensified the effect of the soft curves of her body by contrasting them to the taut geometry of the setting. The allure of her body is also heightened by suggestion of the soothing strains of music played by a slave girl, and is echoed in the cool shadows of the lush water garden beyond—recalling the famous watered gardens of the Islamic world (see figs. 6.47–9). In the portico stands a black eunuch, the watchful guardian of his master's pleasures. Whereas earlier generations of European males had cast their eyes on images of a mythological Venus, now this myth of unalloyed pleasure could be entertained as an actual, if exotic, reality. Even into his eighties, Ingres painted a number of such sensual fantasies, reflecting popular demand.

Delacroix's *Tiger Hunt*

Unlike Ingres, Delacroix did travel in Morocco and Algiers, an experience that directly influenced his art.

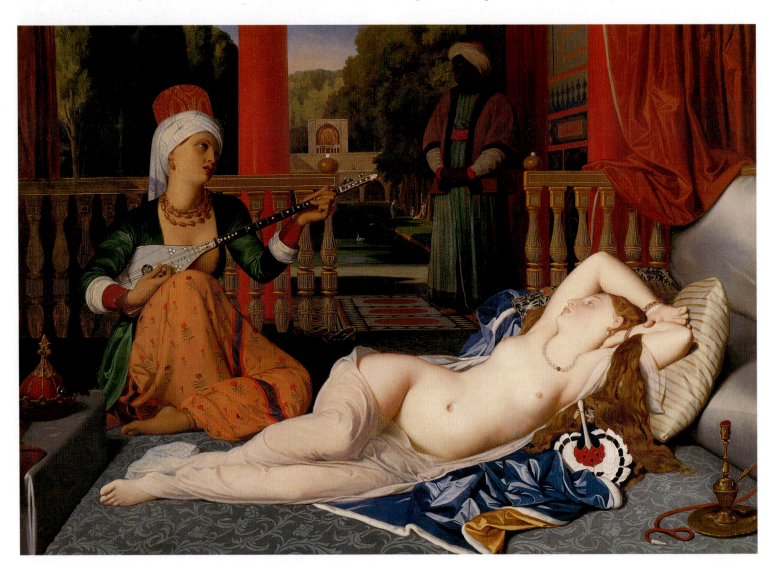

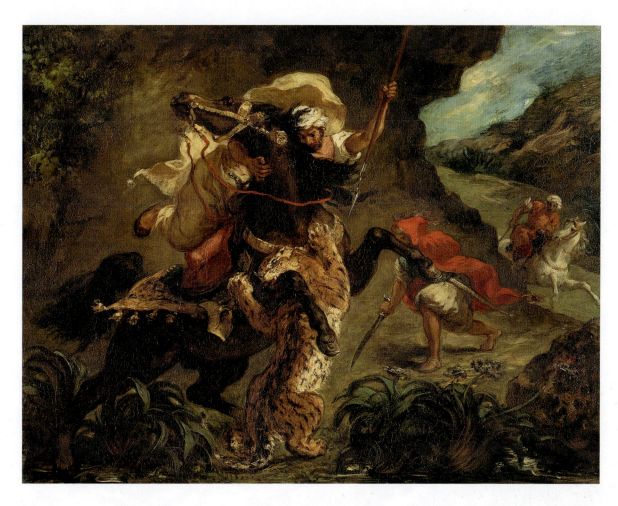

12.24 Eugène Delacroix, *Tiger Hunt*. 1854. Oil on canvas, 29" x 37". Musée du Louvre, Paris

He painted *Tiger Hunt* (fig. 12.24) in 1854, from sketches he'd made in North Africa more than twenty years earlier: In this painting, Delacroix adds an exotic dimension to the Romantic theme of the struggle between man and nature, "red in tooth and claw."

Delacroix was impressed by the courage and dignity of Arab horsemen, and wrote in letters from North Africa of his admiration for the noble bearing and sublime beauty of the inhabitants, whom he compared to the ancient Romans and Greeks for their dignity and beauty. They were, for Delacroix, sublimely "other." His Romantic fascination for Arab horsemen was matched by his attraction to wild animals, and resulted in many vivid sketches of lions and tigers. Putting these together, Delacroix revived an ancient theme of animal combat (see figs. 2.15, 2.28, and 3.23), which embodied the Romantic preoccupation with the ferocity of man and beast.

Delacroix's artistic technique was ideally suited to passionate subjects such as his *Tiger Hunt*. In preparatory sketches he built up his composition with loosely painted massing of contrasted colors to create an agitated drama in which the figures were lightly brushed in with fluid, suggestive daubs of color. The pictorial violence of his sketches evokes the swirling intensity of the subject, which he tamed, however, in his finished painting. Whereas Ingres conceived of line and color separately, for Delacroix, color was the prime vehicle of construction and expression. Even in his finished works, line is just a denser concentration of tonalities, or a transition between contrasting colors.

In *Tiger Hunt*, the spiraling composition of intertwined figures, the dense, jagged rocks, and the strong contrasts of red and black, gray-greens and browns, with touches of yellow (all of which have darkened with time) express violent passion, and, indirectly, the intensity of the artist. His colors were chosen for their expressive power and applied with a freedom of touch that still shows the movement of the brush. This effect of spontaneity was designed to be more engaging than the smooth academic finish of Ingres in arousing the viewer's imagination.

While Delacroix's original inspiration may have come from life, what he painted was nature infused with imagination. Indeed, the Orientalism of both Delacroix and Ingres was the Orient of a European Romantic imagination, and ultimately a reflection of their own longings and fears.

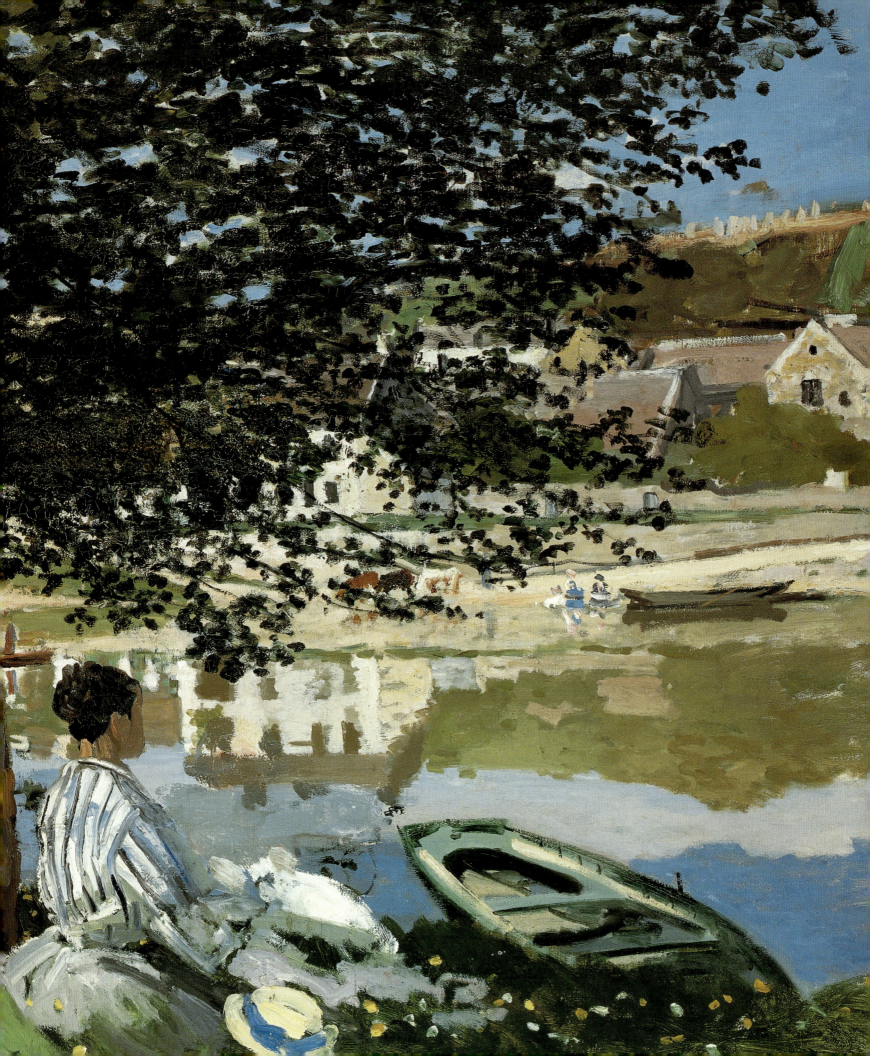

13 The Rise of Modernism: 1848–1900

For the inhabitants of large cities, the surge of industrial and urban growth in the nineteenth century was both a blessing and a curse. It brought prosperity, but also slum housing. Many prospered, but even more toiled in squalid conditions. The railway offered the chance for outings to the country, and among those who gladly took the ride were painters like Claude Monet (1840–1926). In this riverside scene at Bennecourt on the banks of the Seine (fig. 13.1, detail of fig. 13.24), Monet, who later settled in the area, captures the sense of tranquillity that a day trip can provide. Back in town, the painting would have refreshed tired eyes and minds.

Above all else, innovative artists and architects of the second half of the nineteenth century desired to represent their own time on their own terms, rejecting the aristocratic ideals of the past and recognizing the social realities of modern, urban life.

Among those realities was the newly powerful middle class, the ultimate victors in the political and industrial revolutions of the early nineteenth century, who would now become the patrons of the arts, and often its subjects. Shaping the identity of this class was modernity itself; the wealth and social position of the newly rich depended on the industrial and commercial prosperity of the modern city, not on inherited aristocratic privilege.

Art in the Modern City

Expanding cities like Paris, with its wide new boulevards, cafés, and places of entertainment, had the power to both attract and repel (see fig. 13.31). Accompanying the fashionable streets and buildings were smoke-belching trains and factories, overcrowding, slum housing, and social dislocation. Thus many desired to escape from the city to the suburbs and the countryside, or even further afield. For artists, the modern city provided fresh sources of inspiration.

To the more progressive minds of the French nineteenth-century art world, the academic art sponsored by the annual Salon exhibitions was out of touch with the present. In an age of steam engines, factories, mass production, and mass entertainment, the traditional forms and mythological themes it favored seemed irrelevant. Thus the French poet and art critic Charles Baudelaire, reviewing the Salon of 1845, noted the technical accomplishments of many artists but lamented their sterility. He added: "The true painter for whom we are searching will be the one who can seize the epic quality of contemporary life and make us see and understand, with brush or with pencil, how great and poetic we are in our cravats and patent-leather boots." A similar sentiment was

❖ THE ARTIST as Rebel ❖

The roots of modern art can be traced back to the seeds of revolt against academic practice which began in the Romantic period (see Chapter 12, "The Artist as Visionary Romantic," page 374). Here too lie the origins of the bohemian spirit of non-conformity, inspiring the independent artist as social rebel and agent of change.

As we saw in Chapter 12, with the social changes of the revolutionary years, artists lost most of their traditional support and had to reach new markets, especially the newly wealthy middle-classes. As artists grew more autonomous, their social function became less secure. Thus the role of critics in promoting or opposing the latest artistic innovations expanded, as did the need for art dealers and commercial galleries to market their works.

This new form of commercial competition fed on the Romantics' ideal of individuality, inspiration, and innovation, rather than reliance on tradition. The social and political unrest stirred by the revolutions of 1789, 1830, and 1848 provoked awareness that the artist, too, could function as an agent of change, whether political, social, or simply artistic. When this mentality was married to an evolutionary view of history, which emphasized cultural progress, the result was the birth of the notion of an artistic avant-garde, a military term meaning "advance guard."

Avant-garde artists, those doing the most experimental work, were believed to be at the cutting edge of progress and therefore were esteemed by modern art critics as the most vital and relevant of their time. From the mid-nineteenth to the mid-twentieth centuries, modern artists thrived on the art world's acceptance of these ideas, until people grew skeptical of the concept of progress and focused instead on notions of difference. By the late 1960s, people in the art world began to value diversity rather than progress, and to describe these new circumstances in terms of postmodernism.

expressed in 1863 with respect to architecture by the French architectural theorist Eugène-Emanuel Viollet-le-Duc. Rather than imitating the past, he believed that "the first law of art ... is to conform to the needs and customs of the times." This radical notion challenged architects to find ways of using modern materials, such as iron and steel, in the construction of new types of buildings, such as railway stations and public libraries.

The use of iron and steel by pioneering architects shaped the look of the modern city. The ultra-modern Eiffel Tower, begun 1887, would come to symbolize Paris as well as the modern age, in contrast to London's Gothic-style Houses of Parliament (see fig. 12.21). Artists responded to modern city life by depicting the world of work and pleasure; they evoked its alienation and spiritual poverty, and the search for relief in nature. For some, that search would extend far beyond Western culture.

When nineteenth-century artists rejected tradition and embraced modernity, they began a trend that endured almost to the present (when notions of evolutionary cultural progress have been called into question, see Chapter 15). But in the late nineteenth century, fueled by Charles Darwin's theory of evolution, published in his *On the Origin of Species* of 1859, belief in the inevitable upward progress of human culture seemed irrefutable. In the arts, therefore, the new was to be preferred over the old. The term avant-garde ("in the vanguard") was first applied to progressive artists in 1825. In an age of manifest scientific and material progress, the avant-garde artist was perceived as one who would contribute to social progress by challenging the past and pointing toward the future (see "The Artist as Rebel," page 402).

The artists represented in this chapter belonged to the avant-garde. In their own time, they received less public support than the academic artists whose works strike us today as less relevant to the intellectual and sociological issues of their age. Contemporary challenges were the main focus for the innovations of the Realists, Impressionists, Post-Impressionists, and even the Symbolists, as well as those who developed an entirely new medium, photography. The epicenter for avant-garde art was France, especially Paris (see "Avant-garde Art in the Late Nineteenth-Century," page 404).

Each new artistic approach was, in many ways, a reaction to the art that preceded it. Thus, within the first three themes, we will follow the broad sequence in which works were produced, tracing their treatment from Realism through Impressionism and Post-Impressionism to Symbolism. In the section on Parallel Cultures, we will explore the attraction of non-Western culture and art, notably that of Polynesia and Japan, for some nineteenth-century artists.

SPIRITUALITY

"Show me an angel, and I will paint one," said the painter Gustave Courbet (1819–77), directly addressing the problem of religious art for modern artists, at a time when traditional beliefs were being challenged by science.

The Clash of Science and Religion

In England, Darwin's theory of evolution appeared to overturn the biblical account of creation. In France, Auguste Comte claimed that human thought had evolved in stages as well: The earliest stage, dependence on theological authority, had given way to empiricism, the scientific method that sought truth through observation and measurement. As the power of the scientific method gripped the public's imagination, it weakened the authority of traditional religious beliefs. Many artists abandoned orthodox Christian belief in the supernatural for a naturalistic vision of reality. Some, however, still addressed religious concerns, but on personal terms, following the example of Romantic artists such as William Blake and Caspar David Friedrich (see Chapter 12). They devised forms of art which attempted to represent spirituality in the everyday lives of ordinary people

Sacred Simplicity: The Spiritual in Everyday Life

Nineteenth-century artists in effect naturalized spirituality: Some represented natural phenomena that traditionally carried religious connotations; others depicted ordinary people in the act of expressing their devotion. The pious peasant, unaffected by the secularism of modern urban life, became a popular theme. This rural fantasy was another variation on the ancient theme of rustic simplicity contrasted to urban corruption.

Avant-Garde Art in the Late Nineteenth Century

Avant-garde artists of the late nineteenth century, especially those working in France, explored a succession of fresh artistic strategies or styles. These are typically categorized as Realism, Impressionism, Post-Impressionism, and Symbolism.

Realism

"Show me an angel and I will paint one." In his call for realism, Gustave Courbet argued that art should be "concrete," depicting only what artists could see and touch in their own time and place. The Realists, including Édouard Manet, rejected both the Romantic imagination and the artificial poses and polished finish of classically inspired academic art. Photography, invented in the 1830s, introduced a new artistic medium and also offered artists fresh viewing angles as well as insight into the representation of the physical mechanics of movement. Photographic effects also added to the possibilities of Realist forms of art.

Impressionism and Post-Impressionism

The Realists' successors, the Impressionists, wanted to create works that were not only true to life but also true to sight. Impressionism was the derisive name given to works in what became known as the first Impressionist Exhibition (1874), and was derived from a work by Monet, *Impression, Sunrise*, of 1872 (Paris, Museé Marmottan), which exploits the pictorial effects of light on water. To achieve truth to sight, Claude Monet, Pierre-Auguste Renoir, and other Impresssionists studied recent discoveries regarding color, light, optics, and the way the human eye receives sensory data. These discoveries, as well as the invention of synthetic pigments, were partly responsible for the brilliance of the Impressionists' palette. Because these new pigments were packaged in tubes, artists could take them anywhere—including outdoors. The result was works that are fresh, brilliant, and lifelike.

Post-Impressionism primarily refers to two main reactions to Impressionism. Georges Seurat and Paul Cézanne (see figs. 13.14, 13.27), while respecting the ideal of truth to nature, sought greater formal order than the deliberately momentary effects of Impressionism (see figs. 13.12, 13.24). Taking a different direction, Vincent van Gogh and Paul Gauguin (see figs. 13.15, 13.41) attempted to stay true to nature, but gave more emphasis to personal expression and subjective emotion than Seurat and Cézanne.

In many ways these two sides to Post-Impressionism reinterpreted the old contrast of classical formalism and Romantic expressionism in terms of the Impressionists' brilliant palette and commitment to nature. In so doing, these two sides of Post-Impressionism set up a modern opposition between art stressing formal values and art which focuses more on expression of feeling and the inner life.

Symbolism

Alienated by the materialism of the age, Symbolist artists turned inward. Artists such as Gauguin and Edvard Munch abandoned the naturalism of much nineteenth-century art, using color and line to express an inner world of thoughts, feelings, and dreams, rather than objective appearance. As artists rethought the purpose of art, so did its public. Elevating personal expression above the imitation of nature eventually made art less accessible and began to undermine its traditional role in public life. As this tendency continued into the twentieth century, the public sometimes felt excluded from the private world of artists, dealers, and critics.

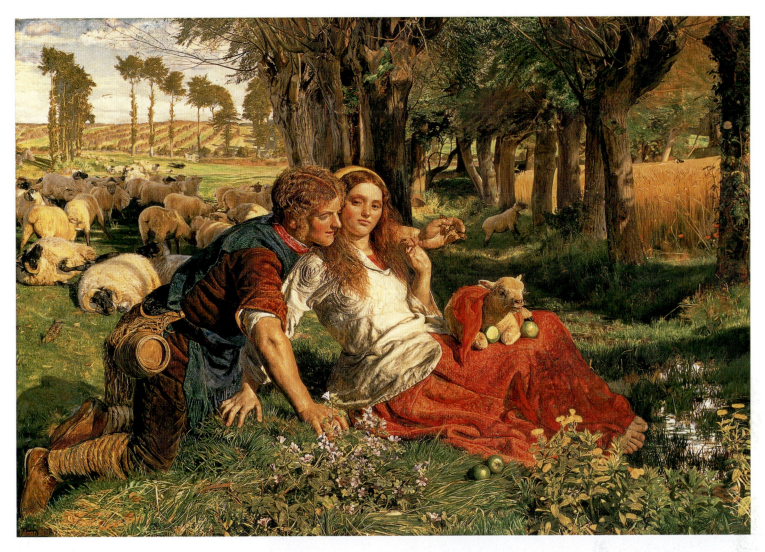

William Holman Hunt's *The Hireling Shepherd*

In his painting *The Hireling Shepherd* of 1851–2 (fig. 13.2), English artist William Holman Hunt (1827–1910) naturalized the biblical metaphor of good and bad "shepherds" (pastors) through the image of rosy-cheeked farm hands, set in the fertile English countryside. Hunt was a leader of the Pre-Raphaelites, a movement that sought to recapture the supposed sincerity of subject and clarity of color and line of Italian painting before Raphael. He wanted to reform art and society through the technical integrity of his style and the serious moral content of his subjects. His painting alludes to the New Testament story of the hireling shepherd, who neglects the sheep, in contrast to Christ, the good shepherd. Hunt was taking a jab at clergymen who were distracted by worldly temptations from the needs of their parishioners.

For today's viewer, such allusions seem secondary to the sheer sensuous richness of Hunt's extraordinary detail. The English midsummer landscape is painstakingly painted

13.2 William Holman Hunt, *The Hireling Shepherd*. 1851–2. Oil on canvas, 30" x 43". Manchester City Art Gallery, England

from life. We can see each detail of the wayside plants and flowers, the teeth marks of the lamb on the sour apple (from which it will die, unnoticed by the shepherd) and the foreboding death's head moth in the shepherd's hand.

Vincent van Gogh's *The Sower*

Vincent van Gogh's (1853–90) painting, *The Sower*, of 1888, is another classic example of the naturalization of Christian motifs (fig. 13.3). Van Gogh, who had earlier been involved in Christian ministry, alludes in some of his paintings to the drama and suffering of human existence as embodied in the natural world of sowing, reaping, and old, gnarled olive trees. With its generalized shapes, faceless figure, schematic willow tree, and broad areas of thick color, van Gogh's painting could not be more different from Hunt's *Hireling Shepherd*. Yet it, too, draws on the New Testament, namely Christ's famous parable of the sower. Van Gogh

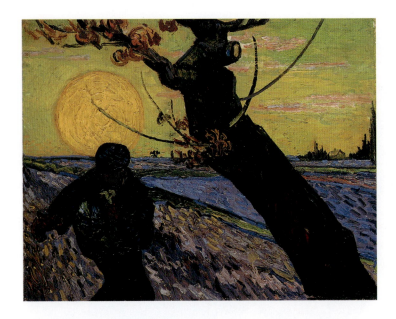

13.3 Vincent van Gogh, *The Sower*. 1888. Oil on canvas, 12¹/₂" x 15³/₄". Van Gogh Museum, Amsterdam

represents the sun as a great golden orb of energy hovering over the horizon, more symbolic than real. Its life-giving power transforms the landscape while also creating a natural halo over the sower's head, endowing the encounter between the peasant and the soil with the aura of a symbolic ritual.

Paul Gauguin's *Vision after the Sermon*
Van Gogh's friend Paul Gauguin (1848–1903), desiring to counter the deadening materialism of his age, occasionally attempted religious subjects. In 1888 (the year of

van Gogh's *Sower*) he painted religious scenes of Breton peasants, such as *Vision after the Sermon (Jacob Wrestling with the Angel)* (fig. 13.4). He treated this visionary subject in visionary (or, as it came to be called, Symbolist), rather than naturalistic, terms. Gauguin depicted a group of Breton peasants, kneeling piously, with the village priest on the right, as if all are imagining the priest's sermon. A leaning tree separates them from the struggling figures of Jacob and the Angel, who appear on a red ground where one might expect grass.

In the same year, 1888, Gauguin advised a fellow artist: "Don't copy nature too much. Art is an abstraction; derive this abstraction from nature while dreaming before it, and think more of the creation which will result." Gauguin's own handling of color, line, and the flattening of the human form departs radically from nineteenth-century standards of naturalistic representation to serve the artist's imaginative and expressive intentions. In so doing, he moved much further from the Realists and Impressionists (see below) in his non-naturalistic handling of pictorial elements than van Gogh ever would. His decorative design, with areas of bold, non-naturalistic colors (such as the red grass) and distinct outlines around the contours of the figures, suggests the influence of Japanese prints (see "Parallel Cultures," pages 434–5).

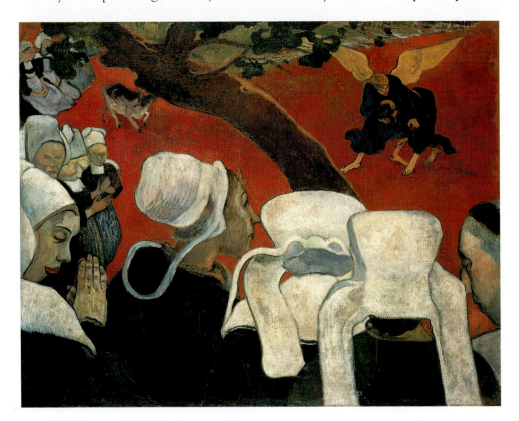

13.4 Paul Gauguin, *Vision after the Sermon (Jacob Wrestling with the Angel)*. 1888. Oil on canvas, 28³/₄" x 36¹/₄". National Gallery of Scotland, Edinburgh

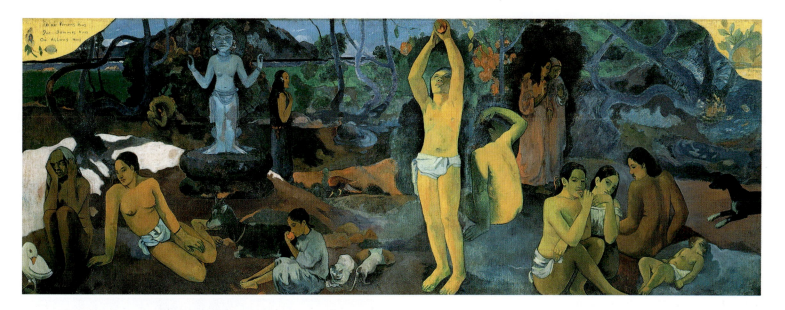

Searching for Meaning

Gauguin's search for spiritual and artistic renewal led him to study the art of non-Western cultures, including that of India, Egypt, and Indonesia. A Parisian stockbroker, married with five children, Gauguin began searching for an antidote to Western materialism. Drawn to the myth of primitivism, in 1891, aged forty-three, he abandoned his family and moved to Tahiti. There, he hoped to live in a society free from the decadence of Western culture, in tune with the rhythms of nature, and sexually free—in short, in an earthly paradise of pleasure and plenitude—and much cheaper than Paris, too. What he actually found was a culture whose traditions had been corrupted beyond recognition by a century of French colonialism. Nevertheless, Gauguin maintained the myth of a primitive tropical paradise in his paintings. The work he produced in Polynesia is a visually brilliant and sensuously evocative portrayal of a tropical paradise dripping with fruits and compliant young girls. These images of plenty are completely at odds with the reality of his subsistence on imported tinned foods and his crude exploitation of local girls and their family food supplies. Neither does it reveal even a trace of the disease and hardship that drove him to attempt suicide.

Paul Gauguin's *Where Do We Come From? What Are We? Where Are We Going?*

While contemplating suicide, in 1897 Gauguin painted a large canvas, intended as a summary of all his art and philosophy: *Where Do We Come From? What Are We? Where Are We Going?* (fig. 13.5). In this work Gauguin posed allusive existential questions through sensuously decorative forms. He wrote that the power of the painting

13.5 Paul Gauguin, *Where Do We Come From? What Are We? Where Are We Going?*. 1897. Oil on canvas, 57³/₄" x 147¹/₂". Museum of Fine Arts, Boston

lay in its raw energy rather than its narrative, yet he nevertheless identified most of the figures and actions, which he intended to be viewed from right to left.

Starting with the sleeping baby at the lower right, the viewer proceeds to the central figure, a young girl picking fruit—a Tahitian Eve plucking a fruit from the fateful Tree of Knowledge—and concludes with the crouching figure of an old woman on the left "approaching death ... and resigned to her thoughts." In the right background, "two figures dare to think of their destiny;" presiding over the left half is a Maori idol which, with "both arms mysteriously and rhythmically raised, seems to indicate the beyond." Here the primitive and the feminine join with nature into one living mystery. Gauguin's painting evokes a world which has no apparent meaning beyond its own mythic abundance and luxuriant sensuality. Like its title, it raises more questions than it answers.

Despair

Around the same time that Gauguin struggled to maintain his dream of mythical bounty in a tropical paradise, the philosopher Friedrich Nietzsche first raised for Europeans the notion of the death of God, who he said had been killed by the advance of scientific knowledge. This left humanity severed from traditional sources of spiritual sustenance, alone in a seemingly impersonal and material universe, and struggling with alienation.

Edvard Munch's *The Scream*

No artist has captured this spiritual alienation more acutely than the Norwegian Edvard Munch (1863–1944). In his 1893 painting *The Scream* (fig. 13.6), Munch turned to the non-naturalistic, expressionistic techniques of Gauguin and Van Gogh in a characteristically Symbolist approach to art. This artistic strategy perfectly suited his melancholy, introspective temperament, and his need to use art as a vehicle to express strong feelings. Munch took extreme liberties with his torturous manipulation of form and color: The cosmos appears to vibrate with the intensity of his colors and sweeping brushstrokes. Munch tipped the balance held by Van Gogh and Gauguin between feeling and nature in favor of feeling. His art powerfully expressed his sense of alienation in ways that have spoken forcefully to others, including many in the twentieth century.

THE SELF

The desire of nineteenth-century avant-garde artists to paint the life of their own time led to artistic exploration of contemporary experience unmatched since Dutch seventeenth-century art. In nineteenth-century France, this new focus can be related to the demise of aristocratic influence, the prominence of the middle classes, and the appeal of socialism to a number of gifted artists. In America, a spirit of rugged independence also prompted an interest in painting ordinary people in their everyday contexts.

Artists and writers who adopted social realism as their model represented a whole new spectrum of human experience: The weary road-worker, the gaiety of dance hall patrons, the Sunday outing, the sleazy denizens of the night cafés, the youthful ballet dancer, and the rural schoolboy. Many such novel subjects appear in the paintings of the period, even as photography made pictorial immortality available to all. The Realists, Impressionists, Post-Impressionists, and Symbolists each developed distinct approaches to these themes; we will follow them in the same sequence, looking finally at American artists' fresh responses to their particular experiences.

Realism and Socialist Ideals

In 1849, a year after the collapse of the French Revolutionary government of 1848, Courbet painted two controversial large-scale works, *The Stonebreakers* (fig.

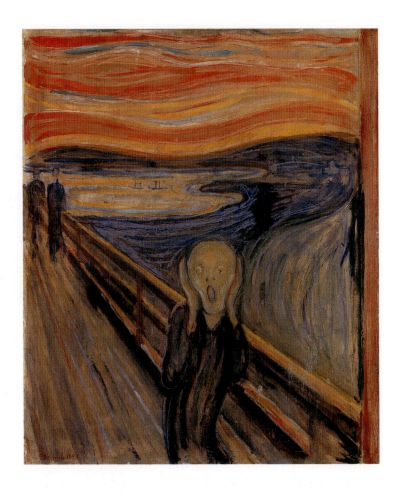

13.6 Edvard Munch, *The Scream*. 1893. Oil, pastel, and casein on cardboard, 35³/₄" x 29". Nasjonalgalleriet, Oslo

13.8) and *The Burial at Ornans*. Technically, both paintings were relatively conventional, but their subjects were not. Sympathetic to the socialist ideals of the anarchist philosopher, Pierre Joseph Proudhon, Courbet presented common people on a scale formerly reserved for princes and heroes. The plebeian subject matter combined with its huge scale caused an uproar. Courbet was, in effect, making a plea in behalf of oppressed laborers, similar to that made (unbeknown to Courbet) by Karl Marx in the *Communist Manifesto* of 1848.

Gustave Courbet's *The Stonebreakers*

Courbet's *Stonebreakers* is an unsentimental representation of two ragged laborers. Salon viewers, used to idealized human figures, were confronted with the awkward, disheveled rear-view of a boy sorting rocks. Courbet refused to deliver the expected portrayal of youth in the sensual glory of its prime, and his subsequent works were rejected by the Paris Universal Exhibition of 1855. He responded by holding his own show in a separate pavilion. This event marked the beginning of the modern

avant-garde artistic stance, challenging the status quo. Courbet had dared to elevate the poor at a time of social and political unrest, thoroughly offending the establishment (see "The Artist as Rebel," p. 402).

Gustave Courbet's *The Young Ladies of the Banks of the Seine*

At the Salon of 1857, Courbet exhibited a painting entitled *The Young Ladies of the Banks of the Seine (Summer)* (fig. 13.7) that approaches the female figure in the direct, uncompromising terms of *The Stonebreakers*. One girl has stripped off her dress, flopped down on it, and dozed off; the other gazes vacuously into the distance. Their unrefined features, languid abandon, and the nearer woman's lavish display of her petticoats and chemise identifies them as two disreputable women enjoying some leisure moments in the protective shade of a tree.

The women's air of moral abandon might escape our modern eye, but Courbet's contemporaries found their portrayal indecent. One writer, however, supported Courbet's truth to the realities of daily life and, scorning the

artifice and hypocrisy of much Salon art, observed astutely that the public "accepts monsters with goat's feet who carry off completely naked fat women, but it does not want to see the garters of the girls of the Seine." The Salon public had gladly accepted Ingres's culturally distant *Odalisque with a Slave* (see fig. 12.23), but they found Courbet's art too raw, and direct.

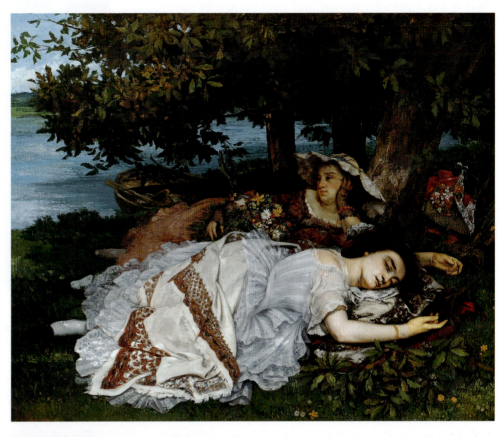

13.7 (above) Gustave Courbet, *The Young Ladies of the Banks of the Seine (Summer)*. 1857. Oil on canvas, 68 1/8" x 81 1/8". Musée du Petit Palais, Paris

13.8 Gustave Courbet, *The Stonebreakers*. 1849. Oil on canvas, 5'3" x 8'6". Formerly Gemäldegalerie, Dresden (destroyed in World War II)

Photography and Democratic Portraiture

Since the Renaissance, artists had been interested in creating images that conformed to the way the eye perceives things, and they had experimented with a number of mechanical aids. The **camera obscura** (literally "dark room") was a popular device, and could range in size from an enclosed room to a small box. It had a tiny hole in one end, which acted as a lens through which the exterior light projected an inverted image on the opposing interior surface. The word photography comes from the Greek word meaning "writing with light." An artist could trace the image projected in a camera obscura as an aid to drawing from nature, but there was no other way to make the image permanent. The development of light-sensitive silver salts finally made it possible to reproduce the projected image. In the 1830s Louis-Jacques-Mandé Daguerre (1789–1851) invented a silver-plated copper sheet, called a **daguerreotype**, that produced a clearer image and required less exposure time than the earliest photographs. Improvements would further reduce the exposure time, allowing for photographs not only of still-life and landscapes, but also of people and events.

A conceptual and stylistic interaction between painting and photography soon began. Each medium now had to take account of the other. Many artists began—sometimes surreptitiously—to use photographs as a substitute for or aid to preliminary drawings. Photographs could also capture and hold novel angles of vision. Photographers, for their part, had to find their way somewhere between imitating the visual effects and poses of the painters, and discovering modes of representation uniquely suited to their new medium. In 1839, an Englishman, William Henry Fox Talbot (1800–77), invented the negative. Now multiple prints could be made but a longer exposure time was required. This explains the rigid look of early photographs. Cheap photographic portraiture was available to virtually everyone. Portrait photography soon also became a fine art, as in Robert Howlett's portrait of *Isambard Kingdom Brunel* of 1857 (see fig. 13.9).

Robert Howlett's *Isambard Kingdom Brunel*

Photographic portraiture meant that anyone—not just the social elite who could hire a portrait painter—could enjoy a form of visual immortality. There were portrait factories which mimicked industrial mass production, but portrait photography could also be a fine art, as in the case of

13.9 Robert Howlett, *Isambard Kingdom Brunel*. 1857. Photograph. The National Portrait Gallery, London

Robert Howlett's (1831–58) portrait of the British engineer Isambard Kingdom Brunel of 1857 (fig. 13.9).

Brunel designed the largest steamship of the century, the *Great Eastern*, and the success of the photograph derives largely from the juxtaposition of the engineer's nonchalant pose against a background comprised of the powerful links of the ship's anchor chains. Standing there in his wrinkled clothes, cigar in mouth and hands in pockets, he cuts a swaggering image of the type of rugged, hard-nosed individual who forged Britain's industrial prosperity.

Manet and the Impressionists: Painters of Modern Life

Baudelaire had called on artists to "seize the epic quality of contemporary life." Among French artists, the one who seemed, above all, to respond was the Realist Édouard Manet (1832–83). Unlike Courbet, Manet belonged to a

socially conservative and fashionable milieu, but he shared Courbet's commitment to painting the life of his own time. He focused on the pleasures of the urban social elite, and developed pictorial techniques that would make the painted image seem more lifelike.

Édouard Manet's *Luncheon on the Grass*

In 1863 Manet submitted his painting *Luncheon on the Grass* (*Déjeuner sur l'herbe*) (fig. 13.10) to the Paris Salon. The Salon responded by rejecting it in disgust. A public and critics who had so recently been offended by Courbet's *The Young Ladies of the Banks of the Seine* (see fig. 13.7) were not likely to approve Manet's radical transformation of the ideal into the real. Both the subject and technique provoked outrage.

Although paintings of idealized nude figures could be seen in the Louvre, the naked woman in Manet's painting was not an allegorical figure, but the artist's own model, Victorine Meurent. She sits there naked and unashamed, gazing directly at the viewer, accompanied by Manet's brother and his friend, decked out in their frock coats and cravats. Nor did it help Manet that their poses were derived from three nude figures from a Renaissance allegory, because Manet had transposed the acceptable abstraction of imaginary, mythic nudes into the concrete and immediate terms of a woman of doubtful virtue picnicking with two Parisian students.

The writer Émile Zola defended Manet's painting for its formal qualities—the solidity of the figures and the picnic still life, contrasted to the delicacy of the landscape. But the most notable aspect of his technique, which Zola also noted, is the way he attempted to establish a sense of immediacy by using broad, light areas of bright color offset by black and grays in the shadows, and by virtually eliminating the half-tones between the areas of light and shadow. In so doing, Manet rejected the subtly modulated tonal transitions of established practice in favor of harsher contrasts and brighter highlights, creating a flatter surface effect. His paintings exude a freshness which, by comparison, make Courbet's art appear dark and conventional.

Critics have attributed Manet's strongly contoured forms and the virtual elimination of half-tones to various sources—photography, Japanese prints, and effects of color and light in such Spanish masters as Velázquez and Goya, with whom he was familiar. As a result, he found a way to counter the stiff conventions of academic art with more lifelike effects, and to treat color and light more as they appear naturally to the eye.

The rejection of Manet's painting, along with many others that year, led to the establishment of the famous Salon des Refusés, which allowed the public to judge (or ridicule) the rejected works for themselves. Thereafter this alternative Salon became a forum for other avant-garde artists, most notably the Impressionists (see below).

13.10 Édouard Manet, *Luncheon on the Grass*. 1863. Oil on canvas, 6'9⁷⁄₈" x 8'8". Musée d'Orsay, Paris

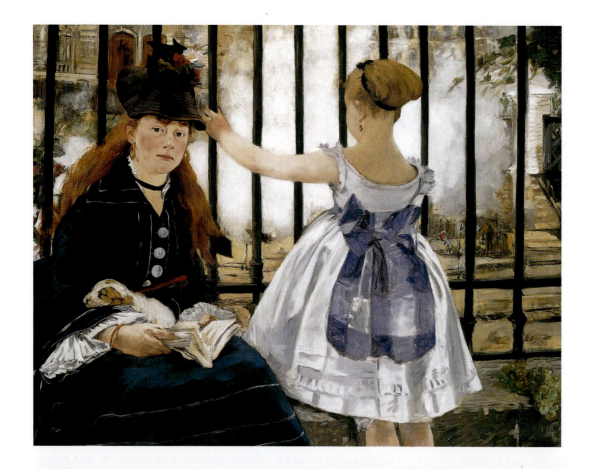

13.11 Édouard Manet, *The Railroad*. 1873. Oil on canvas, 36 1/2" x 45". National Gallery of Art, Washington, D.C.

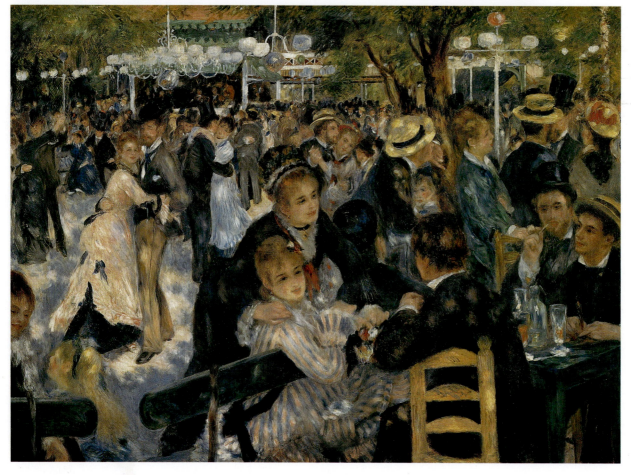

13.12 Pierre-Auguste Renoir, *Le Moulin de la Galette*. 1876. Oil on canvas, 51 1/2" x 69". Musée d'Orsay, Paris

Édouard Manet's *The Railroad*

Manet continued to submit works to the official Salon, including his painting *The Railroad* of 1873 (fig. 13.11). When he painted *Luncheon on the Grass*, Manet was still attached to traditional motifs, such as the nude, although he interpreted them in radical new ways. By the time he painted *The Railroad* he had befriended a younger group of artists, the Impressionists, who attempted to capture the present moment more directly. Their example led Manet to brighten his colors and render the immediacy of contemporary life, with no concession to traditional subjects or standard compositional formulas.

In this painting, Manet depicts a casual moment of modern experience, organizing his image around the rhythm of the railings. These railings divide the field of interest that commands the gaze of the woman and the girl: Leaning against them, the woman looks up from her book to engage the passer-by, while the little girl, peering through them, is intrigued by the wafting smoke and bustle of the new railroad station, the Gare St.-Lazare in Paris. The subject could hardly be more informal or more contemporary, yet it gave Manet vivid materials from which to create a powerful painting. Here, then, was Baudelaire's painter of modern life.

Pierre-Auguste Renoir's *Le Moulin de la Galette*

In Manet's art, individual figures remain dominant, but with the Impressionists, the emphasis shifts on to the multitude, caught up in the whirl of life and bathed in radiant color and light. Such is Pierre-Auguste Renoir's (1841–1919) *Le Moulin de la Galette* of 1876 (fig. 13.12). This is a world of urban bourgeois pleasures, devoid of the elevated subject matter of earlier art. Renoir's art, like that of other Impressionists, brims over with the vitality of each fleeting sensation of everyday life. In this painting, the scattered grouping of the dance hall patrons evokes a whirl of human energy. Where artists had traditionally focused light to model forms and draw attention to the primary figures, Renoir's random blobs of light and shadow break up the solidity of human forms and create the impression of an undifferentiated multitude seen in a chance moment. His painting claims no significance beyond delight in the festive sight of dancing couples.

13.13 Edgar Degas, *Ballet Rehearsal ("Adagio")*. 1874. Oil on canvas, 23" x 33". The Burrell Collection, Glasgow, Scotland

Edgar Degas's *Ballet Rehearsal ("Adagio")*

Edgar Degas (1834–1917), an associate of the Impressionists, never adopted their technique of using flecks of brilliant color to simulate the shimmering effect of people and objects as seen in bright sunlight. He preferred indoor subjects, such as his *Ballet Rehearsal ("Adagio")* of 1874 (fig. 13.13). Degas relied more on drawing than the Impressionists, as can be seen in his taut definition of the limbs of the dancers. But he shared the Impressionists' goal of capturing momentary action in a way that would make the viewer feel immediately present as in Renoir's *Le Moulin de la Galette* (see fig. 13.12).

Degas also cultivated seemingly accidental, unframed effects, with figures rendered from odd angles or partly cut off, as they are often seen in photographs. He also admired and collected Japanese prints, which often used a high viewpoint so as to manipulate architectural lines to accentuate surface pattern rather than spatial recession, as Degas does with the floorboards in this painting (compare fig. 13.43).

All these devices contribute to the informal effect of a casual encounter in Degas's *Ballet Rehearsal*. Here, it is as if we have just entered the room and chanced upon an arbitrary moment in an everyday routine. With nothing of significance directly before us, our attention is drawn off to either side, and even then our view of the graceful young ballerinas is partly obstructed on one side by the spiral stairs. As a result, a secondary incident, in which a lady adjusts a dancer's costume, dominates the right foreground,

and the dancing master takes backstage beyond the dancers. For Degas, as for his Impressionist friends, the casual experiences of everyday existence provided subject enough for art.

This informal, decentralized composition ignores the traditional practice of placing the most important figure in center-front stage. Instead, Degas observes the human body in a variety of informal, unposed moments, as seen in the arbitrary fall of light streaming in the windows.

Post-Impressionist Responses to Modern Life

The Post-Impressionists continued to draw human themes primarily from the modern urban world of pleasure and recreation, but they abandoned the Impressionists' preoccupation with instantaneity. Instead they steered Impressionism's vitality toward either a greater sense of enduring order, or a deeper expression of human feeling. We will take Georges Seurat (1859–91) as representative of the first strategy, and van Gogh and Henri de Toulouse-Lautrec (1864–1901) as examples of the latter.

Georges Seurat's *A Sunday Afternoon on the Island of the Grande Jatte*

The subject of Seurat's large painting, familiar from the Impressionists, is recreation on the outskirts of Paris (fig.

13.14). A variety of city types idle under the trees, stroll, fish, and go boating on the Seine, but the whole effect is strangely impersonal. We see a cross-section of society as if frozen in time, gazing out over the water without encountering one another. While the subject addresses issues of social class, this concern appears suffocated by the artist's rigorously systematic working methods.

Underlying Seurat's method was the desire to achieve harmony through a carefully balanced design. Forms, typically seen in silhouette, were reduced to basic geometric shapes, and repeated in rhythms of vertical and horizontal bands. To achieve this, and in contrast to the direct approach of the Impressionists, Seurat made numerous preparatory studies. His paintings also show some of the geometric structure and compositional stability of traditional classical art.

As part of this search for formal harmony, he employed a carefully calculated opposition of contrasting colors. Indeed, there are no solid lines in Seurat's painting, only series of colored dots. He juxtaposed small uniform dots of unmixed pigments, which the eye itself blends to produce secondary hues. This method of optical mixture, known as **divisionism**, can be traced back through Impressionism to the experiments of Constable and Delacroix (see Chapter 12).

Seurat's method drew on contemporary theories of color perception. He also believed that the affective qualities of color followed scientific principles in naturally evoking particular moods. Seurat hoped to restore to painting something of its former cultural authority and enduring order.

13.14 Georges Seurat, *A Sunday Afternoon on the Island of the Grande Jatte.* 1884–6. Oil on canvas, 6'9³/₄" x 10'1¹/₄", The Art Institute of Chicago

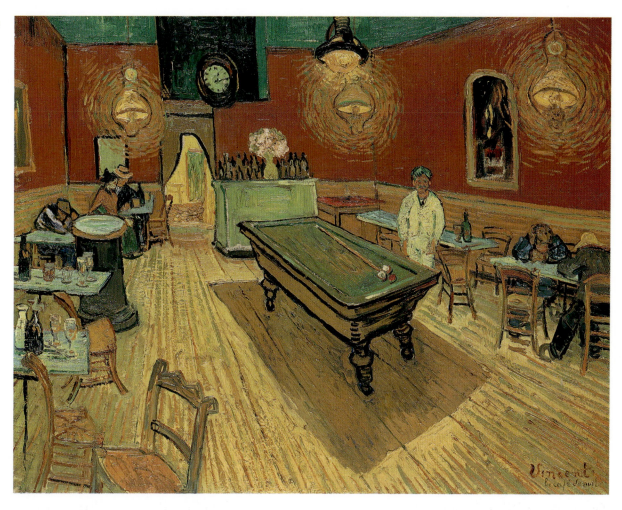

13.15 Vincent van Gogh, *The Night Café at Arles*. 1888. Oil on canvas, 28½" x 36¼". Yale University Art Gallery, New Haven, Connecticut

Vincent van Gogh's *The Night Café at Arles*

When van Gogh left Paris for the south of France, he also moved away from Impressionism. Where the Impressionists brilliantly projected the play of light on surfaces, van Gogh used color, line, and pattern to represent the mood and emotion of people and places. His pictorial technique was influenced by the strong, flat colors of Japanese prints (see "Parallel Cultures," pages 422–3). In the process, he developed his own highly charged style, vividly apparent in his painting *The Night Café at Arles* of 1888 (fig. 13.15).

Through its violent colors, agitated brushmarks, and unstable composition, van Gogh evokes not only the atmosphere of the night café, but also a sense of anguished solitude. Describing *The Night Café* in a letter to his brother Theo, he wrote: "I have tried to express the terrible passions of humanity by means of red and green. The room is blood red and dark yellow with a green billiard table in the middle ... everywhere there is a clash and contrast of the most disparate reds and greens." Chromatic contrasts, used so clinically by Seurat, with van Gogh become the vehicle of intense passion. As he wrote in another letter, he sought to

convey in this painting "the idea that the café is a place where one can ruin oneself ... So I have tried to express, as it were, the powers of darkness in a low public house." In moving beyond Impressionism, van Gogh thus shifted the emphasis from depicting an impression of surfaces to giving expression to what lies within.

Henri de Toulouse-Lautrec's *At the Moulin Rouge*

A similar shift away from Impressionism can be seen in the work of the Parisian Toulouse-Lautrec. In his style, elements of Degas's informal compositional structures and van Gogh's use of intense colors come together, as in *At the Moulin Rouge* of 1892 (fig. 13.16). This painting is also a masterly characterization of the life of Parisian music and dance halls.

Toulouse-Lautrec is best known for color lithographs and posters that manifest a boldness of design, broad washes of color, and memorable human characterizations (see fig. 13.44). But his painting *At the Moulin Rouge* reaches beyond striking design to capture potently the seedy atmosphere of the era's dance halls, with their mix

of elegance and emptiness. He also sums up the fascination of a number of artists with the pictorial effects of Japanese prints—the tilting up of perspective, the flattening of architectural elements into an intricate surface pattern, and weaving the contours of the figures into a surface pattern that challenges the centuries-old tradition of receding perspective. In so doing, Toulouse-Lautrec rejected tenets of the Western artistic tradition, which those in his circle associated with the social decadence represented by the subject of the painting—a decadence in which they too found themselves to be caught.

The Symbolist Retreat from Naturalism: Rising *Ennui*

Already in 1859, even before the Impressionists had made their mark, the Symbolist poet Baudelaire, usually an advocate of addressing contemporary experience, criticized the Realists. "Each day," he wrote, "art further diminishes its self-respect by bowing down before external reality." For Baudelaire the visible world was like a "pasture which the imagination must digest and transform." Symbolist painters such as Gauguin and Munch shared Baudelaire's views on art; they aimed to capture, not external reality, but their own inner experience. The same tendency appears in the art of the Parisian sculptor Auguste Rodin (1840–1917).

Auguste Rodin's *The Gates of Hell*

Rodin exemplifies Baudelaire's ideal of transforming nature in the imagination. Rodin always started by making a series of studies based on live models. But he went on to transform these studies so that they represented states of mind and depths of feeling. As a result, in works such as *The Burghers of Calais* (see fig. 1.8), he fathomed the life of the human soul in a way that few sculptors had since Michelangelo and Bernini.

In his unfinished masterpiece *The Gates of Hell*, Rodin powerfully expressed the spiritual malaise and sense of futility that affected a number of late nineteenth-century French artists disenchanted by the materialism of society (fig. 13.17). It was commissioned in 1880 as a monumental bronze door for a new museum, but was never completed or installed. Rodin worked by endlessly adding and subtracting clay and plaster figures on a plaster model for the *Gates*, whose architectural framework was designed to recall Gothic and Renaissance portals (see fig. 6.10). But Rodin's despairing theme and endlessly swirling figures reflect his distance from the more certain spiritual vision of those periods.

did with many of the figures from the *Gates of Hell*.

The pose of *The Thinker* recalls both Carpeaux's tragic *Ugolino* (see fig. 12.12) and Dürer's famous engraving of *Melencolia*, stooped over, with head in hand. Rodin's *Thinker*, too, sits pensively with head on hand, denoting the mood of the creative individual whose personal "inferno" is the incapacity to give effective form to his or her understanding of the depth of human experience. *The Thinker*, like the artist, is thus doomed to pursue endlessly an unattainable goal, like the futile striving of the figures on *The Gates of Hell*. This theme is echoed in Rodin's endless, unresolved process of adjusting the composition of *The Gates of Hell*.

13.18 Auguste Rodin, *The Thinker*. 1880–89. Bronze, height 27¹/₂". The Metropolitan Museum of Art, New York

The theme of *The Gates of Hell* was inspired by scenes in Dante's *Inferno*, but Rodin's hell was a modern one, influenced by Baudelaire's concept of spiritual weariness or *ennui*. This hell is one of flux and endless, futile striving, of unfulfilled longing, in which surging figures rise and fall, grasping at air, reaching out toward one another but never connecting. Presiding over this tragic world of psychic distress, on the lintel above, where medieval artists placed Christ in Majesty (as at Chartres, see fig. 6.10), Rodin placed *The Thinker*, a figure he also enlarged into an independent sculpture (fig. 13.18), as he

13.17 (above)
Auguste Rodin,
The Gates of Hell.
1880–1917.
Bronze,
18' x 12' x 2'7".
Kunsthaus, Zurich

13.19 Edvard Munch, *The Dance of Life*. 1899–1900. Oil on canvas, 49¹/₂" x 75". Nasjonalgalleriet, Oslo

Edvard Munch's *The Dance of Life*

The Symbolists' tendency toward morbid introspection inspired a series of paintings by Munch. As a student in Paris, Munch had been influenced by van Gogh and Gauguin. The series was conceived as a *Frieze of Life*, with *The Dance of Life* (fig. 13.19), painted in 1899–1900, intended as its summary. Its motif of couples dancing out of doors derives from the ritual of Scandinavian midsummer dance festivals. Munch grouped the dancing couples like figures on a traditional triptych altarpiece, drew them in bold outline, and painted them in broad, flat areas of emotionally charged colors.

The painting's theme is the cycle of life, portrayed in terms of human sexuality and the rhythms of nature. The cyclical moon, with its (phallic) reflection on the sea (whose ebb and flow it rules), presides over the midsummer ritual, uniting the couples not only with each other, but also with the rhythms of nature. This frieze of life starts on the left with a fresh young woman in virgin white standing beside a blooming flower. She motions toward the couple at center. Here the woman's burning red robe arouses and answers her partner's desire, whose more animal drives are repeated in one of the background figures. On the right a widow, dressed in black, her spent sexuality suggested by the gesture of her folded hands, stands mournfully contemplating her sorrowful lot.

Munch's color symbolism suggests (as well as the opposition of the sexes), an inescapable and ultimately meaningless cycle of arousal, encounter, and withdrawal, or growth, maturity, and decline. Like other Symbolists, Munch gives form to inner experience rather than the surface appearance of reality.

The American Experience

Among the many different artistic responses to the American experience of the late nineteenth century, two stand out. There were those who saw in America a country with no history, and only a "commonplace prosperity," as the writer Nathaniel Hawthorne put it, which offered little inspiration to the aspiring artist. Others believed that American democracy could and would produce its own distinct culture, which would be guided by the pragmatic American sensibility and a deep-rooted Protestant distrust of the imagination.

For artists of both persuasions—and for their patrons—European travel was a formative experience. In Paris and Rome, Americans were exposed to works of art, cultural traditions, and an artistic discourse that was scarcely available in the New World. There were, however, dissenting voices, such as that of Mark Twain, whose account of European

13.20 Winslow Homer, *Snap the Whip*. 1872. Oil on canvas, 22¼" x 36½". The Butler Institute of American Art, Youngstown, Ohio

sight-seeing in his book *Innocents Abroad* is as much a put down of the glories of European culture as his *Tom Sawyer* is a celebration of earthy American life. This tension between cosmopolitan attractions and the home-grown virtues of American culture runs through the art we will explore.

Mary Cassatt's *Woman in Black at the Opera*

Mary Cassatt (1844–1926) is a significant exponent of the cosmopolitan trend. After studying for four years at the Pennsylvania Academy in Philadelphia, she tired of drawing from plaster casts rather than live models, and moved to Paris, where she became a friend of Degas and a member of the Impressionist

13.21 Mary Cassatt, *Woman in Black at the Opera*. 1880. Oil on canvas, 31½" x 25½". Museum of Fine Arts, Boston

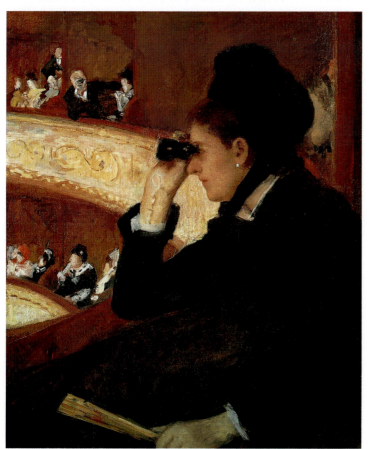

group. She adopted the Impressionists' bright palette, and, like them and Manet, painted informal, everyday subjects. These included intimate domestic scenes of women and children, visits to the opera, and boating parties. She also shared Degas's interest in the treatment of line, space, and form in Japanese prints, which is particularly evident in her graphic art.

Cassatt's *Woman in Black at the Opera* (fig. 13.21), painted in 1880, recalls works by Manet and Renoir of spectators seen at the theater or opera or on balconies overlooking the street. Whereas in their works the woman is typically the passive object of the male gaze, Cassatt depicts the woman asserting her independent right as an active observer. The woman leans forward forcefully, striking a determined and active pose, and remains ironically oblivious to the man across the balcony who uses his opera glasses to stare at her.

Here Cassatt sounds a theme that informs a number of her paintings—the acquisition of knowledge by women. More often, however, she painted women in the more traditional maternal role, which she herself did not occupy. Her financial independence allowed her to live in Paris and cultivate a cosmopolitan artistic outlook.

Winslow Homer's *Snap the Whip*

In contrast to Cassatt, the Boston painter Winslow Homer (1836–1910) embraced the rugged American scene. Although he had spent almost a year (1866–7) in Paris, where he was exposed to the work of Courbet and Manet, Homer was a largely self-taught Realist, who learned from the careful study of nature. His sharp eye, deft brushwork, and intent realism—a legacy from his

experience as an illustrator—all create a sense of directness in his painting *Snap the Whip* of 1872 (fig. 13.20).

The unpretentious subject of a group of country boys enjoying recess outside a one-room school set in a sheltered meadow amidst an otherwise untouched landscape expresses exactly the lack of sophistication in American culture that some lamented but others valued. The novelist Henry James, a notable cosmopolitan in outlook and life-style, grudgingly acknowledged Homer's agreeable qualities and the integrity of his realism, but found his subjects "horribly ugly." His "big, dreary, vacant lots of meadows, his freckled, straighthaired Yankee urchins, his flatbreasted maidens," James laments, have been chosen from "the least pictorial features of the least pictorial range of scenery and civilization." Yet Homer has "treated them as if they were pictorial, as if they were every bit as good as Capri or Tangiers."

Thomas Eakins's *The Gross Clinic*

Another American artist who adopted a radical realism in style and subject was the Philadelphia artist Thomas Eakins (1844–1916). He too spent time in Europe (1866–70), where he absorbed much of the heavy impasto, dark tonality, atmosphere, and lighting of seventeenth-century masters such as Rembrandt and the Spanish

painters Velázquez and Jusepe de Ribera. The fruits of this study are evident in Eakins's dramatic portrait of a famous physician, Samuel Gross, painted in 1875 for the Jefferson Medical College, Philadelphia (fig. 13.22).

Eakins shows his debt to Rembrandt in the painting's conception, spot-lighting technique, and large shadowy areas, in which one can barely pick out the medical students observing the operation. But the glistening authenticity of the blood on the surgeon's hand, and of the area around the incision reflects Eakins commitment to an unsparing realism. Contemporaries reacted much like the patient's relative on the left, who shields her eyes from the shock of the sight. Eakins's pursuit of pictorial truth led him to use photography as a visual resource. He became an insightful portrait painter who, like Rembrandt, made few concessions to fashionable elegance. His paintings have the distinct ring of raw, American pragmatism.

Henry Ossawa Tanner's *The Banjo Lesson*

For a time, Eakins taught at the Pennsylvania Academy, where his most remarkable pupil was Henry Ossawa Tanner (1859–1937). As the son of a minister, Tanner developed strong Christian beliefs, and as Eakins's student, he would come to share his teacher's admiration for Rembrandt. When he moved to Paris in 1891, Tanner concentrated on biblical subjects, but he also painted a number of genre scenes of the African-American culture in which he had been raised, including *The Banjo Lesson* of about 1893 (fig. 13.23). The painting's composition, technique, and quiet, concentrated atmosphere reflect debts to Eakins and Rembrandt. Tanner surrounds the two figures in an aura of light, giving the subject a quasi-religious air which seems to sanctify the value of lessons transmitted from one generation to the next. Tanner captures the intimate bond between the old man and the young boy, and the contrast between ripe experience and innocent youth, beautifully accented in the figures' juxtaposed heads, and the way the strong, bony knees and wrinkled trousers of the old man form a protective shelter for the small, supple body of the young boy.

Tanner explained that he had turned to African-American subjects out of disgust for the lack of sensitivity shown by other artists when treating such subjects, who saw only the "comic" and the "ludicrous," and "lacked sympathy with and affection for the warm big heart within such a rough exterior."

13.22 Thomas Eakins, *The Gross Clinic*. 1875.
Oil on canvas, 8' x 6'6". The Jefferson Medical College of Thomas Jefferson University, Philadelphia

The life and art of these four American artists reflect the need each felt to draw from European sources in the formation of their style. Yet their subject matter was fitting to their particular experiences as Americans. There was, however, a time lag in trans-Atlantic cultural exchange, since it was not until the 1913 Armory Show in New York that American artists and collectors first became aware of European Post-Impressionist and Symbolist art of the late nineteenth century.

NATURE

In the second half of the nineteenth century, landscapes and cityscapes were popular subjects with artists, all the more so in light of the Realists' and Impressionists' rejection of academic subjects (especially historical and mythological themes) and commitment to truth to nature. As had been the case in seventeenth-century Holland, the absence of large-scale commissions from

Church and state, and an increasing middle-class demand for domestic art also boosted the market for landscapes and cityscapes.

Taking their lead from Romantics such as Constable, artists in both Europe and America approached their chosen environment directly and naturalistically, as did photographers. As we've seen in the section on "The Self," likewise in representing nature, Post-Impressionists reacted to the perceived limitations of such naturalism by seeking to heighten either the formal order of their compositions or their expressionistic responses to their subject. In considering these different approaches to nature, we will focus on the Impressionists and Post-Impressionists, as well as American landscape painting and photography.

Impressionism: The Landscape of Pleasure

The commanding authority of nature over the minds of nineteenth-century artists reached its peak with the Impressionists. Their subjects and method were dictated by a radical naturalism, painting only what is seen, and consistent with the way it is seen. There were many precedents for painting ordinary, local landscape, including those of recent French Realists, Romantics such as Constable (see fig. 12.16), and Dutch seventeenth-century artists such as Jan van Goyen and Jacob van Ruisdael (see figs. 10.16, 10.17). Precedents also existed for the Impressionists' handling of paint, notably Delacroix's application of color in individual brushstrokes that cause each daub of color to heighten the adjacent one. But the critical innovation of the Impressionists was to think and paint not in terms of an object's inherent form, but rather to capture something much more elusive, namely the coloristic quality of the light reflected from it (see also "Avant-garde Art in the Late Nineteenth Century," page 404).

Claude Monet's *On the Seine at Bennecourt*
Claude Monet (1840–1926) was the most consistent practitioner of Impressionism, through a lifetime of exploring its possibilities. Already in an early experimental work, *On the Seine at Bennecourt*, painted in 1868, Monet produced brilliant effects of color and sparkling light (fig.

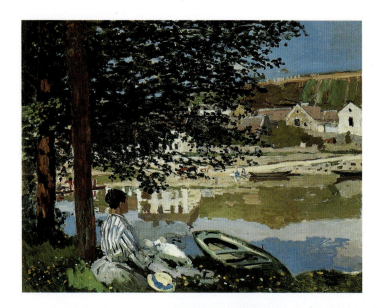

13.24; see also fig. 13.1). In this painting, Monet depicted his mistress (later his wife) Camille seated beneath a tree on an island of the Seine, at Bennecourt, northwest of Paris. Like many such Impressionist paintings, it evokes the appeal of weekend escape from the city. Monet puts before the viewer's eyes what Camille sees—the sheltered riverside village, and its reflection in the water. The viewer's eye is also captured by the distribution of color and light in bold brushstrokes across the surface of the painting.

Despite its restful subject and handling, the painting's first viewers found it shockingly bright, as indeed it is when compared to a scene such as Courbet's *The Young Ladies of the Banks of the Seine*, painted twelve years earlier (see fig. 13.7). Monet and his fellow Impressionists Renoir, Camille Pissarro (1830–1903), and Alfred Sisley

13.24 Claude Monet, *On the Seine at Bennecourt*. 1868. Oil on canvas, 32" x 39³/₅". The Art Institute of Chicago

13.25 Claude Monet, *Poplars*. 1891. Oil on canvas, 32¹/₄" x 32¹/₈". The Metropolitan Museum of Art, New York

(1839–99) went on to paint countless colorful scenes of the city, the popular cafés, and boating spots of the Parisian suburbs and the countryside beyond. Because of their bold technique, however, their paintings were slow in being accepted. Created at a time when life was becoming more urbanized, the Impressionists' colorful and refreshing images of country pleasures have become objects of universal admiration for our even more urbanized society.

Claude Monet's *Poplars*

Monet once explained his impressionistic procedure as an effort to forget the identity of the object in front of one, because that influences what one thinks one ought to see, in order to concentrate on painting what one really sees—little patches and streaks of color. From this fascination sprung Monet's search for subjects that offered him maximum potential for studying color and light. Increasingly, he was drawn to those of the most subtle and evanescent quality, as can be seen in his painting *Poplars*, from a series on this motif painted in 1891 (fig. 13.25).

Monet often worked in series, treating the same motif—whether a haystack, a cathedral façade, a river valley, or a row of poplar trees—under varying lighting conditions, at different times of the day and all seasons of the year. He worked in series, not to refine his portrayal of an object's form, but to capture the subtle changes of light. In *Poplars*, Monet focused his attention almost exclusively on gradations of light and color, and heightened their abstract pictorial qualities. In the contrasting rhythm of near and far trees, and the sensuous dance of color on the surface of the canvas, Monet transformed actual optical sensation into something almost trance-like. The varied quality of his brushstrokes and his brilliant color create a vibrating, painterly surface of extraordinary sensory allure, whose abstract, decorative beauty matches Monet's desire to paint the way a bird sings.

Yet Monet came to realize—when his wife lay dying and he instinctively tried to capture the changing gradations of gray that death was imposing on her face—that his artistic concerns had become completely absorbed by the process of observation and representation rather than on the significance of the subject matter. In the work of Whistler this tendency to stress visual sensation over subject had meanwhile taken a different turn.

James Abbott McNeill Whistler's *Nocturne in Black and Gold: The Falling Rocket*

The American-born James Abbott McNeill Whistler (1834–1903) moved to Paris in 1855 to study art, and subsequently settled in London, where he spent the rest of his life. His art reflects his interest in French artists such as Manet, Degas, and the Impressionists. But he is best known for his *Nocturne in Black and Gold: The Falling Rocket* (fig. 13.26), painted about 1874, deliberately titled like a musical score to suggest that he desired his works to be experienced as something close to pure form, virtually non-representational.

When accused by the English art critic John Ruskin of "flinging a pot of paint in the public's face," Whistler sued for libel and won. The painting is based on his observations of a firework display. In defending his work, Whistler stressed his aesthetic intentions, in orchestrating the formal elements of art (light, color, and composition) above any extraneous, narrative content, based on its subject matter. As such, he anticipated the focus on the sensory qualities of color and light seen in Monet's 1891 *Poplars* (see fig. 13.25). Whistler thereby also articulated a formalist aesthetic which anticipates, in some respects, the twentieth-century development of non-figurative, abstract painting.

13.26 James Abbott McNeill Whistler, *Nocturne in Black and Gold: The Falling Rocket.* c. 1874. Oil on panel, 23³/₄" x 18³/₈". The Detroit Institute of Arts

Post-Impressionism: Naturalized Classicism and Expressionism

The work of both Whistler and late Monet called into question the conflicting authority of nature and art in constituting a painting. Paul Cézanne (1839–1906) once said that he wanted to make of Impressionism something solid and durable, like the art of the Old Masters. By this he implied that he sought to retain the Impressionists' subjects and methods, working directly before motifs from everyday life, but without abandoning the structured order of traditional art. The desired outcome of these goals was a form of naturalized classicism, as seen in his *Mont Sainte-Victoire* of 1885–7 (fig. 13.27).

Paul Cézanne's *Mont Sainte-Victoire*

In Cézanne's painting, the landscape is "framed" and scaled by the foreground tree, beyond which a cultivated plain in the mid-ground opens up, with mountains in the background to close off a balanced, orderly composition. Compared to the fleeting and fragmentary quality of Monet's *Poplars*, Cézanne's composition suggests a complete microcosm, ordered and balanced in its elements.

In that respect, it resembles the landscapes of the French seventeenth-century artists Nicolas Poussin or Claude Lorraine (see figs. 9.33, 9.34). Yet, when

Cézanne's painting is compared to those of Poussin and Claude, what strikes the eye is the bright palette and freshness of outdoor vision, and also the way Cézanne lays each brushstroke on the surface of the canvas so as to register individually on the eye. These brushstrokes typically took the form of a repeated series of short gestures. Cézanne used the shape, size, and direction of each brushstroke broadly to define the object represented; but the distinct mark of each brushstroke also heightens the surface texture of the painting. This distinct mark-making became even more pronounced in Cezanne's later work, and signaled a further shift away from naturalism toward abstraction, with a strong emphasis on a painting's visual balance and composition, rather than on the expression of subjective inner feelings.

The way in which Cézanne's mark-making draws attention to the materiality of paint on a flat canvas proved critical to Pablo Picasso (1881–1993) and Georges Braque (1882–1963), and thereafter to many other twentieth-century artists (see Chapter 14). Cézanne, having set out to hold nature and art in balance, ended up by moving more toward abstract formalism; he is sometimes called the father of modern art.

Vincent van Gogh's *View of Arles*

While Cézanne moved toward abstract formalism, van Gogh pushed the Impressionists' brilliant color and deft handling of paint toward expressionism. He used color and painterly gestures as a vehicle to express the intensity of his feelings. Exposure to the Impressionists had transformed van Gogh's palette and technique (once somber and heavy), and like many late nineteenth-century artists, he was captivated by the composition, line, and color of Japanese prints, then readily available in Paris.

His *View of Arles* (fig. 13.28), painted in 1889, manifests his desire to see the landscape of the south of France in terms of the form and feeling of Japanese art. By emulating Japanese art, van Gogh departed

13.27 Paul Cézanne, *Mont Sainte-Victoire*. c. 1885–7. Oil on canvas, 26³/₈" x 36¹/₄". Courtauld Institute Galleries, London

13.28 Vincent van Gogh, *View of Arles.* 1889. Oil on canvas, 28¼" x 36¼". Neue Pinakothek, Munich

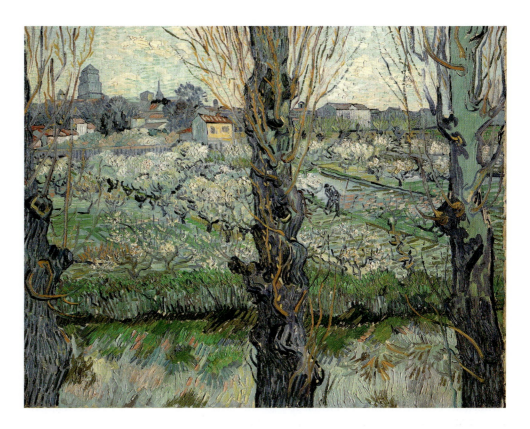

radically from the compositional and graphic conventions of Western landscape painting. We can see this Japanese influence in the spiky trunks of the three foreground poplar trees that slice the canvas vertically from top to bottom, much as in Monet's equally unconventional *Poplars* of 1891 (compare fig. 13.46).

Van Gogh's fluid, drawn-out brushstrokes recall the graphic marks of some of his drawings, in which he attempted to emulate the quality of Japanese penmanship. For van Gogh, these marks carry as much an emotional as a descriptive charge, since their linear movements give off a visual energy that vibrates throughout the painting. Thereby, van Gogh's initial joy in his imaginary "Japan" resonates through the whole landscape, with its blossoming almond trees and its cheerful palette, with pink and yellow contrasted with bright green and cooled by gray-blue. Both line and color, then, serve expressionistic rather than naturalistic ends.

Exploring the American Landscape

American artists of the late nineteenth century responded to many of the experiments by their European counterparts. Some continued the Romantic tradition of landscape painting. But perhaps the most original

❖ MATERIALS AND TECHNIQUES ❖

Watercolor

Watercolor, or aquarelle, is a fluid and transparent paint made of pigment mixed with gum arabic and thinned with water. Watercolor paintings are built up by applying thin washes of color to (often dampened) white paper. It is a fairly difficult medium, since the paint is very fluid and hard to control. White pigment is not used in watercolor, as it makes a transparent medium into an opaque one. Where it is needed, the white of the paper is left to shine through the color wash, or is left unpainted. Corrections are difficult in watercolor, because painting over colors will reduce their transparency and muddy the end result.

Watercolor is a spontaneous and fresh medium, whose color can range from pure and brilliant hues to soft, delicate tints.

Although pure watercolor was sometimes used in medieval manuscript illuminations, it was not until the late fifteenth century that Dürer painted with it as a transparent medium (see fig. 8.26). Because of its fluidity, watercolor is ideal for rapid sketches and studies. If applied skillfully, its effects can be stunning, as in the watercolors of Winslow Homer—one of the exceptional watercolorists of the nineteenth century (see fig. 13.29).

13.29 Winslow Homer, *The Blue Boat*. 1892. Watercolor over graphite, 15¹/₈" x 21¹/₂". Museum of Fine Arts, Boston

Landscape Photography

Daguerre's photographic process spread from Europe to America within months of its publication in 1839. The possibility to create images made by the "pencil of nature" (as it was called by William Henry Fox Talbot, inventor of the photographic negative) was timely. Since photography could, it was claimed, reproduce nature not only with truth but also with art, its unique potential was compatible with the current taste for visual realism. With the westward expansion of America, photography was the ideal means by which to satisfy curiosity about this vast continent.

In the years after the American Civil War (1861–5), the first war documented by photographers, photographers regularly accompanied the U.S. Geological Survey that followed the westward expansion of the United States. One of the most imaginative of these photographers was Timothy H. O'Sullivan (1840–82), who had also documented some of the battlefield carnage of the Civil War.

American contributions to landscape in the later nineteenth century were done in watercolor and photography (see "Materials and Techniques: Watercolor," page 425).

Winslow Homer's *The Blue Boat*

Homer was not only a great American realist but also a superb watercolorist, whose merits are sometimes overshadowed by his large and better-known works in oils. His watercolors are characterized by sure draftsmanship, fluent execution, economy of means, luminosity, and intense, saturated color. These qualities are all apparent in his watercolor *The Blue Boat*, painted in the Adirondacks in 1892, at the peak of his career (fig. 13.29).

Homer was most in his element in scenes of fishing, hunting, and sailing. In *The Blue Boat* the intent of the two hunters is shown by their watchful gaze and the rifle propped between them. Aesthetically, the viewer's eye is drawn by the contrast between the green and brown earth tones of the wild vegetation and the saturated blue of the intruding boat and the guide's red shirt and yellow vest. The fluency of Homer's sure touch and the luminosity of his color are especially evident in the pine trees and the foreground pool of water. Homer captures in watercolor a distinctly American scene with great virtuosity, while avoiding both the romantic melodrama and detailed realism to which his fellow American landscapists were drawn.

Timothy H. O'Sullivan's *Ancient Ruins in the Canyon de Chelly, Arizona*

O'Sullivan traveled to Arizona and New Mexico, as well as accompanying a U.S. expedition to Panama. His photograph *Ancient Ruins in the Canyon de Chelly, Arizona* of 1873 (fig. 13.30) is remarkable for its avoidance of pictorial cliché (such as the usual schema of foreground, middle distance, background, and sky). Instead he focuses on the subtle gradations of texture and pattern that eons of time have etched into the rock surface, and which the photographic process could effectively capture. Ancient Pueblo ruins perched on a niche in the rock face and backed by dark shadows add an intriguing historical dimension to the image. Landscape photography in America thus coincided with the needs and interests of exploration. But as interest in truth to nature declined in the art world, both photographers and painters had to find different subjects or new approaches, as will be seen in the following chapters.

13.30 Timothy H. O'Sullivan, *Ancient Ruins in the Canyon de Chelly, Arizona*. 1873. International Museum of Photography and Film, George Eastman House, Rochester, New York

THE CITY

In the mid- to late nineteenth century, as European industry and commerce boomed, and overseas imperialistic expansion boosted European wealth, cities were transformed by grand monuments, large department stores, and wide boulevards, on the one hand, and railway stations, smoking factories, and slum housing, on the other. In the context of this growth, we will look at two intriguing phenomena—the bold transformation of Paris and the architectural innovations made possible by new materials, particularly, iron, steel, and reinforced concrete. These materials, however, were mostly hidden from view, as most architects considered them unfit for use in monumental architecture. Many nineteenth-century architects were retrospective in outlook, preferring to face their buildings with traditional materials and in the styles of the past.

Haussmann's Parisian Boulevards

Between 1853 and 1870, through force of will, two autocratic figures, Napoleon III and his urban planner Baron Haussmann (1809–91), transformed Paris by driving a network of broad, straight, tree-lined boulevards through the heart of the city, demolishing all that lay in their way. The wide, elegant, gas-lit boulevards added openness and grandeur to the ancient city, by linking both old monuments and new structures, such as railroad stations and the new Opéra (see figs. 1.11, 12.22). Haussmann also demolished the old city walls to create new residential districts. Haussmann's new boulevards were built in the wake of much political unrest, and served as much to facilitate the rapid deployment of government troops as to enhance the elegance of the city. Their completion in 1870 assured the stature of Paris as a modern city whose broad, straight boulevards were widely emulated in other European cities.

Gustave Caillebotte's *Paris, a Rainy Day*

Gustave Caillebotte's (1848–94) painting *Paris, a Rainy Day* of 1877 celebrates the spacious effect and grand scale achieved by Haussmann's urban renovation of Paris (fig. 13.31). Blocks of apartment houses of uniform height and roof design lined the new boulevards. Their elegance was enhanced by new department stores, shops, and cafés. The fashionable couple approaching the viewer typify the upper middle-class inhabitants who could enjoy these amenities, as well as the newly built Paris Opéra.

13.31 Gustave Caillebotte, *Paris, a Rainy Day* (*Place de Dublin*). 1877. Oil on canvas, 6'11 1/2" x 9'3/4". The Art Institute of Chicago

Building with Iron, Steel, and Reinforced Concrete

For most of the nineteenth century architects continued to build in historical revival styles. However, some architects reacted against such imitation of the past and sought to create an architecture that was true to the character of their own time by exploring the aesthetic potential of iron and steel construction. The use of iron and steel in construction has been as significant for modern cities as the development of the steam-engine, which is more commonly associated with the Industrial Revolution.

Cast iron, and later steel, were first used on utilitarian structures such as bridges, factories, and warehouses. Because of these associations, architects were reluctant to apply their potential for ceremonial public buildings, unless they could hide these inelegant materials from view. However, their great strength, capacity to span large open spaces, and to replace masonry load-bearing walls in building construction offered advantages both practical and aesthetic, so that cast iron and steel eventually became the materials of choice.

Claude Monet's *Saint-Lazare Train Station, the Normandy Train*

From the 1830s on, cast iron was a vital ingredient in the integration of new railroads into old cities. It was especially visible in the train sheds and the iron bridges needed to support or span the railroad tracks. Monet's *Saint-Lazare Train Station, the Normandy Train* (fig. 13.32), painted in 1877, gives a vivid impression of the vast open spaces that could be spanned by cast iron, easily accommodating several tracks with platforms between, while providing sufficient height to allow the smoke from the trains to dissipate. Monet's painting also shows the utility of setting glass panes in iron roofing frames to admit light. Cast iron was, however, typically reserved for the train sheds that Monet depicts; the street entry of such railway stations was invariably built of stone in a grand, historicist style resembling anything from a stately city hall to an opera house.

Pierre-François-Henri Labrouste's Bibliothèque Sainte-Geneviève, Paris

In the Bibliothèque Sainte-Geneviève, a Parisian library built between 1843 and 1850, Pierre-François-Henri Labrouste (1801–75) attempted to integrate these two

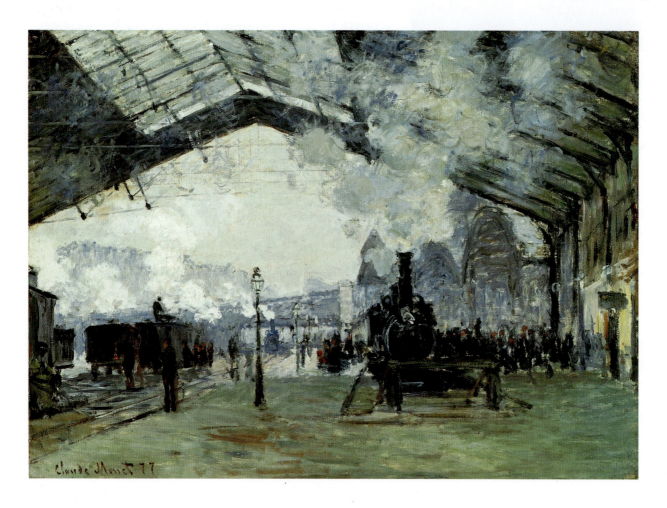

13.32 Claude Monet, *Saint-Lazare Train Station, the Normandy Train*. 1877. Oil on canvas. 23 1/2" x 31 1/2". The Art Institute of Chicago

13.33 Henri Labrouste, Reading Room, Bibliothèque Sainte-Geneviève, Paris. 1843–50

13.34 Sir Joseph Paxton, the Crystal Palace, London. Interior view. 1851; reerected in Sydenham 1852; destroyed 1936

different systems. He used stone treated in a historicist style for the exterior, and spanned the interior Reading Room with exposed cast iron (fig. 13.33). It is still a compromise between old and new—an Italian Renaissance style stone shell with modern cast-iron columns and arches on the interior. But whereas in train stations, cast iron was reserved for the smoky train shed, here it openly adorns the heart of a repository of learning.

Labrouste attempted to integrate the two systems of construction by repeating the arch of the stone window openings in the cast-iron arches of the twin barrel-vaulted roof, while contrasting the massiveness of the masonry with the delicacy of the cast iron. Its lightness is accentuated by the thinness of the columns and the perforated scroll pattern of the ceiling arches. Despite the harmony and contrasts achieved at the Bibliothèque Sainte-Geneviève, Labrouste was exposed to the same type of ridicule that greeted the Realist painters Courbet and Manet because of his breach of convention in openly displaying an industrial material in a house of learning.

Sir Joseph Paxton's Crystal Palace, London

Architects and their public were more willing to tolerate an open embrace of new materials in utilitarian buildings, such as greenhouses, train sheds, public markets, and the temporary exhibition halls erected to show off the wealth and industry of modern nations, as well as the exotica of their overseas colonies. London's Crystal Palace was the earliest and most famous of all such nineteenth-century

exhibition halls. It covered 18 acres, making it, at the time, the largest enclosed space in the world (fig. 13.34).

Designed in 1850 by Sir Joseph Paxton (1801–65), a noted horticulturalist and innovator in greenhouse construction, the Crystal Palace was erected in less than nine months, to the astonishment of the world. Its standardized iron and glass components made possible this speedy construction: These components were mass produced in factories, delivered by rail, and assembled on site. This also made it the first, masterly example of coordinated, industrialized building construction. Nevertheless, the Crystal Palace was considered an object of utility rather than beauty, and was taken down after the 1851 Universal Exhibition to be reassembled elsewhere. Like the goods it temporarily displayed, it had served to celebrate the progress and prosperity of the Industrial Age.

Iron in Bridges, Monuments, and Department Stores

Iron bridges were also prominent symbols of industrialization. The earliest of these, spanning the Severn River at Coalbrookdale in England, dates from 1779. With the spread of railroads, iron bridges began everywhere to invade the rural landscape due to the spanning capacity of iron, and its ability to withstand the weight of steam engines. Such bridges consisted largely of a series of cast iron trusses. A truss is a triangle made from wood, cast iron, or steel beams. Its strength stems from the principle that, once

joined, the sides of a triangle cannot be forced out of shape. Because trusses can span large distances between upright supports, they were (and still are) widely used in bridge construction. Though functionally effective, such iron bridges seemed ugly to eyes used to stone construction.

Designers achieved greater architectural grace with the development of suspension bridges, in which the road or rail surface was suspended from wrought-iron chains slung from stone piers. By substituting steel cables for the earlier iron chains, a light, graceful effect was achieved and breathtaking expanses could be spanned. A fine example is John (1806–69) and Washington (1837–1926) Roebling's Brooklyn Bridge in New York (fig. 13.35), built between 1867 and 1883. Besides its functional efficiency, it stands as a symbol in a modern city of science, engineering, and progress—notwithstanding its nod to the past in the Gothic-style arches that span the roadway.

In 1889, for the Paris World's Fair, the French engineer Gustave Eiffel (1832–1923) turned the structural principles of bridge construction on end to create a triumphal entry arch to the fair-grounds. Consisting largely of a series of trusses, the soaring wrought-iron Eiffel Tower rises 300 meters (984 feet), and completely dwarfed the existing city with an unprecedented symbol of modern technology (fig. 13.36). Despite initial protest at such a complete anomaly, standing in utter contradiction to France's historical architecture, it has become a world-renowned landmark of Paris, and of France itself.

Parisians also exploited the potential of cast-iron construction in creating the concept of the large department

13.36 Alexandre Gustave Eiffel, Eiffel Tower, Paris. 1887–9. Wrought-iron structure on a reinforced concrete base, original height 984'; current height 1,052'

store. Large plate glass display windows, framed and supported by cast iron, faced the street on the ground floor. Inside, high, open interiors were surrounded by balconies and covered with a glazed roof, all supported by iron columns. This open-centered design, which became a permanent commercial fixture, was adapted from the concept of the central display court of Paxton's Crystal Palace (see fig. 13.34). Today's vistor to Paris can still see the spectacular Galeries Lafayette, built in 1910. The success of these prototypes led to the huge department stores and shopping malls of American cities, and their structure has been imitated world-wide.

Skyscrapers Rise in Chicago

North American architects had a unique opportunity to experiment with new building technology in Chicago after a disastrous fire destroyed most of the business section in 1871. Chicago had become a major agricultural and manufacturing center, and railroad hub. From the beginning, its architecture was driven by commercial interests and a competitive drive to exploit the available space to the maximum. Masonry construction had limited height, because for each added story, the thickness of the

13.35 John and Washington Roebling, the Brooklyn Bridge, New York. 1867–83

walls at the base had to be increased, consuming valuable space. However, with iron- and, later, steel-frame construction, the elevator, prefabricated parts, and new engineering techniques, architects could exploit each plot of land to the full, by building what we now call skyscrapers (see "Materials and Techniques: Reinforced Concrete and Steel-frame Construction," page 432).

When iron and steel construction first replaced the massive brick load-bearing walls, the most innovative architects, such as Henry Hobson Richardson (1838–86), enclosed their iron structures behind massive masonry façades, giving them a more traditional look, as was done in so much nineteenth-century historicist architecture. Chicago architects, starting with William Le Baron Jenney (1832–1907) and Louis Henry Sullivan (1856–1924), rejected such historicism to develop an aesthetic in keeping with the logic of steel-frame construction, with three main features: Vertical expansion; flexible, open interior space; and extensive use of glass on the exterior.

Louis Sullivan's Carson Pirie Scott Department Store, Chicago

Louis Sullivan's Carson Pirie Scott Department Store in Chicago, built between 1899 and 1904, is a fine example of an early skyscraper (fig. 13.37). Here the grid pattern of the skeletal frame isn't hidden, but instead exploited for the rhythmic contrast of the long horizontal courses on the two

13.38 Louis Sullivan, Carson Pirie Scott Department Store, Chicago. Detail of cast-iron ornament

sides and the narrow vertical emphasis on the corner section. The windows are designed on the two long sides to span the width between the upright girders with one large fixed central pane and two narrow side windows that open. This design became a standard feature of Chicago architecture.

Sullivan, who coined the phrase "form follows function" as a design principle, also tackled the problem of imparting grace to such massive new structures. His solution in the Carson Pirie Scott building and elsewhere was to articulate the façade in terms of the three main elements of a column—base, shaft, and capital—here, most evident on the corner section. He used decorative terracotta tiles to face the exposed surfaces between the windows, and florid, organic ornamentation in cast iron at the ground level, to enhance and draw attention to the entrance and the shop-window displays (fig. 13.38). This florid ornamentation (comparable to that used in Parisian department stores) reflects the aesthetics of Art Nouveau ("New Art") in its geometric and organic interlace and carries no reference to the classical architectural orders. Art Nouveau, as the name implies, was an attempt to devise a new decorative principle for the modern world.

Ignoring such decorative detail, subsequent Modernist architects interpreted Sullivan's "form follows function" as a principled rejection of any ornamentation that was not an integral part of a structure. Taken to its extreme, this principle would influence the way in which a third new industrial material, reinforced concrete, was eventually put to use. In the nineteenth century the versatility of

13.37 Louis Sullivan, Carson Pirie Scott Department Store, Chicago. 1899–1900, enlarged 1903–4

Reinforced Concrete and Steel-frame Construction

The concrete developed by the ancient Romans had great compressive strength (that is, resistance to heavy loads), but it lacked tensile strength (resistance to lengthwise stress), so it could easily crack and be torn apart. Nineteenth-century engineers solved this problem by reinforcing concrete with the tensile strength of steel interior rods or wire mesh supports. The resulting material is known as reinforced concrete or ferroconcrete (fig. 13.39). It is also more fire-resistant than steel alone. Reinforced concrete is formed by pouring still-fluid materials into temporary wooden molds, allowing the concrete to be molded into any form, and offering architects unlimited sculptural potential in shaping mass. The versatility of reinforced concrete made it a very popular construction method during the twentieth century (see figs. 14.3, 14.37, 14.40–42).

The modern skyscraper, in fact, relies on steel- or reinforced concrete frame construction. This is a method of building in which, instead of thick exterior walls, a skeletal frame of vertical and horizontal steel girders (I-beams; fig. 13.40) or reinforced concrete pillars are interlinked to provide support for reinforced concrete floors and roofing. The entire structure is then clad with a "curtain wall," an exterior covering that does not carry the load of the structure. Mid-twentieth-century architects typically chose glass or aluminum, but other materials can be used for the curtain wall as well. An early example of such construction is Louis Sullivan's Carson Pirie Scott Department Store, Chicago, built 1899–1900 (see fig. 13.37).

Steel-frame construction results in buildings that are relatively light and yet much stronger than those built from stone or brick. The tensile strength of steel allows for sufficient sway under pressure of high winds, so steel-frame buildings could be raised to great heights, and, since the walls are non-load-bearing, the exterior sheathing can be as transparent as desired. This allows for maximum use of expensive building sites in dense, urban areas. As a product of modern industrial technology, such buildings as Ludwig Mies van der Rohe's Seagram Building in New York, built between 1954 and 1958 (see fig. 15.35), create a high-technology look that had wide appeal in the twentieth century, especially in civic and corporate contexts. Another advantage of steel-frame construction is that all the members are prefabricated, needing only to be bolted or welded together at the site.

13.39 Diagram of a reinforced-concrete joint

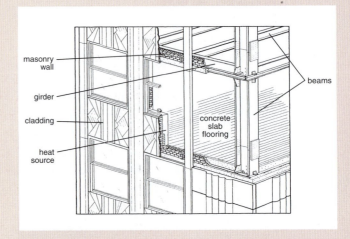

masonry wall

girder

cladding

heat source

concrete slab flooring

beams

13.40 Diagram of a steel frame

concrete, which had been used for more than two thousand years, was enhanced through the insertion of steel rods which greatly increases its tensile strength.

Because it is poured into molds, reinforced concrete offers an architect a flexibility of design that can produce highly sculptural effects. In the nineteenth century, when historicism still dominated architectural design, the use of concrete was restricted to non-visible functions. But in the twentieth century, as the principle of form follows function took hold, modern industrial materials, including concrete, were used openly in buildings and public monuments. Experiments with industrial materials in the nineteenth century had opened the way for such use.

PARALLEL CULTURES
Polynesia and Japan

At different times, non-Western cultures have provided a form of exotic escapism for the Western imagination, as, for example, Orientalist subjects did for the Romantics (see Chapter 12, page 275–6). By the mid-nineteenth century, avant-garde artists had become disaffected with Western materialism and bourgeois complacency. They were also disenchanted with the regimented standard of beauty that dominated academic classicism and continued to be celebrated in the official Salon exhibitions.

In this context, the appeal of non-Western art and culture was more than a diverting fantasy. Gauguin, as we saw, fled to Polynesia, but even there, he found a predatory Western presence. Other artists looked for fresh forms of artistic expression through which to renew an exhausted Western tradition. Japanese art offered one such model.

The Myth and Reality of Polynesia

In one mysterious and remarkable painting, *Primitive Tales* (fig. 13.41), painted close to the end of his life, in 1902, Gauguin addressed the theme of a menacing Western presence within a tropical paradise. He depicts a male predator, with clawed toes and devilish appearance, wearing a French beret and a violet dress, similar to those given to Polynesian women by French missionaries. Crouching like a cat or a tiger eyeing its prey, the man stares at two young girls. One, with black hair, sits cross-legged in the Oriental Buddhist pose, the other, viewed in profile, is a red-haired Polynesian.

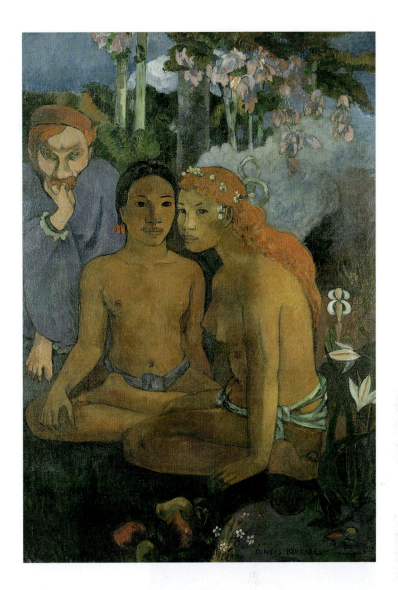

13.41 Paul Gauguin, *Primitive Tales*. 1902. Oil on canvas, 51⁴/₅" x 35³/₅". Folkwang Museum, Essen

In contrast to Gauguin's usual Polynesian landscapes, the deep tones and inaccessible space of the dense tropical landscape is sinister rather than inviting. While deliberately enigmatic, the painting evokes a disturbing predatory encounter between an evil Western presence and the exotic mystery and mythic innocence of the Orient and Polynesia. Indeed, by the time he reached Tahiti in 1891, more than a century of French domination and missionary activity had eliminated nearly all traces of indigenous religious practices. Their associated art and artifacts were either destroyed or shipped back to Europe as examples of heathenism.

Such was the case with a sculptural figure of the god Tangaroa (or A'a) from Rurutu, in the Austral group south of Tahiti, collected in 1821 (fig. 13.42). The procreative power of the god, who is represented abstractly as both

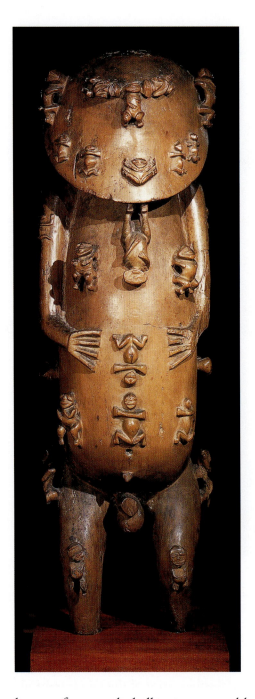

13.42 The god Tangaroa (or A'a) from Rurutu, Austral Islands, Polynesia. Wood, height 3'8". Collected c. 1820. The British Museum, London

Japanese Prints and Western Artists

Since 1639 Japan, fearful of Western domination, had been almost completely closed to the West. The Japanese had carefully insulated themselves, but in 1853 this isolation was sundered by the intrusion of the U.S. Navy. This unleashed a series of events that led to the total modernization of Japanese life. While Japan eagerly absorbed Western technology, the West fell under the spell of Japanese art, as its exotically beautiful porcelain, lacquerwork, and colored woodblock prints were exported to Europe and America. Japanese art arrived in Europe at a time when the conventions of classical Western art were being challenged by a restless avant-garde. Japanese brush-drawing, screen and scroll painting, and particularly its popular colored woodblock prints captured the imagination of many artists of the second half of the nineteenth century. These included Manet, Degas, Cassatt, van Gogh, Gauguin, and Toulouse-Lautrec.

Japanese colored woodblock prints of a type known as *Ukiyo-e*, that is "paintings of the floating world," were a

13.43 Suzuki Harunobu, *Courtesan on Veranda*. Late 1760s. Woodblock print, 10" x 7 1/2". Musée Guimet, Paris

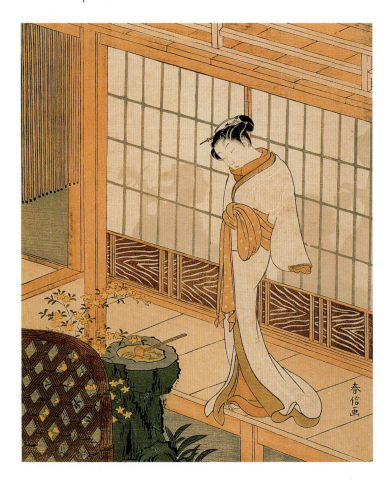

human figure and phallus, is conveyed by a series of minute figures that cover it and comprise its various body parts. Each tiny figure is in a squatting position, with legs drawn up and splayed apart, to signify procreation. This squatting figure motif pervades the art of Oceania, and bears testimony to two critical human concerns. It signifies a universal preoccupation with fertility, and it promotes social control under a ruling clan's authority through their mythological claim of descent from the gods (as we've seen in art as widely dispersed as that of Mesopotamia, Mesoamerica and Africa; see figs. 2.9, 5.39, 7.49). Gauguin, finding in Tahiti no remaining traces of such indigenous religious artifacts, even went so far as to carve some substitutes.

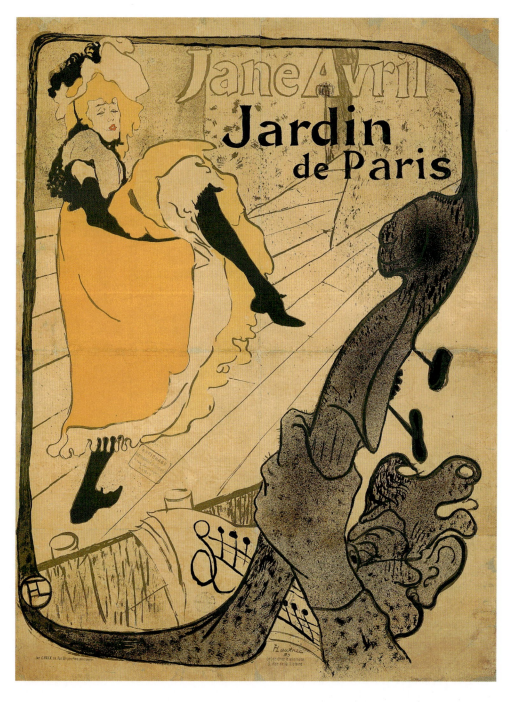

13.44 Henri de Toulouse-Lautrec, *Jane Avril at the Jardin de Paris*. 1893. Color lithograph, 49" x 35¼". Musée de la Publicité, Paris

form of popular art created primarily for the rich merchant class of the cities. They were known as *Ukiyo-e* because they took for their subjects the transient experiences of life, love, and landscape. *Ukiyo-e* were viewed by Japan's elite intellectuals as coarse folk art that existed quite apart from the courtly art that had been pursued with great refinement for centuries. Despite their low status at home, Japanese woodblock prints offered a fresh aesthetic appeal to jaded Western eyes. Their chromatic richness, fluency of line, and decorative surface patterns are particularly striking. Crisp recessional lines that remain integral to the surface pattern of the print are used

to represent depth; and forms are defined by broad, flat areas of color bounded by firm, black contour lines, with no modeling of three-dimensional forms by means of light and shade. The resulting brilliant interplay of bold color and firm line offered a refreshing contrast to traditional chiaroscuro, in which much of the brilliance of color is muted by shadow.

The Japanese artist Suzuki Harunobu (1725–70) is credited with the development of color prints using a full scale of colors, known as *nishiki-e* ("brocade pictures"). The *Courtesan on Veranda*, a small print from the late 1760s, is characteristic of Harunobu's work (fig. 13.43).

Lithography

Unlike intaglio and relief printing (see Chapter 8, "Materials and Techniques: Printmaking," page 250), lithography is a printing process, in which prints are made from a flat surface. This technique was invented in the late eighteenth century. Nineteenth-century artists such as Toulouse-Lautrec used it to make posters, as it offered relative ease and flexibility. Lithography can reproduce both lines and tones as well as color, making it a versatile medium that has also been adapted for commercial use.

Lithography is based on the fact that water and grease do not mix. An image is drawn directly onto the surface of a flat limestone with a greasy substance, such as a wax litho crayon or oily lithographic ink painted on with a brush. The stone is treated to fix the grease and then dampened. The water adheres to the non-greasy areas only. Then, when ink is applied to the stone, it only adheres to the greasy drawing, leaving the non-greasy areas blank (fig. 13.45). This technique allows for a variety of effects and can reproduce both lines and areas of gray tone. A large number of prints can be pulled because the stone does not wear out.

Many of Toulouse-Lautrec's lithographs, including *Jane Avril at the Jardin de Paris* (see fig. 13.44), were posters. A separate stone had to be made for each color, and the paper carefully aligned on each stone when printing. This layering of the image results in a beautiful interaction of colors.

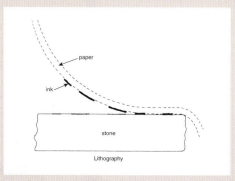

13.45 Diagram of the lithography technique

This poignant print depicts a petite young courtesan wrapped in her outer kimono standing on a veranda, wistfully contemplating her flower garden. Through the thin paper panels of the *shōji* (sliding wall panels) behind her the gray silhouette of two *geisha* (female entertainers) diverting a male client with music show the world of bought pleasures from which she has momentarily retreated. Besides the theme itself, this print's high view point, pattern of perspective lines, and decorative play of flat areas of color bounded by contour lines are typical of the qualities which Western artists admired.

Henri de Toulouse-Lautrec's color lithograph *Jane Avril at the Jardin de Paris* (fig. 13.44) of 1893 is a good example of the influence of Japanese prints on a Western artist. Toulouse-Lautrec took his subjects, including this one, from the demi-monde—that is, the world of socially-marginalized women of questionable repute. He portrayed the female entertainers of the music halls, the brothels, and the night cafés, and—like the *Ukiyo-e* artist—made his prints for a popular audience. Lautrec applied to lithography what his Japanese counterparts had done in woodblock prints, simplifying his designs to bold areas of color contained within vivid contour lines (see "Materials and Techniques: Lithography," above). In this lithograph, Lautrec has adapted a number of Japanese devices: A high viewpoint, transformation of the background into surface pattern, inclusion of lettering as part of the design, and particularly the use of a foreground motif—the hand, fingerboard, and scroll of the cello (or double bass)—as a framing device. As a result, the flattened silhouette of the dancer's body, the stage floor, lettering, and musician form a unified pattern on the picture plane.

Two other *Ukiyo-e* artists, Katsushika Hokusai (1760–1849) and Andō Hiroshige (1797–1858), are especially admired for their landscapes. Hokusai is notable for his transformation of natural motifs into beautiful decorative patterns, as seen in his famous series *One Hundred Views of Mount Fuji*, published in 1834, whereas Hiroshige tends to be more realistic. Western artists were particularly inspired by Hiroshige's novel framing devices,

13.46 Andō Hiroshige, *Blooming Plum Tree*, from *One Hundred Views of Edo*. c. 1857. Woodblock print, 13⁷⁄₈ " x 8⁵⁄₈". Van Gogh Museum, Amsterdam

such as close up figures, objects, or plants, beyond which distant views open up. Van Gogh, for instance, owned and also copied Hiroshige's *Blooming Plum Tree* from the latter's *One Hundred Views of Edo*, made about 1857, in which the branches of a plum tree cut right across the picture plane (fig. 13.46). Similar effects, unprecedented in Western art, can be seen in Van Gogh's *Sower*, Gauguin's *Vision after the Sermon*, Monet's *Poplars*, van Gogh's *View of Arles*, and indeed in Toulouse-Lautrec's *Jane Avril* (figs. 13.3, 13.4, 13.25, 13.28, and 13.44 respectively).

In these and other ways Japanese prints influenced many leading late nineteenth-century artists, and offered them an alternative way to think of the relationship between art and reality. Japanese prints showed Western artists a different way to render the three-dimensional world on a two-dimensional surface, as is most evident in the lithographs and posters of Toulouse-Lautrec. Above all, Japanese prints played a significant role in prompting Western artists to abandon the picture-as-window concept inherited from the Renaissance, in favor of greater emphasis on formal design on a flat painted surface.

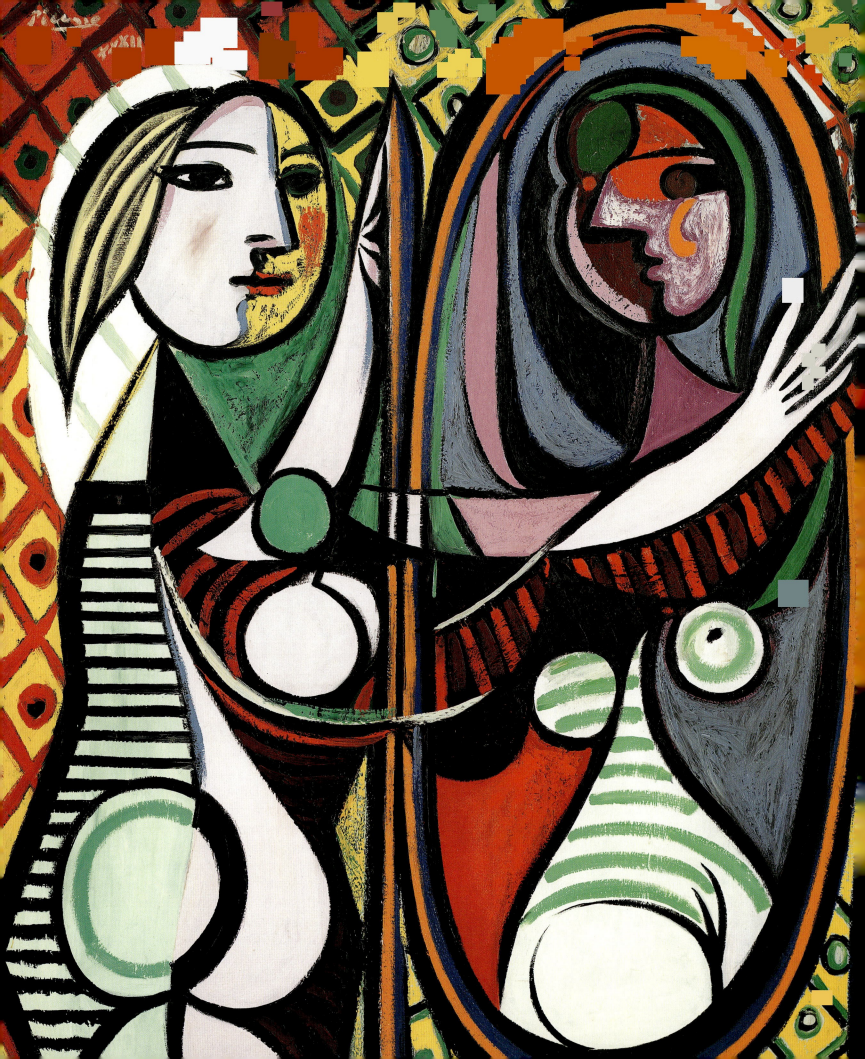

14 Early Twentieth-century Modernism

The general public has often found modern art incomprehensible, but as artists have always done, modern artists expressed many of the shared concerns of their age. The links between modern art and life are at first less obvious, because artists largely abandoned the ideal of art as imitation or representation. Nevertheless, modern artists continue to hold up mirrors to life, though more as metaphors than as literal representations, and the form of their work conveys its meaning as much as the content. We will see this more clearly as we explore how the radical and spectacular developments of modern art in the first half of the twentieth century transformed the great themes of art.

No early twentieth-century artist was more instrumental in this transformation than Pablo Picasso (1881–1973). In such works as *Girl Before a Mirror* of 1932 (fig. 14.1, see also fig. 14.16), Picasso confronted the age-old theme of self-discovery and wonder in a totally original way, inspired by his own time and place.

The terms "modern art" and "Modernism" refer to a period from approximately the 1860s to the 1970s. The social, economic, and spiritual stresses of World Wars I (1914–8) and II (1939–45) profoundly affected artists and architects. Many of the new artistic and architectural forms they fashioned are to a large degree a response to those upheavals. These artistic responses confronted the major themes we have explored throughout this book. Throughout this period artists and architects maintained their independence from artists' traditional sources of support—Church, state, and aristocracy—and rejected patrons' traditional values. Indeed, at the heart of Modernism lies artistic independence, profound questioning of tradition, and a willingness to take great risks in exploring new modes of expression. The outcome is the modern art and architecture of the twentieth century.

New Artistic Processes

Modern avant-garde artists were experimental. The thirst for innovation led to new materials and processes in painting, sculpture, and architecture. The tendency, seen already in Post-Impressionism (see Chapter 13), to emphasize the flatness of the picture plane encouraged artists to develop **collage**, in which an artist affixes pieces of paper, printed matter, or other materials to a flat surface, often in combination with drawing and painting. Artists have also enhanced the textural quality of painting with granular additives such as sand, and modern sculptors have experimented with welded sheet metal, wire and steel, Plexiglas, and plastics to explore transparency as well as solid mass. Pursuing Sullivan's ideal that "form follows function," architects have explored the design implications of materials such as reinforced concrete (see Chapter 13, "Materials and Techniques: Reinforced Concrete and Steel-frame Construction," page 432), structural steel, and plate glass, as well as the potential for on-site assembly, based on the mass production of identical units.

The Legacy of Nineteenth-century Art

Many modern artists and architects worked from the fundamental premise—first voiced in the nineteenth century—that God is dead and humanity stands alone, either self-sufficient or lost and alienated. Several motivating factors can be seen at work in modern art and architecture: The legacy of nineteenth-century artistic practices, spiritual disillusionment and alienation, the assertion of freedom from nature's authority, and a search to find new foundations for art and life. The styles of art associated with the early twentieth century—Cubism, Expressionism, Dada, and Surrealism—evolved in this matrix. At the same time, some artists reacted against avant-garde Modernism by adopting Realism; their works typically contain an element of social commentary. The least technically experimental of the strategies twentieth-century artists have pursued, Realism remained as a counter-current to the dominant trends of Modernism. As a result, strict advocates of Modernism have disparaged its reliance on older-established artistic practice.

Twentieth-century artists perpetuated the Romantic ideal of avant-garde artists as heroic individuals seeking to express themselves in original ways (see Chapters 12 and 13). Seeking individual freedom and radical innovation, modern artists generated an abundance of movements, manifestos, and styles. Like the nineteenth-century avant-garde, they sought new forms of art that expressed both the values of their own time and place and their individual vision.

The artists of the twentieth century expressed the notion of artistic freedom in ways that nineteenth-century artists could scarcely have imagined. Yet, while the first great innovators of twentieth-century art built on the legacy of the Post-Impressionists—Cézanne, Seurat, van Gogh, Gauguin, and Munch—they pushed the earlier artists' distortion of color, line, shape, and space to extremes, transforming the accepted terms of pictorial and sculptural representation, extending the formal and expressive range of art.

Disillusionment and Alienation: Expressionism, Dada, and Surrealism

At the heart of Modernism was the feeling that Western culture and the values that sustained it had

become bankrupt. As we've seen, ever since the Enlightenment (see Chapter 11), scientific rationalism had undermined Christian faith. Modern artists and writers often rejected the Church's traditional explanations for evil and suffering, and felt alienated from the power structures, economic prosperity, and dominant values of Western society. Avant-garde artists adopted the role of cultural critic, challenging dominant attitudes rather than affirming the status quo (see Chapter 13, "The Artist as Rebel," page 402).

The massive and pointless slaughter of millions during World War I (1914–18) heightened this sense of disillusion. The scale of the war's carnage, its senseless destruction, and the political and economic upheavals that followed it discredited militant nationalism in the eyes of artists, as well as the illusion of cultural progress, resulting in cynicism and despair among the artistic community. The "Great War" shook the confidence of artists and writers in their own traditions—the European heritage of Christianity and classical humanism. Modern artists and writers became disenchanted not only with the values they had inherited, but with the forms of art associated with those values. In searching for ways to express their disenchantment and alienation, German artists such as Ernst Ludwig Kirchner (1880–1938), Max Beckmann (1884–1950), Franz Marc (1880–1916), and the Russian Vassily Kandinsky (1866–1944)—known as Expressionists—sought to depict their subjective emotions in the visual arts. In Kirchner's case, this is particularly trenchant, since he implies that war destroyed his ability to create (fig. 14.2).

Reflective individuals also began to see images of fragmentation, chance, and chaos as more accurate metaphors of reality than traditional symbols of ordered meaning and purpose. This unsettling new vision had an even more disturbing conclusion: Human existence might be a meaningless struggle in an arbitrary universe. The implications for the arts were far-reaching. Since the Greeks, the idea that a transcendent or unifying order governed the cosmos had shaped and ordered the creative arts. Now artists could no longer assume such governing principles, and the use of chance, dissonance, and fragmentation in art deliberately undermined them (see for example, the works of Duchamp and Schwitters, figs. 14.21, 14.22). Dada, an artistic movement founded in 1916 to protest the irrationality of the Great War and the scientific rationalism and technology of its perpetrators, is the most striking example of this trend. Dada was a randomly chosen term that signified an attitude toward art and life, one that was provocative, expressing absurdity, irrationality, anarchy, and nihilism.

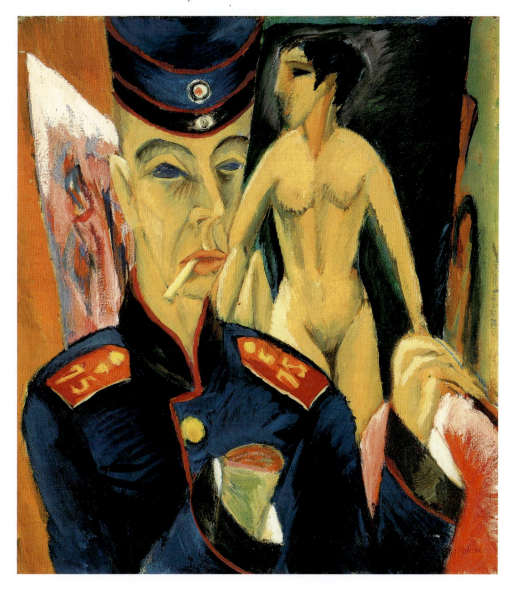

14.2 Ernst Ludwig Kirchner, *Self-Portrait as Soldier*. 1915. Oil on canvas, 27¼" x 24". Allen Memorial Art Museum, Oberlin College, Ohio

While artists were questioning traditional models for understanding humanity and the cosmos, the psychologists Sigmund Freud and Carl Jung were exploring the irrational and the unconscious in human psychology. Their findings appeared to reveal the subconscious forces that drive human behavior and illuminated the uncertainty of the age. Since modern artists were skeptical of traditional values and inherently individualistic, the insights of Freud and Jung offered them a promising new field—their own psyches. Freud and Jung thus pointed artists inward, and by suggesting that dreams expose the life of our unconscious being, helped to inspire a movement in art known as Surrealism, which began in Paris in the 1920s.

Surrealists rejected the control of reason, and aesthetic and moral codes in favor of dreams and random thoughts. Surrealist art grew out of the fusion of these ideas with those of Dada and nineteenth-century Symbolism (see Chapter 13) to express an understanding of humanity based on Freud's ideas. Surrealist artists took as their themes the world of dreams, the irrational, subconscious states of being, and their surface manifestations in human sexuality, aggression, and other drives.

The Search for New Foundations

While modern life alienated some artists, others attempted to construct a new social and artistic order

14.3 Frank Lloyd Wright, Unity Temple, Oak Park, Illinois. 1906

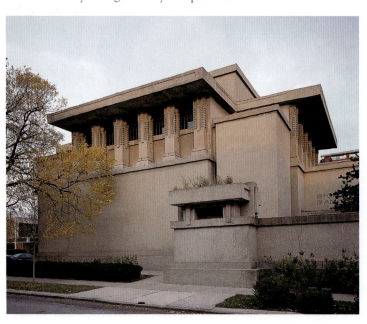

through the marriage of art and technology. Out of this effort emerged a new language of forms and new standards for design that led to prototypes for the modern city. Yet technology, especially in modern warfare, also threatened depersonalization and destruction. So some artists pursued an ideal, purist aesthetic that presented the material world as inherently evil and created an abstract art based on the pure beauty and energy of color and line, virtually freed from representing physical reality.

SPIRITUALITY

If God appears at all in modern art, it has been as an impersonal, cosmic life force. To express religious aspiration, the Romantics and later nineteenth-century artists had portrayed the sublime in landscape or the piety of those untouched by modernity. In the twentieth century, most modern artists abandoned the traditional Christian focus on a historical drama of human sin and divine redemption. Instead, they typically evoked the spiritual through images of cosmic energy, expressed through non-figurative, abstract forms of art. They believed that pure color and line, or sculptural form could evoke the essence of the energy that flows through all life. For these artists, sublime artistic form assumed the role that sublime natural phenomena had played earlier for the Romantics. Modern spiritual aspirations have thus contributed to the development of abstract art.

14.4 Frank Lloyd Wright, plan of Unity Temple, Oak Park, Illinois. 1906

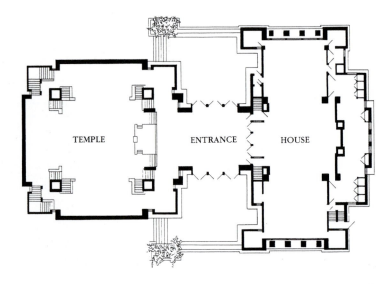

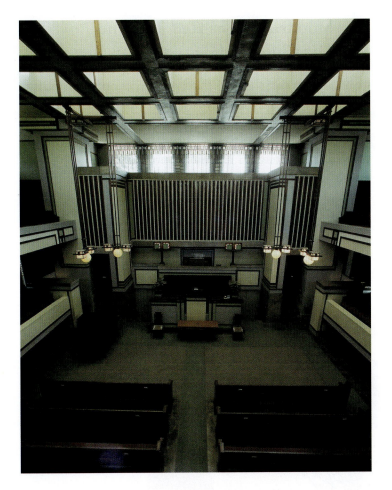

rows of glazed doors links this plain-faced, flat-roofed cubical auditorium to a similarly rectangular social hall. Deeply recessed windows set between square columns and living plants soften the building's austere form; the columns' rectangular decorative motif echoes the elemental, geometric concept of the whole.

Within the auditorium (fig. 14.5), Wright strung two levels of balconies between three of the four projecting bays; an organ behind the podium occupies the fourth. The elements of the interior—ceiling beams, window frames, piers, balconies, seating, wood-trim, lighting fixtures, and organ pipes—are all aligned to create repeated grid patterns. Plain surfaces painted in subdued yellow and green offset these patterns. The auditorium, insulated from the street and lacking traditional religious symbols, seems to protect its intimate, egalitarian community. Wright's architectural vision inspires a sense of harmony between nature and humanity; it manifests, through modern materials and architectural form, contemporary spiritual aspirations.

Modern Architecture for Modern Spirituality

Like individual modern artists, some communities have sought to create architectural settings that express a modern form of spirituality. One of the most original of these buildings is the Universalist Unity Temple, in Oak Park, Illinois, that one of its members, the architect Frank Lloyd Wright (1869–1959), designed in 1906 (figs. 14.3, 14.4, 14.5).

Frank Lloyd Wright's Universalist Unity Temple, Oak Park, Illinois

Unitarianism has no traditional sacraments and is more concerned with the relations between human beings on earth than with God. To represent Unitarianism's rational, modern values, Wright broke with traditional church architecture. He dispensed with a steeple as a "misleading symbol" for a group that thinks that there is no God in heaven toward whom to point. For the main auditorium, he used exposed reinforced concrete and the most elemental form, a cube, with four slightly projecting bays. A vestibule lined with

Abstract Art and the Spiritual

In response to a pervasive sense of alienation and skeptical of traditional Christian faith, modern artists frequently expressed their spiritual aspirations in abstract terms, divorced from the imperfections of material reality. The Russian-born painter Kandinsky abandoned figurative representation and traditional symbols, expressing modern spirituality through abstraction. His pivotal innovation was to attempt to make the inner life-force manifest through artistic form. In this respect, his work would influence the Abstract Expressionists of late 1940s and 1950s America.

Vassily Kandinsky's *Black Lines No. 189*

Kandinsky believed that the abstract qualities of color and line alone could create sensations that move a person's inner being. His spiritual quest thus led him to express his inner being through color and line, without depicting material reality. In *Black Lines No. 189* (fig. 14.6) painted in 1913 energized black lines jump and dart, rise and fall, race back and forth, loop and splay across brilliant red,

pink, orange, blue, yellow, and green patches. In some areas these lines follow the patterns of the underlying color; in others they seem to dance at random. But overall the play of color and line addresses the eye and arouses emotion, without referring to the visible, material world.

The Quest for Pure Essence

The Dutch painter Piet Mondrian (1872–1944), the French painter Robert Delaunay (1885–1941), and the Romanian sculptor Constantin Brancusi (1876–1957) also sought to express universal harmony and the pure essence of things through abstract art.

Piet Mondrian's *The Red Tree* and *Flowering Apple Tree*

Mondrian conceived *The Red Tree*, painted in 1909, to reveal the tree's inner life through its outer form (fig. 14.7). The lines, pattern, color, and directional force of the tree mediate between an elemental opposition of earth and sky. Mondrian rejected natural colors in favor of a contrast between an intense red, signifying the energy pushing up from the earth, and a cool blue, representing absorption in an infinite expanse of sky. The horizontal spread of the tree's branches complements its vertical thrust; while the left branches droop towards the earth, those on the right reach up toward the heavens. With this tree, Mondrian tries to depict

14.6 Vassily Kandinsky, *Black Lines No. 189.* 1913. Oil on canvas, 51" x 51¼". Solomon R. Guggenheim Museum, New York

14.7 Piet Mondrian, *The Red Tree.*
c. 1909. Oil on canvas, 27³/₈" x 39".
Gemeentemuseum, The Hague

14.8 Piet Mondrian, *Flowering Apple Tree.*
c. 1912. Oil on canvas, 30³/₄" x 41³/₄".
Gemeentemuseum, The Hague

universal reality—an underlying structure, an opposition of forces, a unifying pattern, and a constant rhythm.

In his *Flowering Apple Tree* (fig. 14.8), painted around 1912, the natural motif is almost entirely relinquished in favor of the universal forces suggested in the earlier painting. As with Cubism (see below), color is suppressed in favor of structure and form, which Mondrian organizes according to the abstract principles explored in the earlier painting: The opposition of forces from below and above, the complementarity of vertical and horizontal balance, an underlying structure, unifying pattern, and constant rhythm. However, Mondrian diffuses the nucleus of energy in the center of the painting toward the periphery, suggesting infinite extension beyond it. The pastel colors may speak of blossoms, of the annual renewal of life; the arching lines may hint at branches reaching out into space—but overall Mondrian reaches toward the universal not the particular.

14.9 Robert Delaunay, *Simultaneous Contrasts: Sun and Moon*. 1913 (dated on painting 1912). Oil on canvas, 53" diameter. The Museum of Modern Art, New York

Robert Delaunay's *Simultaneous Contrasts: Sun and Moon*

Like Kandinsky and Mondrian, and many subsequent artists, the Parisian painter Robert Delaunay viewed the spiritual in impersonal terms, as a heightened awareness of the essential life-force and cosmic order that lift us beyond the reach of the material world. In images of the dynamo, electric power, radio signals, and aircraft propellers, Delaunay sought to express both the life-force in nature, and the dynamic energy of modern life. From 1912 to 1914, on the eve of World War I, Delaunay created a series of works in this vein, such as his *Simultaneous Contrasts: Sun and Moon* of 1913 (fig. 14.9).

Constantin Brancusi's *Bird in Space*

The quest for the pure essence of things, for the spirit of a being, was the life-long preoccupation of the Romanian sculptor Constantin Brancusi, who settled in Paris in 1904. Having worked briefly as Rodin's studio assistant, Brancusi rejected the dominance of the human figure and Rodin's naturalism in 1907 (see Chapter 13), seeking instead the essential inner spirit of things, which he considered more real and more enduring than the outer form. Brancusi's quest for the spirit and essence of his subjects led him, as he wrote, to search for "the key form that would powerfully sum up the idea of that subject." This aesthetic journey led him toward a non-figurative art, in which he sought to grasp the essential by shedding the details. In *Bird in Space*, a polished bronze made about 1924 (fig. 14.10), Brancusi was working less to distil the essence of a bird's form than to evoke what the bird itself signified—flight, freedom, purity, the vertical release of energy, and the aspiration toward heaven. As with Kandinsky and Mondrian, in Brancusi's art, the spiritual was expressed through "pure" artistic form.

14.10 Constantin Brancusi, *Bird in Space*. c. 1924. Polished bronze, height 49³/4". Philadelphia Museum of Art

A Catholic Vision of Suffering: Georges Rouault

Georges Rouault (1871–1958) was almost unique among modern artists in finding inspiration in Catholicism and identifying the spiritual with themes of human suffering that other artists seeking purity of form avoided. His figures invite us to identify with their sorrow and imperfection; by implication they share in the archetypal passion and sufferings of Christ.

Rouault made an epic series of etchings entitled *Miserere* ("Have Mercy"), which are comparable to Goya's *Disasters of War* for their moving human commentary (see Chapter 12). One plate in the series entitled *Qui ne se grime pas?* (*Don't We All Wear Make-up?*), made in 1927, confronts us with the sad, distorted grimace of a tragic clown (fig. 14.11), which asks us to see the mask behind which we all cover our sorrows. Instead of offering escape from our human condition, as other Modernists did when engaging the spiritual in terms of purity of form, Rouault helps us to identify with and find meaning within our common human destiny, drawing us to his themes through the humanity of his figures, bold draftsmanship, and, in his paintings, glowing color.

THE SELF

For many of the leading artists of the first half of the twentieth century, traditional beliefs about the meaning of human life and of our place within the universe no longer seemed to hold. This doubt and uncertainty was matched by a growing sense of fragmentation, chance, and chaos, in which the irrational and the unpredictable overshadowed earlier beliefs in transcendent order. Responding to such uncertainty, the most daring and inventive artists created new modes to express these underlying sentiments.

The Promethean Urge: Pablo Picasso, Georges Braque, and Henry Moore

The early twentieth century witnessed one of the most radical transformations of Western art since the Italian Renaissance. The Promethean urge—named for the Greek mythological figure who stole fire from heaven to benefit humankind and was duly punished by the gods—identifies the individuals whose creativity brings new life at great risk and cost to themselves. Such were the avant-garde artists of the early twentieth century, who, mostly working in Paris, rejected the past and sought to invent new artistic strategies that could bear the weight of modern experience. In so doing, they gave definitive shape to what we now call modern art.

Pablo Picasso's *Les Demoiselles d'Avignon*

The life and art of the Spanish-born Pablo Picasso symbolize the Promethean spirit of artists of his generation. Throughout his long life Picasso forged fresh means to express his passionate, liberated sensibilities. Working in Paris in 1906, he discovered in the raw power and

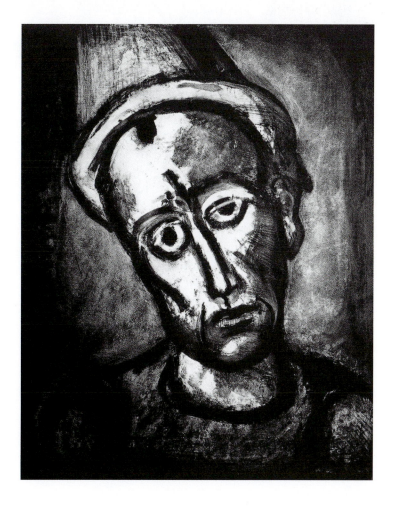

14.11 Georges Rouault, *Qui ne se grime pas?* (*Don't We All Wear Make-up?*), plate no. 8 from *Miserere* series. 1927. Etching, aquatint and drypoint, 26" x 16³⁄₄"

14.12 Pablo Picasso, *Les Demoiselles d'Avignon*. 1907. Oil on canvas, 8' x 7'8". The Museum of Modern Art, New York

elemental, semi-abstract forms of African masks a fresh way to express the intensity of his own passions.

From this encounter with African art emerged *Les Demoiselles d'Avignon*, completed in 1907 (fig. 14.12). Its harsh, geometricized human figures, shattered pictorial space, and blurred distinctions between figures and ground shocked his friends. Picasso was the first Western artist to break with tradition so profoundly. He seems to have treated this revolutionary painting like an experimental workshop, as evidenced by his disparate handling of the various figures. For example, the opposition of flat planes of uniform color and spare lineal gestures, with the nose flattened into profile on a frontal face, defines the central woman. By contrast, a series of geometric facets composes the body of the standing figure on the right, and the mask-like face is built up with ferocious hatching. Such daring experimentation seemed to tear down the established conventions of Western art. Picasso's vehement gesture opened the way for further experimentation; its dissonance and ferocity, emerging from the darkest recesses

of human fear, desire, and aggression, erupted like a volcano into the Parisian art world. This painting laid bare the intensity of such deeply rooted human passions and embodied them in an unprecedented visual vocabulary that anticipates Cubism and many subsequent forms of abstraction. *Les Demoiselles d'Avignon* was the first significant manifestation of the Promethean spirit of twentieth-century Modernism.

Georges Braque's *The Portuguese*

Shortly after Picasso finished *Les Demoiselles d'Avignon* he met Georges Braque (1882–1963), a French artist working in Paris. In 1908 Braque produced a series of landscapes strongly influenced by Cézanne (see fig. 14.30). In Braque's landscapes, all the elements were abstracted, meshed into a grid of interlocking planes, and rendered in subdued ochers, gray, and green. Picasso and Braque formed a close artistic alliance from which Cubism and its outgrowth collage emerged. These innovations transformed the range of visual art and abandoned the ideal of representation.

Collage and Assemblage

"Collage" comes from the French word *coller*, meaning "to paste." The first collages were made in 1912 by the Cubists Picasso and Braque, who pasted flat materials onto a surface to create a single, unified image. An early example is Picasso's *Guitar* of 1913 (see fig. 14.14). By using materials such as newspaper, colored paper, and cloth to great effect, these artists enlarged the range of acceptable artistic media.

Assemblage extends the concept of collage into three-dimensional media. Non-art objects or materials, which may consist of preexisting or found objects, are joined together by such means as gluing, bolting, or welding to create a work of art. Picasso's *Guitar* of 1912 is considered the first assemblage (see fig. 14.15), though the practice became more widespread in the 1950s.

Cubism constituted one of the most significant movements of early twentieth-century Modernism and paved the way for more artistic innovations.

In Braque's painting *The Portuguese* (fig. 14.13) of 1911, Cubism breaks down form and space into flat, interlocking planes set at varying angles that rupture traditional expectations for illusionistic representation. Instead, these interlocking planes, which abut and bleed into one another, form an all-over pattern that comprises the image. The picture becomes the picture surface, a succession of distinct marks of paint on canvas, and the rhythms and patterns these marks create. Cubist artists also made fragmentary allusions to the people or objects that inspired their paintings—in this case a figure playing a musical instrument. The Cubists denied the illusion of pictorial depth and instead emphasized the painted surface. This enabled them, as in this example, to include lettering and numbers as part of the image, because there was no illusion of space to disrupt. It also allowed them to paste fragments of other materials on to the canvas, so developing the process known as collage (see "Materials and Techniques: Collage and Assemblage," above).

Picasso's *Guitar* (collage)

Collage enabled Braque and Picasso to move beyond the severe abstraction of works such as *The Portuguese*. They could reintroduce elements of tangible reality by using newsprint, wallpaper, or other such materials, and still maintain the physical integrity of the flat surface of the picture. Collage also offered endless scope for Picasso's fertile sense of formal invention, as seen in

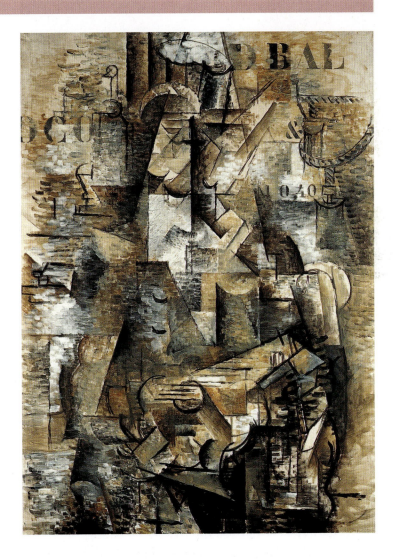

14.13 Georges Braque, *The Portuguese*. 1911. Oil on canvas, 45 1/8" x 32 1/8". Kunstmuseum, Basel, Switzerland

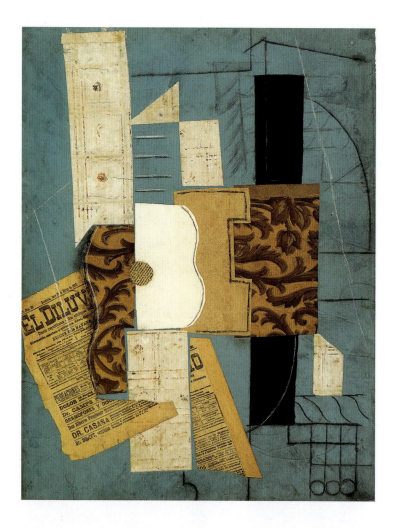

14.14 Pablo Picasso, *Guitar*. 1913. Charcoal, crayon, ink, paper. Collage, 25 5/8" x 19 5/8". The Museum of Modern Art, New York

expectations for sculpture. Furthermore, just as Cubist painting discards traditional expectations for figure, ground, and space, so in *Guitar* Picasso subverts conventional treatment of mass and volume by constructing the sculpture out of a series of overlapping planes. Finally, his sculpture focuses on an everyday object, not some elevated theme.

Ultimately Cubism weakened the descriptive ties between art and reality. Now artists could focus on abstract form. Many critics saw in the fragmented, multi-faceted abstraction of Cubism and its offshoots, a new, dynamic view of the world, conceived in terms of endless random change. While few non-scientists understood its complexities, Albert Einstein's theory of relativity undermined traditional beliefs in a predictable, stable universe (see Chapter 11, "Natural Science, Reason, and Progress: Enlightenment Ideals for a New Age," page 340). Cubist fragmentation was a similar expression of modern consciousness.

his collage *Guitar* of 1913 (fig. 14.14). Here Picasso used a strip of patterned wallpaper to suggest the neck of the guitar and other pieces of paper for its body, then echoed and countered these basic forms in glued pieces of paper and newsprint. He drew lines to accentuate and repeat the rhythms of the collage, and unified the whole composition with the blue background. The result is a totally new kind of visual image, and an example of the Cubists' urge to reject the unified vision of illusionistic art and find a visual language that fit their sense of the fragmentary nature of reality.

Picasso's *Guitar* (assemblage)

Picasso also reconceived sculpture in Cubist terms. His methods enabled artists to approach sculpture in terms of construction, rather than carving or modeling, a revolutionary method artists have pursued to this day. Picasso's 1912 sculpture, also called *Guitar* (fig. 14.15), was an **assemblage** of common sheet metal and wire—combined like the newsprint and wallpaper used in collage—to be hung on a wall. Like collage, assemblage subverts traditional materials, processes, and

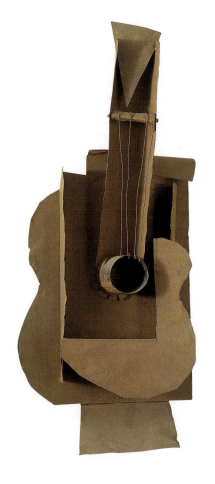

14.15 Pablo Picasso, *Guitar*. 1912. Sheet metal and wire, 30 1/2" x 13 1/8" x 7 5/8". The Museum of Modern Art, New York

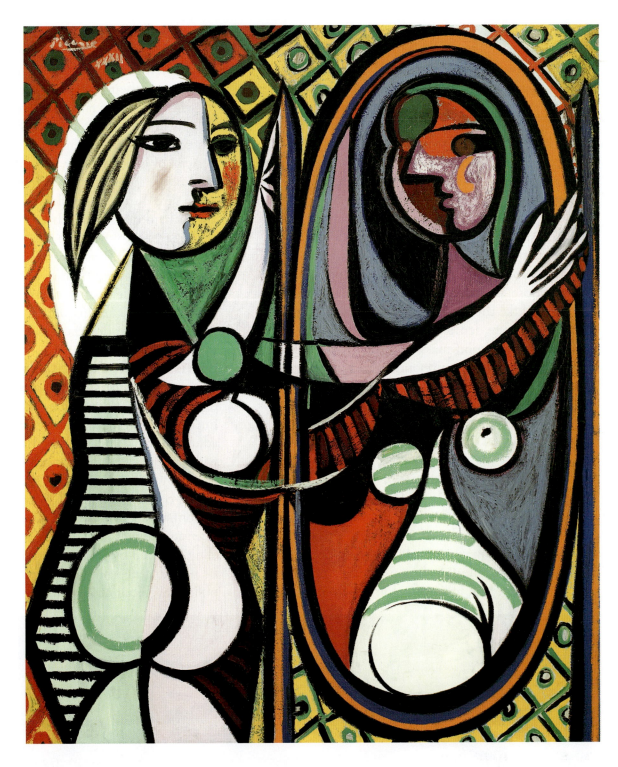

14.16 Pablo Picasso, *Girl Before a Mirror.* 1932. Oil on canvas, 64" x 51¼". The Museum of Modern Art, New York

Picasso's *Girl Before a Mirror*

Picasso's restless spirit and active imagination drove him beyond Cubism's disintegration of the human figure to reincorporate the psychological content associated with figurative art. In his *Girl Before a Mirror* of 1932, he juxtaposes a young girl and her distorted image in a mirror (fig. 14.16). He adapts classicism to evoke her sensual beauty and Surrealism to conjure up her sinister image in the mirror, unifying these opposites through Cubism. In the rich surface pattern Picasso transfers back into painting what he earlier explored in collage, creating a masterpiece in terms equally of design, color, and psychology. With this painting Picasso demonstrates that artists do not need to represent the human figure in conventional terms or to set it within an illusionistic three-dimensional space to convey intense emotion or address the deepest anxieties.

Henry Moore's *Recumbent Figure*

The English sculptor Henry Moore (1898–1986), who came to prominence in the 1930s, looked beyond the natural appearance of things to penetrate the inner reality. He drew his strength from the Surrealists' use of intuition and Modernists' leanings toward abstraction; the work of Picasso; ancient Mexican sculpture; and the suggestive forms of well-worn natural objects like stones and bones. Many of his sculptures, such as his *Recumbent Figure* (fig. 14.17), carved from elmwood in 1938, suggest a close affinity to organic forms, and he liked to display them in natural settings. Their semi-abstract shapes suggest simultaneously the scale of cliffs and caves, mountains and stones, and a reclining woman whose generous forms enfold an embryonic life within her. Like the works of Picasso before him, Moore's sculpture demonstrates that a void can speak as powerfully as a solid mass, and that literal figurative art is not necessary to convey powerful human content. Moore's figures exemplify the Promethean urge to break with tradition and create a new sculptural language to convey a fresh vision of humanity.

The Pursuit of Pleasure: Henri Matisse

The Parisian Henri Matisse (1869–1954) was another artist who forged new directions for twentieth-century art. He took it, however, in a different direction, exploring joyful themes through the possibilities of surface pattern and large, flat areas of color, which are sensuous and decorative in their impact. In 1905–6 Matisse was the leading figure among a group of French artists nicknamed the Fauves ("Wild Beasts") for the intense contrasts of their high-key color. In reality, Matisse was no wild beast, but rather an artist who took epicurean delight in the sensuous quality of color and line. These he judiciously manipulated to create surface designs of lyrical beauty and often festive subject matter. Unlike some other Modernists, Matisse wanted his art to give pleasure; he likened it to a comfortable chair after a hard day's work, that should serve as an antidote to the stresses of modern life.

Matisse and Picasso worked in friendly rivalry, each exploring new possibilities, but in different terms. Both possessed fertile imaginations, but while Picasso's volcanic eruptions are frequently unnerving, Matisse's images are often delectably soothing.

Matisse's *The Red Studio*

In paintings such as *The Red Studio* of 1911, Matisse distills his sensations of the motif (in this case, the studio interior) to an orderly essence of balance and harmony, adjusting the shape, size, rhythm, and pattern of objects with the utmost economy and refinement (fig. 14.18) (see also Chapter 1). In his Cubist experiments, Picasso muted color and flattened space with geometric faceting. In contrast, in *The Red Studio*, Matisse heightened the intensity of color and eliminated three-dimensional modeling. Inspired by Japanese prints (see figs. 13.43, 13.46), he hinted at depth by using crisp outlines to define obliquely placed objects that also provide surface pattern.

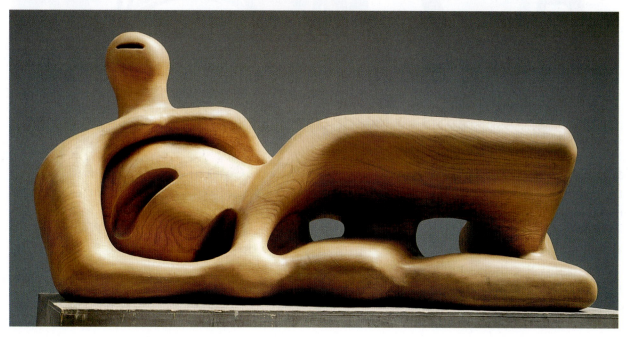

14.17 Henry Moore, *Recumbent Figure*. 1938. Elmwood, length 6'3". Henry Moore Foundation

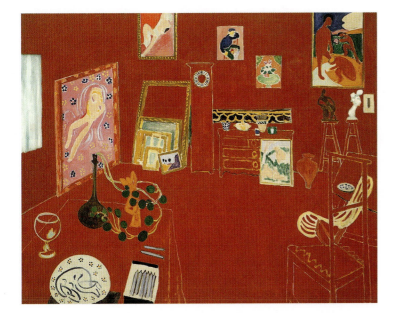

14.18 Henri Matisse, *The Red Studio*. 1911. Oil on canvas, 71¼" x 86¼". The Museum of Modern Art, New York

Through different strategies, Picasso and Matisse maintained the integrity of the picture plane as a flat, painted surface, setting a standard that was followed widely throughout the twentieth century. Matisse's flat, patterned surfaces and economy of design inspired later generations of artists and designers.

Suffering and Alienation: German Expressionism

While Matisse created an art form of joy, German artists expressed the spiritual disillusion and alienation that dogged many modern artists. Unlike Paris, the German academies of Berlin, Munich, and Dresden had not faced avant-garde challenges in the late nineteenth century. In Germany the Industrial Revolution had produced a complacent, prosperous middle class, and by the early twentieth century, the country was rich and powerful. Many artists, however, felt alienated from this prosperity and scorned the smug bourgeoisie.

Ernst Ludwig Kirchner's *Self-Portrait as Soldier*

Around 1905, artists in Dresden, among them Ernst Ludwig Kirchner, formed Die Brücke ("The Bridge"), an Expressionist protest movement that they hoped would act as a bridge to an anti-bourgeois, egalitarian utopia. Their work is introspective, filled with neurotic emotion. Works like Kirchner's *Self-Portrait as Soldier* of 1915 (see fig. 14.2), which protested

World War I as the enemy of art, show not only the suffering and alienation of Modernism, but its subjective quality. His mutilated arm in the painting was symbolic, not actual.

Kirchner and other Die Brücke artists developed a form of Expressionism based on nineteenth-century painters like van Gogh and Munch, while emulating the vivid color of the French Fauves. In pursuit of emotional intensity, they cultivated the harsh angularities of African sculpture and used jarring color contrasts.

In 1938, after the Nazis attacked what Hitler deemed "degenerate" art and confiscated six hundred works by Kirchner, the artist committed suicide. Yet his powerful artistic output revealed that it was society itself—not just the artist—that had become degenerate.

Käthe Kollwitz's *Memorial Sheet for Karl Liebknecht*

Käthe Kollwitz (1867–1945) broadened the Expressionists' critique of German culture, getting closer to the truth of Germany's social and political crisis. Her socialist themes protested war, poverty, and injustice. She chose to work in graphic media, such as lithography and woodcut, because the multiple reproductions they allowed made her social message more accessible to the oppressed, with whom she identified.

Her woodcut *Memorial Sheet for Karl Liebnecht* of 1920 (fig. 14.19) commemorates the leader of the

14.19 Käthe Kollwitz, *Memorial Sheet for Karl Liebknecht*. 1920. Woodcut, 14" x 19½"

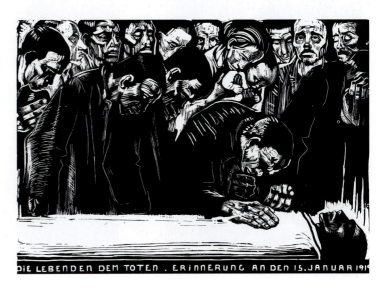

DIE LEBENDEN DEM TOTEN . ERINNERUNG AN DEN 15. JANUAR 191

German Communist party, murdered by government agents. Kollwitz chose woodcut instead of her usual medium of lithography because she believed she could achieve a more forceful effect by emphasizing the roughness and sharpness of edges in gouging out the wood (see Chapter 8, "Materials and Techniques: Printmaking," pages 250–1). She represents a group of workers mourning Liebknecht, modeling her composition on older religious images of Christ's followers lamenting his death. Like Kirchner and other Die Brücke artists, Kollwitz was condemned by the Nazis as "degenerate."

Max Beckmann's *Departure*

The most powerful German Expressionist was Max Beckmann. His epic triptych *Departure* (fig. 14.20) was made in 1932–3, on the eve of his dismissal by the Nazis from his professorial post. When ten of his works were included in Hitler's 1937 "Degenerate Art Show," Beckmann made his own "departure," leaving the country for good.

As a medical orderly, Beckmann had seen the brutalities of World War I, and then had witnessed the sufferings of the post-war years in Germany, personally enduring persecution, exile, and deprivation. The imagery of works like *Departure* represents his memories of these experiences, resurfacing as dreams. Such works defy logical explanation, but express potently his stated view that "all important things in art ... have always originated from the deepest feelings about the mystery of Being ... It is the quest of our self that drives us along the eternal and never-ending journey we must all make." Beckmann's *Departure* conveys two key aspects of the Modernist vision of human experience: The sense of dreadful oppression and suffering, and the yearning for escape.

Beckmann acknowledged that his vision contained "the white and truly beautiful" as well as "the black, ugly and destructive;" for him, these essential opposites constituted "the great and eternally changing terrestrial drama." In speaking about his art in 1938, he emphasized the function of space, the space that contains us, the infinity that surrounds us. In *Departure*, the serene image of the central panel, with its expansive calm of

14.20 Max Beckmann, *Departure*. 1932–3. Triptych. Oil on canvas, center panel, 84³⁄4" x 45³⁄8"; side panels, each 84³⁄4" x 39¹⁄4". The Museum of Modern Art, New York

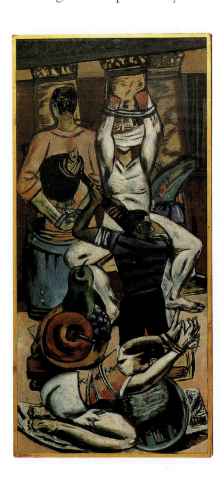 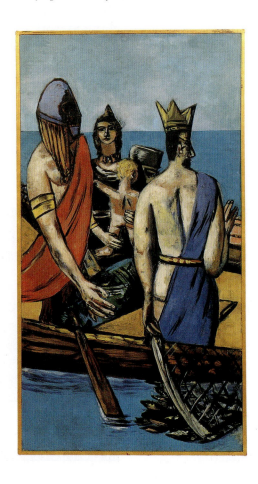 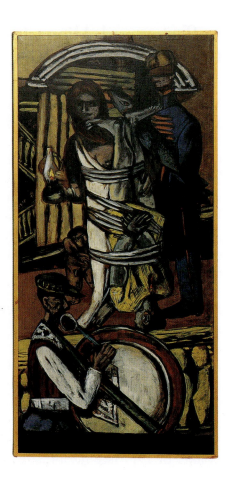

blue water and sky, stands in contrast with the horrific actions depicted in the oppressive, claustrophobic space of the two side panels. These tensions convey Beckmann's universal dialogue between the pain of finite travail and the desire for infinite release.

Dada and the Threat of Randomness

Belief in reason, order, progress, and predictability in human life had been shattered by World War I. The disillusionment that followed shook the confidence of many in the art world. Some wondered whether human existence amounted to any more than a meaningless struggle in an arbitrary universe. In the face of such despair, fragmentation and randomness seemed more fitting artistic metaphors for human experience than the formal order of established art. To such artists Cubism, Fauvism, and German Expressionism did not seem radical enough to express the dislocation and futility embedded in modern consciousness. They wanted to subvert the entire structure of Western aesthetics, based as it was on a humanistic trust in reason and order. To confront these traditional assumptions, they acted as jesters and *provocateurs*, concocting nonsense and cynical, random, cultural fragments to protest the entrenched values of Western culture. Among them all was Marcel Duchamp (1887–1968).

Marcel Duchamp's *The Bride Stripped Bare by Her Bachelors, Even (The Large Glass)*

Around 1913, Marcel Duchamp introduced the principle of chance to the artistic process, and the following year exhibited the first of his notorious "readymades," including a bicycle wheel, a bottle rack, and a urinal, as art. Duchamp claimed to act from visual indifference—the artist merely selects uncaringly from mass-produced, common objects—a perspective that completely reversed traditional expectations for art.

During 1915–23, Duchamp worked on a series of images and objects suspended between two panes of double-thick glass, known as *The Bride Stripped Bare by Her Bachelors, Even (The Large Glass)* (fig. 14.21). It is widely considered the definitive mechanical-sexual metaphor of the era. The upper glass is the zone of the robotic, bird-like bride—suspended in space on the left, forever out of reach—a dehumanized object of desire. The "bachelors" are trapped in the lower glass, permanently separated from the bride. The "cloud" to

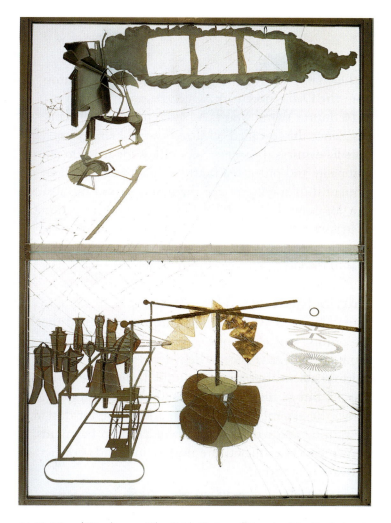

14.21 Marcel Duchamp, *The Bride Stripped Bare by Her Bachelors, Even (The Large Glass)*. 1915–23. Oil, lead wire, foil, dust, and varnish on plate glass, 9'1¼" x 5'9⅛". Philadelphia Museum of Art

the right of the bride, perhaps signifying her fertility, contains three forms derived from photographs of a square of net curtain wafting in a breeze—shapes created by chance. Duchamp drilled the holes below the cloud in the upper glass in spots left by matches dipped in paint, then fired at the piece from a toy cannon, a metaphor for impregnating the bride.

In the lower pane Duchamp drew the form of "Nine Malic Molds" (signifying the "bachelors") by dropping one-meter-long pieces of thread on to a canvas and fixing them wherever they fell, so using the process of chance to question a standard unit of measurement. This sense of alienation is heightened by Duchamp trapping the "bachelors" in the lower pane, forever out of reach of the bride. The work thus functions as a metaphor of dehumanized sexuality, isolation, and frustrated desire.

Duchamp's subversive strategies gained momentum from the Dada movement, which began in Zurich in 1916 during World War I. A basic premise of Dada is that, since the so-called "civilized" world behaves irrationally—witness the war—it is pointless for artists to affirm rationality and order. Dada artists thus rejected Enlightenment thinking in favor of the irrational and the absurd (see, for example, fig. 14.22). Given its scorn for traditional art forms, Dada produced more extravagant gestures than durable art. What survived was Dada artists' expression of disgust at the status quo, which others emulated.

Kurt Schwitters's *Merz 19*

Kurt Schwitters (1887–1948), who once asserted that "everything the artist spits is art," created some of the more lasting Dada pieces. Schwitters made an art of random assemblage that he dubbed *merzbild* (random image). But as his collage of 1920, *Merz 19* (fig. 14.22) shows, he assembled them with a keen eye for design. By putting aesthetic order into his random fragments, Schwitters contradicted the underlying Dada conviction that life is random.

The Irrational, Subconscious, and Collective Unconscious: Surrealism

While Dada raised many questions about human existence, Surrealism is perhaps Modernism's most radical exploration of the psyche. It evolved in the 1920s out of the nineteenth-century Symbolist preoccupation with the inner life and Dada's sense of the irrational and the absurd. Surrealists were also preoccupied with Freudian psychoanalytic thought—the human sex drive, the meaning of dreams, and the power of the subconscious. At the same time, they explored Carl Jung's ideas about the importance of symbolic images that emerged spontaneously in fantasies and dreams. Jung—and the Surrealists—believed that these images derived from a collective unconscious that all humankind shares. If true, Surrealist art would have universal power. The Spaniards Salvador Dali (1904–89) and Joan Miró (1893–1983) introduced these ideas into the subject matter and processes of their art. Miró incorporated intuition and spontaneity into the process of painting itself (see fig.

14.33). Dali painted in a traditional, representational style that was highly controlled and detailed in finish, letting intuition and spontaneity govern the subject matter alone.

Salvador Dali's *Metamorphosis of Narcissus*

In his *Metamorphosis of Narcissus* of 1937 (fig. 14.23), Dali presents us with the kind of random collision of images that we encounter in dreams. Dali rendered his dreamlike images more believable through the use of traditional realism. Dali often constructed his images to suggest two divergent realities within the same pictorial form. Through the technique of traditional realism, he attempted to make his conflicting images more believable. Thus in *Metamorphosis of Narcissus*, he plays with the double identity of Narcissus: The flower, a type of daffodil, and the self-absorbed youth of Greek mythology. Here the flower sprouts from a crack in an egg held by a hand with a crack down its thumb—as much weird rock as strange hand. To the left, the viewer can read a comparable "rock formation" as the crouching youth. Set in a bizarre landscape, Dali's visual essay on narcissism subverts the conventions of realist art and unhinges all logical expectations.

Aggression and Anger: Picasso's *Guernica*

Picasso also exploited the potential of Surrealism. In 1937, outraged by news of the fascist destruction of the Basque town of Guernica during the Spanish Civil War of 1936–9, Picasso created a monumental work, *Guernica* (fig. 14.24), in which he protested violence and human suffering in images that have devastating impact. Drawing from his broad repertory of images, Picasso uses formal distortion as a visual metaphor for anger, aggression, and grief, and a palette of black, white, and gray to register destruction and grief. Held together by a Cubist-derived grid of densely interlocking forms and space, *Guernica* is a succession of tormented figures in a claustrophobic space dominated by a wounded horse and a defiant bull. Around them Picasso scattered the remains of a fallen warrior and four desperate women: One woman cries to heaven for her dead child; another stumbles through the rubble in flight; a third falls through a floor; the fourth defiantly thrusts a lamp, age-old symbol of truth and virtue, from a window. Like Goya in his age (see Chapter 12), Picasso reiterated, in Surrealist terms, the horrors of war.

14.23 Salvador Dali, *Metamorphosis of Narcissus*. 1937. Oil on canvas, 20" x 30". Tate Modern, London

14.24 Pablo Picasso, *Guernica*. 1937. Oil on canvas, 11'5 1/2" x 25'5 3/4". Museo Nacional Centro de Arte Reina Sofia, Madrid

14.25 Grant Wood, *American Gothic.* 1930. Oil on beaverboard, 29⁷/₈" x 24⁷/₈". The Art Institute of Chicago

American Realism: Rural Virtue and Urban Solitude

In 1913 at the Armory Show in New York, the American art world got its first exposure to Post-Impressionist and modern European art. Shocked and stimulated, some American artists began to emulate it. But in the 1920s, after World War I, America retreated into political and artistic isolationism, which increased after 1929 with the coming of the Great Depression. As a result, American artists rejected European Modernism in favor of the home-grown traditions of Realism. Grant Wood (1892–1942) and Edward Hopper (1882–1967) were both familiar with European Modernism. However, they focused on the American scene, and their Realistic styles were independent of their European contemporaries.

Grant Wood's *American Gothic*

Grant Wood, who was raised in Iowa, created a national icon of honest, forthright American values in his 1930 painting *American Gothic* (fig. 14.25). He posed his two figures in stances as direct and forthright as the values they signify; their frontal poses carry the quasi-sacred aura of two saints in an icon painting. The pointed upper window of the farmhouse is in a Gothic style whose religious associations allude to the values this farm couple represents. Wood's intent could not be more resolutely anti-Modernist, or more assertive of regional American values.

Edward Hopper's *Nighthawks*

Edward Hopper also worked in a traditional Realist style, but he explored the isolation and loneliness of modern urban life. Hopper trapped his subjects in hotel bedrooms, offices, movie theatres, cheap diners, or, as in *Nighthawks* of 1942, an all-night café (fig. 14.26). His figures are sometimes alone, or, more frequently, isolated amid others—together, but awkwardly disconnected. The space around them provides no protection or comfort. In *Nighthawks*, none of the protagonists—the rough-cut barman, the dapper businessmen and the dressy woman—reaches out toward the others. The empty street, the bare shop windows, the subdued colors exude an empty sadness that the café's shrill light only heightens. While not Modernist in style, Hopper's work is contemporary, even universal, in its content.

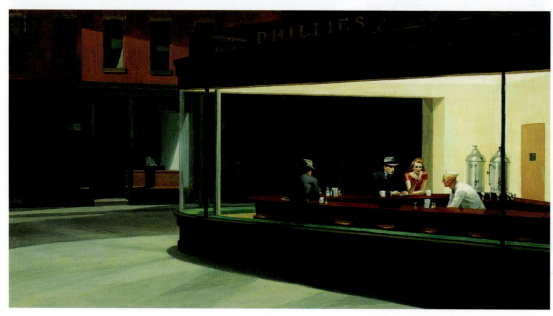

14.26 Edward Hopper, *Nighthawks.* 1942. Oil on canvas, 33¹/₄" x 56¹¹/₁₆". The Art Institute of Chicago

The Photographic Image: Man Ray and Henri Cartier-Bresson

Photography offered fresh possibilities and unique challenges to the modern artist. Photographers could emulate Modernist artistic strategies or function as astute observers of contemporary life. The photographs of the American Surrealist Man Ray (1890–1977), who lived in Paris in the 1920s, exemplify how photographers could manipulate imagery in the studio to achieve effects like those of modern art. Man Ray had moved to Paris in 1921 and by the mid-1920s had joined the Surrealists. His photograph *Noire et Blanche* (*Black and White*) of 1926 (fig. 14.27), printed as a positive and a negative, has rich multiple allusions to the essence of photographic media, the symbolic irony of the positive and negative image, the contrasting strains of the human race, and both African and contemporary sculpture (particularly a work of

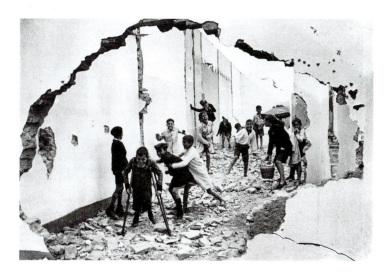

14.28 Henri Cartier-Bresson, *Séville, 1933*. 1933. Gelatin-silver print

Constantin Brancusi called *Sleeping Muse* of 1909–10 [Hirshhorn Museum, Washington, D.C.]).

By contrast the Frenchman Henri Cartier-Bresson (b. 1908) was the consummate photographic observer of the telling ironies of everyday life. In developing the pictorial qualities that capture human drama, as in his photograph *Seville, 1933* (fig. 14.28), Cartier-Bresson established the tradition of photojournalism. Photojournalism provides a different dimension to Modernism by using the unique documentary potential of photography to illuminate the human condition.

While the development of small, lightweight, portable cameras made action photographs like *Seville, 1933* possible, the image's success results from Cartier-Bresson's eye for framing and forming his subject and from his ability to move around it without disrupting the unfolding events. Here he used a shell-hole in a wall as a viewing point and frame. The casual grouping of the playing children echoes the shell-hole's ragged edge, which the rubble on the ground repeats. The irregular shape and texture of these elements also contrast with the whiteness of the walls, the regularity of the left wall's receding perspective, and the rectangular frame of the photograph itself. These formal elements direct attention to the playful group of boys. One boy's cheerful spirit rises above his disability to speak for the scene as a whole. Like Hopper, in his independence from Modernism, Cartier-Bresson captures a universal element of the human spirit.

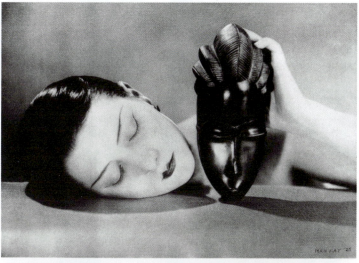

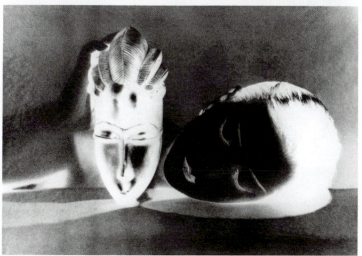

14.27 Man Ray, *Noire et Blanche* (*Black and White*). 1926. Photograph, printed as a positive and a negative

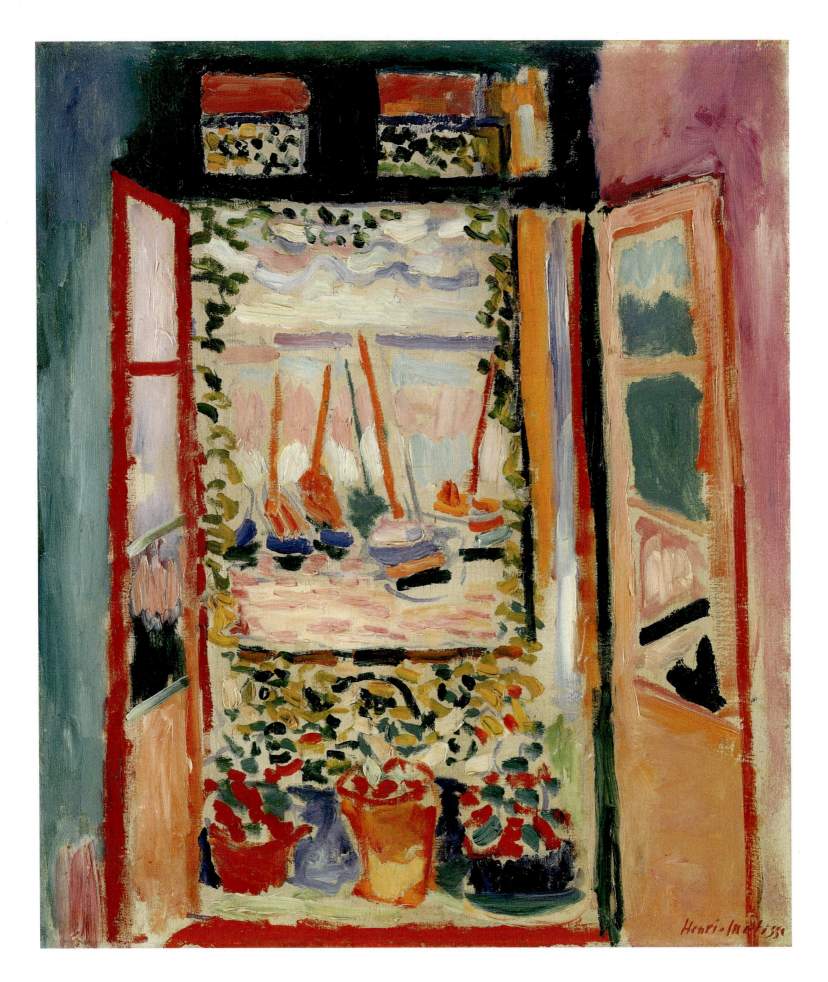

14.30 Georges Braque, *Houses at L'Estaque*. 1908. Oil on canvas, 28³/₄" x 23⁵/₈". Kunstmuseum, Bern, Switzerland

land of peace and plenty into a pictorial realm of sumptuous color—much as he did later with an indoor subject in his *Red Studio* of 1911 (see fig. 14.18).

Matisse's *Open Window, Collioure*

In *Open Window, Collioure* nature has exploded onto Matisse's canvas in myriad brilliant hues, applied in broad slashes and daring juxtapositions of complementary colors. Yet this seemingly slap-dash application disguises the artist's careful analysis of his visual sensations and his deliberate calculation of the effects of color placement.

In this painting, Matisse holds reality at a safe distance. We see the bright little pleasure boats beyond a cheery balcony, from the protective comfort of indoors. The alluring beauty of this scene vibrates directly before us as bold marks of paint on the surface of the painting. The resulting aesthetic stimulus derives from a harmony between the soothing motif and the sensuous vehicle in which it is embodied.

NATURE

For centuries, Western art was conceived as a form of mimesis, or imitation of nature. As if in revenge, avant-garde artists repudiated representational art, and with it the notion of art as a "window on the world." Instead, as we've seen, modern artists emphasized the internal, formal elements of art and the integrity of the picture plane as a painted surface. They asserted the autonomy of art's visual language and its independence from naturalistic representation. In modern art, nature is a pretext to explore artistic form and the artist's personal vision.

Landscape as Pleasure

As we noted earlier, Matisse took twentieth-century art in a new direction. He sought to lift the viewer's spirits through sensuous and decorative surface patterns and color. In such works as *Open Window, Collioure* of 1905 (fig. 14.29), he transforms the age-old dream of a

14.29 Henri Matisse, *Open Window, Collioure*. 1905. Oil on canvas, 21³/₄" x 18¹/₄". National Gallery of Art, Washington, D.C.

Landscape as Form: Braque and O'Keeffe

Georges Braque went further than Matisse in asserting artistic form over natural representation. Braque took his lead from Paul Cézanne's manipulations of landscape (see fig. 13.27). In *Houses at L'Estaque* of 1908 (fig. 14.30), Braque ignored specific details and focused on the rhythm of an all-over pattern of interlocking geometric shapes. (Critics first used the term "Cubist" for this painting.) In defiance of traditional perspective, Braque wedged these shapes against each other as a series of abutting planes that flattened forms and contradicted traditional notions of pictorial illusion. He further negates realism by reducing the colors to ocher, dark green, and gray. The result is an abstract formal structure inspired by landscape but no longer representational in intent. In effect, Braque asserted the autonomy of Modernist art over the authority of nature.

In America the landscape artist Georgia O'Keeffe (1887–1986) paralleled the Modernist tendency to transpose natural motifs into semi-abstract formal compositions. O'Keeffe transformed motifs from the New

Mexico landscape into generalized planes of color, or made close-up studies of skulls or flowers, such as her *Black Iris* of 1926 (fig. 14.31), which shows her attempt to represent natural forms in quasi-abstract terms.

Expressionist Landscape

While O'Keeffe did not intend that her natural imagery be read as symbolic of anything other than the motif itself, German Expressionists were more likely to use natural motifs as metaphors for the human condition.

Franz Marc's *The Fate of the Animals*

In Marc's work, images of animals stand out in landscapes of emotional intensity. His tragic *The Fate of the Animals*, painted in 1913, on the eve of World War I (fig. 14.32), centers on a terrified blue deer, an image of innocence, thrusting its neck and head toward the sky. Bolts of flashing color rip across the canvas, illuminating distorted green horses, foxes, and wild pigs. Devastation gathers from all sides. No painting seems more prophetic of the war that was to sweep across

14.31 Georgia O'Keeffe, *Black Iris*. 1926. Oil on canvas, 36" x 29⁷/₈". The Metropolitan Museum of Art, New York

14.32 Franz Marc, *The Fate of the Animals*. 1913. Oil on canvas, 6'4¹/₂" x 8'7". Kunstmuseum, Basel, Switzerland

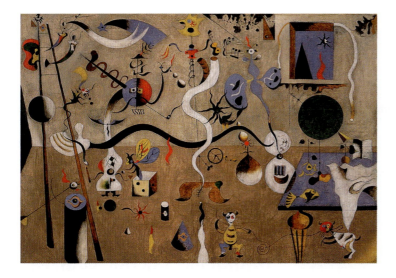

Europe, in which Marc was killed. Despite the power of Marc's landscapes, Kandinsky (see fig. 14.6) concluded that the representation of nature hindered the free expression of feeling. But for both artists, nature reflects the inner world of the artist, not just itself.

Landscape as Fantasy

While Surrealists such as Dali (see fig. 14.23) held nature at a distance, and rendered it strange and disturbing, landscape played a significant if bizarre role in their art, recalling in some ways the medieval artist, Hieronymus Bosch (see Chapter 8). In their landscapes, Surrealists such as Dali and Miró exploited the unnerving power of metamorphosis, embodying the imaginary forces that haunt our consciousness and invade our dreams. In following the lead of Freud and Jung, the Surrealists transformed nature into a landscape of the mind.

Joan Miró's *The Harlequin's Carnival*

There was no more witty and inventive creator of this landscape of the mind than the Catalan painter Joan Miró, who between 1919 and 1940 also kept a studio in Paris. Although Miró was never a formal member of the Surrealist group, he was one of the finest painters of Surrealistic sensibilities. His art is playful, outrageous, and absurd. It conjures up a world of biomorphic creatures that twitter, wriggle, squirm, and play erotic games, bearing just enough resemblance to creatures and things in the waking world—even to ourselves—to fascinate and disturb us. In Miró's *The*

14.33 Joan Miró, *The Harlequin's Carnival*. 1924–5. Oil on canvas, 26" x 36¹/₂". Albright-Knox Art Gallery, Buffalo, New York

Harlequin's Carnival painted in Paris in 1924–5 (fig. 14.33), a mass of little creatures and insects, painted in a cheerful rainbow of colors, floats and dances in space, with no natural light source, animating our fears and desires. In its flat, spaceless composition and disturbing manipulation of imagery derived distantly from nature, Miró's art is quintessentially modern.

Alexander Calder's *Lobster Trap and Fish Tail*

In the **mobiles** of the American artist Alexander Calder (1846–1923), Miró's bright little creatures seem to share our space—even moving around within it. In works like *Lobster Trap and Fish Tail* of 1939 (fig. 14.34), Calder, by introducing the dimension of movement, opened up new potential for sculpture, since, prior to Picasso's innovations (see fig. 14.15), it had traditionally been conceived in terms of three-dimensional mass, in high or low relief. Delicately balanced, and sensitive to the slightest air currents, Calder's mobiles offer an endlessly changing dance of forms in space, which in *Lobster Trap and Fish Tail* also suggests the silent world of swimming fish. As with other modern artists, however, the imaginative abstraction of form prevails over any attempt to represent nature. Nature is only the trigger for the artist's creative fantasy and Promethean drive to invent new forms.

14.34 Alexander Calder, *Lobster Trap and Fish Tail*. 1939. Mobile of steel wire and sheet aluminum, 8'6" x 9'6". The Museum of Modern Art, New York

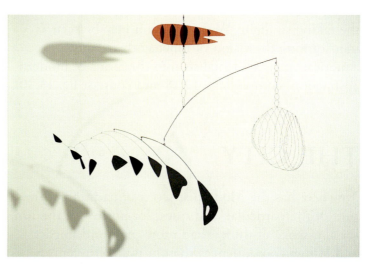

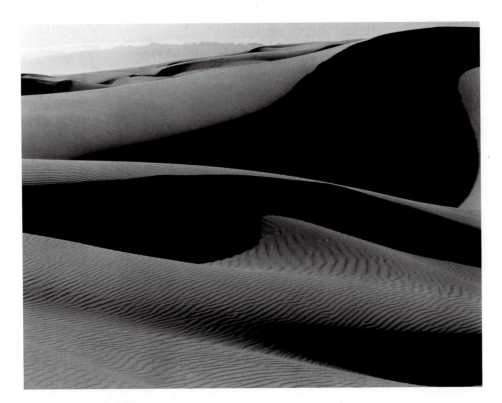

14.35 Edward Weston, *White Dunes, Oceano, California*. 1936. Gelatin-silver print. Center for Creative Photography, University of Arizona, Tucson

architecture, design, and urban planning. When the path towards abstraction captured the imagination of architects, it changed the face of the modern city and gave birth to the International Style of architecture.

Prototypes for the Modern City

The movement pioneered by Walter Gropius (1883–1969) at the Bauhaus school in Germany, Le Corbusier (Charles-Édouard Jeanneret; 1887–1966) in France, and Frank Lloyd Wright in the United States did not transform cities on a global scale until after World War II, when the building boom of the 1950s began. Many of the buildings that would become the prototypes for the modern city—as well as ideal city plans—were developed by architects working on projects outside of the cities themselves. Others, such as Ludwig Mies van der Rohe's (1886–1969) 1921 proposed crystal skyscraper for Berlin, remained unrealized. Nevertheless, whether isolated or unbuilt, the architectural vision developed in the first half of the century—mostly in the context of isolated buildings—would soon enough bear its fruit, transforming the look of modern cities around the world.

Fernand Léger's *The City*

Much of modern architecture was rooted in a spirit of optimism: Artists and architects believed that they could achieve social and aesthetic renewal by renouncing the past and allying art with technology. Fernand Léger's (1881–1955) painting *The City* (fig. 14.36) of 1919 celebrates this hope while allowing its dehumanizing potential. Léger's artistic roots were in Cubism, which he develops here as a collage-like assembly of crisp geometric shapes defined with mechanized precision and pure, evenly applied primary colors—red, yellow, and blue—contrasted with slabs of black and white. Enmeshed within this abstract world of mechanical

Landscape Photography: Edward Weston

Landscape photography also expressed the Modernist tendency toward abstraction even though the camera lens is not designed to edit out and simplify visual data. However, in photographs such as *White Dunes, Oceano, California* of 1936 (fig. 14.35), the American photographer Edward Weston (1886–1958) photographed the natural world in terms that accentuated the formal qualities of abstract design. The sand dunes offered Weston an ideal subject with their rich contrasts of soft, flowing forms, crisp edges, and textures varied and patterned by the wind, as accentuated by the raking sunlight. Weston's vision may be seen as transforming the vision of nineteenth-century American transcendentalists into the terms of modern abstraction (compare fig. 12.18 and contrast fig. 13.30).

THE CITY

Nowhere has the Modernist scorn of tradition, disregard of the particular, and quest for purity—for the universal essence of things—had more profound impact and lasting consequences than in twentieth-century

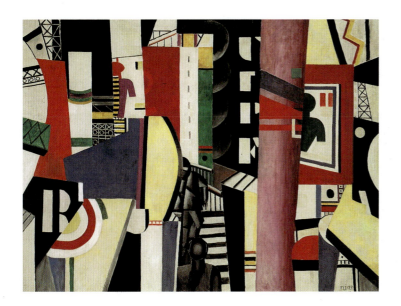

14.36 Fernand Léger, *The City*. 1919. Oil on canvas, 7'7" x 9'8¹/₂". Philadelphia Museum of Art

precision are traces of the modern city—a telegraph pole, steel girders, stencilled lettering, puffs of smoke, and a robot-like figure climbing a flight of steps. The painting reveals the essence of the ideal modern city: Pure as a primary color, sharp as a razor, stripped of reference to nature or tradition, defined by the machine, yet inhabited by robotic humanoids. Léger's bright colors and trust of modern technology may exude an optimism absent from the works of his more jaded contemporaries, but his optimism seems to come at the expense of human individuality.

14.37 Gerrit Rietveld, Schröder House, Utrecht, the Netherlands. 1924

Gerrit Rietveld: De Stijl and the Birth of the Machine Aesthetic

The Dutch De Stijl ("The Style") movement, founded in 1917, nurtured Léger's Modernist aesthetic. Its name signified its members' belief in the possibility of developing a style of such absolute purity—free from individual subjectivity or emotion—that it would become, literally, *the* enduring style based on geometric abstraction, primary colors, and the intersection of vertical and horizontal lines.

We can see the application of these austere principles in Mondrian's nature painting (see figs. 14.7, 14.8), and in Gerrit Thomas Rietveld's (1888–1964) Schröder House, at Utrecht in the Netherlands, built in 1924 (fig. 14.37). The Schröder House is what art

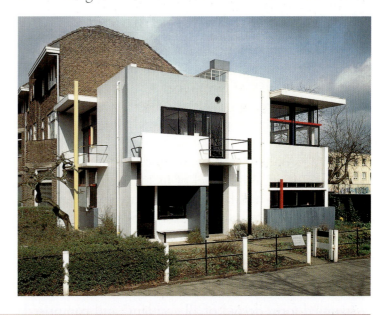

❖ MATERIALS AND TECHNIQUES ❖

Cantilever

A cantilever is a wooden, steel, or reinforced concrete beam or concrete slab that extends horizontally into space beyond its point of support. Its extended end is unsupported, but its other end must be secured; an intermediary support carries the tensions exerted from either end. Cantilevering allows upper floors to project beyond lower ones. In a city, this can allow for the upper levels of buildings to project over the pavement without narrowing the width of the street and pavement. This technique is also commonly used for window and theater balconies, and provides cover in sports stadiums. In twentieth-century architecture, cantilevering was also used by architects such as Gerrit Rietveld and Frank Lloyd Wright to project mass into open space in ways that appear to defy gravity (see, for example, figs. 14.37, 14.42).

historians call "antihistoricist." That is, it carries none of the traditional design elements that recall earlier styles of architecture: We see no classically inspired columns, for example, no decoration of any sort. It is also anti-monumental and elemental: Rietveld replaced solid mass with thin, flat planes of glass and reinforced concrete suspended on a grid of vertical and horizontal steel members. Significantly, too, this house is strictly functional, an adaptable machine for habitation. Other key features of the style are the flat roof, cantilevered balconies (see "Materials and Techniques: Cantilever," page 465), steel pipe railings, continuous strip windows, and pure white surfaces. These features influenced the designs of another movement, the Bauhaus.

Walter Gropius: Bauhaus, and the Marriage of Art and Technology

One of the most influential schools of architecture, design, and industrial technology was the Bauhaus. Founded in Germany in 1919, its aesthetic principles were nourished by many sources, including the Dutch De Stijl.

In 1924, Walter Gropius designed buildings for the Dessau Bauhaus as a model of its ideals (fig. 14.38). He grouped the buildings in "an asymmetrical but rhythmical balance" (as seen also in Schröder House, fig. 14.37), using a weightless curtain wall of glass, crystalline and pure, the obligatory flat roofs, machined steelwork, and pure white surfaces. Gropius's design reflects a machine aesthetic, based on the use of "exactly stamped form devoid of all accident" and comprised

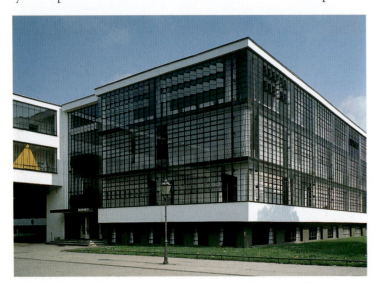

of "the arrangement of like parts in series." Gropius's Bauhaus stressed the importance of the universal rather than the individual. Its members called for "a clear, organic architecture whose inner logic will be radiant and naked, unencumbered by lying facings and trickery; we want an architecture adapted to our world of machines, radios and fast cars, in which the strength of new materials—steel, concrete, glass—will give 'a new lightness and airiness.'" This was the ideal behind the International Style in architecture. In 1933, the Nazis deemed the school ideologically subversive and closed it down, but its faculty carried Bauhaus ideas elsewhere, notably the United States. In process, the International Style in architecture was born.

Le Corbusier: Sculptural Form and Utopian Social Engineering

Meanwhile in France, Le Corbusier (the pseudonym of the Swiss-born architect Charles-Édouard Jeanneret) was applying the utopian ideal of rational social engineering to urban planning and endowing Modernist, International Style architecture with a more sculptural quality. Both of his initiatives have affected the modern city. He first revealed the ambitious scale and futuristic nature of his thinking in 1922, in a series of drawings of a "Contemporary City for Three Million Inhabitants" (fig. 14.39). He based this ideal city plan on the intersection of vertical and horizontal lines, with a rigid geometric grid built around a central axis as the main traffic thoroughfare. At its core was a vast layered intersection, whose upper level was an airport. Grouped around this core were twenty-four glass skyscrapers 600 feet high for the technocrats, bankers, and managerial class. Beyond these stretched a grid of high-density apartment buildings in park-like settings, with workers' suburbs and an industrial zone. With its separation of functions and open spaces the plan seemed perfectly suited to the city of the future.

In theory, Le Corbusier's city plan allowed for optimum mobility and high-density living that preserved open space and fresh air. It promised a brave new world of order, light, pure air, green grass, and cold efficiency. But it sacrificed the social vitality of the corner store, the

14.38 Walter Gropius, Workshop Block, the Bauhaus, Dessau, Germany. 1925–6

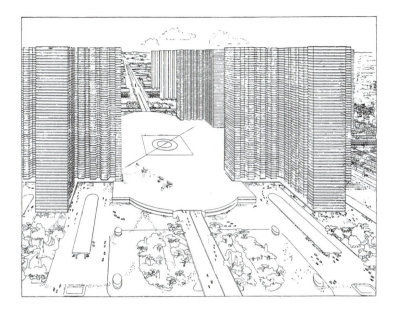

14.39 Le Corbusier, plan for a "Contemporary City for Three Million Inhabitants." 1922

Le Corbusier's Villa Savoye

The Villa Savoye (1928–30) stands on a hillside at Poissy overlooking the River Seine valley, twenty miles north-west of Paris (fig. 14.40). The first impression is of a long, low white box raised on stilts–Le Corbusier's signature reinforced concrete cylindrical pillars, which he called "pilotis"–crowned by abstract sculptural forms that play off against the regularity of its box-like structure. Strip windows running along each side of the villa create an alternating horizontal rhythm of light and shadow.

Inside, the upper level combines both closed and open spaces, including a secluded roof garden open to the sky, separated from the living room by floor-to-ceiling plate glass. Thus, although designed as a "machine for living in," as Le Corbusier put it, the interchange between inside and outside, culture and nature, allows its occupants to enjoy the organic world, whether through the roof garden or the generous views through the strip windows. As a Modernist building, its crisp, white rectilinear forms contrast sharply with its natural setting.

market square, and the conventional street. It was a city more fit for Léger's robotic humanoids than for everyday social exchange. In time, its principles invaded modern cities, and many people find them dehumanizing.

Le Corbusier's ideal city plan was never realized, but his completed buildings were equally revolutionary and influential. He moved the International Style of architecture in a more sculptural direction by emphasizing the plastic potential of poured concrete. Le Corbusier's efforts reached their climax after World War II; here, we will consider two of his early projects.

Le Corbusier's Unité d'Habitation

The Unité d'Habitation, a large apartment complex built in 1947–52 on a hilltop in Marseilles, France, reinterprets the basic principles of the Villa Savoye in monumental and even more sculptural terms (fig. 14.41). It, too, is raised on pilotis (obscured by shrubbery), and the strip windows have become balconies

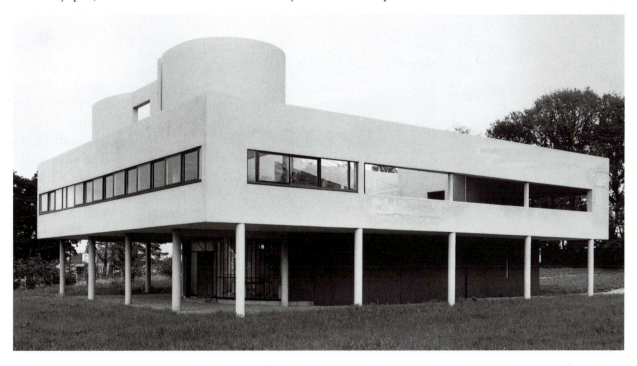

14.40 Le Corbusier, Villa Savoye, Poissy-sur-Seine, France. 1928–9

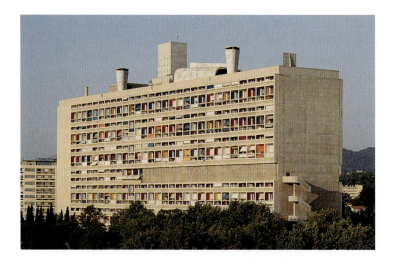

14.41 Le Corbusier, L'Unité d'Habitation, Marseilles, France. 1947–52

Frank Lloyd Wright: Harmonizing with Nature

The American Frank Lloyd Wright developed an organic conception of architecture that referred more to nature than to the machine. Wright built low-strung houses, conceived as protective human shelters that blended into their surroundings. He designed these houses from the inside out, starting with the fireplace and chimney as the heart of the home. From there units of space reached out into the natural environment. Like other modern architects, Wright made the desired functions drive the design and exposed rather than hid the structural materials. However, he preferred natural materials and open forms, extending into the surrounding space, to achieve an organic architecture that harmonized with its environment.

and sunbreakers. A series of sculptural protuberances on the roof signals the recreational facilities that Le Corbusier optimistically provided for the inhabitants. In two other optimistic gestures, he designed the apartments in varying sizes to assure a good social mix, and included a shopping arcade on the fifth floor.

Le Corbusier conceived of the Unité as a self-sufficient community that planners could multiply to create a city. In practice, however, it provided a model for high-density, low-cost public housing projects, which tended to separate their inhabitants from the wider community, rather than integrate them with it.

Wright's Kaufmann House ("Falling Water")

Wright's masterpiece of domestic housing is the Kaufmann House, "Falling Water," at Bear Run, Pennsylvania, built in 1936 (fig. 14.42). Cantilevered over a waterfall, "Falling Water" is built around a vertical chimney core of rough-cut, locally-hewn stone. From this solid core, the surrounding living spaces project into open space. The smooth horizontal concrete slabs contrast with the textured vertical core, and echo the form of the rock slabs below. Long, horizontal strips of windows line the open-plan interior space, maximizing the continuity between interior and exterior. Wright also designed most of the interior fixtures and living-room furniture to harmonize with the overall design and scenery. While few could build on such a spectacular site, "Falling Water" served a wider purpose. If International Style buildings ignored their specific sites and contexts, here was an alternative that integrated the design of a building with its natural environment.

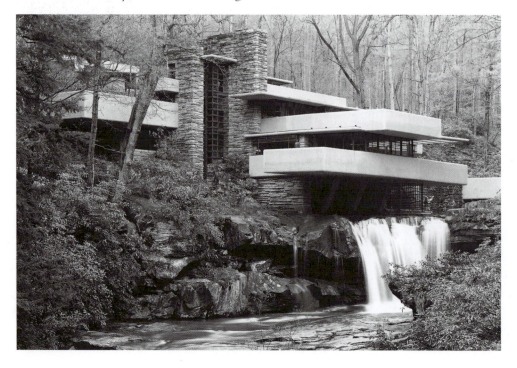

14.42 Frank Lloyd Wright, Kaufmann House ("Falling Water"), Bear Run, Pennsylvania. 1936

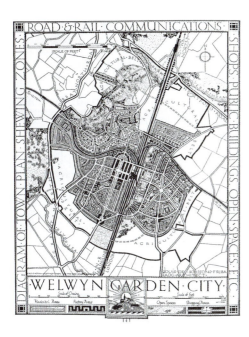

14.43 Louis de Soissons, plan of Welwyn Garden City. c. 1920

"Falling Water" was an exclusive project for a wealthy client, but, like Le Corbusier, Wright dreamed of a utopian city. His ideal, which he called Broadacre City, was a decentralized city in which householders would cultivate their own plot of land, tall buildings would be far apart, and the car and the telephone would render Le Corbusier's centralized ideal redundant. Like "Falling Water," it was an attempt to reconcile nature and culture, but on a city-wide scale.

The English Garden City

Wright's plan went unrealized, but other attempts to reconcile culture and nature captured the imagination of modern urban planners such as Ebenezer Howard (1850–1928), a prominent advocate of the English Garden City movement of the early twentieth century—a movement that grew out of earlier initiatives to integrate town and country, as at Regent's Park, London (see fig. 12.20). Welwyn Garden City in Hertfordshire, England, was inspired by Howard and designed in 1920 by Louis de Soissons. The plan combines formal geometric elements for the city center, and irregular, serpentine configurations for the outlying residential areas, which also include generous parklands that follow the site's natural contours (fig. 14.43). A railroad forms the central axis of the town and divides its middle-class housing from the

14.44 Baga *nimba* fertility mask, Guinea, West Africa. Wood and fibres, height 48" without fibre costume. The British Museum, London

industrial section and its housing. Many modern cities have been modeled on Howard's ideas. However, the aspiration to reconcile culture and nature has proved elusive, forcing city dwellers to chose between the compressed urban core and the dependent suburbs, often separated by industrial wasteland.

PARALLEL CULTURES
Africa and Mexico

Africa: The Guinea Coast and Gabon

In the nineteenth century, Western avant-garde artists began looking beyond their own tradition to non-Western art and culture for inspiration; Gauguin turned to Polynesia, other artists to Japan (see Chapter 13). Later in the century, missionaries, colonial administrators, and merchants brought indigenous art from Africa to the West. Considered exotic souvenirs, these pieces included carved ritual masks, ancestor figures, ceremonial furniture, and weapons. Most were housed in ethnographic museums as evidence of "primitive" cultures. Around 1905, Picasso, Braque, Matisse, and other artists working in Paris began collecting and imitating this work, much as their predecessors had the art of Japan. This interest became so intense that "primitivism" (as the trend came to be called) became a central theme of modern art.

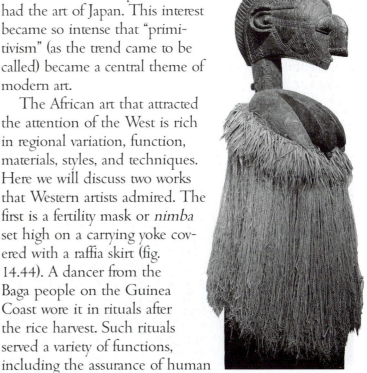

The African art that attracted the attention of the West is rich in regional variation, function, materials, styles, and techniques. Here we will discuss two works that Western artists admired. The first is a fertility mask or *nimba* set high on a carrying yoke covered with a raffia skirt (fig. 14.44). A dancer from the Baga people on the Guinea Coast wore it in rituals after the rice harvest. Such rituals served a variety of functions, including the assurance of human

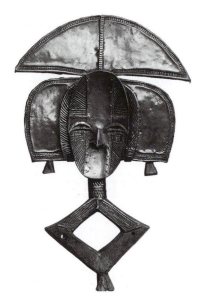

14.45 Kota ancestor figure, Gabon, central Africa. Late 19th century. Wood, brass, and copper, height 26". The British Museum, London

Mexico: Rivera, Orozco, and Kahlo

Unlike African art, Mexican art took more from European practice than Europe took from Mexico. Mexican history left Mexican artists with an ambivalent identity composed of indigenous Indian and imported European elements. Extended periods of both conflict and successful coexistence between diverse peoples have marked this history. A group of modern Mexican mural painters transcribed elements of it into their art.

The Muralists

In an expansive series of murals painted during 1929–35 in Mexico City, Diego Rivera (1886–1957) attempted to inscribe the drama of the history of Mexico in a churning sea of striving mortals. His work presents an endless series of conflicts and revolutions; it reaches back to an idealized Mayan past–purified of violence and human sacrifice–and projects an equally idealized Marxist future, in which multi-racial girls and workers toil like well-oiled cogs in a Bolshevik machine over which Lenin presides.

Rivera captures more of the diversity of modern Mexico in a mural he painted in 1947 entitled *Dream of a Sunday Afternoon in the Alameda* (fig. 14.46) filled with figures from Mexico's history. From Spanish conquistadors to peasant revolutionaries, this seems a truer Mexico. The conception and style of these images betray Rivera's own dependency on European Modernism; the mural echoes a painting by Manet of fashionable Parisians strolling under the trees of the Tuileries Gardens (*Music in the Tuileries*, 1862 [The National Gallery, London]), updated in terms of Fauvist color. With Soviet Marxism in his head, and French Modernism in his eyes, Rivera looks out on a society brimming with memories of many races,

survival, through fertility and the provision of adequate food supplies, protection against evil spirits, and the social initiation of the young. Removed from this context, the mask's raised upright figure projects authority; its abstract form impresses the Western eye. To Picasso, who owned a similar Baga fertility mask, it demonstrated the expressive power of non-naturalistic forms.

The second piece is also from central Africa, an ancestor figure from the Kota tribe of Gabon (fig. 14.45). Made of wood and covered with brass or copper sheeting, such guardian figures were placed over a container holding the bones of prominent ancestors to fend off evil spirits. The frontal stare and aggressive posture show its purpose. These distinctive two-dimensional, severely abstracted figures, in which the human form has been simplified into sharply defined geometric shapes, opened new artistic possibilities into abstraction for Western artists.

14.46 Diego Rivera, *Dream of a Sunday Afternoon in the Alameda*. 1947. Mural, approx. 14'2½" x 56'. Formerly Prado Hotel, Mexico City, now Museo Mural Diego Rivera, Mexico City

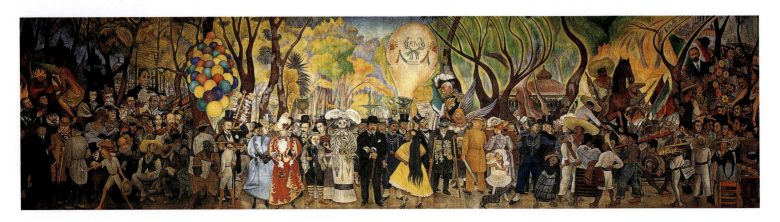

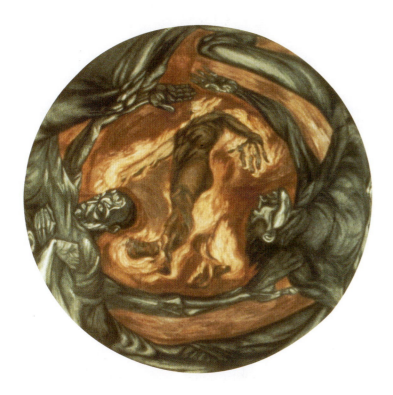

conflicts, and possibilities, struggling with its own identity within the wider human community.

Another Mexican muralist, José Clemente Orozco (1883–1949), addressed the fundamental tensions between an Indian past and a European present in more pessimistic terms. As Orozco lived through the years of the Mexican Revolution (1910–20), he saw only corruption, evil, and destruction from all sides: The ancient blood-sacrifice of the indigenous peoples, the violence of European imperialists, and the corruption of modern bureaucrats.

In contrast to Rivera's vision of an idyllic pre-Columbian, pre-imperialist past, for Orozco none could be exonerated. There were no innocent victims to champion, nor glorious heroes, only a succession of violence perpetrated by human beings on each other. This gloomy vision drove his art toward an expressionistic style and mythical subjects, that could represent all of humanity, as in his epic ceiling fresco, *Man in Fire*, of 1939 (fig. 14.47). Orozco painted *Man in Fire* in the cupola of Cabanas Hospice, in Guadalajara, Mexico, as a variation on the classical theme of Prometheus. In the original myth, Prometheus was condemned by the gods for stealing fire from heaven to help humankind. Orozco's fresco depicts this gift of fire as a consuming force, bringing only sorrow and suffering in its wake.

14.47 José Clemente Orozco, *Man in Fire*. 1939. Mural, diameter of cupola 30'6". Hospicio Cabanas, Guadalajara, Mexico

Frida Kahlo's *The Two Fridas*

Other Mexican artists expressed the anguished multiple identity spawned by the European intrusion into Indian culture in Surrealist terms, which allow for the coexistence of contradictory realities. Frida Kahlo (1907–54), who was severely injured as a child, examined her self-identity in a series of self-portraits: As an invalid, with a sound mind in a crippled body; as a wife (of the muralist Diego Rivera), experiencing marriage's joys and torments; and as a Mexican, valuing both traditional Mexican family values and the self-sufficiency of a modern Western woman. In one famous double portrait, *The Two Fridas* of 1939 (fig. 14.48), Kahlo clothes herself in both the discreet bridal garments of Mexican tradition and the liberated low-cut clothes of the modern Western world to signify these tensions. She also echoes ancient Aztec sacrifice, in which priests tore out the heart to appease the gods, by depicting her own heart as torn out and bleeding. To be a modern woman, Kahlo's painting suggests, traditional identity and values must die. The figure in Kahlo's self-portrait seems unprepared to endure this loss, yet willing to accept it—she wields the surgical scissors with her own hand.

14.48 Frida Kahlo, *The Two Fridas*. 1939. Oil on canvas, 69" x 69". The Museum of Modern Art, Mexico City

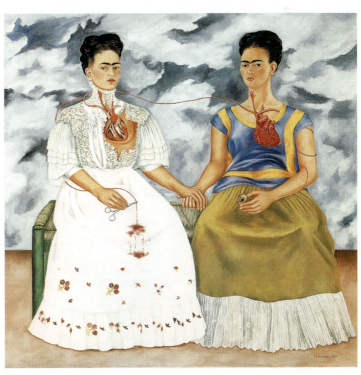

The Bitter nest Part II: Harlem Renaissance Party

15 Post-war to Postmodern Art

In the late 1940s, in the aftermath of World War II, the center of the art world passed from Europe to North America. While initially stimulated by European Modernism, artists of the post-war years followed no single unifying vision. Demoralized by the impact of two world wars, artists and writers of both continents became cynical about the possibility of human progress. Values became less certain; voices and viewpoints, silent or ignored in earlier eras, now demanded to be heard. In the political and economic arenas, major shifts were occurring as well. While the war had devastated much of Europe, it had reinvigorated American industry, pulling the country out of the Great Depression. Now, the United States would emerge as an economic and political power. The art of the post-war years reflects those unfolding social changes.

The 1960s and 1970s saw enormous social unrest, sparked by the civil rights movement and the war in Vietnam. In turn, that unrest fueled the pluralism of the 1980s and 1990s, in which the issues of feminism, gender politics, and multiculturalism rose to prominence. In these contexts, the work of artists such as Faith Ringgold (b. 1930), whose *Bitter Nest Part II: Harlem Renaissance Party* of 1988 we see in figure 15.1, acquired a particular relevance.

During the post-war years, three strands of thought deeply influenced the character of art—existentialism, materialism, and pluralism (as well as an underlying threat of nihilism—that is, the notion that there is no valid basis for knowledge, meaning, or truth). Each of these "isms," which we will discuss briefly below, rejects the notion that human experience is guided by a single, unifying order, and all have contributed to the pervasive individualism of our age.

These ways of understanding human experience also marked a shift from Modernism's belief in progress to the profound skepticism of postmodernism. Postmodernists reject all traditional grounds for meaning, including a divinely created universe, traditional gender roles, and the certainty of knowledge. From a postmodern perspective, all values are arbitrary and no social institutions are to be taken as universal and permanent. This means that everything we take for granted as "right" is subject to a new interpretation. Even "masculinity" and "femininity", say postmodernists, are not biologically fixed but rather, they are flexible roles, shaped and reshaped by society. The only certainties in a postmodern world are uncertainty and ambiguity. Images of fragmentation and paradox, first seen in Cubism, Dada, and Surrealism (see figs. 14.14, 14.22, and 14.23), recur in new forms in the art of Robert Rauschenberg (b. 1925), Gerhard Richter (b. 1932), Yasumasa Morimura (b. 1951), and others (see figs. 15.3, 15.33, and 15.45).

The Late 1940s and 1950s: Existentialism and the Rise of the New York School

The avant-garde artists who gave birth to modern art still assumed human culture was moving forward, and that their art contributed to the process of social change. But the assumption of progress had already been undermined by the senseless butchery of World War I, and it was further betrayed by the atrocities of World War II, specifically by the methodical mass murder of millions of European Jews and others, including homosexuals, whom the Nazis deemed unfit to live. Disillusion in the post-war years would transform the artistic vision of the West.

In his 1957 Nobel Prize acceptance speech, French existentialist author Albert Camus captured this sense of disillusionment:

> Those men who were born at the beginning of the First World War and were twenty at the time of Hitler's coming to power and the first revolutionary trials, who were then confronted, to complete their education, with the Spanish war, the Second World War, the universal concentration camp, Europe ruled by the [jailer] and the torturer, have now to bring up their [children] and produce their works in a world threatened by nuclear destruction. Nobody, surely, can expect them to be optimists ... None the less, the greater number of us, in my own country and throughout Europe, have rejected such nihilism and have tried to find some law to live by. They have had to forge for themselves an art of living through times of catastrophe, in order to be reborn, and then to fight openly against the death-instinct which is at work in our time.

Camus also points to the consequences for writers and artists of the horrors of twentieth-century history. Some were drawn toward nihilism, the belief that there is no meaning or purpose to existence. Many others followed existentialist thinkers such as Camus himself and Jean-Paul Sartre, who taught that meaning derives from life as it is experienced, not from any universal set of values. Each of us must construct our own meaning for our own lives. Yet many thinkers and artists sensed a profound loss of meaning; the possibility of any unifying order—whether based on traditional Judeo-Christian beliefs or anything else—seemed increasingly remote to minds dazzled by modern science yet disillusioned by brutal human conduct. Such thinking permeates the work of post-war artists. The British artist Francis Bacon (1909–92) potently expressed the anxieties generated by this outlook, in works such as his *Study after Velázquez's Portrait of Pope Innocent X* of 1953 (fig. 15.2), which we will discuss later in the chapter.

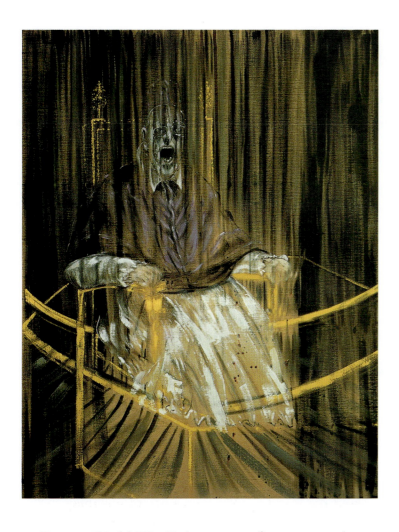

to defeat the Nazis, and now, as returning soldiers were eager to start life afresh, optimism reigned. During the 1950s and 1960s—even in the shadow of the arms and space race generated by the Cold War between the United States and the Soviet Union—suburbs, shopping malls, golf courses, and theme parks spread out across the country.

Economic growth fueled the myth of progress and lent commercial support for the avant-garde art of the New York School. Previously, collectors and museum directors had invested in the well-proven art of the past; now, everyone wanted the experimental and the new. The craze for contemporary art drove prices for the work of living artists to unprecedented heights. Some artists benefited from their new celebrity status, but many were suspicious of the commercialization of their works, which were essentially non-conformist and anti-bourgeois. Becoming wealthy from such art ran counter to the ideological thrust of the art itself. In effect, while artists rejected the materialism of the age, some were caught within it.

During World War II the center of experimental art shifted from Paris to New York. Some artists had fled from Germany to America after the Nazis gained power in the 1930s. With the fall of France in 1940, many Parisian artists also left for New York. The city's museums already had rich collections of the works of European Modernists, inspiring artists of the New York School to forge a new movement known as Abstract Expressionism. Their works came to dominate avant-garde art from the 1940s to the early 1960s; they reflect the existentialist emphasis on individual self-authentication. Other previously dominant forms of art, such as figurative realism, were now regarded as outdated.

Progress, Materialism, and Art as a Commodity

After years of deprivation, first during the Depression and then during the war, post-war Americans went on a buying binge. The United States had helped Europe

The 1960s and 1970s: Social Unrest and Artistic Protest

While many prospered in the 1950s, others—including most artists—were left behind. Black soldiers had returned to the same racially segregated society they had left. Although the civil rights movement, which began in the 1950s, would ultimately widen opportunities for blacks, even with the Civil Rights Act in 1964, deep fissures remained in American society. Widening those fissures were the assassinations of President Kennedy, Martin Luther King Jr., and Robert F. Kennedy. Many Americans had come to think that such things didn't happen anymore in the U.S. Their country now seemed a different place.

By the mid-1960s, a diverse counter-culture was challenging the establishment, and by the late 1960s, as U.S. involvement in the war in Vietnam grew, race rioting in American cities was also becoming a familiar sight. Students in both Europe and America protested against the loss of life and futility of American

Pop Art, Assemblage, and Non-studio Art

Pop artists, such as Andy Warhol (see fig. 15.13), Roy Lichtenstein, and Richard Hamilton (see fig. 15.11), embraced in their work many of the flashy commercial qualities of the culture they parodied. Assemblages are a form of sculptural collage (see Chapter 14, "Materials and Techniques: Collage and Assemblage," page 449). Installations are three-dimensional tableaux that occupy an entire space (see, for example figs. 15.7, 15.15, and 15.18). For artists of the 1960s, such assemblages and installations—like earlier Dada art—typically embraced the random, disjointed, and chaotic elements of life. They expressed an alienated, at times nihilistic, outlook that sought no coherence in existence.

Besides these art forms, various other new modes of art were developed outside the context of the studio. Among them were "happenings"—a type of mixed-media public performance (see fig. 15.6) —and earthworks—large scale interventions in the environment, often created at remote sites (see figs. 15.28 and 15.31). Expressing various social concerns, such forms of non-studio art were also conscious attempts to avoid art being sold as a commodity, since in themselves they could not be possessed.

involvement in Vietnam. Many among this counter-culture were disillusioned by the spiritual void of Western materialism and were drawn to the mysticism of Eastern religions. Others experimented with hallucinatory drugs. As these new spiritual and experiential worlds expanded, the geographical world seemed to shrink; affordable travel and expanding telecommunications increased awareness of non-Western lifestyles and art, and respect for multi-cultural diversity.

Rejecting Modernism: Toward Postmodern Fragmentation

Younger American artists, coming to prominence in the 1960s, were both wary of the affluence of post-war American culture and extremely sensitive to the social unrest of the 1960s. As we've noted, they were suspicious of the institutionalization of avant-garde art, specifically Abstract Expressionism (see page 480). Many felt caught between contrary impulses: They could either let their work stand as social criticism, or sell it as a market commodity. In the late 1950s and early 1960s, this struggle spawned several trends, including Pop art, assemblage, and installations (see "Pop Art, Assemblage, and Non-studio Art, " above). These new art forms reveal a younger generation's

growing rejection of the underlying principle of Modernism—that art must always evolve new forms, and that only the new was valid. To younger artists, these attitudes were doctrinaire and exclusive. They viewed the world as offering a range of possible options, none inherently more valid than another. Everything was ambiguous, open to interpretation, and dependent on its context; truth was an illusion; everything was relative. Life appeared more like a collage of fragmented experiences, open-ended, pluralistic, and lacking any unifying pattern or meaning. The American artist Robert Rauschenberg gave powerful form to this view of life in collaged works such as *Retroactive I* (fig. 15.3).

The Late 1970s, 1980s, and 1990s: Postmodern Skepticism and Consumer Culture

Postmodern pluralism acknowledges that different ideals and cultural values can coexist, a position that also implies that nothing has any absolute value. For postmodern artists, difference and diversity are a given (see "The Artist as Woman and Minority," page 478).

Western consumer culture peaked in the 1980s and 1990s, as the idealism of the 1960s and 1970s yielded

to shallow materialism. American artist Jeff Koons (b. 1955) parodies this phenomenon in such works as *Pink Panther* of 1988 (see fig. 15.24). The late 1980s also witnessed the collapse of communism in eastern Europe, and the horror of the AIDS (acquired immune deficiency syndrome) virus. Even if the collapse of communism and authoritarian regimes in eastern Europe marked the end of the Cold War, however, the new opportunities this created often delivered little more than the spread of consumer culture and the values of American materialism.

Visual artists from the late twentieth century to the present have been competing with glitzy consumer goods and the media information overload that marks modern life. If artists once attempted to give form to shared cultural values, and in some way to make sense of human experience and universal truths, today such ideals seem to make little sense. Postmodern artists recognize that reality is filtered by our own culture. This holds true even of supposed "facts" like those reported on the TV news. Change the filter, say postmodernists, and the story changes as well. When knowledge is thought of as merely relative, we are left to pick and choose meaning at will. After thousands of years of reliance on certainties, postmodernism constitutes a profound identity crisis for Western civilization. When values are fluid, there may seem to be greater freedom, but life loses its solid grounding and can appear to be an endlessly futile spectacle.

Recurrent Themes of Post-war and Contemporary Art

Among the issues of our time that most deeply engage contemporary art are our pervasive sense of human suffering, disillusionment, and alienation. Artists echo the search for spiritual fulfillment and personal authenticity; they express the threat of all-engulfing chaos; and they contend with our immersion in popular culture, and estrangement from nature. They also voice our concerns about the struggles of minority groups. Through a range of visual strategies, artists have explored the significance of our individual choices and actions, and questioned the meanings of life.

SPIRITUALITY

In the first half of the twentieth century, artists expressed the spiritual in terms of the aspiration to transcend materialism (see Chapter 14). Such artists as Mondrian, Delaunay, and Kandinsky invoked a sense of universal order and the inner life-force. In elemental, abstract terms Mondrian used balanced blocks of color, repetition of shapes and linear patterns, and a stable structure of verticals and horizontals to express a vision of order. He believed that "the artist sees the tragic to such a degree that he is compelled to express the non-tragic."

Religious Skepticism and Spiritual Yearning

Some artists, nevertheless, have felt compelled to express the tragic, among them the British artist Francis Bacon and the American Barnett Newman (1905–70). For

In Chapters 1 to 14, women have appeared more on the canvas than in front of it, more as models than as artists. As we noted in Chapter 1, like most other professions, the art world was not considered an appropriate place for women. When academies were founded, only a few women were admitted, but even then, the nude model was off limits. Over the course of history, such social conventions, as well as the usual restrictions against women working outside the home, have greatly restricted women's opportunities to study or practice art. Until recently, very few women artists had become prominent, but the Women's Movement of the 1970s began to open the doors in the art world that had been traditionally closed to women.

For nearly three decades, feminist artists, critics, curators, and historians have stood at the vanguard of the postmodern, pluralistic outlook. Feminists like Judy Chicago (see fig. 15.19) and Cindy Sherman (see fig. 15.20) have struggled to make inroads into the art world establishment, questioning assumptions which they view as white, Western, and male.

The efforts of feminists have also opened the way for other under-represented racial and ethnic minorities. They are represented here by artists such as Jorge Rodriguez and Charles Abramson (see fig. 15.7), Romare Bearden (see fig. 15.22), Faith Ringgold (see fig. 15.1), and Betye Saar (see fig. 15.43). Advocates for feminism and multiculturalism have also noted that the formal aesthetic qualities valued in traditional Western art were almost exclusively defined by privileged Euro-American white males, and thus—consciously or unconsciously—used by them as an instrument of exclusion.

Gays and lesbians have also sought recognition for their distinct cultural identity, taking advantage of postmodernism's ideological openness to voice their concerns in both word and image. In these ways, building on feminist initiatives begun in the 1970s, the pursuit of multicultural pluralism in the 1980s and 1990s has freed some space for the diverse concerns of feminism, gender politics, and non-white ethnic groups. At the dawn of a new millennium, such artists as Shirin Neshat, Mariko Mori, and Yasumasa Morimura (see figs. 15.26, 15.44, and 15.45) reflect the interests of a far-reaching international art scene, made possible by the unprecedented speed with which artists and their ideas can travel.

them, as for many others, traditional belief in God was dead; what remained was to come to terms with the void.

Francis Bacon's *Study after Velázquez's Portrait of Pope Innocent X*

Bacon expressed his sense of existential anguish in a long series of figurative works. He derived his images from photographs, films, and other visual sources, some suggestive of the Nazi holocaust. Bacon transformed these sources with sensuous intensity into blurred, violent images of writhing couples or single figures in claustrophobic settings. Notable among them is a series of variations on Velázquez's seventeenth-century *Portrait of Pope Innocent X* (see fig. 15.2).

In these paintings Bacon subverts the confident poise of this former prince of the Church into an image of terror and oppression. Through the use of dark, empty space, streaked and blurred forms, Bacon suggests that the religious hope that sustained earlier generations has vanished, leaving humanity trapped. Bacon wrote that, in the time of Velázquez and Rembrandt, people were still conditioned by "religious possibilities, which man now ... has had cancelled out for him." All that is left is for man to "beguile himself for a time," with art as "a game by which man distracts himself." For Bacon, in the absence of God, life is stripped of significant meaning.

15.4 Barnett Newman, *Broken Obelisk*. 1963–7. Steel, height 25'1". Rothko Chapel, Houston, Texas

15.5 Mark Rothko, wall paintings in the Rothko Chapel, Houston, Texas. 1965–6 (opened in 1971). Oil on canvas

Barnett Newman's *Broken Obelisk*

The sense of spiritual void that informs Bacon's work comes through in completely different terms in the abstract art of the American Barnett Newman. Barnett Newman was an Abstract Expressionist painter who, somewhat like Kandinsky and Mondrian (see Chapter 14), sought to invoke humanity's most exalted aspirations. His meaning is clear in his sculpture *Broken Obelisk* (fig. 15.4). Made between 1963 and 1967, this sculpture now marks the approach to the Rothko Chapel, Houston, Texas.

Executed in burnished steel, a perfect pyramidal form, rising out of water, supports at its tip an upturned and broken obelisk. These three elements—water, pyramid, and obelisk—signify, in turn, the origins of life in watery chaos, the desire for enduring stability as evoked by the Egyptian pyramids, and, finally, the highest human aspirations, as alluded to in a traditionally Egyptian and Roman form— the obelisk. Here the obelisk—broken and upturned—is charged with profound tragedy.

The Rothko Chapel

The pathos of Newman's *Broken Obelisk* is a fitting prelude to the non-denominational Rothko Chapel. This chapel contains a set of murals by Mark Rothko (1903–70); commissioned in 1964, they were completed by 1966, though not installed until 1971 (fig. 15.5). A Russian Jewish emigré to America, Rothko was a friend of Newman and, like him, an Abstract Expressionist painter who sought to express profound emotions through abstract use of color. To achieve this, he painted large rectangular fields of rich, vibrant color, often stacking one rectangle above another, letting the paint bleed off at the edges into the surrounding field. These works' large scale and intensity of color communicate a vague hovering presence, suggesting spiritual and emotional feelings that cannot attach themselves to any specific divine image or idea.

In the chapel murals, Rothko pared away all visual distractions, leaving only vast canvases of purplish red, which shade off into murky, dark maroons. These

paintings are often viewed as the culmination of the Romantic impulse toward the sublime (see Chapter 12). Few painters have come closer to evoking a sense of ultimate void. According to the patron of the Rothko Chapel, Dominique de Menil, these murals express "the tragic mystery of our perishable condition. The silence of God, the unbearable silence of God."

Ritual Performance

By the time Rothko's huge chapel panels were installed, few in the art world believed that the exalted aspirations of the Abstract Expressionists could be sustained in painting. Instead, the priestly or shamanistic role of the artist was redirected toward transforming society, and expressed through other means—notably by Joseph Beuys.

Joseph Beuys' *Coyote*

During the social unrest of the 1960s, associated with the civil rights movement, the Vietnam War, and authority structures, artists created **performance art** "happenings" that challenged the materialism of modern society. Among them is the German Joseph Beuys (1921–86). As a pilot in World War II, Beuys was shot down in the Crimea and rescued by nomadic Tartars, who wrapped him in fat and felt to restore proper body temperature. He later turned his rescue into a form of personal mythology of catastrophe and healing, which he exploited in some of his installations and performances.

In true priestly fashion, Beuys developed the happening into a form of ritual performance. On one occasion in 1974 he came to New York for a week-long performance in a New York gallery, where he was enclosed in a space with a coyote (fig. 15.6). Protected

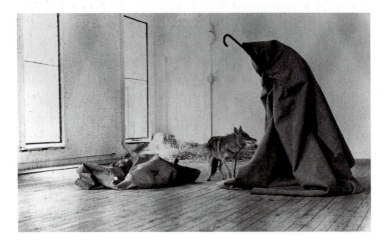

by a tent of his trademark felt, with a shepherd's crook protruding from the top, he followed and mimicked the movements of the coyote, resting on a pile of hay with the animal once it had grown used to him. Given the coyote's associations with the American wilderness, and its persecution by Euro-Americans bent on economic development, these ritualized actions signified a desire for reconciliation and healing. They also cryptically signaled a growing concern for ecology and for wildlife threatened by spreading industrial technology.

Multicultural Spirituality

During the 1980s and 1990s, many people became concerned that Western culture was producing dangerous ecological imbalances. Some sought alternatives in non-Western attitudes toward nature and the purposes of human existence. In the U.S., interest in non-Western value systems coincided with a new openness to the cultural traditions of minority groups within American society. For example, in both African and American Indian religious traditions, art expresses the need for ritual appeasement of natural forces. Art inspired by these traditions offers an alternative to the humanistic confidence of Western rationalism and Christianity. During the 1990s, this art became increasingly available to the broader public.

Jorge Rodriguez and Charles Abramson's *Orisha/Santos*

An example of late twentieth-century spiritual art inspired by non-Western traditions is Jorge Rodriguez (b. 1944) and Charles Abramson's (1945–87) *Orisha/Santos* **installation** of 1985 (fig. 15.7). The artists, one Hispanic, one African-American, collaborated to give an artistic interpretation of seven hybrid *orisha*/saints that are popular in the Caribbean and South America, and also in the United States. When Yoruba-speaking people from West Africa were transported to the New World as slaves, they continued to worship their forbidden Yoruba deities, *orisha*, under the guise of these deities' Catholic counterparts, *santos*, the Spanish word for "saints." The combined worship of Orisha and Santos is known as Santeria.

15.6 Joseph Beuys, *Coyote: I Like America and America Likes Me.* Photo of performance at Rene Block Gallery, New York, 1974

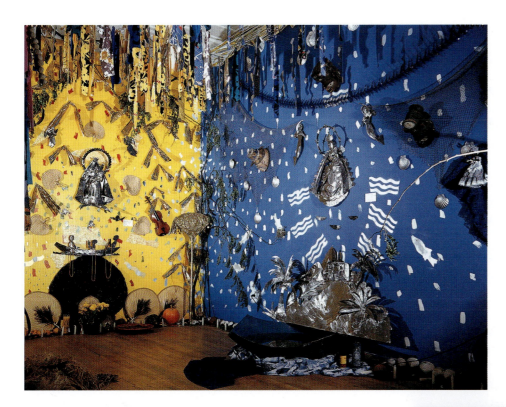

15.7 Jorge Rodriguez and Charles Abramson, *Orisha/Santos: An Artistic Interpretation of the Seven African Powers.* 1985. Installation at the Museum of Contemporary Hispanic Art, New York

15.8 Bill Viola, *The Crossing.* 1996. Detail of installation with two channels of color video projection onto 16'-high mounted back-to-back screens. Solomon R. Gugenheim Museum, New York

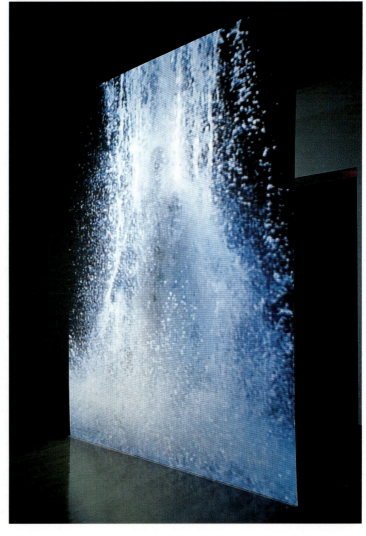

In Rodriguez and Abramson's installation, the two artists used the environmental scale of installation art to create a sense of sanctuary and ritual, complete with votive offerings. To represent the *orisha/santos*, Rodriguez cut the figurines from steel sheets. These not only evoke Catholic Puerto Rican wooden *santos*, they also represent seven Yoruba *orisha*. Charles Abramson, who was an African-American *santero*, or priest of the Santeria religion, created the altars for Rodriguez's *orisha/santos* figures and surrounded them with appropriate attributes and votive offerings. The installation draws attention to Yoruba beliefs that, to maintain the essential balance in nature, *orisha* must be respected as helping humans. As such this work offers a counterpoint to Western rational pragmatism. It also invokes the deities of non-Western cultures to fill the spiritual void experienced in Western cultures.

Bill Viola's *The Crossing*

American artist Bill Viola (b. 1951) has made a sustained study of Christianity, Buddhism, and other forms of Eastern mysticism. Whereas, with *Orisha/Santos* (see fig. 15.7), Rodriguez and Abramson created an installation with traditional ritual objects, Viola manipulates the potential of a modern technology, video (see "Materials and Techniques: Video and Digital Imagery," page 482). This is presented in large-scale museum installations, which create an

Video and Digital Imagery

In the 1960s, portable video equipment and devices for manipulating the electronic data they generated became accessible, allowing artists to explore their expressive potential. As with computer graphics, video images comprise a series of points of colored light on a grid, which can be edited on a computer. This allows an artist to manipulate, overlay, break up, change the color and scale of an image, as well as introduce other special effects. This new medium has been adopted by such artists as Bill Viola (see fig. 15.8) and Shirin Neshat (see fig. 15.26). Unlike painting, it can embrace motion, sound, and time.

Video is also much cheaper and easier to work with than film, even though expensive to exhibit. Video artists use the same technology as television, yet television programming is generally commercially orientated, popular and fast-paced in presentation, and prone to the channel surfing of restless viewers. By contrast, video artists such as Viola and Neshat invite viewers into a slowly evolving visual experience, accompanied by sound, and played out on small monitors or large-scale projection screens. Such an environment leads viewers to reflect, just as sculptural or other forms of installation do.

environment for provoking questions about the spiritual dimensions of reality. Such questions are particularly evident in *The Crossing* (fig. 15.8), a 1996 video/sound installation with two channels of color video, projected simultaneously onto either side of a 16'-high screen. Countering the fast pace and fast talk of contemporary television, Viola's narrative unfolds in acute slow motion, harmonized to the beat of his sound track.

In *The Crossing*, a figure emerges from darkness on a distant horizon, slowly advancing to fill the whole screen. On one screen drops of water falling on his head build to a cascade that drowns him; on the other screen, a small flame rises from his feet, finally to engulf him. After the mighty roar of deluging water and consuming fire reaches a crescendo, everything falls to silence and darkness, and the figure is no more. The viewer is left to ponder the void, with only the title and traditional religious associations of fire and water as reassurance that *The Crossing* may signify a refining and cleansing ritual, a "crossing over" into a purer state of being.

THE SELF

In the post-war years, artists expressed a sense of identity and reflected on our human predicament in many different ways. We focus primarily on artists' responses to America's ascendancy during the late 1940s and 1950s; the social unrest and protest movements of the 1960s and 1970s; and the increasing pluralism of the 1980s and 1990s. We begin with Abstract Expressionists of the 1940s and 1950s.

The Search for Personal Identity

The artistic style most closely associated with America's growing power in the immediate post-war period is Abstract Expressionism of the New York School. Although different artists' work is notably distinct, the movement overall reflects the existentialist emphasis on the individual's need to give one's life meaning. Best-known of the Abstract Expressionists are Jackson Pollock (1912–56) and Willem de Kooning (1904–97) (see figs. 15.9 and 15.10). These artists express their identity through **action painting**, in which the marks left by the artist's vibrant painterly gestures are seen as direct expressions of the soul, unique to the artist's creative spirit.

Jackson Pollock's *Autumn Rhythm: Number 30, 1950*

Pollock's *Autumn Rhythm: Number 30, 1950* (fig. 15.9) was the culmination of Pollock's experiments with self-expression; the result effectively transformed the concept of painting. A painting is no longer a

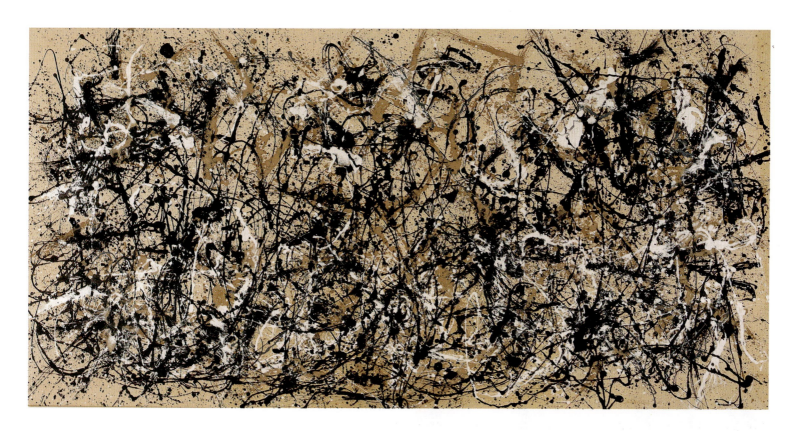

15.9 Jackson Pollock, *Autumn Rhythm: Number 30, 1950.* 1950. Oil on canvas, 8'9" x 17'3". The Metropolitan Museum of Art, New York

representation but an arena in which the artist has acted and on which the traces of his being remain.

Pollock's aesthetic developed in part from his intellectual roots in existentialist notions of human existence and the theories of the psychoanalyst Carl Jung. From Sartre and other existentialists, Pollock derived the belief that each individual must authenticate his own being through direct, spontaneous engagement with the world. This translated into unpremeditated engagement in the act of painting, in which the content of the painting, the gesture of the arm, and the resulting mark on the canvas were not considered beforehand. He found further support for this strategy in Jungian theory, believing that, through a process of painterly spontaneity, elements from his subconscious being would arise. According to Jung these belong to a "collective unconscious" shared by all humankind. Thus, Pollock thought, paintings spontaneously released by the unique genius of the artist would have universal validity.

Pollock was also inspired by abstract Surrealists such as Miró (see fig. 14.33) and the large-scale, shallow Cubistic space of Picasso's *Guernica* (see fig. 14.24), which he saw in New York. He became famous for pouring or dripping his paint onto large canvases laid out on the floor, a process that resulted in fluid, energetic runs of paint. In these works he abandoned all traditional notions of representing objects in space with a compositional focus toward the center. Instead he created whirls of line, color, and surface texture distributed over the entire surface, and limited only by the edges of his vast canvases. The sheer scale and ambition of these works set the course for subsequent art and contributed to the international acclaim Pollock and other Abstract Expressionists received. Their works were taken as expressions of rugged American individualism.

Willem de Kooning's *Woman and Bicycle*

In the early 1950s, as critics declared the human figure irrelevant to avant-garde painting, Willem de Kooning stunned the New York art world with a series of sensuous and violent paintings of women, among them his *Woman and Bicycle* of 1952–3 (fig. 15.10). After migrating from Holland to New York, he began to draw on sources similar to Pollock's. Like Pollock, de Kooning approached painting as an arena for action, only in his case the existential drive to engage with life—however fraught with uncertainty—expressed itself in the continuous struggle of reworking his paintings.

De Kooning's masterful sense of color and gesture creates surfaces resembling highly charged battlefields of

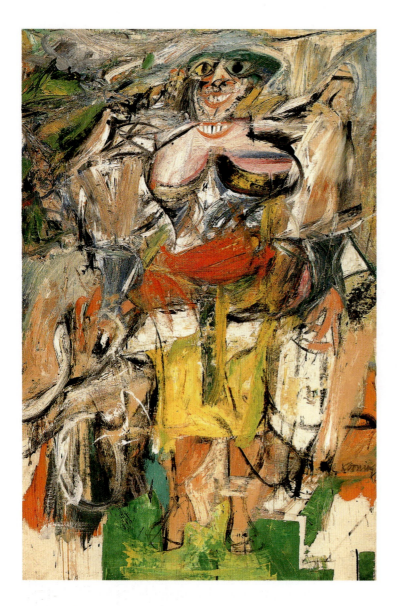

15.10 Willem de Kooning, *Woman and Bicycle*. 1952–3. Oil on canvas, 76" x 49". Whitney Museum of American Art, New York

The Self as Consumer and Consumed

By the late 1950s, a younger generation of artists in the U.S. and Europe had grown up in a consumer culture. They were alienated by this culture's tendency to smother individualism under mass-produced conformity to materialistic values. But they were also skeptical of the Abstract Expressionists, viewing their work as pretentious posturing, remote from the world of popular culture. In reaction, many younger artists of the late 1950s and 1960s—prompted further by the social unrest of the 1960s—rejected the claims of Modernism. Their protests against both Modernism and consumer culture gave rise to Pop art and the so-called Neo-Dada of Jasper Johns (b. 1930) and Robert Rauschenberg, so-called for their embrace of paradox, ambiguity, and, in Rauschenberg's case, use of junk and found objects.

Pop art emerged amid an upsurge in popular entertainment. When encountered in the blown-up comic-strip images of Roy Lichtenstein (b. 1923) or the multiple celebrity images of Andy Warhol (1928–87) (see fig. 15.13), Pop art can seem easy and accessible. But such media-based imagery often masked an underlying tone of irony and cynicism. Such art also challenged traditional notions of the unique qualities of individual works of art, and the elevated significance attached to them. In this respect both Pop art and Neo-Dada mocked the high pretensions of avant-garde Modernism, then represented by Abstract Expressionism.

While Abstract Expressionists sought the source of art and meaning within the self, Pop and Neo-Dada artists believed that human experience in the modern world is potently influenced by popular culture through movies, advertising, television, electronic music, fashion, and magazines. Furthermore, the uniqueness of art was undermined by the multiple imagery generated by photographic reproduction. In response to mass consumerism, Pop artists such as Andy Warhol in the United States and Richard Hamilton (b. 1922) in England exposed the predicament of individuals in a prosperous, materialistic society. They suggest that people are not only consumers of popular culture but are also themselves consumed by the same culture of mass production.

colliding forces. Lush reds, yellows, blues, and greens slam against each other, held in check only by contours of black, and cooled by planes of pink and white. In effect the rich palette of a Titian or Rubens is charged with the raw energy of the action painter.

In the series of women, de Kooning's aggressive technique intensifies the disturbing impact of his female figures. They glare out at us, with big eyes, flashing teeth, and abundant breasts, part pin-up, part fertility idol, part vampire, rendered both seductive and menacing by the energy of his gestural painting. Many consider them as archetypal figures arising from the artist's subconscious, expressing universal male anxieties.

Richard Hamilton's *Just What Is It That Makes Today's Home So Different, So Appealing?*

At a 1956 London exhibition called "This is Tomorrow," Hamilton exhibited a small collage entitled *Just What Is It That Makes Today's Home So Different, So Appealing?* (fig. 15.11). This collage epitomized the show's attempt to turn attention away from the pretensions of modern art toward popular culture. Without a trace of personal style, Hamilton appropriated an array of media signs and symbols, including the characteristic exploitation of glamor and sex to sell an assortment of consumer goods. His parody is astute,

but its deliberate overstatement reveals a detached stance of ironic criticism. Equipped with every modern gadget, the consumer ends up a clone of every other consumer.

Jasper Johns's *Painted Bronze (Ale Cans)*

Around the same time, the American artist Jasper Johns began to challenge Abstract Expressionism through ironic parody. For example, he parodied the flatness of color field paintings in a series of painted targets and flags. In his *Painted Bronze (Ale Cans)* of 1960 (fig. 15.12), Johns treated a popular, mass-produced consumer product with the mock

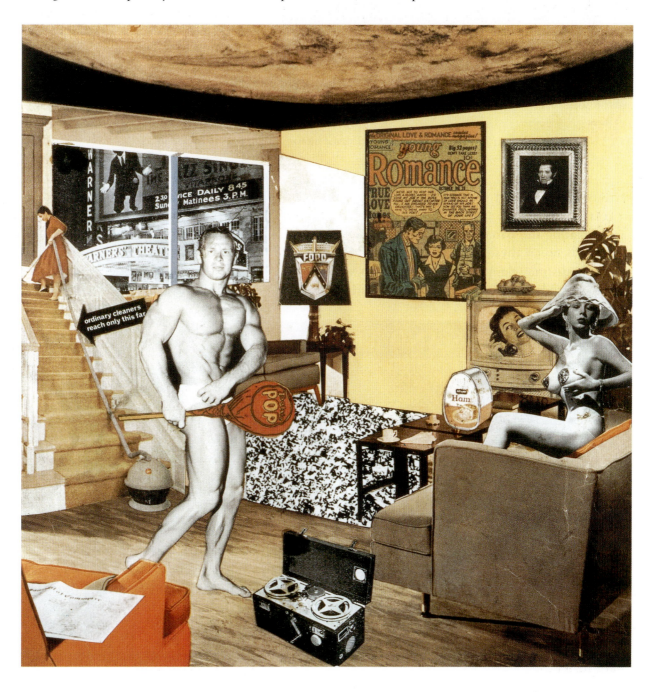

15.11 Richard Hamilton, *Just What Is It That Makes Today's Home So Different, So Appealing?*. 1956. Collage on paper, 10¼" x 9¼". Kunsthalle, Tübingen

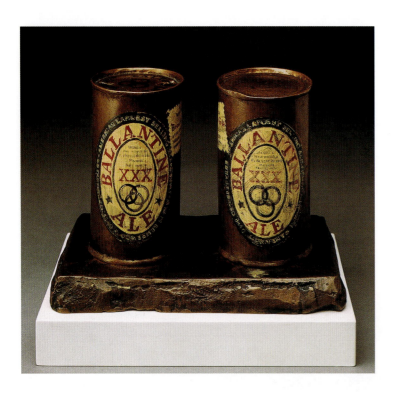

15.12 Jasper Johns, *Painted Bronze (Ale Cans)*. 1960. Painted bronze, 5¹/₂" x 8" x 4³/₄". Rheinisches Bildarchiv, Köln, Germany

seriousness of fine art sculpture, mimicking a beer can in costly, hand-made and hand-lettered bronze.

By treating the banal as fine art, Johns closed the distance between these categories, and questioned the normally distinct claims made about them, as the Dada artist Marcel Duchamp had done earlier by exhibiting found objects (see Chapter 14). Johns asks us to consider what claims can be made for originality, what differentiates a copy and its original, what is real and what is illusion. Furthermore, by rejecting the difference between high and low art, he also suggests that attempts to rise above popular culture, or to escape its hold—as modern artists had repeatedly sought to do—are illusory. Johns implies that our reality is defined by material culture. Individualism, as perceived on the Abstract Expressionist's terms, s an illusion.

Andy Warhol's *Marilyn Diptych*

The individual's relation to mass culture dominated the work of Pop artist Andy Warhol. His fame derived as much from his public persona as from his art, both of which touched a vital cultural nerve in 1960s America. As his 1962 photo-silkscreened *Marilyn Diptych* shows (fig. 15.13), Warhol created the perfect icons for a media-saturated culture (see "Materials and Techniques: Acrylic," below, and "Materials and Techniques: Silkscreen," page 487). The film star Marilyn Monroe is immediately recognizable, utterly familiar, yet ultimately distanced and anonymous. Warhol suppresses all claims to individuality or originality. The image itself is derived from other media. A bevy of assistants using photo-transfer techniques generated the image. There is no trace of the artist's hand. Instead, the artist was free to float around the studio in

❖ MATERIALS AND TECHNIQUES ❖

Acrylic

Acrylic paint was first developed in the twentieth century and is often used as an alternative to oil paint. Unlike oil paint, acrylics are made with a water soluble synthetic vehicle which gives the paint different properties from oil paint. Acrylic dries quickly, allowing the painter to work more rapidly. Unlike linseed oil, the chemically derived binder dries colorless, permanently preserving the brilliance and purity of the colors, but acrylic lacks some of the rich luminosity of oil paint. Most colors will not fade (though ultra-violet light still has some effect on blues and purples). Acrylic can be used on a variety of grounds that do not have to be specially prepared. Because acrylics don't blend as readily on the canvas as oil paints do, artists working in acrylics can achieve different effects. For example, acrylic can be thinned to the consistency of watercolor and applied to an unprepared canvas. The paint will be absorbed into the canvas, like a dye, and colors will bleed together while preserving their individual brilliance. Alternatively, acrylic can be used to juxtapose colors along crisp, hard edges, as seen in Andy Warhol's *Marilyn Diptych* (see fig. 15.13).

Silkscreen

Silkscreen, also called serigraphy, was developed as a commercial means for reproducing images and is still used today for almost all commercial printing, including posters, labels on cans, and images on clothing. In the 1960s Andy Warhol reversed the usual pattern of using serigraphy for commercial purposes and instead elevated silkscreen to the realm of fine art, using his images of Campbell's soup cans, Elvis Presley, Marilyn Monroe (see fig. 15.13) among others, as a satirical commentary on contemporary culture.

A silkscreen print is made by stretching a piece of silk or nylon on a wooden frame, and works on the same principle as a stencil. Areas of the image which are not to be printed are masked off with stencils or are painted over with varnish. Ink is brushed across the screen with a squeegee and forced through the open areas onto a piece of paper that has been placed underneath. Different colors can be applied by using different stencils on successive screens. Flat and opaque layers of color result, although graduated tones can be achieved through a photographic process, which allows images to be transferred onto a screen covered with a light-sensitive emulsion, which hardens and acts as a stencil.

cool detachment, cultivating his public image—an image much like Warhol's representation of Marilyn Monroe—carefully manicured, instantly recognizable, but revealing nothing.

Warhol's work exposes something chilling. He shows us that, when the media become our primary reality, we lose sight of the distinction between illusion and reality; we feed on surrogate, second-hand experience. The media give us the illusion of knowing directly, when in fact we encounter only what passes through its selective filter. Reality is mediated for us by someone else; we can know nothing directly.

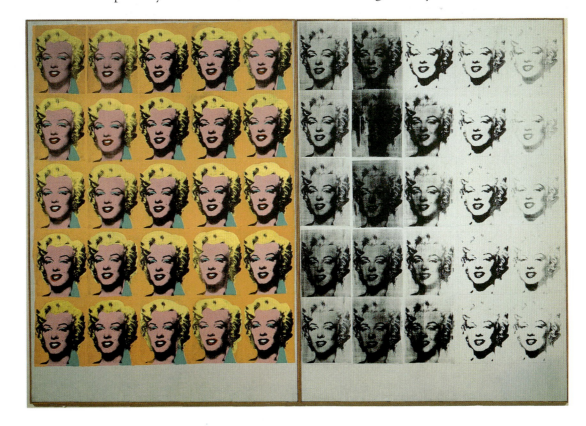

15.13 Andy Warhol, *Marilyn Diptych*. 1962. Oil, acrylic, and silkscreen enamel on canvas, two panels, each 82" x 57". Tate Modern, London

Warhol shows us that, in a media-saturated culture, celebrity status and anonymity are two sides of the same coin. He asks us to acknowledge that only the image is knowable; the reality behind it is not. The direct expression of individuality, so cherished by the Abstract Expressionists, dissolves in the acid of media saturation. For the postmodern artists who followed Warhol, reality is ultimately relative and unknowable, as everything is shaped by the cultural filters through which it passes.

Robert Rauschenberg's *Retroactive I*

Robert Rauschenberg responded in a different but equally significant way to media saturation. Influenced by Marcel Duchamp, especially by his use of found materials and random effects, Rauschenberg developed a random collage technique he called "combine" paintings. In them, he used paint to combine various objects—art reproductions, comic strips, images from newspapers, discarded materials, and even three-dimensional objects.

In works such as *Retroactive I* of 1964 (see fig. 15.3), Rauschenberg uses **silkscreen** printed imagery derived from photojournalism to suggest the effect of scanning the newspaper or surfing television channels for the news. Pictures of John F. Kennedy and a parachuting astronaut jostle and compete for attention with other, less evident images. Rauschenberg used silkscreens of these and other images repeatedly, juxtaposing them in ways that suggest random incoherence, to which the

artist—and viewer—can bring no meaningful order. Life's random occurrences, Rauschenberg implies, are to be experienced as they wash over one. But they cannot be made to fit any inherent hierarchy of meaning.

The Existential Self

Rauschenberg's metaphors of random incoherence reflect the alienation felt by many artists in the postwar years. Many represented the self as without firm anchor, drifting in isolation like human flotsam on the waves of history.

Alberto Giacometti's *City Square* (*La Place*)

One of the most poignant expressions of such an outlook came from the Swiss-born sculptor Alberto Giacometti (1901–66), who worked for most of his life in Paris. His friendship with Sartre took his art in an existentialist direction, focused on human alienation. Giacometti found that he could not escape a tendency to make his figures smaller and smaller, even when working from the live model. The outcome was a series of long, wiry figures such as *City Square* (*La Place*) of 1948 (fig. 15.14).

In striking contrast to Western sculptural tradition, in which the human figure confidently dominates its surrounding space, Giacometti's elongated little figures barely hold their own against the pressure of space that

❖ MATERIALS AND TECHNIQUES ❖

Modern and Contemporary Sculpture

In the twentieth century, artists have gone beyond traditional sculptural materials and techniques. Sculpture is not only carved and modeled, but welded, bolted, nailed, and glued into assembled and constructed pieces (see for example fig. 1.9). Found objects are incorporated into three-dimensional compositions, and everyday objects placed in galleries as art. One of the newer forms of sculpture, first attempted early in the century, is kinetic sculpture, which incorporates moving elements that are propelled by motors, wind, light, or the hand of the observer. In the 1960s, artists experimented with three-dimensional materials in happenings, environments, and tableaux. At that time, the earth itself also became a medium, to be shaped into large environmental sculptures with the help of bulldozers and shovels. In the 1970s, another art form emerged. Installations, as they are called, are placed in a three-dimensional environment that is often only temporary. These are only a few examples of the enormous possibilities for interacting with form in space that have opened up in the twentieth century.

15.14 Alberto Giacometti, *City Square* (*La Place*). 1948. Bronze, 8$\frac{1}{2}$" x 25$\frac{3}{8}$" x 17$\frac{1}{4}$". The Museum of Modern Art, New York

15.15 (below) Edward Kienholz, *The State Hospital*. 1966. Mixed media, 8' x 12' x 10'. Moderna Museet, Stockholm

surrounds and all but annihilates them. Set for contrast on a large base, his small bronze figures appear to edge forward with a certain dignity, but never escape their anonymity and isolation.

Edward Kienholz's *The State Hospital*

The American West Coast artist Edward Kienholz (1927–94) began his career in a Neo-Dada vein, transforming assembled junk into metaphoric objects (see also "Materials and Techniques: Modern and Contemporary Sculpture," page 488). Working with his wife Nancy Reddin (b. 1943), he went on to create installations of room-sized tableaux. As seen in his *The State Hospital* of 1966 (fig. 15.15), its stark realism was the vehicle for biting criticism of the consumer society. A Kienholz tableau confronts viewers with what most prefer to push out of sight—old age, mental illness, and death.

Kienholz once worked in a mental institution, and in *The State Hospital* he takes us there too, jarring us out of our comfortable complacency. Strapped to the lower tier of a grim and grimy iron bunk-bed, an emaciated man lies naked in his own filth. Above, encircled in a neon comic-strip thought balloon, lies his alter ego, presumably his mental image of himself. Inside each head is a goldfish bowl, complete with live goldfish. He is more trapped than they, and less well cared for. The institutionalized man cannot escape what swims round and round in the waters of his mind—endless, claustrophobic misery, unrelieved by hope. The bare cell, stark light, and dirty bed pan heighten the pitch of misery and neglect. For the observer, the installation's shocking immediacy is unforgettable.

Magdalena Abakanowicz's *Backs*

Another form of human alienation—the oppression brought about by totalitarian regimes—surfaces in a

work such as *Backs* (fig. 15.16), made by the Polish artist Magdalena Abakanowicz (b. 1930) in 1976–80. Whereas Giacometti's figures lost their mass, and Kienholz's hospital patient his mind, Abakanowicz's bent burlap figures have lost all but the backs on which they carry the burden of oppression. Since the *Backs* are placed on the floor, the viewer is obliged to assume the dominant perspective of the oppressor. These works were inspired by Abakanowicz's suffering

15.16 Magdalena Abakanowicz, *Backs*. 1976–80. Burlap and resin, 80 lifesize figures

under German occupation and subsequent communist rule. Despite the absence of fronts, heads, arms, and legs, the varying texture and organic warmth of woven burlap, hemp, and twine lend these hollow forms sufficient individuality to arouse a sense of empathy in the viewer. Lined up in postures of submission, these figures call up images of forced labor and repression, and function as a silent plea for compassion.

Jerome Witkin's *Terminal*

The 1960s brought a return to figurative painting and opened the way for narrative work. An American narrative painter of part Jewish, part Catholic background, Jerome Witkin (b. 1939) has created notable works on themes related to the Holocaust, such as his understated *Terminal* of 1987 (fig. 15.17). We look through the door of a railroad cattle-car, inside which sits a young man, propped against an old leather suitcase, his hands clasped, waiting. The eye is drawn to the yellow Star of David pinned to his shabby clothes. The man's journey, we know, will end when his unlaced boots bring him to the gas chamber, and the boots themselves will be tossed on the pile of boots behind him. On the right the jailor's hands grasp the cattle-car's door—opening it or closing it—to seal the traveler's fate. The man looks out at us, with a frozen stare. It is his last glimpse at life, or perhaps his first sight of what lies before him. This he faces alone. Witkin puts a human face on the sense of alienation, anonymity, and isolation registered in other terms by Giacometti, Kienholz, and Abakanowicz.

Christian Boltanski's *Reserve of Dead Swiss (Large)*

The French artist Christian Boltanski (b. 1944) was born to a Jewish father and a Catholic mother in occupied Paris on Liberation Day, 1944. He addresses the

15.17 Jerome Witkin, *Terminal*. 1987. Oil on canvas, 123" x 70½". Courtesy of Mr. and Mrs. Lang, USA

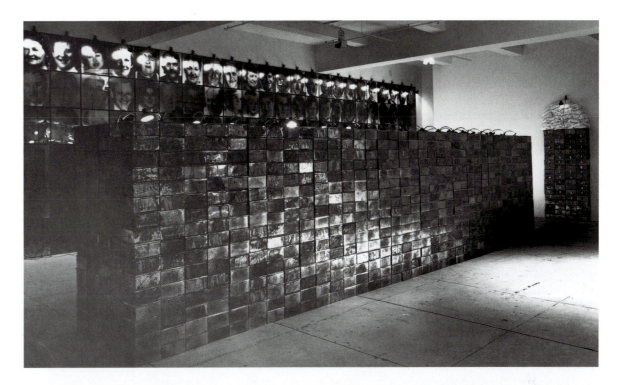

15.18 Christian Boltanski, *Reserve of Dead Swiss (Large)*. 1990. Photographs, tin biscuit boxes, and lamps, 6'8" x 26'11" x 3'8"

long shadows cast on memory and the sense of displacement and loss evoked by the Holocaust through an austere minimalist installation of stacked rows of aged metal biscuit boxes, stark gooseneck lamps, and routine photographs gathered from anonymous sources. In works such as *Reserve of Dead Swiss (Large)* of 1990 (fig. 15.18), Boltanski engulfs us with the fictitious "archives" of the lives of an anonymous multitude, stored, like a child's keepsakes, in old biscuit tins, individually identified by a head-shot photograph, and exposed to the hard glare of a row of metallic lamps.

The boxes suggest the archive of an oppressive regime, but the title, by referring to a neutral country, implies a more universal meaning. The individual photographs on each of the boxes, of people presumably now dead or forgotten, are people like ourselves. We too, by extension, may imagine our individuality vanish into the past, preserved only in the blurry photographic image, which will itself fade under the incessant glare of the lamps. With different means, both Witkin and Boltanski mourn the inevitability of suffering and extinction.

Feminist, Gay, and Multicultural Pluralism

Feminist artists, critics, and historians have been at the vanguard of the postmodern, pluralistic outlook of the mid-1970s onward. Long excluded from the mainstream of art, women have cultivated a more expansive historical viewpoint. Feminist artists and critics have raised a range of concerns, challenging an institutionalized sexism ingrained within art history, calling attention to distinctly female contributions, and suggesting that female identity is not so much innate as socially constructed.

Judy Chicago's *The Dinner Party*

The feminist agenda of the 1970s was prominently displayed in Judy Chicago's (b. 1939) large-scale installation *The Dinner Party* of 1979 (fig. 15.19). It was first conceived as a dinner table set for thirteen women, on the model of the all-male Christian Last Supper. But to accommodate the many worthy women from history Chicago sought to celebrate, the number was tripled to thirty-nine place settings around three 48-foot-long tables that formed an equilateral triangle. Each honored guest was given an individualized place setting with a porcelain plate bearing a stylized butterfly or vaginal design set on a table runner embroidered with personalized symbols. Besides containing considerable female symbolism, the work also embraced traditional female arts such as china painting and needlework. It thus celebrated neglected female accomplishments and feminine artistic sensibilities. As a collaborative project realized over five years, it also offered a social model of art-making derived from the traditional female art of

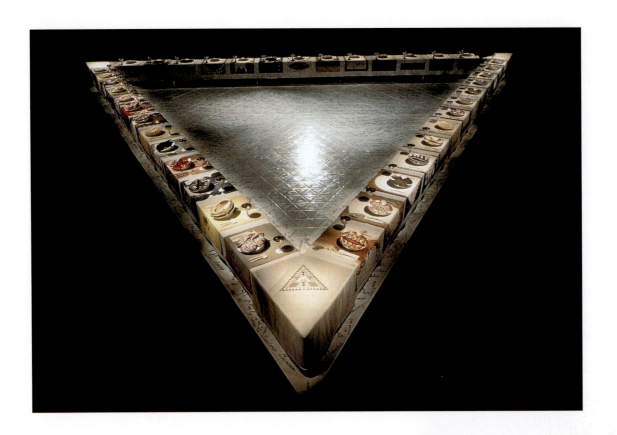

15.19 Judy Chicago, *The Dinner Party*. 1979. Multimedia installation, including ceramics and stitchery, 48' x 48' x 48'

15.20 Cindy Sherman, *Untitled*. 1990. Color photograph, 4' x 3'2"

quilting—a contrast to the male model of the artist as solitary genius (see "The Artist as Woman and Minority," page 478).

Cindy Sherman's *Untitled* Figure

A later generation of feminist artists focused more on the issue of female identity as a social construct created by men and reduced to conventional stereotypes—the woman as child-bearer, seducer, or sex-object.

Photographer Cindy Sherman (b. 1954) has explored a range of such constructed media stereotypes. Using herself as model, she exposes the way an image can mask the real person. Sherman has also used an array of costumes, wigs, false beards, and prosthetic body parts to assume identities depicted by earlier artists such as Caravaggio, as in a photograph of 1990 (fig. 15.20). By impersonating Caravaggio's male Bacchus figure—which in the original work reveals an ambivalent sexuality—Sherman adds a further twist to masked identity by switching sex roles in both artist and model. Sherman's role playing exposes the way reality is shaped and masked by culture. In the process, true womanhood, she suggests, is smothered by the culturally created expectations imposed upon it by others—typically male.

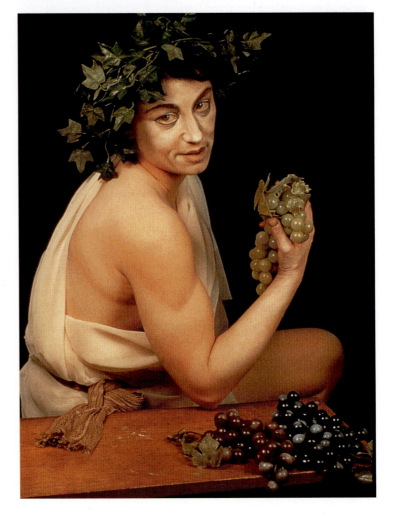

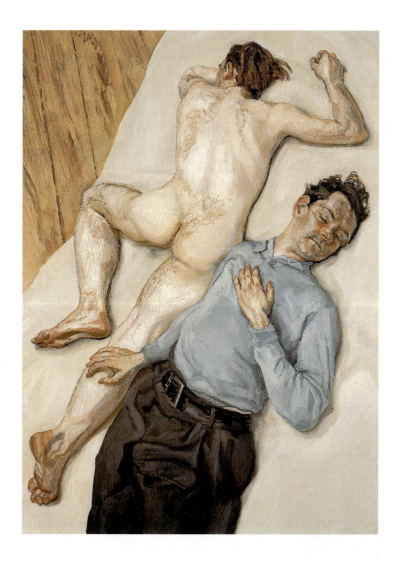

unblinking matter-of-factness that accepts what is given, including sexuality, whether straight or gay. That both Freud's directness and Sherman's masked indirection receive critical attention is indicative of contemporary artistic and social pluralism.

Romare Bearden's *Black Manhattan*

Feminist efforts to open up the art world establishment also opened doors for other under-represented groups, notably ethnic minorities. The African-American artist Romare Bearden's (1911–88) artistic education had brought him into contact with social realism, Cubism, and the photomontage techniques of Dada (see Chapter 14). He had also participated in the "Harlem Renaissance," a flowering of African-American art and literature of the late 1920s and 1930s in Harlem, New York's predominantly black community. In the wake of the Civil Rights movement of the 1960s, Bearden focused on the experience of African-Americans, as in his collage *Black Manhattan* of 1969 (fig. 15.22), a fusion of black experience with white artistic forms.

15.22 Romare Bearden, *Black Manhattan*. 1969. Collage of paper and synthetic polymer paint on composition board, 25³/₈" x 21". Schomburg Center for Research in Black Culture, New York Public Library

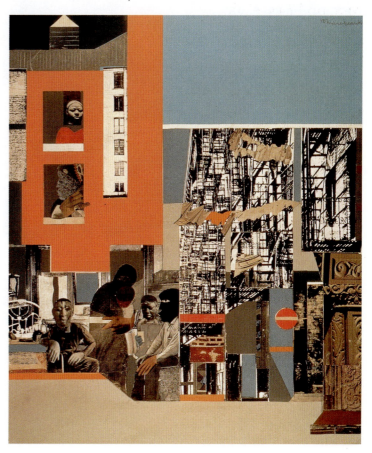

15.21 Lucian Freud, *Two Men*. 1987–8. Oil on canvas, 42" x 29¹/₂". Scottish National Gallery of Modern Art, Edinburgh

Lucian Freud's *Two Men*

The English artist Lucian Freud (b. 1922) has also addressed issues of sexual identity, both straight and gay. While many American artists such as Sherman have been preoccupied with the distancing effects of the way identity is "mediated" in art or the media, Freud has relentlessly pursued a radically different direction. His intense scrutiny of nude models—both male and female—has resulted in a long succession of paintings such as *Two Men* of 1987–8 (fig. 15.21). In these paintings, human flesh, with all its natural imperfections, is transformed into the physical substance of paint on canvas. Freud's palpable and uncompromising realism delivers works of great presence, belying any notion that, after Modernism, the realistic figure is no longer a viable option. Freud's subjects are neither distanced nor idealized; rather they are treated with an

This fusion constitutes a metaphor of the adaptation and independence that marked the African-American experience. The grid structure and collaged imagery of *Black Manhattan*—similar to works of Rauschenberg (see fig. 15.3)—draw from Bearden's early exposure to Cubism and Dada. But the quick, staccato rhythm, offset by vibrating fields of complementary colors, perhaps owes as much to his love of jazz.

Faith Ringgold's *Bitter Nest*

Another prominent African-American Harlem artist is Faith Ringgold. In a series of story-telling quilts such as *Bitter Nest Part II: Harlem Renaissance Party* of 1988 (see fig. 15.1), Ringgold promotes the notion of a distinctly feminine artistic sensibility while also using materials, techniques, and themes derived from her black heritage. Descended from a female line of dress designers and quilt-makers, but trained as a painter, Ringgold turned to painted, dyed, and quilted fabrics as a means to celebrate her African, feminine heritage. This technique enabled her to reinvigorate modern abstract art with the qualities of fabric as well as added human content. In quilts such as *Bitter Nest*, brilliantly patterned fabrics frame domestic tales from the Harlem community, or stories of slavery and protest, and are overlaid with handwritten texts. The heroine of *Bitter Nest* is the eccentric mother of a young black woman doctor. This mother wore "oddly pieced and quilted costumes, masks and headdresses" as she moved among her distinguished Harlem guests. In the quilt, she stands before a table, a symbolic figure who signifies continuity between the artist's African heritage and her modern American context. (See also figs. 15.7, 15.22, and 15.43 for other examples in which artists combine the traditions of different cultures.)

Postmodern Malaise and Commodity Culture

The art of Bearden and Ringgold has a freshness and vitality drawn from the directness of the experiences that nourished it. By contrast the work of many white artists today speaks in a more jaded, ironic, and distanced voice. Some appear to work from cynical indifference, believing that everything has already been tried. With the ability of modern information and communications technology to access data and images from sources world-wide, these artists imply that there is little to do but recycle the old in new packaging.

Eric Fischl's *The Old Man's Boat and the Old Man's Dog*

This sense of jaded irony is potently conveyed in the works of the American artist Eric Fischl (b. 1948). Through figurative paintings such as *The Old Man's Boat and the Old Man's Dog* of 1982 (fig. 15.23), Fischl introduces a tone of disturbing social criticism. Fischl works in a realist vein recalling the

15.23 Eric Fischl, *The Old Man's Boat and the Old Man's Dog*. 1982. Oil on canvas, 7' square

painterly qualities of such artists as Winslow Homer and Manet. But his subject matter is far from comfortable or reassuring. His settings are often the bedroom or the beach, and the disconcerting mix of his protagonists typically touches on the unspoken, prurient, and perverted aspects of human sexuality. In this example, a family pleasure boat becomes the stage for incestuous voyeurism, in which a mother's gaze appears set on her naked adolescent sons. Fischl leaves open-ended the question of what is holding the attention of the two boys, or the significance of the barking Dalmatian. The girl in the foreground both directs the viewer into the scene—making us accomplices in its lewd intimacy—as well as pointing us to the dark, swelling wave and ominous sky that hangs forebodingly above.

Through such works, Fischl exposes the well-to-do bourgeoisie as dangerously self-absorbed and indifferent to reality beyond the horizons of desire. Like Manet (see fig. 13.10) and others before him, Fischl also raises the question of a credibility gap between appearance and reality in respectable, middle-class society. In the process, he seduces the viewer with glimpses of worlds suspected, and perhaps secretly desired, touching a raw nerve of contemporary self-awareness.

Jeff Koons's *Pink Panther*

Another American artist, Jeff Koons (b. 1955), uses parody to reach for the jugular of American consumer culture. In works such as *Pink Panther* of 1988 (fig. 15.24), in which a magazine centerfold "babe" clutches a well-known cartoon character, Koons confronts us with our cultural icons in all their cheap, slick superficiality. That the artist sees himself as carving for himself one more slice of the market is evidenced by the fact that his works are made by others, following his specifications. This leaves him in the role of product designer and market strategist. It has often been noted that Koons came to art from a previous career as a commodities broker, and that his kitsch-like works—that is, gaudy and formulaic, offering a fake and shallow sentiment—function to highlight the commodity-driven nature of the art world as much as of the surrounding culture.

Gender and Ideology

In the 1990s, artists employing a wide range of different strategies, gave significant attention to the politics of gender—both within the art world and within the wider culture.

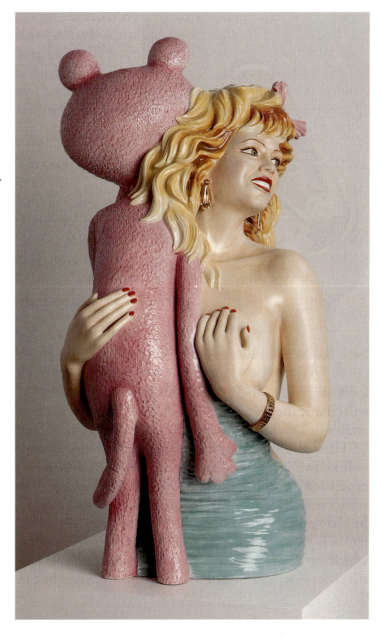

15.24 Jeff Koons, *Pink Panther*. 1988. Porcelain, 41" x 20½" x 19". Museum of Contemporary Art, Chicago

Sherrie Levine's *Fountain (After Duchamp: 1)*

Sherrie Levine (b. 1947) strikes the postmodern note of indifference and boredom, viewing life as devoid of direction, an endless repetition of meaninglessness. Levine drew attention to this by exhibiting a slick, bronze version of Marcel Duchamp's *Fountain* (fig. 15.25). In 1917, Marcel Duchamp had submitted a porcelain urinal for exhibition as a work of art (see Chapter 14). In 1991, Levine added a characteristically postmodern twist to this much-debated event, by presenting her version of Duchamp's urinal. Because of the reflective sheen of its polished surface, the same

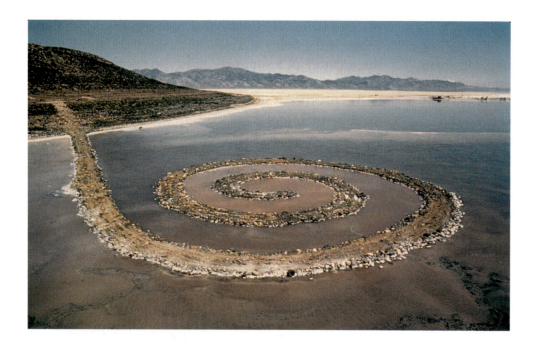

found the ideal setting for his best-known work, *Spiral Jetty*, constructed in 1970 (fig. 15.28). He had tons of rubble dropped in the water to create the 1,500-foot-long spiral form. The contradiction between human creation and nature's ever-present power to transform the landscape became clear as Smithson's construct slowly sank. Smithson wrote, "This site gave evidence of a succession of man-made systems mired in abandoned hopes." His *Spiral Jetty* transformed his own cultural aspiration into a metaphor: Ultimately, nature will dissolve the order that humans attempt to impose upon it.

Anselm Kiefer's *Nürnberg*

Kiefer is one of a number of expressionistic figurative artists—both European and American—who came to the fore in the early 1980s. His paintings are typically large in scale, gestural in execution, and laden with content. In expansive landscapes, such as *Nürnberg* painted in 1982 (fig. 15.29), Kiefer often inscribes the names of places related to the Nazi era, as a means of confronting a past that many

Germans had chosen to avoid. Kiefer uses perspective to draw the eye into and through bare, war-stricken spaces toward a distant horizon. Thickly painted in a palette of somber grey, ocher, and black, into which real straw is mixed, Kiefer transforms a Pollock-like surface into an image of barren, charred fields. Their grim ruts suggest the passage of tanks in war and hope for the plough in peace. Encouraged by his mentor Beuys to see in art the means to initiate a "healing process," Kiefer sometimes introduces to his landscapes images of a bird or a ladder that invoke the notion of rising above the scars on the land, symbolic of the scars in his nation's past. By confronting this reality, the artist hopes to overcome it, as new life rises from scorched earth.

David Wojnarowicz's *Death in the Cornfield*

Other artists have used elements of nature as images of the vulnerable human body. With the spread of the AIDS virus into and through the art community, some

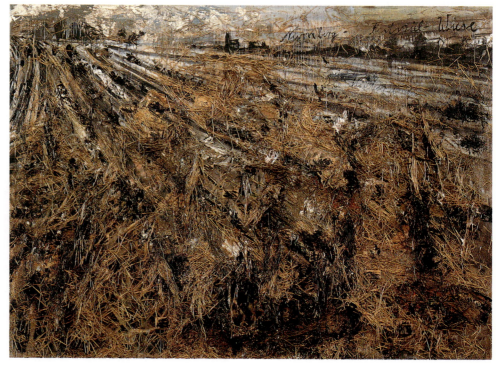

15.29 Anselm Kiefer, *Nürnberg*. 1982. Oil, straw, mixed media on canvas, 9'2¼" x 12'5⅝". Eli and Edythe L. Broad Collection

15.30 David Wojnarowicz, *Death in the Cornfield*. 1990. Silver print, 26" x 38"

artists have transformed their personal experience to reflect on this form of human suffering. David Wojnarowicz's *Death in the Cornfield* of 1990 (fig. 15.30), reveals the terror of AIDS, and the questions the disease raises for its victims. In Wojnarowicz's photograph, a masked figure stands in a cornfield, hands raised in the ancient gesture of intercession. The fearsome mask, designed by the artist, echoes tribal rituals intended to ward off evil forces. The mask and setting, and the phallic form of the corn cob deepen the questioning look of terror on the masked face. Why should the seed of life have become a bearer of death? How can disaster be averted?

Nature Temporarily Transformed

Extending the environmental scale of Earth Works initiated in the mid-1960s, Christo and Jeanne-Claude have focused on temporary, but grand-scale transformations of the environment.

Christo's and Jeanne-Claude's *Surrounded Islands*

For Christo and Jeanne-Claude, nature presents an opportunity for stunning—though temporary—transformation. With vast lengths of fabric, they cover its surfaces, or span open spaces. Christo and Jeanne-Claude have worked with both city and land sites, using fabric wrapping to envelop an art museum in Bern, Switzerland, the oldest bridge in the heart of Paris (the Pont Neuf), and a million square feet of the Australian coastline. They also ran a 24$\frac{1}{2}$ mile-long fabric fence across Sonoma and Marin counties, California.

One of their most colorful projects was *Surrounded Islands*, Biscayne Bay, Greater Miami, Florida, negotiated 1980–83, and installed May 1983 (fig. 15.31). Their transformations of both public monuments and natural scenery—always dismantled within weeks—survive only in memory and in secondary documentation, both filmed and photographic. Christo and Jeanne-Claude exploit capitalist systems to realize their costly projects, yet paradoxically, once dismantled, little remains of these vast works. The artists generate funds through the sale of preliminary drawings, collages, scale models, and early works to finance the projects. The irrationality of their schemes and the absence of a tangible end-product have been seen as both a critique of capitalism and a questioning of the nature of art.

15.31 Christo and Jeanne-Claude, *Surrounded Islands*, Biscayne Bay, Greater Miami, Florida. 1980–83. 6 million square feet of polypropylene fabric

Nature at a Distance

The modern city dweller typically experiences nature in a safe, prepackaged form, rarely directly. We visit nature as an electronic tourist, watching a televised documentary, or in the pages of *National Geographic* magazine. David Hockney (b. 1937) and Gerhard Richter (b. 1932), in different ways, confront this artificial aspect of modern life.

David Hockney's *Gregory Watching the Snow Fall, Kyoto, Feb. 21, 1983*

In Frankenthaler's work (see fig. 15.27) the experience of landscape is filtered through memory and abstraction. The English artist David Hockney distances the subject in another way, in his bewitching photographic collage *Gregory Watching the Snow Fall, Kyoto, Feb. 21, 1983* (fig. 15.32). This collage, with its fragmented, multiple viewpoints, slowly unfolds in a series of intervening spaces, culminating in the quiet, enchanted world of an enclosed Japanese garden dappled by fresh snow.

Early in the twentieth century, Matisse painted a view through a window (see fig. 14.29), and the image is also found in Romantic art. Hockney has masterfully made this theme contempoary. The viewpoint is Hockney's—we see his feet in the center foreground. He sees the garden not only twice removed—beyond two

15.33 Gerhard Richter, *Wasserfall–Waterfall*. 1997. Oil on canvas, 49^1/$_{10}$" x 35^1/$_2$". Kunstmuseum, Winterthur, Switzerland

15.32 David Hockney, *Gregory Watching the Snow Fall, Kyoto, Feb. 21, 1983*. 1983. Photographic collage, 43^1/$_2$" x 46^1/$_2$"

protective screens—but he also views it through the eyes of another—his friend Gregory. His friend gazes out from within the protective warmth of bedcovers. His head is collaged three times, twice absorbing the tranquil garden, once turned to engage the viewer. The experience, however, like much of modern life, remains vicarious. Nature is no longer experienced directly. We travel to find our Eden, and then feast on it from cocoon-like isolation. It is a landscape of nostalgia.

Gerhard Richter's *Wasserfall–Waterfall*

The German artist Gerhard Richter passes the encounter with nature through yet another filter, by making oil paintings of photographs of the landscape, in works such as *Wasserfall–Waterfall* (fig. 15.33) of 1997. At first sight, his grainy, soft-focused landscapes, often soaked in a misty atmosphere, recall the works of German Romantics such as Caspar David Friedrich

(see fig. 12.16), in whose home town, Dresden (then in communist Germany), Richter was born and educated, before crossing over to the West in 1961.

Richter's landscapes may resonate with the general public's longing for recognizable images in art; they may offer the allure of a nostalgic gaze into wide open spaces, forgotten valleys, or a remote waterfall, free from the turbulence of modern cities. Yet his blurring of all detail pulls one back to the realization that this is a painting of a photograph, not a landscape, and that, in one sense, it is a painting about the nature of photographic images. For the Romantics nature was a trigger for spiritual yearning; now it is something held nostalgically in the grainy surface of a soft-focus photograph.

THE CITY

Two opposing impulses have shaped the architecture of the modern city. The Modernists sought to leave the past out of the present, while postmodernists attempted to integrate architectural traditions into contemporary buildings. In the post-war years, the ideals of International Style architecture radically changed the look and feel of modern cities. At its core was an aesthetic inspired by modern materials and construction technology, and the belief that a building's form should derive—without embellishment—from its function and construction methods.

After the Nazis closed the Bauhaus school of architecture and design in 1933 (see Chapter 14), its faculty left and carried those ideals with them. Walter Gropius (1883–1969) went to Harvard, and Ludwig Mies van der Rohe (1886–1969) established an architectural practice in Chicago. Their purist vision inspired an entire generation of architects, who during the post-war building boom would put their ideals into practice, transforming the face of modern cities.

In the late 1960s and 1970s, however, a younger generation of architects began to react against the

purity and rigid, doctrinaire attitudes associated with the Modernist International Style, much as painters and sculptors reacted against Modernist art theory. Architects such as Robert Venturi (b. 1925), Philip Johnson (b. 1906), Michael Graves (b. 1934), the one-time partners Renzo Piano (b. 1937) and Richard Rogers (b. 1933), Charles Moore (1925–93), Frank Gehry (b. 1929), and others developed more whimsical and diversified forms of architecture, commonly called postmodern. Like postmodern painters and sculptors, postmodern architects draw on a wide range of historical references in their work. Here we will contrast Modernist and postmodernist attitudes toward existing structures and spaces: Modernists attempting to transcend the past, postmodernists to embrace it.

The Artist Views the City: Richard Estes

Richard Estes's (b. 1936) large, photo-realist painting *Williamsburg Bridge* (Manhattan) of 1987 captures the glossy, high-tech tone of a post-war North American city (fig. 15.34). Estes evokes this world of glass and steel, much as Léger had evoked the emergence of Modernism in *The City* (see fig. 14.36), and Caillebotte and Monet had captured the atmosphere of nineteenth-century Paris (see figs. 13.31, 13.32). In Estes's work, the accented recession of many lines toward a vanishing point evokes a sense of rapid convergence on the city, and suggests the magnetic pull of the "Big Apple." Individuals in the subway car will soon pass into anonymity, moving between the

15.34 Richard Estes, *Williamsburg Bridge*. 1987. Oil on canvas, 3' x 5'6"

skyscrapers glimpsed through the window. This is a world of glimmering chrome, glass and steel, fluorescent lights, and slick advertising. Its polish is emulated by the artist's photo-realist style. It calls up the impersonal, mechanized world of the glass-box skyscraper.

The Isolated Glass Box: Ludwig Mies van der Rohe and Philip Johnson

The glass-box skyscraper became the signature structure of the post-war years. A classic example is Ludwig Mies van der Rohe's Seagram Building in New York (fig. 15.35), designed with Philip Johnson in 1954–8. In conformity with Mies's now-famous adage that "less is more," no concession is made to any form of embellishment. The building's appearance is largely determined by the nature of materials—steel and tinted glass—the steel frame construction technique, and a carefully considered set of mathematical proportions. Since New York's building code did not permit him to leave the steel frame exposed, Mies used costly bronze beams on the exterior to signify the hidden frame. Although Mies's buildings are severe and unadorned, each element and detail is carefully considered. Many lesser architects neglected

15.35 Ludwig Mies van der Rohe, with Philip Johnson, Seagram Building, New York. 1954–8

those considerations while exploiting his system to produce cheap, standardized imitations. These offer a look of rational efficiency, but typically lack the sleek elegance and measured proportion of Mies's buildings.

As pure architectural forms devoid of any historical reference, Mies's buildings are characteristically indifferent to their specific context, climate conditions, or even function. There is little to differentiate an office building from a residential apartment building, or an art museum from an aircraft hangar. Out of a desire to transcend the past, Mies made no attempt to relate his designs to the surrounding architecture, or to the human scale, histories, and local attachments of their users. Instead he offered an abstract model of industrial efficiency to function as a container for the ambitions of corporate America. As first envisioned in the early days of Bauhaus, the light, reflective, crystalline structure—in contrast to the massive weight of earlier brick and stone structures—symbolized a luminous future, enlightened by human reason and technology. As ideal structures, they were intended to transcend history.

Minimalist Public Sculpture: Richard Serra

Mies van der Rohe's idealist defiance of the local and particular was echoed in the realm of public sculpture, notably by Richard Serra's (b. 1939) 120-foot-long *Tilted Arc* (fig. 15.36). It was installed in the Federal Plaza, Foley Square, New York City in 1981, but—after New Yorkers rallied against it—the sculpture was removed in 1989. Serra designed this piece on commission as a site-specific work, attending to strictly formal rather than human concerns. He intended its pure, curving Minimalist forms to play off the surrounding space, and to work against the curving pattern of the Plaza's paving stones, and received approval for his design. Serra's 12-foot-high wall of steel appeared to defy gravity, since it leaned inward 12 inches from its base, thus menacing the passer-by, while its length severely restricted the possible routes taken by pedestrians.

In both his work and his public statements, Serra expressed a detached indifference to the needs of the people using the space. Some may say that Serra's detached Modernist stance, in which the elite artist imposes his idealist vision on a reluctant public, reflects an attitude that has increased the distance between artists and the general public; but it has also provoked

took as its point of reference the existing City Hall, built in the 1930s in a Spanish Neo-Baroque colonial style. He translated this style into contemporary terms for the new adjoining complex of municipal buildings, library, and plaza. The result is a sequence of unfolding vistas whose flow and rhythm is articulated by a converging succession of stairs, ramps, pedestals, pilasters, arches, and openings.

These elements recall the flow toward a visual climax found in Baroque architecture. To avoid International Style curtain walls of endless glass strung over a steel frame, Moore clad the buildings with stuccoed walls that harmonize with the existing City Hall. Instead of striking a Modernist stance and opposing the old with the new, Moore harmonized the new with the old. He also created an inviting environment on an accessible, human scale that is fresh and original. The resulting complex, rather than denying the city's history, affirms it.

Confronting the Past: Modernist Opposition and Postmodern Accommodation

Toward the end of the twentieth century, art galleries and museums themselves became showcases in the debate between Modernist and postmodernist ideas about architecture. Here we will consider three, in Paris, Washington D.C., and London.

15.37 Charles Moore, with the Urban Innovations Group, Beverley Hills Civic Center, California. 1983–91

discussion about freedom of expression. Since removal effectively destroys site-specific works such as Serra's, this incident also raised the issue of what continuing rights artists may have over their works, as well as the rights of those who commission them, and those who live with them. It also provoked reconsideration of the relationship of old and new within the overall fabric of a city.

Site Sensitivity

Postmodern architects and town planners have rejected Mies van der Rohe's concept of the isolated box, seeking instead to integrate buildings into urban spaces and to create arenas for social exchange.

Charles Moore's Beverley Hills Civic Center

The Beverly Hills Civic Center in California exemplifies this postmodern impulse (fig. 15.37). This complex was designed and built from 1983 to 1991 by Charles Moore in collaboration with the Urban Innovations Group. Moore's design for this 10-acre Civic Center

Architecture and Urban Renewal

During the economic boom of the 1990s, several landmark buildings were designed to call attention to the cities that house them, attracting tourism and boosting the local economy. One such structure is the Guggenheim Museum in Bilbao in northern Spain, a large, industrial seaport, designed by the California-based architect Frank Gehry.

Frank Gehry's Guggenheim Museum, Bilbao

Rather than suggesting balance and order, Gehry's buildings suggest disequilibrium and instability. Accordingly, he is the leading proponent of so-called Deconstructivist architecture. When completed in 1997, critics hailed Gehry's Guggenheim Bilbao as an epoch-making structure (fig. 15.42). The heart of the building is a soaring, glass-walled atrium, 165 feet high, capped by a cluster of forms that Gehry has described as a "metallic flower." Complementing the vertical thrust of this core are the lateral galleries, which, when seen from the harbor side, resemble a ship's hull. The building's exterior surfaces are clad in scaled limestone and titanium, a highly reflective material that gives the whole a space-age feel, and a sheen that changes with the light of day. This stunning and unsettling building has transformed Bilbao into a "must-see" tourist attraction—surely, one of the goals of commissioning a landmark building as an instrument of urban renewal.

PARALLEL CULTURES
Cultural Blending and Borrowed Identities

Until recently in the United States, the art of non-Western countries was valued, if at all, as "other," primarily on the grounds of its sheer exoticism. But today, as America becomes ever-more heterogeneous, many are realizing that "the other" is in our midst. Today, the works of contemporary African-American, Hispanic, indigenous American, and Asian-American artists are occasionally exhibited, but acquisitions by major museums of contemporary works from such sources remain minimal.

Earlier, we discussed the work of Faith Ringgold and Romare Bearden (see figs. 15.1, 15.22), whose art grew out of their experiences as African-Americans. We've also discussed the collaborative work of Jorge Rodriguez and Charles Abramson (see fig. 15.7). All these artists were concerned with the issue of cross-cultural experience. Here, we consider this issue on its own terms.

Betye Saar's *Mojotech*

Betye Saar (b. 1926), an African-American artist, first attracted attention in the 1970s by drawing on African perceptions of the material world. Saar is an assemblage artist who gathers objects and materials from garage sales and junk shops. She presents these assemblages in a

spirit akin to the magical quality of African tribal fetish objects. Most of her works of the 1970s were quite small, but she has also made a number of larger works, such as *Mojotech*, a shrine-like installation of 1988 (fig. 15.43). Saar's thinking and experience is steeped in the occult and shamanism. Objects, she believes, contain energy and spiritual power, and she seeks to release this power through her art. *Mojotech* signifies this intention: Western technology is to be animated by traditional religious practices (*mojo*). Saar represents this process by lining the innards of an old radio with an animal skin, then setting this artifact on an altar-like pedestal. In this pairing, she unites technological and animist power; an aura of spiritual power seems to emanate from the core of the shrine-like installation in Saar's attempt to cross-fertilize Western and non-Western perceptions of the material world.

Since the 1990s, new concerns have surfaced about ethnic and national identity. As the power of global corporations grows, and international travel—both virtual and actual—increases, some artists are particularly interested in cultural "cross-fertilization." The expression of sameness—as well as

difference—is evident in all spheres of life, including art. Contemporary Japanese artists Mariko Mori and Yasumasa Morimura have focused on the cultural blending of East and West.

Mariko Mori's *Play with Me*

Mariko Mori (b. 1967) was born in Tokyo, studied fashion, and worked as a model before studying art in London. She now lives and works in New York and

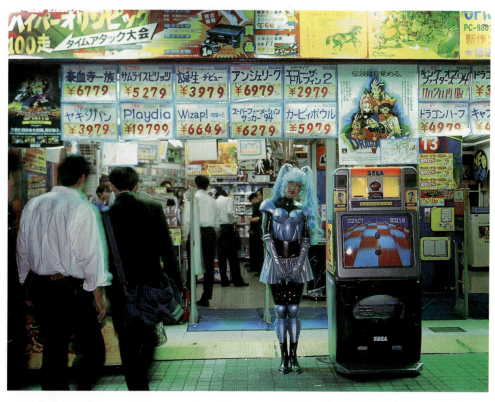

15.44 (above) Mariko Mori, *Play with Me*. 1994. Fuji supergloss (duraflex) print, wood, pewter frame, edition of three, 10' x 12' x 3"

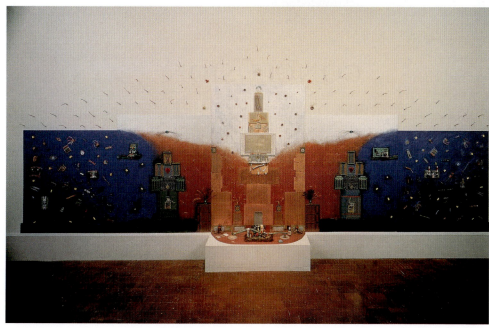

15.43 (left) Betye Saar, *Mojotech*. 1987–8. Mixed media installation, 7'6½" x 28' x 1'2".

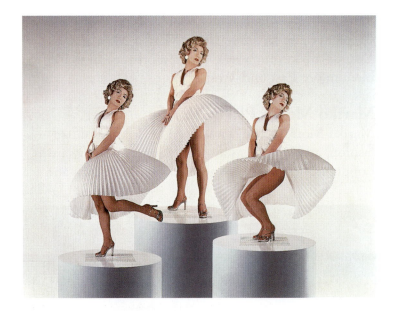

15.45 Yasumasa Morimura, *Self-Portrait (Actress)/White Marilyn.* 1996. Ilfrochrome/acrylic sheet, 37¹/₄" x 47¹/₄"

Tokyo. Her early experience in the fashion world, combined with her international art education and lifestyle, led her to explore the relationship between constructed identity and appearance, and, by extension, the crossing of cultural boundaries. In large-scale works such as *Play with Me* of 1994 (fig. 15.44), Mori used the techniques of the fashion industry to transform herself into a science-fiction porn star posed in front of a video arcade, documented in a large-scale photograph. While the specific components are her own, this strategy for exploring constructed identity immediately recalls the works of Cindy Sherman (see fig. 15.20), erasing cultural boundaries.

Yasumasa Morimura's *Self-Portrait (Actress)/White Marilyn*

Like Mori, the Japanese artist Yasumasa Morimura (b. 1951), who has been called the "Japanese Cindy Sherman," uses costume, make-up, camera, and computer technology. But Morimura has consistently focused his attention on the construction of borrowed identity, in this case impersonating figures—both female and male—from works of Western art history, and more recently female Hollywood film stars. In works such as *Self-Portrait (Actress)/White Marilyn* of 1996 (fig. 15.45), Morimura adds to Mori's blended national identity a blended gendered identity. His work begs the question: What, in the construction of our identity, remains uniquely national, uniquely male or female,

and given from birth; and what is merely pressed upon us by the forces of consumer capitalism and the international media?

We cannot predict to what extent multicultural art will enter the mainstream of American art, or indeed transform it. Such art calls for an openness to a much wider range of human concerns and aesthetic sensibilities—an openness far more expansive than many are used to. As we are challenged, perhaps not only our aesthetic horizons but also our understanding of humanity will grow. As Mexican author Carlos Fuentes has wisely observed:

> People and their cultures perish in isolation, but they are born or reborn in contact with other men and women, with men and women of another culture, another creed, another race. If we do not recognize our humanity in others, we shall not recognize it in ourselves.
> (*The Buried Mirror*, p. 353)

As ethnic and religious tensions continue to cause death and suffering around the world, the need to recognize ourselves in others remains acute, as does the need to respect the real differences between us. Art created out of cross-cultural contexts can only help us to acknowledge and bridge these differences.

CONCLUSION

As we look back over the history we have surveyed, and consider our contemporary situation, we must ask ourselves what has sustained our society, and inspired its art. We may want to reflect on the choices made and consider what we have gained, but also what we have lost, leading us to ask: How best can the art and ideas of the past and present continue to nourish, challenge, and serve us into the future—both in the realm of art, and in the wider culture?

Glossary

Compiled by Cherith A. Lidfors Lundin

ABACUS The flat slab of stone above a **Doric capital**, supporting the **entablature**.

ABBEY A **monastery** headed by an abbot. The term is also used of the church building of the monastery.

ACADEMY An institution for training artists through systematic teaching of art and art theory, also providing opportunity for discussion and exhibitions. The first academies were founded in the Renaissance, replacing the **guild** oversight of artists' workshops as the main source of artistic training.

ACANTHUS A leaf-like architectural ornament resembling a Mediterranean plant, used in the **Corinthian capital**.

ACROPOLIS The upper city, or **citadel**, of a Greek city, functioning as a protective enclosure for temples, royal palace, and the city treasury.

ACRYLIC A fast-drying synthetic paint developed about 1960.

ACTION A term invented by Joseph Beuys (1921–86) for a staged event put on by an artist.

ACTION PAINTING A method of painting with bold gestures, runs of paint, splattering, and dripping, suggestive of the painter's actions.

ADOBE Sun-dried mud-brick, used for building in New Mexico, Latin America, and elsewhere.

AERIAL PERSPECTIVE See **perspective**.

AGORA A central, open gathering place or market in a Greek town. In Roman times termed a **forum**.

AISLE A corridor running parallel to the main central space, or **nave**, of a Roman **basilica** or Christian church, separated from this space by an **arcade** or **colonnade**.

ALTAR A table where religious rites are performed; in Christian churches the place where the holy Eucharist or mass is celebrated.

ALTARPIECE A painted or carved work of art at the back of an **altar** which contains religious imagery.

AMBULATORY The **aisle** leading around the edge of the **apse** and the **choir** of a Christian church.

AMPHITHEATER A circular or oval open-air building with tiers of seats developed by the Romans for sports and entertainment.

AMPHORA An ancient Greek vase with a tall, curved body and two handles, used for storing oil and wine.

ANICONIC A term for art that uses symbols rather than figures to represent the sacred, as often in Islamic art.

APOCRYPHA Early Christian writings accepted into the biblical canon by Catholics but rejected by Protestants.

APPROPRIATION The practice of taking a preexisting image from art history, advertizing, media, or other source, and reworking it into a new work of art, often in combination with other elements.

APSE A semicircular space at the end of the **nave** of a Christian church, usually surmounted by a half **dome** or **vault**; it can also be at the end of a **transept**.

AQUATINT An **intaglio printmaking** process which creates tonal areas by sprinkling a metal plate with powdered resin, which when etched in acid gives uneven, granular effects.

AQUEDUCT A Roman structure built to transport water over long distances.

ARABESQUE An ornamental surface decoration combining organic and geometric forms to create flowing lines.

ARCADE A series of arches supported by columns or piers; when attached to a wall, it is called a blind arcade.

ARCADIA A mountainous region of Greece that gave its name to an idealized place, often celebrated in art and poetry, where the inhabitants were imagined to live in perfect rustic peace and simplicity.

ARCH Usually a semicircular structure used to span an opening. It is built out of wedge-shaped elements, or **voussoirs**, and capped by a **keystone**. Other shapes are pointed, ogee ("S" curved) or horseshoe arches.

ARCHITRAVE The lowest part of a **classical entablature** which rests directly on the **columns**, beneath the **frieze**.

ARCHIVOLT A decorative band or **molding** that frames an **arch** or a **tympanum**, often decorated with sculpture in medieval Christian churches.

ASSEMBLAGE The transformation of non-art objects into sculpture by assembling found objects and other three-dimensional forms. The technique of assemblage originated in the early twentieth century.

ATMOSPHERIC PERSPECTIVE See **perspective**.

ATRIUM An open entrance or central courtyard in a Roman house; also the forecourt to a Christian church.

ATTIC The low, upper story above the **entablature** of a **classical** building.

AVANT-GARDE A French term meaning "vanguard," applied from the mid-nineteenth century to artists with radically new, experimental concepts. The term suggests the role of the artist as catalyst for social change.

AXIS An imaginary straight line through the center of a form, space, or composition around which it is arranged symmetrically.

BALDACCHINO An ornamental canopy placed over an **altar** or throne. Also called baldachin. See also **ciborium**.

BALUSTRADE A railing or barrier supported by short posts called balusters.

BAPTISTERY A round or polygonal building used for the Christian ritual of baptism. A baptistery may be a separate structure or built adjacent to the main church.

BARREL VAULT An arched ceiling that usually requires continuous buttressing (see **buttress**); also known as a tunnel **vault**.

BASILICA A large colonnaded Roman hall (see **colonnade**) for public use and administration; later used as a basic building type for Christian churches. Usually built with a central **nave** and side **aisles**, an **apse**, and a **clerestory**.

BASKET CAPITAL A **capital** whose surface is carved to create an effect like a woven basket.

BAY Vertical division of the exterior or interior of a building into regular units, as marked by **columns**, **piers**, **buttress**es or windows.

BLACK-FIGURE A style of ancient Greek painted pottery in which figures are silhouetted in black **slip** against red clay. Details are scratched into the black slip to reveal the red ground.

BOOK OF HOURS A late medieval book of private prayers containing devotions for the seven canonical hours of the Roman Catholic Church, liturgies for individual saints, and sometimes a calendar; often elaborately illuminated (see **illuminated manuscript**).

BRACKET An architectural support that projects from a wall to support a statue, beam, **cornice**, etc. (see also **console**).

BREVIARY A medieval book containing prayers, hymns, and psalms that Roman Catholic clergy are required to recite daily.

BRONZE A metal alloy, mainly of copper and tin. Also, any sculpture or object made of bronze.

BUST A sculptural portrait limited to the head and shoulders of the subject.

BUTTRESS An architectural support to counteract the outward thrust of an **arch** or a wall. See also **flying buttress**.

CAMERA OBSCURA Latin term meaning "a dark chamber ." A room or, later, box similar to a camera, with a small opening that allows light to come in and cast an image on the inside, which can then be traced. It was first used for artistic purposes during the Renaissance.

CAMPANILE Italian for bell tower; usually a separate structure next to a church.

CANTILEVER A horizontally projecting beam supported only on one end.

CAPITAL The sculpted top of a **column**, **pier**, or **pilaster**, providing a transition from the vertical support to the horizontal **entablature**.

CARDO A north–south street in a **grid-iron**

Roman town plan, commonly used of the principal north–south axis. See also **decumanus**.

CARTOON A full-scale preparatory drawing for a painting or tapestry.

CARYATID A support in **post-and-lintel** building construction that is carved to represent a female figure (male caryatids are generally called atlantes).

CASTING A method of reproducing a three-dimensional object by pouring a hardening material, such as plaster or metal, into a mold. See **cire perdu**.

CATACOMB An underground burial place consisting of a system of tunnels and rooms used by ancient Romans, Jews, and Christians.

CATHEDRAL A Christian church designated as the seat of residence of the bishop of a diocese.

CELLA The inner sanctuary of a Greek temple which houses the cult figure, also known as the **naos**.

CENTRAL-PLAN CHURCH A church of circular, polygonal, or square design. The latter is typically based on the form of a **Greek cross**, with the central space surrounded by four arms of equal length. Its center is typically domed, and in ground plan a circle inscribed within a square.

CHAMPLEVÉ See **enamel**.

CHANCEL East end of a church, east of the **transept** crossing, reserved for clergy and choir.

CHAPEL A small place of worship. Chapels for private devotion are often built off of the central areas of large churches, such as a side **aisle** or the **ambulatory**.

CHERUB (pl. CHERUBIM) An angelic being represented in Christian art as a winged child or winged head of a child. See also **putti**.

CHIAROSCURO Italian for "light and dark." A technique used in painting and drawing to suggest three-dimensionality through **modeling** of light and shadow.

CHOIR The area of a church near the **altar** between the **apse** and the **crossing** where the clergy and singers conduct the service.

CIBORIUM A canopy over an **altar** supported on **columns**; also called a **baldacchino**.

CIRE PERDU French for "lost wax." A **casting** process in which a clay model coated with wax is encased in clay or plaster. When the model is heated the wax layer melts away, and the resulting mold is then filled with molten metal.

CITADEL A fortified place on a high point, serving as the last point of defence in a city.

CLASSIC A model of its kind; a prime example.

CLASSICAL A term referring to the art and architecture of ancient Greeks and Romans and, by extension, to later art based on similar principles or stylistic elements.

CLERESTORY The upper part of the **nave** wall of a **basilica**, extending above the side **aisle** roofs and pierced with windows to illuminate the central nave.

CLOISONNÉ See **enamel**.

CLOISTER An open courtyard surrounded on all sides by a covered **arcade** or **colonnade**; usually part of a **monastery**.

COFFER A recessed geometrical panel that decorates a ceiling or the interior of a **vault**.

COLLAGE A composition created out of cut and glued materials, such as newsprint, cloth, and colored paper which was developed in the early twentieth century; also called **papier collé** (French for "glued paper").

COLONNADE A series of regularly spaced columns supporting an **entablature**.

COLUMN A vertical architectural support, usually free-standing, that consists of a base, a cylindrical **shaft**, and a **capital**.

COMPOSITE ORDER A combination of **Ionic** and **Corinthian** architectural orders with slender **columns** and **capitals** that combine both **volutes** and **acanthus** leaves.

CONCEPTUAL ART Originating in the 1960s, art in which the artist's concept or idea takes precedence over the making of an aesthetically pleasing art object. Conceptual art often comprises or includes written documentation.

CONCRETE A fast-drying mortar developed by the Romans that hardens into a strong building material. Mainly used today in form of **reinforced concrete**.

CONSOLE An ornamental **bracket**, often scroll-shaped, projecting from a wall.

CONTRAPPOSTO A representation of the human body in which the weight is resting on one leg while the other is relaxed. The upper torso counterbalances this pose, suggesting freedom of movement.

CORBEL A projecting block (usually) of stone that supports something.

CORINTHIAN The most ornate Greek **order**, consisting of a fluted **column**, a **capital** decorated with stylized **acanthus** leaves, and an **entablature** with a decorated **architrave** and **frieze**.

CORNICE The upper part of an **entablature** in Greek architecture. More generally, a projecting **molding** that surmounts a wall or arch.

CROSS-HATCHING A method of shading drawings and engravings with closely spaced intersecting lines (see **hatching**).

CROSS-SECTION An architectural diagram that shows the inside of a building cut breadthwise by a vertical plane.

CROSSING The intersection of the **nave** and the **transept** in a Christian church.

CROSSING TOWER A tower on the exterior of a Christian church marking the **crossing**.

CROSS VAULT A **vault** formed by the intersection of two **barrel vaults** at right angles; also called a groin vault.

CUPOLA A small roof structure in form of a rounded **vault** or **dome** which lets light into the interior.

CURTAIN WALL A non-load-bearing wall, used in modern architecture to clad reinforced concrete- or steel-framed buildings in glass, aluminum, or other materials.

DAGUERREOTYPE An early photographic process invented by L.J.M. Daguerre and first made public in 1839 in which a silver-coated copper plate was treated to create a positive print.

DECUMANUS An east-west street in a **gridiron** Roman town plan, commonly used of the principal east–west axis. See also **cardo**.

DEËSIS Greek for "supplication." The Byzantine representation of Christ enthroned between the Virgin Mary and St. John the Baptist, who serve as intercessors for humanity.

DIPTYCH An image composed of two separate painted panels or carved **reliefs** which are usually hinged together.

DIVISIONISM The technique of painting with small areas of unmixed **pigment** so that colors placed next to each other appear to combine when viewed from a distance.

DOME A rounded **vault** rising from either a circular or polygonal base (see also **cupola**).

DORIC The first ancient Greek architectural **order**, consisting of a **column** without a base, a **capital** with undecorated **echinus** and **abacus**, and an **entablature** with **architrave**, and a **frieze** with alternating **triglyphs** and **metopes**.

DRUM A cylindrical wall supporting a **dome**. Also a cylindrical unit in the **shaft** of a **column**.

DRYPOINT An **intaglio printmaking** technique in which an **etching** needle is used to scratch the image directly into the metal plate, creating ridged lines.

EARTH WORKS Usually large-scale art works made by manipulating the natural environment.

ECHINUS The rounded **molding** below the **abacus** of a **Doric capital**.

EDITION A limited number of prints made from one printing surface, which are signed and numbered by the artist.

ELEVATION An architectural diagram that shows the exterior or interior surface of a building.

EMBLEM BOOK A book of symbolic illustrations accompanied by texts, usually of inspirational or moral character; especially common in the sixteenth and seventeenth centuries in England and the Netherlands.

ENAMEL A technique in which powdered, colored glass is fused to a metal ground by firing; the two main techniques are: cloisonné, in which the surface is divided into compartments for the enamel using thin metal strips; and champlevé, in which the areas to be filled are dug out of the metal ground.

ENCAUSTIC A painting technique in which **pigment** is dissolved in hot wax; particularly used in ancient Egypt.

ENGAGED COLUMN A **column** that is attached to a wall or **pier**.

ENGRAVING An **intaglio printmaking** technique in which grooves are cut into a metal plate by using a special tool, or burin.

ENTABLATURE The horizontal structure above the **columns** in a Greek architectural **order**, consisting of **architrave**, **frieze**, and **cornice**.

ENTASIS The slight outward bulge of a Greek **column**, intended to compensate for the illusion of concavity otherwise created by rows of parallel columns.

ETCHING An **intaglio printmaking** process in which a drawing is scratched with an etching needle into the surface of a metal plate that has been coated with an acid-resistant resin. The plate is then immersed in acid, which eats out the exposed areas of the drawing, creating grooves for the ink.

FAÇADE The front or main face of a building.
FAIENCE A type of glazed earthenware used for pottery, small sculpted figurines, and wall tiles.
FERROCONCRETE See **reinforced concrete**.
FILIGREE ORNAMENTATION Delicate, lacelike ornamentation. In jewelry it is made of fine gold or silver wire; a similar effect is used in some architectural decoration.
FLUTING Shallow, ornamental grooves that run vertically on the **shaft** of a **column**.
FLYING BUTTRESS An **arch** built on the exterior of a structure to transfer the lateral thrust of the roof **vaults** down to a solid **pier**.
FORESHORTENING A method of **perspective** that makes figures appear to protrude or recede into space; used in painting, drawing, and **relief** sculpture.
FORUM A public meeting place that served as the official center of a Roman town and the site of the main administrative buildings and temples. See **agora**.
FRESCO A painting technique in which **pigment** is applied onto fresh moist plaster and becomes part of the wall itself when dry. This is sometimes termed **buon fresco** ("good fresco"). In a less durable variant known as **fresco secco** ("dry fresco") paint is applied to the surface of dry plaster.
FRIEZE The middle section of an **entablature**, between the **architrave** and the **cornice**, usually decorated with **relief** sculpture or **moldings**. Also, any continuous band decorated with painting or relief sculpture.

GABLE The triangular wall area formed by a pitched roof, called a **pediment** in **classical** architecture. Also a triangular decorative element shaped like a gable.
GALLERY A story built above the side **aisles** of a **cathedral**, usually overlooking the **nave**. Also, a long room used for exhibiting art works.
GENRE A type or category of artistic expression. Also, a work of art that represents scenes of daily life. **Genre** painting depicts such subjects as domestic, tavern, and street scenes.
GESSO A smooth **medium** usually made of glue and ground chalk or plaster, used as a **ground** on canvas to prepare for painting in **oil paint** or **tempera**.
GLAZES In working with **oil paint**, transparent layers of paint applied on top of each other to modify color. In ceramics, a glassy coating applied to a piece of pottery which when fired creates a waterproof and often decorative surface.
GOLDEN SECTION The ideal ancient Greek proportions of visual harmony, in which, when dividing a line, the shorter part is the same proportion to the longer part as the longer is to the whole.
GREEK CROSS A cross with four arms of equal length, often used as a basis for the **central-plan church** and roofed with a **dome**, or domes.
GRID-IRON PLAN A town plan based on regularly spaced straight streets intersecting at right angles.
GROIN VAULT See **cross vault**.
GROUND The prepared surface on which paint can be applied.

GROUND PLAN An architectural diagram showing the horizontal floor plan of a building.
GUILD An association of artists and craftsmen in the medieval and Renaissance times which provided training, upheld artistic standards, and assured economic protection.

HAPPENING An art form developed in the 1960s combining theatrical performance and visual images according to chance and spontaneous audience participation; a type of **performance art**.
HATCHING A drawing technique to create shading through a series of closely spaced parallel lines. When two sets of lines are drawn over each other at an angle it is called cross-hatching.
HERM A tapering rectangular pillar terminating in a head, **bust**, and/or torso, and sometimes including a phallus.
HISTORY PAINTING In Western art, a figurative painting showing a scene from history, classical mythology, the Bible, or the lives of saints.
HUE The actual shade of a color.
HYPOSTYLE HALL A large interior space—as in ancient Egyptian temples—whose roof is supported by numerous rows of closely spaced **columns**.

ICON An Eastern Orthodox or Byzantine panel painting representing sacred figures, such as Christ, the Virgin Mary, or saints.
ICONOCLASM A movement to ban and destroy religious images. Historically this arose in opposition to the representation of Christ (e.g. in the Byzantine Church in the eighth and ninth centuries) and in opposition to the veneration of relics, Mary and the saints (e.g. by Protestants in the sixteenth and seventeenth centuries).
ICONOGRAPHY The study of the meaning of visual images.
ICONOLOGY The interpretation of visual images in their historical and cultural context.
ICONOSTASIS A screen covered with icons, separating the sanctuary from the body of the church in Early Christian or Greek Orthodox churches.
IDEALISM The perfecting and improving of forms according to the ideal standards of beauty of the particular culture.
IGNUDI A young male nude figure, such as those found in Michelangelo's Sistine Chapel.
ILLUMINATED MANUSCRIPT A richly decorated manuscript, often with illustrations embellished in gold and brilliant colors, common in medieval times and the Renaissance.
IMPASTO **Oil paint** or **acrylic** paint applied thickly to a canvas or panel.
INSTALLATION A work of art that consists of a site-specific three-dimensional environment or ensemble of objects.
INTAGLIO A **printmaking** process in which the drawing to be printed is incised into the printing surface by methods of **aquatint**, **engraving**, **etching**, or **drypoint**. The resulting grooves are inked, and the image is printed on paper.
IONIC An ancient Greek architectural **order**, consisting of a **column** with **fluting** on the **shaft** and a **scroll capital** decorated with **volutes** supporting a decorated **entablature**.
IWAN A large vaulted hall in Near Eastern architecture with an arched opening on one side, often functioning as an entrance **portal**.

JAMBS The upright areas forming the sides of an opening, such as a door or a window. In Romanesque and Gothic churches the jambs are often decorated with sculpture.
JAPONISME The influence of Japanese art and culture on Western artists in the mid-nineteenth century.

KEYSTONE The uppermost **voussoir** of an **arch**, which, when in place, exerts pressure that holds the other voussoirs in place, so long as the arch is buttressed by solid masonry at either side.
KITSCH Formulaic and often gaudy art that offers a fake and shallow sentiment.
KONDO The main hall in a Japanese Buddhist temple-monastery complex where the images of Buddha are placed.
KORE (pl. KORAI) Greek for "maiden." An Archaic Greek statue of a young clothed female.
KOUROS (pl. KOUROI) Greek for "youth." An Archaic Greek statue of a young nude male.
KRATER A large ancient Greek ceramic or metal vessel for mixing wine and water.
KYLIX An ancient Greek drinking cup with a wide, shallow bowl and two handles.

LANCET A tall, narrow window with a pointed **arch**.
LANTERN A small structure with windows above a tower or dome that allows light into the space below.
LATIN CROSS A cross with a longer vertical arm than horizontal arm, used as the basis for **basilica**-plan churches that include a **transept**.
LINTEL A horizontal beam spanning an opening in a **post-and-lintel** system.
LITHOGRAPHY A **printmaking** process in which an image is drawn onto a flat stone or a metal plate with a greasy substance. The surface is moistened and rolled up with ink, which is repelled by the water on the unmarked stone and adheres to the greasy drawing and can then be printed on paper.
LOGGIA A covered **gallery** or **arcade** open on one or more sides.
LONGITUDINAL SECTION An architectural diagram that shows how the inside of a building would look if cut in half by a vertical plane from front to back.
LOST-WAX PROCESS See **cire perdu**.
LUNETTE A framed semicircular opening or surface area, as over a door or window. Also a painting, relief sculpture, or window of the same shape.

MANDORLA An almond-shaped form surrounding Christ or the Virgin Mary, indicating divinity or holiness.
MARTYRIUM A **chapel** or shrine built above the grave or relics of a martyr.
MASTABA A rectangular Egyptian tomb with sloping sides and a flat roof, with entrance shaft to the burial chamber.
MAUSOLEUM A large building used for burial, named after the tomb of Mausolos at Halikarnassos (around 350 BCE).
MEDALLION Any round decoration or ornament in a wall; also a large medal.
MEDIUM (pl. MEDIA) The material or

technique used to create a work of art. Also the liquid substance, such as water or oil, in which **pigment** is suspended to create paint.

MEGALITH A large, irregularly shaped stone used in prehistoric monuments, such as Stonehenge.

METOPE The square spaces between the **triglyph**s in a **Doric entablature** which are often decorated.

MIHRAB A wall **niche** within a **mosque** that distinguishes the **qibla** wall—the wall directed toward Mecca.

MILIEU PORTRAIT A portrait that presents the sitter or sitters as though engaged in a characteristic activity.

MINARET A tall slender tower on the exterior of a **mosque** from which Muslims are called to prayer.

MINIATURE A painting on a small scale, often portraits on ivory or pictures in an **illuminated manuscript**.

MIXED-MEDIA The use of a variety of media (see **medium**) or techniques within one piece of art.

MOBILE A carefully balanced sculpture whose parts are set in motion by either air currents or a motor.

MODELING In two-dimensional art, creating the effect of mass and weight by using variations of color, light, and shadow. In three-dimensional art, building a form out of a pliable **medium**, such as clay.

MOLDING An ornamental band used for decoration and definition of architectural surfaces. On the exterior walls of buildings, a projecting horizontal band is termed a string course.

MONASTERY An establishment for monks or nuns who have withdrawn from the world to live under religious vows.

MONOCHROME A painting executed in shades of black and white, or in values of a single **hue**.

MOSAIC The use of small pieces of glass, colored stone, or tile (see **tessera**) to create designs on walls, floors, or ceilings.

MOSQUE A Muslim place of worship.

MOTIF A recurring element or theme within a work of art.

MUDRA Symbolic hand gestures in Indian Buddhist and Hindu art, each with specifically defined meanings.

MURAL A large painting executed directly on a wall, often using *buon fresco* or *fresco secco* techniques (see **fresco**).

MUSES The nine goddesses of Greek mythology who preside over the arts, literature, and science.

NAOS See **cella**.

NARTHEX The entrance hall or vestibule in Christian churches.

NATURALISM The representation of objects according to their appearance in nature.

NAVE The long central area, in which the congregation assembles, between the side **aisle**s of a **basilica**-plan Christian church.

NICHE A recess in a wall, often containing a statue.

NON-OBJECTIVE A term used to describe art of abstract (i.e. non-representational) nature,

that is, art that does not represent forms of the natural world.

NON-REPRESENTATIONAL See **non-objective**.

OBELISK An ancient Egyptian stone monument built with a four-sided, tapering shaft and a pyramidal top.

OCULUS A round opening in a wall or at the apex of a **dome**.

OIL PAINT A slow-drying paint developed in the fifteenth century which uses oil as the **medium** for binding the **pigment**.

ORDER A system categorizing Greek and Roman architecture into five different types of **column**s and **entablature**s. The **classical** orders are **Doric**, **Ionic**, **Corinthian**, Tuscan, and Composite.

ORIENTALISM A fascination, especially in the nineteenth century, with the art and culture of North Africa and the Near East, and a preference for exotic Islamic subjects such as harems, baths, and odalisques.

PALAZZO (pl. PALAZZI) Italian for a large town house. Used of palaces, large civic buildings, and more modest town houses.

PAPIER-COLLÉ See **collage**.

PAPYRUS SCROLL An early form of paper, produced in rolled format, called scrolls, and made by the Egyptians from the papyrus plant.

PASSION The events and suffering of Christ's last week on earth as recounted in the Gospels.

PASTEL A drawing **medium** made of dry, ground **pigment** mixed with gum into stick form.

PEDESTAL The base of a sculpture, vase, or **column**, also termed a plinth.

PEDIMENT A triangular **gable** over a **classical portico**, window, or door and, over classical porticoes, often decorated with sculpture.

PENDANT A picture devised to match or parallel another work by the same artist.

PENDENTIVE A curved triangular wall section in a domed building that provides a transition from the square frame of the supporting piers to the circular base of the **dome**.

PERFORMANCE ART A theatrical work of art of a type developed in the late 1960s that is performed live in front of an audience.

PERISTYLE A **colonnade** that completely surrounds the exterior of a building, e.g. of a Greek temple. A peristyle court is an open inner courtyard with columns around all sides.

PERSPECTIVE The illusion of depth on a two-dimensional picture plane, created by such techniques as aerial (or atmospheric) perspective and linear perspective. In aerial perspective a sense of depth in landscape is created by making distant objects appear paler and bluer than those in the foreground, imitating the way the atmosphere affects light. Linear perspective is a mathematical method developed in the Renaissance for creating the illusion of three-dimensional space on a picture plane by causing straight lines to recede and meet at a vanishing point on the horizon.

PHOTOMONTAGE A work of art in which photographs have been combined and arranged to form a new image, similar to a **collage**.

PIANO NOBILE The principal story of an

Italian **palazzo**, or other mansion, one floor above street level, housing the main reception rooms.

PIAZZA Italian word for a public square.

PIER A solid masonry support—distinct from a **column**—used in an arched or vaulted structure.

PIETÀ An image of the grieving Virgin Mary holding the dead Christ in her lap.

PIGMENT The powdered substance that gives color to paint.

PILASTER A shallow pier or rectangular version of a **column** attached to a wall that sometimes has a structural function but is generally decorative.

PLEIN-AIR PAINTING Painting outdoors ("*en plein air*"), rather than in the studio.

PLINTH The base on which a column or statue is placed. See **pedestal**.

PODIUM A raised platform that forms the base of a building.

POLYCHROME A term used to describe a painting executed in several colors.

POLYPTYCH A painted or carved **altarpiece** consisting of more than three panels.

PORTAL Entrance door(s) framed by an elaborate architectural composition, especially an entrance to a church.

PORTICO A porch with a roof supported by columns, often an entrance.

POST-AND-LINTEL An architectural system in which vertical elements, or posts, support the horizontal elements, or lintels.

PRESBYTERY The area of a church to the east of the **choir**, where the high **altar** is located.

PRIMITIVISM A desire to recover a sense of primary human consciousness by incorporating into modern art non-naturalistic, pre-modern, and non-Western influences.

PRINTMAKING An art form in which an image is reproduced from a printing surface onto paper in numerous copies. Printmaking techniques include **intaglio**, **lithography**, **silkscreen**, and **relief**.

PROPYLAEUM Ceremonial entrance gateway to a temple precinct or other enclosure.

PSALTER An **illuminated manuscript** copy of the Book of Psalms, often richly decorated, used for liturgical and devotional purposes.

PUTTI (sing. PUTTO) A naked male infant who is often winged, popular in Renaissance art. Also called cupid or cherub.

PYLON Entrance to an Egyptian temple complex, consisting of a pair of wide, truncated pyramidal towers, flanking a central opening.

QIBLA The wall of a **mosque** indicating the direction of Mecca, towards which Muslims face in prayer.

QUATREFOIL A four-lobed ornamental pattern, similar in shape to a four-leaved clover, found in Gothic art and architecture.

READYMADE A manufactured object exhibited by the artist as a work of art, a concept introduced by Marcel Duchamp (1887–1968).

REALISM The representation of objects and experiences as they are actually experienced.

RED-FIGURE Ancient Greek pottery (developed around 530 BCE) in which the background is painted in black, leaving the figures the color of the red clay.

REFECTORY The dining hall of a monastery or convent.

REGISTER Horizontal bands of pictorial images or sculptural relief placed one above the other. In **printmaking**, the marks used to align the print for multiple-block color printing.

REINFORCED CONCRETE **Concrete** strengthened with imbedded wire or mesh steel supports; also called ferroconcrete.

RELIEF Sculpted forms which project from or are sunk into a plane, called high or low relief depending on the degree of projection. Also a **printmaking** technique in which the areas not to be printed are cut away, leaving the image projecting from the surface.

RELIQUARY A container or casket for sacred relics.

REPOUSSOIR (from French: *repousser*, "to push back") A means to suggest depth in a painting by placing a prominent figure or object in the immediate foreground, in contrasting scale to all the smaller elements beyond.

REREDOS See **retable**.

RETABLE A structure above and behind an **altar**, usually composed of carved or painted figures; also called a reredos.

RIB A slender **arch** which defines and supports a **vault**, called a ribbed vault.

ROSE WINDOW A large round window made of **stained glass** and stone **tracery**, characteristically found on the facades of Gothic **cathedral**s.

ROTUNDA A circular building, often surmounted by a **dome**.

RUSTICATION Blocks of masonry with deep joints and rough-textured surfaces, an effect that is often copied in plaster.

SACRISTY A room or building attached to a church in which the sacred vessels and vestments are kept; also called a vestry.

SALON A reception room in a large mansion. Also the term for the annual officially sponsored art exhibit in the Louvre in Paris from the early seventeenth through the nineteenth century.

SARCOPHAGUS A stone coffin, often decorated with **relief** sculpture.

SCRIPTORIUM A writing room in monasteries and convents where manuscripts were produced.

SCROLL A long roll of paper or other material used for writing and/or printing. Also the **volute** form of **Ionic** and **Corinthian capital**s.

SCUMBLING The application of a top layer of paint done so that areas of color underneath remain visible.

SECTION An architectural diagram showing a building as if cut vertically breadthwise (**cross section**) or lengthwise (**longitudinal section**).

SFUMATO **Modeling** a form through delicate variations of hazy light and shadow, especially as used by Leonardo da Vinci.

SHAFT The vertical, cylindrical part of a **column**, between the base and the **capital**.

SIBYL A divine prophetess of Greek and Roman mythology, also appearing in Christian representations, as in Michelangelo's Sistine Chapel.

SILKSCREEN A **printmaking** technique in which ink is squeezed through the mesh of a silkscreen that has been masked off in parts to create a stencil.

SILVERPOINT A drawing technique, in which a stylus with a silver point was used on a sheet of paper coated with lead white and gum water.

SKELETAL CONSTRUCTION A method of construction with a steel or **reinforced concrete** frame of vertical and horizontal members, clad with a non-load-bearing **curtain wall** of glass, aluminum, or other material.

SLIP A mixture of water and clay used to decorate pottery.

SPANDREL The triangular space between two adjoining arches or between a single **arch** and the rectangular frame that encloses it.

SQUINCH A system of gradually projecting arches built over the corners of a square space, to support and make a transition to a circular or polygonal dome.

STAINED GLASS Windows composed of pieces of colored glass held together by strips of lead.

STEEL-FRAME CONSTRUCTION See **skeletal construction**.

STELE An upright stone slab, usually carved with inscriptions or **relief**s for a commemorative purpose.

STOA A covered **portico** or **colonnade** facing a public meeting place in ancient Greek cities.

STUCCO A type of durable cement used to cover the walls of buildings; also fine plaster used for architectural decoration.

STUPA A sacred mound—hemispherical, bell-shaped, or pyramidal—used by Buddhists to enshrine sacred relics or mark a sacred site.

STYLOBATE The top level of the stone platform on which a **classical** temple **colonnade** stands.

SWAG A carved ornament in the form of a garland of flowers, fruits, or draped cloth.

TABERNACLE A place of worship, derived from the portable shrine housing the Ark of the Covenant carried by the Israelites. Also a canopied recess or **niche** for an image.

TABLINUM Reception room in Roman town house, immediately beyond the **atrium**, in which ancestor busts were displayed and visitors were received.

TEMPERA A paint in which the **pigment** is mixed with a **medium** made of egg yolk; popular in panel paintings in the fourteenth and fifteenth centuries.

TENEBRISM The dramatic contrast of a few brightly illuminated objects in a predominantly dark painting used by Caravaggio and his followers.

TERRACOTTA A rust-colored baked or fired clay that is often glazed, used for pottery, sculpture, and building material.

TESSERA (pl. tesserae) The individual pieces of tile, glass, or stone used to compose a **mosaic**.

THOLOS A small circular building, often domed.

TONDO A circular-shaped painting or relief.

TRACERY The thin ornamental stonework used in Gothic windows. Also the similar decoration applied to walls or panels.

TRANSEPT The cross arm of a **basilica**-plan church, placed perpendicular to the **nave**.

TRIFORIUM The section of the **nave** wall above the **arcade** and below the **clerestory** in Gothic architecture, comprising either a blind arcade or arcaded passageway.

TRIGLYPH In a **Doric frieze**, the rectangular blocks between the **metope**s, carved with three vertical grooves.

TRIPTYCH A painted or carved **altarpiece** consisting of three panels. The two **wing**s often fold over the center panel.

TROMPE L'OEIL Illusionistic painting which deceives the viewer into thinking that the painting is reality.

TRUMEAU A stone post at the center of a two-door **portal** supporting the **lintel** and often decorated with sculpture.

TRUSS A triangular construction of wooden beams, or cast-iron or steel bars, forming a rigid framework for a roof. Also used in bridge construction.

TYMPANUM The area between the doorway or **portal** of a church and the arch above it, often decorated with sculpture.

UNDERDRAWING A preparatory drawing executed directly on the painting **ground** over which the final work is painted.

VALUE The degree of lightness (high value) and darkness (low value) of a **hue**.

VANITAS A still life or **genre** painting symbolizing the transience of temporal life and the inevitability of death, popular in the seventeenth century.

VAULT An arched masonry roof or ceiling based on the principle of the **arch**; see also **barrel vault**, **cross vault**, and **rib**.

VERISM An extreme form of realism.

VILLA A large country house in antiquity, as also revived in the Renaissance.

VOLUTE The spiral scroll motif decorating **Ionic capital**s.

VOTIVE FIGURE A sculptural figure placed in or before a temple or shrine and dedicated to a deity or religious cult.

VOUSSOIRS Wedge-shaped stones set in a semicircular structure to form an **arch**.

WASH A thin, translucent layer of color or ink, as used in **watercolor** and brush drawing.

WATERCOLOR A paint made of water-soluble **pigment**s and usually applied to paper.

WESTWORK The monumental, multi-storied west end of a Christian church—as developed in the Carolingian era—with two towers, and including a **chapel** or **gallery** overlooking the **nave**.

WING A side panel of an **altarpiece** which is hinged to fold over the center panel.

WOODCUT A **relief printmaking** technique in which the image is carved on the surface of a block of wood by cutting away the areas not to be printed.

ZIGGURAT A stepped pyramid of ancient Near Eastern cultures made of mud brick surmounted by a temple or shrine.

Bibliography

This bibliography is composed of books in English that provide the most useful art history reference tools as well as general period surveys, and works on selected topics suitable for further reading and exploration. Monographs, on single artists, have been mostly excluded due to their sheer quantity, but can more easily be found in indexes and computer searches.

General Reference Works

Atkins, Robert. *Art'Speak: A Guide to Contemporary Ideas, Movements, and Buzzwords.* New York: Abbeville, 1990.

_____. *Art'Spoke: A Guide to Modern Ideas, Movements, and Buzzwords, 1848–1944.* New York: Abbeville, 1993.

Biedermann, Hans. *Dictionary of Symbolism.* New York/Oxford: Facts on File, 1992.

Dictionary of Art. Jane Turner, ed. 34 vols. New York: Grove, 1996.

Encyclopedia of World Art. 15 vols. New York: McGraw-Hill, 1959–68.

Fleming, John, Hugh Honour, and Nikolaus Pevsner. *Glossary of Architectural Terms.* 4th ed. Harmondsworth: Penguin, 1991.

Hall, James. *Dictionary of Subjects and Symbols in Art.* 2nd ed. New York: Harper & Row, 1979.

Murray, Peter and Linda. *The Penguin Dictionary of Art and Artists.* 4th ed. Harmondsworth: Penguin, 1976.

General Surveys

Gardner, Helen. *Gardner's Art Through the Ages.* 11th ed., ed. Fred S. Kleiner, Christin J. Mamiya, and Richard G. Tansey. Fort Worth: Harcourt College Publishers, 2001.

Hartt, Frederick. *Art: A History of Painting, Sculpture, Architecture.* 4th ed., 2 vols. Upper Saddle River, NJ: Prentice-Hall, 1997.

Honour, Hugh, and John Fleming. *The Visual Arts: A History.* 5th ed. Upper Saddle River, NJ: Prentice-Hall, 2000.

Janson, H.W. *History of Art.* 6th ed. Anthony F. Janson. Upper Saddle River, NJ: Prentice-Hall, 2001.

Kostof, Spiro. *A History of Architecture: Settings and Rituals.* New York: Oxford Univ. Press, 1985.

Pevsner, Nikolaus. *An Outline of European Architecture.* 7th ed. Baltimore: Penguin, 1970.

Sayre, Henry M. *A World of Art.* 3rd ed. Upper Saddle River, NJ: Prentice-Hall, 2000.

Sculpture: From Antiquity to the Middle Ages: From the Eighth Century BC to the Fifteenth Century. Köln: Taschen, 1999.

Sculpture: From the Renaissance to the Present Day: From the Fifteenth to the Twentieth Century. Köln: Taschen, 1999.

Stokstad, Marilyn. *Art History.* Rev. ed. Upper Saddle River, NJ: Prentice Hall, 1999.

Trachtenberg, Marvin, and Isabelle Hyman. *Architecture, from Prehistory to Post-Modernism: The Western Tradition.* Upper Saddle River, NJ: Prentice-Hall, 1986.

Specialized Studies

Ackerman, James S. *The Villa: Form and Ideology of Country Houses.* Princeton: Princeton Univ. Press, 1990.

Bacon, Edmund N. *Design of Cities.* New York: Viking, 1967.

Belting, Hans. *Likeness and Presence: A History of the Image before the Era of Art.* 1990. Transl. Edmund Jephcott. Chicago: Univ. of Chicago Press, 1994.

Broude, Norma, and Mary D. Garrard, eds. *Feminism and Art History: Questioning the Litany.* New York: Harper & Row, 1982.

_____. *The Expanding Discourse: Feminism and Art History.* New York: Harper Collins, 1992.

Calo, Carole Gold. *View Points: Readings in Art History.* 2nd ed. Upper Saddle River, NJ: Prentice-Hall, 2001.

Chadwick, Whitney. *Women, Art, and Society.* New York: Thames & Hudson, 1990.

Chicago, Judy, and Edward Lucie-Smith. *Women and Art: Contested Territory.* New York: Watson-Guptill Publications, 1999.

Clark, Kenneth. *The Nude: A Study in Ideal Form.* New York: Pantheon, 1956.

_____. *Landscape into Art.* London: John Murray, 1976.

Ebert-Schifferer, Sybille. *Still Life: A History.* Transl. Russell Stockman. New York: Harry N. Abrams, 1999.

Feldman, Edmund B. *The Artist: A Social History.* 2nd ed. Upper Saddle River, NJ: Prentice-Hall, 1995.

Freedberg, David. *The Power of Images: Studies in the History and Theory of Response.* Chicago: Univ. of Chicago Press, 1989.

Girouard, Mark. *Cities and People.* New Haven: Yale Univ. Press, 1985.

Gombrich, E.H. *Art and Illusion.* 4th ed. New York: Pantheon, 1972.

Harrison, Charles, and Paul Wood, eds. *Art in Theory, 1900–1990: An Anthology of Changing Ideas.* Cambridge, MA: Blackwell, 1993.

Harrison, Charles, Paul Wood, and Jason Gaiger, eds. *Art in Theory, 1648–1815: An Anthology of Changing Ideas.* Malden, MA: Blackwell, 2000.

Holt, E.G. *A Documentary History of Art.* 2nd ed., 2 vols. Garden City, NY: Doubleday, 1981.

Jellicoe, Geoffrey and Susan. *The Landscape of Man: Shaping the Environment from Prehistory to the Present Day.* London: Thames & Hudson, 1975.

Kostof, Spiro. *The City Shaped: Urban Patterns and Meanings Through History.* Boston: Bulfinch, 1991.

Minor, Vernon Hyde. *Art History's History.* 2nd ed. Upper Saddle River: Prentice-Hall, 2001.

Panofsky, Erwin. *Meaning in the Visual Arts.* Reprint of 1955 ed. Chicago: Univ. of Chicago Press, 1982.

Roskill, Mark. *The Languages of Landscape.* University Park, PA: Penn State Press, 1996.

Schama, Simon. *Landscape and Memory.* New York: Knopf, 1995.

Schneider, Norbert. *The Art of Still-Life, Still-Life Painting in the Early Modern Period.* Köln: Taschen, 1990.

Schneider, Norbert. *The Art of the Portrait: Masterpieces of European Portrait Painting, 1420-1670.* Köln: Taschen, 1999.

Surveys of Non-Western Art

Barrow, Terence. *The Art of Tahiti and the Neighboring Society, Austral and Cook Islands.* London: Thames & Hudson, 1979.

Brend, Barbara. *Islamic Art.* Cambridge, MA: Harvard Univ. Press, 1991.

Craven, Roy C. *Indian Art: A Concise History.* New York: Thames & Hudson, 1985.

D'Alleva, Anne. *Arts of the Pacific Islands.* New York: Harry N. Abrams, 1998.

Fane, Diana, ed. *Converging Cultures: Art and Identity in Spanish America.* The Brooklyn Museum/New York: Harry N. Abrams, 1996.

Fisher, Robert E. *Buddhist Art and Architecture.* New York: Thames & Hudson, 1993.

Fuentes, Carlos. *The Buried Mirror: Reflections on Spain and the New World.* New York: Houghton Mifflin Company, 1992.

Irwin, Robert. *Islamic Art in Context: Art, Architecture, and the Literary World.* New York: Harry N. Abrams, 1997.

Kaeppler, Adrienne L., Christian Kaufmann, and Douglas Newton. *Oceanic Art.* New York: Harry N. Abrams, 1997.

La Plante, John D. *Asian Art.* 3rd ed. Dubuque, IA: Wm. C. Brown, 1992.

Lee, Sherman E. *A History of Far Eastern Art.* 5th ed. Upper Saddle River, NJ: Prentice-Hall, 1994.

Levenson, Jay A., ed. *Circa 1492: Art in the Age of Exploration.* Washington: National Gallery of Art/New Haven: Yale Univ. Press, 1991.

Miller, Mary Ellen. *The Art of Mesoamerica: From Olmec to Aztec.* New York: Thames & Hudson, 1986.

Rodríguez, Antonio. *A History of Mexican*

Mural Painting. New York: G.P.Putnam's Sons, 1969.

Stanley-Baker, Joan. *Japanese Art.* New York: Thames & Hudson, 1984.

Toussaint, Manuel. *Colonial Art in Mexico.* Trans. and ed. Elizabeth Wilder Weismann. Austin: Univ. of Texas Press, 1967.

Visonà, Monica Blackmun, *et. al. A History of Art in Africa.* New York: Harry N. Abrams, 2001.

Willett, Frank. *African Art: An Introduction.* 1971. New York: Thames & Hudson, 1985.

1 ENGAGING ART

Source References

p. 12 For the varied and changing roles of artists in history, see Edmund B. Feldman, *The Artist: A Social History,* 2nd ed. Englewood Cliffs, NJ: Prentice-Hall, 1995, which served as a key source for "The Artist" boxes throughout this book.

p. 22 For Gabo's "The Realistic Manifesto," see Herschel B. Chipp, *Theories of Modern Art,* Berkeley: University of California Press, 1969, pp. 325–37, especially pp. 328–31.

p. 25–6 For Utzon's designs for the Opera House, see Sigfried Giedion, *Space, Time and Architecture: The Growth of a New Tradition,* 5th ed. Cambrige, MA: Harvard University Press, 1967, pp. 674–5.

General Surveys

Barnet, Sylvan. *A Short Guide to Writing About Art.* 5th ed. New York: Longman, 1997.

Barrett, Terry. *Criticizing Photographs: An Introduction to Understanding Images.* Mountain View, CA: Mayfield, 1990.

_____. *Criticizing Art: Understanding the Contemporary.* Mountain View, CA: Mayfield, 1994.

Diepeveen, Leonard, and Timothy van Laar. *Art with a Difference: Looking at Difficult and Unfamiliar Art.* Mountain View, CA: Mayfield, 2001.

Fichner-Rathus, Lois. *Understanding Art.* 5th ed. Upper Saddle River, NJ: Prentice-Hall, 1998.

Feldman, Edmund Burke. *Varieties of Visual Experience.* 4th ed. Upper Saddle River, NJ: Prentice-Hall, 1993.

Roth, Leland M. *Understanding Architecture: Its Elements, History, and Meaning.* New York: Harper Collins, 1993

Sayre, Henry M. *Writing About Art.* 3rd ed. Upper Saddle River, NJ: Prentice-Hall, 1999.

2 PREHISTORIC AND ANCIENT ART

Source References

p. 41 For the moon goddess Nanna myth, see S.N. Kramer, *Sumerian Mythology,* New York: Harper, 1961, p. 43, quoted by Paul Lampl, *Cities and Planning in the Ancient Near East,* New York: George Braziller, 1968, p. 9.

General Surveys

Aldred, Cyril. *Egyptian Art in the Days of the Pharaohs, 3100–320 BC.* London: Thames & Hudson, 1980.

Amiet, Pierre. *Art of the Ancient Near East.* New York: Harry N. Abrams, 1980.

Doumas, Christos. *The Wall-paintings of Thera.* Trans. Alex Doumas. Athens: Thera Foundation, 1992.

Higgins, Reynold A. *Minoan and Mycenaean Art.* Rev. ed. Oxford: Oxford Univ. Press, 1981.

Lampl, Paul. *Cities and Planning in the Ancient Near East.* New York: Braziller, 1968.

Leroi-Gourhan, André. *The Dawn of European Art: An Introduction to Paleolithic Cave Painting.* Cambridge: Cambridge Univ. Press, 1982.

Powell. T.G.E. *Prehistoric Art.* New York: Oxford Univ. Press, 1966.

Woolley, Charles L. *The Art of the Middle East, including Persia, Mesopotamia, and Palestine.* New York: Crown, 1961.

3 GREEK ART

Source References

pp. 75–6 For Lucian quotation, see Lucian, *Amores,* 13, and *Imagines,* 6, quoted by J.J. Pollitt, *Art and Experience in Classical Greece,* Cambridge: Cambridge University Press, 1972, p. 159.

p. 84 Aristotle quoted (without source citation) and discussed by Spiro Kostof, *A History of Architecture: Settings and Rituals,* New York: Oxford University Press, 1985, p. 146.

General Surveys

Boardman, John. *Greek Art.* London: Thames & Hudson, 1985.

Fullerton, Mark D. *Greek Art.* Cambridge: Cambridge Univ. Press, 2000.

Pedley, John Griffiths. *Greek Art and Archaeology.* 2nd ed. Upper Saddle River, NJ: Prentice-Hall, 1998

Pollitt, J.J. *The Art of Greece 1400–31 BC. Sources and Documents.* Englewood Cliffs, NJ: Prentice-Hall, 1965.

_____. *Art and Experience in Classical Greece.* Cambridge: Cambridge Univ. Press, 1972.

Sprenger, Maja, Gilda Bartoloni, and Max Hirmer. *The Etruscans: Their History, Art, and Architecture.* New York: Harry N. Abrams, 1983.

Ward-Perkins, J.B. *Cities of Ancient Greece and Italy: Planning in Classical Antiquity.* New York: Braziller, 1974.

4 ROMAN ART

Source References

p. 97 For the symbolism of the Pantheon, see Spiro Kostof, *A History of Architecture,* pp. 217–8.

pp. 106–7 For Roman writers on villa life, see James S. Ackermann, *The Villa: Form and Ideology of Country Houses,* Princeton: Princeton University Press, 1990, pp. 37–42, 52–6.

p. 109 For the comments of Constantinius II, see *Ammianus Marcellinus,* with an English translation by John C. Rolfe, Loeb Classical Library, Cambridge, MA: Harvard University Press, 1963, XVI, 10, 15, p. 251.

General Surveys

D'Ambra, Eve. *Roman Art.* Cambridge: Cambridge Univ. Press, 1998.

Groenewegen-Frankfort, H.A., and Bernard Ashmole. *Art of the Ancient World.* Englewood Cliffs, NJ: Prentice-Hall, 1972.

Ramage, Nancy H., and Andrew Ramage. *Roman Art: Romulus to Constantine.* Englewood Cliffs, NJ: Prentice-Hall, 1991.

Strong, Donald. *Roman Art.* 2nd ed. Harmondsworth: Penguin, 1988.

Ward-Perkins, J.B. *Roman Architecture.* New York: Electa/Rizzoli, 1988.

5 THE RISE OF CHRISTIANITY

Source References

p. 122 On the relations between early Christians and the Roman state, see Pliny the Younger's letter to Trajan, Pliny, Epp.X (ad Trajan), xcvi, quoted in Henry Bettenson, *Documents of the Christian Church,* 2nd ed. Oxford: Oxford University Press, 1963, pp. 3–4.

p.123 For Christian beliefs and rituals, see Tony Lane, *Harper's Concise Book of Christian Faith,* San Francisco: Harper & Row, 1984, p. 51.

p. 123 On the differences between Orthodox and Catholic views of art, see Marilyn Stokstad, *Medieval Art,* pp. 124–6.

Early Christian and Byzantine Surveys

Beckwith, John. *Early Christian and Byzantine Art.* 2nd ed. Harmondsworth: Penguin, 1979.

Belting, Hans. *Likeness and Presence: A History of the Image before the Era of Art.* 1990. Transl. Edmund Jephcott. Chicago: Univ. of Chicago Press, 1994.

Gough, Michael. *The Origins of Christian Art.* London: Thames & Hudson, 1973.

Graber, André. *Christian Iconography: A Study of Its Origins.* Princeton: Princeton Univ. Press, 1968.

Krautheimer, Richard. *Early Christian and Byzantine Architecture.* 4th ed. Harmondsworth: Penguin, 1986.

Mango, Cyril. *Art of the Byzantine Empire, 312–1453.* Sources and Documents. Englewood Cliffs, NJ: Prentice-Hall, 1972.

Mathews, Thomas F. *The Clash of Gods: A Reinterpretation of Early Christian Art.* Princeton: Princeton Univ. Press, 1993.

Mathews, Thomas F. *Byzantium: From Antiquity to the Renaissance.* Upper Saddle River, NJ: Prentice-Hall, 1998.

Pelikan, Jaroslav. *Imago Dei: The Byzantine Apologia for Icons.* Princeton: Princeton Univ. Press, 1990.

Early Medieval Surveys

Beckwith, John. *Early Medieval Art: Carolingian, Ottonian, Romanesque.* New York: Thames & Hudson, 1985.

Conant, Kenneth. *Carolingian & Romanesque*

Architecture 800–1200. 4th ed. Harmondsworth: Penguin, 1978.

Henderson, George. Early Medieval. Harmondsworth: Penguin, 1972.

Lasko, Peter. Ars Sacra, 800–1200. Harmondsworth: Penguin, 1972.

6 MEDIEVAL ART

Source References
p. 175 Gerard of Cambrai quoted in Georges Duby, History of Medieval Art, vol. I, p. 61

Medieval Art Surveys
Duby, Georges. History of Medieval Art (980 –1440). 2 vols. New York: Rizzoli, 1986.

Snyder, James. Medieval Art: Painting– Sculpture–Architecture, Fourth– Fourteenth Century. Upper Saddle River, NJ: Prentice Hall, 1989.

Stokstad, Marilyn. Medieval Art. New York: Harper & Row, 1986.

Romanesque Art Surveys
Cahn, Walter. Romanesque Bible Illuminations. Ithaca: Cornell Univ. Press, 1982.

Conant, Kenneth. Carolingian and Romanesque Architecture 800–1200. 4th ed. Harmondsworth: Penguin, 1978.

Hearn, M.F. Romanesque Sculpture: The Revival of Monumental Stone Sculpture in the Eleventh and Twelfth Centuries. Ithaca: Cornell Univ. Press, 1981.

Kubach, Hans. Romanesque Architecture. New York: Electa/Rizzoli, 1988.

Petzold, Andreas. Romanesque Art. Upper Saddle River, NJ: Prentice-Hall, 1996.

Verdon, Timothy G., and John Dally, eds. Monasticism and the Arts. Syracuse, NY: Syracuse Univ. Press, 1983.

Gothic Art Surveys
Camille, Michael. Gothic Art: Glorious Visions. Upper Saddle River, NJ: Prentice-Hall, 1997.

Cole, Bruce. Giotto and Florentine Painting, 1280–1375. New York: Harper & Row, 1976.

Duby, Georges. The Age of Cathedrals: Art and Society 980–1420. Chicago: Univ. of Chicago Press, 1976

Gothic and Renaissance Art in Nuremberg, 1300-1550. Exh. cat. New York: The Metropolitan Museum of Art/Munich: Prestel, 1986.

Grodecki, Louis. Gothic Architecture. New York: Electa/Rizzoli, 1985.

_____, and Catherine Brisac. Gothic Stained Glass 1200-1300. Ithaca: Cornell Univ. Press, 1985.

Henderson, George. Gothic. Harmondsworth: Penguin, 1967.

Katzenellenbogen, Adolf. The Sculptural Programs of Chartres Cathedral. Baltimore: Johns Hopkins Univ. Press, 1959.

Mâle, Émile. The Gothic Image: Religious Art in the Twelfth Century. Rev. ed. Princeton: Princeton Univ. Press, 1978.

Pächt, Otto. Book Illumination in the Middle Ages. New York: Oxford Univ. Press, 1986.

Panofsky, Erwin. Gothic Architecture and Scholasticism. Latrobe, PA: Archabbey, 1951.

Pope-Hennessy, John. Italian Gothic Sculpture. 3rd ed. Oxford: Phaidon, 1986.

Smart, Alastair. The Dawn of Italian Painting, 1250–1400. Ithaca: Cornell Univ. Press, 1978.

Swaan, Wim. The Late Middle Ages: Art & Architecture from 1350–Renaissance. Ithaca: Cornell Univ. Press, 1977.

Thomas, Marcel. The Golden Age: Manuscript Painting at the Time of Jean, Duke of Berry. New York: Braziller, 1979.

White, John. Art and Architecture in Italy: 1250–1400. Harmondsworth: Penguin, 1993.

Wilson, Christopher. The Gothic Cathedral: The Architecture of the Great Church, 1130-1530. New York: Thames & Hudson, 1990.

7 ITALIAN RENAISSANCE ART

Source References
p. 195 For Renaissance humanists, see Paul Oskar Kristeller, Renaissance Concepts of Man, and other Essays, New York: Harper & Row, 1972, pp. 1–63.

p. 195 Gianozzo Manetti, as quoted in Ruth Butler, Western Sculpture: Definitions of Man, New York: Harper & Row, 1979, p. 108.

p. 212 Giovanni Rucellai, as quoted in Michael Baxandall, Painting and Experience in Fifteenth-Century Italy, London: Oxford University Press, 1972, pp. 2–3.

p. 226 See Giorgione's The Three Shepherds Adoring the Christ Child, The National Gallery, Washington, D.C., and see also Johannes Wilde, Venetian Art from Bellini to Titian, Oxford: Clarendon Press, 1974, pp. 66–7.

pp. 226–8 On the significance of the child urinating, see Bruce Cole, Italian Art 1250–1550: The Relation of Renaissance Art to Life and Society, New York: Harper & Row, 1987, pp. 49–52, and figs. 41, 43.

General Surveys
Hartt, Frederick. History of Italian Renaissance Art: Painting, Sculpture, Architecture. 4th ed. New York: Harry N. Abrams, 1994.

Murray, Peter. Renaissance Architecture. New York: Harry N. Abrams, 1976.

Paoletti, John T. and Gary M. Radke. Art in Renaissance Italy. Upper Saddle River, NJ: Prentice-Hall, 1997.

Specialized Studies
Baxandall, Michael. Painting and Experience in Fifteenth-Century Italy: A Primer in the Social History of Pictorial Style. 2nd ed. New York: Oxford Univ. Press, 1988.

Blunt, Anthony. Artistic Theory in Italy 1450–1600. Oxford: Clarendon Press, 1959.

Brown, Patricia Fortini. Art and Life in Renaissance Venice. Prentice Hall, NJ: Prentice-Hall, 1998.

Cafritz, Robert C., Lawrence Gowing, and David Rosand. Places of Delight: The Pastoral Landscape. Exh. cat. Washington, D.C.: The Phillips Collection/ National Gallery of Art, 1988.

Campbell, Lorne. Renaissance Portraits: European Portrait-Painting in the Four-teenth, Fifteenth, and Sixteenth Centuries. New Haven: Yale Univ. Press, 1990.

Cole, Alison. Virtue and Magnificence: Art of the Italian Renaissance Courts. Upper Saddle River, NJ: Prentice-Hall, 1996.

Cole, Bruce. Italian Art 1250–1550: The Relation of Renaissance Art to Life and Society. New York: Harper & Row, 1987.

Gilbert, Creighton E. Italian Art, 1400 –1500. Sources and Documents. Englewood Cliffs, NJ: Prentice-Hall, 1980.

Goffen, Rona. Piety and Patronage in Renaissance Venice: Bellini, Titian, and the Franciscans. New Haven: Yale Univ. Press, 1986.

Humfrey, Peter. The Altarpiece in Renaissance Venice. New Haven: Yale Univ. Press, 1993.

Humfrey, Peter and Martin Kemp, eds. The Altarpiece in the Renaissance. Cambridge: Cambridge Univ. Press, 1990.

Huse, Norbert and Wolfgang Wolters. The Art of Renaissance Venice: Architecture, Sculpture, and Painting, 1460–1590. Trans. Edmund Jephcott. Chicago: University of Chicago Press, 1990.

Klein, Robert and Henri Zerner. Italian Art 1500–1600. Sources and Documents. Englewood Cliffs: Prentice-Hall, 1966.

Levenson, Jay A., ed. Circa 1492: Art in the Age of Exploration. Washington: National Gallery of Art/New Haven: Yale Univ. Press, 1991.

Murray, Peter. Architecture of the Italian Renaissance. Rev. ed. New York: Thames & Hudson, 1986.

Partridge, Loren. The Art of Renaissance Rome: 1400–1600. Upper Saddle River, NJ: Prentice-Hall, 1997.

Pope-Hennessy, John. Italian Renaissance Sculpture. 3rd ed. New York: Oxford Univ. Press, 1986.

_____. Italian High Renaissance and Baroque Sculpture. 3 vols. 3rd ed. New York: Oxford Univ. Press, 1986.

Shearman, John. Mannerism. Harmondsworth: Penguin, 1967.

Turner, A.R. The Vision of Landscape in Renaissance Italy. Princeton: Princeton Univ. Press, 1974.

Turner, A. Richard, Renaissance Florence: The Invention of a New Art. Upper Saddle River, NJ: Prentice-Hall, 1997.

Vasari, Giorgio. The Lives of the Painters, Sculptors and Architects. Trans. Gaston Du C. de Vere. 3 vols. New York: Harry N. Abrams, 1979.

Welch, Evelyn. Art and Society in Italy 1350–1500. Oxford: Oxford Univ. Press, 1997.

Wittkower, Rudolf. Architectural Principles in the Age of Humanism. New York: St. Martin's Press, 1988.

8 NORTHERN RENAISSANCE ART

General Surveys
Cuttler, Charles P. Northern Painting from Pucelle to Bruegel. New York: Holt, Rinehart & Winston, 1968.

Murray, Peter. *Renaissance Architecture*. New York: Harry N. Abrams, 1976.

Snyder, James. *Northern Renaissance Art: Painting, Sculpture, the Graphic Arts From 1350–1575*. Upper Saddle River, NJ: Prenctice-Hall, 1985.

Specialized Studies

Argan, Giulio C. *The Renaissance City*. New York: Braziller, 1969.

Baxandall, Michael. *The Limewood Sculptures of Renaissance Germany*. New Haven: Yale Univ. Press, 1980.

Blunt, Anthony. *Art and Architecture in France: 1500–1700*. 4th ed. Harmondsworth: Penguin, 1981.

Christensen, Carl C. *Art and the Reformation in Germany*. Athens, OH: Ohio State Univ. Press, 1979.

Falkenburg, Reindert. *Joachim Patinir: Landscape as an Image of the Pilgrimage of Life*. Amsterdam: John Benjamins, 1988.

Gibson, Walter S. *"Mirror of the Earth:" The World Landscape in Sixteenth-Century Flemish Painting*. Princeton: Princeton Univ. Press, 1989.

Gothic and Renaissance Art in Nuremberg, 1300–1550. Exh. cat. New York: The Metropolitan Museum of Art/Munich: Prestel, 1986.

Koerner, J. *The Moment of Self-Portraiture in German Renaissance Art*. Chicago: Univ. of Chicago Press, 1993.

Harbison, Craig. *The Mirror of the Artist: Northern Renaissance Art in its Historical Context*. Upper Saddle River, NJ: Prentice-Hall, 1996.

Lane, Barbara G. *The Altar and the Altarpiece: Sacramental Themes in Early Netherlandish Painting*. New York: Harper & Row, 1984.

Panofsky, Erwin. *Early Netherlandish Painting, Its Origins, and Character*. 2 vols. Cambridge, MA: Harvard Univ. Press, 1953.

Smith, Jeffrey Chipps. *Nuremberg, A Renaissance City, 1500–1618*. Austin: Huntington Art Gallery, Univ. of Texas, 1983.

Stechow, Wolfgang. *Northern Renaissance, 1400–1600*. Sources and Documents. Englewood Cliffs, NJ: Prentice-Hall, 1966.

9 THE COUNTER-REFORMATION AND ARISTOCRATIC BAROQUE ART

Source References

p. 274 For observations on Mannerism see John Shearman, *Mannerism*, Harmondsworth, p. 55.

p. 277 On the Council of Trent, Paleotti, and Counter-Reformational critique of art, see Robert Klein and Henri Zerner, *Italian Art 1500–1600*, Sources and Documents, Evanston, IL: Northwestern University Press, 1989, pp. 119–33. See also Julius S. Held and Donald Posner, *Seventeenth and Eighteenth Century Art*, Englewood Cliffs, NJ: Prentice-Hall, 1974, pp. 70–73.

p. 278 For an insightful study of the Baroque, see John Rupert Martin, *Baroque*, New York: Harper & Row, 1977.

p. 283 For De Piles on Rubens' *Descent from the Cross* see Roger de Piles, *Conversations sur la connoissance de la peinture*, 1677, p. 135, and quoted by J.R. Martin, *Rubens: The Antwerp Altarpiece: The Raising of the Cross and the Descent from the Cross*, London: Thames & Hudson, 1969, p. 62.

pp. 297–9 See Mary D. Garrard, "Artemisia and Susanna," in Norma Broude and Mary D. Garrard, eds., *Feminism and Art History: Questioning the Litany*, New York: Harper & Row, 1982, pp. 147–71.

pp. 302–303 For the influence of Virgil's *Georgics* on Rubens, see Lisa Vergara, *Rubens and the Poetics for Landscape*, New Haven: Yale University Press, 1982, Chapters 4 and 5.

p. 303 For Poussin to Chantelou, from Rome, November 24, 1647, see Elizabeth B. Holt, *A Documentary History of Art*, vol. II, Garden City, New York: Doubleday Anchor Books, 1958, pp. 154–5.

General Surveys

Held, Julius S. and Donald Posner. *Seventeenth and Eighteenth Century Art: Baroque Painting. Sculpture. Architecture*. New York: Harry N. Abrams, 1971.

Minor, Vernon Hyde. *Baroque and Rococo: Art and Culture*. Upper Saddle River, NJ: Prentice-Hall, 1999.

Norberg-Schulz, Christian. *Baroque Architecture*. New York: Rizzoli, 1986.

_____. *Late Baroque and Rococo Architecture*. New York: Rizzoli, 1985.

Toman, Rolf, ed. *Baroque: Architecture, Sculpture, Painting*. Köln: Könemann, 1998.

Specialized Studies

Blunt, A. *Art and Architecture in France, 1500–1700*. 4th ed. Harmondsworth: Penguin, 1981.

Brown, Jonathan. *The Golden Age of Painting in Spain*. New Haven: Yale Univ. Press, 1991.

Engass, Robert, and Jonathan Brown. *Italy and Spain, 1600–1750*. Sources and Documents. Englewood Cliffs, NJ: Prentice-Hall, 1970

Haskell, Francis. *Patrons and Painters: A Study in the Relations between Italian Art and Society in the Age of the Baroque*. Rev. ed. New Haven: Yale Univ. Press, 1980.

Kubler, G. and M. Soria. *Art and Architecture in Spain and Portugal and Their American Dominions, 1500-1800*. Harmondsworth: Penguin, 1959.

Lagerlöf, Margaretha Rossholm. *Ideal Landscape: Annibale Carracci, Nicolas Poussin, and Claude Lorrain*. New Haven: Yale Univ. Press, 1990.

Mâle, Émile. *Religious Art from the Twelfth to the Eighteenth Century*. 1949. Princeton: Princeton Univ. Press, 1982.

Martin, John Rupert. *Baroque*. New York: Harper & Row, 1977.

Sutton, Peter C. *The Age of Rubens*. Boston: Museum of Fine Arts, 1993.

Vergara, Lisa. *Rubens and the Poetics of Landscape*. New Haven: Yale Univ. Press, 1982.

Wittkower, R. *Art and Architecture in Italy,
1600–1750. 3rd ed. Harmondsworth: Penguin, 1973.

10 DUTCH SEVENTEENTH-CENTURY ART

Source References

p. 316 For Dutch cartographic innovation, see the maps of Plancius, Blaeu, Hondius, and van der Keene discussed and illustrated by Dirk de Vries, " 'Chartmaking is the Power and Glory of the Country': Dutch Marine Cartography in the Seventeenth Century," in exh. cat., *Mirror of Empire: Dutch Marine Art of the Seventeenth Century*, Minneapolis Museum of Art, 1990, pp. 60–76, nos. 127, 128.

p. 318 For Rembrandt quotation, see Gary Schwartz, *Rembrandt: His Life, His Paintings*, Harmondsworth, Middlessex: Viking, 1985, p. 218.

p. 327 For Steen's allusion to the saying about the whore's lap see Simon Schama, *The Embarrassment of Riches*, New York: Alfred A. Knopf, 1987, p. 391, quoting Johan de Brune's *Emblemata ofte Sinnewerck*, Amsterdam, 1624, p. 231: "een hoeren schoot is duyvel's boot."

p. 330 For references to Huygens and Spiegel, see E. John Walford, *Jacob van Ruisdael and the Perception of Landscape*, New Haven: Yale University Press, 1991, pp. 15–28, especially pp. 17, 19ff, 27.

p. 332 Karel van Mander, *Den Grondt der Edel vry Schilder-Const...*, Haarlem, 1604, 2nd ed. 1618, V, p. 20, quoted in E. John Walford, *Jacob van Ruisdael*, p. 27.

p. 337 For significance of the ruins of Olinda, see Alan Chong in exh. cat. *Masters of Seventeenth-Century Dutch Landscape Painting*, Boston: Museum of Fine Arts, 1987-8, pp. 414–5, cat. no. 72.

General Surveys

Haak, Bob. *The Golden Age: Dutch Painters of the Seventeenth Century*. New York: Harry N. Abrams, 1984.

Kahr, Madlyn Millner. *Dutch Painting in the Seventeenth Century*. 2nd ed. New York: Harper Collins, 1993.

Rosenberg, Jacob, Seymour Slive, E.H. terKuile. *Dutch Art and Architecture 1600-1800*. Rev. ed. Harmondsworth: Penguin, 1972.

Specialized Studies

Alpers, Svetlana. *The Art of Describing: Dutch Art in the Seventeenth Century*. Chicago: Chicago Univ. Press, 1983.

Bergstrom, Ingvar. *Dutch Still-life Painting in the Seventeenth Century*. 1956, reissued New York: Hacker, 1983.

Brown, Christopher. *Images of a Golden Past: Dutch Genre Painting of the Seventeenth Century*. New York: Abbeville, 1984.

Franits, Wayne. *Paragons of Virtue: Women and Domesticity in Seventeenth-Century Dutch Art*. Cambridge: Cambridge Univ. Press, 1993.

Keyes, George S., *et al. Mirror of Empire:*

Dutch Marine Art of the Seventeenth Century. Exh. cat. Minneapolis: Institute of Arts, 1990.

Kloek, Wouter Th., *et al. Dawn of the Golden Age: Northern Netherlandish Art 1580–1620.* Exh. cat. Amsterdam: Rijksmuseum, 1993.

Schama, Simon. *The Embarrassment of Riches: An Interpretation of Dutch Culture in the Golden Age.* New York: Knopf, 1987.

Segal, Sam. *A Prosperous Past: The Sumptuous Still Life in the Netherlands, 1600–1700.* Exh. cat. Delft: Het Prinsenhof/The Hague: SDU, 1988.

Sutton, Peter C., *et al. Masters of Seventeenth Century Dutch Genre Painting.* Exh. cat. Philadelphia Museum of Art, 1984.

_____. *Masters of Seventeenth Century Dutch Landscape Painting.* Exh. cat. Boston: Museum of Fine Arts, 1987.

Walford, E. John. *Jacob van Ruisdael and the Perception of Landscape.* New Haven: Yale Univ. Press, 1991.

Westermann, Mariët. *A Worldly Art: The Dutch Republic 1585–1718.* Upper Saddle River, NJ: Prentice-Hall, 1996.

11 ENGLISH BAROQUE AND EIGHTEENTH-CENTURY EUROPEAN AND AMERICAN ART

Source References

p. 340 For the old social order, see C.B.A. Behrens, *The Ancien Régime,* New York: Harcourt Brace Jovanovich Inc., 1967.

p. 340 For the development and influence of Enlightenment ideas, see A.G. Lehmann, *The European Heritage: An Outline of Western Culture,* Phaidon: Oxford, 1984, Chapter 6, especially pp.169–175.

p. 356 Sources for the lives of Roman Stoic heroes and heroines were Roman historians such as Livy, and the *Parallel Lives* of the Greek historian Plutarch, whose moral outlook—emphasizing the virtues of Stoic self-control and high sense of public duty—was particularly influential, especially in France. See further, L.D. Ettlinger, "Jacques Louis David and Roman Virtue," in Harold Spencer, ed., *Readings in Art History,* vol. II, 3rd ed., New York: Charles Scribner's, 1983, pp. 235–58.

pp. 361–62 For Gessner, see Lorenz Eitner, *Neoclassicism and Romanticism 1750–1850,* Sources and Documents, vol. I, Englewood Cliffs, NJ: Prentice-Hall, 1970, p. 51.

p. 371 Major Handley's survey of the "industrial arts of Rajputana" in the *Journal of Indian Art,* 1886, quoted by Roy C. Craven, *Indian Art: A Concise History,* London: Thames & Hudson, new ed. 1985, p. 244.

General Studies

Baetjer, Katherine and J.G. Links. *Canaletto.* Exh. cat. New York: The Metropolitan Museum of Art, 1989.

Boime, Albert. *Art in the Age of Revolution, 1750–1800.* Chicago: Univ. of Chicago Press, 1987.

Conisbee, Philip. *Painting in Eighteenth-Century France.* Ithaca: Cornell Univ. Press, 1981.

Craven, Wayne. *American Art: History and Culture.* Madison: WCB Brown & Benchmark, 1994.

Crow, Thomas E. *Painters and Public Life in Eighteenth-Century Paris.* New Haven: Yale Univ. Press, 1985.

Eitner, Lorenz. *Neoclassicism and Romanticism 1750–1850.* Vol. I, *Enlightenment/ Revolution.* Sources and Documents. Englewood Cliffs, NJ: Prentice-Hall, 1970.

Honour, H. *Neo-Classicism.* Harmondsworth: Penguin, 1978.

Jackson-Stops, Gervase, and James Pipkin. *The English Country House: A Grand Tour.* Boston: Little, Brown & Co., 1985.

Levey, M. *Rococo to Revolution: Major Trends in Eighteenth-Century Painting.* New York: Thames & Hudson, 1986.

Rosenblum, R. *Transformation in Late Eighteenth Century Art.* Princeton: Princeton Univ. Press, 1967.

Summerson, J. *Architecture in Britain: 1530–1830.* 3rd rev. ed. Baltimore: Penguin, 1958.

Waterhouse, Ellis K. *Painting in Britain: 1530–1790.* 4th ed. Harmondsworth: Penguin, 1978.

12 ART IN THE ROMANTIC AGE

Source References

p. 374 For the emphasis on innate genius, inspiration, and imagination, see further W. Blake, quoted in Lorenz Eitner, *Neoclassicism and Romanticism,* vol. I, p.123, and Baudelaire, Eitner, vol. II, p. 163.

p. 375 For Friedrich quotation, see Lorenz Eitner, *Neoclassicism and Romanticism 1750–1850,* vol. II, pp. 54 and 55.

p. 392 For Carus quotations, see Eitner, vol. II, pp. 48 and 51; for Kant on sublimity, Eitner, vol. I, pp. 96–7.

p. 394 Thomas Cole, "Essay on American Scenery," 1835, pp. 11–2, quoted in Joseph S. Czestochowski, *The American Landscape Tradition,* New York: E.P. Dutton, Inc., 1982, pp. 15–6.

p. 396 George Gilbert Scott, as quoted by Nikolaus Pevsner, *An Outline of European Architecture,* 7th ed., Harmondsworth, Middlessex: Penquin Books Ltd., 1963, p. 383.

p. 399 Delacroix's "Letter to J.B. Pierret, from Tangier, 29 February 1832," quoted in Eitner, vol. II, p. 115.

General Studies

Boime, Albert. *Art in the Age of Bonapartism, 1800–1815.* Chicago: Univ. of Chicago Press, 1990.

Czestochowski, Joseph S. *The American Landscape Tradition.* New York: Dutton, 1982.

Eitner, Lorenz. *Neoclassicism and Romanticism 1750–1850.* Vol. II. Sources & Documents. Englewood Cliffs, NJ: Prentice-Hall, 1970.

Honour, Hugh. *Romanticism.* London: Allen Lane, 1979.

Kroeber, Karl. *British Romantic Art.* Berkeley: Univ. of California Press, 1986.

Rosenblum, Robert. *Modern Painting and the Northern Romantic Tradition: Friedrich to Rothko.* London: Thames & Hudson, 1975.

Vaughan, William. *German Romantic Painting.* New Haven: Yale Univ. Press, 1980.

_____. *Romanticism and Art.* New York: Thames & Hudson, 1994.

13 THE RISE OF MODERNISM: 1848–1900

Source References

p. 402 Baudelaire, as quoted in Eitner, vol. II, pp. 154–5.

p. 403 Viollet-le-Duc, as quoted in William J.R. Curtis, *Modern Architecture: Since 1900,* Englewood Cliffs, NJ: Prentice-Hall, 1983, p. 14.

p. 406 Letter of Gauguin to Schuffenecker, August 14, 1888, quoted by R. Goldwater, *Paul Gauguin,* New York, 1957, p. 80.

p. 407 Letter of Gauguin to Daniel de Monfried, February 1898, quoted by Herschel B. Chipp, *Theories of Modern Art,* Berkeley: University of California Press, 1969, p. 72.

p. 409 Théophile Thoré, review of the Salon of 1861, quoted in Linda Nochlin, *Realism and Tradition in Art 1848–1900,* Sources and Documents. Englewood Cliffs, NJ: Prentice-Hall, 1966, p. 55.

p. 415 Comments on *The Night Café* from a letter of Van Gogh to his brother Theo van Gogh, 8 September 1888, and a second letter of no date (c. September 1888), both quoted by Chipp, pp. 36–7.

p. 416 Baudelaire, as quoted in Eitner, vol. II, pp. 161 and 163.

p. 420 Henry James in *Galaxy,* July 1875, quoted and discussed by Wayne Craven, *American Art: History and Culture,* Madison, WI: Brown & Benchmark Publishers, 1994, pp. 330 and 336.

p. 420 Statement by H.O. Tanner in 1894, quoted by Stephen F. Eisenman, *Nineteenth-Century Art: A Critical History,* London: Thames & Hudson, 1994, p. 186.

p. 423 Monet's explanation of his methods was recorded by Lilla Cabot Perry, "Reminiscences of Claude Monet from 1889 to 1909," *The American Magazine of Art,* vol. 18, no. 3, March 1927, p. 120.

General Surveys

Arnason, H.H., and Marla F. Prather. *History of Modern Art: Painting, Sculpture, Architecture, Photography.* 4th ed. Upper Saddle River, NJ: Prentice-Hall, 1999.

Craven, Wayne. *American Art: History and Culture.* Madison: WCB Brown & Benchmark, 1994.

Chipp, Herschel B. ed. *Theories of Modern Art: A Source Book by Artists and Critics.* Berkeley: Univ. of California Press, 1968.

Frampton, Kenneth. *Modern Architecture: A Critical History.* New York: Thames & Hudson, 1985.

Hamilton, George H. *Nineteenth and Twentieth Century Art: Painting, Sculpture, and Architecture.* New York: Harry N. Abrams, 1972.

Hughes, Robert. *The Shock of the New.* New York: Knopf, 1981.

Hunter, Sam, John Jacobus, and Daniel Wheeler. *Modern Art: Painting, Sculpture, Architecture.* 3rd rev. ed. Upper Saddle River, NJ: Prentice-Hall, 2000.

McCoubrey, John W. *American Art 1700–1960.* Sources & Documents. Upper Saddle River, NJ: Prentice-Hall, 1965.

Middleton, Robin, and David Watkin. *Neoclassical and Nineteenth Century Architecture.* 2 vols. New York: Electa/Rizzoli, 1987.

Newhall, Beaumont. *The History of Photography: From 1839 to the Present.* Rev. ed. New York: Museum of Modern Art, 1982.

Rosenblum, Naomi. *A World History of Photography.* Rev. ed. New York: Abbeville, 1989.

Tafuri, Manfredo. *Modern Architecture.* 2 vols. New York: Electa/Rizzoli, 1986.

Weaver, M. *The Art of Photography, 1839–1989.* New Haven: Yale Univ. Press, 1989.

Nineteenth Century: General Surveys

Eisenman, Stephen F. *Nineteenth-Century Art: A Critical History.* London/New York: Thames & Hudson, 1994.

Eitner, Lorenz. *An Outline of 19th-Century European Painting: From David through Cézanne.* 2nd ed. New York: Harper Collins, 1992.

Rosenblum, Robert and H.W. Janson. *Nineteenth-Century Art.* Upper Saddle River, NJ: Prentice-Hall, 1984.

Nineteenth Century: Specialized Studies

Clark, T.J. *Image of the People: Gustave Courbet and the 1848 Revolution.* Princeton: Princeton Univ. Press, 1982.

_____. *The Painting of Modern Life: Paris in the Art of Manet and His Followers.* Princeton: Princeton Univ. Press, 1986.

Denvir, Bernard. *Post-Impressionism.* New York: Thames & Hudson, 1992.

Hamilton, George H. *Painting & Sculpture in Europe, 1880–1940.* Harmondsworth: Penguin, 1972.

Herbert, Robert L. *Impressionism: Art, Leisure, and Parisian Society.* New Haven: Yale Univ. Press, 1988.

Nochlin, Linda. *Realism and Tradition in Art 1848–1900.* Sources and Documents. Englewood Cliffs: Prentice-Hall, 1966.

_____. *Realism.* Harmondsworth: Penguin, 1971.

_____. *Impressionism and Post-Impressionism, 1874–1904.* Sources and Documents. Englewood Cliffs: Prentice-Hall, 1976.

_____. *The Politics of Vision: Essays on Nineteenth-Century Art and Society.* New York: Harper & Row, 1989.

Novak, Barbara. *American Painting of the Nineteenth Century: Realism, Idealism, and the American Experience.* 2nd. ed. New York: Harper & Row, 1979.

_____. *Nature and Culture: American Landscape Painting, 1825–1875.* New York: Oxford Univ. Press, 1980.

Pevsner, Nikolaus. *The Sources of Modern Architecture and Design.* New York: Oxford Univ. Press, 1968.

The Pre-Raphaelites. Exh. cat. London: Tate Gallery, 1984.

Rewald, John. *Post-Impressionism: From Van Gogh to Gauguin.* 2nd ed. New York: Museum of Modern Art, 1962.

_____. *The History of Impressionism.* 4th ed. New York: Museum of Modern Art, 1973.

Rosenblum, Robert. *Modern Painting and the Northern Romantic Tradition: Friedrich to Rothko.* London: Thames & Hudson, 1975.

Whitford, Frank. *Japanese Prints and Western Painters.* New York: MacMillan, 1977.

14 EARLY TWENTIETH-CENTURY MODERNISM

Source References

p. 446 Constantin Zarnescu, *Aforismele si textele lui Brancusi,* Craiova, 1980, no. 79, quoted and discussed by Roger Lipsey, *An Art of Our Own: The Spiritual in Twentieth-Century Art,* Boston: Shambhala, 1988, p. 231.

p. 454 Beckmann's views on art and his personal vision are from Max Beckmann's London lecture, "On My Painting," 21 July 1938, as quoted in Herschel B. Chipp, *Theories of Modern Art: A Source Book by Artists and Critics,* Berkeley: University of California Press, 1969, pp. 188–9.

p. 466 For Walter Gropius, see *Idee und Aufbau,* 1923, and his earlier statement from 1913, as quoted by William J.R. Curtis, *Modern Architecture since 1900,* Englewood Cliffs, NJ: Prentice-Hall, 1983, pp. 118 and 126

General Studies

Arnason, H.H., and Marla F. Prather. *History of Modern Art: Painting, Sculpture, Architecture, Photography.* 4th ed. Upper Saddle River, NJ: Prentice-Hall, 1999.

Hunter, Sam, John Jacobus, and Daniel Wheeler. *Modern Art: Painting, Sculpture, Architecture.* 3rd rev. ed. Upper Saddle River, NJ: Prentice-Hall, 2000.

Lucie-Smith, Edward. *Lives of the Great Twentieth Century Artists.* New York: Rizzoli, 1986.

Lucie-Smith, Edward. *Visual Arts in the Twentieth Century.* Upper Saddle River, NJ: Prentice-Hall, 1997.

Specialized Studies

Golding, John. *Cubism: A History and an Analysis, 1907–1914.* 3rd. ed. Cambridge, MA: Belknap Press, 1988.

Herbert, James D. *Fauve Painting: The Making of Cultural Politics.* New Haven: Yale Univ. Press, 1992.

Jaffé, Hans L. C. *De Stijl, 1917–1931: The Dutch Contribution to Modern Art.* Cambridge, MA: Belknap, 1986.

Joachimides, Christos M., ed., with Norman Rosenthal and Wieland Schmied. *German Art in the Twentieth Century.* Exh. cat. London: Royal Academy of Arts/Munich: Prestel, 1985.

Kandinsky, Wassily, *Concerning the Spiritual in Art.* Trans., with introduction, M.T.H. Sadler. New York: Dover, 1977.

Lipsey, Roger. *An Art of Our Own: The Spiritual in Twentieth-Century Art.* Boston: Shambhala, 1988.

Nadeau, M. *History of Surrealism.* Cambridge: Harvard Univ. Press, 1989.

"Primitivism" in Twentieth Century Art: Affinity of the Tribal and the Modern. New York: Museum of Modern Art, 1984.

Richter, Hans. *Dada: Art and Anti-Art.* New York: McGraw-Hill, 1965.

Stangos, Nikos. *Concepts of Modern Art.* 2nd ed. New York: Harper & Row, 1981.

Whitford, Frank. *Bauhaus.* London: Thames & Hudson, 1984.

15 POST-WAR TO POSTMODERN ART

Source References

p. 474 John Cruickshank, *Albert Camus and the Literature of Revolt,* New York: Oxford University Press, 1960, p. x, as quoted by Jack A. Hobbs and Robert L. Duncan, *Arts, Ideas, and Civilization,* 2nd ed., Englewood Cliffs, NJ: Prentice-Hall, 1992, p. 464.

p. 478 John Russell, *Francis Bacon,* London: Methuen, 1965, p. 1, quoted by H.R. Rookmaaker, *Modern Art and the Death of a Culture,* London: Inter-Varsity Press, 1970, p. 174.

p. 480 Mrs. John de Menil, *Address made at the Opening of the Rothko Chapel in Houston,* February 27, 1971, mimeograph distributed at the chapel, as quoted by Jonathan Fineberg, *Art Since 1940: Strategies of Being,* Englewood Cliffs, NJ: Prentice-Hall, 1995, p. 107.

p. 498 For Smithson quotation see Nancy Holt, ed., *The Writings of Robert Smithson,* New York: New York University Press, 1979, p. 111, quoted by Fineberg, p. 330.

p. 508 For Fuentes quotation, see Carlos Fuentes, *The Buried Mirror, Reflections on Spain and the New World,* New York: Houghton Mifflin Company, 1992, p. 353.

General Surveys

Arnason, H.H., and Marla F. Prather. *History of Modern Art: Painting, Sculpture, Architecture, Photography.* 4th ed. Upper Saddle River: Prentice-Hall, 1999.

Fineberg, Jonathan. *Art Since 1940: Strategies of Being.* 2nd ed. Upper Saddle River, NJ: Prentice-Hall, 2000.

Hunter, Sam, John Jacobus, and Daniel Wheeler, *Modern Art: Painting, Sculpture, Architecture,* 3rd rev. ed. Upper Saddle River, NJ: Prentice Hall, 2000.

Lucie-Smith, Edward. *Visual Arts in the Twentieth Century.* Upper Saddle River, NJ: Prentice-Hall, 1997.

Specialized Studies

Anderson, Maxwell L., *et al. Whitney Biennial: 2000 Biennial Exhibition.* New York: Whitney Museum of American Art, 2000.

Anfam, David. *Abstract Expressionism.* New York: Thames & Hudson, 1990.

Ashton, Dore. *American Art Since 1945.* New York: Oxford Univ. Press, 1982.

Beardsley, J. *Earthworks and Beyond: Contemporary Art in the Landscape.* New York: Abbeville, 1989.

Chayat, Sherry. *Life Lessons: The Art of Jerome Witkin.* Syracuse, NY: Syracuse Univ. Press, 1994.

Elger, Dietmar, ed. *Gerhard Richter, Landscapes.* Exh. cat. Sprengel Museum Hanover, 1998–99. Cantz Verlag: Ostfildern-Ruit, c. 1998.

Friis-Hansen, Dana, *et. al. Outbound: Passages from the 90's.* Exh. cat., Contemporary Arts Museum, Houston, 2000.

Godfrey, Tony. *The New Image: Painting in the 1980s.* New York: Abbeville, 1986.

Greenberg, Clement. *Art and Culture: Critical Essays.* Boston: Beacon Press, 1961.

Honnef, Klaus. *Contemporary Art.* Köln: Taschen, 1990.

Hopkins, David. *After Modern Art: 1945–2000.* Oxford: Oxford Univ. Press, 2000.

Jenks, Charles. *The Language of Post-Modern Architecture.* 6th ed. New York: Rizzoli, 1991.

Johnson, Ellen H., ed. *American Artists on Art, From 1940–1980.* New York: Harper & Row, 1982.

Jones, David Lloyd. *Architecture and the Environment: Bioclimatic Building Design.*

The Overlook Press: Woodstock and New York, 1998.

Kaprow, Allan. *Assemblage, Environments & Happenings.* New York: Harry N. Abrams, 1966.

Lippard, Lucy R. *Mixed Blessings: New Art in a Multicultural America.* New York: Pantheon, 1990.

Lucie-Smith, Edward. *Movements in Art Since 1945.* Rev. ed. London: Thames & Hudson, 1984.

_____. *Art in the Seventies.* Ithaca: Cornell Univ. Press, 1980.

_____. *Art in the Eighties.* Oxford: Phaidon, 1990.

_____. *Art Today.* London: Phaidon, 1995.

Mori, Mariko. Exh. cat.Chicago, Museum of Contemporary Art and the Serpentine Gallery, London, 1998/99.

Powell, Kenneth. *City Transformed: Urban Architecture at the Beginning of the Twenty-first Century.* New York: te Neues, 2000.

Raven, Arlene, Cassandra Langer, and Joanna Frueh. *Feminist Art Criticism: An Anthology.* 1988. New York: HarperCollins, 1991.

Risatti, Howard, ed. *Postmodern Perspectives: Issues in Contemporary Art.* 2nd ed. Upper Saddle River, NJ: Prentice-Hall, 1998.

Robins, Corinne. *The Pluralist Era: American Art 1968–1981* New York: Harper & Row, 1984.

Rodríguez, Antonio. *A History of Mexican Mural Painting.* G.P. Putnam's Sons, New York, 1969.

Rose, Barbara, ed. *Readings in American Art 1900–1975.* New York: Praeger, 1975.

Rosenberg, H. *The De-Definition of Art:*

Action Art to Pop to Earthworks. New York: Collier, 1972.

Rosenthal, Norman, *et. al. Sensation: Young British Artists from the Saatchi Collection.* Exh. cat. London, Royal Academy of the Arts, 1997. New York: Thames & Hudson, 1998.

Ross, David A. *Bill Viola.* Exh. cat. New York: Whitney Museum of American Art; Paris/New York: Flammarion, c. 1997.

Sandler, Irving. *The New York School: The Painters and Sculptors of the Fifties.* New York: Harper & Row, 1978.

_____. *American Art of the 1960s.* New York: Harper & Row, 1988.

Semin, Didier, *et. al. Christian Boltanski.* Phaidon: London, 1997.

Stangos, Nikos. *Concepts of Modern Art.* 2nd ed. New York: Harper & Row, 1981.

Taylor, Brandon. *Avant-Garde and After: Rethinking Art Now.* Upper Saddle River, NJ: Prentice-Hall, 1996.

Venturi, Robert. *Complexity and Contradiction in Architecture.* New York: Museum of Modern Art, 1966.

Wallis, Brian, ed. *Art after Modernism: Rethinking Representation.* Documentary Sources in Contemporary Art. New York: New Museum of Contemporary Art, 1984.

Weintraub, Linda. *Art on the Edge and Over: Searching for Art's Meaning in Contemporary Society: 1970s–1990s.* Litchfield, CT.: Art Insights, 1996.

Picture Credits

Calmann & King and the author wish to thank the institutions and individuals who have kindly provided photographic material. Collections are given in the captions alongside the illustrations. Sources for the illustrations not supplied by museums or collections, additional information, and copyright credits are given below. Numbers are figure numbers unless otherwise indicated.

Every effort has been made to contact the copyright holders, but should there be any errors or omissions, Calmann & King would be pleased to insert the appropriate acknowledgement in any subsequent printing of this publication.

The following abbreviations have been used:

AIC: The Art Institute of Chicago
Artothek: Artothek, Peissenberg, Germany
BPK: Bildarchiv Preussischer

Kulturbesitz, Berlin
DACS: Design and Artists Copyright Society
Giraudon: Giraudon, Paris
Hirmer: Fotoarchiv Hirmer, Munich
Maeyaert: Paul M.R. Maeyaert, Mont de l'Enclus (Orroir), Belgium
MMA: The Metropolitan Museum of Art, New York
NGAW: National Gallery of Art, Washington, D.C.
RHPL: Robert Harding Picture Library, London
RMN: Réunion des Musées Nationaux, Paris
Scala: Scala, Florence

1.2 ©Succession H. Matisse/DACS 2002 ©2002 The Museum of Modern Art, New York
1.4 RMN
1.7 ©Mario Quattrone, Florence
1.8 Gift of Joseph H. Hirshhorn, 1966

1.9 Tate Gallery Archive photo ©Frits Monshouwer
1.10 Frank O. Gehry & Associates photo Whit Preston
1.11 ©A.F. Kersting, London
1.12 ©Paul A. Souders/Corbis

2.1, 2.3 Colorphoto Hans Hinz, Allschwil, Switz.
2.4 ©Skyscan Balloon Photography
2.7 Giraudon
2.8 Drawing by Mrs G. Huxtable, *Anatolian Studies* (British Institute of Archaeology at Ankara) 1963 ©James Mellaart
2.9, 2.10 Hirmer
2.12, 2.16, 2.17 photos The Oriental Institute, University of Chicago
2.13 RMN
2.18 Carolyn Clarke/Spectrum Colour Library, London
2.20 Powerstock Zefa
2.23 ©Jürgen Liepe, Berlin
2.24 Harvard-Museum Expedition. Courtesy Museum

of Fine Arts, Boston
2.25, 2.30 Scala
2.28, 2.29, 2.31, 2.33 ©Craig and Marie Mauzy, Athens
2.32 ©Studio Kontos/Photostock, Athens

3.1, 3.2, 3.8, 3.14 ©Craig and Marie Mauzy, Athens
3.4, 3.20, 3.30 Hirmer
3.10, 3.16, 3.21, 3.26 ©Fotografica Foglia, Naples
3.11 Sonia Halliday Photographs, Weston Turville, UK
3.12 MMA Fletcher Fund, 1932
3.17, 3.19 Scala
3.22, 3.32 ©Araldo De Luca, Rome
3.23 By permission Civici Musei d'Arte e Storia di Brescia photo Fotostudio Rapuzzi, Brescia
3.27 Ekdotike Athenon, Athens
3.29 Deutsches Archaologisches Institute, Abteilun Istanbul Neg 70/21
3.31 BPK
3.33 Ann and Bury Peerless,

Birchington-on-Sea, UK
3.34 MMA Department of Asian Art, objects in "The Great Bronze Age of China" a Loan Exhibition from The People's Republic of China

4.2, 4.25 Fototeca Unione/American Academy, Rome
4.22, 4.24 Alinari, Florence
4.3, 4.14 Canali Photobank, Milan
4.4 NGAW Samuel H. Kress Collection
4.6, 4.10, 4.16, 4.19 ©Fotografica Foglia, Naples
4.7, 4.12 ©Araldo De Luca, Rome
4.9 MMA Rogers Fund
4.11 Charles Clifton Fund, 1938
4.15, 4.18, 4.20, 4.27 Scala
4.17 ©Julius Shulman
4.21 Giancarlo Costa, Milan
4.23, 4.30 ©Vincenzo Pirozzi, Rome
4.28 Aerofototeca dell'I.C.C.D. Rome
4.31 Courtesy the Director General of Antiquities and

Index